Dictionary of Literary Biography

Documentary Series

Yearbooks

Concise Series

Concise Dictionary of American Literary Biography, 7 volumes (1988-1999): *The New Consciousness, 1941-1968; Colonization to the American Renaissance, 1640-1865; Realism, Naturalism, and Local Color, 1865-1917; The Twenties, 1917-1929; The Age of Maturity, 1929-1941; Broadening Views, 1968-1988; Supplement: Modern Writers, 1900-1998.*

Concise Dictionary of British Literary Biography, 8 volumes (1991-1992): *Writers of the Middle Ages and Renaissance Before 1660; Writers of the Restoration and Eighteenth Century, 1660-1789; Writers of the Romantic Period, 1789-1832; Victorian Writers, 1832-1890; Late-Victorian and Edwardian Writers, 1890-1914; Modern Writers, 1914-1945; Writers After World War II, 1945-1960; Contemporary Writers, 1960 to Present.*

Concise Dictionary of World Literary Biography, 20 volumes projected (1999-): *Ancient Greek and Roman Writers; German Writers; African, Carribbean, and Latin American Writers; South Slavic and Eastern European Writers.*

Dictionary of Literary Biography® • Volume Two Hundred Thirty-Nine

American Women Prose Writers, 1820–1870

Dictionary of Literary Biography® • Volume Two Hundred Thirty-Nine

American Women Prose Writers, 1820–1870

Edited by
Amy E. Hudock
University of California, Berkeley
and
Katharine Rodier
Marshall University

A Bruccoli Clark Layman Book
The Gale Group
Detroit • San Francisco • London • Boston • Woodbridge, Conn.

Printed in the United States of America

The paper used in this publication meets the minimum requirements
of American National Standard for Information Sciences–Permanence
Paper for Printed Library Materials, ANSI Z39.48-1984. ∞™

Library of Congress Cataloging-in-Publication Data

American women prose writers: 1820–1870 / edited by Amy E. Hudock and Katharine Rodier.
 p. cm.–(Dictionary of literary biography: v. 239)
"A Bruccoli Clark Layman book."
Includes bibliographical references and index.
ISBN 0-7876-4656-3 (alk. paper)
1. American prose literature–Women authors–Bio-bibliography–Dictionaries. 2. Women and literature–United States–History–19th century–Dictionaries. 3. American prose literature–19th century–Bio-bibliography–Dictionaries. 4. American prose literature–Women authors–Dictionaries. 5. American prose literature–19th century–Dictionaries. 6. Women authors, American–Biography–Dictionaries.
I. Hudock, Amy E. II. Rodier, Katharine. III. Series.

PS149.A55 2001
[P301.3.G7]
818'.30809287–dc21 00-069921
[B] CIP

10 9 8 7 6 5 4 3 2 1

Contents

Plan of the Series

. . . Almost the most prodigious asset of a country, and perhaps its most precious possession, is its native literary product—when that product is fine and noble and enduring.

Mark Twain*

The advisory board, the editors, and the publisher of the *Dictionary of Literary Biography* are joined in endorsing Mark Twain's declaration. The literature of a nation provides an inexhaustible resource of permanent worth. Our purpose is to make literature and its creators better understood and more accessible to students and the reading public, while satisfying the needs of teachers and researchers.

To meet these requirements, *literary biography* has been construed in terms of the author's achievement. The most important thing about a writer is his writing. Accordingly, the entries in *DLB* are career biographies, tracing the development of the author's canon and the evolution of his reputation.

The purpose of *DLB* is not only to provide reliable information in a usable format but also to place the figures in the larger perspective of literary history and to offer appraisals of their accomplishments by qualified scholars.

The publication plan for *DLB* resulted from two years of preparation. The project was proposed to Bruccoli Clark by Frederick G. Ruffner, president of the Gale Research Company, in November 1975. After specimen entries were prepared and typeset, an advisory board was formed to refine the entry format and develop the series rationale. In meetings held during 1976, the publisher, series editors, and advisory board approved the scheme for a comprehensive biographical dictionary of persons who contributed to literature. Editorial work on the first volume began in January 1977, and it was published in 1978. In order to make *DLB* more than a dictionary and to compile volumes that individually have claim to status as literary history, it was decided to organize volumes by topic, period, or

*From an unpublished section of Mark Twain's autobiography, copyright by the Mark Twain Company

genre. Each of these freestanding volumes provides a biographical-bibliographical guide and overview for a particular area of literature. We are convinced that this organization—as opposed to a single alphabet method—constitutes a valuable innovation in the presentation of reference material. The volume plan necessarily requires many decisions for the placement and treatment of authors. Certain figures will be included in separate volumes, but with different entries emphasizing the aspect of his career appropriate to each volume. Ernest Hemingway, for example, is represented in *American Writers in Paris, 1920–1939* by an entry focusing on his expatriate apprenticeship; he is also in *American Novelists, 1910–1945* with an entry surveying his entire career, as well as in *American Short-Story Writers, 1910–1945, Second Series* with an entry concentrating on his short fiction. Each volume includes a cumulative index of the subject authors and articles.

Since 1981 the series has been further augmented by the *DLB Yearbooks,* which update published entries, add new entries to keep the *DLB* current with contemporary activity, and provide articles on literary history. There have also been nineteen *DLB Documentary Series* volumes which provide illustrations, facsimiles, and biographical and critical source materials for figures whose work is judged to have particular interest for students. In 1999 the *Documentary Series* was incorporated into the *DLB* volume numbering system beginning with *DLB 210, Ernest Hemingway.*

We define literature as the *intellectual commerce of a nation:* not merely as belles lettres but as that ample and complex process by which ideas are generated, shaped, and transmitted. *DLB* entries are not limited to "creative writers" but extend to other figures who in their time and in their way influenced the mind of a people. Thus the series encompasses historians, journalists, publishers, book collectors, and screenwriters. By this means readers of *DLB* may be aided to perceive literature not as cult scripture in the keeping of intellectual high priests but firmly positioned at the center of a nation's life.

DLB includes the major writers appropriate to each volume and those standing in the ranks behind them. Scholarly and critical counsel has been sought in

deciding which minor figures to include and how full their entries should be. Wherever possible, useful references are made to figures who do not warrant separate entries.

Each *DLB* volume has an expert volume editor responsible for planning the volume, selecting the figures for inclusion, and assigning the entries. Volume editors are also responsible for preparing, where appropriate, appendices surveying the major periodicals and literary and intellectual movements for their volumes, as well as lists of further readings. Work on the series as a whole is coordinated at the Bruccoli Clark Layman editorial center in Columbia, South Carolina, where the editorial staff is responsible for accuracy and utility of the published volumes.

One feature that distinguishes *DLB* is the illustration policy—its concern with the iconography of literature. Just as an author is influenced by his surroundings, so is the reader's understanding of the author enhanced by a knowledge of his environment. Therefore *DLB* volumes include not only drawings, paintings, and photographs of authors, often depicting them at various stages in their careers, but also illustrations of their families and places where they lived. Title pages are regularly reproduced in facsimile along with dust jackets for modern authors. The dust jackets are a special feature of *DLB* because they often document better than anything else the way in which an author's work was perceived in its own time. Specimens of the writers' manuscripts and letters are included when feasible.

Samuel Johnson rightly decreed that "The chief glory of every people arises from its authors." The purpose of the *Dictionary of Literary Biography* is to compile literary history in the surest way available to us—by accurate and comprehensive treatment of the lives and work of those who contributed to it.

The *DLB* Advisory Board

Introduction

DLB 239: American Women Prose Writers, 1820–1870 treats the lives and works of fiction and nonfiction prose writers who contributed to the development of American literature during a period when it was establishing its own identity as distinct from European literary traditions. The authors in this volume represent diverse cultural groups. Susan Petigru King, Mary Boykin Chesnut, Mary Anne Cruse, Sarah Morgan Dawson, Katharine Sherwood Bonner McDowell, and Margaret Junkin Preston were white Southerners; Elizabeth Keckley, Silvia Dubois, and Harriet Jacobs were once slaves. Harriet Beecher Stowe, Margaret Fuller, Louisa May Alcott, Sophia Peabody Hawthorne, and Mary Peabody Mann were tied to the New England literary tradition; Sarah Bagley and Harriet Farley were mill workers in Lowell, Massachusetts; Ann Plato, Nancy Gardner Prince, and Harriet Wilson were free black women born in New England.

These women expressed themselves in a variety of literary forms. Some wrote fiction and nonfiction for the reading public; others kept journals and wrote letters for their own edification or for the amusement of family members and perhaps a small circle of friends. Sophia Hawthorne's "Cuba Journal" was circulated among her family's literary circle of Salem, Massachusetts, and was never intended for publication. Similarly, Sarah Morgan Dawson never intended the diary she kept during the Civil War to be published and read by strangers. Mary Boykin Chesnut clearly distinguished between private and public writing when she extensively revised her personal diary to make it "suitable" for publication.

Despite social disapproval of women who took on public roles outside the home, some writers in this volume did write for publication, either for financial reasons or to further causes in which they believed. Louisa May Alcott, E. D. E. N. Southworth, and Lydia Sigourney used their earnings to bolster family finances. Sigourney, Mary Peabody Mann, and Emma Willard advocated equal educational opportunities for women. Ann Plato, an African American essayist, advanced the cause of education for blacks as well as women. Some, such as Zilpha Elaw, wrote as evangelists. Mary Jemison, a white woman who was kidnapped by and later chose to live among Native Americans, told her story in large part because she hoped to dispel the popular perception that Indians were savages. Charlotte Forten, Sarah Moore Grimké, Harriet Jacobs, Sojourner Truth, and Harriet Wilson contributed in various ways to the abolition movement, as did Lucretia Mott, Maria W. Stewart, and Lucy Stone, who went on to establish the foundation for the modern feminist movement. Rebecca Harding Davis shocked *Atlantic Monthly* readers with her fictional exposé *Life in the Iron Mills* (1861) and later write fiction that examined the effects of the Civil War on the lives of American families.

Many of these politically active women were better known as orators. Sojourner Truth, in fact, was illiterate, and her story, which is recognized as a major contribution to the slave-narrative genre, was dictated to and shaped by her editor. The slave narrative of Silvia DuBois and the captivity narrative of Mary Jemison, also "as-told-to" books, tell their stories in distinctive narrative voice. These figures are included here to create a full representation of female authorship during the fifty years between 1820 and 1870.

While this period is most often remembered as the time of the Civil War and the disputes over slavery that preceded it, these years also marked the rise of the novel as an American literary form and its gradual acceptance as suitable reading matter by a public whose Puritan forebears had distrusted all fiction as lies. As Dale Spender in *Mothers of the Novel: 100 Good Women Writers before Jane Austen* (1986) and Cathy N. Davidson in *Revolution and the Word: The Rise of the Novel in America* (1986) have argued, women helped to guide the rise of the novel as an art form, both in Europe and in its colonies and former colonies. In fact, by the mid nineteenth century, prose fiction by women had come to dominate the literary marketplace in the United States, and male writers, such as Nathaniel Hawthorne, despaired of comparable success. Capable of disparaging efforts by male authors as well, Hawthorne also aimed his invective at women who wrote for publication (even as he expressed admiration for the private writings of his wife, Sophia Peabody Hawthorne). Early in his career he identified these "public women" as "ink-stained Amazons." Later, in an 1855 letter to his publisher William D. Ticknor, he blasted the "d---d mob of scribbling women."

Offended by what he saw as the sentimental excesses of their fiction, he was also envious of their success in the marketplace. Yet, Hawthorne was also willing to modify his judgment when he felt praise was deserved. In another 1855 letter to Ticknor, Hawthorne wrote about Fanny Fern (Sara Payson Willis Parton) and her sensational novel of female artistic independence, *Ruth Hall* (1855), contending:

> The woman writes as if the devil was in her; and that is the only condition under which a woman ever writes anything worth reading. Generally, women write like emasculated men, and are only to be distinguished from male authors by greater feebleness and folly; but when they throw off the restraints of decency, and come before the public stark naked, as it were–then their books are sure to possess character and value.

Like so many of his contemporaries–both male and female–Hawthorne had firm notions of female propriety, lauding his wife because she "positively refuses to be famous, and contents herself with being the best wife and mother in the world" rather than expose her talents in *The Atlantic Monthly*.

The strong abolitionist movement and the campaigns to establish sympathy for the Southern viewpoint divided the United States during the period 1820–1870 and at the same time helped to foster women's move into the literary forefront. As the issues surrounding slavery split the nation, European American and African American women entered the crusade on behalf of their regions and their respective causes–writing, speaking, organizing. Former slaves entered the public arena with their personal stories, among them women such as Harriet Jacobs, who challenged the middle-class ideal of white femininity–the "True Woman," fragile, pure, pious, submissive, in need of protection–calling it a travesty that denied the true experiences of both black and white women. Working women, such as Sarah Bagley and Harriet Farley, further challenged these ideals and definitions; gradually readers of all classes began to see that traditional standards of femininity were restrictive, if not damaging.

These new ideologies of womanhood began a slow and erratic transformation, building on old beliefs to create a public role for women. Society had long held that women were fundamentally more pious and pure than men and therefore should serve as "Angels in the House," or domestic redeemers, training good children and providing men with a moral retreat from the immorality of the public world. Celebrated as "Mothers of the Republic," women were taught that though they remained in the private sphere, they could influence the public sphere by teaching their strong values and work ethic to the husbands and sons who determined the course of the nation. The large number of homemaking advice books written by authors such as Harriet Beecher Stowe, Lydia Maria Child, and Mary Peabody Mann helped women to create a discipline of home management. Those women who later joined the abolitionist movement or became defenders of the South justified their apparent transgression of entering the public sphere by extending the ideal of the domestic sphere to include the whole nation: the country, they argued, could be run better if it were managed as if it were a large household. Many sought to teach and preach a new home- and family-centered "religion" that wedded their domestic ideology to Christianity, claiming the traditionally "feminine" virtues of Christ, represented in one instance by the hero of Stowe's *Uncle Tom's Cabin* (1852) but also by heroines created by male writers, such as the title character in Henry Wadsworth Longfellow's *Evangeline* (1847).

As Mary Kelley has demonstrated, more and more women moved into the public arena during this time period, shielding themselves with moral lessons against the criticism they faced because they were crossing the boundaries between public and private life. The domestic ideology they promoted justified their writing for the purpose of self-improvement or social reform. While few women of the period became lifelong political reformers to the exclusion of their traditional domestic roles, even in personal diaries or letters never intended for the public eye, the written documents these women produced reveal the centrality of a domestic vision that they hoped would transform society.

Indeed, most of the women included in *American Women Prose Writers, 1820–1870* would not have identified themselves as advocates for woman's rights, and certainly not as "pre-feminists," as some twentieth-century critics have called them. Rather, many would argue that their vision of a better social order inspired more respect for woman's primary role: moral guardian of the home and the values associated with home. Yet, while many of these women's writings focus on issues such as love and marriage, children and family, or simply the daily events of their lives, undercurrents of social commentary flow through their words. Nina Baym and Susan K. Harris, among others, have identified a coverplot/underplot structure, whereby a traditional plot structure "covers" nontraditional ideas. "What happens" in women's narratives of the period often reveals deeper meanings.

The area of women's writing in the mid nineteenth century most frequently studied has been published fiction. Many twentieth-century critics disparaged mid-nineteenth-century women writers, some–such as Fred Lewis Pattee in his *The Feminine Fifties* (1940)–with negligible attention to their literary productions. As

Joanne Dobson has argued, "Critics influenced by the precepts of modernist literature tend to favor exclusively a literature that is ironic and psychological over one possessing other time honored qualities of the novel, such as adventure, romance, broad comedy, and—yes—even sentiment." In fact, the word *sentiment* had different connotations in the mid nineteenth century than it does in the twenty-first; hence the usage of the word in the 1848 "Declaration of Sentiments" that grew out of the Seneca Falls women's rights convention. In this context *sentiment* implies political beliefs, not excessive emotionalism.

The change in critical standards came in the late nineteenth and early twentieth centuries with the rise of realism and, then, modernism. Philip Fisher argues that the novel was, in the beginning, a democratic form, but the "campaign to purge the novel, generally by the means of irony, of its sentimental texture . . . spells the end of the novel as a popular form, or rather divides the novel into, on the one hand, a popular form of entertainment, and, on the other, a high art form in which the elimination of sentimentality is a central goal." Novels by writers such as Warner, Stowe, and Southworth far outsold those of male authors, both at home and abroad. Yet, in the late nineteenth century literary men and women became engaged in a battle to establish in the eyes of the world a distinctly "American" literature, with William Dean Howells in the vanguard of a fight to establish realism as the dominant literary form. In the United States, the rise of the modern novel accompanied the first wave of feminism, a fact that also influenced the formation of critical standards during this period. Sandra M. Gilbert and Susan Gubar link the rise of a "modernist" aesthetic with sexual politics: "The literary phenomenon ordinarily called 'modernism' is itself—though no doubt overdetermined—for men as much as for women a product of the sexual battle." One set of evaluative criteria came to be applied to all forms of the novel, with the result that the novel of sentiment is, by definition, excluded. This model, which has functioned in the evolving critical dialogue since the turn of the twentieth century, has allowed for little diversity, devaluating in particular "sentimental" fiction, identified primarily as women's discourse.

Critics continue to rethink the standards by which they judge nineteenth-century women writers to allow for the difference in perspective created by changing definitions and interpretive standards. Often, nineteenth-century American women writers did not seek to write for a cultured literary elite; neither, however, did many of their male contemporaries such as Samuel Langhorne Clemens (Mark Twain). In fact, Clemens once wrote in a letter to British writer Andrew Lang:

The little child is permitted to label its drawings "This is a cow—this is a horse" and so on. This protects the child. It saves it from the sorrow and wrong of hearing its cows and its horses criticized as kangaroos and work-benches. A man who is whitewashing a fence is doing a useful thing, so also is the man who is adorning a rich man's house with costly frescoes; and all of us are sane enough to judge these performances by standards proper to each. Now then, to be fair an author ought to be allowed to put upon his book an explanatory line: "This is written for the Belly and the Members." And the critic ought to hold himself in honor bound to put away from him his ancient habit of judging all books by one standard and thenceforth follow a fairer course.

In a similar sense scholars have come to recognize and respect the different purposes and intended audiences, as well as the varying motivations, that shape a particular artistic work. The conditions of an author's production, whenever those can be determined, have become significant factors in contemporary critical evaluations. Works that differ greatly, such as Susan Warner's popular didactic novel *The Wide, Wide World* (1850) and Nathaniel Hawthorne's *The Scarlet Letter* (1850), can be appreciated for different reasons.

Aware of the prevailing literary standards of her time, Willa Cather expressed exactly this point of view in her moving account of a visit to E. D. E. N. Southworth, who had worked unstintingly for years to support her family by the products of her pen, creating some of the most popular fiction of her time:

I am afraid I went to the place in a spirit of jest, with the cries of queenly servant girls, who were spirited away in cabs and married to disinherited lords, ringing in my ears. But somehow or other . . . one came into a more respectful frame of mind. It is rather appalling to think of the mere physical labor the poor woman accomplished, sitting in the little library facing on the river, writing thousands of pages with a fine pointed pen, in her tiny, laborious chirography. . . . it must be understood that this woman was no mere mercenary; I doubt whether Mr. Henry James himself is more sincere, or whether his literary conscience is more exacting than hers, according to her light. . . . we must remember that Mrs. Southworth was not always the butt of jests as now, particularly the jests of the very newly emancipated in the matter of literary taste. . . . we are so emphatically of the *nouveau riche* that we should be duly humble, and never forget that our grandparents were entirely convinced that the fiction of Mrs. Southworth was more engaging, more elevating, and of far higher literary merit than the stories of Master Edgar Allan Poe.

Cather defended her admiration of Southworth on the same grounds that critics now use to defend "domestic" or "sentimental" writing as a genre. She points out that

literary taste is not universal or static but varies from generation to generation, as well as within generations. Awed at the powerful response that Southworth's fiction evoked from her reading public, Cather argued that this response is significant, that popular fiction is important because it embraces and engages its audience. She recognized the will of her contemporaries, an aspiring literary elite, to establish their inferiors, a role that Southworth, as well as many other domestic or sentimental novelists, filled within the critical world.

As early as the 1950s literary scholars began to strike back at critics who believed that any fiction that is not realist or modernist is by definition inferior. In her *Villains Galore: The Heyday of the Popular Story Weekly* (1954) Mary Noel offered an early version of the coverplot/underplot theory, suggesting that the so-called women's fiction of the mid nineteenth century needed to veil its message of female strength in moral lessons and sentiment, making its point without overt militancy. The rebellious elements of such fiction, she claimed, appealed to the housewife who believed deep down that she was capable of achieving much more than society allowed her to do. Noel, however, did not challenge the idea that sentiment was only a cover and not part of the argument itself.

Helen Waite Papashvily in *All The Happy Endings* (1956) asserted that the impact of the domestic novels was not as simple as it may appear to many critics. She attributed the popularity of these novels to a hidden agenda that taught nineteenth-century women to survive in a hostile world controlled by men. Papashvily argued that these writers challenged male authority, exhibiting a thorough understanding of the psychology of power by recognizing the complicity of the dominated in their domination and encouraging women to rebel against their oppression. However, as Susan K. Harris has warned, Papashvily "reads the convention of female moral superiority as one strategy to mutilate the male" rather than to uplift the female, and views attacks on men and affirmation of women as intrinsically intertwined.

Nina Baym's *Woman's Fiction: A Guide to Novels By and About Women in America, 1820–1870* (1978) takes a different approach. She defines the "domestic" novel as "woman's fiction": formula fiction that presents a female protagonist overcoming obstacles that would limit her personal and moral growth. Instead of trying to validate "woman's fiction" by labeling it feminist or by recognizing subversive elements, she constructed a new set of critical criteria that accept the general characteristics of "woman's fiction" as the norm and then critiques each author's acceptance or rejection of that form. In essence, she explores an alternative canon, discussing in detail individual authors, their works, and their relation to the genre. Baym labeled what many critics consider the greatest weakness in fiction

of the era—the decorative and overstated prose—as a flamboyant rejection of the female decorum of other women writers of the time. The women who wrote domestic fiction, through their rich style and socially conscious themes, urge their readers to abandon fear. For Baym, their female protagonists do not accept a traditional passive role; instead they strike out to distance and control the male domination in their lives in efforts to better the domestic sphere. The happy endings of these novels show these women succeeding at controlling their own destinies.

Susan K. Harris, in her *19th-Century Women's Novels: Interpretative Strategies* (1990), built on Baym's observations, especially her discussion of a common structural overplot (or coverplot). Harris added to Baym's work by examining how "the overplot functions to disguise multiple hermeneutic possibilities." In addition, Harris traced the devaluation of emotion and sentiment by male critics, arguing : "They saw sentimental literature—and women—as irrelevant because they could not see that women's literature, too, engaged in the national dialogue about the American Dream; that women's novels emphasized feelings that did not, within their historical context, preclude their engagement with American history or American ideals." Harris offered strategies that encouraged reading women's novels on several levels and recognizing their "engagement" with "American ideals." She dismissed the broad terms *domestic* or *sentimental* to make distinctions among the works she studied, and provided readers with useful terminology through which to discuss nineteenth-century women writers.

Other critics have continued to enlarge and clarify perspectives on women's writing in the nineteenth-century United States, challenging the absolute distinction between the "separate spheres" of the nineteenth century even as they affirm the legacy of this ideology to twentieth- and to twenty-first-century attitudes. Monika Elbert argued in her introduction to *Separate Spheres No More: Gender Convergence in American Literature* (2000):

> Literary critics and historians of the 1960s and 1970s who analyzed women's sphere were focused so myopically on middle-class women's separate sphere of the home that class wars or divisive economic factors were not acknowledged. Indeed, for working women the public space was always accessible. . . . Where was the separate sphere demarcation for those below the middle class or for those daring to bend rules?

Studies such as Elbert's affirm the importance of the literary recovery that guides the organization of *American Women Prose Writers, 1820–1870,* which seeks not to present its subjects in isolation, but to reconstruct their

lives and works within the critical, biographical, and social milieu that surrounded their work.

Clearly, the literary history of the nineteenth century consists of more than commemorating the rise of romanticism and realism. Another mode of writing dominated the marketplace and found considerable favor with the reading public. The tremendous success of sentimentalism seems to be owed to its ability to tap into the feelings and values of nineteenth-century Americans, even as it could criticize the values of that culture while seeming to venerate the status quo.

Women writers who wrote autobiographical works for publication, as well as those who wrote diaries and letters intended as private communications, have received less attention than published fiction writers, but they too represent a consciousness of their literary age. As a distinct literary field for scholarly study, autobiographical writing, both public and private, is still emerging. The nineteenth-century woman who wrote in these personal genres may never have imagined such an audience, or even readers outside her family and close circle of friends. Such women wrote for their own purposes, asserting their visions, sometimes with political, historical, or didactic intent, but sometimes more emphatically as a mode of self-definition.

In the introduction to *Autobiographics: A Feminist Theory of Self-Representation* (1994) Leigh Gilmore wrote:

> For all the instability and incoherence in the category of "women," as well as the category of autobiography, both generate a remarkable negative capability: both categories hold together disparate and contradictory histories of identity and history and collect an irreconcilable variety of experience and representation under a single name. The names "women" and "autobiography," then, come to represent diversity as a natural and stable identity.

In juxtaposing the literary biographies of women whose writing was fiercely private with others whose ambitions were admittedly public, *American Women Prose Writers, 1820–1870* depicts the complexity of the cultural milieu in which nineteenth-century American women lived and worked. The selection of writers for this volume of the *Dictionary of Literary Biography* encompasses professional authors, artists, travelers, reformers, conservatives, missionaries, critics, columnists, educators, lecturers, slaves, freeborn women of color, plantation mistresses, mill workers, mothers, wives, daughters, and sisters. This project is an effort to inspire readers to imagine the range of the nineteenth-century women writers' lives still left to be chronicled.

—*Amy E. Hudock and Katharine Rodier*

Acknowledgments

This book was produced by Bruccoli Clark Layman, Inc. Karen L. Rood, senior editor, was the in-house editor. She was assisted by Penelope M. Hope and Nikki La Rocque-Lyles.

Production manager is Philip B. Dematteis.

Administrative support was provided by Ann M. Cheschi, Amber L. Coker, José A. Juarez, and Angi Pleasant.

Accountant is Ann-Marie Holland.

Copyediting supervisor is Phyllis A. Avant. The copyediting staff includes Brenda Carol Blanton, Allen E. Friend Jr., Melissa D. Hinton, William Tobias Mathes, Rebecca Mayo, Nancy E. Smith, and Elizabeth Jo Ann Sumner.

Editorial associates are Andrew Choate and Michael S. Martin.

Layout and graphics supervisor is Janet E. Hill. The graphics staff includes Karla Corley Brown and Zoe R. Cook.

Office manager is Kathy Lawler Merlette.

Photography supervisor is Paul Talbot. Photography editors are Charles Mims and Scott Nemzek.

Permissions editor is Jeff Miller.

Digital photographic copy work was performed by Joseph M. Bruccoli.

The SGML staff includes Frank Graham, Linda Dalton Mullinax, Jason Paddock, and Alex Snead.

Systems manager is Marie L. Parker.

Typesetting supervisor is Kathleen M. Flanagan. The typesetting staff includes Patricia Marie Flanagan, Mark J. McEwan, Pamela D. Norton, and Alison Smith. Freelance typesetters are Wanda Adams and Vicki Grivetti.

Walter W. Ross did library research. He was assisted by Steven Gross and the following librarians at the Thomas Cooper Library of the University of South Carolina: circulation department head Tucker Taylor; reference department head Virginia W. Weathers; Brette Barclay, Marilee Birchfield, Paul Cammarata, Gary Geer, Michael Macan, Tom Marcil, Rose Marshall, and Sharon Verba; interlibrary loan department head John Brunswick; and interlibrary loan staff Robert Arndt, Hayden Battle, Barry Bull, Jo Cottingham, Marna Hostetler, Marieum McClary, Erika Peake, and Nelson Rivera.

Amy E. Hudock and Katharine Rodier would like to thank A. E. Stringer, former chairman of the English Department, Joan T. Mead, Dean of the College of Liberal Arts, and Leonard J. Deutsch, Dean of the Graduate School at Marshall University.

Dictionary of Literary Biography® • Volume Two Hundred Thirty-Nine

American Women Prose Writers, 1820–1870

Dictionary of Literary Biography

Louisa May Alcott

(29 November 1832 – 6 March 1888)

Christine Doyle
Central Connecticut State University

See also the Alcott entries in *DLB 1: The American Renaissance in New England; DLB 42: American Writers for Children Before 1900; DLB 79: American Magazine Journalists, 1850–1900; DLB 223: The American Renaissance in New England, Second Series;* and *DS 14: Four Women Writers for Children, 1868–1918.*

BOOKS: *Flower Fables* (Boston: George W. Briggs, 1855);

Hospital Sketches (Boston: James Redpath, 1863); enlarged as *Hospital Sketches and Camp and Fireside Stories* (Boston: Roberts, 1869);

The Rose Family. A Fairy Tale (Boston: James Redpath, 1864);

On Picket Duty, and Other Tales (Boston: James Redpath / New York: H. Dexter, Hamilton, 1864);

Moods (Boston: Loring, 1865; London: Routledge, 1866; revised edition, Boston: Roberts, 1882);

The Mysterious Key, and What It Opened (Boston: Elliott, Thomes & Talbot, 1867);

Morning-Glories, and Other Stories (New York: Carleton, 1867; enlarged edition, Boston: Horace B. Fuller, 1868);

Kitty's Class Day (Boston: Loring, 1868);

Aunt Kipp (Boston: Loring, 1868);

Psyche's Art (Boston: Loring, 1868);

Louisa M. Alcott's Proverb Stories (Boston: Loring, 1868); republished as *Three Proverb Stories* (Boston: Loring, after 1870); republished as *Kitty's Class-Day at Harvard* (Boston: Loring, after 1876)—comprises *Kitty's Class Day, Aunt Kipp,* and *Psyche's Art;*

Little Women or, Meg, Jo, Beth and Amy, 2 parts (Boston: Roberts, 1868, 1869; London: Sampson Low, 1868, 1869);

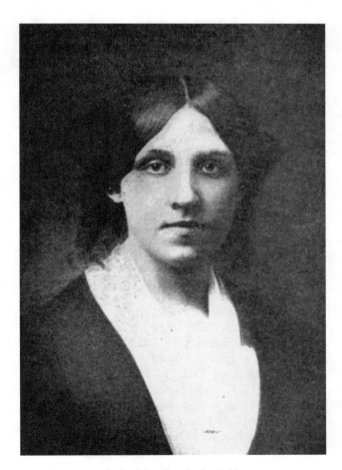

Louisa May Alcott in the 1850s

Will's Wonder Book (Boston: Horace B. Fuller, 1870); republished in *Mink Curtiss; or, Life in the Backwoods* (New York: James Miller, 1877);

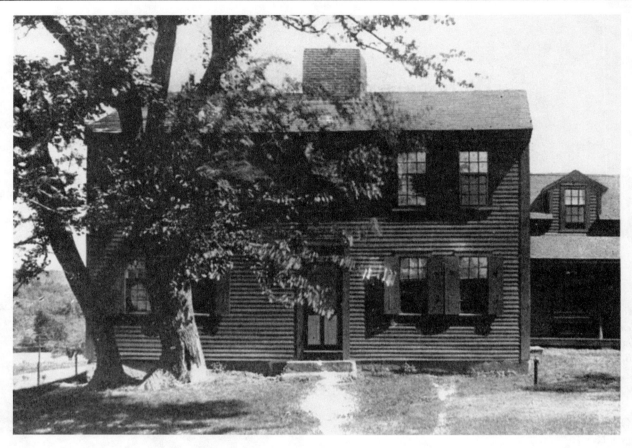

Fruitlands, the farm in Harvard, Massachusetts, where the Alcott family experimented in communal living during the second half of 1843

An Old-Fashioned Girl (Boston: Roberts, 1870; London: Sampson Low, 1870);

Little Men: Life at Plumfield with Jo's Boys (London: Sampson Low, Son & Marston, 1871; Boston: Roberts, 1871);

Aunt Jo's Scrap-Bag. My Boys (Boston: Roberts, 1872; London: Sampson Low, 1872);

Aunt Jo's Scrap-Bag. Shawl-Straps (Boston: Roberts, 1872; London: Sampson Low, 1872);

Work: A Story of Experience (Boston: Roberts, 1873; London: Sampson Low, 1873); second half republished as *Beginning Again. Being a Continuation of Work: A Story of Experience* (London: Sampson Low, Marston, Low & Searle, 1875);

Aunt Jo's Scrap-Bag. Cupid and Chow-Chow (Boston: Roberts, 1874; London: Sampson Low, 1874);

Eight Cousins; or, The Aunt-Hill (Boston: Roberts, 1875; London: Sampson Low, 1875);

Silver Pitchers: and Independence, A Centennial Love Story (Boston: Roberts, 1876; London: Sampson Low, 1876); republished in *Silver Pitchers; Laurel Leaves. Original Poems, Stories, and Essays* (Boston: William F. Gill, 1876);

Rose in Bloom. A Sequel to "Eight Cousins" (Boston: Roberts, 1876; London: Sampson Low, 1876);

A Modern Mephistopheles (Boston: Roberts, 1877; London: Sampson Low, 1877);

Under the Lilacs (11 monthly parts, London: Sampson Low, Marston, Searle & Rivington, 1877–1878; 1 volume, Boston: Roberts, 1878);

Aunt Jo's Scrap-Bag. My Girls (Boston: Roberts, 1878);

Aunt Jo's Scrap-Bag. Jimmy's Cruise in the Pinafore (Boston: Roberts, 1879; London: Sampson Low, 1879);

Sparkles for Bright Eyes, by Alcott and others (New York: Crowell, 1879);

Meadow Blossoms, by Alcott and others (New York: Crowell, 1879);

Water-Cresses, by Alcott and others (New York: Crowell, 1879);

Jack and Jill: A Village Story (Boston: Roberts, 1880; London: Sampson Low, 1880);

Aunt Jo's Scrap-Bag. An Old-Fashioned Thanksgiving (Boston: Roberts, 1882; London: Sampson Low, 1882);

Spinning-Wheel Stories (Boston: Roberts, 1884; London: Sampson Low, 1884);

First issue of the Alcott sisters' family newspaper, including "To Pat Paws" by Louisa May Alcott (Houghton Library, Harvard University)

FLOWER FABLES.

BY

LOUISA MAY ALCOTT.

" Pondering shadows, colors, clouds,
Grass-buds, and caterpillar shrouds,
Boughs on which the wild bees settle,
Tints that spot the violet's petal."
EMERSON'S WOOD-NOTES.

BOSTON:
GEORGE W. BRIGGS & CO.
1855.

Earth and air seemed filled with beauty.

Frontispiece and title page for Alcott's first book, fairy tales written for Ralph Waldo Emerson's daughter Ellen

Lulu's Library. Vol. I. A Christmas Dream (Boston: Roberts, 1886; London: Sampson Low, 1886);

Jo's Boys, and How They Turned Out. A Sequel to "Little Men" (Boston: Roberts, 1886; London: Sampson Low, 1886);

Lulu's Library. Vol. II. The Frost King (Boston: Roberts, 1887);

A Garland for Girls (London: Blackie, 1887; Boston: Roberts, 1888);

A Modern Mephistopheles and A Whisper in the Dark (Boston: Roberts, 1889; London: Sampson Low, 1889);

Lulu's Library. Vol. III. Recollections (Boston: Roberts, 1889);

Comic Tragedies Written by "Jo" and "Meg" and Acted by the "Little Women" (Boston: Roberts, 1893; London: Sampson Low, 1893);

A Modern Cinderella or the Little Old Shoe and Other Stories (New York: Hurst, 1908);

Three Unpublished Poems, Fruitlands Collection (N.p., 1919);

Behind a Mask: The Unknown Thrillers of Louisa May Alcott, edited by Madeleine B. Stern (New York: Morrow, 1975; London: W. H. Allen, 1976);

Plots and Counterplots: More Unknown Thrillers of Louisa May Alcott, edited by Stern (New York: Morrow, 1976; London: W. H. Allen, 1977); republished as *A Marble Woman: Unknown Thrillers of Louisa May Alcott,* edited by Stern (New York: Avon, 1995);

A Free Bed, edited by Stern (Provo: Friends of the Brigham Young University Library, 1978);

Diana and Persis, edited by Sarah Elbert (New York: Arno, 1978);

A Modern Mephistopheles and Taming a Tartar, edited by Stern (New York: Praeger, 1987);

1861.	My Earnings.	
Father has good talks in B & reforms our schools. Nan & John happy as turtle doves. Lu writing & grubbing as usual. Mother beginning to feel easy & quiet. Ab busy at the asylum doing well. John Brown's girls board with us. April 19th war was declared with the South. A month at the White Mts with L. W. & write letters home that amuse the town.	A Pair Of Eyes.	40
	Whisper In The Dark.	50
	M. L.	20
	Began Moods.	
		110

1862.		
I keep a Kinder Garten for six months in Boston. Visit at the Fields & among friends. Make nothing & give up teaching. L Willis died. Dec 11th to Washington as an Army nurse. Stay six weeks & fall ill. Am brought home nearly dead & have a fever which I enjoy very much, at least the crazy part.	School.	30
	Nursing.	10
	Pauline's Punishment	100
	King Of Clubs.	30
		170

1862		
Get well & fall to work. March 29th Nan's boy was born, Frederick Alcott Pratt. Ab to Clarke's Island. Grandma died. The first colored regiment went to the war. In the Fall Ab went to Kimmer to study moulding. Hospital Sketches come out & I find I've done a good thing without knowing it.	On Picket Duty.	50
	Hospital Sketches.	200
	Mountain Letters.	30
	My Contraband.	50
	Thoreau's Flute.	10
		330

Page from Alcott's "Notes and Memoranda" journal, including her earnings for 1861–1863 (Houghton Library, Harvard University)

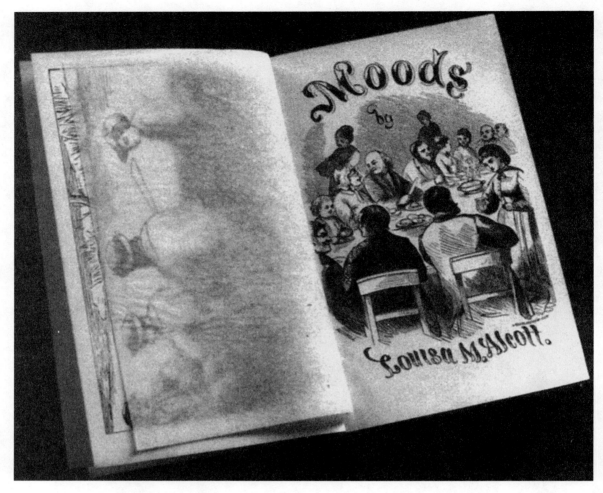

Decorated title page for Alcott's first novel (1865), inspired by Emerson's "Experience" (1844), in which he wrote:
"Life is a train of moods like a string of beads"

A Double Life: Newly Discovered Thrillers of Louisa May Alcott, edited by Stern, Joel Myerson, and Daniel Shealy (Boston: Little, Brown, 1988);

The Journals of Louisa May Alcott, Myerson, Shealy, and Stern (Boston: Little, Brown, 1989);

Louisa May Alcott: Selected Fiction, edited by Shealy, Stern and Myerson (Boston: Little, Brown, 1991);

Freaks of Genius: Unknown Thrillers of Louisa May Alcott, edited by Shealy, Stern, and Myerson (Westport, Conn.: Greenwood Press, 1991);

From Jo March's Attic: Stories of Intrigue and Suspense, edited by Stern and Shealy (Boston: Northeastern University Press, 1993); republished as *The Lost Stories of Louisa May Alcott* (New York: Carol, 1995);

Louisa May Alcott Unmasked: Collected Thrillers, edited by Stern (Boston: Northeastern University Press, 1995);

A Long Fatal Love Chase, edited by Kent Bicknell (New York: Random House, 1995); republished as *The Chase; or, A Long Fatal Love Chase* (London: Century, 1995);

The Feminist Alcott: Stories of a Woman's Power, edited by Stern (Boston: Northeastern University Press, 1996);

A Whisper in the Dark: Twelve Thrilling Tales, edited by Stefan Dziernianiowicz (New York: Barnes & Noble, 1996);

The Inheritance, edited by Myerson and Shealy (New York: Dutton, 1997);

The Early Stories of Louisa May Alcott, 1852–1860 (New York: Ironweed Press, 2000).

Editions: *Louisa's Wonder Book,* edited by Madeleine B. Stern (Mount Pleasant: Clarke Historical Library, Central Michigan University, 1975);

Moods, edited by Sarah Elbert (New Brunswick, N.J.: Rutgers University Press, 1991);

Louisa May Alcott's Fairy Tales and Fantasy Stories, edited by Daniel Shealy (Knoxville: University of Tennessee Press, 1992);

Norna, or The Witch's Curse (Edmonton: University of Alberta Press, 1994).

For most of the twentieth century Louisa May Alcott's literary reputation rested largely on her masterpiece, *Little Women* (1868, 1869). Yet, late in the twentieth century, Alcott—whose first biographer, Ednah Dow Cheney, hailed her as "The Children's Friend"—began to attract an adult audience as well as juvenile readers. Beginning in 1975, republication of Alcott's anonymously and pseudonymously published sensation stories has spurred interest in her long out-of-print adult novels. These rediscoveries have contributed to a more complete portrait of the artist, revealing a writer who understood well the conventions of various nineteenth-century genres, adeptly shaping her artistic vision to reach a variety of audiences and markets. In her best work Alcott resisted sentimentality while presenting complex characters, often maintaining control of several plot threads. She also used vernacular speech and intricate detail to depict realistically New England life in the nineteenth century. Alcott was known to sign her letters, "Yours for reform of all kinds," and this phrase was truly the signature of her literary efforts as well. Educational reform, abolition, temperance, and women's rights issues figure prominently in her work. This last subject particularly interested her; as a woman who remained single in an era when more than 90 percent of American women married, she was committed to presenting portraits of independent, self-supporting women.

Alcott's interest in economic independence for women, as well as many other concerns in her work, may well have had their roots in the circumstances of her early life. She was born in Germantown, Pennsylvania, on 29 November 1832, on the thirty-third birthday of her father, Transcendentalist educator Amos Bronson Alcott. Her mother, Abigail (Abba) May Alcott, descended from two leading New England families, the Sewalls and the Quincys; to her fell the lifelong task of tempering her husband's idealism with a measure of practicality. Louisa May Alcott was the second of four daughters. (A much wished-for son died shortly after birth in 1839.) Louisa, who inherited her mother's darker physical features as well as her volatile temperament and active approach to life, sought to live up to her father's ideals. His inattention to economic matters resulted in precarious family finances throughout Alcott's youth. The family moved to Boston in 1834, when her father founded a school embodying some of his Pestalozzian educational theories: notably, that education was for the whole child, body, mind, and spirit, and that the best school functioned like the best family, with students motivated to learn by love. Although his

Alcott, circa 1865

Temple School initially succeeded, Bronson Alcott ran into difficulties, particularly after he and his fellow teacher, Elizabeth Peabody, published some of the children's speculations about God. Later, when they admitted an African American child, parents began to withdraw their children from the school, which permanently closed in 1840. Though Bronson Alcott remained an educator and a lecturer all his life, his income never again sufficed to keep the family solvent. For the next ten years the family moved frequently around the Boston and Concord area, often financially sustained by Abigail Alcott's brother Samuel May and by Ralph Waldo Emerson, a close family friend and one of young Louisa's idols.

Bronson and Abba Alcott encouraged their children to write; both parents kept journals, and their children did likewise. For the young Louisa Alcott the journal sometimes became a means of communication between herself and her mother, as Abba would read her daughter's entries and comment on them. Collabo-

An issue of the children's magazine Alcott edited from 1868 until 1870

rative writing also flourished among Louisa and her sisters. Like the March girls in *Little Women,* the Alcott sisters wrote a family newspaper and theatricals in which they performed.

During the second half of 1843 Bronson Alcott and his family experimented in communal living at Fruitlands, a farm situated in Harvard, Massachusetts. Louisa's 1843 journals describe their tenure at Fruitlands, especially its beginnings, with the generally joyous eye of a ten-year-old at an extended nineteenth-century version of summer camp. Her short story "Transcendental Wild Oats" (first published in *The Independent,* 18 December 1873), however, satirizes the impracticality of its male founders, Alcott and Charles Lane. Although they intended the farm to be self-supporting, for example, they did not move in until June, well after planting time; refused to use fertilizer because of their opposition to exploiting animals; and sowed three different kinds of seed in the same field. A major part of the work fell to the women and children. When it was time to harvest the poor crop, "some call of the

Oversoul wafted all the men away," and the women and children were left to manage alone. Alcott's story and accounts of the experiment by her father and Lane suggest that the final blow to the community was Lane's insistence on disbanding traditional family groupings in favor of a sexually segregated, celibate lifestyle akin to the Shaker model, which Bronson Alcott resisted. Many critics have called "Transcendental Wild Oats" Louisa May Alcott's repudiation of Transcendentalist ideals. Certainly, her fiction generally praises those who attend to the practical details of life. Her work, however, also positively presents other unorthodox but family-centered communities. She continued to honor the ideal of the Utopian community, even as she adjusted it to encompass feminism and practicality.

The Fruitlands experience was one of a series of further financial setbacks for the Alcotts in the 1840s. Toward the end of the decade, Abba Alcott and the girls went to work to shore up the family financially. Abba Alcott's friends found several wealthy patrons to pay her salary as a social worker in Boston, where she even-

tually founded an "intelligence office," or employment service. Louisa May Alcott and her sisters worked at many of the jobs available to women of the day: seamstress, governess, and teacher. When her mother could not find anyone to fill a position, Alcott worked as a domestic servant. She earned only $4 for seven weeks' employment but eventually turned the experience into "How I Went Out to Service" (*The Independent,* 4 June 1874), a short story decrying the difficulties of domestic wage labor for women.

Throughout the 1850s, Louisa May Alcott took whatever work became available to her–teaching, sewing, and cleaning–in order to contribute to the family income, but she also kept writing. An early attempt to publish "How I Went Out to Service" earned her publisher James T. Fields's well-known dismissal, "Stick to your teaching, Miss Alcott. You can't write." The young, aspiring author persisted. Her poem "Sunlight" appeared in *Peterson's Magazine* in September 1851, under the pseudonym Flora Fairfield, and she published her first story, "The Rival Painters," in the 8 May 1852 issue of the *Olive Branch.* She received $5 dollars for the story. Also around this time, when she was about eighteen, Alcott wrote her first novel, *The Inheritance,* which was not published until April 1997. (The novel was also adapted as a television movie, which aired at the same time.) While this novel shows many of the technical limitations of a beginning writer, it also features structures, themes, and characters prefiguring her more accomplished later work. Like much of Alcott's writing, *The Inheritance* shows the influence of Charlotte Brontë's *Jane Eyre* (1847), a novel–and a novelist–that remained a lifelong favorite. The central character, Edith, an orphaned young woman, acts as governess to the teenage daughter of a wealthy family. Like Jane Eyre, Edith endures social slights, is eventually revealed to be an heiress, and marries a man of higher status with a tragic past. The novel features tableaux as evening entertainments that reveal how the characters regard each other. In Edith, Alcott introduced her distinctly American vision of the active female hero. On an outing Edith surprises everyone by rescuing her charge, who has slipped partway down a cliff. Later, Edith subdues a bolting horse. Despite its weaknesses, this early Alcott novel places strength of character over social standing, and its heroine foreshadows the physically active Jo March.

In 1855 Alcott published her first contribution to children's literature. *Flower Fables,* a collection of fairy tales written to amuse Ralph Waldo Emerson's daughter Ellen, earned Alcott public accolades and $32 in royalties. The fairy-tale elements in the collection are intermixed with the didacticism typical of nineteenth-century works for children, making *Flower Fables* unap-

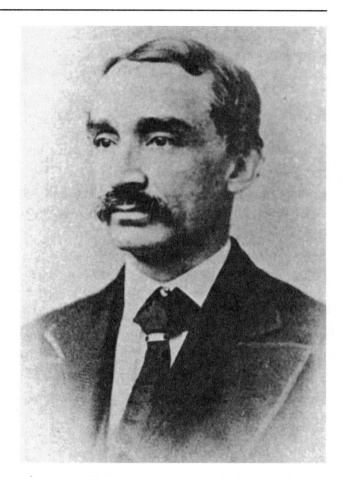

Thomas Niles of Roberts Brothers, who asked Alcott to write a book for girls, prompting her to produce Little Women

pealing for most modern readers. Alcott persisted in producing short stories throughout the decade and found she could usually place them in periodicals such as *The Atlantic Monthly* and *Saturday Evening Gazette.*

In addition to teaching, sewing, and writing during this time, Alcott also periodically indulged one of her great lifetime loves, the theater. She performed in amateur theatricals, organized theatricals as benefits for the poor, and wrote a short play, *Nat Batchelor's Pleasure Trip,* which was accepted in 1855 and performed as an afterpiece on 4 May 1860 at the Harvard Athenaeum. She also turned her short story "The Rival Prima Donnas" into a play that was accepted by Thomas Barry for the Boston theater in 1856 but never performed.

Alcott's considerable success in publishing her short fiction over several years inspired her to attempt her first adult novel. She wrote in her journal for August 1860, "Genius burned so fiercely that for four weeks I wrote all day and planned nearly all night." At the end of those four weeks, she had an ungainly but complete manuscript of the novel that was eventually published as *Moods* (1865). For the time being, however,

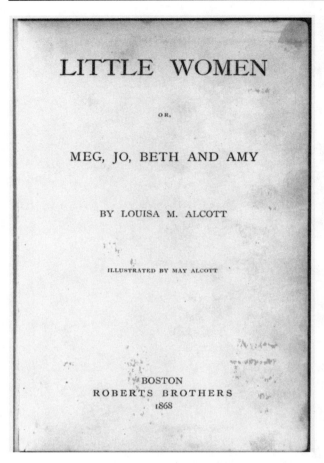

LITTLE WOMEN

OR,

MEG, JO, BETH AND AMY

BY LOUISA M. ALCOTT

ILLUSTRATED BY MAY ALCOTT

BOSTON
ROBERTS BROTHERS
1868

Title page for Alcott's most popular novel, which has never been out of print (Houghton Library, Harvard University)

she shared it only with family. She began another work, which she alternately called "Success" and "Christie." A series of personal tragedies, however, soon moved Alcott to turn her literary talents in a different direction.

Alcott's next younger sister, Lizzie, died in 1858 from complications of scarlet fever. Her older sister, Anna, announced her engagement shortly thereafter and was married in 1860. Although Louisa grew to dearly love her brother-in-law, John Pratt, at the time it seemed to her that she was quickly losing her whole family. Beloved family friend Henry David Thoreau, the young Alcott girls' botany teacher, died in mid 1862. Added to these personal losses were the larger issues of slavery and the Civil War. The Alcotts, adamant abolitionists, had grieved with many people of Concord when John Brown was executed for the raid on Harper's Ferry in 1859. Alcott commented in her journal at the time, "Wish I could do my part in it [the antislavery movement]." When she turned thirty in November 1862, restlessness, grief, and idealism convinced her to volunteer as a war nurse.

Alcott began nursing on 13 December 1862 at the Union Hotel Hospital in Georgetown, D.C. Her stay lasted only six weeks, for she contracted typhoid fever and had to be brought home. Despite the short duration of her work, Alcott's nursing experience had lasting repercussions in her life. Three months of delirium and pain passed before she recovered enough to leave her room. The side effects of mercury, a component of the contemporary treatment for typhoid, stayed with her the rest of her life, often causing her excruciating headaches and robbing her of her former stamina. One positive aftereffect of her experience, however, was the publication of her book *Hospital Sketches* (1863), which she based on her letters home from Georgetown.

Hospital Sketches not only established Alcott as a literary figure worthy of notice, but also "showed me '*my style*'"—as she wrote in an 1879 addendum to her 1863 journal. That style comprised rich realistic detail and a witty narrative voice, bright but satirical. Tribulation Periwinkle narrates *Hospital Sketches*. An initially naive woman, Trib finds herself in a Civil War hospital, which she calls the Hurly-Burly House, motivated solely by the feeling that "I want something to do." Trib's idealistic impulses soon run directly into the realistic horrors of war. Her Victorian sense of propriety cannot keep pace with her supervisor's command to undress and wash the wounded male bodies in her charge. Nurse Periwinkle develops as a character and adopts an increasingly satirical voice as she rages against bureaucratic tangles, unsympathetic doctors, and Confederates. But she always speaks of Union soldiers with compassion and respect. Responding to the emotional power of humor coupled with painful realism, Alcott's Northern readership also seemed to appreciate the absence of pious platitudes in her report and to find in it resonances of deep truths regarding the courage of their sons, husbands, and brothers.

The success of *Hospital Sketches* had publishers clamoring for more of Alcott's stories. From her firsthand knowledge of the Civil War, she produced "My Contraband," published in the November 1863 issue of *The Atlantic Monthly* as "The Brothers," again told by a nurse, this time named Faith Dane. The story concerns a strangely sensual and clearly biracial slave with one side of his face burned and scarred, who has escaped from the South to fight for the Union. In the hospital he meets his half brother, a white Confederate soldier. "An Hour," published in the 26 November and 3 December 1864 issues of *The Boston Commonwealth*, is a tension-filled tale of a young slave woman who tries to intercede to save the son of the plantation owner (with whom she has fallen in love) after the slaves have rebelled and taken over the plantation.

One of the results of Alcott's new popularity was that she finally published her novel *Moods,* written in 1860 and revised in February 1861. Publishers had wanted it but had been put off by its length. Alcott finally excised ten chapters and "sacrificed many of my favorite things, but being resolved to make it simple strong & short I let everything else go & hoped the book would be better for it," she wrote in her October 1864 journal entry. The book was immediately popular with the public when it appeared at Christmas 1864, with 1865 on its title page. Critics generally praised *Moods,* though they often commented at the same time on its uneven quality, which may have owed to Alcott's inexperience as well as to her abridgment of the novel. In his critique for *The North American Review* (September 1865) Henry James suggested that the young writer handled everyday realities quite well but did not know enough about great passion to convey it convincingly.

The title and epigraph for *Moods* come from Ralph Waldo Emerson's essay "Experience" (1844): "Life is a train of moods like a string of beads, and, as we pass through them, they prove to be many-colored lenses which paint the world their own hue, and each shows only what lies in its focus." In a letter to a "Mr. Ayer" dated 19 March 1865, Alcott wrote, "The design of *Moods* was to show the effect of a moody person's moods upon their life, and Sylvia, being a mixed and peculiar character, makes peculiar blunders and tries to remedy them." Because Sylvia Yule is young and "moody," and sees only what she sees at a particular moment instead of considering life as a whole and the long-range consequences of her actions, she unwisely marries Geoffrey Moor, a man she does not love, while in the throes of a melancholy "mood," brought on because she believes Adam Warwick, the man she does love, has married another.

Despite its lapses into melodrama, the novel presents fascinating, well-drawn characters, especially the women. Self-reliant, adventurous Sylvia matures as she deals with the consequences of her "moodiness." Her sister Prue provides comic relief with her fussiness and sense of propriety. One of the most interesting characters in the novel is Moor's thirty-year-old cousin Faith Dane. No longer a nurse (as in "My Contraband"), independent, single Faith voices common sense and wise counsel throughout the novel. While awkward in her portrayal of passion, Alcott convincingly depicts the main characters' growing self-awareness as they ultimately recognize and cope with their incompatibility. A rather stunning feature of this novel, at least by mid-nineteenth-century standards, is a frank discussion of divorce as an option for unhappy couples–even though Alcott could not quite bring herself to propose this solu-

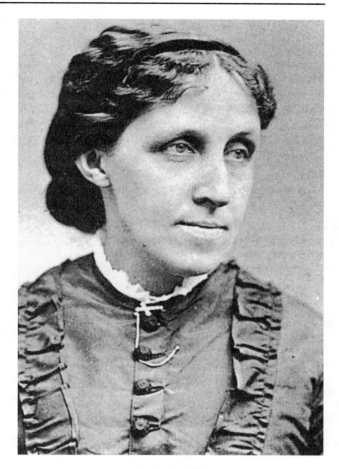

Alcott in the 1870s

tion for her heroine, who escapes her unhappy situation only when she dies from an incurable illness.

Alcott was never satisfied with the truncated version of *Moods.* When her publisher returned the copyright of *Moods* to her in 1881, she revised the novel for republication in 1882, excising some of the melodramatic scenes. She also changed the ending so that Sylvia does not die. Instead, she recalls her husband from his self-imposed exile in Europe and announces her intention to make the best of their marriage, even though he is not her life's consuming passion. The divorce discussion from the first version remains intact. Alcott presented compelling reasons for her changes in the preface to the new edition, commenting that "having learned the possibility of finding happiness after disappointment, and making love and duty go hand in hand, my heroine meets a wiser if less romantic fate." Despite its artistic flaws *Moods* still merits attention because of its powerful characterizations (what Sarah Elbert's introduction to her 1991 edition of *Moods* calls "Alcott's virtual invention of the American Girl") and the skillful

Page from the manuscript for Little Men, *published in England in May 1871 and in the United States the following month (Louisa May Alcott Collection, Clifton Waller Barrett Library, Manuscript Division, University of Virginia Library)*

way Alcott combines humor and compassion to explore complex, painful issues.

If inexperience with writing and life had limited the degree of artistic mastery in *Moods,* Alcott took steps during the 1860s to rectify both insufficiencies. Amid the exuberant reception of her novel and the end of the Civil War, Alcott realized a longed-for dream when she toured Europe for the first time in 1865–1866. Rather than traveling as a tourist on holiday, however, Alcott was a nurse-companion to Anna Weld, the invalid daughter of a wealthy Boston shipping merchant. Alcott found her charge demanding but still managed to gather rich details for future stories from her travels to England, Germany, Switzerland, Italy, and France. When Anna Weld's physician-uncle arrived in Nice in April 1866, Alcott managed to extricate herself from her obligations and to spend two months in Paris and then England, poor but free, before returning to Boston almost exactly a year to the day from her departure.

Alcott did not neglect her professional career during these years. She knew she had a talent for quickly producing sensation fiction. These stories of intrigue, diabolical plotting, drug addiction, and murder could be published anonymously or under a nongendered pseudonym, A. M. Barnard, thus protecting Alcott's reputation as a serious writer. Writing them helped her to bolster the "Alcott Sinking Fund," as she called her family's finances, for she had already become the family's most-dependable source of income. These stories also provided valuable practice in developing her craft. Although the genre was deemed "rubbish" by polite society, it allowed Alcott's style to develop. Typically including a wealth of realistic detail along with wild romance and employing the shocking, sordid details of current social problems, sensation stories often feature complex female characters whose exploits move them beyond hearth and home. Thus, in both style and content the genre was an ideal form for Alcott to develop proficiency with realistic detail, treatment of social problems, and resilient female characters. By matching names and dates in Alcott's ledgers with stories that appeared in periodicals during the 1860s, Madeleine B. Stern has recovered twenty-nine of these tales. The pieces show a clear progression in Alcott's growth as a writer. Some of the most successful, such as "A Nurse's Story," "Behind a Mask," and a full-length novel, *A Long Fatal Love Chase,* were written in 1865–1866, during and shortly after Alcott's trip to Europe and before the creation of *Little Women.*

"A Nurse's Story," published in installments in *Frank Leslie's Chimney Corner* (2 December 1865 – 6 January 1866), features double plotting, as Alcott tells the story of Kate Snow, a young woman hired as a companion to an "invalid" who is mad. A fascinating parallel

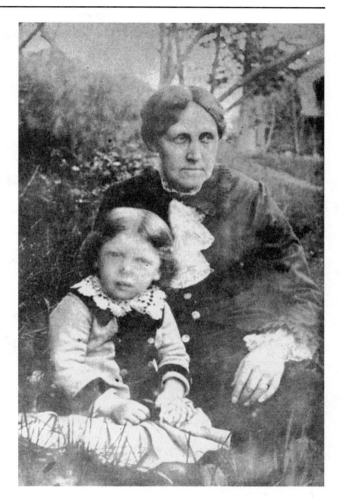

Alcott with her niece, Louisa May Nieriker (Lulu), shortly after she arrived in Boston to live with her aunt in 1880

plot develops between Kate and the mysterious Robert Steele, who appears on the scene and seems to exert strange power over the madwoman's family. The psychological dimensions of the struggle between Snow and Steele lift this tale far above most of Alcott's sensation fiction.

Serialized in *Flag of our Union* (3 October – 3 November 1866), "Behind a Mask"–subtitled "A Woman's Power"–has become one of the most popular of Alcott's recently uncovered stories, mainly because of its complex heroine, Jean Muir. Although early plot details echo *Jane Eyre,* Jean is no eighteen-year-old waif, but a thirty-year-old, divorced former actress. Her goal in accepting the position of governess at the Coventry estate is to manipulate her way into the affections of her charge's younger and elder brothers and through them to ensnare their old uncle, Lord Coventry, who controls the family fortune. Alcott's multifaceted portrait of her manipulative and ultimately successful heroine, how-

Emerson's death — Thursday 27th —

Mr Emerson died at 9 p.m. suddenly. Our best & greatest American gone. The nearest & dearest friend father has ever had, & the man who has helped me most by his life, his books, his society. I can never tell all he has been to me from the time I sung Mignon's song under his window, a little girl, & wrote letters a la Bettine to him, my Goethe, at 15, up through my hard years when his essays on Self Reliance, Character, Compensation, Love & Friendship helped me to understand myself & life & God & Nature.

Illustrious & beloved friend, good bye!

Sunday 30th — Emerson's funeral. I made a golden lyre of jonquils for the church & helped trim it up. Private services at the house & a great crowd at the church. Sanborn read his sonnet & Judge Hoar & others spoke. Now he lies in Sleepy Hollow among his brothers under the pines he loved.

I sat up till midnight to write an article on R. W. E. for the Youth's Companion, that the children may know something of him. A labor of love.

Alcott's 27 April 1882 journal entry on the death of Emerson (Houghton Library, Harvard University)

ever, also acknowledges the joy and energy Jean brings into the household. She wins approval on both sides of the class barrier, from the Coventry family and from the servants. Alcott's story attacks class consciousness and reaffirms an American belief in the possibilities attendant on adherence to a work ethic while also presenting a fascinating portrait of "woman's power" at once frightening and benevolent.

A Long Fatal Love Chase, written in August and September 1866, was not published until 1995. In some respects long and unwieldy, the novel (originally titled "A Modern Mephistopheles") reveals the hold of Europe on Alcott's imagination and presents another bold heroine, Rosamund Vivian. The opening lines evoke Johann von Goethe's *Faust* (1808), as eighteen-year-old Rosamund (who has been caring for her crotchety invalid grandfather since her parents' deaths) rages, "I'd gladly sell my soul to Satan for a year of freedom." Almost immediately Philip Tempest knocks at her door. He woos and wins Rosamund, but after a year of marriage she discovers he is already married. A wild chase across Europe ensues, eventually resulting in Rosamund's death. Though Rosamund is Tempest's victim, she is clearly also another precursor of Alcott's heroine Jo March. Rosamund resists inactivity, refuses to be commanded, and exhibits daring, tomboyish behavior, such as climbing on ledges and across Parisian rooftops to elude her pursuer. The wildness of the story is at times almost comic, typical of Alcott, but the characterizations of the evil Tempest, the good priest Father Ignatius, and Rosamund herself demonstrate the writing power Alcott was beginning to wield.

Alcott had returned from her European tour energized. But the next year proved emotionally draining, owing to the pressures of family debt, her mother's illness, and then her own. Alcott endured the first of many serious attacks of the pain ("neuralgia," as it was diagnosed) from aftereffects of her Civil War mercury poisoning. She suffered from these attacks for the rest of her life. After a year of intense physical and professional struggle on Alcott's part, publisher Horace Fuller offered her $500 per year to edit the children's monthly *Merry's Museum.* Alcott accepted the position as a chance to help her family and to move to Boston, where she could enjoy living on her own, writing, and acting in charity theatricals. The first issue that she edited appeared in January 1868. She returned to Concord in May 1868 to find that publisher Thomas Niles had reiterated the request he had made a year earlier, that Alcott write a book for girls. She agreed to try, confiding to her journal that she "Never liked girls or knew many, except my sisters, but our queer plays and experiences may prove interesting, though I doubt it."

Alcott wrote the first volume of *Little Women* in about two months in 1868. Although both Niles and Alcott had doubts about its marketability, Niles's young niece loved the book and could not put it down. Published in October 1868, it was immediately and immensely popular. Roberts Brothers asked for a sequel, which Alcott produced by New Year's. It appeared in mid April 1869–two weeks later than the publisher had intended, apparently in order to have more copies available to meet anticipated demand. The 2,000-copy printing of volume one had sold out in a month. The combined volumes sold 30,000 copies within fourteen months–phenomenal sales, especially for what was marketed as a children's book. Contemporary reviews lauded its refreshingly realistic look at young adult life, its Americanness, its ability to rivet readers and touch them deeply, evoking laughter and tears. The book has never been out of print. Part of its appeal seems to be that it reached, and reaches, an audience not exclusively composed of children. It has become something of an American cultural icon, attracting new readers generation after generation. As of 1994, three motion-picture versions of the novel have been produced.

Little Women is the first–and best written–of Alcott's three novels about the March family. The first volume covers just one year, from Christmas to Christmas. Mr. March, a minister, is physically absent for most of the book, working as a Civil War chaplain. His wife and daughters feel his presence, however, resolving to become the kind of people who will make him proud on his return. The structure of the novel overtly parallels John Bunyan's *Pilgrim's Progress* (1678), one of Bronson Alcott's favorite books. Like Bunyan's Christian, each of the daughters strives to overcome her most grievous fault: Meg her vanity, Jo her temper, Beth her shyness, and Amy her selfish thoughtlessness. Marmee, the March family matriarch, guides her daughters throughout with her calm bearing, selflessness, and wisdom. The March women touch the lives of the wealthy next-door neighbors, Mr. Laurence, his grandson Theodore (Laurie), and Laurie's tutor, John Brooke. The girls encourage the best character traits in the men as they make progress in their own pilgrimages. Volume 1 ends with Mr. March's return and Meg's engagement to John Brooke. Public clamor for a sequel to Alcott's first volume overwhelmingly insisted the author marry off the remaining March sisters in the form most becoming the conventions of the domestic novel. As Alcott confided to her journal on 1 November 1868, "Girls write to ask who the little women marry, as if that was the only end and aim of a woman's life. I *won't* marry Jo to Laurie to please any one." Nevertheless, the public demands created narrative problems for Alcott, not

Late nineteenth-century publisher's advertisements for some of Alcott's books

only because of her own independent nature, but also because she had drawn so heavily on her family in the first book. Only her elder sister, Anna, had actually married. Lizzie, the model for Beth, had died of complications from scarlet fever. Alcott especially resisted the expected match between her counterpart, Jo, and Laurie, close and loving friends in the first book. She finally reported Beth's death in terms much less sentimental than in many books of the time, married Laurie to Amy, and created, as a mate for Jo, a new character, Friedrich Bhaer, a kindly teacher who espouses many of Bronson Alcott's educational ideas. Jo and Friedrich found a school for boys on the grounds of Plumfield, a home and estate Jo inherits from her Aunt March. The book closes with a family celebration in honor of Marmee's sixtieth birthday, and all the girls reflect on the extent to which their dreams have been realized.

Part of the appeal of *Little Women* stems from the way in which Alcott drew from her childhood experiences and enriched them with realistic detail to create a group of characters who seem to have actual existence. The March family theatricals, the family newspaper, Jo's writing career, Meg's courtship and marriage, and Beth's death have basis in the biography of the Alcotts. As the author once said, "for we really lived most of it." Further, Alcott's novel presented virtually the first imperfect children (that is, real children) who were allowed to thrive in children's literature, predating Samuel Langhorne Clemens's Tom Sawyer and Huck Finn, as well as Thomas Bailey Aldrich's "bad boy." Nearly a century and a half later, many of the girls' faults look minor, but they do produce serious physical and emotional repercussions. Beth's negligence causes her bird to die; Amy burns Jo's manuscripts in a fit of jealous anger; and Jo retaliates by knowingly allowing Amy to go skating on thin ice, nearly causing her sister's death. In fact, Meg and Jo's laziness does inadvertently cause Beth's death. Going to visit the ailing Hummel family after Meg and Jo both refuse to do so as they had promised, Beth contracts scarlet fever while tending the dying baby and later dies from complications.

Undoubtedly, the strongest reason for the continuing appeal of *Little Women* is the well-delineated personalities of the four sisters. Most readers find a character who strikes a deep resonance within themselves. Certainly the most prominent sister is Alcott's alter ego, Jo. For more than a century she has been a model to women and women writers, including Gertrude Stein, Joyce Carol Oates, and Simone de Beauvoir. Jo's literary ambition, her active approach to life, and her struggle against the bonds of domesticity have made her one of the most recognized and admired heroines in American literature.

Jo March and *Little Women* do not, however, always meet with universal approval. In the late twentieth century critics were troubled by the extent to which Alcott seems to propose radical, feminist ideas and then retract them. Republication of Alcott's sensationalized fiction has caused some scholars to re-evaluate *Little Women* using the lens of the darker, more subversive, and overtly feminist side of the "children's friend." Martha Saxton, for example, calls *Little Women* "a regression for Louisa as an artist and as a woman." Judith Fetterley says that Jo's fate amounts to "self-denial, renunciation, and mutilation." Some scholars place their readings within the historical context of the mid-nineteenth century, rather than the modern era, and therefore more willingly acknowledge Alcott's achievements in *Little Women*. Elaine Showalter, for example, calls it "both convincing and inspiring" and asserts that it is "more tightly constructed and more stylistically controlled than any of Alcott's other books."

The financial success of *Little Women* enabled Alcott to take another tour of Europe, this time as a celebrated author, in the company of her sister May and a friend, Alice Bartlett. Leaving on 2 April 1870, she stayed in Europe, frequently hampered by ill health, until news of the death of her brother-in-law, John Pratt, drew her back to Boston fourteen months later. May, a budding artist, stayed in Europe another six months, largely financed by her sister's writing royalties, and she spent as much time as possible there for the rest of her life. She married Ernest Nieriker, a handsome Swiss businessman fifteen years her junior, in London in 1878 and died in Paris from complications of childbirth the following year. In the twenty years of her life after *Little Women*, Alcott wrote seven more children's novels. All were popular with the reading public, though critics agree that none of the later works is as aesthetically mature as *Little Women*.

Little Men (1871) recounts school adventures at Jo and Friedrich's Plumfield, and in many ways Alcott pays tribute to her father's theories of education in this sequel. The rich and poor children are educated in mind, body, and spirit. Discipline is enforced by love. In one incident Friedrich punishes a mendacious scholar by having the boy strike him. The child never lies again. Plumfield is a co-educational school; in this respect Alcott extended her father's theories to incorporate her own belief in female education. Another pair of books, *Eight Cousins* (1875) and *Rose in Bloom* (1876), traces the history of Rose Campbell, an orphaned heiress who comes to live with her aunts, cousins, and eventually her Uncle Alec. She learns an active, physical approach to life from the boys and in turn becomes a civilizing and moral exemplar for them. These books represent a singular achievement in plot construction.

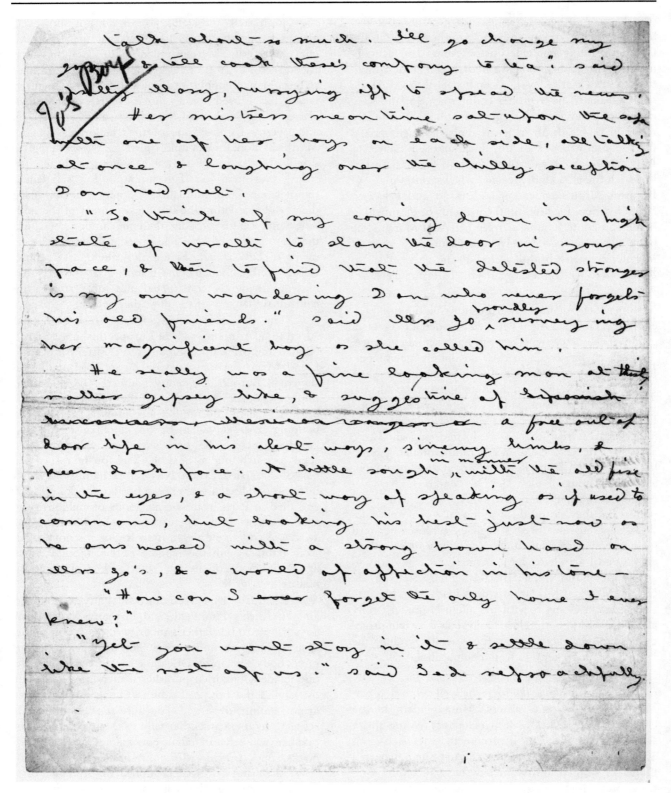

Page from the manuscript for Jo's Boys, *published in autumn 1886 (Louisa May Alcott Collection, Clifton Waller Barrett Library, Manuscripts Division, University of Virginia Library)*

Much less episodic than many of her works, these later novels demonstrate her ability to focus on a single main character. In September and October 1875, between writing these two books, Alcott attended the Women's Congress in Syracuse and visited a prison, an orphanage, and the Newsboys Home in New York. Her impulse toward social reform manifests itself more in *Rose in Bloom* than in *Eight Cousins*. The two books present Alcott's theories regarding women's education, her support of "sensible" clothing for women (including a vehement rejection of corsets), her increasingly overt feminism, her assertion that everyone needs meaningful work, and her insistence on the companionate marriage ideal.

Although Alcott's fame during her later years rested most strongly on her writing for children, two of her adult works garnered contemporary public acclaim and modern scholarly attention. On the eve of her fortieth birthday, in 1872, Alcott returned to the novel she had begun twelve years earlier, which she was calling "Success," and suddenly found her way around the "muddle," as she called it. She finished the story, renamed it *Work,* and published it first in serial form in *The Christian Union* (18 December 1872 – 18 January 1873) and then as a book in June 1873. *Work* tells the story of Christie Devon's experiments in fending for herself and describes many of Alcott's own jobs: servant, actress, companion, governess, and seamstress. Christie eventually falls in love with Thoreau-like David Sterling. The two marry just hours before they both march off to war, he as a soldier and she as a nurse. David dies in the Civil War, leaving Christie pregnant with their child. The novel ends with Christie "At Forty" as the driving force behind a community of women that includes her daughter, mother-in-law, sister-in-law, and some of the women she has befriended, including a former slave, a washerwoman, and a wealthy philanthropist. Each woman has her own fulfilling "work." Christie acts as liaison between the philanthropic women's rights activists and the working women they are trying to help.

Another novel from this period of Alcott's life is *A Modern Mephistopheles* (1877), whose title she had first used for *A Long Fatal Love Chase*. Written in response to her publisher's request for a volume for its No Name Series, *A Modern Mephistopheles* is much more traditionally Faustian than *A Long Fatal Love Chase:* a struggling writer, Felix Canaris, "sells his soul" to the dastardly Jasper Helwyze in return for artistic fame. The book includes many allusions to Goethe's tale, as well as to works by Nathaniel Hawthorne and George Gordon, Lord Byron. While the characterizations (especially of women) are not as noteworthy or original as those in many other Alcott works, the story provides remark-

Alcott in 1887

able insights into Alcott's struggles as a writer. For example, Felix laments his impatience with revision and worries about his lover's suggestion that "fear of the world and the loss of fame" will prevent him from ever surpassing the greatness of his first acclaimed work, which—says another character—"came from your heart." Alcott's letters and journals reveal her struggles with both these artistic difficulties.

In increasingly ill health and with growing familial responsibilities over the years, Alcott put to rest the March family, and for all practical purposes, her writing career, when she finally completed *Jo's Boys* in 1886. The novel shows the effects of Alcott's many starts and stops in writing it. In contrast to her usual writing speed, she took four years, rather than four weeks, to finish it. *Jo's Boys* moves the March/Bhaer/Alcott experiment in education to the next academic level. Old Mr. Laurence's will provides the financial backing to establish Laurence College, a co-educational institution on the grounds of Plumfield School. Alcott allows Jo's boys and girls a wide range of careers in this novel. Jo's alter ego, Nan, pursues a career in medicine and remains single; Bess and Josie become an artist and actress respectively but give up their careers when they marry. One

of the most troubling characters is Dan Kean, the "bad boy" of *Little Men*. He remains a dark, untamed, sensual force. Mrs. Jo heads off his interest in the artistic Bess, and Dan eventually leaves for the West, dying while defending Native Americans victimized by westward expansion. For the most part the next generation, schooled in intellectual and domestic pursuits, gains some of the freedoms that Alcott could not quite bring herself to demand for herself and her contemporaries. Mrs. Jo herself resumes the writing career she abandoned before her marriage, and the "Jo's Last Scrape" chapter, obviously drawn from Alcott's own life, ironically reconsiders the joys of fame.

Having taken care of her fictional March family, having provided for her real family's financial future by adopting Anna's son John Pratt so he could continue to renew her copyrights as her legal heir, having seen her father to the end of his last illness, she died less than forty-eight hours after him on 6 March 1888.

Had Louisa May Alcott not written *Little Women*, her name would probably be at best included in a footnote to nineteenth-century literary history. Nothing she wrote before or after captured the attention of America and the world quite so powerfully as her "girls' story." Alcott did write a great deal more than *Little Women*, however—more than three hundred published works, including children's novels, adult novels, sensation fiction, poems, plays, and many shorter tales. The body of her work reminds the reader of a passage in Emerson's "Experience": "we live amid surfaces, and the true art of life is to skate well on them." The true and enduring life of Louisa May Alcott's art derives from her ability to "skate well" among the many forms of artistic expression she tried, understanding the conventions of the various nineteenth-century genres to which she contributed, adapting them to express her feminist, reformist views, while also contributing unforgettable characters and vivid impressions of life to the body of nineteenth-century American literature.

Letters:
Edward W. Bok, "Louisa May Alcott's Letters to Five Girls," *Ladies' Home Journal,* 13 (April 1896): 12;
Alfred Whitman, "Letters to Her Laurie," *Ladies' Home Journal,* 18 (11 September/October 1901): 5–6;
Jessie Bonstelle and Marian DeForest, *Little Women: Letters from the House of Alcott* (Boston: Little, Brown, 1914);
Elizabeth Bancroft Schlesinger, "The Alcotts through Thirty Years: Letters to Alfred Whitman," *Harvard Library Bulletin,* 11 (August 1957): 363–385;
Madeleine B. Stern, "Louisa May Alcott's Feminist Letters," in *Studies in the American Renaissance 1978,*

edited by Joel Myerson (Boston: Twayne, 1978), pp. 429–452;
Stern, "Louisa Alcott's Self-Criticism," in *Studies in the American Renaissance 1985,* edited by Myerson (Charlottesville: University Press of Virginia, 1985), pp. 333–382;
The Selected Letters of Louisa May Alcott, edited by Myerson, Daniel Shealy, and Stern (Boston: Little, Brown, 1987).

Bibliographies:
Lucile Gulliver, *Louisa May Alcott: A Bibliography* (Boston: Little, Brown, 1932);
Judith C. Ullom, *Louisa May Alcott: A Centennial for "Little Women"* (Washington, D.C.: Rare Books Division, Library of Congress, 1969);
Alma J. Payne, *Louisa May Alcott: A Reference Guide* (Boston: G. K. Hall, 1980).

Biographies:
Ednah Dow Cheney, *Louisa May Alcott: The Children's Friend* (Boston: Prang, 1888);
Cheney, *Louisa May Alcott: Her Life, Letters, and Journals* (Boston: Roberts, 1889);
Belle Moses, *Louisa May Alcott, Dreamer and Worker: A Story of Achievement* (New York: Appleton, 1909);
Edith Willis Linn and Henry Bazin, eds., *Alcott Memoirs Posthumously Compiled from Papers, Journals, and Memoranda of the Late Dr. Frederick L. H. Willis* (Boston: Badger, 1915);
Cornelia Meigs, *Invincible Louisa: The Story of the Author of Little Women* (Boston: Little, Brown, 1933);
Katherine S. Anthony, *Louisa May Alcott* (New York: Knopf, 1938);
Madeleine B. Stern, *Louisa May Alcott* (Norman: University of Oklahoma Press, 1950);
Marjorie Worthington, *Miss Alcott of Concord: A Biography* (Garden City, N.Y.: Doubleday, 1958);
Helen Waite Papashvily, *Louisa May Alcott* (Boston: Houghton Mifflin, 1965);
Martha Saxton, *Louisa May: A Modern Biography of Louisa May Alcott* (Boston: Houghton Mifflin, 1977);
Madelon Bedell, *The Alcotts* (New York: Clarkson Potter, 1981).

References:
Nina Auerbach, *Communities of Women: An Idea in Fiction* (Cambridge, Mass.: Harvard University Press, 1978);
Beverly Lyon Clark, "Domesticating the School Story, Regendering a Genre: Alcott's *Little Men*," *New Literary History,* 26 (Spring 1995): 323–342;
Christine Doyle, *Louisa May Alcott and Charlotte Brontë* (Knoxville: University of Tennessee Press, 2000);

Sarah Elbert, *A Hunger for Home: Louisa May Alcott and Little Women* (Philadelphia: Temple University Press, 1984);

Judith Fetterley, "Impersonating 'Little Women': The Radicalism of Alcott's Behind a Mask," *Women's Studies,* 10 (1983): 1–14;

Richard Francis, "Circumstances and Salvation: The Ideology of the Fruitlands Utopia," *American Quarterly,* 25 (May 1973): 202–234;

Katherine F. Gerould, "Miss Alcott's New England," *Atlantic Monthly,* 108 (August 1911): 180–186;

Abigail Hamblen, "Louisa May Alcott and the Racial Question," *University Review* (Kansas City), 37 (1971): 307–313;

Elizabeth Lennox Keyser, *Whispers in the Dark: The Fiction of Louisa May Alcott* (Knoxville: University of Tennessee Press, 1993);

Elizabeth Langland, "Female Stories of Experience: Alcott's *Little Women* in Light of Work," in *The Voyage In: Fictions of Female Development,* edited by Elizabeth Abel, Marianne Hirsch, and Elizabeth Langland (Hanover: University Press of New England, 1983), pp. 112–130;

Ruth K. MacDonald, *Louisa May Alcott* (Boston: Twayne, 1983);

Joy A. Marsella, *The Promise of Destiny: Children and Women in the Short Stories of Louisa May Alcott* (Westport, Conn.: Greenwood Press, 1983);

Sandra Harbert Petrulionis, "By the Light of Her Mother's Lamp: Woman's Work versus Man's Philosophy in Louisa May Alcott's 'Transcendental Wild Oats,'" *Studies in the American Renaissance,* edited by Joel Myerson (Charlottesville: University Press of Virginia, 1995), pp. 69–81;

Leona Rostenberg, "Some Anonymous and Pseudonymous Thrillers of Louisa May Alcott," *Papers of the Bibliographical Society of America,* 37 (Second Quarter, 1943): 131–140;

Elaine Showalter, *Sister's Choice: Tradition and Change in American Women's Writing* (Oxford: Oxford University Press, 1991);

Madeline B. Stern, *Louisa May Alcott: From Blood and Thunder to Hearth and Home* (Boston: Northeastern University Press, 1998);

Stern, "Louisa May Alcott's Contributions to Periodicals, 1868–1888," *More Books,* 18 (1943): 411–420;

Stern, ed., *Critical Essays on Louisa May Alcott* (Boston: G. K. Hall, 1984);

Lorenzo Dow Turner, "Louisa May Alcott's 'M.L.,'" *Journal of Negro History,* 14 (October 1929): 495–522;

Jean Fagan Yellin, "From *Success* to Experience: Louisa May Alcott's Work," *Massachusetts Review,* 21 (1980): 527–539.

Papers:
The primary collections of Louisa May Alcott's papers are at the Houghton Library, Harvard University; the Fruitlands Museum in Harvard, Massachusetts; and the Boston Public Library, and the Clifton Waller Barrett Library, Manuscript Division, University of Virginia Library.

Sarah G. Bagley

(29 April 1806 – 1848?)

Miguel A. Cabañas
College of the Holy Cross

PERIODICAL PUBLICATIONS: "Pleasures of Factory Life," *Lowell Offering*, series 1 (December 1840): 25–26;

"Tales of Factory Life, No. 1," *Lowell Offering*, 1 (June 1841): 65–68;

"Tales of Factory Life, No. 2: The Orphan Sisters," *Lowell Offering*, 1 (October 1841): 263–266;

"Sarah G. Bagley's Speech at the New England Workingmen's Association, May 27, 1845," *Voice of Industry*, 5 June 1845;

Letter to the *Lowell Advertiser* (10 July 1845);

"Sarah G. Bagley Defends Her Speech," *Voice of Industry*, 17 July 1845;

Letter to the *Lowell Advertiser* (26 July 1845);

"Voluntary?" *Voice of Industry*, 18 September 1845;

"To Our Friends and Readers," *Voice of Industry*, 7 November 1845;

"Introductory," *Voice of Industry*, 9 January 1846;

"What Was Omitted in the Report," *Voice of Industry*, 9 January 1846;

"The Ten Hour System & Its Advocates," *Voice of Industry*, 16 January 1846;

"The Ten Hour System & Its Advocates," *Voice of Industry*, 24 January 1846;

"Ten Hour System & Its Advocates, Again," *Voice of Industry*, 16 February 1846;

"Report of the Lowell Female Labor Reform Association to the New England Workingmen's Association," *Voice of Industry*, 10 April 1846;

"To E. R. L.," *Voice of Industry*, 24 April 1846;

"To E. R. L.–No. 2," *Voice of Industry*, 6 May 1846;

"To E. R. L.–No. 3," *Voice of Industry*, 8 May 1846;

"To the Editor of The Voice and Ourself," *Voice of Industry*, 15 May 1846;

"A Pledge," *Voice of Industry*, 15 May 1846;

"How the Corporations Procure Help: Chapter I," *Voice of Industry*, 22 May 1846;

"To the 'Circle' for Mutual Agreement," *Voice of Industry*, 29 May 1846;

"The Introduction into the Mill: Chapter II," *Voice of Industry*, 12 June 1846;

"The Improvement Circle," *Voice of Industry*, 12 June 1846;

"Some Incidents of My Journey," *Voice of Industry*, 11 September 1846;

"To W.E.B., Correspondent to the Dundee (Scotland) Warder," *Voice of Industry*, 18 September 1846;

Letter to the *Voice of Industry*, 23 September 1846;

Letter to *Vox Populi*, 20 November 1846.

The first woman labor editor and labor leader in the United States, Sarah G. Bagley was also the first president of the Female Labor Reform Association of Lowell, Massachusetts. During the 1840s Bagley became an important figure in New England, earning respect from both male and female workers. Representing a new moral consciousness in the United States, she exposed the oppression of women within the capitalist economy and brought about a change in attitudes toward the role of working women in American society. Even in the twenty-first century, when she has been largely forgotten, her views on class and gender and her suggestions for reforms continue to be relevant.

Sarah George Bagley was born in Candia, New Hampshire, on 29 April 1806. She was the third of five children of Nathan and Rhoda Witham Bagley. Her father was a farmer of some means, while her mother came from a family that had suffered financial difficulties. In 1814 the Bagley family moved to Gilford and in 1827 to Meredith Bridge (now Laconia), New Hampshire. Little is known of Bagley's youth. She probably went to Lowell in search of factory work because of family financial problems that were caused by her father's involvement in litigation over some of his property during the 1820s. Before she started at the Hamilton Company of Lowell on 22 September 1837, she may have worked at cotton mills in New Hampshire. In her 1845 testimony to the Massachusetts legislature Bagley revealed that after long days of weaving work, she often taught night classes at the mill. She was older and more experienced and had more education than the average "factory girl."

Once she settled in Lowell, Bagley began writing for *The Lowell Offering,* a local literary magazine. In "Pleasures of Factory Life," published in the December 1840 issue, she discussed the exciting learning environment that enabled "farm girls" to grow morally and intellectually within an "ideal" society. Bagley pointed to many opportunities for personal improvement in factory life—including moments of contemplation, intelligent conversation among the operatives, the pleasure of work in an enjoyable environment full of plants and flowers, and the ability to assist one's family financially. She also noted:

> In Lowell, we enjoy abundant means of information, especially to suit the convenience of the operatives; and sad indeed would be the picture of our Lyceums, Institutes, and scientific Lecture rooms, if all the operatives should absent themselves.
>
> And last, though not least, is the pleasure of being associated with the institutions of religion, and thereby availing ourselves of the Library, Bible Class, Sabbath School, and all other means of religious instruction. Most of us, when at home, live in the country, and therefore cannot enjoy these privileges to the same extent; and many of us not at all. And surely we ought to regard these as sources of pleasure.

Bagley also published two short pieces in *The Lowell Offering:* "Tales of Factory Life, No. 1" (June 1841) and "Tales of Factory Life, No. 2: The Orphan Sisters" (October 1841). "Tale No. 1" is the story of Sarah T., a farm girl who goes to the city of Lowell at the time of the "Lowell fever" that drew farm girls to the city with the promise of education, clothing, means of family support, and ultimately, economic independence. In "Tale No. 2" Bagley presents Catherine B., an orphan, who through sacrifice and hard work is able to support her younger brother and sisters, to improve herself socially, and even to marry. The style of these three contributions to *The Lowell Offering* is sober and their tone calm and factual. All three praise the virtuous mill girl and her way of life. They reinforce the myth that mill life is benign and beneficial to the individual and to society as a whole; the mill appears as a paradise for both worker and employer. All Bagley's writings in *The Lowell Offering* fit into what might be described as her genteel phase (before she began her militant and activist life). Her utopian ideas of progress for the "New World" society were about to be crushed by the events that followed.

In the early 1840s the situation at the mills was starting to deteriorate for the workers, and Bagley certainly must have been aware of the changes that corporation managers were imposing on factory operatives in order to increase production. The workplace had bad

Label for the cloth mill where Sarah G. Bagley went to work in 1837

ventilation and more machinery was added. Housing quality declined, and mealtimes were made even shorter for the operatives, who began having to work as many as five looms at once, thirteen to fourteen hours per day. In 1845 Bagley became ill and had to stop working for some time.

From December 1844 until January 1847 Bagley served as the first president of the Female Labor Reform Association of Lowell (FLRA). As reported in the *Lowell Advertiser* on 13 December 1845, John C. Cluer, an English weaver and labor organizer associated with the ten-hour movement to limit work hours, met with the FLRA, and his plan was "enthusiastically received." A petition signed by John Quincy Adams Thayer, Sarah Bagley, James Carle, and two thousand others (mostly women) finally convinced the legislature to hold a hearing. In February 1845 Bagley and others testified before the legislative committee, which did not grant them the ten-hour day. As a result of this experience, Bagley became more cynical about the workings of the political system, seeing it as manipulated by and for corporations and as disinterested in the common good of workers. Bagley's involvement in the ten-hour movement and her eloquence as a public speaker

resulted in her contributions to a weekly newspaper, the *Voice of Industry*. Her 27 May 1845 speech at a meeting of the New England Workingmen's Association—especially her words about unity and common goals for male and female operatives against the corporations—impressed and persuaded the male public: "For the last half a century, it has been deemed a violation of woman's sphere to appear before the public as a speaker; but when our rights are trampled upon and we appeal in vain to the legislators, what shall we do but appeal to the people?" Bagley argued that woman's voice must be heard, but, not wanting to alienate the male workers, she rhetorically downplayed women's role in the struggle as secondary: "We do not expect to enter the field as soldiers in this great warfare; but we would, like the heroines of the Revolution, be permitted to furnish the soldiers with a blanket or replenish their knapsacks from our pantries." With this elocution of secondary importance (but prominence nonetheless) Bagley made her case for the inclusion of women in the workers' "Revolution."

In 1845 two thousand workingmen attended an Independence Day rally in Woburn, Massachusetts, where Bagley declared her discontent with *The Lowell Offering*, accusing it of being a "mouthpiece of the corporations." Harriet Farley, editor of the *Offering*, responded firmly, defending what she believed to be the true liberating spirit of the magazine. Bagley's answer to Farley's comments appeared in the *Lowell Advertiser* on 26 July 1845. Bagley questioned the seriousness of the *Offering* and its editor's ability to veil its political agenda: "She speaks of the labor question as the 'reform topic of the day,' and in her classification assigns me a place I could not hope to have attained, with all my 'unwomanly love of notoriety.'" Bagley's notoriety was "unwomanly" because she was respected among male and female operatives as a true leader and advocate of their political rights, challenging women's passive role in the socioeconomic and political life of the Republic.

Bagley's first goal was to dispel the many myths about factory life that had been created through *The Lowell Offering*. She wrote in the 17 July 1845 issue of the *Voice of Industry*:

We asked the question what kind of an organ of defence would the operatives find with Mr. Schouler for a proprietor and publisher? We repeat the question, and if anyone should look for an article in the publisher's columns, they would find something like the following: "Lowell is the Garden of Eden (except the serpent) the gates thereof are fine gold. The tree of knowledge of *good* is there, but the evil is avoided through the *judicious* management of the superintendents. Females may work nineteen years without fear of injuring their health, or imparing [*sic*] their intellectual

and moral powers. They may accumulate large fortunes, marry and educate children, build houses, and buy farms and all the while be operatives." Thus would the *Offering* under such a control, and those who are as stupid as Mr. Mellen made himself, *would believe it.*—We have not written this article to evince that there is "mind among the spindles" but to show that the minds here are not *all spindles*.

In this passage Bagley juxtaposed the cliché of "the mind among the spindles," the motto of *The Lowell Offering,* with a spindle metaphor that represents objectification and mechanical aimlessness, crushing the mythical image with a single blow of rhetorical wit. Her commentary is sarcastic, parodic, and playful, forcefully poking fun at the discourse of establishment propaganda woven into the magazine. Bagley points to the conflict of interest of William Schouler, who had opposed the ten-hour legislation and was the editor and publisher of *The Lowell Courier* as well as having significantly funded *The Lowell Offering* for two years. As editor of the *Offering,* Farley respected the factory establishment and ignored the crucial political and social issues that affected the "factory girls." Farley's literary ambitions for the *Offering* and her proposed "neutrality" eventually caused the weekly magazine to lose subscribers. By 1845 there were only fifty-two, and by the end of the same year the magazine had folded.

In spite of the initial failure of the ten-hour movement, Bagley was determined to continue her fight for women's rights—to "Try Again" in the words of the FLRA motto. Bagley actively organized female workers and spoke to women's groups all over New England. She wrote for the *Voice of Industry* and was also a member of its editorial committee, along with Huldah J. Stone, secretary of the FLRA, and Mehitable Eastman, a labor leader. As a leader, Bagley communicated honest and clear goals. In her "Introductory" to the "Female Department" of the *Voice of Industry* (9 January 1846), she declared: "Our department devoted to woman's thoughts will also defend woman's rights, and while it contends for physical improvement, it will not forget that she is a social, moral, and religious being. It will not be neutral, because it is female, but it will claim to be heard on all subjects that effect her intellectual, social or religious condition." This declaration of principles established the *Voice of Industry* as a forum in which women operatives could articulate their concerns and as a place to address women's issues in a society that rigidly controlled their sociopolitical influence and power. Bagley envisioned women as occupying a public political role in society. In this sense the working women of Lowell anticipated the public articulation of the early feminist struggle two years before the historical suffrage con-

The Middlesex Woolen Mills, where Bagley went to work in 1842

vention at Seneca Falls, New York (1848). In her writing and in her deeds Bagley expanded the possibilities for women. She scrutinized the oppressive forces that shaped women's lives at the time. For her there would be no standing still under the gaze of patriarchy, no passive contentment with women's limited roles within institutions; instead, there would be "improvement of the mind" and active resistance.

One of Bagley's major concerns was the exploitation of women laborers by corporations. In "Voluntary?", which appeared in the 18 September 1845 issue of the *Voice of Industry,* Bagley argued against notions that evade the moral issues implicit in the treatment of women factory workers: "Whenever I raise the point that it is immoral to shut us up in a close room twelve hours a day in the most monotonous and tedious of employment, I am told that we have come to the mills voluntarily and that we can leave when we will." She went on to pose the philosophical question of free will:

> By what charm do these great companies immure human creatures in the bloom of youth and first glow of life within their mills, away from their homes and kindred? A slave too goes voluntarily to his task, but his will is in some manner quickened by the whip of the overseer. The whip which brings us to Lowell is NECESSITY. . . . Is this freedom? To my mind it is slavery quite as really as any in Turkey or Carolina. It matters little as to the fact of slavery, whether the slave

be compelled to his task by the whip of the overseer or the wages of the Lowell Corporations. In either case it is not free will, leading the laborer to work, but an outward necessity that puts free will out of the question.

Bagley's comparison of factory life to slavery was a common rhetorical device used in FLRA tracts written to increase support among the mill operatives. In this article necessity is the force corporations employ to attract factory girls, as well as the "whip" that keeps these women from exercising their rights. Once she established that free will was absent or nonexistent, Bagley reinforced and radically emphasized the unscrupulous and depraved morality of the corporations.

Bagley proposed a new society built on the moral power of women. This idea was a traditional concept of New England womanhood but with a significantly different slant: Women could and should intellectually seek social justice, their goal was to change a patriarchal class-based society that oppressed its workers. Bagley firmly believed that her ideas for reform and the advancement of workers' rights would constitute a "progressive" and universal achievement. In the report of the Lowell Female Labor Reform Association to the New England Workingmen's Association, published in the 10 April 1846 issue of the *Voice of Industry,* Bagley spoke positively of the gains the movement had made, emphasizing the creation of one spirit, one community, and one family: "There is a spirit abroad in the wide world, which will not rest,

until Justice shall be established on every hill—until Righteousness with its peaceful, regenerating streams shall flow through every vale—until a union of interest, a bond of brotherhood, shall make in *deed* and in *truth,* all *one* in the great family of man." In this report Bagley enumerated the improvements that the association had already attained: "The Press is manifesting a more active interest in the subject of labor's rights, all over the land. The Clergy are beginning to throw off the shackles which have so long crippled their efforts for good," and finally, "To aid on the cause of human improvement and intellectual culture, our Association have established and Industrial Reform Lyceum, in the city of Lowell." But perhaps most important, Bagley explained that they now had a medium to unite female workers, one through which they might speak "the *truth boldly!*"—the *Voice of Industry.* This report carries its force and momentum from its beginning to the final line. Not unlike her contemporaries, Bagley employed Christian religious images to explain her hopes for the labor movement and to convey those aspirations to the workers. The cheerful and hopeful intelligence of the community "in earnest," the attention the reform was attracting from different groups of society, and finally, the presence of God, who provides the workers with wisdom and an untiring thirst for "Justice, equity and love"—all lead to images of peace that proclaim the final steps of the "mighty reform":

> Let us all be true to ourselves, mentally, morally and physically, and the blessings of high heaven, will crown our labors with abundant success. Our pathway through life will be strewn with flowers which never fade—our hearts retain the freshness and vigor of youth until the last sands of life have run, and death like a kind friend, shall give us a welcome passport to the joys of heaven—to the *home* of *Angels!*

Here, the report acquires the depth and eloquence of an inspirational sermon, poetically transporting the listener/reader to a serene heaven.

Bagley both understood and systematically dismantled women's expected roles. Her articles often include self-conscious comments about women's writings, authorizing women to disregard the conventions typical of women's writing of the time. On 15 May 1846, when editor William F. Young was ill, she took his position and announced that the *Voice of Industry* was "under the Editorial control of a common schooled New England female factory operative" (Bagley). She asserted, "What we lack in editorial ability, in rhetorick, or historical research, be assured we will make up in heart. Our heart, yea, our whole soul, is wrapped up in the cause of the oppressed—of the downtrodden mil-

lions throughout the world." Speaking for the community, she declared:

> Our end, aim and soul's wish, is the improvement of the condition of the laboring masses. . . . Famishing want among large classes of operatives, starving Ireland, oppressed Leeds, Manchester and Liverpool, the cries of the oppressed from every other land, and the murder of the Chartists, shot down in cold blood, by orders of a woman,—the millions at the same time appropriated for the support of Prince Albert's wet nurses, and Lord Chamberlains, wrung from the brow of labor, all come as a warning voice, terrible as the thunder of Almighty God, *that we too, are in danger.*

In this passage Bagley's global consciousness is evident, including a reference to the Chartist Movement, which sought voting rights for the working class in England. Her views of contemporary labor issues stemmed from a broad understanding of historical oppressive practices.

She directed her radical proposals for reform at the heart of what she considered to be the force tyrannizing honest laborers, that is, capitalists, contending: "Two great principles must be introduced as the basis for the organization of the factory system in this country, or the same results are to flow in here that have caused such crying anguish in the old world. *Capital must not be permitted to demand so much of labor. Education to the mass, must be made to possess an individual certainty, past escape.*" Whatever she wrote, Bagley did so under the Romantic impetus of her desire to change the world. Even though her major emphasis was demanding equal rights for women workers, she clearly suggested the similarities in the relationships between women and men under patriarchy and workers and management under capitalism. In doing so, Bagley kept stretching the limits of "women's sphere" away from the "cult of true womanhood," questioning the powerful social networks of U.S. society.

Bagley's attacks on the abuses of capital over labor developed the themes of the immorality and greed of Lowell corporations. On 18 September 1846 Bagley wrote an article in the *Voice of Industry* replying to W.E.B., correspondent to the *Dundee* (Scotland) *Warder.* Her intent was to dispel his assertions that religion in Lowell had become "highly prosperous." She openly denounced the hypocrisy of corporate ethics:

> It is true you might have seen a by-law, making it obligatory on the females employed by the company to attend church and pay five dollars per year for a seat but it would cost you no more pains to find 14 men who were employed by one company, where you visited, who were discharged from the employ for refusing to work on the Sabbath.

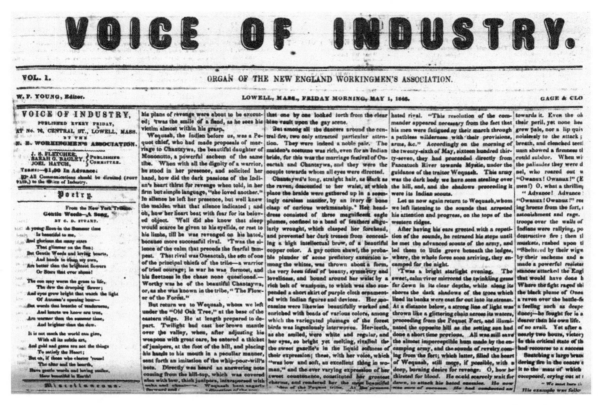

An issue of the labor weekly with which Bagley was associated in the 1840s. She is listed on the masthead (top left) as a member of the publishing committee.

This is the real, actual, practical religion of the corporations, a very different thing from profession. It looks well on paper when the piety of the manufacturers of Lowell is sent abroad, especially in a country as distant as Scotland.

Bagley condemned the avarice of the employer, the double standards applied to women and men, and the pressure corporations used to force workers to comply with their rules of production, even when it meant putting aside their religious beliefs.

According to Bagley, the alternative for women was not "true womanhood" but "sisterhood." In the *Voice of Industry* (15 May 1846), Bagley condemned the paternalism of mill agents and legislators:

What! deprive us after working thirty hours, the poor privilege of finding fault—of saying our lot is a hard one. Intentionally turn away a girl unjustly—persecute her as men have been persecuted, to our knowledge, for free expression of honest political opinions! We will make the name of him who dares the act, stink with every mind, from all points of the compass. His name shall be a by-word among all laboring men and he shall be hissed in the streets, and in all the cities in this widespread republic; for our name is legion though our oppression

be great. Our sympathies are for the sailor and soldier, as well as the citizen. We war with oppression in every form—with rank, save that which merit gives.

Bagley was unafraid to fight oppression even if it meant opposing powerful men. As she explained in the same article, "oppression however slight, abuse of trust however trivial, insolence from whatever source, and whether from the agent, the overseer or petty tender, in the capacity of under clerk, from the Bank managers, men in authority of the city government, or gentlemen of the professions, whether Doctor, Lawyer, or Priest, we will punish as it merits." Bagley saw oppressed women themselves as the force that would eventually dismantle the chain of injustice and the patriarchal structure that oppressed them. Bagley encouraged her "sisters" to uphold their own standards of virtue and to be aware of the "fiend in human form who for a momentary job, would rob you of bliss of life and destroy girl's happiness."

Bagley stressed the importance of maintaining community values, both to join forces to combat oppression and to pursue the good and the happiness of everyone. In an article published in the *Voice of Industry* on 12 June 1846, she explained:

Much of our happiness, nay, every thing depends upon our *social* existence. Make us rich and give us no social intercourse and what will it avail us? . . . Our *whole* life is interwoven with each other, and our happiness made to depend upon each other in a greater or less degree. . . . Then let *us* as *real* lovers of the good, the beautiful, and the true, live not for ourselves alone, but for each other, and the good of our race.

Sarah Bagley was involved in many different cultural fronts. In Lowell she helped found an Industrial Reform Lyceum to discuss controversial subjects ignored by the regular town lyceum. The 13 February 1846 *Voice of Industry* announced that Bagley would participate in the new enterprise of the "Magnetic Telegraph." On 21 February 1846 she became the first woman telegrapher in the United States, beginning work at the Lowell Telegraph Depot, and on 24 August 1846 she demonstrated the new technology publicly in front of the citizens of Lowell. That summer Bagley was elected vice president of the Lowell Union of Associationists, an organization that was part of a utopian socialist movement based on the ideas of Charles Fourier.

Toward the end of her career at the *Voice of Industry*, Bagley wrote an especially interesting piece. In "Some Incidents of My Journey" (11 September 1846) she compared the management of a mill to that of a prison in New Hampshire. She observed the neatness of prison facilities at New Hampshire State Prison, the shorter labor hours for prisoners than for factory workers, and the civil treatment of the prisoners. Her insinuation is direct, and her analysis suddenly became satiric:

Among the other prisoners was a man of much beauty. A full, round, well developed head–a keen black eye, and straight, genteel figure. What a pity, thought I, that you did not make a more judicious selection for the practice of rascality. You might have selected some game equally dishonest, that would not have exposed you, but have made you looked up to, as a man of wealth, and, therefore, to be respected without regard to the means by which it was procured. You might have performed some "hocus pocus" means of robbery, without forgery, and passed as an Appleton, a Lawrence, or an Astor in society. Foolish man! Let others learn wisdom by their small games, and take to wholesale plunder, and not only escape the prison, but have a ticket to the circles of the "upper ten thousand."

The prisoner's dishonesty is compared with that of the richest men of New England, but his foolishness seems much more tragic because he did not choose to steal by the thousands as his wealthy counterparts did. Bagley had become a sharp and cunning writer, her tone close to that of a satirist, her style subtle and effective.

Bagley wrote her last letter to the *Voice of Industry* on 23 September 1846, and 18 October 1846 marked her last day on the publishing committee. According to Helena Wright, Bagley returned to the Hamilton Company in April 1848 and worked for five months. At that point the ten-hour movement had been crushed and she had developed health problems. She returned to New Hampshire because her father was ill; he died of typhoid fever on 27 September 1848. Researchers have been trying to discover what happened to Bagley after this date. It is possible that she died not long after her father. She was physically and mentally exhausted after her union struggles, and the illness she contracted at the mill in 1845 may have finally overcome her. Another possibility is that she married and moved away, but this possibility seems unlikely because she was middle aged and lacked wealth. In any event her leadership and feminist voice disappeared from the public arena.

Bagley's obsession with the amelioration of the factory system on behalf of the workers brought about the creation of a community of laborers and the articulation of women's rights and responsibilities. Bagley not only criticized the capitalist system for its immorality and hypocrisy, she also created the opportunity for other women workers to express their political concerns in the *Voice of Industry*. She helped to transform women's silence into a song of change and hope. She was respected by her peers and feared by her critics. She has been overshadowed by nineteenth-century figures whose impact on society was not quite as large, especially taking into consideration Bagley's humble background and her extraordinary life.

References:
Philip S. Foner, ed., *The Factory Girls* (Urbana: University of Illinois Press, 1977);

Teresa Anne Murphy, *Ten Hour's Labor: Religion, Reform and Gender in Early New England* (Ithaca, N.Y.: Cornell University Press, 1992);

Judith O'Sullivan, *Workers and Allies: Female Participation in the Trade Union Movement* (Washington, D.C.: Smithsonian Traveling Exhibition Service, 1976);

Harriet H. Robinson, *Loom and Spindle or Life Among the Early Mill Girls* (Kailna, Hawaii: Pacific Press, 1976);

"Sarah Bagley–First Telegraphic Service in January 1, 1845," *Lowell Sunday Telegram,* 28 May 1944;

Bernice Selden, *The Mill Girls: Lucy Larcom, Harriet Hanson Robinson, Sarah G. Bagley* (New York: Atheneum, 1983), pp. 117–180;

Madeleine B. Stern, *We the Women: Career Firsts of Nineteenth Century America* (New York: Schulte, 1963);

Helena Wright, "Sarah G. Bagley: A Biographical Note," *Labor History,* 20 (Summer 1979): 398–413.

Papers:
A few papers relating to Sarah G. Bagley are available at the American Antiquarian Society in Worcester, Massachusetts, and in Special Collections at the University of Lowell in Lowell, Massachusetts.

Mary Boykin Chesnut

(31 March 1823 – 22 November 1886)

Melissa A. Mentzer
Central Connecticut State University

BOOKS: *A Diary from Dixie, As Written by Mary Boykin Chesnut, Wife of James Chesnut, Jr., United States Senator from South Carolina, 1859–1861, and a Brigadier-General in the Confederate Army,* edited by Isabella D. Martin and Myrta Lockett Avary (New York: Appleton, 1905; London: Heinemann, 1905);

A Diary from Dixie by Mary Boykin Chesnut, edited by Ben Ames Williams (Boston: Houghton Mifflin, 1949);

Mary Chesnut's Civil War, edited by C. Vann Woodward (New Haven & London: Yale University Press, 1981);

The Private Mary Chesnut: The Unpublished Civil War Diaries, edited by Woodward and Elisabeth Muhlenfeld (New York & Oxford: Oxford University Press, 1984).

Mary Boykin Chesnut's Civil War diary is one of the most insightful and well-written accounts of the war and of life in the Confederacy. According to her biographer, Elisabeth Muhlenfeld, Chesnut's text is, "Of all the books to come directly out of the Civil War, one of the most remarkable" and "an important literary portrait of the Confederacy." Chesnut's blending of fiction with diary and memoir created an impressive work of personal recollection, social commentary, and literary anecdote. The liberties taken by her various editors altered Chesnut's work, sometimes significantly, causing some controversy and confusion about the diary, which Chesnut began writing just before the Civil War.

Born at Mount Pleasant, the home of her maternal grandparents in Statesburg (now Stateburg), South Carolina, to Mary Boykin and Stephen Decatur Miller, Mary Boykin Miller was the eldest of four children. Her father was a lawyer and politician, who served as a state senator, governor of South Carolina, and U.S. senator. In the version of her diary she revised for publication Chesnut stated, "My father was a South Carolina nullifier. . . . So I was of necessity a rebel born."

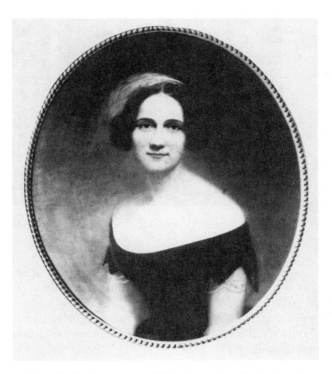

Mary Boykin Chesnut in the 1850s (portrait by Charles Osgood; National Portrait Gallery, Washington, D.C.)

During her early childhood Chesnut was educated at her family home, Plane Hill, and at a day school in nearby Camden. In 1833 her father decided to resign his senate seat. Plagued by illness and homesickness, he returned to South Carolina. In 1835 he moved his family to the frontier of Mississippi, where he owned three plantations. Mary was sent to Charleston, South Carolina, to Madame Talvande's French School for Young Ladies. She became fluent in French, learned to read German, and generally excelled in her studies. During her education at Madame Talvande's, Mary Miller developed her love of literature, particularly novels, and polished her skills as a witty conversationalist. This social aptitude served her well in the political circles of Wash-

Mulberry Plantation, three miles south of Camden, South Carolina, where Mary and James Chesnut spent the early years of their marriage

ington, D.C., and Richmond, Virginia, and earned her the reputation of a belle with a sharp tongue. In Charleston she fell in love with James Chesnut. They were married on 23 April 1840 and went to live at Mulberry Plantation, James's parents' estate three miles south of Camden.

Plantation life quickly became a trial for Chesnut, who hated the boredom of the quiet, provincial plantation. She was left with untapped energy, unappreciated ambitions for herself and her husband's political career, and untried literary talents. Her situation worsened when it became clear she and James would not have children. Her childlessness meant that she would not soon have her own household or a family on which to expend her energies. Chesnut always self-consciously felt she had somehow failed to fulfill her role as a woman in a strongly patriarchal society that limited upper-class white women to the duties of wife, mother, and hostess. In a diary entry for 1861 Chesnut recorded that her mother-in-law bragged to Mary about her twenty-seven grandchildren. Her father-in-law, Colonel James Chesnut, added that his wife had not been "'a useless woman in this world' because she had so many children. & what of me! God help me. . . ."

James Chesnut's election to the U.S. Senate in 1858 offered his wife a way out of rural life, and she enthusiastically accompanied him to Washington, D.C. The election of President Abraham Lincoln sent the Chesnuts back home, where in December 1860, James Chesnut attended the South Carolina Secession Convention and helped to draft the Ordinance of Secession. On 25 February 1861, while in Montgomery, Alabama, with her husband, who was attending the constitutional convention that formed the Confederacy, Mary Chesnut decided to turn the private diary she had begun earlier that month into a fuller work to record the historic events she was witnessing for herself and a future audience.

For the rest of the war Chesnut moved between Camden, which she considered a place of rural exile, and Richmond, the capital of the Confederacy. She also spent time at Mulberry, had two extended stays in Columbia, and had two long visits with her sister in Flat Rock, North Carolina. Traveling was always difficult and an impediment to her writing.

As Chesnut began her Civil War diary, she was frustrated at the limits on her observation of events and was critical of those in power: "It is hard for me to believe these people are in earnest. They are not

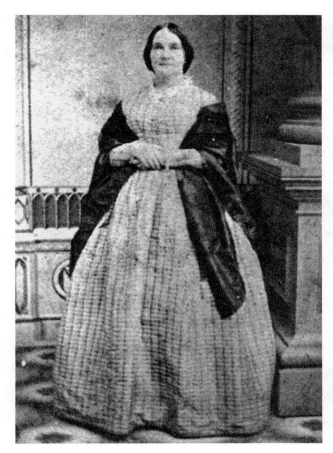

Mary and James Chesnut in 1861 (South Caroliniana Library, University of South Carolina)

putting the young, active, earnest, efficient in place anywhere. . . . There never was such a resurrection of the dead and forgotten." By 27 April 1861, after Confederate troops had attacked Fort Sumter, Chesnut wrote, "Oh, if I could put some of my restless spirit into these discreet, cautious, lazy men." Her own husband served in the Confederate army and was promoted to brigadier general in 1864. On 30 May of that year, she exclaimed,

> If I was a *man* I would not doze & drink & drivel here until the fight is over in Virginia. . . . These people make me weary of humanity. . . . Never know their own minds ten minutes. Can have no desire—no plan— no enterprise strong enough not to act. Stopped by an obstacle that would not deter a chicken.

A few days earlier, on 27 May, she had written, "They look for a fight at Norfolk. Beauregard is there. I think if I were a man I'd be there, too. . . . Sixty of our cavalry taken by Sherman's brigade."

Her candid remarks also include references to friends, family, and her marriage. She commented on fights with her husband and on her use of opium for headaches. One acquaintance is described as "that horrid woman." The diary became a spontaneous and fascinating record of the noteworthy and the trivial in the daily life of the Confederacy.

Mary Chesnut's antislavery views, for example, are stated openly in the original diary. On 18 March 1861 she asked herself,

> I wonder if it be a sin to think slavery a curse to any land. Sumner said not one word of this hated institution which is not true. Men and women are punished when their masters and mistresses are brutes and not when they do wrong—and we live surrounded by prostitutes.

This passage is noteworthy because it agrees with Charles Sumner, the Massachusetts senator who argued against James Chesnut in the Senate. Although Mary

Chesnut's original diary entry for 28 June 1861 and her revised entry for the same date
(South Caroliniana Library, University of South Carolina)

48

In Mrs Davis drawing room last night
the President took a seat by me on the sofa
where I sat. He talked for nearly an
hour. He laughed at our faith in our
own prowess. We are like the British.
We think every Southerner equal
to three Yankees at least. We will
have to be equivalent to a dozen ~~Yan-
kees~~ now. After his experience of the
fighting qualities of Southerners in
Mexico he believes that we will
do all that can be done by pluck
and muscle - endurance - and
dogged courage - dash - and red hot -
patriotism &c - And yet his
tone was not sanguine. There was
a sad refrain - running through it
all ⊙ for one thing - either way -
He thinks it will be a long war.
That floored me at once. It has been
too long for me already. Then he
said - Before the end came we
would have many a bitter experience

Chesnut continually worked to support her husband's political career, she acknowledged their political differences both in her diary and to her husband. Like many Southern white women, Chesnut worried about the effects of slavery on whites, and she could and did blame African Americans, the victims of slavery, for the horrific abuses of the institution. In the same diary entry she bitterly complained about the sexual exploitation of enslaved women and the effect on white women: "God forgive us, but ours is a *monstrous* system. . . . like the patriarchs of old our men live all in one house with their wives & their concubines, & the Mulattoes one sees in every family exactly resemble the white children" Chesnut went on to criticize slaveholders who "seem to think themselves patterns—models of husbands & fathers." Although Chesnut opposed slavery she remained loyal to the Confederacy.

As the war progressed Chesnut found it increasingly difficult to write. She could not always find paper and used the back of a recipe book, as well as booklets of poor quality "Confederate paper." When Union troops closed in on Richmond in 1863, she burned papers and letters, including parts of the diary. Her frank discussion in her diary of the condition of the Confederacy may have led her to fear that her writings could be used to the North's advantage. Re-creating the entry for September 1863 later, Chesnut recalled that "In Stoneman's raid I burned my journal proper. . . . The guns did sound very near. And when Mr. C rode up and told me if Mrs. Davis left Richmond I must go with her, I confess I lost my head."

One problem for modern scholars is determining how much of the original diary Chesnut still possessed when she began revising it for publication. In all, about one hundred thousand words of the original diary have survived, but Chesnut may have had double that number when she rewrote the diary. This problem is difficult to solve because Chesnut sometimes wrote diary entries on scraps of paper, and the revisions were also written on various kinds of paper and in notebooks. Not only did she burn some entries in 1863, but the entries for 1864 have been lost, either by Chesnut or her editors. Chesnut did not catalogue her manuscripts before her death.

The chaos of the postwar years added to Chesnut's difficulties as a writer. During the last three months of the war, she fled advancing Union troops. A refugee with no negotiable money, she feared that she would be captured. At the end of the war her husband met her in Chester, South Carolina, and they returned penniless to Mulberry, where the cotton crop had been burned and the plantation pillaged. James Chesnut's mother had died in 1864, and with his father's death in 1866, James was left two plantations and heavy debts. By 1868 he had returned to politics, and Mary Chesnut had taken over the management of their business interests. Although still in debt, with a strict budget and the sale of family heirlooms, the Chesnuts were able to build a new house in Camden and move into it in 1873.

Mary Chesnut continued writing during the 1870s despite financial setbacks and ill health. James Chesnut suffered a stroke in early 1885 and died on 1 February. Five days later Mary Chesnut's mother died. Ill herself and struggling financially, Mary Chesnut turned again to her writing.

After the war Mary Chesnut used the extant portions of her diary to provide material for fiction, beginning a manuscript titled "The Captain and the Colonel." Unsatisfied with this work, Chesnut next attempted an autobiographical novel that she called "Two Years of My Life." Neither manuscript was finished or published. They served as apprentice pieces in which Chesnut refined her skills. Her last attempt at a novel was "Manassas," set during the Civil War. Only ten pages of this manuscript survive, but since they are numbered 411–419, "Manassas" must have been the longest of Chesnut's fictional works. In 1875 Chesnut decided to revise her Civil War journal. She kept the diary format but changed some of the content.

At one point in the original diary Chesnut mentioned ten volumes of journals, and she may have had more. Only the sections from 1861 and 1865 still survive. Chesnut noted in her revision that she relied on memory alone to re-create the period from August 1862 to October 1863. The final draft of Chesnut's revision fills forty-nine notebooks and includes approximately four hundred thousand words.

Using her memory as well as papers and letters, Chesnut filled in the gaps of the original diary. She also added description and background, as well as dialogue and characterization. The revised diary retains the same form, with dated entries and the sometimes urgent tone of the original, but it includes novelistic elements as well. The revision has a clearer chronological order; yet, the chaos and the false rumors reported in the original are included, giving the revision the feel of an original wartime record.

The most striking change in the revision is Chesnut's persona. In 1883 Chesnut wrote to her friend Varina Davis, wife of Jefferson Davis, that she was revising the diary and "leaving myself out." Chesnut deleted insulting comments and personal

Sarsfield, the house in Camden where Chesnut lived from 1873 until her death in 1886

information about marital and family problems. She also attributed her own thoughts and comments to either Isabella Martin, a longtime friend, or anonymous women speakers. Therefore, in the revision unidentified women, not Mary Chesnut, complain about the patriarchal institution of slavery. Isabella, not Chesnut, thinks the diary is important. The Mary Chesnut of the revised work is a belle, the wife of James Chesnut, and a Confederate citizen. The author revised her work in a way that allowed her simultaneously to accomplish self-erasure and self-expression. She becomes a fictionalized persona who acts as witness and reporter of the events around her. The author of the original diary—one person who was variously the belle, the politically ambitious woman, the wife, the critic of slavery, the feminist, the intellectual, and the Confederate—is present in the revised work as divergent voices that neatly form a fragmented portrait of a woman.

The revised diary could even be called fictional autobiography, or perhaps a journal-novel. The revised work still retains many elements of history and autobiography, but the original and revised diaries are two different works, and they have two dif-

ferent narrators, both of whom are literary creations. The revision was intended for publication; yet, it has never been published as she wrote it.

Before she could publish her narrative, Chesnut died on 22 November 1886 at her home in Camden. She left her manuscripts to Isabella Martin, who, together with Myrta Lockett Avary, edited the revised version of the diary for publication by Appleton. Martin and Avary's edition leaves out about one-third of the work. In addition the editors reworded passages and changed dates. Martin excluded or altered entries that she considered critical of the antebellum South or presented Chesnut as anything other than a "Southern lady." For example, Chesnut included in her revised work an account from the original diary of her cousin Betsey Witherspoon being murdered by her slaves. Martin changed the account to read that "family troubles" killed Chesnut's cousin. Serialized in *The Saturday Evening Post,* from 28 January through 22 February 1905, the first edition of 1905 was immediately successful and praised as an original Civil War diary. Yet, the persona, descriptions, characters, and dialogues that earned this early acclaim were not the spontaneous

recordings of Mary Chesnut but a painstakingly and consciously produced literary effort that had been further shaped by editors.

Ben Ames Williams included more of Chesnut's revised version in his 1949 edition. He worked from Chesnut's manuscripts, but he edited, changed dates, and rewrote some of Chesnut's prose. Although Chesnut never liked or used the term *Dixie,* Williams kept the title chosen by Martin: *A Diary from Dixie.* Both the 1905 and 1949 editions were presented to the public as authentic diaries and documentary history. When C. Vann Woodward published his edition of the diary in 1981, however, the nature of Mary Chesnut's revision became clearer.

Woodward carefully reconstructed Chesnut's revision and documented all his editorial decisions. He also added parts of the original diary to the revision. Readers finally got a fuller picture of Chesnut's accomplishment, but Woodward combined two diaries, each of which has a distinct narrator and narrative structure. Chesnut's literary decisions were largely ignored. In 1984 Woodward and Elisabeth Muhlenfeld published what has survived from the original diary. Readers can now compare what remains of the wartime writing with Woodward's version of Chesnut's final work.

Mary Boykin Chesnut's Civil War diaries are still some of the most fascinating portrayals of the Confederacy. Her writing is an important part of Civil War literature and women's autobiography. Her accomplishment has yet to be appreciated fully and studied as literature.

Biography:

Elisabeth Muhlenfeld, *Mary Boykin Chesnut: A Biography* (Baton Rouge: Louisiana State University Press, 1981).

References:

James Flynn, "Mary Chesnut's Reconstruction: The Literary Imagination of a Diarist," *Kentucky Philological Association Bulletin* (1983): 63–72;

George F. Hayhoe, "Mary Boykin Chesnut: The Making of a Reputation," *Mississippi Quarterly,* 35, no. 1 (1981): 60–72;

John L. Idol, "Mary Boykin Chesnut and George Eliot," *George Eliot–George Henry Lewes Newsletter,* 2 (April 1983): 1–3;

Melissa A. Mentzer, "A Note on Textual Concerns in the Journals of Mary Chesnut," *Auto/Biography Studies,* 4 (Fall 1988): 53–56;

Mentzer, "Rewriting Herself: Mary Chesnut's Narrative Strategies," *Connecticut Review,* 14 (Spring 1992): 49–55;

Rosemary Morgan, "Seconding the Self: Mary Chesnut's Civil War," in *Mortal Pages, Literary Lives: Studies in Nineteenth-Century Autobiography,* edited by Vincent Newey and Philip Shaw (Aldershot, U.K.: Scolar Press, 1996), pp. 204–216;

Elisabeth Muhlenfeld, "The Civil War and Authorship," in *The History of Southern Literature,* edited by Louis D. Rubin (Baton Rouge: Louisiana State University Press, 1985), pp. 178–187;

C. Vann Woodward, "Mary Chesnut in Search of Her Genre," *Yale Review,* 73, no. 2 (1984): 199–209.

Papers:

The remaining fragments of Mary Boykin Chesnut's original diary, her revised journal, and the surviving pages of her unpublished novels are in the South Caroliniana Library at the University of South Carolina, which also has some of her letters.

Susan Fenimore Cooper

(17 April 1813 – 31 December 1894)

Susan Goodier
Cazenovia College

BOOKS: *Elinor Wyllys. A Tale,* anonymous, edited by James Fenimore Cooper (3 volumes, London: Bentley, 1845); republished as *Elinor Wyllys: or, The Young Folk of Longbridge. A Tale,* as Amabel Penfeather, edited by James Fenimore Cooper (2 volumes, Philadelphia: Carey & Hart, 1846);

Rural Hours. By a Lady (New York: Putnam, 1850; anonymous, 2 volumes, London: Bentley, 1850); republished as *Journal of a Naturalist in the United States* (London: Bentley, 1855); enlarged as *Rural Hours* (New York: Putnam, 1868);

Mount Vernon: A Letter to the Children of America. By the Author of "Rural Hours" (New York: D. Appleton, 1859);

Rear-Admiral William Branford Shubrick. A Sketch, anonymous (New York, 1877).

Editions: *Rural Hours,* 1887 edition, edited by David Jones (Syracuse, N.Y.: Syracuse University Press, 1968);

Rural Hours, 1850 edition, edited by Rochelle Johnson and Daniel Patterson (Athens & London: University of Georgia Press, 1998).

OTHER: "A Dissolving View," in *The Home Book of the Picturesque: or, American Scenery, Art, and Literature* (New York: Putnam, 1852), pp. 79–94; also published as *Home Authors and Home Artists; or American Scenery, Art, and Literature* (New York: Leavitt & Allen, 1852);

John Leonard Knapp, *Country Rambles in England, or Journal of a Naturalist,* edited, with an introduction, notes, and additions, by Cooper (Buffalo: Phinney, 1853);

The Rhyme and Reason of Country Life; or, Selections from Fields Old and New, edited, with a preface, introduction, and headnotes, by Cooper (New York: Putnam, 1854);

Pages and Pictures from the Writings of James Fenimore Cooper, edited, with a preface, introduction, and notes, by Cooper (New York: Townsend, 1861); republished as *The Cooper Gallery; or Pages and Pictures From the Writings of James Fenimore Cooper* (New York: Miller, 1865);

Appletons' Illustrated Almanac for 1870, edited, probably with contributions, by Cooper (New York: D. Appleton, 1869);

The Works of James Fenimore Cooper, Household Edition, 15 volumes, introductions by Cooper (Boston: Houghton, Mifflin, 1876–1884);

"Mrs. Philip Schuyler: A Sketch," in *Worthy Women of Our First Century,* edited by Mrs. Owen J. Wister and Miss Agnes Irwin (Philadelphia: Lippincott, 1877), pp. 71–111;

"The Wonderful Cookie: A True Story," in *Wide Awake Pleasure Book,* volume 8 (Boston: Lothrop, 1879), pp. 348–353; republished in *Wonder Stories of History* (Boston: Lothrop, 1886);

"The Thanksgiving Hospital" and "Orphan House of the Holy Savior," in *A Centennial Offering Being a Brief History of Cooperstown,* edited by Isaac N. Arnold (Cooperstown, N.Y.: Freeman's Journal Office, 1886);

James Grant Wilson and John Fiske, eds., *Appletons' Cyclopaedia of American Biography,* 7 volumes, includes contributions by Cooper (New York: D. Appleton, 1887–1900);

William West Skiles. A Sketch of Missionary Life at Valle Crucis, in Western North Carolina. 1842–1862, edited, with a biographical essay, by Cooper (New York: James Pott, 1890);

J. K. Bloomfield, *The Oneidas,* includes a portion of Ellen Goodnough's diary, edited by Cooper (New York: Alden, 1907);

"Small Family Memories (1883)," in *Correspondence of James Fenimore-Cooper,* 2 volumes, edited by his grandson James Fenimore Cooper (New Haven: Yale University Press, 1922), I: 9–72.

Edition: *Pages and Pictures from the Writings of James Fenimore Cooper* (Secaucus, N.J.: Castle Books, 1980).

SELECTED PERIODICAL PUBLICATIONS–UNCOLLECTED: "The Lumley Autograph," *Graham's Magazine,* 38 (January 1851): 31–36; (February 1851): 97–101;

"Sally Lewis and Her Lovers," *Harper's New Monthly Magazine,* 18 (April 1859): 644–653;

"Fragments from a Diary of James Fenimore Cooper," edited by Cooper, *Putnam's Magazine,* 1 (February 1868): 167–172;

"Passages from a Diary by James Fenimore Cooper," edited by Cooper, *Putnam's Magazine,* 1 (June 1868): 730–737;

"Bits," *Putnam's Magazine,* 2 (August 1868): 145–148;

"The Battle of Plattsburgh Bay: An Unpublished Manuscript of J. Fenimore Cooper," edited by Cooper, *Putnam's Magazine,* 3 (January 1869): 49–59;

"The Eclipse: From an Unpublished MS. of James Fenimore Cooper," edited by Cooper, *Putnam's Magazine,* 4 (September 1869): 352–359;

"Village Improvement Societies," *Putnam's Magazine,* 4 (September 1869): 359–366;

"The Magic Palace," *Putnam's Magazine,* 5 (February 1870): 160–162;

"The Chanting Cherubs," *Putnam's Magazine,* 5 (February 1870): 241–242;

"Insect-Life in Winter," *Putnam's Magazine,* 5 (April 1870): 424–427;

"Madame Lafayette and Her Mother," *Putnam's Magazine,* 6 (August 1870): 202–213;

"Female Suffrage: A Letter to the Christian Women of America," *Harper's New Monthly Magazine,* 41 (August 1870): 438–446; (September 1870): 594–600;

"Two of My Lady-Loves," *Harper's New Monthly Magazine,* 45 (June 1872): 129–133;

"Otsego Leaves I: Birds Then and Now," *Appletons' Journal,* 4 (June 1878): 528–531;

"Otsego Leaves II: The Bird Mediaeval," *Appletons' Journal,* 5 (August 1878): 164–167;

"Otsego Leaves III: The Bird Primeval," *Appletons' Journal,* 5 (September 1878): 273–277;

"Otsego Leaves IV: A Road-Side Post-Office," *Appletons' Journal,* 5 (December 1878): 542–545;

"The Hudson River and Its Early Names," *Magazine of American History,* 4 (June 1880): 401–418;

"The Adventures of Cocquelicot. (A True History)," *St. Nicholas: An Illustrated Magazine for Young Folks,* 8 (October 1881): 942–946;

"Mission to the Oneidas," *Living Church,* 8 (11 April 1885): 14–15; (18 April 1885): 26–27; (25 April 1885): 38–39; (20 February 1886): 709–710; (27 February 1886): 720–721; (6 March 1886): 736–737; (13 March 1886): 73; (20 March 1886): 768–769; (27 March 1886): 784; 9 (10 April 1886): 28; (24 April 1886): 60–61; (1 May 1886): 75–76; (15 May 1886): 107–108; (22 May 1886): 123–124; (29 May 1886): 139; (5 June 1886): 155;

"A Glance Backward," *Atlantic Monthly,* 59 (February 1887): 199–206;

"A Second Glance Backward," *Atlantic Monthly,* 60 (October 1887): 474–486;

"Financial Condition of New York in 1833," edited by Cooper, *Magazine of American History,* 22 (October 1889): 328–330;

"The Talent of Reading Wisely," *Ladies' Home Journal,* 9 (February 1892): 18;

"A Lament for the Birds," *Harper's New Monthly Magazine,* 87 (August 1893): 472–474;

"An Outing on Otsego Lake," *Freeman's Journal,* 86 (12 April 1894): 3; (19 April 1894): 2;

"The Cherry-Colored Purse. (A True Story)," *St. Nicholas: An Illustrated Magazine for Young Folks,* 22 (January 1895): 245–248.

Susan Fenimore Cooper was the first woman in the United States to publish a book of nature writing. Although she was not formally educated in botany, people interested in nature sought her expertise. Gifted and highly intelligent, she wrote prolifically in several genres for fifty years. Her first major work, *Rural Hours* (1850), was a popular success, and many journals accepted her work, but she was a pious and self-effacing woman whose desire to be known as an accomplished writer was limited by the bounds of her conservative views on a woman's role in society. Committed to the duties society expected of women of her social status, she firmly opposed any extension of women's rights. Although usually discussed in connection with her father, novelist James Fenimore Cooper, Susan Fenimore Cooper should be evaluated in light of her own literary and social contributions.

Because she wrote more about her father than she did about herself, it is difficult to construct a biography of Susan Fenimore Cooper. She included few details of her own life in the unfinished "Small Family Memories (1883)," a memoir covering the years up to 1828, which she wrote for her nieces and nephews. The second child of James Fenimore Cooper and Susan De Lancey Cooper, Susan Augusta Fenimore Cooper was born on 17 April 1813 at Heathcote Hill in Mamaroneck, Westchester County, New York, the home of her grandfather John Peter De Lancey. (A few months after Susan Cooper's birth, the eldest child, Elizabeth, died of food poisoning.) Susan Cooper descended on her mother's side from Etienne De Lancey, a French Huguenot. Susan Fenimore Cooper's great-grandfather James De Lancey had been a colonial lieutenant governor of New York, and her grandfather John Peter De Lancey had fought for the British during the Revolution and fled to England after the war but had returned to the United States in 1789 and become a staunch

*Susan Fenimore Cooper's 1832 portrait of herself and her siblings: Caroline Martha, Susan, Paul Fenimore, Anne Charlotte,
and Maria Frances (from James Franklin Beard, ed.,* The Letters and Journals of
James Fenimore Cooper, *volume 2, 1960)*

American Federalist. Her paternal grandfather, William Cooper, of English Quaker ancestry, was a Federalist representative in Congress, the founder of Cooperstown, New York (1786), a judge, and the author of *A Guide in the Wilderness; or, The History of the First Settlements in the Western Counties of New York with Useful Instructions to Future Settlers* (1810).

In July 1813 the family moved to Cooperstown, New York. Two more daughters, Caroline (born 1815) and Anne (born 1817), were born to the Cooper family before autumn 1817, when they returned to Mamaroneck. That same year, in nearby Scarsdale, James Fenimore Cooper built Angevine, where he began his writing career. Susan Cooper remembered playing with her doll under a table in the parlor while listening to her father read portions of his first novel, *Precaution* (1820), to her mother.

Precaution was not successful, but James Fenimore Cooper's second novel, *The Spy* (1821), established him as a popular author, and in autumn 1822 he moved his family—which now included another daughter, Maria Frances (born 1819), and a son, Fenimore (born 1821)—to New York City, to be near his publisher. While the family lived there, Fenimore died in August 1823 of a fever. Another boy, Paul Fenimore, was born to the family in 1824, before they left New York. In 1883 Susan Cooper remembered two important events of

that period: the triumphant return visit to the United States of Marie Joseph, Marquis de LaFayette, in 1824–1825 and the completion of the Erie Canal in 1825.

In 1826 James Fenimore Cooper was appointed U.S. consul in Lyons, France, and the family lived abroad until 1833. As was customary practice at the time, Cooper never visited Lyons and hired a Frenchman to perform his duties there. The family's primary base was Paris, and they spent some two years in Italy, traveled to Switzerland during several summers, and visited Germany, England, and the Low Countries. While in Europe, the family visited various historic and cultural sites, and socialized with people such as the LaFayette family, Sir Walter Scott, the Princess Galitzin, and several artists, including Pierre-Jean David d'Angers and the American Horatio Greenough.

Susan Cooper was educated and "finished" according to the standards of the time. She and her sisters began their education at Angevine, where they were taught by their mother and father, and then attended a private school in New York. While in Europe they studied at a boarding school in Paris and were taught Italian, music, and drawing by private tutors in Italy. Cooper eventually acquired a thorough knowledge of American and European literature and history, the ability to use four languages, an understanding of zoology and botany, and skill in music and

dancing. She was a talented artist, as is apparent in her 1832 portraits of family members.

Returning from Europe in late 1833, the family lived for a time in New York City before permanently settling in Cooperstown in 1836. In 1834 James Fenimore Cooper purchased and began to refurbish Otsego Hall, the family home that had been sold after William Cooper's death. Initially finding it difficult to settle into the quiet rural life in Cooperstown, Susan Cooper was encouraged by her father to put some of her energy into her writing. Since 1832 she had assisted him as his literary secretary and continued to do so until his death. The two were extremely close, and she frequently accompanied him when he traveled. In a 25 December 1849 letter to William Bradford Shubrick, the father described his daughter as having the looks of someone twenty-one and having the "sobriety and good sense" of one who was a hundred. He cared deeply that her literary work sold, and made her his literary executor. After her father's death she defended his reputation, keeping a promise she had made to burn many of his papers so that a complete biography could never be written. She also wrote reverential memoirs and introductions for his novels, as well as editing excerpts from his diaries and some of his unpublished articles.

According to extant letters, James Fenimore Cooper may have had some influence on Susan Cooper's decision not to marry. She apparently did not lack suitors, and her father reported in a 2 January 1832 letter to Peter Augustus Jay that he had told his nearly nineteen-year-old daughter she would "get a better husband, by waiting three or four years." In 1832 a Dr. Smith seemed interested in Susan Cooper, but her mother made an effort to quell rumors of a connection. Her father commented in 1833 that a Frenchman requested Susan Cooper's hand, "but the thing would not do. We mean to continue Americans." Samuel F. B. Morse, a talented painter and the inventor of the telegraph who was some twenty years older than Susan Cooper, was a guest of the Coopers in 1834 and was also rumored to be a suitor. According to Ralph Birdsall, the local gossips said that James Fenimore Cooper "had no mind to yield so fair a prize to an impecunious painter, a widower, and already forty-three years old." When Susan Cooper was thirty-eight, her father still worried "that some fellow would be after her" (letter to Sarah Heyward Cruger, 18 January 1851).

Susan Cooper was a prolific author who wrote romantic fiction, ghost stories, nature studies, stories for children, biographical sketches, and articles on a variety of other subjects. In a 22 September 1843 letter to her, James Fenimore Cooper mentioned that he expected success in selling a collection of her stories, although the collection was apparently never published. She had

some success with a novel, *Elinor Wyllys* (1845), which was published in England anonymously and in the United States under the pseudonym Amabel Penfeather. Her father wrote the preface and edited the work and was originally thought to have written it. Yet, he wrote in his introduction that he had done little substantive editing, and the style and subject matter of the book bears little resemblance to any of his writings.

Elinor Wyllys is the story of a physically unattractive, but good, orphaned girl, who waits patiently at home while her betrothed spends two years in Europe. Her fiancé falls in love with Elinor's beautiful friend, breaks off his engagement to Elinor, and is then rejected by the friend. He eventually understands the error of his ways and marries Elinor. They and their children have a happy life. Patriotic, moral, and sentimental, the novel touts the advantages of simple country living in the United States, a theme that recurs in Cooper's subsequent works. The novel also includes subplots that suggest Cooper's diverse talents and interests. One subplot, about a sailor who claims to be a missing heir, is perhaps the first American fictional plot to include a detailed description of court and trial proceedings as well as a critique of judicial processes. Artistic and national issues are raised in another subplot, which involves a young American landscape painter, and the novel ends with an exciting maritime adventure that rivals those written by her father. According to Lucy B. Maddox, Cooper's writing often "revealed a self-conscious sense of her identity as the inheritor and guardian of her father's vision of America, in which the daughter is defined as crucially important to the future of the nation."

Susan Cooper's best-known book is *Rural Hours* (1850), a journal that follows the cycle of nature and village life over the course of a year in a rural New York community. She credited her grandfather De Lancey with inspiring *Rural Hours,* which again celebrates plain country living. When she was a child, he frequently took her for rides in his buggy, telling her the names of the trees, plants, birds, and animals. During 1848 and 1849 Cooper kept a journal of the turning seasons in rural New York. She also wrote to acquaintances to ask questions about plants, trees, animals, and customs. Her main purpose for writing the book was to show humankind's obligations to nature.

James Fenimore Cooper negotiated the contract for *Rural Hours* with George P. Putnam in December of 1849. After the first one thousand copies were sold, Susan Cooper was to receive 12½ percent of the profits. In a February 1850 letter to her, her father expressed his satisfaction with the proof sheets, praising the "purity of mind, the simplicity, elegance, and knowledge" in his daughter's work. By September he was

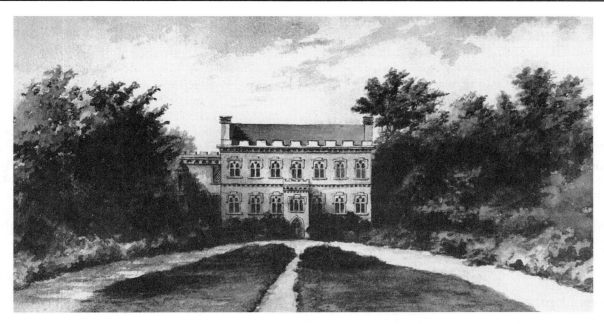

Otsego Hall as it appeared after James Fenimore Cooper refurbished it in 1835 (watercolor signed "c T e"; New York State Historical Society)

accepting congratulations from people who stopped him on the street to praise *Rural Hours*. William Cullen Bryant considered the book "the greatest of the season." During the nineteenth century *Rural Hours* went through nine editions, including two published in England and one abridgment. The 1851 edition is illustrated with colorplates of birds and plants native to Cooperstown and central New York State.

Divided into four sections corresponding to the seasons of the year, *Rural Hours* is further broken into days of the months. The abiding appeal of the book is based on the freshness of Cooper's observations of changes through the seasons. Cooper described the lives of birds, the growth and changes in plants, superstitions, village gardens, and spring cleaning. The book is also the result of careful research into works by other authors.

Having a strong moral belief in the need to preserve the environment, Cooper lamented the "weeds" that had been brought to America by the Europeans and were imperiling the existence of native plants. When presenting her concerns for the environment, Cooper tried to instill in her readers a sense of pride in the United States while developing what Rochelle Johnson and Daniel Patterson have called an "argument for a sustainable balance between human culture and its natural surroundings."

Cooper believed that the natural world existed for the pleasure and use of human beings. Though she was influenced by the prevailing view of her day that cultivation was the paramount use of the land, she believed in preserving the landscape and using natural resources wisely. For Cooper, educating the public about the natural world was the key to preserving it. As Maddox has observed, the book offers "complex lessons which constantly return, implicitly, to the central issues of the daughter's location in the domesticated landscape of America and the voice she can use to speak from, and about, that place." The theme of the book is the need for society to co-exist with nature.

After the publication of *Rural Hours,* Cooper enjoyed some public distinction; professors of natural history wrote to her, and her autograph was requested. Two subsequent works appear not to have been published as books and have apparently been lost. In a December 1849 letter to Susan, her father mentioned having received from her an unidentified manuscript that was "already in Appleton's hands" and in a 26 May 1850 letter to his wife James Fenimore Cooper wrote that he had "not offered Susy's religious book to any one." He thought that it would sell better after the success of *Rural Hours. Memorial of James Fenimore Cooper* (1852) notes that Susan Fenimore Cooper had a book in press, *The Shield: A Narrative* (1852). There is correspondence concerning the book with publishers Richard Bentley in London and George P. Putnam in New York, and in a letter dated 6 August 1851 Susan Cooper wrote that the work relates to the habits and life of Native Americans before contact with Europeans. She hoped that its publication would boost sales of *Rural Hours* in England. The book is listed in Patrick K. Foley's *Amer-*

ican Authors, 1795–1895 (1897) as having been published. Some scholars, however, believe the book was never published. To date, neither the manuscript nor any printed copies of the work has been located.

One book-length work that has been rediscovered is "Missions to the Oneidas," a series of fifteen articles published in *The Living Church,* an Episcopal weekly newspaper, in 1885–1886. In his introduction to the fourth article, the editor of the paper wrote, "It is hoped that some publisher may think them worthy of being permanently preserved to our Church literature in book form."

In 1859 Cooper wrote *Mount Vernon: A Letter to the Children of America,* contributing to efforts of the Mount Vernon Ladies' Association to purchase and restore the home of the first president. Cooper's pamphlet described George Washington's career and called on children to contribute their coins to the preservation efforts.

Even without another popular book to enhance its author's reputation, *Rural Hours* sold steadily. Acknowledged as an authority on nature writing, Cooper was frequently asked to write articles on the subject and to edit the nature writings of others. In "A Dissolving View," written for *The Home Book of the Picturesque* (1852), Cooper again expressed her belief that the "hand of man generally improves a landscape . . . unless there is some evident want of judgment, or good sense. . . ." The essay gracefully blends architectural history, a tribute to the power of man, a reverie on an American autumn, and a fanciful imagining of another place and time. Among the books she edited are *Country Rambles in England, or Journal of a Naturalist* (1853) by John Leonard Knapp and *The Rhyme and Reason of Country Life; or, Selections from Fields Old and New* (1854). Dedicated to William Cullen Bryant, the 1854 book is a collection of ancient and modern poems translated from a dozen different languages and categorized by themes relating to country life. Some scholars believe that Cooper also edited another anthology of nature writing, *Rural Rambles, or, Some Chapters on Flowers, Birds, and Insects* (1854).

Editing her father's work, a task for which Cooper was eminently qualified, occupied a great deal of her time. Through articles and introductions to his novels, she offered an informal personal history of her father. One such memoir was published in *Pages and Pictures from the Writings of James Fenimore Cooper,* which Susan Cooper edited in 1861. She also wrote introductions for the fifteen volumes of the Household Edition of her father's works, published by Houghton, Mifflin between 1876 and 1884.

Cooper edited *Appletons' Illustrated Almanac for 1870* (1869) and, according to one scholar, she may also have written most of the text. The detailed discussions of seasonal activities, birds, flowers, and plants, written in a graceful style that resembles Cooper's, are strong indicators of her authorship. She also wrote a biographical sketch of Mrs. Philip Schuyler, the wife of a Revolutionary War general, for *Worthy Women of Our First Century* (1877), and Cooper is named as one of the chief contributors to *Appletons' Cyclopaedia of American Biography* (1887–1889), but it is impossible to determine what she wrote because none of the articles is signed. She also wrote a short biography of missionary William West Skiles for his account of his experiences as a missionary in western North Carolina in 1842–1862, a work she edited in 1890.

Cooper wrote fiction and nonfiction on an impressive range of subjects for popular magazines such as *Appletons' Journal, Graham's Magazine, Harper's New Monthly Magazine, Putnam's Magazine, Magazine of American History, St. Nicholas, The Atlantic Monthly,* and *The Freeman's Journal.* The fashion of collecting autographs is the subject of "The Lumley Autograph," published in two parts in the January and February 1851 issue of *Graham's Magazine.* Using a masculine voice, Cooper satirized some people's obsessive behavior regarding their collections. The autograph of a poet, probably Thomas Otway (1652–1685), who starved to death, is discovered in a book, is lost, found again, then pasted into a trunk as a lining, and finally presented to a collector by a suitor for his daughter's hand in marriage. It later passes to the woman who coveted it most, is stolen by another woman, recovered, and then burned before the eyes of the narrator, the owner, the woman who stole it, and the boy whose responsibility it was to watch the owner's autograph album. There is a moral to this highly amusing, yet poignant, story—"In the present age of universal enlightenment, we don't trouble ourselves to make up our opinions—we take and give them, we beg, borrow, and steal them." Moreover, the story criticizes the social values of the idle rich, who can bandy about the last letter of a starving poet as though it is just another luxury item.

Cooper's first contribution to *Harper's New Monthly Magazine* was "Sally Lewis and her Lovers" (April 1859), the story of Benjamin Wright, who carved statues for Central Park in New York and the public gallery in Albany. Representing the differences between country living and city living, Sally's lovers each confront a ghost. The citified dandy is terrified by an apparition he sees at midnight, but when Ben, the hardworking country boy, also sees the "ghost" the following night, he discovers that it is only a statue. Ben not only convinces Sally to marry him but comes to realize that he has the artistic talent to create his own statues.

In the 1860s Cooper began contributing articles to *Putnam's Magazine*. "Bits" (August 1868) is a collection of trivial information on topics such as fashion, the omnibus, and the electric telegraph. "Village Improvement Societies" (September 1869) reveals Cooper's social consciousness, calling for improvements in areas such as hygiene, water quality, ventilation, roads and bridges, recreation facilities, and the protection of birds. During 1868 and 1869 she also edited extracts from her father's journals and one of his previously unpublished manuscripts for *Putnam's*.

In 1870 Cooper wrote several articles for *Putnam's*. "The Magic Palace" (February) describes a beautiful ice palace built in Russia in 1739 for the amusement of aristocrats. Though she expressed admiration for this ephemeral creation, Cooper the practical American added, "we are not told at what cost to the treasury this dream of a courtier became a reality. . . ." In "The Chanting Cherubs" (February) Cooper responded to Sophia Peabody Hawthorne's charge that Horatio Greenough had "plagiarized" his sculpture *The Chanting Cherubs* from two cherubs in a painting by Raphael. Cooper described how her father had commissioned Greenough to copy Raphael's work in 1828 and stated that when Greenough's sculpture was shown in the United States it was clearly identified as a copy. "Insect-Life in Winter" (April) discusses the tenacity of insects that live in cold climates. "Madame Lafayette and Her Mother" (August) is the horrifying tale of the mother, grandmother, and sister of General Lafayette's wife confronting execution by guillotine in 1794 with honor and courage.

Also in 1870 Cooper wrote a long article for *Harper's*. "Female Suffrage: A Letter to the Christian Women of America" (August and September 1870), makes Cooper's case for prohibiting women from voting. Elaborating on ideas she expressed in *Rural Hours*, she argued that because women were already the moral guardians of the nation, universal suffrage would do no more than what women had done already to improve the country. To Cooper, women were clearly subordinate and intellectually inferior to men, ideas for which she found a basis in Christianity, a religion that "raised" and "protects" women. The duty of women to the state must be different from those of men, she argued; besides, she added, "women could never be made to take a deep, a sincere, a discriminating, a lasting interest in the thousand political questions ever arising to be settled by the vote."

The themes of woman's proper place and the virtues of country living come together in "Two of My Lady-Loves," published in the June 1872 issue of *Harper's*. This story is written from the point of view of an elderly man who makes several visits to the home of

ELINOR WYLLYS;

OR, THE

YOUNG FOLK OF LONGBRIDGE.

A TALE.

BY

AMABEL PENFEATHER.

"Familiar matter of to-day;
Some natural sorrow, loss or pain,
That has been, and may be again."
WORDSWORTH

IN TWO VOLUMES,

VOL. I.

EDITED BY J. FENIMORE COOPER.

PHILADELPHIA:
CAREY AND HART.
1846.

Title page for the first American edition of Cooper's only novel, about a young woman whose fiancé falls in love with her best friend (Collection of Hugh C. MacDougall, James Fenimore Cooper Society)

a widow and her servant girl in the country. On one such occasion the servant's cousins—one who works in a factory and one who works in a dollar store—are also visiting, setting up a contrast between country and city living. The servant girl is left an inheritance by the widow, marries, and lives happily, while her city cousins have "gone to the bad."

Another of Cooper's contributions to *Harper's* (August 1876) was a brief biography of Rear Admiral William Branford Shubrick, which was also published as a pamphlet in 1877. Cooper remembered the admiral, who had been a close friend and "messmate" of her father, from his visits to her family during her child-

Cooper in the 1850s (photograph by W. G. Smith, Cooperstown)

hood. The reverential article is primarily a summary of Shubrick's naval career.

Among Cooper's nature writings is the four-part series "Otsego Leaves," published by *Appletons' Journal* in June, August, September, and December 1878. In the first of these articles, "Birds Then and Now," Cooper argued that the noticeable decline in the number of birds is caused by sportsmen overhunting fowl, not just as game but to supply ornaments for fashionable hats. She discusses the custom of using animal skulls for nesting birds in the second article, "The Bird Mediaeval." The third, "The Bird Primeval," tells how swallows used to nest in hollow trees but had begun to nest almost exclusively near humans. The fourth article, "A Road-Side Post-Office," deviates from the nature theme to tell the story of Bill, a man feared to be dead; Amanda, the woman he was supposed to marry; and a little postmistress, Bill's sister, who never stopped believing he would come home.

Cooper also wrote a few stories for children. "The Wonderful Cookie" was published in 1879 in *Wide Awake Pleasure,* an annual series of books for children. It is the story of Gretel, a little German goose girl whose poor village is visited by two kings. Preparations for the kings' lavish holiday celebrations take six months, during which Gretel and her mother work in a bakery that makes the largest cookie in the world. The story ends with Gretel tending a new flock of geese, the holiday a memory, and her life returning to the way it began. Written in a charming and chatty style, the story details a way of life far different from that of its nineteenth-century American readers.

In yet another vein, Cooper wrote "The Hudson River and Its Early Names," a scholarly article for the June 1880 issue of the *Magazine of American History.* A history of the twenty names by which the river has been called, the essay also discusses the discovery of the river and the meeting of Native Americans and Europeans, criticizing the introduction of "that fatal poison, treacherous bane of the red race . . . *fire water.*" Describing the various trees, animals, birds, plants, and terrain of the river valley, Cooper remarked on the changes that occurred as European settlers brought new plants and animals to the region and employed new methods to farm the fertile soil.

In the 1880s Cooper also wrote two stories for the popular children's magazine *St. Nicholas.* In an 18 March 1880 letter to the editor, Mary Mapes Dodge, Cooper explained that "The Adventures of Cocquelicot" is "the *true* story of a pet cat of our family in my Father's time. He was really a remarkable animal, and his adventures were out of the common way. The narrative is entirely true—nothing imaginary." Published in the October 1881 issue of *St. Nicholas,* the story describes an angora cat that belonged to an American family living in France. Not above turning General LaFayette out of a chair, the cat traveled with the family from France across the Channel to England and eventually sailed with the family to America. Lost while the family was traveling from Albany to Lake Otsego, the cat was restored to its grateful family six weeks later. In a 4 February 1884 note to Dodge, Cooper described "The Cherry-Colored Purse. (A True Story)" as "a bit of real life in the way of woodcraft a sketch from nature taken from the window of my cottage home on the Susquehanna." Finally published in *St. Nicholas* in January 1895, after Cooper's death, the story is a pious and sentimental account of a little girl who happily gives a Christmas coin to a group of orphans.

In 1887 *The Atlantic Monthly* published two of Cooper's memoirs of her father, "A Glance Backward" (February) and "A Second Glance Backward" (October). They recount James Fenimore Cooper's career as

RURAL HOURS.

BY

A LADY.

" And we will all the pleasures prove
That valleys, groves, or hills, or field,
Or woods, and steepy mountains yield."

MARLOW

NEW YORK:
GEORGE P. PUTNAM, 155 BROADWAY,
LONDON: PUTNAM'S AMERICAN AGENCY.

1850.

*Title page for Cooper's observations on the cycles of nature and village life in Upstate New York
(Collection of Hugh C. MacDougall, James Fenimore Cooper Society)*

a writer, from the moment at Angevine when he declared that he could write as well as the author of the book he was reading, to his struggles to write and his novelistic successes. The articles cover the years the family spent in Europe, but Cooper kept the focus of her reminiscences on her father. He is also the main focus of the earlier "Small Family Memories (1883)" which was posthumously published in 1922, in the first volume of *Correspondence of James Fenimore-Cooper,* edited by her nephew James Fenimore Cooper.

Cooper returned to nature writing with "A Lament for the Birds," published in the August 1893 issue of *Harper's.* The article mourns the extinction of several species of birds native to the Lake Otsego region during the nineteenth century, including the white pelican, the swan, and the wild passenger pigeon. Even more common birds, such as the robin, bluebird,

and goldfinch, Cooper pointed out, had become scarcer in the forty years preceding the writing of the article.

Another late article is "An Outing on Otsego Lake," which appeared in the 12 and 19 April 1894 issues of *The Freeman's Journal,* a weekly published in Cooperstown. After discussing the visual appeal of the lake, the article focuses on the 11 November 1778 massacre in which two hundred Loyalists and five hundred Iroquois attacked and destroyed the village of Cherry Valley, killing fifty inhabitants and taking thirty to forty people prisoner. The second part of the article discusses the activities of Generals John Sullivan and James Clinton to quell the "Indian problem" (Native Americans fighting for the British), finally returning to the description of the lake she loved so well.

Cooper was a deeply religious woman and involved with the Sunday School and its charities. Her concern with humanitarian community projects began

Note, written in the 1880s, in which Cooper invites the wife of Judge Harris to attend a meeting about the Orphan House of the Holy Savior,
which Cooper founded in 1873 (Collection of Hugh C. MacDougall, James Fenimore Cooper Society)

when she founded a school for poor children in a basement room within a year after the Coopers settled in Cooperstown. Soon afterward, she raised money to build The Charity House on South Fair Street in Cooperstown, where a few poor families could live for a nominal rent. In 1860 she organized the Christ Church Sewing School, enrolling about eighty girls.

Cooper used her fund-raising skills in 1865 when she wrote an appeal for help with the creation of the Thanksgiving Hospital. Writing as the secretary of the association, she was instrumental in establishing the hospital, which was incorporated in January 1868. She acted as one of five trustees elected to serve five years. Funded by annual subscriptions, some payments from patients, collections in local churches, and contributions from private individuals and the state, the hospital frequently made good use of Cooper's literary skills and her social contacts. After 1875, when a financial panic

temporarily closed the hospital, Cooper helped to set up a fund to help people in need of medical care.

By 1873 Cooper had founded the Orphan House of the Holy Savior, which began with housing for five children. By 1883 the institution had built a new house large enough to accommodate orphans from the whole county, eventually as many as one hundred boys and girls. Surviving poor drainage that caused an outbreak of diphtheria and a fire that necessitated repairs to the basement and the first floor, the orphanage seems to have been well supported by the people of the community. Several letters Cooper wrote to the children as their "mother" demonstrate her deep concern for the project. Even when she was no longer able to attend holiday functions at the orphanage, she wrote letters to the children offering advice and comfort.

Cooper also founded and was president of the Girls' Friendly Society of Christ Church in Cooperstown. Several

of her letters request that women or their daughters join the society. Each woman in the society provided special attention to a girl chosen from the orphanage. According to one of the obituaries for Cooper, she chose the motto for the group: "A Good name is rather to be chosen than great riches, and loving favor than place and gold." Cooper's other charitable work included visits to the local poorhouse, prison, and home for old women. The Susan Fenimore Cooper Foundation helped to fund a church school for boys and girls "of moderate means" until long after her death.

Dying peacefully in her sleep at dawn on the last day of 1894, Cooper was mourned deeply by those who knew her, as several obituaries attest. According to family legend, she was buried with the "most interesting" of her father's journals at the cemetery across from Cooper Park, near Christ Episcopal Church in Cooperstown. Yet, according to James Franklin Beard, who collected and edited James Fenimore Cooper's surviving letters and journals, Susan Cooper wrote careful directions for her funeral and requested only that her parents' prayer book be placed under her head. A stained-glass window in Christ Church memorializes the woman who devoted her life to the well-being of others.

The republication of the 1850 edition of *Rural Hours* in 1998 heralded a resurgence of interest in the writing of Susan Fenimore Cooper. A prolific and versatile author, she deserves recognition and respect for her documentation of life in a rural New York community during the mid nineteenth century.

References:

James Franklin Beard, ed., *The Letters and Journals of James Fenimore Cooper,* 6 volumes (Cambridge, Mass.: Harvard University Press, 1960–1968);

Ralph Birdsall, *The Story of Cooperstown* (Cooperstown, N.Y.: Arthur H. Crist, 1917);

Anna K. Cunningham, "Susan Fenimore Cooper—Child of Genius," *New York History,* 25 (1944): 339–350;

Rochelle L. Johnson, "Placing *Rural Hours,*" in *Reading Under the Sign of Nature: New Essays in Ecocriticism,* edited by John Tallmadge and Henry Harrington (Salt Lake City: University of Utah Press, 2000);

Johnson, "Susan Fenimore Cooper's *Rural Hours* and the 'Natural Refinement' of American Culture," *ISLE: Interdisciplinary Studies on Literature and Environment,* 7 (Winter 2000): 47–77;

Johnson, "*Walden, Rural Hours,* and the Dilemma of Representation," in *Thoreau's Sense of Place: Essays in American Environmental Writing,* edited by Richard J. Schneider (Iowa City: University of Iowa Press, 2000);

Johnson and Daniel Patterson, eds., *Susan Fenimore Cooper: New Essays on* Rural Hours *and Other Works* (Athens: University of Georgia Press, forthcoming 2001);

Rosaly Torna Kurth, "Susan Fenimore Cooper: A Study of Her Life and Works," dissertation, Fordham University, 1974;

Hugh C. MacDougall, ed., *James Fenimore Cooper: His Country and His Art: Papers from the 1999 Cooper Seminar* (Oneonta: State University of New York College at Oneonta, forthcoming 2001);

Lucy B. Maddox, "Susan Fenimore Cooper and the Plain Daughters of America," *American Quarterly,* 40 (June 1988): 131–146;

Jessie A. Ravage, "Susan Fenimore Cooper: Nature's Observer," *Kaatskill Life: A Regional Journal,* 11 (Summer 1996): 36–41.

Papers:

Some of Susan Fenimore Cooper's letters are in the Research Library of the New York State Historical Society, the Alderman Library at the University of Virginia, the Beinecke Library at Yale University, and the Historical Society of Pennsylvania.

Mary Anne Cruse

(1825? – 1910)

Amy E. Hudock
University of California, Berkeley

BOOKS: *The Little Episcopalian; or, The Child Taught by the Prayerbook* (New York: General Protestant Episcopal S.S. Union and Church Book Society, 1854);

Bessie Melville; or, Prayer Book Instructions Carried Out into Life. A Sequel to the "Little Episcopalian" (New York: Daniel Dana, 1858);

Cameron Hall: A Story of the Civil War (Philadelphia: Lippincott, 1867);

Auntie's Christmas-Trees: The Child's Gift-Book for the Christmas Holidays (New York: General Protestant Episcopal S.S. Union and Church Book Society, 1875);

The Tiny Lawn Tennis Club (New York: Dutton, 1880; London: Dean, 1883);

The Children's Kettledrum (London: Dean, 1881);

Little Grandpa (New York: Whittaker, 1888).

On 11 April 1862 Mary Anne Cruse watched Union troops march through the streets in her hometown of Huntsville, Alabama, to begin an occupation that lasted—except for an interlude from September 1862 to July 1863—through the end of the Civil War. Her two-story brick home, located at 600 Adams Street, proved a useful vantage point from which to view history in the making. General Ormsby Mitchel took 517 Adams Street as his residence and headquarters, and Union troops set up tents in open spaces all along the avenue. Set in the mythical hamlet of "Hopedale, Virginia," Cruse's only novel for adults, *Cameron Hall: A Story of the Civil War* (1867), presents in fictional form the harsh realities of the Huntsville occupation. As Cruse (or "M.A.C.," as she signed her books) wrote in her preface, *Cameron Hall* "claims to belong rather to truth than to fiction."

Cruse's personal story is intertwined throughout *Cameron Hall.* The Cameron family of the novel often mirrors the real-life Cruse family. One of five children, Mary Anne Cruse was the daughter of Samuel and Harriet Maria Coleman Cruse, members of a well-respected Alabama family. Her parents had moved from Maryland and Virginia to Alabama in the land rush of the late 1810s and early 1820s. Soon after their arrival in Huntsville, they began construction on a federal-style family home at 600 Adams Street, which was completed circa 1823. Samuel Cruse became the treasurer of the Memphis & Charleston Railroad Office at the Northern Bank of Alabama and was listed in the 1860 census as owning $1,600 in real estate and $30,000 in personal estate. Like Julia and Eva Cameron in her novel, Mary Anne Cruse lived an aristocratic lifestyle. She was well educated and had leisure time for developing the mind and spirit.

In her *Living Female Writers of the South* (1872) Mary Tardy reported that "Miss Cruse, even at school began to distinguish herself, by the studiousness of her deportment and the rapidity with which she acquired her tasks." Tardy credited this early self-discipline with helping to make the adult Cruse "highly cultivated and a fine classical scholar." Cruse's intellectual pursuits seem to have been guided by her extensive religious education. A list of the books in Cruse's personal library, currently in the possession of descendants, reveals a fascination with theology that apparently motivated her to write moral tales for children, including *The Little Episcopalian* (1854), *Bessie Melville* (1858), and *Little Grandpa* (1888). She donated her earnings from these books for stained-glass windows in her parish church, the Church of the Nativity, where a large plaque was hung to honor her generosity.

The strong Christian influence in Cruse's life resonates throughout *Cameron Hall.* In addition to reflecting the general flavor of Cruse's southern upbringing, *Cameron Hall,* written before the end of the hostilities, draws on specific events in her family's life and the history of Huntsville. For example, Cruse's brother, Samuel Ridgely Cruse, and her brother-in-law, Robert Coles, enlisted in the Confederate Army, as does Walter Cameron in the novel. The military scenes in the novel may have been based on information she gathered from these two

THE

LITTLE EPISCOPALIAN;

OR,

THE CHILD TAUGHT BY THE
PRAYER-BOOK.

BY M. A. Cruse

"Plant in the heart of childhood the seed of religious truth,
foster its growth by a mother's prayers and instructions: and
sweet will be the blossoms of early piety."

NEW YORK:
GENERAL PROTESTANT EPISCOPAL S. S. UNION
AND
Church Book Society,
762 BROADWAY.
1858.

Title page for a later printing of one of Mary Anne Cruse's moral tales for children. First published in 1854, this popular story had been reprinted at least six times by 1905 (courtesy of SpecialCollections, Thomas Cooper Library, University of South Carolina).

men. Robert Coles served with the Fourth Alabama Regiment, and later wrote a regimental history. Her brother served as an officer with Ward's Battery. Male friends may also have provided Cruse information about life in military camps.

While she did not experience military life firsthand, Cruse was personally familiar with southern Unionist sympathizers. In general, northern Alabamians were more reluctant to secede from the Union than their cotton-growing neighbors in southern Alabama. When they were called to service, many men from the northern part of the state accepted the challenge of defending the Confederacy despite their reservations. Yet, the strong Unionist sympathies in the area explain why the largest percentage of the some

two thousand Alabamians who enlisted on the Union side were from northern Alabama, the section of the state in which Huntsville is located. Historian Charles Rice has suggested that Cruse's idea for having her character George Cameron enlist on the Union side, offending his family and community, could have had several real-life inspirations, including the local Union supporter Jeremiah Clemens, a cousin of Samuel Langhorne Clemens (Mark Twain).

The scene in which Union troops loot the Cameron home and burn the smokehouse also has historical roots. Many Huntsville civilians suffered the loss of property, possessions, and dignity as the occupying Union forces attempted to paralyze the Confederate forces in the area by damaging the infrastructure

of the society. Huntsville resident Jane Chadwick recorded in an August 1862 diary entry that a Union band had ransacked her house and stolen her horse. She later reported random shooting in the streets, raids on private houses for food, silver, and firearms, and attacks on citizens. Even General Mitchel recognized the severity of the crimes committed in the Union name, writing to the war department in May 1862 that "'The most terrible outrages—robberies, rapes, arson, and plundering—are being committed by lawless brigands and vagabonds connected with the army." Given these circumstances, the looting scene in *Cameron Hall* seems well within the realm of possibility.

Cruse also drew from the experience of her father, Samuel Cruse, for the scene depicting the Union "trial" of Mr. Derby, Mr. Cameron, Uncle John (probably based on Cruse's uncle William Cruse), and others when they are asked to swear allegiance to the Union or forfeit home and property. Samuel Cruse was one of a group of twelve Huntsville citizens held hostage by the occupying Union forces in retaliation for Confederate attacks. Refusing to take the oath, he, like Mr. Cameron in the novel, fled further into Confederate territory. Again like his fictional counterpart, Samuel Cruse eventually died as a refugee. On 21 February 1864 he was buried in St. Wilfrid's Episcopal Cemetery in Marion, Alabama. According to Mary Tardy, Mary Anne Cruse—like Julia in her novel—appears to have traveled with her father during his exile.

Considering the personal traumas Cruse experienced, *Cameron Hall* includes surprisingly little bitterness. Cruse claimed in her opening note to the reader that "In the delineation of the scenes, all exaggeration has been avoided, and a middle ground has been taken." While she did try to present a true account of her experiences during the war, she may have been motivated less by the desire to be fair to the Union forces than by a sense that the truth was damning enough. Cruse was an ardent supporter of the Confederate cause. Yet, despite its pro-Confederate stance the novel resonates with another theme as well: her strong antiwar sentiments.

In *Cameron Hall* Cruse supported the right of the Confederate states to secede from the Union and harshly criticized instances of Union racism and violence. Yet, the novel seems to condemn the nature of war itself as much as the Union forces. The effect of the war on its combatants clearly horrified her and is depicted in the novel.

Cruse's ambiguity concerning the war is understandable, given her social and religious training as a nineteenth-century woman. European-American women of the middle and upper classes were taught that they were the moral centers of their families and, by extension, the nation, because their virtue favorably affected their husbands and sons, who then affected the political climate. Women of these classes were encouraged to remain at home so their honor and virtue would not be degraded by contact with public life. In Cruse's novel, women (and the feminized Uncle John) exert a regenerative and civilizing influence. Eva takes Willie to church, and Julia is the moral center in her home. She is the one to whom everyone brings problems and the one who feeds, sustains, and assists her family. Cruse's deeply felt duty to exhibit humanity, morality, and nurturing love was, therefore, sometimes at odds with her sectional politics. While she seems to have attempted to write a strongly partisan novel, her sense of moral duty kept her from endorsing the Confederate cause without reservation.

The overt statements about the war in the novel challenge the justifications for it. At one point the narrator explains:

> Southern politicians urged dismemberment, and declared that it could be accomplished without bloodshed; and Northern fanaticism urged the election of a sectional President on the grounds that the South was too weak and cowardly to attempt resistance; but the thoughtful and far-seeing of both sections looked on with trembling anxiety and apprehension, and their hearts were failing them for fear of the terrible vortex of civil war into which they believed that the nation was about to plunge.

Except for the inexperienced and idealistic Eva, the Cameron family is among the "thoughtful and far-seeing" who neither welcome war nor often celebrate Confederate victories. They manage to bear the defeats, the horror, the brutality, and the pain.

Cameron Hall often depicts the emotional and physical hardship civilians, particularly women, face. The two Cameron sisters' wait for news about their brother at the front is excruciating, as is the scene in which Union troops ransack the Cameron home. In fact, the scene can be interpreted as a symbolic rape. Often metaphorically linked with women, the house is violated by the pillagers, and in a particularly telling incident a Union officer enters Eva's bedroom, opens a locked box, and reads the love letters he finds there while she watches in helpless humiliation. In this depiction of the indignities of war, Cruse condemned not only the Union troops but also the capacity of war to turn men into monsters and make women the "spoils of war."

The fates Cruse chose for her characters pointedly show the long-term effects of the war. Eva slowly goes mad during her unbearable wait for her husband's return. After she learns he has been killed, she wears her wedding gown daily and sits on the front porch, still waiting for him to come home. She eventually wastes away and dies. Julia flees with her father and nurses him on his deathbed. The novel offers some hope for the future: Julia returns to Hopedale; her brother comes home safely from the war; and a secondary couple decides to marry. Yet, the ending is ultimately bleak. For Cruse the only true hope in life was for Christian salvation, not military or political intervention.

Christian faith is the only powerful, unchanging force in *Cameron Hall,* revealing Cruse's ultimate lack of faith in worldly solutions. Unlike the matrimonial endings that tie together the various plot strands in most domestic novels of the period, the ambiguous ending of Cruse's novel does not restore balance and order to the universe. Rather, its open-ended structure reveals Cruse's unresolved emotions about the war, the Confederate defeat, and the Union occupation. As Mr. Cameron predicts, "A civil war will not leave us as it found us."

Perhaps because Cruse feared retaliation from the Union officials who governed her town as she wrote *Cameron Hall* or—as Mary Kelley has noted—because she felt the common nineteenth-century discomfort with discussing the private in public, she sought to mask the real-life people and events of the occupation behind a fictional facade. Literary critics such as Nina Baym, Joanne Dobson, and Susan K. Harris have long recognized that nineteenth-century American women writers often created a "coverplot," a conventional story line, to hide an unconventional "underplot" that challenges the status quo. Cruse used the same structure in *Cameron Hall* to reveal to the world, without exposing herself, the suffering and injustices civilians, particularly women, faced during the Civil War occupation of the South.

Cameron Hall provides a fascinating firsthand examination of the life of an upper-class, white Southern woman during the Civil War. Although war has traditionally been considered the exclusive domain of men, women writers have persisted in writing stories of war because it has always made women a part of its story. As Hope Norman Coulter explains:

> Someone packs the knapsack of those warriors and bids them goodbye. Someone turns back to mundane labors, to the day-to-day responsibilities of a life that has suddenly, drastically changed. Some-

Title page for the novel Cruse based on her experiences during Union Army occupation of Huntsville, Alabama (courtesy of Special Collections, Thomas Cooper Library, University of South Carolina)

one runs the small farms and businesses that feed the hyperactive economics of wartime. Someone rears the next generation, and answers its questions about the killing of this one.

Another perspective on warfare has always existed, but it has often been ignored. Civil War novels by women have frequently been dismissed as domestic fiction, defensive southern commentary, or the work of women writing on a subject of which they were ignorant. Yet, Elizabeth Moss's *Domestic Novelists of the Old South* (1992) and the increasing republication of fiction by nineteenth-century Southern women has sparked new interest in such writers, including those

who wrote about the Civil War. The perspectives of these women—as well as other men and women, black and white, northern and southern, who wrote about the war—are necessary to re-creating a complete picture of their era.

Cameron Hall focuses on a specific place at a critical moment in American history and reveals the emotions of an occupied people, not through the words of a soldier, but in the voice of a woman on the home front. The Civil War is the only war since the Revolution that was fought in the towns, yards, and houses of American women. As these women sent their husbands, sons, and brothers off to war, they also produced food, fought off foragers, took up arms, and wrote about their experiences. Civil War fiction by women is part of the record of those tumultuous times, and *Cameron Hall* is a significant contribution to that genre.

References:

Nina Baym, *Woman's Fiction: A Guide to Novels by and about Women in America, 1820–1870* (Ithaca, N.Y.: Cornell University Press, 1978);

Willis Brewer, *Alabama: Her History, Resources, War Record, and Public Men from 1540–1872* (Tuscaloosa: Willo Publishing, 1964);

Hope Norman Coulter, Introduction to *Civil War Women: American Women Shaped by Conflicts in Stories by Alcott, Chopin, Welty, and Others*, edited by Frank McSherry Jr., Charles G. Waugh, and Martin Greenburg (Little Rock, Ark.: August House, 1988), pp. 7–11;

Joanne Dobson, "The Hidden Hand: Subversion of Cultural Ideology in Three Mid-Nineteenth-Century Women's Novels," *American Quarterly*, 38 (1986): 223–242;

Drew Giblin Faust, *Mothers of Invention: Women of the Slave Holding South in the American Civil War* (Chapel Hill: University of North Carolina Press, 1996);

Walter L. Fleming, *Civil War and Reconstruction in Alabama* (New York: Peter Smith, 1949);

Susan K. Harris, *19th-Century American Women's Novels: Interpretive Strategies* (Cambridge & New York: Cambridge University Press, 1990);

Robert Hunt, "Domesticity, Paternalism, and Isolation: Mary Anne Cruse and the Search for Moral Asylum," *Southern Quarterly*, 34 (Summer 1996): 15–24;

Mary Kelley, *Private Woman, Public Stage: Literary Domesticity in Nineteenth-Century America* (New York: Oxford University Press, 1984);

Elizabeth Moss, *Domestic Novelists of the Old South: Defenders of Southern Culture* (Baton Rouge: Louisiana State University Press, 1992);

Thomas McAdory Owen, *The History of Alabama and Dictionary of Alabama Biography*, 4 volumes (Chicago: Clarke, 1921);

Charles Rice, *Hard Times: The Civil War in Huntsville and North Alabama, 1861–1865* (Huntsville: Old Huntsville, 1994);

H. E. Sterkx, *Partners in Rebellion: Alabama Women in the Civil War* (Rutherford, N.J.: Fairleigh Dickinson University Press, 1970);

Mary Tardy, *Living Female Writers of the South* (Philadelphia: Claxton, 1872);

Benjamin Buford Williams, *A Literary History of Alabama* (Rutherford, N.J.: Fairleigh Dickinson University Press, 1979).

Rebecca Harding Davis

(24 June 1831 – 29 September 1910)

Janice Milner Lasseter
Samford University

See also the Davis entry in *DLB 74: American Short-Story Writers Before 1880.*

BOOKS: *Margret Howth: A Story of To-Day* (Boston: Ticknor & Fields, 1862);

Dallas Galbraith (Philadelphia: Lippincott, 1868);

Waiting for the Verdict (New York: Sheldon, 1868);

John Andross (New York: Orange Judd, 1874);

Kitty's Choice: A Story of Berrytown (Philadelphia: Lippincott, 1874);

A Law Unto Herself (Philadelphia: Lippincott, 1878);

Natasqua (New York: Cassell, 1887);

Silhouettes of American Life (New York: Scribners, 1892; London: Osgood, Mellvaine, 1892);

Kent Hampden (New York: Scribners, 1892);

Doctor Warwick's Daughters (New York: Harper, 1896);

Frances Waldeaux (New York: Harper, 1897; London: Osgood, Mellvaine, 1897);

Bits of Gossip (Boston & New York: Houghton, Mifflin, 1904);

Life in the Iron Mills and Other Stories, edited by Tillie Olsen (New York: Feminist Press, 1972);

A Rebecca Harding Davis Reader, edited by Jean Pfaelzer (Pittsburgh: University of Pittsburgh Press, 1995).

Editions: *Waiting for the Verdict* (Upper Saddle River, N.J.: Gregg, 1968);

Silhouettes of American Life (New York: Garrett Press, 1968);

Margret Howth: A Story of To-Day, afterword by Jean Fagan Yellin (New York: Feminist Press, 1990);

Waiting for the Verdict, edited by Don Dingledine (Albany, N.Y.: New College University Press, 1995);

Life in the Iron Mills: A Bedford Cultural Edition, edited by Cecelia Tichi (New York: St. Martin's Press, 1997).

SELECTED PERIODICAL PUBLICATIONS– UNCOLLECTED:

FICTION

"Paul Blecker," *Atlantic Monthly,* 11 (May 1863): 580–598; (June 1863): 677–691;

Rebecca Harding Davis

"Ellen," *Peterson's Magazine,* 44 (July 1863): 38–48;

"The Pearl of Great Price," *Lippincott's Magazine,* 2 (December 1868): 606–617; 3 (January 1869): 74–83;

"Put Out of the Way," *Peterson's Magazine,* 57 (1870): 413–443;

"Two Women," *Galaxy,* 9 (June 1870): 799–815;

"Between Man and Woman," *Peterson's Magazine,* 65 (March 1874): 190–198;

"The Pepper-Pot Woman," *Scribner's Monthly,* 8 (September 1874): 541–543;

"The Rose of Carolina," *Scribner's Monthly,* 8 (October 1874): 723–726;

"The Poetess of Clap City," *Scribner's Monthly,* 9 (March 1875): 612–615;

"Married People," *Harper's New Monthly,* 43 (April 1877): 730–735;

"A Strange Story from the Coast," *Lippincott's Magazine,* 23 (January 1879): 677–685;

"Here and There in the South," *Harper's New Monthly,* 75 (July–November 1887): 235–246, 431–443, 593–606, 747–760, 914–925;

"An Old-Time Love Story," *Century,* 77 (December 1908): 219–221;

"The Coming of Night," *Scribner's Magazine,* 45 (January 1909): 58–68.

NONFICTION

"Ellen," *Atlantic Monthly,* 16 (July 1865): 22–34;

"Low Wages for Women," *Independent,* 40 (8 November 1888): 1425;

"Are Women to Blame?" essays by Davis, Rose Terry Cooke, Marion Harland, Catherine Owen, and Amelia E. Barr, *North American Review,* 148 (May 1889): 622–641;

"Shop and Country Girls," *Independent,* 41 (15 August 1889): 1;

"Some Hobgoblins in Literature," *Book Buyer,* 14 (April 1897): 229–231;

"Women and Patriotism," *Harper's Bazaar,* 21 (28 May 1898): 455;

"The Curse of Education," *North American Review,* 168 (May 1899): 609–614; republished as "Education and Crime," in *Report of the Department of Interior–Education, 1899,* volume 2, House Document volume 31, Fifty-sixth Congress, First session, 1899–1900 (Washington, D.C.: U.S. Government Printing House, 1900);

"Under the Old Code," *Harper's New Monthly,* 100 (February 1900): 401–412;

"On the Jersey Coast," *Independent,* 52 (15 November 1900): 2730–2733;

"The Disease of Money-Getting," *Independent,* 54 (19 June 1902): 1457–1460;

"War as the Woman Sees It," *Saturday Evening Post,* 176 (11 June 1904): 8–9;

"A Middle-Aged Woman," *Independent,* 57 (1 September 1904): 489–494;

"The Love Story of Charlotte Bronte," *Saturday Evening Post,* 178 (13 January 1906): 14–15;

"One Woman's Question," *Independent,* 63 (July 1907): 132–133.

Rebecca Harding Davis broke new ground as an American fiction writer and journalist. When her novella *Life in the Iron Mills* appeared in the April 1861 edition of *The Atlantic Monthly,* it startled readers with its depiction of the grim lives of the working class. The stark realism of this story was unprecedented. Building on the earlier forms of realism in works by Hannah Foster and Harriet Beecher Stowe, Davis inaugurated literary realism twenty years prior to the writers usually credited for its advent. *Life in the Iron Mills* launched Davis's fifty-year career, during which she wrote some five hundred published works, including short stories, novellas, novels, sketches, and social commentary. She was one of the first writers to portray the Civil War nonpolemically, to expose political corruption in the North, and to unmask bias in legal constraints on women.

Davis's importance to literary history rests primarily in the groundbreaking aspects of her work. Her pioneering realist fiction with a naturalist element was published two decades before works by William Dean Howells and six years before Emile Zola. Her work anticipated Kate Chopin's portraits of women's lives thwarted by social confines, Stephen Crane's depiction of the individually tragic dimensions of the Civil War, and Upton Sinclair's indictment of industrial capitalism.

Davis's artistic achievement is distinguished not only by the aesthetic of realism but also by the essentially female perspective infusing her social advocacy. Though she affirmed women's traditional roles, she exposed stultifying attitudes or conditions that stymied women's professional pursuits, and she strategically challenged the ideology of domesticity. Like the adverse effect of industrialism on American life and the class distinctions that undermined Americans' concept of democracy, the problems of the woman artist were an impetus for her fiction.

Born on 24 June 1831 in Washington, Pennsylvania, to Richard W. and Rachel Leet Wilson Harding, Rebecca Blaine Harding spent her first five years in Big Spring (now Florence), Alabama. Her mother came from a prominent Washington, Pennsylvania, family; her father was an English immigrant. In 1837 Richard and Rachel Harding took the nearly six-year-old Rebecca and her one-year-old brother, Wilson, to live in Wheeling, in the western part of Virginia that later became West Virginia. With her imagination and creative expression nurtured by her mother's linguistic virtuosity and her father's storytelling and love of classic literature, young Rebecca Harding was an avid reader and often climbed into the backyard tree house to read books by John Bunyan, Maria Edgeworth, and Sir Walter Scott. Most

LIFE IN THE IRON-MILLS.

"Is this the end?
O Life, as futile, then, as frail!
What hope of answer or redress? "

A CLOUDY day: do you know what that is in a town of iron-works? The sky sank down before dawn, muddy, flat, immovable. The air is thick, clammy with the breath of crowded human beings. It stifles me. I open the window, and, looking out, can scarcely see through the rain the grocer's shop opposite, where a crowd of drunken Irishmen are puffing Lynchburg tobacco in their pipes. I can detect the scent through all the foul smells ranging loose in the air.

The idiosyncrasy of this town is smoke. It rolls sullenly in slow folds from the great chimneys of the iron-foundries, and settles down in black, slimy pools on the muddy streets. Smoke on the wharves, smoke on the dingy boats, on the yellow river,—clinging in a coating of greasy soot to the house-front, the two faded poplars, the faces of the passers-by. The long train of mules, dragging masses of pig-iron through the narrow street, have a foul vapor hanging to their reeking sides. Here, inside, is a little broken figure of an angel pointing upward from the mantel-shelf; but even its wings are covered with smoke, clotted and black. Smoke everywhere! A dirty canary chirps desolately in a cage beside me. Its dream of green fields and sunshine is a very old dream,—almost worn out, I think.

From the back-window I can see a narrow brick-yard sloping down to the river-side, strewed with rain-butts and tubs. The river, dull and tawny-colored, (*la belle rivière!*) drags itself sluggishly along, tired of the heavy weight of boats and coal-barges. What wonder? When I was a child, I used to fancy a look of weary, dumb appeal upon the face of the negro-like river slavishly bearing its burden day after day. Something of the same idle notion comes to me to-day, when from the street-window I look on the slow stream of human life creeping past, night and morning, to the great mills. Masses of men, with dull, besotted faces bent to the ground, sharpened here and there by pain or cunning; skin and muscle and flesh begrimed with smoke and ashes; stooping all night over boiling caldrons of metal, laired by day in dens of drunkenness and infamy; breathing from infancy to death an air saturated with fog and grease and soot, vileness for soul and body. What do you make of a case like that, amateur psychologist? You call it an altogether serious thing to be alive: to these men it is a drunken jest, a joke,—horrible to angels perhaps, to them commonplace enough. My fancy about the river was an idle one: it is no type of such a life. What if it be stagnant and slimy here? It knows that beyond there waits for it odorous sunlight, —quaint old gardens, dusky with soft, green foliage of apple-trees, and flushing crimson with roses,—air, and fields, and mountains. The future of the Welsh puddler passing just now is not so pleasant. To be stowed away, after his grimy work is done, in a hole in the muddy graveyard, and after that,——*not* air, nor green fields, nor curious roses.

Can you see how foggy the day is? As I stand here, idly tapping the window-pane, and looking out through the rain at the dirty back-yard and the coal-boats below, fragments of an old story float up before me,—a story of this old house into which I happened to come to-day. You may think it a tiresome story enough, as foggy as the day, sharpened by no sudden flashes of pain or pleasure. —I know: only the outline of a dull life, that long since, with thousands of dull lives like its own, was vainly lived and lost: thousands of them,—massed, vile,

First page of Davis's groundbreaking contribution to literary realism, in the April 1861 issue of The Atlantic Monthly

MARGRET HOWTH.

A STORY OF TO-DAY.

" My matter hath no voice to alien ears."

BOSTON:
TICKNOR AND FIELDS.
1862.

Title page for the novel in which Davis attempted to "dig into this commonplace . . . vulgar American life"

when it appeared in April 1861 it shook the eastern intellectual community to its foundations, launching Harding's social reform efforts not only for the working class, but eventually for blacks, women, and others she believed to be essentially powerless.

Life in the Iron Mills is one of the first detailed pictures of the factory in American fiction. The characters in *Life in the Iron Mills* speak in authentic vernacular and varying dialects. The story announces its commonplace aesthetic not only in its realistic language but also in the narrator's vow to be honest, to make real the lives of the working class. The narrative structure parallels the hierarchical social strata of mid-nineteenth-century America. The narrator stands outside and above the iron mills. At the start of the story, the narrator is in an upper room of a house where the basement rooms were once inhabited by a Welsh puddler's family. The narrator's identity and gender are not made explicit in the story. Most readers agree that the narrator expresses a romantic vision and a belief in art as redemptive, largely because of the narrator's conscious attention to works of art, including the Korl Woman, a sculpture by Hugh Wolfe, one of the Welshmen who lived in the basement. A grim pall hangs over the house, suggesting a shroud of industrial pollution enveloping the lives of working people.

Two protagonists are the focus of the story. Wolfe and his cousin Deborah, both Welsh mill workers, signify two sorts of starvation. The physically deformed Deborah works in the cotton mill and hungers for love. The intelligent and artistically gifted Hugh has a ravenous hunger for freedom. The wolfish Korl Woman, which he created from the refuse of the iron mills, symbolizes the crippling damage to the human spirit created by abusive working conditions, raising the central question of the story: how can the working class be saved from such exploitation?

After Deborah steals a wallet from a man touring the mill and passes it to Hugh, his decision to keep it lands him in jail, where he commits suicide. Hugh's consuming hunger, which could have been satisfied by education and opportunity, instead brutally determines his descent. Thus, Hugh is one of the first naturalistic portraits in American literature. The insular Christianity of main-line churches has failed the desperate Hugh, who crept into a worship service before he was caught and imprisoned. If grace exists for Hugh, it is in the creative process that produced the sculpture of the Korl Woman. Deborah is saved from jail and crushing poverty by a Quaker woman and membership in the Society of Friends.

influential was her reading of Nathaniel Hawthorne, to whom she attributed her choice of commonplace subject matter in her writing.

Schooled at home by her mother and various tutors until she was fourteen, Harding entered Washington Female Seminary in 1845. After graduating in 1848 as valedictorian, the seventeen-year-old returned home to help her mother manage a bustling household of seven. Twelve years elapsed between graduation and her first published literary work. During this time Harding honed her writing skills by working occasionally for the *Wheeling Intelligence.* She was transformed from obscure spinster to renowned writer when James T. Fields, editor of *The Atlantic Monthly,* accepted *Life in the Iron Mills* for his prestigious journal. According to Sharon M. Harris, that initial publication was so compelling and daring that

The large, unlovely, lupine Korl Woman suggests the futility of the iron-mill puddler's hopes.

The stark realism of *Life in the Iron Mills* caught the immediate attention of well-known figures such as Ralph Waldo Emerson, Louisa May Alcott, Henry Ward Beecher, and, most important to Harding, Nathaniel Hawthorne, the writer she considered her literary forefather.

In January 1861, when Fields had sent Rebecca Harding $50 in payment for *Life in the Iron Mills,* he had also requested a second story, for which he offered her an advance double the amount he had paid for her first work. The $100 figure implies the promise Fields saw in her work. At this point she was still living in Virginia, a border state that would soon be divided over the issue of secession. Federal troops put Wheeling under martial law on 30 July 1861. During this time of national and local crisis, the fledgling writer was working on a second work of fiction. Her novel *Margret Howth: A Story of To-Day* was serialized as "A Story of To-Day" in *The Atlantic Monthly* from October 1861 through March 1862 and published as a book by Ticknor and Fields later in 1862. In her afterword to the 1990 edition of *Margret Howth,* Jean Fagan Yellin explains Rebecca Harding's unfortunate decision to succumb to Fields's editorial control, which diluted her critique of the deleterious effects of industrial capitalism on American democracy. She dropped her original title, turned the conclusion into an unnatural "sunny" ending, and allowed excisions to trim the length. The book focuses not on the imminent Civil War but on the working-class struggle for physical and spiritual food. She had wanted to tell the story of class warfare openly, to draw the characters' experiences with unrelenting candor. Relinquishing her own judgment caused her purpose to be violated, which severely damaged the artistry of the book.

Rebecca Harding's literary intention, conveyed by the narrator of *Margret Howth,* was to create a world in which beauty can be found in the outcasts and in the mundane, as readers "dig into this commonplace . . . vulgar American life" to find "awful significance." Although it begins and ends with Margret, the book is dominated by Stephen Holmes. Full of Fichtean ideas about self-reliance and development, Holmes returns to Indiana to put those notions into practice. Davis's familiarity with writings of philosopher Johann Gottlieb Fichte and poet-dramatist Johann Wolfgang von Goethe was probably a result of her brother's passing along to her the learning in German he had acquired in college. At odds with Margret's father's aristocratic notions, Holmes decides to abandon Margret, whom he loves, and

marry the mill owner's daughter, who can supply the money he believes necessary to develop his higher moral nature. A fire at the mill forces Holmes to confront the inadequacy of material abundance to feed one's soul. The jarring "happily ever after" ending that Harding added at Fields's insistence, includes a marriage, as well as a Christmas feast that belies the Howths' prior poverty-stricken status and turns the story line into a Cinderella plot. Harding did manage to retain the death of little Lois Yare, a mulatto cripple who is the embodiment of purity. Yellin blames Fields for insisting on the reversal of the plot movement with a comic denouement and criticizes Harding for capitulating to editorial demands that reduced the novel to a strange generic hodgepodge. The profession of authorship in nineteenth-century America was increasingly subject to the restraints of commercialism and conventional propriety, but for writers who attempted to create accurate portraits of crushing social conditions, their efforts were especially constrained.

Shortly after *Margret Howth* was published, Rebecca Harding visited James Fields and his wife, Annie, in Boston and Nathaniel and Sophia Hawthorne at the Wayside, their home in Concord. Sometime around 1860 Harding had read *Twice-Told Tales* (1837; expanded, 1842) and learned to her great surprise and delight that some stories that had enchanted her as a child were written by none other than Nathaniel Hawthorne. Davis was welcomed warmly into the Fields' and Hawthornes' coterie. Both couples hosted dinner parties in her honor, inviting friends such as Ralph Waldo Emerson, Bronson Alcott, Oliver Wendell Holmes, Elizabeth Palmer Peabody, and Louisa May Alcott. On one occasion, when the Hawthornes had brought together Emerson, Bronson Alcott, and Harding in their home, Alcott's justifications of the Civil War and Emerson's attentive submission to his viewpoint repelled Harding, who was grateful when Hawthorne called a halt to the monologue. Hawthorne had just returned from visiting several battle sites at the request of President Abraham Lincoln. Harding had watched her hometown of Wheeling face the daily, hard facts of the war. Not only was Wheeling a crossroads for the Underground Railroad, but Federal troops had recently set up headquarters across the street from her home. Like her, Hawthorne had seen effects of the war firsthand. Her feeling of literary kinship with Hawthorne deepened when she discovered Hawthorne's political and philosophical views on the war were similar to her own. They also shared, she believed, an inclination to see "the other side" of every question. Hawthorne wrote little spe-

Clarke and Rebecca Davis, circa 1863 (Collection of Kristen Kehrig)

cifically about the Civil War other than "Chiefly about War Matters" (July 1862), his report on his trip for *The Atlantic Monthly*. Harding became one of the few writers of her era to depict the national catastrophe realistically. The contrasting ways the two artists dealt with a subject on which they seemed kindred spirits signal the difference in romantic and realist aesthetics. Still in awe of Hawthorne despite their differences, she considered her visit to the Wayside one of the "brightest and best" memories of her life. Yet, by May 1863 Sophia Hawthorne was writing to Annie Fields that Hawthorne could "no longer read [Davis's] productions" and criticizing the "slimy gloom, . . . the mouldiness, . . . the east wind and grime" in *Margret Howth*. The dirty facts of class warfare and the Civil War were precisely Harding's point, but the Hawthornes, like many genteel Easterners of the time, were unwilling to accept them as literary subject matter.

The Atlantic Monthly published four of Harding's stories in 1862 and 1863. All were about slavery: "John Lamar" (April 1862), "David Gaunt" (September and October 1862), "Blind Tom" (November 1862), and "Paul Blecker" (May and June 1863). In these stories she treated the personalities and experiences of blacks as complex rather than one-dimensional, as in most renderings of her era. The stories also take issue with the tacit sanctioning of the war by mainstream Southern churches, while also revealing her abhorrence of the institution of slavery and suggesting that women's inferior position in American life allowed them a better understanding of the suffering of slaves.

"John Lamar" paints a complicated picture of a Confederate officer and his slave. The title character, who has been taken prisoner by Union forces, expects his slave Ben to help him escape. When faced with choosing between his master's escape or his own, Ben opts for personal freedom. The story includes a "Little Eva" figure, Floy, who does not effect the spiritual transformation of either Lamar or Ben, as Eva reforms her father in *Uncle Tom's Cabin* (1852). Neither Lamar nor Ben experiences the redemptive domestic influence found in Stowe's novel. The story closes without hope for Ben, who is now a criminal not only because he has murdered his master, but also because he is an escaped slave. Harding's frank portrayal of racial privilege and animos-

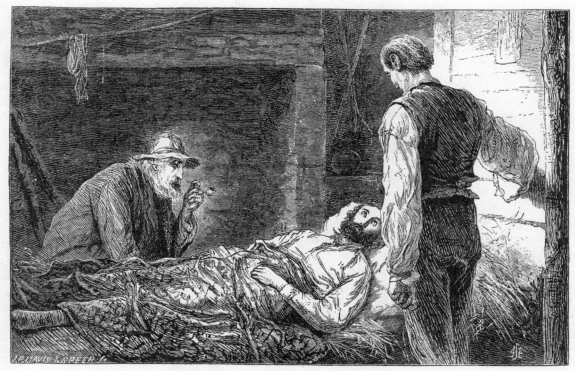

"You 've not once said by your looks dat you was white and I was black."—*Chap.* 18.

Illustration from Waiting for the Verdict *(1868), set during the Civil War*

ity was unusual for that period. She offered a female perspective on suffering without employing Christian rhetoric to gloss over abject degradation and dehumanization.

Set in a western Virginia hamlet during the Civil War, "David Gaunt" questions the efficacy of traditional evangelical religion (especially the meaning of sacrifice), includes an ongoing debate on the subject of secession, examines the connection between faith and tolerance, and challenges gender roles as they relate to and grow out of the war. The central character of the story is a young woman who must choose among three men vying for her affection. One of these men is her father, whose jealousy and blindness to his daughter's intelligence help to develop her autonomy and courage. Jean Pfaelzer considers this story a fictionalized version of the particular circumstances in Harding's life during this time. The war was omnipresent; Harding's career was taking shape; and she was about to leave home at age thirty to marry Lemuel Clarke Davis, a young Philadelphia lawyer and journalist. "David Gaunt" effectively combines two of her primary concerns: the nefarious effects of the war on individual lives and the need for female autonomy and love.

Through a joint-publication strategy Fields had developed with Charles Dickens, the editor of *All the Year Round,* "Blind Tom" was published in the British periodical a month before it came out in *The Atlantic Monthly.* The story has a factual basis that gives it a journalistic cast. Harding was present at a performance by a blind slave named Tom, a musical prodigy, who was taken on tour by his master, and saw in Tom's talent confirmation of her belief that creative genius may reside in lower-class individuals. Similar to Hugh Wolfe in *Life in the Iron Mills,* the fictional Tom is a frustrated artist whose blindness makes him even more susceptible to exploitation and tyranny than the oppressed Hugh. The fourth Civil War piece was "Paul Blecker," which explores death and love amid the war and reveals her growing interest in the subject of female independence.

Following her 1862 visit to Boston, Rebecca Harding had traveled to Philadelphia to see Lemuel Clarke Davis, who had begun writing to her after reading *Life in the Iron Mills* and then visited her in Wheeling. They were married on 5 March 1863 and moved into the home of his widowed sister, Carrie Cooper, and her children in Philadelphia. Living with her husband's relatives at the same time she was

adjusting to marriage was trying for her physically and emotionally. Her plans to write at the Philadelphia Library went awry. Soon after the wedding, Davis was faced with nursing her sick husband and his sister. About the time they recovered, Davis herself became ill and then learned she was pregnant. The illness was not named but was considered to be a disease of the "nerves," which required her to cease all reading or writing. Her severe depression lasted until the spring of 1864. When her first child was born on 18 April 1864, she named him Richard Harding Davis in honor of her father, who had died a month earlier on 20 March 1864.

Rebecca Harding Davis's next publication followed soon after Richard's birth. "The Wife's Story," published in the July 1864 issue of *The Atlantic Monthly,* explores Davis's feelings about the effect of marriage on the woman artist's struggle for creative expression and autonomy. Prior to her wedding, Davis had worried that familial and domestic duties would interfere with her literary work. In a late January 1863 letter to Annie Fields, Davis had written, "I must have leave to say my word in the Atlantic as before, when the Spirit moves me. It is necessary for me to write—well or ill—you know every animal has its speech and that is mine." In "The Wife's Story" Davis turned her concerns into a nightmare experienced by Hester, the protagonist. Hester dreams that she leaves her husband and child to regain her autonomy and to realize her artistic gifts, then experiences the dismal failure of her opera. When she awakens, she realizes that she never left her family and that her artistic failure has been part of a nightmare. This story introduces a motif that recurs frequently in Davis's writing: the woman writer's conscious and constant mediation of the public and private spheres.

In the summer of 1864 Davis and her husband and son vacationed in Point Pleasant, New Jersey. When the family returned to Philadelphia, they moved into their own home, a modest house on Twelfth Street. That same year Clarke Davis assumed the editorship of the *Legal Intelligencer.* Because of his new position and Rebecca Davis's growing literary reputation, they began associating with nationally prominent figures, remaining in those circles for the rest of their lives. In that same year the financial needs of her family convinced Davis to begin placing more of her writing in less-prestigious, but higher-paying, journals. During the next year she published four stories in *Peterson's Magazine* and two in *The Atlantic Monthly.*

"Out of the Sea," a story set in Point Pleasant, where the Davis family spent their first and many future vacations, was published in the May 1865 issue of *The Atlantic Monthly.* The story includes a favorite Davis theme: the subordination of female autonomy to the demands of domesticity.

Davis's next publication in *The Atlantic Monthly,* "Ellen" (July 1865), brought to light her two publishing identities. Until 1863 Davis's publications had been unsigned, but when *Peterson's Magazine,* where she had been publishing since 1862, published her fictional story "Ellen" in July 1863, its author was identified as "The Author of 'The Second Life.'" When *The Atlantic Monthly* published Davis's factual account—also titled "Ellen"—of the events on which she based her short story, identifying the author of "Ellen" as "The Author of 'Life in the Iron-Mills,'" careful readers noticed similarities between the two stories and alerted Fields to what they believed was plagiarism. Fields accepted Davis's explanation that the account in *The Atlantic* gave "the fact of an incident," while the story in *Peterson's* was fiction. Both versions tell the story of a slow-witted orphan child traveling alone through Virginia and Ohio in search of her soldier brother—again revealing Davis's abiding interest in the disasterous toll the Civil War wreaked on soldiers' families.

In 1866, the same year in which she gave birth to her second son, Charles Belmont Davis (24 January), Davis published for the first time under her own name when *Galaxy* published "The Captain's Story" in its December issue as the work of "Mrs. R. H. Davis." In February 1867, nearly two years after the assassination of President Lincoln, Davis's ambitious Civil War novel, *Waiting for the Verdict,* began to appear serially in *Galaxy,* continuing through the December issue. Sheldon Press published the novel in book form in late 1867, with 1868 on the title page.

The central issue in *Waiting for the Verdict* was a major question of the Reconstruction era: How would the nation integrate the freed slaves into the mainstream of American life? In Davis's novel this dilemma is voiced by a slave. Most of the action occurs during the war, but the book is concerned primarily with the future of a country split by fratricide. Essentially about miscegenation, the book focuses on love relationships between two unlikely couples. One couple is Northerner Rosslyn Burley and Southerner Garrick Randolph. In addition to sectional differences, Burley's illegitimate birth further complicates the match, until Garrick learns of his mixed blood. Rosslyn and Garrick manage to bridge the gaps bred by regional animosities and by the taboo against racial intermarriage. The other couple consists of white abolitionist Margaret Conrad and mulatto phy-

sician Dr. John Broderip, who passes as white. After Broderip divulges his secret, Margaret rejects him.

The broken relationship of the second couple dramatizes the dilemma Davis believed the nation was facing during Reconstruction. Although she never explicitly endorsed interracial marriage, the novel suggests that racial equality can exist only when interracial families are socially acceptable. The slave family in the novel–Nathan, Anny, and their children–represents the black race, whose future after the war seems unclear to them and to the country. The slave family stands on the brink of a frightening new world, and Davis believed that Americans needed to redefine what they meant by humanity and democracy. *Waiting for the Verdict* suggests that dehumanizing some of the members of the human family finally brutalizes the whole.

The artistic quality of *Waiting for the Verdict* suffered from its piecemeal serialization in *Galaxy*. In a savage review for *The Nation* (21 November 1867), Henry James assailed the gloominess of the novel, the same objection that Fields had raised against *Margret Howth*. Davis's uncompromising realism offended the literary tastes of many members of the cultural elite. Yet, a few rallied to her support. Harriet Beecher Stowe, seeking to counter James's review, wrote Davis offering encouragement and comfort. The literary editor of *Lippincott's* (January 1868) acknowledged the strength of the book on the same grounds James assailed it: "Mrs. Davis is a powerful writer. . . . Her field is that realism wherein authors of less talent would fail utterly." The editor of *The Atlantic,* however, did not share this view. Whether it was Fields's literary taste, his insistence on exclusive rights to her work, or his care not to offend his readers, nothing by Davis appeared the next year in the journal that had launched her career. Having been a principal contributor to *The Atlantic Monthly* for six years, she was summarily removed from the list of contributors. Soon after she realized her protest to Fields was not going to receive a reply, Davis expanded the list of journals to which she sent her work to include *Lippincott's* and *Hearth and Home*.

"In the Market" appeared in *Peterson's* in January 1868. One of Davis's best stories, it features two sisters of marriageable age. Because of their family's poverty, the sisters are forced to seek husbands so that their parents will no longer have the burden of supporting them. Having observed the abominable match her older sister, Clara, entered under duress, Margaret considers the whole process legal prostitution. Though her parents and siblings urge her to marry the financially struggling young man she loves, she realizes that she would be exacerbating the

Binding for Davis's 1892 book, which a reviewer called a "thoroughly and truthfully American" collection of short stories

financial straits of his family even as she eased the economic burden of her own. She refuses to relieve her parents at the expense of another family. Instead, Margaret uses the small amount of money she earned as a seamstress to invest in an herb farm. Over time she prospers enough not only to live well, but also to alleviate her parents' financial distress and to help her siblings. The return of the man she spurned earlier results in a marriage of equal partners. As in most of Davis's fiction, the independent woman's ingenuity, persistence, and ambition do not deprive her of personal fulfillment as a wife.

In 1868, the same year Clarke Davis became managing editor of the *Philadelphia Inquirer*, Rebecca Davis began writing for *Lippincott's,* which serialized *Dallas Galbraith* in its January through October issues. This novel has a more romantic plot than in most of Davis's fiction and explores the fate/freewill dichotomy. Dallas Galbraith seeks to overcome the depriva-

tion of having been abandoned as a child and victimized as a young man by the physician who had helped him escape the coal mines. The narrative ends with Dallas in a happy marriage and home. This time Henry James complained about the book "instructing us, purifying us, stirring up our pity" (*The Nation*, 22 October 1868). Most readers have agreed that *Dallas Galbraith* is a weak novel.

An early misattribution to Davis of the ultra-conservative tract *Pro Aris et Focis: A Plea for our Altars and Hearths* (1870), which has continued in some recent literary history and criticism, has contributed to misrepresentations of her stance on the woman question. As Philip Eppard and Sharon M. Harris have documented, Davis did not write *Pro Aris et Focis*. Yet, she was a conservative feminist. Throughout her life, she insisted that a woman needed both personal fulfillment as wife and mother and professional fulfillment through meaningful work.

In January 1873, when Fields was no longer editor, Davis published another short story in *The Atlantic Monthly*. Based on a pamphlet published in 1698, "A Faded Leaf of History" is a story about the power of maternal love. An unlikely group of would-be colonists is shipwrecked and finds itself at the mercy of cannibals. Male suspicion almost dooms the crew, until female trust rescues the castaways. (When the settlers finally arrive in Philadelphia, however, they reveal an equally vexed attitude toward the Native Americans there.)

Scribner's Monthly serialized Davis's modernist story, "Earthen Pitchers," between November 1873 and April 1874. Quite experimental in form, this story features two women whose aspirations for a complete identity diminish as they opt to give up their lives for others. Later in the decade Lippincott published *A Law Unto Herself* (1878), a new novel about female independence.

During the 1870s Davis expanded her range to include juvenile literature, the political novel, and journalism, the form best suited to her feminist leanings and social conscience. After the birth of her third child, Nora, on 16 October 1872, Davis combined her personal and professional interests by writing a novella and two stories for adolescents, *Kitty's Choice: A Story of Berrytown,* which was published by Lippincott in 1874. Her novel about political corruption in the administration of President Ulysses S. Grant, *John Andross* (1874), was published serially in *Hearth and Home* from January to May 1874 one year after the fraud conviction of William Marcy "Boss" Tweed, a prominent New York City politician, contributed to public concerns about dishonesty in government.

Davis's most impressive writing of the 1870s was her journalism, as she carried through the social protest she had voiced in her fiction. From this time forward, Davis was a full-fledged journalist, contributing regularly to the *New York Daily Tribune*, edited by Horace Greeley, and later for *The Independent*. Much of her journalistic writing continued her thoughts on the mediation of the dual spheres voiced in her fiction. Among these nonfiction articles are "Men's Rights" (*Putnam's Magazine,* February 1869), "The Middle-Aged Woman" (*Scribner's Monthly,* July 1875), and "Are Women to Blame?" (*North American Review,* May 1889). In "Men's Rights," Davis asks, "What do they [women] want? What is it they do not want?" The article concludes with the suggestion that men will have better, happier homes if their wives are well educated and engaged in work commensurate with their intellects–a conclusion that particularly echoes Margaret's combination of business success and late marriage to a man who is her equal in "In the Market."

"The Middle-Aged Woman" features a woman journalist much like Davis who writes all day at a publishing house and still runs the home for her large family. Along with Rose Terry Cooke, Marion Harland, Catherine Owen, and Amelia E. Barr, Davis contributed to "Are Women to Blame?"–a symposium on whether women caused Americans' domestic woes when they began to gain new social and economic rights during the second half of the nineteenth century. Davis argued that selecting a mate for economic advantage undermines marriage. She concluded her essay by contending that most American marriages were happy, and by asking: "How can we decide whether the credit of this is due to the husband or wife?"

Davis addressed women's political and economic problems in other social-commentary articles. "Low Wages for Women" (*The Independent,* 8 November 1888) argues that women cannot enter the male labor market and must create their own occupations. "Shop and Country Girls" (*The Independent,* 15 August 1889) discusses the plight of the country girl who moves to the city for economic reasons only to find herself enslaved by long work hours and low, unregulated wages. "Women in Literature" (*The Independent,* 7 May 1891) expresses hope for women writers intent on social reform. Thirty years after writing *Life in the Iron Mills* and some four hundred other works, Davis forecast a dramatic rise in the number of women writers: "It is but reasonable to expect that all the avenues now open to women who can hold a pen will be crowded." Furthermore, she hoped these women would "help them-

Davis's sons, Richard Harding and Charles Belmont Davis

selves and the world by so writing . . . and will paint as they only can do, for the next generation, the inner life and history of their time with a power which shall make that time alive for future ages."

Davis continued to address women's issues for the rest of her career. "The Newly Discovered Woman" (*The Independent*, 30 November 1893) reveals her resistance to the "shrill feminine hurly-burly" of political women. "In the Grey Cabins of New England" (*Century*, February 1895) delineates the stifled lives of single women and widows living in decaying New England towns. "One Woman's Question" (*The Independent*, July 1907) does not deal with women's issues, but the title suggests Davis's belief in the reforming power of a woman's view of moral and social issues. The essay examines the moral decline of the nation, situating it in the context of small dishonesties rather than the major crimes that normally garner public attention.

Racial issues continued to dominate Davis's thinking throughout the 1880s and 1890s, as she directed her readers' attention to poverty-stricken blacks. In "Some Testimony in the Case" (*The Atlantic Monthly,* November 1885) Davis, like many of her contemporaries, argued that blacks should receive technical training rather than college educations, which she believed would not prepare them for the job market. In "Two Points of View" (*The Independent,* 9 September 1895) and "Two Methods with the Negro" (*The Independent,* 31 March 1898) she compared the philosophies of Booker T. Washington and W. E. B. Du Bois. Ever the pragmatic mediator, Davis preferred Washington's vocational-training approach as the best means to provide socioeconomic health and cohesion within the black community over Du Bois's argument in favor of liberal-arts college education. "The Black North" (*The Independent,* 6 February 1902) decries the prevailing stereotyping of

African Americans. Throughout her writings on the subject, Davis consistently stressed the connections between racism and economic deprivation.

In 1889, after Horace Greeley was no longer editor, Davis resigned from the *New York Tribune* in protest over editorial censorship of her work and became a weekly contributor to *The Independent,* for which she had been writing occasionally for four years. In the same year Clarke Davis had also changed newspapers, moving from the *Inquirer* to the *Philadelphia Public Ledger* as associate editor.

Two years after her son Richard's first story, "Gallegher" appeared in *Scribner's* in 1890, Rebecca Davis published *Kent Hampden,* another novel for the young. Also in 1892, Davis became a regular contributor to *The Saturday Evening Post,* and Scribners published the only collection of her short fiction to appear during her lifetime, *Silhouettes of American Life.* During the second half of the decade Harper published two novels of manners by Davis: *Doctor Warwick's Daughters* (1896) and *Frances Waldeaux* (1897).

Silhouettes of American Life is a collection of thirteen stories that had been published over a twenty-year period in journals such as *The Atlantic, Harper's, Scribner's,* and *Lippincott's.* The first story, "At the Station" (*Scribner's,* December 1888), returns to the literary program she had announced in her early work by asserting the "commonplace" subject matter it shares with all the stories in the collection. "At the Station" depicts a woman whose generosity of spirit and good cheer persist despite the pain of neuralgia and her twenty-year wait for her brother, who, having set her up in an inn in North Carolina, had gone away and promised to return for her. "Tirar y Soult" (*Scribner's,* November 1887), set on a Louisiana rice plantation, explores the ancient dualisms in human history: love and ambition, poverty and wealth, nobility and crudity, and materialism and intellectualism. The story suggests that travel can mediate suspicions about people of different regions. "Walhalla" (*Scribner's,* May 1880) opposes glory and wealth to humility and simple life, even as it impugns the financial pressures that compromise the artist's craft. "The Doctor's Wife" (*Scribner's,* May 1874) portrays a simple woman, Mrs. Dode, whose joyful selflessness allows her to transcend the jealousy and class consciousness of her antagonist, Mrs. Fanning, who withers in comparison.

When she wrote "Anne" (*Harper's New Monthly,* April 1889), Davis was in a situation similar to that of her protagonist, Anne Palmer, who finds herself in what might be described as a midlife crisis. In 1889 Davis was the fifty-eight-year-old mother of three children whose ages ranged from seventeen to twenty-five. A successful businesswoman whose children seem unaware of her essential identity, Anne is unable finally to banish her sense of loss. A chance encounter with an old sweetheart, George Forbes, who had become a famous author, transforms Anne's opinion of him from "seer" to "huckster." With Emerson (the prophet of American Transcendentalism) the obvious analogue for Forbes, the story seems also to be a gloss on Davis's indictment of Emerson's impractical philosophies and the arrogance she detected in him. The sixth story in *Silhouettes,* "An Ignoble Martyr" (*Harper's New Monthly,* March 1890), explores the life of a woman whose dignity and purpose counters her having sequestered herself in a New England cabin to care for her ailing mother in impoverished circumstances. "Across the Gulf" (*Lippincott's,* July 1881) reveals the hypocrisy in the social ostracism of actresses, a subject of personal interest to Davis and her husband, who were friends with several theater people and whose sons both wrote plays. In "A Wayside Episode" (*Lippincott's,* February 1883), a young woman's search for a sense of self is daunted by the materialism of her social circles. In "Mademoiselle Joan" (*The Atlantic Monthly,* September 1886) the will of a good woman finally overcomes the forces of evil, even if from the grave.

"The End of the Vendetta," which had been published in *Harper's* (September 1883), satirizes Northerners' presuppositions about Southerners and life in the South.

The earliest story in the collection is "A Faded Leaf of History," the story that ended Davis's absence from *The Atlantic Monthly* in 1873. The collection also includes two other stories from the 1870s. "The Yares of Black Mountain" (*Lippincott's,* July 1875) depicts the abject poverty of mountain life, especially that of a family who had tried to remain neutral during the Civil War. The story also shows the important roles women played in the Underground Railroad. "Marcia" (*Harper's New Monthly,* November 1876) features an indigent woman, who is determined to be a writer despite her average talent. The story treats the woman-artist problem differently from Davis's earlier stories. Destitute and hopeless, Marcia finally is taken away by the man whose marriage proposal she has so long resisted, dressed magnificently but bitter about her failure.

Silhouettes of American Life lives up to its title; the collection includes compelling, authentic, realistic portraits of late-nineteenth-century American life. The book received laudatory reviews. The reviewer for *The Nation* (6 October 1892) refused to select a "best" story because there was such "an even range of excellence" in them all. *The Independent* (3 Novem-

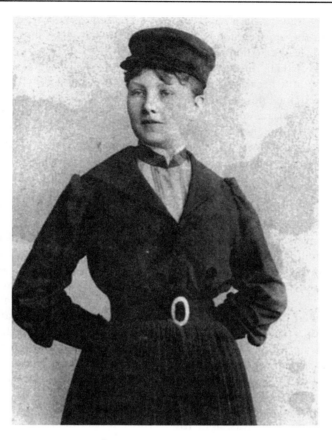

Davis's daughter, Nora Davis

ber 1892) said the stories were "strikingly original, and they are all thoroughly and truthfully American." The book went through three Scribners printings by the turn of the century.

By the mid 1890s both Davis's sons, Richard and Charles, had become writers. For a period of about ten years, Rebecca, Richard, and Charles Davis were all vying for space in various periodicals. In its 1897 volume *Harper's* published works by all three: Richard's "The Coronation" (February), Charles's "La Gommeuse" (March), and Davis's "The Education of Bob" (May). Richard Harding Davis became an international celebrity as a popular playwright, novelist, and journalist—and especially as the model for the Charles Dana Gibson's "Gibson man," the handsome companion to the "Gibson girl." Richard Davis's work as a war correspondent, his best writing, glorified adventure and honor, ideals that prevailed at the end of the nineteenth century. His first marriage into a wealthy family provided privilege and entry into aristocratic circles. Though not as famous as his brother, Charles became a well-known playwright and wrote the first biography of

his brother, *Adventures and Letters of Richard Harding Davis* (1917).

During the 1890s the Davis family became one of the most prominent families in America, frequent companions of two U.S. presidents. Clarke Davis and President Grover Cleveland were close friends and frequent fishing companions. In 1893 President Cleveland appointed Charles Davis U.S. consul to Italy. Richard Davis was a supporter and friend of President Theodore Roosevelt. Although the family records include fewer mentions of Nora Davis than of her brothers, she and her mother were evidently socially prominent and traveled abroad together. Several of President Roosevelt's letters to Richard mention Nora's attendance at social events, on one occasion as one of a party of four that included William Jennings Bryan.

In 1904 Houghton, Mifflin published Davis's memoir *Bits of Gossip,* a book far more substantive than its title implies. In her brief introduction Davis wrote, "It has always seemed to me that each human being, before going out into the silence, should leave behind him, not the story of his own life, but of the

time in which he lived,—as he saw it,—its creed, its purpose, its queer habits, and the work which it did or left undone in the world. Taken singly, these accounts might be weak and trivial, but together they would make history live and breathe." *Bits of Gossip* fulfills her aim. While it includes less about her own life than scholars or historians might wish, the book offers a clear and often poignant account of her times and indelible portraits of people whose lives she wanted to memorialize, including Edgar Allan Poe, Walt Whitman, James G. Blaine (her cousin), and Henry Clay. Reviewing the book for *The Dial* (16 November 1904) Percy F. Bicknell lauded Davis's emphasis on the cultural context and contended that the "only serious fault [of the book] is that it is not longer." The compelling human story of Davis's time, *Bits of Gossip* is a significant book, helpful for understanding the nineteenth-century American milieu.

When Clarke Davis died in 1904, tributes poured in from eminent people such as President Cleveland and Secretary of State John Hay. Following her husband's death, Davis began to experience increasing problems with failing eyesight. At times she was unable to read or write. Clarke Davis had left an estate of only $4,000, so writing remained necessary to her. Five months later she was able to resume writing, and during her remaining six years she published seventeen pieces, including social commentaries and two works of fiction.

In "Undistinguished Americans" (*The Independent,* 26 April 1906) Davis reviewed a collection of autobiographies of working-class people, finding "the real" essence of humanity she had sought to chronicle in her own work. Her last two short stories were "An Old-Time Love Story" (*Century,* December 1908), about American pioneers, and "The Coming of the Night" (*Scribner's,* January 1909), about growing old and the need to remain active. In 1910 Davis suffered a stroke while visiting her son Richard at his estate in Mount Kisco, New York. She died there of heart failure on 29 September, at the age of seventy-nine.

Davis was enormously proud of her family's literary legacy, and Richard Harding Davis returned her praise for his work by extolling her contribution to American life and literature:

From the day you struck the first blow for labor, in 'The Iron Mills' . . . with all the good the novels, the stories brought to people, you were always year after year making the ways straighter, lifting up people, making them happier and better. No woman ever did better for her time than you and no shrieking suffragette will ever understand the influence you

wielded, greater than hundreds of thousands of women's votes. (June 1901)

Whether Rebecca Harding Davis's reform efforts accomplished as much good as her son thought may be debatable, but her intent is not. Moreover, her literary achievement has always eclipsed her accomplishments as a social reformer.

In the year of Davis's death, Elizabeth Stuart Phelps assessed Davis's achievement. In "Stories that Stay" Phelps claimed: "Her intensity was essentially feminine, but her grip was like that of a masculine hand. She may have had her faults in style, but those were minor matters. Her men and women breathed and suffered, loved and missed of love, won life or wasted it with an ardor that was human, and a power that was art." Critical assessment of Davis's work increased significantly in the late twentieth century. Her primary contribution was to the development of literary realism. Her steadfast employment of subject matter previously considered unsuitable for literature provoked criticism of her fiction from her contemporaries—on the same grounds for which twentieth-century readers and scholars praised her work. The aesthetic ground Davis broke might have produced an even more impressive harvest had she not fallen prey to the demands of sentimentalism imposed by her first editor and to the financial needs of her growing family. Yet, as scholars continue to address various aspects of Davis's work, her place as a pioneer realist is secure.

Bibliographies:

Sharon M. Harris, "Rebecca Harding Davis: A Bibliography of Secondary Criticism, 1958–1986," *Bulletin of Bibliography,* 45 (1988): 233–246;

Jane Atteridge Rose, "A Bibliography of Fiction and Non-Fiction by Rebecca Harding Davis," *American Literary Realism,* 22 (1990): 67–86.

Biographies:

Charles Belmont Davis, *The Adventure and Letters of Richard Harding* (New York: Scribners, 1917);

Gerald Langford, *The Richard Harding Davis Years: A Biography of Mother and Son* (New York: Holt, Rinehart & Winston, 1961).

References:

James C. Austin, "Success and Failure of Rebecca Harding Davis," *Midcontinent American Studies Journal,* 3 (1962): 44–46;

Thomas Beer, *The Mauve Decade: American Life at the End of the Nineteenth Century* (New York: Knopf, 1926);

Kristin Boudreau, "'The Woman's Flesh of Me': Rebecca Harding Davis's Response to Self Reliance," *American Transcendental Quarterly*, 6 (1992): 132–140;

J. F. Buckley, "Living in the Iron Mills: A Tempering of Nineteenth-Century America's Orphic Poet," *Journal of American Culture*, 16 (1993): 67–72;

Jan Cohn, "The Negro Character in Northern Magazine Fiction of the 1860's," *New England Quarterly*, 43 (1970): 572–592;

John Conron, "Assailant Landscapes and the Man of Feeling: Rebecca Harding Davis's *Life in the Iron Mills*," *Journal of American Culture*, 3 (1976): 94–102;

Margaret M. Culley, "Vain Dreams: The Dream Convention in Some Nineteenth-Century American Women's Fiction," *Frontiers*, 1 (1976): 94–102;

Kirk Curnutt, "Direct Addresses, Narrative Authority, and Gender in Rebecca Harding Davis's 'Life in the Iron Mills,'" *Style*, 2 (1994): 146;

Fairfax Downey, "Portrait of a Pioneer," *Colophon*, 12 (1932);

Louise Duus, "Neither Saint nor Sinner: Women in Late Nineteenth-Century Fiction," *American Literary Realism*, 7 (1974): 276–278;

Philip B. Eppard, "Rebecca Harding Davis: A Misattribution," *Papers of the Bibliographic Society of America*, 69 (1975): 265–267;

Judith Fetterley, Introduction and critical commentary to *Life in the Iron Mills*, in *Provisions: A Reader from 19th-Century American Women* (Bloomington: Indiana University Press, 1985), pp. 306–314;

Charlotte Goodman, "Portraits of the Artiste Manque by Three Women Novelists," *Frontiers: A Journal of Women's Studies*, 5 (1980): 57–59;

William Frazer Grayburn, "The Major Fiction of Rebecca Harding Davis," dissertation, Pennsylvania State University, 1965;

Gordon S. Haight, "Realism Defined: William Dean Howells," in *Literary History of the United States*, edited by Robert E. Spiller, third edition, revised, 3 volumes (New York: Macmillan, 1963), pp. 878–898;

Sharon M. Harris, Introduction to *Redefining the Political Novel: American Women Writers, 1797–1901*, edited by Harris (Knoxville: University of Tennessee Press, 1995);

Harris, "Rebecca Harding Davis: A Continuing Misattribution," *Legacy*, 5 (1987): 33–34;

Harris, "Rebecca Harding Davis: From Romanticism to Realism," *American Literary Realism*, 21 (1989): 4–20;

Harris, *Rebecca Harding Davis and American Realism* (Philadelphia: University of Pennsylvania Press, 1991);

Harris, "Redefining the Feminine: Women and Work in Rebecca Harding Davis's 'In the Market,'" *Legacy*, 8 (1992): 118–132;

Walter Hesford, "Literary Contexts of 'Life in the Iron Mills,'" *American Literature*, 49 (1971): 70–85;

Richard A. Hood, "Framing a 'Life in the Iron Mills,'" *Studies in American Fiction*, 23 (1995): 73;

Amy Schrader Lang, "Class and the Strategies of Sympathy," in *The Culture of Sentiment: Race, Gender, and Sentimentality in Nineteenth-Century America*, edited by Shirley Samuels (New York: Oxford University Press, 1992), pp. 128–142;

Janice Milner Lasseter, "'Boston in the Sixties': Rebecca Harding Davis' View of Boston and Concord during the Civil War," *Concord Saunterer*, 3 (1995): 65–72;

Lasseter, "Hawthorne's Legacy to Rebecca Harding Davis," in *Scribbling Women: Engendering and Expanding the Hawthorne Tradition*, edited by John Idol and Melinda Ponder (Amherst: University of Massachusetts Press, 1998), pp. 168–178;

Lasseter, "Hawthorne's Stories and Rebecca Harding Davis: A Note," *Nathaniel Hawthorne Review*, 25 (1999): 31–34;

Deandra Little, "An Alabama Realist: The Influence of the Nineteenth-Century Idea of Womanhood in Rebecca Harding Davis's *Margret Howth*," *Alabama English*, 7 (1995): 31–37;

Frances M. Malpezzi, "Sisters in Protest: Rebecca Harding Davis and Tillie Olsen," *RE: Artes Liberales*, 12 (1986): 1–9;

Lee Clark Mitchell, "Naturalism and Languages of Determinism," in *Literary History of the United States*, edited by Emory Elliott (New York: Columbia University Press, 1988), p. 537;

Maribel W. Molyneaux, "Sculpture in the Iron Mills: Rebecca Harding Davis's Korl Woman," *Women's Studies*, 17 (1990): 157–177;

Tillie Olsen, "A Biographical Interpretation," in *Life in the Iron-Mills and Other Stories*, edited by Olsen (Old Westbury, N.Y.: Feminist Press, 1985), pp. 69–174;

Fred Lewis Pattee, *The Development of the American Short Story: An Historical Survey* (New York: Harper, 1923), pp. 169–173;

Carol Pearson, *The Female Hero in American and British Literature* (New York: Bowker, 1981), p. 43;

Jean Pfaelzer, "Domesticity and the Discourse of Slavery: 'John Lamar' and 'Blind Tom' by Rebecca

Harding Davis," *ESQ: A Journal of the American Renaissance,* 38 (1992): 118–132;

Pfaelzer, "Legacy Profile: Rebecca Harding Davis," *Legacy,* 7 (1990): 39–45;

Pfaelzer, "'Marcia' by Rebecca Harding Davis," *Legacy,* 4 (1987): 3–10;

Pfaelzer, *Parlor Radical: Rebecca Harding Davis and the Origins of American Social Realism* (Pittsburgh: University of Pittsburgh Press, 1996);

Pfaelzer, "Rebecca Harding Davis: Domesticity, Social Order, and the Industrial Novel," *International Journal of Women's Studies,* 4 (1981): 234–244;

Pfaelzer, "The Sentimental Promise and the Utopian Myth: Rebecca Harding Davis's 'The Harmonists' and Louisa May Alcott's 'Transcendental Wild Oats,'" *American Transcendental Quarterly,* 3 (1989): 85–99;

Pfaelzer, "Subjectivity as Feminist Utopia," in *Utopian and Science Fiction by Women: Worlds of Difference,* edited by Jane L. Donawerth and Carol A. Kolmerten (Syracuse: Syracuse University Press, 1994), pp. 93–106;

Elizabeth Stuart Phelps, "Stories That Stay," *Century,* 81 (1910): 118–124;

Arthur Hobson Quinn, *American Fiction: An Historical and Critical Survey* (New York: Appleton-Century, 1936), pp. 180–192;

Jane Atteridge Rose, "The Artist Manque in the Fiction of Rebecca Harding Davis," in *Writing the Woman Artist: Essays on Poetics, Politics, and Portraiture,* edited by Suzanne W. Jones (Philadelphia: University of Pennsylvania Press, 1991), pp. 155–174;

Rose, "Images of Self: The Example of Rebecca Harding Davis and Charlotte Perkins Gilman," *English Language Notes,* 29 (1992): 70–78;

Rose, "Reading 'Life in the Iron Mills' Contextually: A Key to Rebecca Harding Davis's Fiction," in *Conversations: Contemporary Critical Theory and the Teaching of Literature,* edited by Charles Moran and

Elizabeth F. Penfield (Urbana, Ill.: National Council of Teachers of English, 1990), pp. 187–199;

Rose, *Rebecca Harding Davis* (New York: Twayne, 1993);

Andrew J. Scheiber, "An Unknown Infrastructure: Gender, Production, and Aesthetic Exchange in Rebecca Harding Davis's 'Life in the Iron-Mills,'" *Legacy,* 11 (1992): 101–117;

Mark Seltzer, "The Still Life," *American Literary History,* 3 (1991): 455–486;

Helen Woodward Shaeffer, "Rebecca Harding Davis: Pioneer Realist," dissertation, University of Pennsylvania, 1947;

William H. Shurr, "'Life in the Iron-Mills': A Nineteenth-Century Conversion Narrative," *American Transcendental Quarterly,* 5 (1991): 67–86;

Eric J. Sundquist, "Realism and Regionalism," in *Literary History of the United States,* edited by Emory Elliott (New York: Columbia University Press, 1988), p. 510;

Rosemarie Garland Thompson, "Benevolent Maternalism and Physically Disabled Figures: Dilemmas of Female Embodiment in Stowe, Davis, and Phelps," *American Literature,* 68 (1996): 556–586;

Cecelia Tichi, *New World, New Earth: Environmental Reform in American Literature from the Puritans through Whitman* (New Haven: Yale University Press, 1979);

Jean Fagan Yellin, "The 'Feminization' of Rebecca Harding Davis," *American Literary History,* 2 (1990): 203–219;

Yellin, Afterword to *Margret Howth: A Story of To-Day* (New York: Feminist Press, 1990), pp. 271–302.

Papers:

Most of Rebecca Harding Davis's letters are in the Richard Harding Davis Collection (#6109), Clifford Waller Barrett Library, Special Collections Department, University of Virginia Library.

Sarah Morgan Dawson

(28 February 1842 – 5 May 1909)

Donna S. Sparkman
Marshall University

BOOKS: *Les aventures de Jeannot Lapin* (Paris: Hachette, 1903);
A Confederate Girl's Diary, edited by Warrington Dawson (Boston & New York: Houghton Mifflin, 1913; London: Heinemann, 1913).

Editions: *A Confederate Girl's Diary by Sarah Morgan Dawson,* edited by James I. Robertson Jr. (Bloomington: Indiana University Press, 1960);
The Civil War Diary of Sarah Morgan, edited by Charles East (Athens & London: University of Georgia Press, 1991); republished as *Sarah Morgan: The Civil War Diary of a Southern Woman* (New York: Simon & Schuster, 1992).

OTHER: "A Tragedy of South Carolina," in *More Dixie Ghosts: More Haunting, Spine-chilling Stories from the American South,* edited by Frank D. McSherry Jr., Charles G. Waugh, and Martin H. Greenberg (Nashville: Rutledge Hill, 1994).

SELECTED PERIODICAL PUBLICATIONS–
UNCOLLECTED: "Old Maids," *Charleston* (South Carolina) *Daily News,* 15 March 1873, p. 2;
"Bachelors and Widowers," *Charleston* (South Carolina) *Daily News,* 22 March 1873, p. 2;
"Young Couples," *Charleston* (South Carolina) *Daily News,* 29 March 1873, p. 2;
"Work for Women," *Charleston* (South Carolina) *News and Courier,* 15 April 1873, p. 2;
"Suffrage-Shrieking," *Charleston* (South Carolina) *News and Courier,* 20 May 1873, p. 2;
"The Natural History of Women," *Charleston* (South Carolina) *News and Courier,* 20 September 1873, p. 2.

Sarah Morgan Dawson's *A Confederate Girl's Diary,* first published in expurgated form in 1913, is an eyewitness account of the Civil War in Louisiana. It is also a self-portrait of an unusual young woman who, though a member of the Southern aristocracy, was critical of that class's code of chivalry and the status it accorded to

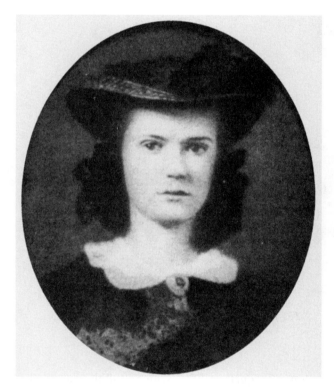

Sarah Morgan, circa 1860

women–but not of the far more oppressed status of African Americans. The diary portrays her development in three years from a naive nineteen-year-old who has only recently encountered death for the first time in the loss of her favorite brother and her beloved father, to a mature woman who understands that sorrow and tragedy are inherent and inescapable parts of life. It also chronicles her transformation, as a result of her experiences in the war, from an opponent of secession to a strong partisan of the Southern cause who, nevertheless, could never bring herself to hate all Yankees. The diary is written in a sprightly and colorful style that reflects the wide reading of the largely self-educated

A CONFEDERATE GIRL'S
DIARY

BY

SARAH MORGAN DAWSON

WITH AN INTRODUCTION BY
WARRINGTON DAWSON
AND WITH ILLUSTRATIONS

BOSTON AND NEW YORK
HOUGHTON MIFFLIN COMPANY
The Riverside Press Cambridge
1913

*Title page for Dawson's account of life in southern Louisiana
during the Civil War*

author. The quality of the writing is all the more striking when one considers that the diary was never intended for publication and was virtually unrevised by the author. Dawson recorded her experiences in five volumes: two bound blank books and three partially used ledgers that she obtained from the office of her half brother, a New Orleans judge. A sixth volume, focusing on her life after the war, remains unpublished.

The youngest of seven children, Sarah Ida Fowler Morgan was born on 28 February 1842 to Thomas Gibbes Morgan and his second wife, Sarah Hunt Fowler Morgan. Both parents were originally from the North and so were not members of the planter class by birth, but both were connected to it through the same man, Colonel Philip Hicky: Thomas Morgan's brother Morris had married one of Hicky's daughters, and Sarah Hunt Morgan had been orphaned young and raised on the Louisiana plantation of Hicky's brother-

in-law. A lawyer, Thomas Gibbes Morgan had moved to New Orleans from Baton Rouge around 1840 and had become customs collector for the port. In 1850 he returned with his family to Baton Rouge, which had just become the state capital, and took a position as a district court judge.

Like most girls of the time, Sarah Morgan had little formal schooling—she claimed only ten months. She was also taught at home by her mother but mainly educated herself through a rigorous program of study. She was fluent in French, as were many young Southern women of her class, and occasionally and unself-consciously uses a French word or phrase in the diary. She appears, from allusions in the diary, to have been familiar with such authors as Joseph Addison; James Boswell; Charlotte Brontë; William Cowper; Mary Cummins; Thomas De Quincey; John Dryden; Alexandre Dumas *père;* George Gordon, Lord Byron; Henry Wadsworth Longfellow; Thomas Macaulay; Thomas Moore; Edgar Allan Poe; Alexander Pope; Sir Walter Scott; William Shakespeare; Alfred Tennyson; and William Makepeace Thackeray. She also taught herself arithmetic. Her brothers, especially her favorite, Henry—also called Harry and, mainly by her, Hal—shared their books with her, and she was encouraged to take part in intellectual discussions with the men in the family.

Thomas Morgan was opposed to secession, and Sarah shared that opinion; but when Louisiana left the Union on 1 February 1861, he remained loyal to his state. Henry Morgan was killed in a duel in New Orleans on 30 April 1861, and Thomas Morgan died on 14 November of the same year. Sarah Morgan began writing her diary in an effort to purge her emotions after the deaths of her brother and father deprived her of her closest confidantes. The first two entries, for 10 and 26 January 1862, vividly recall their deaths and her feelings at the time. The 26 January entry describes her return home after her father's burial:

Home! What a dreary, desolate place it was! How forsaken every thing looked! There was such a strange echo in the deserted rooms, such a forlorn look in every place! All that made our home happy, or secured it to us, was gone; a sad life lay before us. My heart failed me when I remembered what a home we had lost, but I could thank God that I had loved it and valued it while I had it, for few have loved home as I. Sis, Hal, and I, it is all we lived for. How it would have pained Hal to see that day! I was thankful he had gone before. It would have broken his heart if any of us had died. And O Hal my darling, how I miss you now! How I long for you, wait for you, pray for you, and you never come! Do you no longer love your little sister? Father is with him now; both lying so close

together, yet so far apart; side by side, and they speak not, though they once loved one another so much!

Reminiscences of "Hal" are interspersed throughout the diary. Some passages leave the impression that Morgan's relationship with her brother was more intense and even romantic than one would expect between siblings. For example, on 5 April 1862 she recalls an incident that had occurred exactly a year earlier:

Hal made me a promise an hour or two after, which we often talked about during the few, happy days that followed. We were both looking in his trunk for a book he had bought me, when he told me of Sallie Maynadier, and what a nice girl she was, and added "I came *very* near falling in love with her, I can tell you!" I felt jealous of her; I could not help saying, "Did you love her *more* than me, Hal?" "No! I loved both her, and her sister because they reminded me so much of you and Miriam," he said, and then went on to say they were *very* nice girls, laughing at me all the time.

I asked one more question; I was growing jealous of the girl he could even like; so I asked if he could love her enough to marry her, and leave me. He was kneeling on one knee near the trunk, and in his odd, abrupt way, he looked up quickly at me, and said, "Come! Let us make a bargain! Promise me you will never marry, and I promise you *I* will not; and I'll grow rich for both, and you shall take care of me, and be my little housekeeper; will you?" I laughed and said "Yes!"

The Civil War divided the family: Morgan's brothers Gibbes, George, and James fought for the Confederacy; Philip Hicky Morgan, her half brother from her father's first marriage, a Union sympathizer who refused to take up arms against the South, served as a judge in New Orleans throughout the war; and her brother-in-law Richard Drum was a major in the Union army in California. Baton Rouge was occupied by Union troops from May 1862 until the end of the war, except for the period from August to December 1862. Morgan; her mother; her sister Miriam; her sister Eliza (called Lilly); and Eliza's husband, Charles LaNoue, and their five children remained in the Baton Rouge area for most of the war.

Morgan's independent nature and feminist tendencies are revealed in many passages in the diary. One such is the entry for 24 July 1862, where she is reporting on a conversation with her friend Dena Brunot at the State Asylum for the Deaf and Blind, where they and their families have taken refuge from a rumored Confederate invasion of the city (which did not, in fact, take place):

Dena says marriage is awful, but to be an old maid more awful still. I wont agree. I mean to be an old maid

myself, and show the world what such a life can be. It shocks me to hear a woman say she would hate to die unmarried. I have heard girls say they would rather be wretched, married, than happy as old maids. Is it not revolting? If I had my choice of wretchedness on either hand, I would take it alone; for then I only would be to blame, while married, *he* would be the iron that would pierce my very soul. I can fancy no greater hell—if I may use the only word that can express it—than to be tied to a man you could not respect and love perfectly. Heaven help me, and my husband too, if he for an instant lets me see I am the better man of the two! Wouldn't I despise him!

On 11 October 1862 Morgan writes: "O what a dream I had last night! I have not yet recovered from my terror. I dreamed that I was to be married. Awful, was it not?"

Morgan has an almost puritanical view of courting, holding that no kissing should be permitted until after the wedding. Yet, throughout the text she describes daydreams in which she teasingly makes a man fall in love with her and retains the power to end the relationship. If she ever does marry, she says, her husband will have to be a paragon of strength and virtue.

At the beginning of August 1862 Morgan and her family are forced to flee their home ahead of an invasion by Confederate troops under General John C. Breckenridge. (The battle occurred on 5 August; the Union troops held the city, and Breckenridge withdrew.) Unable to return home, Morgan repeatedly refers to herself as "Noah's duck" as she "floats" from one place of refuge to the next.

Near the end of the month Miriam goes back into Baton Rouge and discovers that Union officers had ransacked their abandoned house. On her return she tells Sarah what she has seen:

I never heard such a story as she told. I was heart sick; but I laughed until Mrs Badger grew furious with me and the Yankees, and abused me for not abusing them. She says when she entered the house, she burst into tears at the desolation. It was one scene of ruin. Libraries emptied, china smashed, sideboards split open with axes, three cedar chests cut open, plundered, and set up on end; all parlor ornaments carried off. . . .

Mother's portrait half cut from its frame stood on the floor. Margaret [a slave] who was present at the sacking, told how she had saved father's. It seems that those who wrought the destruction in our house, were all officers. One jumped on the sofa to cut the picture down (Miriam saw the prints of his muddy feet) when Margaret cried "For God's sake, gentlemen, let it be! I'll help you to anything here. He's dead, and the young ladies would rather see the house burn than lose it!" "I'll blow your damned brains out" was the "gentlemans" answer as he put a pistol to her head, which a

April 26th 1862.

65

There is no word in the English language which can express the state in which we are all now, and have been for the last three days. Day before yesterday news came early in the morning of three of the enemy's boats passing the forts, and then the excitement commenced, and increased so rapidly on hearing of the sinking of eight of our gunboats in the engagement, the capture of the forts, and last night of the burning of the wharves and cotton in the city while the Yankees were taking possession, that to day the excitement has reached almost the crazy point. I believe that I am one of the most self possessed in my small circle of acquaintance, and yet, I feel such a craving for news from Miriam, and mother and Jimmy, who are in the city, such patriotic and enthusiastic sentiments etc, that I believe I am as crazy as the rest, and it is all humbug when they tell me I am cool. Nothing can be heard positively, for every report except that our gunboats were sunk, and theirs coming up to the city, has been contradicted, until we do not really know whether it is in their possession or not. We only know we had best be prepared for anything, so day before yesterday Lilly and I secured what little jewelry we had, that may yet be of some use to us if we must run. I vow I will not move one step, unless forced away! I remain here, come what will. We went this morning to see the cotton

Page from Dawson's diary (Manuscript Department, Duke University Library)

brother officer dashed away, and the picture was abandoned for finer sport. All the others were cut up in shreds. Up stairs was the finest fun. . . .

In the pillaging of the armoirs, they seized a pink flounced muslin of Miriam's, which one officer placed on the end of a bayonet, and paraded around with, followed by the others who slashed it with their swords crying, "I have stuck the damned Secesh! that's the time I cut her!" and continued their sport until the rags could no longer be pierced. . . .

Aunt [Ann Morgan] Barker's Charles [another slave] tried his best to defend the property. "Aint you 'shamed to destroy all dis here, that belongs to a poor widow lady who's got two daughters to support?" he asked of an officer who was foremost in the destruction. "Poor? Damn them! I dont know when I have seen a house furnished like this! look at that furniture! *they* poor!" was the retort, and thereupon the work went bravely on, of making us poor indeed.

Even though her family's slaves risked their lives to try to save their owners' possessions, Morgan retains the prejudices of her region and class toward blacks. In an earlier entry (17 August 1862), after relating the story of a neighbor whose property was turned over to a freed slave by Yankee officers, she says:

Wicked as it may seem, I would rather have all that I owned burned, than in the possession of the negroes. Fancy my magenta organdie on a dark beauty! Bah! I think the sight would enrage me!

Later (3 September 1862), she expresses pride in the loyalty of her "servants" (she does not use the word *slaves*):

Our servants they kindly made free, and told them they must follow them (the officers). Margaret was boasting the other day of her answer "I dont want to be any free-er than I is now. I'll stay with my mistress," The conduct of all our servants is beyond praise. Five thousand negroes followed their Yankee brothers, from the town & neighborhood; but ours remained. During the fight, or flight, rather, a fleeing officer stopped to throw a musket in Charles Barker's hands, and bade him fight for his liberty. Charles drew himself up, saying, "I am only a slave, but I am a secesh nigger, and wont fight in such a d——— crew!" Exit Yankee, continuing his flight down to the riverside.

In the entry for 18 August 1862, Morgan makes a tantalizing comment about the self-censorship she has exercised in writing the diary:

If I dared keep the diary that is in my thoughts, what a book this would be! But it is not to be thought of. Wandering about the world as I now am, with no sacred or convenient spot where I can place any thing with security, it would [be] impossible to do so with

any pleasure; for there are some inward thoughts which I would shrink from having rudely exposed. Not that I imagine that any one here would take the trouble to look at this, but because I am told that there are people in the world who might do it from mere curiosity, and I do not know how long it will be before I am thrown among such. So I keep to myself all that is worth recording, and industriously compile a whole volume of trash which even I will never have the patience to review, and which curiosity mongers would soon abandon as a fruitless undertaking. And yet, if I gave way to impulse, I *could* write a diary! Such a one, perhaps, that I could actually look over again. But pshaw! Throw such ideas to the wind, and save your paper; for really when this is gone, journalizing is at an end; for even if I could procure another book, I cannot carry so many volumes around the world.

The comment about concluding the diary is made on page 24 of the third volume; it continues to page 140 and was followed by three more volumes.

By the end of September, Morgan and Miriam have made their way to Linwood, the plantation of Gibbes Morgan's father-in-law some twenty miles north of Baton Rouge. They spend several relatively peaceful months there, while their mother and Lilly remain in nearby Clinton.

While visiting her brother Gibbes in camp on 12 November 1862, Morgan is thrown from a runaway buggy and hurts her spine, an injury that leaves her an invalid for six months. Her main concern at the time of the accident, however, is whether or not she has exposed a limb to the soldiers' view:

The first remark I heard was my young Alabamian crying, "It is the most beautiful somerset I ever saw! Indeed it could not be more gracefully done! Your feet did not show!" Naif, but it was just what I wanted to know, and dared not ask.

By 9 May 1862 Morgan's anger at the losses her family has sustained makes her wish that she could fight the Yankees herself. Even at this point, however, and through the rest of the diary, she is able to feel compassion for the enemy soldiers:

This is a dreadful war to make even the hearts of women so bitter! I hardly know myself these last few weeks. I, who have such a horror of bloodshed, consider even killing in self defense murder, who cannot wish them the slightest evil, whose only prayer is to have them sent back in peace to their own country, *I* talk of killing them! for what else do I wear a pistol and carving knife? I am afraid I *will* try them on the first one who says an insolent word to me. Yes, and repent ever after in sack cloth and ashes! O if I was only a man! Then I could don the breeches, and slay them with a will! If some few Southern women were in the

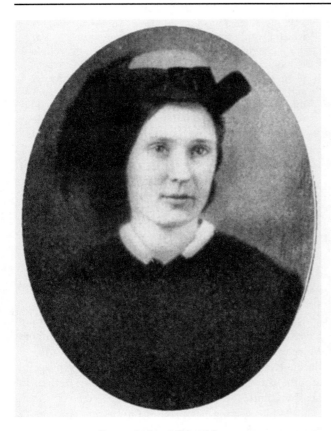

Dawson's sister Miriam Morgan

ranks, they could set the men an example they would not blush to follow. Pshaw! there are no women here! We are *all* men!

By 23 January 1863 she has fully adopted the Confederate cause:

> I confess my self a rebel, body and soul. *Confess?* I glory in it! Am proud of being one; would not forego the title for any other earthly one! Though none could regret the dismemberment of our old Union more than I did at the time, though I acknowledge that there never was a more unnecessary war than this in the beginning, yet once in ernest [*sic*], I have never since then looked back: forward, forward! is the cry; and as the Federal States sink each day in more appalling folly and disgrace, I grow prouder still of my own country and rejoice that we can no longer be confounded with a nation which shows so little fortitude in calamity, so little magnanimity in its hour of triumph.

As Union troops under General Nathaniel P. Banks approach Port Hudson, five miles southwest of Linwood, in the spring of 1863, Morgan, Miriam, and their mother travel to occupied New Orleans to secure medical treatment for Morgan's back injury and for the mother, who has suffered great privation in Clinton,

and to place themselves under the protection of Judge Philip Hicky Morgan. They arrive on 21 April; before being allowed to disembark from the ship that has carried them across Lake Pontchartrain, they are required to take the oath of allegiance to the United States. Later (17 June), Morgan reflects that "A forced oath, all men agree, is not binding," and vows that "I shall break their sham oath without hesitation, on the first opportunity." In New Orleans, Morgan is devastated to learn that her brothers George and Gibbes have been killed, both in the same week.

Morgan remained in New Orleans through the end of the war. In July 1865 she and her younger brother, James, traveled by sea to New York and then to Charleston, South Carolina, where James was married. Morgan and the newlywed couple sailed back to New York and then returned by train to New Orleans via Pittsburgh and Chicago. In the spring of 1872 Morgan and her mother moved to Columbia, South Carolina, to live with James, whose wife had died in childbirth in 1866. She continued to make entries in the diary until January 1873.

In 1873 Morgan met Francis Warrington Dawson, an Englishman who had come to America to join the Confederate army and was then the editor of the *News* in Charleston. At Dawson's urging, Morgan wrote articles for the *News* and—after Francis Dawson and his partner merged it with another paper in April 1873—for the *News and Courier*. Published under the pseudonym "Mr. Fowler," most of them advocated equality for women (but not the right to vote) and reiterated the antimarriage views she had expressed in the diary. While staying at the White Sulphur Springs, West Virginia, resort in the spring, summer, and fall of 1873, she also contributed a society column signed "*Feu Follet*" (Will-o'-the-Wisp). On 9 June 1873 she wrote on the outside of the linen parcel in which she had wrapped the six volumes of the diary: "To be burned unread after my death."

In spite of her often-stated intention to become an old maid, Morgan married Dawson in Charleston—after months of wooing and importuning on his part—on 27 January 1874. Sarah Dawson ceased writing for her husband's paper after their first child, Ethel, was born in November 1874. A son, Warrington, followed in 1878. Another son, Philip Hicky, was born in 1881 but died at the age of five months.

Francis Dawson was shot to death on 12 March 1889 in an altercation at the home of a physician, Thomas B. McDow, whom the Dawsons' governess had accused of pressing unwanted attentions on her; McDow was tried for murder but acquitted. Sarah Dawson believed that she was treated unfairly by her

late husband's business partner in the division of his estate.

In 1895 Dawson published a ghost story, "A Tragedy of South Carolina," in *Cosmopolitan* magazine. The following year, according to her son, Dawson, while on a visit to New York City, told a man from Philadelphia that the official account of a certain naval battle on the Mississippi River was incorrect; she had witnessed the incident from the levee, she said, and had recorded the facts in the diary that she kept throughout the war. The Philadelphian expressed interest in seeing a diary that, unlike other such works that had been published since the war, had not been revised with the benefit of hindsight. When she returned to Charleston, Morgan removed the diary from the linen wrapping in which, apparently, it had remained unread since 1873, and spent several weeks copying parts of it; at this time, presumably, she made some spelling corrections, marginal annotations, and excisions to the original. She sent the transcription to the Philadelphian; according to Warrington Dawson, "It was in due course returned, with cold regrets that the temptation to rearrange it had not been resisted. No Southerner at that time could possibly have had opinions so just or foresight so clear as those here attributed to a young girl." Disappointed, Dawson stitched the diary back into its linen casing and returned it to the wardrobe where she kept it. At her son's request, however, she countermanded her instruction to have the diary burned and deeded it to him.

In 1898 Warrington Dawson moved to Paris to pursue a career as a foreign correspondent, novelist, and diplomat; Sarah Dawson followed him there the next year. She published a children's book, *Les aventures de Jeannot Lapin,* in 1903. In 1904 and 1906 she added some brief notations at the end of the fifth volume of her diary. She died on 5 May 1909 while her son was in Africa; her body was shipped back to Charleston and buried in St. Lawrence Cemetery, next to her husband, on 3 October.

In 1913 Warrington Dawson published *A Confederate Girl's Diary,* an edited version of the first five books—that is, those that deal with the war. He left out entries he deemed private, removed names, and deleted his mother's strong words against marriage, motherhood, and the Yankees. The published diary begins with the entry for 9 March 1862, omitting the two entries in which Morgan discussed the deaths of her brother and father. In all, the 1913 edition amounts to about half the length of the original five books. Clara Juncker suggests that Warrington Dawson attempted to "stress the author's maternal virtues—common sense, forgiveness and martyrdom." A second edition, published by Indiana University Press in 1960, was the same as Warrington Dawson's version except for the

*Dawson in 1886 (Manuscript Department,
Duke University Library)*

addition of a foreword and notes by the editor, James I. Robertson Jr. The third edition, edited by Charles East, who had provided some of the information Robertson had used in his notes, was published by the University of Georgia Press in 1991 as *The Civil War Diary of Sarah Morgan* and republished the following year by Simon and Schuster as *Sarah Morgan: The Civil War Diary of a Southern Woman.* East transcribed the diary from the microfilm copy of the original manuscript at Duke University, restoring material Warrington Dawson had deleted and correcting misreadings he had made. Like Warrington Dawson, East leaves out the postwar sixth volume of the diary.

The most important addition made by East is the restoration to the beginning of the diary of the 1 and 26 January 1862 entries. These missing pages are important for understanding the repetition of references to Morgan's father and brother Hal throughout the text and the ending tone. Without these entries, the diary opens as the diversion of a bored Southern lady: "Here I am, at your service, Madame Idleness, waiting for any suggestion it may please you to put in my weary brain, as a means to pass this dull, cloudy Sunday afternoon. . . ." Yet, the tone of this year in Morgan's life has not been

of boredom: she has suffered the recent deaths of the two men closest to her. Throughout the diary, especially in entries written on the anniversaries of these days, she returns to mourn their deaths. The importance of these pages reappears at the end of the text, when Morgan is in New Orleans–where Hal died in the duel–mourning the deaths of two more brothers. The restoration of the two entries at the beginning of the text also reinforces the change that the once-shy youngest daughter has undergone: at the end of the diary Morgan is a strong, proud woman, even though she has lost all the possessions and status that had once defined her; the girl who hid during thunderstorms has braved the sound of cannons.

Dawson's work belongs to a genre of published Civil War diaries by women that also includes those by Ada W. Bacot, Kate Cumming, Emma Holmes, Emma LeConte, Cornelia McDonald, Clara Solomon, and Kate Stone. The best known of the group is *A Diary from Dixie* (1905), by the Charleston diarist Mary Boykin Chesnut. Unlike Chesnut's diary, which was heavily revised, enlarged, reconstructed from memory in places, and even partly fictionalized years after the events, Dawson's work–contrary to the suspicions of the unnamed Philadelphian–represents the direct observations and immediate reflections of the author. She was not present at any of the major battles of the war; unlike Chesnut, whose husband was a politician and general, she was not close to the inner circles of the Confederate government; and much of the information she received through hearsay about the war turned out to be false. Nevertheless, the diary is valuable as social history and, because of the author's natural and spontaneous style–which was appreciated by the critic Edmund Wilson–as literature.

References:

Charlotte Telford Breed, "Sarah Morgan Dawson: From Confederate Girl to New Woman," M.A. thesis, University of North Carolina, 1981;

Mary Katherine Davis, "Sarah Morgan Dawson: A Renunciation of Southern Society," M.A. thesis, Duke University, 1970;

Clara Juncker, "Behind Confederate Lines: Sarah Morgan Dawson," *Southern Quarterly*, 30 (1991): 7–18;

Edmund Wilson, "Three Confederate Ladies: Kate Stone, Sarah Morgan, Mary Chesnut," in his *Patriotic Gore: Studies in the Literature of the American Civil War* (New York: Oxford University Press, 1962), pp. 258–298.

Papers:

The Francis Warrington Dawson Papers in the Special Collections Library at Duke University include Sarah Morgan Dawson's diaries and scrapbooks. The Louisiana and Lower Mississippi Valley Collections, Hill Memorial Library, Louisiana State University, has a letter from Dawson to a friend, offering the use of her library; a photograph taken on a holiday in North Carolina in August 1899; and two manuscript narratives from an unfinished volume of reminiscences written by her during the last years of her life at the request of her children.

Silvia Dubois

(1788 or 1789? – 1889)

Abbey Zink
Northern Illinois University

BOOK: *Silvia Dubois (Now 116 Yers Old.) A Biografy of the Slav who Whipt Her Mistres and Gand Her Fredom,* by Dubois and Cornelius W. Larison (Ringos, N.J.: C. W. Larison, 1883).

Edition: *Silvia Dubois, A Biografy of the Slav Who Whipt Her Mistres and Gand Her Fredom,* edited, with a transcription and introduction, by Jared C. Lobdell (New York & Oxford: Oxford University Press, 1988).

The narrative of Silvia Dubois, the "Slav who Whipt Her Mistres and Gand Her Fredom" while living in the northern United States, dispels the myth that slavery was confined to the South. Dubois's narrative takes the form of a "colloquy" between her and Dr. Cornelius W. Larison, who—in a textbook example of narrative appropriation—has often been credited as the "author" of her story.

Like many "as-told-to" slave narratives, Dubois's story is mediated by its recorder and reporter. According to Crispin Sartwell, even though Dubois's narrative is a story of freedom, it represents continued domination by the white patriarchy, because Larison framed the questions, recorded Dubois's answers, edited, and published the narrative. Yet, without Larison, Dubois's story would probably have never been preserved.

Scholars have been unable to establish the birth date of Silvia Dubois, who was born on Sourland Mountain, near the border between Hunterdon and Somerset Counties in New Jersey. Dubois, who offered anecdotal evidence for 1768 as her birth date, addressed the problem of establishing her age in her narrative. As she explained,

> They didn't used to keep a record of the birth of niggers; they hardly kept a record of the birth of white children; none but the grand folks kept a record of the birth of their children—they didn't no more keep the date of a young nigger than they did a calf or a colt; the young niggers were born in the Fall or in the Spring, in the Summer or in the Winter, in cabbage time or when the cherries were ripe, when they were planting corn or when they were husking corn, and that's the way they talked about a nigger's age.

(Larison was a spelling reformer who recorded Dubois's story using his own phonetic version of the alphabet. Quotations in this entry are from Jared C. Lobdell's transcription of the original edition.)

When she told her story to Larison in January 1883, Dubois estimated her age as being about 115 years old because, according to oral history, her mother gave birth two days after her master's son Richard Compton was born, and his birth was recorded: "In an old Bible which is now in the possession of Mr. Richard Gomo who lives near Rock Mills, is the record of the Compton family," Dubois said. "By referring to this record they tell me how old I am—I can't read, but I expect they tell me right. I know that I am older than anybody else around here—older than their parents were, and in most cases I knew their great-grandparents." While not establishing the historical reliability of these particular records, Dubois's comments point to a continued (and presumably friendly) relationship with the Compton family long after the end of slavery. Their shared history and continued relationship help to underscore the complexity of race relations in the United States.

After examining records relating to the Compton family and to Dubois's master, Dominicus (Minna) Dubois (1756–1824), Lobdell argues convincingly that Silvia Dubois was probably born in 1788 or 1789 and attributes the discrepancy in dates to the distortion and factual inaccuracy that frequently occur in oral histories.

Silvia Dubois was the daughter of Cuffy Baird and Dorcas Compton, slaves owned by different masters. According to his daughter, Cuffy Baird "was a fifer for the minutemen in the days of the Revolution" and was present at the Battle of Princeton. At the time of Silvia's birth, her mother was owned by Richard Compton, a hotel proprietor at Rock Mills. She attempted unsuccessfully to buy her freedom on three occasions

and was sold several times. According to Lobdell, Silvia Dubois probably spent her early years, from age five, at Minna Dubois's farm in Hillborough Township, New Jersey, and, as a teenager (by Lobdell's estimate, around 1803), went with the family to live at a tavern Minna Dubois had bought in Great Bend, Pennsylvania.

Perhaps because of Larison's choice of questions, Dubois spent little time recalling her childhood. Instead she focused on her life as an adult slave in Pennsylvania and New Jersey and later as a freedwoman in New Jersey.

Like Sojourner Truth, Dubois described her mistress as abusive while praising her master for his kindness. She recalled her mistress, Elizabeth Dubois, as "the very devil himself. Why, she'd level me with anything she could get hold of—club, stick of wood, tongs, fire-shovel, knife, axe, hatchet, anything that was handiest—and then she was so damned quick about it too. I tell you, if I intended to sauce her, I made sure to be off always."

While she said that her master, whom she called "Minical" Dubois, could also be violent, Silvia Dubois's descriptions of him are much more favorable than those of his wife. "I got along with him first rate," Dubois said. "He was a good man and a great man too; all the grand folks liked Minical Dubois." Yet, she also recalled that Minical Dubois "never whipped me unless he was sure that I deserved it. He used to let me go to frolics and balls and to have good times away from home, with other black folks, whenever I wanted to. He was a good man and a good master. But when he told me I must come home from a ball at a certain time, when the time came, the jig was out. I knew I must go; it wouldn't do to disappoint Minical Dubois." These comments suggest that Dubois both feared and respected her master.

Dubois was not always fortunate enough to be out of her mistress's reach: "Once she knocked me till I was so stiff that she thought I was dead. Once after that, because I was a little saucy, she leveled me with a fire-shovel and broke my pate [skull]. She thought I was dead then, but I wasn't." On another occasion her mistress "whipped me until she marked me so badly I will never lose the scars. You can see the scars here upon my head today, and I will never lose them if I live another hundred years."

Her master, Dubois claimed, could do nothing about the abuse: "I have heard him tell her when they thought I was not listening that she was too severe—that such work would not do—that she'd kill me next." Minna Dubois's reproaches were unheeded by his wife. If anything, according to Dubois, they "made her worse. Just put the devil in her." As a result, said Dubois, "I made up my mind that when I grew up I would do it, and when I had a good chance, when some of her grand company was around, I fixed her."

The central event of Dubois's narrative—and the event from which the title is taken—is this "fixing" of her mistress. While Minna Dubois was away from the tavern on grand-jury duty in Wilkes-Barre, Dubois "knocked her [mistress] down and blamed near killed her." According to Dubois,

> There was some grand folks stopping there, and she wanted things to look pretty stylish, and so she set me to scrubbing up the barroom. I felt a little glum and didn't do it to suit her. She scolded me about it and I sauced her. She struck me with her hand. Thinks I, it's a good time now to dress you out, and damned if I won't do it. I set down my tools and squared for a fight. The first whack, I struck her a hell of a blow with my fist. I didn't knock her entirely through the panels of the door, but her landing against the door made a terrible smash, and I hurt her so badly that all were frightened out of their wits, and I didn't know myself but that I'd kill the old devil.

Notably, Dubois waited until Minna Dubois was away to "fix" her mistress, perhaps because her master would have come to his wife's aid.

The barroom was full of travelers, drovers, hunters, and sailors. When these witnesses appeared ready to side with her mistress, Silvia Dubois "sat down on a slop bucket and straightened up, and smacked my fists at 'em, and told 'em to wade in if they dared, and I'd thrash every devil of 'em, and there wasn't a damned a one that dared to come." While this scene may strike some readers as implausible or dramatically embellished, additional evidence suggests that Dubois had both the reputation and the size to be physically intimidating. According to an obituary reprinted by Lobdell, Dubois "became famed for her feats of strength and for the prize-fights in which she engaged. She boasted that she was never beaten and had knocked out scores of the strongest men." Larison also lent credibility to Dubois's story by providing his professional assessment of her physical condition. In his preface he wrote, "Silvia is large of stature. In her palmy days she has been not less than 5 foot 10 inches high. She informs me that she usually weighed more than 200 pounds. She is well-proportioned of a nervo-lymphatic temperament, and is still capable of great endurance. Years ago, she was known to be the strongest person in the settlement, and the one who had the greatest endurance."

After whipping her mistress, Dubois recalled, she "got out pretty quick too. I knew it wouldn't do to stay there, so I went down to Chenang Point and there went to work." When Minna Dubois returned from jury duty, he ordered Silvia Dubois to come back home. She

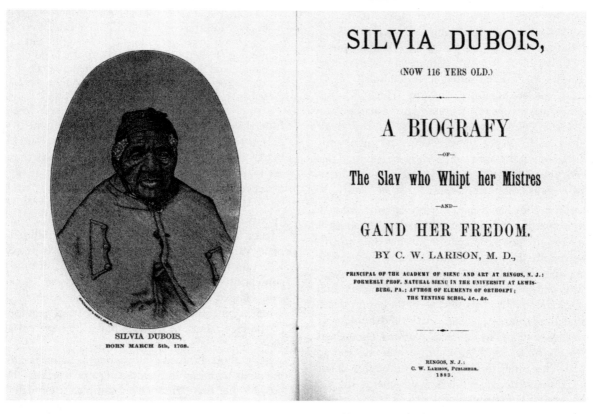

SILVIA DUBOIS,
(NOW 116 YERS OLD.)

A BIOGRAFY
—OF—
The Slav who Whipt her Mistres
—AND—
GAND HER FREDOM.
BY C. W. LARISON, M. D.,

PRINCIPAL OF THE ACADEMY OF SIENC AND ART AT RINGOS, N. J.;
FORMERLY PROF. NATURAL SIENC IN THE UNIVERSITY AT LEWIS-
BURG, PA.; AFTHOR OF ELEMENTS OF ORTHOEPY;
THE TENTING SCHOL, &c., &c.

RINGOS, N. J.:
C. W. LARISON, PUBLISHER.
1883.

SILVIA DUBOIS,
BORN MARCH 5th, 1768.

*Frontispiece and title page for the narrative of a black woman living in New Jersey during the late eighteenth and early
nineteenth centuries, written in a phonetic-spelling system invented by her interviewer*

returned immediately to face the consequences of her actions because, she told Larison, "I was a slave, and if I didn't go, he would have brought me, and in a hurry too. In those days the masters made the niggers mind, and when he spoke I knew I must obey."

When she answered his summons, Minna Dubois offered Silvia Dubois her freedom. "He didn't scold me much," Dubois recalled. "He told me that as my mistress and I got along so badly, if I would take my child and go to New Jersey and stay there, he would give me free. I told him I would go. It was late at night; he wrote me a pass, gave it to me, and early the next morning I set out for Flagtown, New Jersey." This decision seems remarkable considering the laws and customs of the time and points to the emotional complexity of Dubois's relationship with her master.

With her toddler in tow Dubois set out on foot and began her journey to Flagtown through the woods. The journey was often lonely and dangerous: "Sometimes I didn't see a person for half a day; sometimes I didn't get half enough to eat, and never had any bed to sleep in; I just slept anywhere. My baby was about a year and a half old, and I had to carry it all the way. The wood was full of panthers, bears, wildcats, and wolves; I often saw 'em in the daytime, and always

heard 'em howling the night. O! that old panther—when he howled it made the hair stand up all over my head." These descriptions of the dangers she faced on her way to freedom heighten the drama of Dubois's story, thus enhancing the mythic aspects of her journey, and they also recall the travails of the Israelites in the wilderness on their way to freedom in the Promised Land.

When she reached Easton, Silvia went to work for the Brink family in exchange for passage on a raft headed toward Philadelphia. She disembarked near Trenton and headed to Flagtown to find her mother, who—to Dubois's disappointment—had moved to New Brunswick, New Jersey.

On her way she was confronted by a white man who demanded, "Whose nigger are you?" Dubois answered proudly, "I'm no man's nigger—I belong to God—I belong to no man." When this man—encouraged by laws that rewarded the capture of escaped slaves—demanded to see proof of Dubois's freedom, she "showed him my fist"—ready to whip another to maintain her freedom. Dubois's legal freedom emboldened her, and she was ready to stand her ground. The man "moseyed off."

Eventually Dubois arrived in New Brunswick and was reunited with her mother. She stayed in New

Brunswick for several years and later moved to nearby Princeton to work for the family of Victor Tulane. Finally, she returned to the Sourland Mountain area, the place of her birth, to visit her maternal grandfather, Harry Compton. A manumitted slave, Dubois's grandfather was owner of Put's Tavern, which Larison described as "the center for the dissolute." Larison carefully attributed his knowledge of Put's Tavern to his experiences as a "physician to several old gamesters, the maladies of whom were incurred by frequenting this celebrated house of ill fame and the consequent intercourse of such as congregated there."

According to Larison, Harry Compton was "a slave whose spirit prompted him to make the sacrifices necessary to purchase his freedom." In her own words, Dubois recalled, "He was then an old man; they say he was more than a hundred years old, and I guess he was. But he was yet quite active; he wanted me to stay with him and take care of him and I stayed; and at his death I inherited his property. I lived on the old homestead until a few years ago, when them damned Democrats set fire to my house, and burned up my home and all that I had. Since that time, I have lived at this place, with my youngest daughter." These comments suggest that even though Dubois was legally free to move about as she wanted and to own property, she was not free from the tyranny of racial intolerance.

Dubois eventually had six children: Moses, Judith, Charlotte, Dorcas, Elizabeth, and Rachel. There is some dispute over the birth order of Elizabeth and Rachel. The "youngest daughter" with whom she was living in 1883 was Elizabeth.

Dubois's story reveals much about slave relations and family structures in the North, where slaves frequently were isolated from other African Americans and often lacked the sense of community so often celebrated in Southern slave narratives. Dubois's mother and grandfather's placement of such importance on freedom underscores the significance of Dubois's own "fight" for freedom. Her father's involvement in the Revolution highlights African American awareness of and contributions to the War of Independence.

Larison's presentation of Dubois's story often takes on aspects of another familiar form of early American writing—the jeremiad, or cautionary sermon. Michael C. Berthold argues that part of Larison's interest in Dubois stems from his recognition in her of "something of a latter-day Puritan whose sense of modern waywardness mirrors his own."

For example, when Larison questioned Dubois at length about her neighbors, she admitted that she has no use for them, black or white:

they are the worst set of folks that has ever lived; they lie and steal, and cheat and rob, and murder, too. Why, a person is in danger of his life here and he can't keep nothing. They'd steal the bread out of a blind nigger's mouth, and then murder him if he told of it. That's the way it goes up here—they're worse than the devil himself.

Indeed, according to Dubois, "this mountain is worse than hell itself. Why, if some of these folks don't behave better after they go into the infernal regions than they do while here, the devil will have a time of it. He'll never manage 'em."

When Larison suggested that Dubois told a "pretty hard story" on her neighbors, she objected: "Tell a hard story! I tell the truth, and I could tell more of it. Why, you don't know 'em. There is more folks killed up here than anybody knows of, and you know somebody is killed up here every year. And nobody is ever hanged for it and it gets worse and worse." These remarks hint strongly at the nature of race relations and of the inequalities of the criminal-justice system at that time.

Dubois avoided "falling into their ways." As she did with winning and protecting her freedom, Dubois credited her fists: "they never troubled me much. They know it wouldn't do. They know I'd give 'em that." Then, Larison wrote, "she brought her right fist into her left hand until the smack could be heard fifty yards." Once again Larison intervened in the narrative long enough to verify that Dubois loomed as a mountain of a woman.

Larison's description of his investigative process is eerily clinical. He explained that "I had seen Silvia on a former occasion and knew something of her idiosyncrasies. Indeed, I had, during a former interview, heard her relate many of the most important instances of her life. So what follows, in this colloquy, to some extent I had heard her relate before and was at this time drawn out by a series of prepared questions, in order in which it is here stated, so that to the reader it would be somewhat coherent." Larison's participation in Dubois's narrative is problematic, even though he likely viewed his structuring of her story as helpful rather than exploitive.

In many respects the relationship between Larison and Dubois was not atypical. The authenticity of early African American writing was often questioned, and the works of black writers such as Phillis Wheatley and Harriet Jacobs included "white" testimonials attesting to their authorship. As a white, a male, and a professional, Larison lent authority to Dubois's recollections. Larison also clearly had his own agenda—one served in part by Dubois's recollections. As Lobdell suggests, Larison, as well as Dubois, was a product of his cen-

Larison's woodcuts of the hut on Sourland Mountain where Dubois was living in 1883 (from Silvia Dubois [Now 116 Yers Old.]
A Biografy of the Slav who Whipt Her Mistres and Gand Her Fredom, *1883)*

tury. In his 1953 biography of Larison, Harry B. Weiss recorded that Larison worked at various periods of his life as schoolmaster, country physician, farmer, professor, local historian, writer, editor, publisher, and spelling reformer. Born on 10 January 1837, Larison was cofounder of the Seminary of Ringoes, New Jersey, founder of the Academy of Arts of Sciences at Ringoes, and served as a professor of natural history at the University of Lewisburg (now Bucknell University).

Larison began to experiment with spelling reform when he worked as a teacher in 1856. These experiments led to the publication of his *Elements of Orthoepy* in 1881 and later to the formation of his Fonic Publishing Hous. In his introductory remarks to Silvia Dubois's narrative Larison contended that as a physician he worried about Dubois's health during a spell of bad weather. This worry—combined with his recollections of stories that she had previously told him about her colorful life—led him to travel to her home and to record her story. Larison's Fonic Publishing Hous then published Dubois's narrative in the phonetic system that he both developed and advocated. The fact that the narrative was published in this unusual phonetic system no doubt contributed to its relative obscurity. Larison planned to market Dubois's narrative as a reader for schools that adopted his phonetic system, but only a few did so.

Larison insisted that Dubois was the "heroine of this tale" and tried to inflate her legend to make her life's story all the more interesting—and from Larison's perspective, perhaps sellable. As a heroine, Dubois is a lover of freedom, of God, and of salty language. In stark contrast to several other slave narratives written by women, including Harriet Jacobs's *Incidents in the Life of a Slave Girl* (1861), Dubois does not directly address her role as an African American woman in relationship to the dictates of the prevailing cult of "true womanhood." While she may have been pious in her own way, she was not submissive or domestic in any traditional sense. Her account of her life is refreshingly unapologetic, including stories about becoming too drunk on brandy and scaring the neighborhood children, as well as whipping her mistress. Her feisty nature makes her interesting because she comes across as wonderfully—if not, enormously—human.

Dubois recognized the significance of her story and the fact that others might learn from her experiences. As she explained, "Most folks think that niggers ain't no account, but if you think what I tell you is worth publishing, I will be glad if you do it. 'T won't do me no good, but maybe 't will somebody else. I've lived a good while, and have seen a good deal, and if I should tell you all I've seen, it would make the hair stand up all over your head."

For students and scholars Dubois's narrative provides valuable insight into the institution of slavery in the North and offers important details about race relations before and after the Civil War. But the narrative also is frustrating because of narrative gaps—a result, one suspects, of Larison's questions. More than two hundred years after Dubois's birth and more than one hundred years after her colloquy with Larison, scholars remain ambivalent about this highly problematic record of an African American woman's life. Despite the limits of her story and her lack of opportunity to "tell all," this slim record of Dubois's life enriches the scope of the slave-narrative tradition. Yet, her story is far from complete and is riddled with authorial and editorial interference. While Dubois may have struck a blow for freedom, she was not free to tell her story on her terms.

References:

Michael C. Berthold, "'The peals of her terrific language': The Control of Representation in Silvia Dubois, *A Biografy of the Slav Who Whipt Her Mistress and Gand Her Freedom*," *MELUS*, 20 (Summer 1995): 3–13;

Joanne M. Braxton, *Black Women Writing Autobiography: A Tradition within a Tradition* (Philadelphia: Temple University Press, 1989);

Hazel V. Carby, *Reconstructing Womanhood: The Emergence of the Afro-American Woman Novelist* (New York: Oxford University Press, 1987);

Charles T. Davis and Henry Louis Gates Jr., *The Slave's Narrative* (New York: Oxford University Press, 1985);

Bert James Loewenberg and Ruth Bogin, eds. *Black Women in Nineteenth-Century American Life: Their Words, Their Thoughts, Their Feelings* (University Park: Penn State University Press, 1976);

Crispin Sartwell, *Act Like You Know: African-American Autobiography and White Identity* (Chicago: University of Chicago Press, 1998);

Harry B. Weiss, *Country Doctor: Cornelius Wilson Larison 1837–1910, Physician, Farmer, Educator of Hunterdon County, New Jersey* (Trenton: New Jersey Agricultural Society, 1953).

Zilpha Elaw
(circa 1790 – ?)

Valerie M. Smith
University of Connecticut

BOOK: *Memoirs of the Life, Religious Experience, Ministerial Travels and Labours of Mrs. Zilpha Elaw, An American Female of Color; Together with Some Account of the Great Religious Revivals in America. Written by Herself* (London: Printed for the author, 1846).

Editions: *Memoirs of the Life, Religious Experience, Ministerial Travels and Labours of Mrs. Zilpha Elaw,* in *Sisters of the Spirit: Three Black Women's Autobiographies of the Nineteenth Century,* edited by William L. Andrews (Bloomington: Indiana University Press, 1986), pp. 49–160;

Memoirs of the Life, Religious Experience, Ministerial Travels and Labours of Mrs. Zilpha Elaw, in *Can I Get a Witness?: Prophetic Religious Voices of African-American Women: An Anthology,* edited by Marcia Y. Riggs, with biographical sketches and selected bibliography by Barbara Holmes (Maryknoll, N.Y.: Orbis, 1997).

African American evangelist Zilpha Elaw wrote a memoir at the conclusion of a five-year religious sojourn in England and dedicated the volume "To the Saints and faithful Bretheren in Christ, who have honoured my ministry with their attendance, in London and other localities of England." Elaw's book offers readers a glimpse into the lives of the courageous African American women who managed to wrest authority from religious and familial institutions by relying on the higher authority of their God.

The second of three children born to free black parents, Zilpha Elaw was born circa 1790, somewhere in the vicinity of Philadelphia, Pennsylvania. When Elaw was twelve, her mother died while giving birth to her twenty-second child. Only Zilpha, an older brother, and a younger sister survived childhood. Shortly after her mother's death, Elaw was placed in service with the Mitchels, a Quaker family. Her father died approximately eighteen months after her mother, and Elaw remained with the Mitchels until she married at the age of twenty.

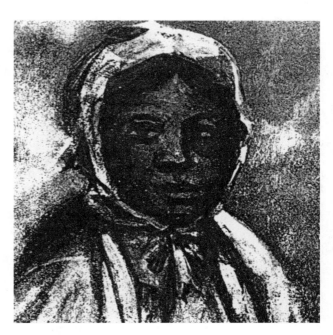

Zilpha Elaw, circa 1846 (painting by Richard J. Watson, after the portrait in Memoirs of the Life, Religious Experience, Ministerial Travels and Labours of Mrs. Zilpha Elaw, *1846)*

Elaw's memoir begins by discussing her youthful dissatisfaction with the Mitchels' informal approach to religion. Elaw had followed strict religious observances in her parents' home, and the Mitchels' lack of formal strictures and the influence of "frolicsome companions" convinced Elaw that she was on the pathway to perdition. Her first religious vision took place when she was approximately fourteen years old, while she was conversing with her Quaker playmates. Encouraged to "take the name of God in vain, in order to cater to the sinful tastes of my companions," Elaw reported that "whilst I was in the very act of swearing, I looked up, and imagined that I saw God looking down and frowning upon me." This vision and an alarming dream that followed it profoundly influenced the young girl. Elaw

continued to have visions, including one in which a cow she was milking bowed its knees and cowered, confirming for Elaw her vision of "a tall figure with long hair, which parted in the front and came down to his shoulders," who was wearing "a long white robe down to the feet" and stood before her with "open arms." Admitting that such visions were overwhelming and astonishing, even to herself, Elaw reassured her readers that "the thing was certain and beyond doubt" and wrote, "I shall give an account to my Judge at the great day, that every thing I have written in this little book, has been written with conscientious veracity and scrupulous adherence to truth."

In her 1994 dissertation on the spiritual autobiographies of Jarena Lee, Zilpha Elaw, and Rebecca Cox Jackson, Candis LaPrade has noted that "the gifts of sanctification, visions, and direct communication with God" allowed these three women to "enter a transcendent realm that allowed for creative resistance to the spatial and temporal boundaries they confronted in their daily lives as African American women," because "racial and gender prejudice have no place in the sanctified Christian's concept of self; these forces exist only as cultural circumstances, not conditions of spiritual reality." Elaw's visions allowed her to separate herself from the many unpleasant aspects of her day-to-day life and eventually to move into a more powerful position based on God's word.

Elaw joined the Methodist Episcopal Society in 1808, and in 1810 she married Joseph Elaw, a fuller. Elaw's marriage was a source of tension because of her husband's lack of religious faith. Believing that women are "formed . . . by nature for subordination" and that "the man is not created for the woman, but the woman for the man," Elaw warned women in her memoir against marrying "unbelievers." Such women, she believed, "would be better, if a millstone were hung about your necks, and you were drowned in the depths of the sea, than that you should disobey the law of Jesus . . . and plunge yourselves into all the sorrows, sins, and anomolies involved in a matrimonial alliance with an unbeliever." In spite of her beliefs that "the wife is destined to be the help-meet of her husband," Elaw testified that "if he be a worldly man, she cannot, she dare not be either his instrument or abettor in worldly lusts and sinful pursuits, but his drawback and curse." Thus, a wife's duty was better fulfilled by restraining her husband from such temptations than by giving in to his every whim. Elaw offered her own experience as evidence. The only time her husband took her to a ballroom where "the violin struck up, and the people began to caper the merry dance, and take their fill of pleasure," she wept "before God." As a result, Elaw's chastened husband never again asked her "to accompany him to such places." Elaw's unwavering conviction that she was an instrument of God allowed her to subvert the submissive wifely role she might otherwise have felt herself duty-bound to accept.

In 1811, when trade ceased between Britain and the United States prior to the War of 1812, Joseph Elaw lost his job, and the couple went to live in Burlington, New Jersey. They had a daughter, Rebecca, in 1812. In 1817 Elaw attended the first of many life-changing camp meetings; her memoir includes one of the few available, detailed descriptions of such meetings during that period. In the course of one camp meeting Elaw discovered her calling: "God was pleased to separate my soul unto himself, to sanctify me as a vessel designed for honour, made meet for the master's use." After sinking on the ground and lying prostrate for quite some time, she noted that her "spirit seemed to ascend up into the clear circle of the sun's disc; and surrounded and engulphed in the glorious effulgence of his rays, I distinctly heard a voice speak unto me, which said, 'Now thou art sanctified; and I will show thee what thou must do.'" After the experience, which she described as a "stupendous elevation," she wrote "the Lord opened my mouth in public prayer" for the first time.

Approached by believers at the meetings to deliver prayers for them and others and convinced that she was acting at God's direction, Elaw took it on herself to spend the next five years on "the errands and services of the Lord," not limiting her "visits to the poor only, but extending them to the rich." For the first time Elaw made use of God's authority to participate actively in a form of public discourse from which she would have otherwise been excluded because of her race and gender.

During a life-threatening illness in 1816 Elaw's sister, Hannah, told her "that an angel came to her, and bade her tell Zilpha that she must preach the gospel." Elaw resisted her sister's urgings, not believing "that God should select and appoint so poor and ignorant a creature as myself to be his messanger." During her own life-threatening illness in 1819–1820, Elaw received another supernatural visitation that asserted she would learn of God's will for her at another camp meeting. At this gathering, attended by approximately seven thousand people, she received and obeyed a command to "preach his holy Gospel . . . as it were involuntarily, or from an internal prompting." Shortly after giving her exhortation, Elaw heard the same voice that had come to her during her illness, this time instructing her that she must "preach the gospel; and . . . travel far and wide." Despite her misgivings, Elaw's course was set.

When Elaw presented her case before the ministers of her church, they advised her to go ahead with her work. They saw "no impropriety" in her decision to preach, but she became ostracized from the Methodist Episcopal community for daring to assume what they saw as a man's role. Despite such disapproval—and her husband's fear that she would become a "laughing-stock" and that they should be "undone"—"great crowds assembled every Lord's day" to hear Elaw's preaching, and her audiences included many "white bretheren and sisters." She affirmed that, since "my heavenly Father had informed me that he had a great work for me to do; I could not therefore descend to the counsel of flesh and blood, but adhered faithfully to my commission." That is, she saw her authority as resting with a power above that of cultural institutions and could pursue her calling without concerning herself with community or familial disapprobation.

After Joseph Elaw's death on 27 January 1823, Elaw was forced to procure positions as servants for herself and her young daughter. Ill health forced her to quit such hard work, and shortly thereafter she opened a school in Burlington for African American children, who were excluded from white schools. At this time she decided her visions had been caused by her overactive imagination. Soon thereafter, however, she sank into a "dark cloud" from which she was released only by further preaching. This episode convinced her that she was indeed called to preach and could no longer be only halfheartedly committed to her vocation. In spite of seemingly insurmountable financial difficulties, Elaw finally determined to begin her life as an itinerant preacher. She placed her daughter in the care of a relative and traveled to Philadelphia, where she "preached in a great many chapels" and—much to her astonishment—"every congregation voluntarily made a collection for my aid; and every person at whose house I visited, gave me something for my journey." After years of hardship and struggling, she found herself in a position where finances were suddenly no longer a problem, a situation that further confirmed for her the correctness of her action. After visiting New York City, Elaw returned home in April 1828 and received further supernatural instructions, advising her: "Be of good cheer, and be faithful; I will yet bring thee to England and thou shalt see London, that great city, and declare my name there."

Instead of journeying across the ocean right away, however, Elaw traveled to the slave states, where "Satan much worried and distressed my soul with the fear of being arrested and sold for a slave, which their laws would have warranted, on account of my complexion and features." Once again her faith held her in good stead, allowing her access to communities that might otherwise have been hostile. Instead of being apprehended and enslaved as she had feared, she was invited to preach to the white Methodist Society "in a small town in one of the slave states." In Maryland, Washington, D.C., and Virginia, she met with great success, even though many slaveholders found it "surpassingly strange that a person (and a female) belonging to the same family stock with their poor, debased, uneducated, coloured slaves, should come into their territories and teach enlightened proprietors the knowledge of God." Elaw also found it "surpassingly strange" that she was allowed to continue her work unaccosted. In fact she was admitted to the homes of many influential Southerners. One gentleman offered to give her "a house and a plot of ground" if she would agree to live there. Another Southerner, a converted profligate, offered to pay her expenses if she would consent to preach in his area again.

After completing her mission in the southern states, Elaw traveled north through New York City, where she apprenticed her daughter to a dressmaker. After arriving in Hartford, Connecticut, she noted that "some of the most influential ministers of the Presbyterian body greatly opposed me; and one of them, a Mr. House, resolutely declared that he would have my preaching stopped." With the help of friends, Elaw overcame their objections and threw herself into preaching from house to house, stopping at even "houses of ill fame" and "the different outskirts of the town, where vice and immorality abounded," because "it pleased God to effect a mighty change in the morals and habits of the people." Her stay in Hartford met with many successful conversions and healings.

After Hartford, Elaw traveled to Boston, Cape Cod, and then Salem, where once again her ministry found much success. A trip to Maine succeeded even though she met with prejudice against women preachers. Elaw answered such objections by basing her authority to preach on the scriptures and was generally successful in winning over her opposition, including "ruffians" so overcome by "the power of the Lord" at one meeting that they were "restrained from their purpose" of disruption. The leader of the ruffians died of a ruptured blood vessel in his lungs just days after the incident, lending credibility to Elaw's position that she was God's messenger.

Elaw and her daughter eventually settled on the island of Nantucket, where she preached and taught for two years. At the end of this time Elaw resumed her travels, going to Philadelphia and New York. Once again dangerous opposition was mysteriously thwarted. In Utica, New York, young men who were throwing stones at her suddenly found their arms paralyzed. On her way back to New York City, a steamer captain

refused to give Elaw passage, chiefly because of her "complexion." In her memoir Elaw implied that she was more concerned with the difficult situation in which his refusal left her than with the prejudice the act displayed. After finding another boat and a friendlier captain to take her to New York City, she "thanked God and took courage."

Elaw next returned to Nantucket, where she preached for an extended period. Then, however, she had three visions in which she was standing "on a very elevated place in the midst of tens of thousands, who were seated all around, clothed in white." Her own "complexion and raiment were also white." Interpreting these signs to mean it was time, once again, to move on and, having been presented with gifts of clothes and money by members of her society, she left Nantucket in the summer of 1835 for fifteen months.

Elaw finally began her much-delayed journey to England in the summer of 1840 and was shocked on her arrival to find commerce taking place on a Sunday. Her reception was cool in some quarters. A "gentleman" advised her immediate departure and the Bible Christians, or Byronites, were also unenthusiastic. Throughout England, she again met with frequent opposition to the idea of a woman preaching and was told she was "too blind to discern, that for a female to warn sinners to flee from the wrath to come; to preach Christ to them, invite them to come to Him, and exhort them to be saved, was equally disorderly and improper." Though she found "a far less favorable soil for the seed of the kingdom in the British mind than the American," in general Elaw's reputation had preceded her and her mission was successful. During her stay in England she preached more than one thousand sermons and converted many souls. As she noted in her memoir, "God hath made my ministry a blessing to hundreds of persons; and many who were living in sin and darkness before they saw my coloured face, have risen up to praise the Lord, for having sent me to preach His Gospel on the shores of Britain" and that many who "had scarcely heard a sermon in their lives, were attracted to hear the coloured female preacher, were inclosed in the gospel net, and are now walking in the commandments and ordinances of the Lord." Elaw concluded her narrative by exhorting her readers to hold true to their faith in spite of "perilous times . . . verging upon us."

The date of Zilpha Elaw's death is unknown. The last extant published reference to her appeared in an 1883 obituary of her daughter, Rebecca Elaw Peirce Crawford, who was at that time a resident of Nantucket.

References:

Margaret Cullen, "'And Lead Her to the Promised Land': Liberty and Patriarchal Containment in Antebellum Women's Narratives," dissertation, University of Tennessee, 1992;

Gloria Goode, "African-American Women in Nineteenth-Century Nantucket: Wives, Modists, and Visionaries," *Historic Nantucket,* 40 (Winter 1992): 76–78;

Goode, "Preachers of the Word and Singers of the Gospel: The Ministry of Women among Nineteenth-Century African-Americans," dissertation, University of Pennsylvania, 1990;

Elizabeth Grammer, "'A Pen in His Hand,' A Pen in Her Hand: Autobiographies by Female Itinerant Evangelists in 19th-Century America," dissertation, University of Virginia, 1995;

Rosetta Haynes, "Radical Spiritual Motherhood: The Construction of Black Female Subjectivity in Nineteenth-Century African-American Women's Spiritual Autobiographies," dissertation, Cornell University, 1996;

Candis LaPrade, "Pens in the Hand of God: The Spiritual Autobiographies of Jarena Lee, Zilpha Elaw, and Rebecca Cox Jackson," dissertation, University of North Carolina, 1994;

Thelma Townsend, "Spiritual Autobiographies of Religious Activism by Black Women in the Antebellum Era," dissertation, Michigan State University, 1993;

Martha L. Wharton, "A 'Contour Portrait of My Regenerated Constitution': Reading Nineteenth-Century African America Women's Spiritual Autobiography," dissertation, University of Massachusetts, 1996.

Augusta Jane Evans

(8 May 1835 – 9 May 1909)

Bradley A. Johnson
University of Connecticut

BOOKS: *Inez: A Tale of the Alamo* (New York: Harper, 1855; London: Nicholson, 1883);

Beulah (New York: Derby & Jackson, 1859; London: Knight, 1860);

Macaria; or, Altars of Sacrifice (Richmond: West & Johnson, 1864; London: Saunders, 1864);

St. Elmo (New York: Carleton / London: Sampson Low, 1867; London: Nicholson, 1883);

Vashti; or, Until Death Us Do Part (New York: Carleton / London: Low, 1869; London: Nicholson, 1883);

Infelice (New York: Carleton / London: Chapman & Hall, 1875; London: Nicholson, 1883);

At the Mercy of Tiberius (New York: Dillingham, 1887; London: Low, 1887);

A Speckled Bird (New York: Dillingham, 1902; London: Hutchinson, 1902);

Devota (New York: Dillingham, 1907; London: Unwin, 1907).

Editions: *Macaria; or, Altars of Sacrifice,* edited, with an introduction, by Drew Gilpin Faust (Baton Rouge: Louisiana State University Press, 1992);

Beulah, edited, with an introduction, by Elizabeth Fox-Genovese (Baton Rouge: Louisiana State University Press, 1992);

St. Elmo, edited, with an introduction, by Diane Roberts (Tuscaloosa: University of Alabama Press, 1992).

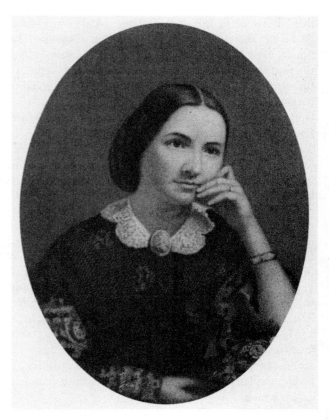

Augusta Jane Evans (Alabama Department of Archives and History, Montgomery)

One of the best-known novelists of the South in the late nineteenth century, Augusta Jane Evans (later Wilson) became little more than a literary footnote in the twentieth. Her most influential novel, *St. Elmo* (1867), rivaled the most-popular books of the time in sales figures, and readers claimed to have reformed their moral sensibilities as a result of reading the book. The name *St. Elmo* was bestowed on plantations, towns, children, and even a recipe for punch. Nonetheless, as with most domestic fiction, Evans's novels were eclipsed by the rise of modernism. The didactic, sentimental, and popular emphases of domestic fiction gave way to the cult of the alienated (and usually male) artist. Evans, who was often criticized in her own day, van-

ished from the literary map. William Perry Fidler, who wrote a biography of Evans in 1951, could not accept her as a serious figure in literary history, observing, "Just as ridicule of her books is unsuited to the purposes of this study, so defense of them as works of art is unwise." During the last twenty-five years of the twentieth century, scholars began to re-examine domestic fiction. Perhaps as a result of her strong proslavery and antisuffrage stances, however, Evans has not received due recognition as one of the most-influential writers of the nineteenth century. Both as a social critic and as a

writer whose career spanned six decades, she is critical to the genre of domestic fiction and to the literary history of the South.

Augusta Jane Evans was born on 8 May 1835 to Matthew Ryan "Matt" Evans and Sarah Howard Evans. Named for her uncle Augustus and her grandmother Jane, Augusta Jane Evans lived in a home of wealth and family tradition. Her father traced his family line to the South Carolina Calhouns, and her mother's family had figured prominently in the Revolutionary War. The combination of Southern aristocratic heritage and a thriving mercantile business made them economically confident, and just prior to their marriage in 1834 her parents began construction on an expansive mansion in Columbus, Georgia. The house, which came to be known as "Matt's Folly," proved too expensive to maintain after a series of financial setbacks, and the Evans family was forced to reassess its financial situation.

In 1845 the Evans family, which by then included five children, decided to seek new opportunities in Texas. Augusta Evans endured a difficult and sometimes dangerous frontier life in San Antonio. Later in life she recalled her mother easing the journey westward with stories of great writers and instruction in poetry. Although Evans enjoyed a brief period of formal education, for the most part she was instructed by her mother. While frontier life just before the outbreak of the Mexican-American War (1846–1848) afforded few opportunities for schooling, it provided Evans with valuable insights into the issues of sectional politics and slavery. She employed what she learned in writing her first novel, *Inez: A Tale of the Alamo* (1855). Begun in 1851 and presented to her father in manuscript as a Christmas present in 1854, the novel demonstrates a strong antipathy for the Roman Catholic Church, a feeling she later abandoned in favor of a more ecumenical approach.

By 1849 the Evans family had relocated again, this time to the thriving city of Mobile, Alabama, where Matt Evans began work in the cotton industry. By 1850 there were eight children in the family. The 1855 publication of *Inez* marked Evans's entrance onto the literary stage, but the novel provided neither the financial security nor the recognition that she sought. Her experiences on the frontier had provided Evans with a sense of drama, but the representation of her interior life in her fiction was the factor that brought her wealth and influence. After suffering a religious crisis brought on by exposure to German skeptical philosophy, Evans concluded that her writing could best serve those who struggled with the same questions of reason and faith.

Her next novel, *Beulah* (1859), charted an orphan's rise to self-reliance, her loss of faith, and the redemption of not only Beulah but also those around her. A medium for Evans's personal thoughts on the triumph of faith over human intellect, *Beulah* appealed to a wide segment of the public, selling twenty-two thousand copies in the first nine months. Its publication brought Evans fame, financial security, and a new didactic purpose. She never became completely comfortable with wealth, and until her death she habitually carried $100 in her pocket in case of catastrophe.

According to J. C. Derby, the publisher of *Beulah,* the novel also attracted the attention of James Reed Spaulding, a Unionist and editor of the *New York Courier and Enquirer*. Spaulding found *Beulah* so moving and entertaining that he asked Derby for a meeting with the author. Spaulding and Evans formed a friendship, and eventually they were engaged to be married. Their differences of opinion on the intensifying sectional debate, however, resulted in the dissolution of the engagement. Evans was a committed secessionist, and she regarded the "Black Republicanism" of Lincoln as a violation of Southern autonomy. Following secession, she dedicated her time and energy to generating physical and propagandist aid to the Confederacy. Her fame as the author of *Beulah* made her an influential voice for the Confederacy, and she participated in its struggle as inspiration for the Beulah Guards and as a nurse at Camp Beulah, a hospital she organized near Mobile. She was friends with Confederate general P. G. T. Beauregard and wrote anonymous articles on behalf of the Confederacy.

Evans's most-significant and most-enduring contribution to the Confederacy was *Macaria; or, Altars of Sacrifice* (1864). The novel was a success in the South, but the fall of the Confederacy prevented Evans from collecting royalties from her Richmond publisher. Yet, *Macaria* had been popular in the North as well—though Union general G. H. Thomas had banned the book among his troops and ordered existing copies burned—and she discovered that the royalties from a northern edition had been held in trust for her by Derby.

After the war Evans considered writing a history of the Confederacy, but she chose instead to work on the novel that became her most celebrated work, *St. Elmo.* (1867). In *St. Elmo* the heroine's taming of the roguish title character became an immediate sensation across the country, and for the remaining forty-two years of her life, Evans received testimonials from readers claiming that the novel had changed their lives. With monetary success and national fame behind her, Evans was married on 2 December 1868 to a successful, much-older widower, Colonel Lorenzo Madison Wilson, a bank director and major figure in the Mobile railroad. He was sixty, and she was thirty-three. The

couple had no children of their own, though Colonel Wilson had a young daughter from his earlier marriage.

Over the next four decades, Evans dedicated her time to answering letters from fans, cultivating the gardens around her home, and managing affairs for Colonel Wilson until his death in 1891. She published five more books: *Vashti* (1869), *Infelice* (1875), *At the Mercy of Tiberius* (1887), *A Speckled Bird* (1902), and *Devota* (1907). These works sold well, but her name continued to be associated principally with *St. Elmo.* She died on 9 May 1909 of a heart attack and was buried next to Confederate soldiers outside Mobile, Alabama.

The three works that gained the most renown among Evans's contemporaries—*Beulah, Macaria,* and *St. Elmo*—remain the most critically acclaimed. Evans envisioned her role as a writer in fundamentally didactic terms. She believed that her novels could help to guide "common" female readers to a proper understanding of Christian womanhood. For Evans this model included a strong commitment to the ideal of self-reliance. Most of her heroines, however, give up their occupations to marry. This apparent contradiction, common in the sentimental novels of the nineteenth century, has challenged modern critics. Some contend that this contradiction is the product of a subversive "double-voice," in which the author forms her critique within the cultural expectations of the period. Evans appears to have been less bothered than modern readers by the contradictions in her work. Though she had the financial independence to remain unmarried, she chose the same path as her heroines, and, by all accounts, she valued her choice. At the same time, she did not lack an independent ideal. Her heroines marry only after they have established themselves as individuals, with independent means of support and intellects to match any of the male characters.

Evans simultaneously contributed to the development of the sentimental novel and was influenced by it. Novels such as Charlotte Brontë's *Jane Eyre* (1847) must have spoken to her fluctuating fortunes, and their heroines, who tame men such as Rochester, may have provided models for Evans's work. The sentimental novels of the nineteenth century followed a generally formalized pattern. The heroine, frequently an orphan, makes her way in the world through cleverness and sheer force of will. Often she is paired with a friend or rival, a shadow figure who may represent an alternate side of her character. Eventually the heroine discovers, either by birth or nobility of character, that she has earned a place in the upper levels of society. Usually she also marries, though only after her lover has proven his ability to conform to her standards of morality.

Evans had her first novel, *Inez,* published in the same year (1855) that Nathaniel Hawthorne made his

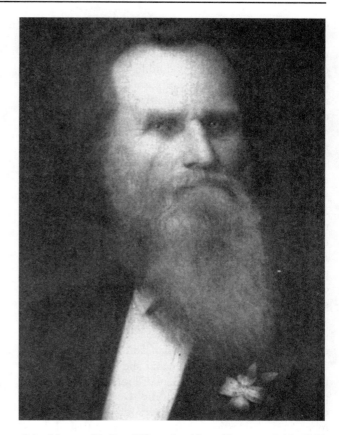

Colonel Lorenzo Madison Wilson, the widower Evans married in 1868

well-known remarks about the women writers of his time. Hawthorne's belief, which modernist critics later echoed, was that "serious" literature suffered from the popularity of the sentimental novel. In a 19 January 1855 letter to William Ticknor, Hawthorne claimed that "America is now wholly given over to a d---d mob of scribbling women, and I should have no chance of success while the public taste is occupied with their trash . . . worse they could not be, and better they need not be, when they sell by the 100,000." These novels did sell by the hundred thousand, but not as "trash" to an ignorant public. Evans and other writers of domestic fiction appealed to the public because their fiction upheld an idealized moral code while simultaneously questioning the cultural prerequisites for being considered an adherent to that code.

Yet, Evans followed no formula in her fiction writing. Her novels question the roles of American women generally and in the context of Southern aristocracy specifically. Her representatives of upper-class Southern womanhood are usually vain, frivolous, and flirtatious. Her heroines admonish women who use sexual attractiveness to advance themselves. Instead, her female protagonists become educated, financially independent,

and resistant to seduction. Evans attacked the heroines created by other practitioners of domestic fiction, particularly those who employ beauty for personal gain. In describing Beulah's shallow double, Clara, Evans wrote that she is aware of her beauty and skeptical of "those characters who grow up to mature beauty, all unsuspicious of the fatal dower, and are someday startled by a discovery of their possessions." The heroines of Evans's novels seek self-respect rather than admiration.

The physically least attractive and most strikingly independent of Evans's characters is Beulah Benton, who grows up in an orphanage with her sister, Lily. After Lily is placed in an upper-class home, Beulah is refused visitation, quickly discovering the brutality of the outside world. When Lily dies early in the novel, Beulah strikes out on her own with a disdain for the privileges of the upper class and a spark of theological doubt. She is taken in by Guy Hartwell, "a proud, gifted and miserable man" whose melancholy expression could be mistaken for "bitter misanthropy." Beulah sees him as a tortured soul who has allowed skeptical inquiry to destroy his Christian faith. She attempts his conversion, only to discover that she has fallen prey to the same brand of doubt. Beulah looks to Emersonian pantheism, rationalism, and the German skepticism espoused by Ludwig Feuerbach for answers to her metaphysical questions, but she discovers that all lines of questioning produce only more questions.

With the death of her friend Cornelia Graham, Beulah's questions intensify. She struggles against dependence on any source outside herself, human or divine. In her defiance she becomes like Herman Melville's Ahab and accepts no power beyond her own mind. Susan K. Harris has argued that domestic fiction does not include any Ahab figures, contending that the "female cover-plot of abandonment, adventure, and redemption" parallels Ishmael's development in Herman Melville's *Moby-Dick* (1851). Yet, Beulah, although she does eventually accept Christian faith and a husband, is much like Ahab for most of the novel. Following Cornelia's death, Beulah cries, "Oh, philosophy! thou hast mocked my hungry soul; thy gilded fruits have crumbled to ashes in my grasp. In lieu of the holy faith of my girlhood, thou hast given me but dim, doubtful conjecture, cold metaphysical abstractions, intangible shadows, that flit along my path, and lure me on to deeper morasses." Unlike Ahab, however, she concludes her lament with a prayer for guidance, and her subsequent return to faith results in Hartwell's conversion and her marriage to him.

Many modern critics have been disturbed by Beulah's move from defiance to marriage. In her introduction to her 1992 edition of the novel, however, Elizabeth Fox-Genovese contends that Beulah's sub-

mission is a moral victory rather than a demoralizing defeat. Like Harriet Beecher Stowe's Uncle Tom, Beulah practices a self-sacrificial Christianity that must be examined in the context of the nineteenth century. Evans's novel celebrates Beulah's independence, but not to the point of rejecting the traditional duties of the Christian woman. Soon after Beulah's prayer, the narrator calls on women to "sever the fetters which fashion, wealth and worldliness" have created, and she prays that God will "lead them back to the hearthstone, that holy-post, which too many, alas, have deserted." The passage has little relevance for Beulah, who has neither vanity nor wealth. It is addressed directly to the reader. Evans wanted women to maintain their intelligence and independence, even while doing their Christian duty. In the final line of the novel the narrator asks that "God may aid the wife in her holy work of love." As Anne Goodwyn Jones points out, the name *Beulah* means "married woman." Although not all of Evans's heroines marry, she views marriage as an institution in which a woman of strong convictions can exercise her most significant influence.

Set during the Civil War and dedicated to the "brave Southern Army," Evans's third novel, *Macaria,* offers a slightly different view of marriage and women's autonomy. Evans could not, however, abandon the themes to which she was committed: women, marriage, Christian self-sacrifice, and art. Evans told J. C. Derby that her "very heart beat in its pages, coarse and brown though the dear old Confederate paper was." *Macaria* is the story of Irene Huntington, Electra Grey, and Russell Aubrey, all of whom dedicate their lives to the Confederate cause. Irene, whose father expects her to marry her morally bankrupt cousin, Hugh, must hide her affection for Russell because her father has prohibited their union and because she had dedicated herself to the Southern cause. She spends her time in scientific pursuits while Electra, her parallel in the realm of the arts, struggles to define herself as a single woman and an artist. When Russell is killed in battle, both women dedicate their lives to aiding the rebel army, Irene through her skill in nursing and Electra through her propagandist art. Thus, both women may be viewed as representing facets of Evans's own personality.

By the end of the novel both Irene and Electra have concluded that the single life may be necessary in times of war, but it also has a strong moral benefit. Irene tells Electra, "in my childhood I always thought of Old-Maids with a sensation of contempt and repulsion; now I regard those among them who preserve their natures from cynicism and querulousness, and prove themselves evangels of mercy, as an uncrowned host of martyrs." In *Macaria* Evans did not consider marriage essential to the ideal of Christian womanhood and

The Pursuit of Knowledge under Difficulties —and a Bucket.

The Crash of Matter and the Wreck of Words.

Safe bind, safe find.

Grandy-eloquence—" Discoursing " a grand-parent to death.

Illustrations by Sol Eylinge Jr. in St. Twel'mo *(1867), C. H. Webb's parody of Evans's* St. Elmo *(1867), whose erudite heroine asserts that "a woman has an unquestionable right to improve her mind, ad infinitum"*

believed that it might in fact be an impediment to accomplishing the work of the world.

In her introduction to the 1992 edition of *Macaria,* Drew Gilpin Faust suggests that the realities of the Civil War in the South, where there was a shortage of marriageable men, might have motivated Evans to emphasize the desirability of the single life. Noting that Evans named one of the heroines *Electra,* which means "unwedded," Faust suggests that Evans saw the single woman as the most beneficial to society because she could provide Christian service to the most people. Evans's deviation from her praise of marriage in other novels may be explained in part by her disgust with her one-time friend Marion Virginia Terhune, who wrote sentimental fiction as Marion Harland. Originally from

Virginia, Terhune had abandoned her secessionist politics when she married a supporter of Abraham Lincoln. Evans's lack of tolerance for Terhune's concessions to her husband's politics indicates that, at least temporarily, she viewed loyalty to the Confederacy as a more-sacred duty than marriage. In *Macaria* Evans is more critical than in other novels of the social constrictions that prevent women from realizing their goals. The irony of *Macaria* is that the ideal women's self-realization is set against the self-sacrificial ideal of Macaria, a Greek woman who sacrificed her life to prevent an invasion of Athens. As Irene and Electra dedicate their lives to the Confederacy, they are persistently pushed into stereotypes of Southern womanhood. In particular Evans used the model of the petrified woman, later

Letter to Senator Edward Cary Walthall, in which Evans expressed gratitude for his praise of her novel Infelice *(1875) and asked how the election of President Benjamin Harrison, an Indiana Republican who had been a brigadier general in the Union Army, would affect Walthall, a Mississippi Democrat who had been a major general in the Confederate Army (University of Southern Mississippi–McCain Library and Archives)*

prevalent in Southern women's fiction. When Irene Huntington's father pushes her toward marriage, she responds by asking, "has he a right to drag me to the altar, and force me to swear to 'love and honor' one whom I can not even respect? . . . What shall I do with my future? I believe I am slowly petrifying; I neither suffer nor enjoy as formerly; my feelings are deadened." Elsewhere Irene is described as a "still figure, which might have been of ivory or granite, for any visible sign of animation." For the Southern wife, being placed on a pedestal for veneration may be accompanied by the paralysis that such a position requires. Evans asserted a woman's right to choose whom, or even if, she would marry. When Major Huntington demands that she marry her cousin Hugh, Irene responds, "I do not hold myself bound by the oaths of another, though he were twice my father. I am responsible for no acts but my own. No one has the right to lay his hand on an unconscious infant, slumbering in her cradle, and cooly determine, for all time, her destiny." Irene's defiance not only liberates herself, but it elevates the other characters in the novel.

While reason was the threat to Christian faith in *Beulah,* in *Macaria* the temptation is art. Like reason, art can function in service to Christian principles or in opposition to them. Electra's enthusiasm for her vocation consumes her, and in her enthusiasm she sets herself up for the scorn of men and creates a false god to worship. She rejects the conventional woman's life for a life of influence: "I want my name carved, not on monumental marble only, but upon the living, throbbing heart of my age. . . . I dedicate myself, my life, unreservedly to Art." To return Electra to the fold of orthodoxy, Evans had to bring her love of art into the service of Christianity. Since Evans equated the divine will with the Lost Cause of the Confederacy, Electra ends up as a propagandist for the Confederacy, offering a painting, her "Modern Macaria," to the service of the new country. Irene qualifies Electra's triumph, however, with the reminder that Electra cannot complete the painting by the end if she continues work in the hospital. The novel concludes with Electra and Irene standing before Electra's portrait of two women, Independence and Victory. As single women they anticipate significant roles in the physical and aesthetic healing of their country. As Faust notes, these images of autonomy ring hollow in a portrait that advocates freedom for white Southerners on the backs of slaves, rendering Evans's "adoption of bourgeois liberal language all the more discordant." Evans's relative silence on the subject of slavery points to some recognition that the already tenuous balance she had created between marital duty and personal autonomy could not accommodate the politics of a slavocracy.

Of all of Evans's novels, *St. Elmo* has generated the most intense and enduring interest. Even after *St. Elmo* ceased to be widely read, it still had widespread influence. For instance, by Eudora Welty's time, interest in *St. Elmo* had significantly waned. In *One Writer's Beginnings* (1984) Welty, who was born in 1909, wrote that during her childhood, "St. Elmo was not in our house; I saw it often in other houses. This wildly popular Southern novel is where all the Edna Earles in our population started coming from. They're all named for the heroine, who succeeded in bringing a dissolute, sinning roué and atheist of a lover (St. Elmo) to his knees. My mother was able to forgo it. But she remembered the classic advice given to rose growers on how to water their bushes long enough: 'Take a chair and *St. Elmo.*'" Welty may not have read *St. Elmo* in her youth, but she borrowed its heroine's name for Edna Earle Ponder in *The Ponder Heart* (1954). Welty's association of Evans's fiction with longwindedness was not a new development. Many of Evans's contemporary critics found the novel long, overly sentimental, and overwrought with obscure allusions and technical language.

Like *Beulah, St. Elmo* begins with the image of a morally fortified orphan who encounters the brutality of the masculine world firsthand. Walking through the woods, young Edna Earle witnesses a duel. When one of the principals is shot and killed, she screams in defiance of what she views as murder. Never having heard of dueling, she is shocked that the men who are there refer to the killing as "honourable satisfaction." Representing all that Evans loathed about Southern aristocratic culture, the duel serves as an appropriate introduction to the novel. The primary problem with dueling is that it defies both human and divine laws. For Evans it illustrated the willingness of some men to ignore the state and religious boundaries that protect women. The duel represented an alternate code that men could follow when conventional laws did not offer them satisfaction. For Edna Earle this violation of law becomes symptomatic of the sexual threat presented by men. The novel is filled with scenes in which Edna treads lightly in fear of the rakish St. Elmo.

Evans also saw a parallel between the duel and the competition between women to attract the most prosperous suitor. Not long after Edna witnesses the duel her grandfather dies, leaving her friendless in the world. As she travels toward Columbus, Georgia, where she hopes to find educational and occupational opportunities, Edna's train is involved in a wreck, and she is taken home by Mrs. Murray, mistress of Le Bocage and mother of St. Elmo. Rumored to lead a wild, godless lifestyle, St. Elmo is a synthesis of Rochester in *Jane Eyre,* the Romantic poet George Gordon, Lord Byron, and the explorer Sir Richard Francis Bur-

ton. Sexually alluring, dangerous, and steeped in orientalism, he spends much of his time away from Le Bocage, seeking to soothe his tortured mind. Before he leaves on a journey to Asia, St. Elmo leaves a key with Edna, giving her strict instructions to open his safe only if he does not return within four years. Edna keeps her promise only to discover later that St. Elmo placed a rigged pistol inside to test her trustworthiness.

During his absence Edna is introduced to Gordon Leigh, the kindly gentleman who serves as the counter figure to St. Elmo. Gordon asks for Edna's hand in marriage, but she declines. As their mutual instructor, Reverend Hammond, explains to Gordon, Edna will never accept him because, "intellectually, she is your superior. She feels this, and will not marry one to whose mind her own does not bow in reverence." His comment illustrates once again Evans's contradictory views of independence and marriage. Edna is intelligent and fiercely autonomous; yet, she can be swayed only by a man whom she considers her superior. That man is St. Elmo.

In order to marry St. Elmo, Edna must learn his complete history and bring him into conformity with Christian principles. Because St. Elmo pushes his suit without undergoing such transformation, Edna leaves Le Bocage to advance her literary projects. Eventually, after her incessant studying causes her health to deteriorate and she sends the manuscript for her book to a publisher, she returns to the plantation, where she discovers the source of St. Elmo's torment: he killed Reverend Hammond's son in a duel and could not forgive himself. Now, however, St. Elmo has been able to end his estrangement from his victim's father, who has always forgiven St. Elmo. Ultimately deciding to study for the ministry, St. Elmo becomes an acceptable suitor to Edna.

The concept of the duel pervades the novel. It is present in the early formation of Edna's character, and it generates St. Elmo's guilt and self-hatred. For Evans the duel also had a deeper significance. Although Evans roundly condemned the act of dueling, she was most disturbed by the implication of that practice for relationships between men and women.

Not only did the consequences of St. Elmo's duel mar his suitability to be Edna's marriage partner, but the duel at the beginning of the novel also has reverberating consequences: shortly after the man dies in the duel, Edna witnesses the death of the man's wife from a grief-induced paralysis. Later in the novel the man who won that first duel, Clinton Allston, appears as a potential suitor for St. Elmo's cousin Estelle. Evans incorporated the language of the duel into scenes of seduction between Clinton and Estelle, as well as St. Elmo and Edna, thus illustrating the small step between masculine

violence and masculine domination of women. For example, when Clinton announces his arrival, Estelle says, "I received a message from him, challenging me to a flirtation at first sight so soon as an opportunity presented itself." Similarly, when St. Elmo professes his love to Edna, his mother functions like a second, claiming that Edna "has a note to answer." Immediately afterward Edna discovers that "one of a pair of gauntlets had fallen on the carpet near the cameo cabinet." The symbols of the duel; the note or challenge; and the dropped gauntlet, awaken Edna to the threat that St. Elmo poses through his violation of Christian and legal codes. St. Elmo's mother, in an attempt to defend her son, claims that "the world sanctions dueling and flirting." Although all Edna's friends and benefactors advocate her acceptance of St. Elmo, Edna refuses to sacrifice herself. The metaphor of dueling alerts her to the danger of playing a game by masculine rules. By the end of the novel Evans has, however, brought her heroine to a conventional acceptance of marriage. St. Elmo is not feminist fiction in any modern sense.

Although Edna is self-reliant and independent, the novel includes some of the strongest antisuffrage language in any of Evans's fiction. She dedicates an entire chapter to attacking women's suffrage. Describing the women who push for the right to vote as "crazy fanatics," "unamiable and wretched wives," and "disappointed old maids," Edna contends that voting is demeaning because a woman should not dirty her hands in the morally questionable realm of politics. Even in discussing education for women, which Evans consistently favored, Edna says that "a woman has an unquestionable right to improve her mind, ad infinitum, provided she does not barter womanly delicacy and refinement for mere knowledge."

In the final scene of the book Edna, weary from her studies and her resistance to suitors, accepts St. Elmo's proposal, shocking the reader who celebrated her independence earlier in the novel, especially when she refused Gordon because he was her intellectual inferior. St. Elmo proclaims, "Today I snap the fetters of your literary bondage. There shall be no more books written! . . . and that dear public you love so well, must even help itself, and whistle for a new pet. You belong to me now, and I shall take care of the life you have nearly destroyed in your inordinate ambition." The passage marks a drastic shift in power from Edna to St. Elmo.

C. H. Webb, who parodied St. Elmo in St. Twel'mo; or, the Cuneiform Cyclopedist of Chattanooga (1867) made Edna's choice of men the principal target for his mockery. His heroine, Etna Early, who is "impossible to quench . . . when eruptive with erudition," finds St. Twel'mo's sin to be his most endearing quality: "On his

Augusta Jane Evans, circa 1900 (Erik Overbey Collection, University of South Alabama Archives)

swarthy and colorless face, midnight orgies and habitual excesses had left their unmistakable plague spot, and Mephistopheles had stamped his signet. Is it any wonder that Etna's love fed as she gazed . . . ?" Etna rejects "Gordon Lee" because he lacks the need for reform. Webb exaggerates, but he correctly identifies an important aspect of Evans's novels. Her heroines do choose difficult paths, usually from the desire for self-improvement initially and self-sacrifice ultimately. Evans understood the role of her novels to be first instructional and second entertaining. Edna's first work as a writer is a story "to portray the horrors and sin of duelling," and her editor objects that she seems to believe that "all works of fiction should be eminently didactic, and inculcate not only sound morality, but scientific theories." Evans never deviated from the belief that her novels should morally uplift readers and educate them on many levels.

All Evans's novels educate the reader, not only with regard to proper conduct, but also in the prevalent philosophical, scientific, and literary theories of her day. Her contemporaries' most consistent criticism was that her novels were too filled with references to obscure branches of learning to be comprehensible. For example, in *Macaria,* when Irene's father refers to

her as a "Diana of Ephesus," Irene responds, "Father, it would not require much stretch of the imagination to believe that, by some descendental metempsychosis, I had become an exhumed member of the sacred gnomides, torn ruthlessly from my sisterhood in Cerro do Frio or the cold dreary caverns of the Agathrysi." The passage is far from unusual. Evans's major novels often include challenging allusions that defy readers to discover what they mean. The description of St. Elmo's study refers to "marquetrie cabinets, loaded with cameos, intaglios, Abraxoids, whose 'erudition' would have filled Mnesarchus with envy, and challenged the admiration of the Samian lapidary who engraved the ring of Polycrates." Such liberal use of allusions generated the running joke among critics that Evans had swallowed an unabridged dictionary or that she wrote with an encyclopedia next to her. In *St. Twel'mo* Webb included extensive passages from *St. Elmo,* arguing that, if the reader could not tell the original work from the parody, his work was a success.

By the time Evans wrote *St. Elmo* her critics had already complained about her style. As a response Evans created a scene in which Edna's tutor, Mr. Hammond, instructs her to "seek illustration from every department of letters" since "what is often denominated 'far-fetchedness' in metaphors, furnishes not only evidence of the laborious industry of the writer, but is an implied compliment to the cultured taste and general knowledge of those for whose entertainment or edification they are employed." Evans's wish to provide the most enjoyment and instruction possible while respecting the intelligence of her readership was a successful literary formula. It also functioned to mitigate the sharp transitions of her heroines from independence to marriage. The conscious and constant display of learning undermines the sacrificial ideal that it ostensibly supports. Evans employed complex metaphors and allusions to argue for charity, humility, and self-sacrifice, but possession of such knowledge implies an independence and self-involvement that Evans did not fully conceal. Characters such as Beulah, Irene, and Edna dedicate countless hours to study, sacrificing health for the sake of knowledge while suitors and other members of the community try to dissuade them from "useless" learning. For Evans such knowledge was not useless. She saw the individual search for truth as a tool with which to elevate and illuminate. What critics viewed as showing off—or even stealing from her sources— was, for Evans, a demonstration that women could not only be highly educated but also put that education to useful ends.

In *St. Elmo,* as Edna Earle completes her masterwork, the strain brings her almost to the point of death.

Like a mother having endured labor, she looks down at her manuscript and brushes her fingers over it, just as "a mother's soft fingers might lovingly stroke the face of a child about to be thrust out into a hurrying crowd of cold, indifferent strangers, who perhaps would rudely jeer at and brow-beat her darling." Like her heroine, Evans, who had no children of her own, left a literary legacy instead. As modern critics have come to the awareness that she is not simply a cultural footnote, Evans is becoming recognized as an intelligent writer with a fascinating, if contradictory, vision of the woman writer's role in society.

Biography:

William Perry Fidler, *Augusta Evans Wilson, 1835–1909* (University: University of Alabama Press, 1951).

References:

Jan Bakker, "Overlooked Progenitors: Independent Women and Southern Renaissance in Augusta Jane Evans Wilson's *Macaria; or, Altars of Sacrifice,*" *Southern Quarterly,* 25, no. 2 (1987): 131–141;

Nina Baym, "Augusta Evans and the Waning of Woman's Fiction," in *Woman's Fiction: A Guide to Novels by and about Women in America, 1820–1870* (Ithaca, N.Y.: Cornell University Press, 1978), pp. 276–299;

Earnest Elmo Calkins, "Named for a Bestseller," *Saturday Review of Literature,* 21 (16 December 1939): 3–4, 14, 16–17;

J. C. Derby, "Augusta J. Evans Wilson," in his *Fifty Years Among Authors, Books and Publishers* (New York: G. W. Carleton, 1884), pp. 389–399;

Drew Gilpin Faust, "*Macaria,* a War Story for Confederate Women," introduction to *Macaria; or, Altars of Sacrifice* (Baton Rouge: Louisiana State University Press, 1992);

Elizabeth Fox-Genovese, Introduction to *Beulah* (Baton Rouge: Louisiana State University Press, 1992);

Susan K. Harris, *19th-Century American Women's Novels: Interpretive Strategies* (New York: Cambridge University Press, 1990);

Anne Goodwyn Jones, "Augusta Jane Evans: Paradise Regained," in her *Tomorrow Is Another Day: The Woman Writer in the South, 1859–1936* (Baton Rouge: Louisiana State University Press, 1981), pp. 51–91;

Mary Kelley, *Private Woman, Public Stage: Literary Domesticity in Nineteenth-Century America* (New York: Oxford University Press, 1984);

Elizabeth Moss, *Domestic Novelists in the Old South: Defenders of Southern Culture* (Baton Rouge: Louisiana State University Press, 1992);

Diane Roberts, Introduction to *St. Elmo* (Tuscaloosa: University of Alabama Press, 1992).

Papers:

Some of Augusta Jane Evans's papers are in the Hoole Alabama Collection at the University of Alabama and in the Alderman Library at the University of Virginia.

Harriet Farley

(18 February 1812 – 12 November 1907)

Ellen O'Brien
Roosevelt University

BOOKS: *Shells from the Strand of the Sea of Genius* (Boston: J. Munroe, 1847);

Operatives' Reply to Hon. Jere. Clemens, Being a Sketch of Factory Life and Factory Enterprise, and a Brief History of Manufacturing by Machinery (Lowell: S. J. Varney, 1850);

Happy Nights at Hazel Nook; or, Cottage Stories (Boston: Dayton & Wentworth, 1854); republished as *Happy Hours at Hazel Nook; or Cottage Stories* (New York: Dayton & Wentworth, 1854); republished as *Fancy's Frolics: or, Christmas Stories Told in a Happy Home (Hazelnook) in New England* (New York: Worthington, 1880); republished as *Christmas Stories, Told in a Happy Home (Hazelnook) in New England* (New York: John W. Lovell, 1884).

OTHER: "The Window Darkened" and "Deal Gently," in *Woman's Record; or, Sketches of all Distinguished Women, from the Creation to A.D. 1854,* edited by Sarah Josepha Hale (New York: Harper, 1853).

SELECTED PERIODICAL PUBLICATION– UNCOLLECTED: "The Children's Welcome to 1893," *The Ladies' World* (January 1893).

Harriet Farley (courtesy of the University of Massachusetts, Lowell, Center for Lowell History)

During mid-nineteenth-century debates about workers' rights, women's roles, and American industry, editor, essayist, publisher, and "factory girl" Harriet Farley produced a body of work that documents tensions over issues of class, gender, and industry. Farley was admired by many of her contemporaries for her pioneering role as one of the first female editors in the United States and for her dedication to defending publicly the respectable character of women laborers. At the same time she offended many others by consistently defending factory overseers and their policies. Although her literary publications include short stories and poetry, Farley is best remembered for her essays and editorials that contributed to public debates. She crafted and refined her essay style over the course of many years as contributor to and editor of the *Lowell Offering,* a periodical written and produced by factory operatives, and then as publisher and editor of the *New England Offering,* an operatives' paper that she started after the *Lowell Offering* closed. These essays constitute the largest portion of her work and demonstrate a wide variety of approaches to the genre of the essay.

Farley was the sixth of ten children of Reverend Stephen Farley and Lucy Saunders Farley. She was born on 18 February 1812 in Claremont, New Hampshire, where her father served as a Congregationalist minister. In her autobiographical entry for the *Woman's*

Record; or, Sketches of all Distinguished Women, from the Creation to A.D. 1854 (1853) Farley emphasizes the "pious, industrious, and agricultural" stock from which she descended on her father's side and notes the connection on her mother's side to the Moodys, a prominent New England family. During her childhood Farley suffered from physical illnesses brought on by asthma and from the problems of poverty that sent her in search of work at the age of fourteen. Farley characterized the first part of her life in terms of employment: "I have plaited palm leaf and straw, bound shoes, taught school, and worked at tailoring; besides my labor in the factory which suited me better than any other." Her ability to do factory work became a source of pride, and it enabled her to escape a teaching career for which she was being trained against her will.

She regarded work in the mills as a weaver as a way for her to "read, think, and write when I could, without restraint." Although Farley's conception of factory labor as an opportunity to engage in unrestrained intellectual activity represents a rather unorthodox view of industrial work, her work in the mills did indeed afford her literary opportunity as contributor to and editor of the *Lowell Offering.* In 1840 Farley began publishing in the *Lowell Offering,* and in 1842 she was invited to edit the paper. Harriot F. Curtis joined her as co-editor a year later, and they continued as editors until the last issue of the *Lowell Offering* was printed in 1845. In 1847 Farley set out on her own to edit the *New England Offering,* publishing one issue in September. She reprinted that issue in April 1848 and continued to publish the magazine through March 1850. It closed in 1850 because of a lack of subscriptions. In 1854, after her major literary works had been published and her editorships had come to an end, Farley became the second wife of John Intaglio Donlevy and the stepmother of his daughter, Alice Donlevy. Thereafter she resided in New York, where she later gave birth to one daughter, Inez.

Farley's work first gained public attention in the *Lowell Offering* through contributions she made under various pseudonyms as well as in signed editorial commentary. In these pieces Farley explored factory life, women's rights, moral problems, religious faith, labor debates, and her own literary aspirations, while experimenting with an essay style that mingled such public issues with imaginative prose. Farley often chose narration as a form of argument, deploying anecdotes, dreams, folktales, or accounts of personal and social history to support her points about pressing issues of the day.

Despite her successful blending of the literary world and the political world in her essays, Farley often tried to separate the two ideologically and was

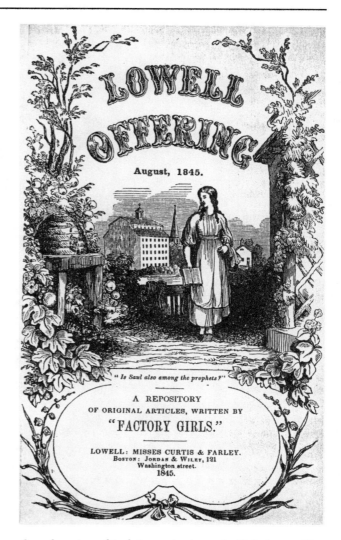

Cover for an issue of the factory workers' magazine Farley began editing in 1840

repeatedly frustrated when literature and politics collided in the *Lowell Offering.* The tension between private and public worlds increased when Farley began serving as editor. During her tenure as editor, the *Lowell Offering* received international attention, drawing curious readers because it provided evidence of both the impressive condition of American workers and the literary abilities of women. Charles Dickens and Harriet Martineau were among the admirers who visited and praised the "factory girls" and their paper. Martineau paid homage to the women by writing an introduction to a selection of excerpts from the *Lowell Offering,* which was published in England as *Mind Among the Spindles* (1844). At the same time, however, critics of the periodical charged that its apolitical and imaginary content masked the harsh realities of factory life and that the paper was nothing more than a propaganda tool of the industrialists.

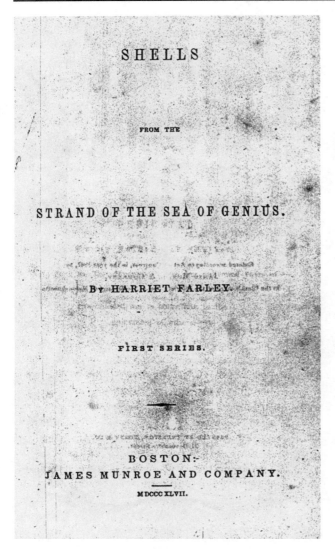

Title page for Farley's first book, in which she attempted to dispel the notion that female factory workers were morally corrupt (courtesy of Special Collections, Thomas Cooper Library, University of South Carolina)

Farley and her fellow editor, Harriot F. Curtis, countered such attacks by noting that they were simply not seeking to produce a political paper. Meanwhile, the formation of labor groups such as the Lowell Female Labor Reform Association and the Ten Hours Movement widened the gap between a paper seeking to represent private life and a community seeking public change. Sarah Bagley, an operative, contributor to, and critic of the *Lowell Offering,* decried the illusion of neutrality in the paper. Bagley contended that "Led on by the fatal error of neutrality, it has neglected the operative as a working being . . . the very position of the *Lowell Offering* as a factory girls' magazine precludes the possibilities of neutrality." As more radical papers were

established, including Bagley's *Voice of Industry,* subscriptions to the *Lowell Offering* declined, bringing the paper to a close in 1845. In the final issue Farley and Curtis were still defending their editorial position. To the claim of "one-sidedness," Farley responded, "If we have too often written of the good and the noble, it was because those characters were more pleasant to dwell upon—because we thought *they* might be allured to like goodness by good example."

The *Lowell Offering* played such a significant role in Farley's writing career that select contributions were deemed worthy of publication in book form. *Shells from the Strand of the Sea of Genius,* her first book, was published in 1847. With the publication of this work, Farley's name was publicly attached to many works that had appeared under one of her various pseudonyms in the *Lowell Offering.* As a collection, it offers a clear example of the diversity and seriousness of Farley's literary interests and reflects the tensions that accompanied her role as a nineteenth-century woman author and worker. The book also ties together central themes and subjects of Farley's work, such as "factory girls," women's roles, and personal duty, while illustrating the power and range of Farley's essay style that blurred distinctions between the direct, or practical, expository essay and the fictional short story.

While Farley spent time defending the strategies of the industrialists, she spent equal, if not more, time defending women laborers against charges of immorality and degradation. She was not unaware of the stresses and anxieties of the "factory girl." Because factory work required women to travel outside the domestic sphere, to live amid urban corruption, and to exercise financial skills, women laborers were deemed by many to be unnatural and morally corrupt. Several selections in *Shells from the Strand of the Sea of Genius* attempt to dispel this myth. In "Abby's Year in Lowell," for example, Farley tells the story of Abby, who works for a year in Lowell under her parents' conditions that she stay only one year and that she remain that entire year without visiting home. During her year in Lowell, Abby withstands the temptation of squandering her earnings on fashions, a temptation that her father was convinced would be her downfall. Abby chooses a course of self-denial, places her money in the bank, and transcends the marketplace of fashionable goods. As a result, she triumphs at her end-of-the-year homecoming when she presents her bank book to her tearful father, who celebrates her "prudence, self-command, and real affection." Abby is rewarded with her father's consent to return to Lowell and his statement that his parental fears about factory-girl labor have been conquered: "I shall never again be afraid to let you spend a year in Lowell."

HAPPY HOURS

AT

HAZEL NOOK;

OR,

COTTAGE STORIES.

BY

HARRIET FARLEY.

BOSTON:
WENTWORTH, HEWES & CO.
114 & 116 Washington Street.
1859.

Frontispiece and title page for Farley's volume of stories narrated by parents and children who have gathered to celebrate Christmas (courtesy of Special Collections, Thomas Cooper Library, University of South Carolina)

While the story of Abby intervenes in public debate as narrative demonstration, Farley's "Woman" follows a more direct approach. "Woman" begins with a summation of the terms of the gender debate of the day: "Woman's Mission, Woman's Sphere, Woman's Rights, Woman as she should be." In this essay, Farley carefully negotiates the terms of the debate, arguing that women do have a "sphere" that binds them to the home and that should exclude them from party politics and voting. Nevertheless, Farley does not hesitate to celebrate women in history who have stepped out of this "sphere" in essays such as "Joanne of Arc" and "The Portrait Gallery," in which she contemplates the power of Pocahontas, Cleopatra, and Zenobia. In many essays Farley firmly maintains that women must undertake mental work and literary activity without the fear that their womanly graces will be undermined.

Farley's essays make clear that she does not represent a radical feminist position, and her hesitation at the crossroads of gender equality and labor movements has been a sore point with contemporary and modern crit-

ics alike. Various explanations for Farley's reluctance to plunge into radical politics can be cited, but most important to remember are the ideological positions that informed her identity and social perspective. She adhered adamantly to tenets of Christian duty and an idea of New England industriousness, characteristics that she traces explicitly to her paternal lineage. She also possessed an abiding faith in the idea of womanly virtue, and this faith sometimes led her to judge other women harshly. In the *Woman's Record* she wrote, "I consider myself superior to many of my sex, principally in qualities where they all might equal me—in hope, in perseverance, content and kindliness." Yet, she was devoted to defending the virtue of her coworkers against charges of moral corruption. Such inconsistencies and tensions exemplify the extent to which Farley was exploring new territory with extreme caution.

Shells from the Strand of the Sea of Genius also introduces the anxiety of the woman author. In "The Sea of Genius," for example, Farley offers an allegory of the woman writer. Farley explains her desire to possess the

gift of genius, and she begins to pray for inspiration. She recounts a vision in which she meets an omnipotent incarnation of Inspiration, a man who monitors the Sea of Genius, where authors attempt to navigate their ships across the stormy depths of genius, fame, and productivity. From the shore, Inspiration decides who will succeed and who will fail. Farley, as narrator, pleads for the gift of genius, but Inspiration refuses and assures her that tears and supplication will not move him. Awakening from her vision, Farley resolves to "go actively about the humbler duties of the day, and never more repine because I might not steer my bark across the black and stormy Sea of Genius." Thus, the solution to her problem comes not in the form of literary success against the odds, a subversion of Inspiration's power, but in the form of resolution to "duty."

The theme of "duty" permeates Farley's work, exemplified in her many roles as Christian, woman, worker, and writer. In "A Weaver's Delight" she contemplates the mill worker's love for nature and notes that in reveries, the qualities of the factory are purged and nature is highlighted. Her own reverie, however, is interrupted by the voice of her boss, who orders her back to work. Duty informs her literary criticism as well. In "Ancient Poetry" she administers advice on how to appreciate the ancient poets of the Bible and finds comfort that in the literature of the Bible, imagination and duty are united. She constructs an aesthetic that links fancy and reason, imagination and duty, and expresses thanks that "the truths of our holy religion have been so often presented in forms which not only reason and conscience will approve, but also which the fancy can admire and the heart must love."

When Farley began publishing and editing the *New England Offering* in 1847, she was still aware of the social tensions that brought about the close of the *Lowell Offering,* and she attempted to explain her editorial position with respect to these tensions. In June 1848 she summed up the conflict that had surrounded her years at the *Lowell Offering:* "With a heart quite radical and, a head somewhat conservative, we get credit for being 'neither one thing or another;' whereas we are, in reality, far more like two things." In the *New England Offering,* this editorial "we" reflected only Farley, who produced the paper herself. She described her solitary efforts in the *Woman's Record:* "I do all the publishing, editing, canvassing. . . . I employ no agents, and depend upon no one for assistance." The characterization of her divided interests—the conflict between a radical heart with a conservative head and the depiction of herself as being "two things"—supplies accurate metaphors for understanding Farley's position throughout her career as she attempted to negotiate among conflicting definitions of woman, writer, and worker.

The *New England Offering* printed operatives' contributions and agreed to publish former operatives' work as well; the tone was similar to that of the *Lowell Offering.* The purpose of the *New England Offering* was "to lay at the altar of our country's literature an 'offering' worthy of that shrine; one that should reflect honor upon our sex, our class, and those institutions of whose blessings we have been the happy recipients." One of these blessings was clearly factory employment, and accordingly, the paper turned away from protest writing, which Farley interpreted as a "continual grumbling and whining" that was in "shocking bad taste." As editor, Farley toured other New England factories to report, usually favorably, on conditions of other workers. She continued to print the *New England Offering* until 1850 when, like its predecessor the *Lowell Offering,* it closed because of a shortage of subscriptions.

In 1850 Farley published the *Operatives' Reply to Hon. Jere. Clemens, Being a Sketch of Factory Life and Factory Enterprise, and a Brief History of Manufacturing by Machinery.* In this essay she launches a forceful refutation of Senator Jeremiah Clemens's critique of New England industry. Clemens, a senator from Alabama, had claimed that Southern slaves were better off than New England factory workers and had characterized factories as prisons, inspectors as inquisitors, overseers as turnkeys, and operatives as slaves. To combat Clemens's prison metaphor, Farley set up pastoral images. She described "dew-damp roads" and "Pleasant Valleys" from which workers emerged for their daily factory jobs. To combat Clemens's arguments, Farley openly attacked his ignorance and proceeded to review a history of New England manufacturing as a corrective. As evidence, she supplied excerpts from the letters of contented factory girls and lists of the various educational and cultural activities available to factory workers in Lowell. In responding to Clemens, Farley also found herself in the familiar position of defending the reputations of *female* operatives, for Clemens, too, spoke of the decay of female virtue. Despite Clemens's request to be "spared all 'cant' respecting morality and improvement," Farley addressed the flaws in this argument and boldly stated that the "Factory Girls of Lowell . . . made the City."

Farley's final book, *Happy Nights at Hazel Nook; or Cottage Stories,* was first published in 1854 and was republished and retitled several times throughout the nineteenth century. The book is dedicated to "the youthful spirit of father, mother, and child, of whatever age." With this collection of fanciful stories and folktales, Farley was able to further develop her interest in narrative fiction and to leave behind the public role that had surrounded her literary work. The stories are told by parents and children gathered together to celebrate Christmas. They are introduced by the reveler's discus-

THE CLERK OF THE WEATHER.

OLD BARTRAND grumbled at the wet and at the drought; at the long, cloudy days, and at the weeks of clear hot sunshine. The weather never suited him, and it was his custom to say that if it were left to his arrangement he could save a deal of trouble. "The clerk of the weather!" that personage was a perfect bugbear to him; and one would have thought, to hear old Bartrand, that this busy being was the most capricious, malicious, and suspicious person in the universe.

"No customers ever in my shop," grumbled old Bartrand; "how should there ever be any? The mud has been ankle deep at the crossing, and no sunshine this sevennight. No, nor moonshine either, for that matter, unless this whole business is moonshine at the bottom. Well, if I could only get hold of 'the clerk of the weather,' I would teach him how he might improve matters. A lesson or so from somebody of common sense might work wonders in him.

"Ah, Bartrand, why were you not put into authority, where there is so much need of it?"

This was his way of grumbling; and if he did

THE VIAL IMPS.

HANS was a doctor in prospective only, but still studying and theorizing for lack of the practice people do not seem disposed to give to those who most need it — the young and penniless. Experience, that old fellow, with white hair and expanded brow, comes through so many sloughs and quagmires to his favorites, that people have learned to trust his seams, and scars, and wrinkles — to look for the best diplomas among the stains and patches of his garments; and they resign few valuables, little of that greatest treasure, life or health, to the smooth cheek and unsoiled garment. So Hans might still as well have called himself an apothecary's clerk, for that was the position his good community seemed to have assigned him.

Hans, moreover, was called a *lazy* student: he was seen sporting in the forests, and fishing by the rivers, dissecting butterflies, and analyzing crickets, when he might better, they thought, have been feasting his brains through mental digestion, with the marrow of old Æsculapius, of the mighty doctors, who had filled vast tomes now in his master's library. But why should

Pages from Happy Nights at Hazel Nook *(courtesy of Special Collections, Thomas Cooper Library, University of South Carolina)*

sion of who will tell the stories, what kind of stories they should tell, and whether the tales should have moral lessons. The reveler's conversation frames the stories, which included "The Golden Demon" (listed in the table of contents as "An Oriental Tale") as well as "The Spectre Housewife" and "Wardrobe Witches" (listed as "New England Superstitions"). After the stories are told the revelers decide to publish their stories "as a Gift for our Friends, by the new Year's Day."

Farley's literary publications decreased after her marriage, although she continued to write poetry and short stories until her death in 1907. Some of her later work, including a children's short story published in *The Ladies' World* in 1893, was printed in women's journals, and some remains unpublished. Farley's obituary in *The New York Times* (15 November 1907) celebrated Farley as one of the first female editors and as a friend of American literary society. In Lowell, Massachusetts, she is considered a foremother of the city, and her portrait hangs in the Harriet Farley Room of the Lowell Public Library.

As Farley made clear repeatedly in her essays, editorial comments, and biographical statements, her motivations behind much of what she accomplished in her public role (and the reason for her decision to seek factory work in the first place) were to engage her intellect and to write. Despite her reluctance to enter the public sphere of reform and politics, her engagement in public debate as an essayist of the nineteenth century remains a valuable example of the concerns surrounding gender, class, and industry at that time. Although Farley is most often remembered in labor histories as an apologist for the industrialists, her literary work demonstrates the complexity of the roles she played and the inevitable ambivalence of her stance. She worked as an advocate for women laborers and served as a pioneer in women's literature while trying to reconcile that work with the social concepts of Christian duty, New England morality, and a woman's sphere. In the midst of these competing roles and throughout her life, Farley consistently argued for the power of intellectual activity, and this belief was what led her to choose intellect over social protest as the balm that could soothe the discomforts of industrial labor: "we are cheered and invigorated by hopes of better times, and also by the sustaining power of 'mind amongst the spindles.'"

References:

Benita Eisler, ed., *The Lowell Offering: Writings by New England Mill Women (1840–1845)* (Philadelphia: Lippincott, 1977);

Philip S. Foner, *The Factory Girls* (Urbana: University of Illinois Press, 1977);

Foner, *Women and the American Labor Movement: From the First Trade Unions to the Present* (New York: Free Press, 1979);

Hannah Josephson, *The Golden Threads: New England's Mill Girls and Magnates* (New York: Duell, Sloan & Pearce, 1949);

Mind Among the Spindles: A Selection from the Lowell Offering (London: Charles Knight, 1844);

New England Offering, 1–3 (April 1848 – March 1850) (Westport, Conn.: Greenwood Reprint Corporation, 1970);

Harriet H. Robinson, *Loom and Spindle; or, Life Among the Early Mill Girls with a Sketch of "The Lowell Offering" and Some of its Contributors* (New York: Crowell, 1898);

David A. Zoderman, *Aspirations and Anxieties: New England Workers and the Mechanized Factory System 1815–1850* (New York: Oxford University Press, 1992).

Papers:

A collection of Harriet Farley's letters, clippings, and unpublished poetry, donated by her stepdaughter, Alice Donlevy, is located at the Lowell Library in Lowell, Massachusetts.

Charlotte L. Forten

(17 August 1837 – 23 July 1914)

Katharine Rodier
Marshall University

See also the Forten entry in *DLB 50: Afro-American Writers Before the Harlem Renaissance.*

BOOKS: *The Life and Writings of Charlotte Forten Grimké,* volume 2 of *Life and Writings of the Grimké Family,* edited by Anna Julia Cooper (N.p., 1951);

The Journal of Charlotte L. Forten, edited by Ray Allen Billington (New York: Dryden Press, 1953; London: Collier-Macmillan, 1961);

The Journals of Charlotte Forten Grimké, edited by Brenda Stevenson (New York: Oxford University Press, 1988).

OTHER: Emile Erckmann and Alexandre Chatrian, *Madame Thérèse; or, The Volunteers of '92,* translated by Forten (New York: Scribner, 1869).

SELECTED PERIODICAL PUBLICATIONS–
UNCOLLECTED: "To W.L.G. on Reading His 'Chosen Queen,'" *Liberator* (16 March 1855);

"Glimpses of New England," *National Anti-Slavery Standard* (18 June 1858);

"The Two Voices," *National Anti-Slavery Standard* (15 January 1859);

"The Wind Among the Poplars," *National Anti-Slavery Standard* (2 April 1859);

"The Slave-Girl's Prayer," *Liberator* (3 February 1860);

"Letter," *Liberator* (12 December 1862);

"Interesting Letter from Miss Charlotte L. Forten [,] St. Helena Island, Beaufort, S. C.[,] Nov. 27, 1862," *Liberator* (19 December 1862);

"Life in the Sea Islands," *Atlantic Monthly,* 8 (May 1864): 587–596; 8 (June 1864): 666–676;

"Waiting for the Verdict," *National Anti-Slavery Standard* (22 February 1868);

"A Visit to the Birthplace of Whittier," *Scribner's Monthly* (May 1872);

"The Flower Fairies' Reception," *Christian Register* (8 August 1874);

Letter, *Christian Register* (20 and 27 June 1876);

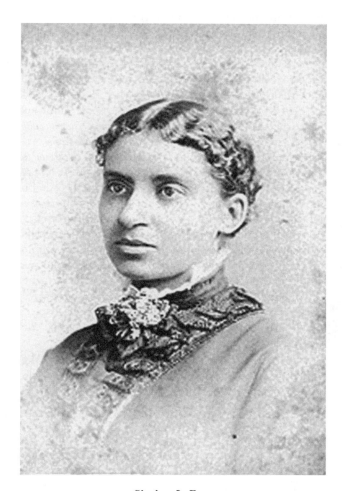

Charlotte L. Forten

"The Centennial Exposition," *Christian Register* (22 July, 29 July, and 5 August 1876);

"Mr. Savage's Sermon: 'The Problem of the Hour,'" *Commonwealth* (23 December 1876);

"One Phase of the Race Question," *Commonwealth* (December 1885);

"Personal Recollections of Whittier," *New England Magazine,* 8 (June 1893): 468–476.

"A wish to record the passing events of my life, which, even if quite unimportant to others, naturally posses great interest to myself, and of which it will be pleasant to have some remembrance, has induced me to commence this journal." So opens the first diary of Charlotte L. Forten Grimké, a nineteenth-century teacher, civil rights proponent, poet, and essayist, who is now better known for her private writing in her five extant journals than for her public expressions. Forten's journals, begun in May 1854, when she was sixteen, provide a detailed account of the antebellum life of a relatively privileged woman of color in the North, tracing the author's eventual involvement in the Port Royal Experiment during the Civil War as a teacher of contraband slaves in South Carolina. Drawn as well from this remarkable experience, Forten's most significant publication during her lifetime, "Life in the Sea Islands," appeared in *The Atlantic Monthly* in May and June 1864. Less well known is her postwar prose, some published in journals such as *Scribner's Monthly, The Commonwealth, The Christian Register,* and *The New England Magazine,* and some remaining in private circulation. In *"Doers of the Word": African-American Women Speakers and Writers in the North (1830–1880),* Carla L. Peterson argues, "What in fact characterizes Forten's Reconstruction oeuvre is a bifurcation of sensibility that underscores the complexity of literary expression for an African-American woman with links to both the black and white communities." Whereas Forten imagined that her journal would chronicle "the growth and improvement of her mind from year to year," it reveals this intimate growth within the political and social conflicts that inspired much of the later writing she submitted for public consideration.

Born in Philadelphia to Robert Bridges Forten and Mary Virginia (Woods) Forten, free blacks who were prominent abolitionists, Charlotte Forten inherited both the privileges and the inequities of her family's four generations of freedom in antebellum America, a legacy she turned into a career of public service, despite racial and sexual discrimination and her own frequent ill health. Most biographies of Forten assert her family's prominence not only in antislavery work but also in business and intellectual enterprises. Her grandfather James Forten (1766–1842), who had served shipboard as a powder boy during the American Revolution, grew deeply committed to a life of abolitionist activism during the year he spent in England after the war. After returning to Philadelphia he worked his way from apprentice sailmaker under Robert Bridges to owner of Bridges's company in 1798, introducing an innovation to handle sails that earned him more than $100,000 by 1832. James Forten's economic success did not deter him from the pursuit of racial equality. Challenging by

petition the Fugitive Slave Law of 1793, he continued to advocate both education and emancipation for slaves, vehemently opposing the American Colonization Society's efforts to relocate blacks to Liberia. In 1813 he published a pamphlet to counter legislative efforts that would bar free blacks from entering Pennsylvania. His friendship with abolitionist William Lloyd Garrison led Forten to become a financial supporter of Garrison's antislavery publication, *The Liberator.* James Forten's only son, Robert Bridges Forten, shared this passion for reform as well as his father's trade, although Peterson contends that the son lacked his father's confidence. In 1836 Robert Forten married Mary Virginia Woods, who had also grown up in a family of Philadelphia activists. The couple's only child, Charlotte L. Forten, born 17 August 1837, was named for her paternal grandmother, with whom Mary Woods and the elder Forten's daughters had helped found the Philadelphia Female Anti-Slavery Society in 1833.

Although her mother died of tuberculosis when Charlotte was only three years old, the child was not without female exemplars. The Forten matriarch lived until 1884. Her namesake Charlotte spent the first several years of her life in her grandparents' home on Lombard Street. James Forten died in 1842, but his energetic dedication to liberty had clearly inspired his female heirs, so much so that John Greenleaf Whittier titled his 1833 poetic tribute to Charlotte Forten's aunts, "To The Daughters of James Forten," asserting their familial connection to that great man rather than their individual identities by name. In the poem the renowned Quaker poet addressed the Forten women as "all my sisters" and conferred upon them a "Brother's blessing and a Brother's prayer," again reiterating the rhetoric of male relation, apparently to sanction their contributions to the cause of racial unity.

Harriet Forten Purvis embraced her young niece Charlotte as one of her own children, welcoming her on visits to Byberry, the elegant home outside of Philadelphia that Harriet Purvis shared with her husband, Robert, the influential head of the Philadelphia Anti-Slavery Society and the local Underground Railroad. At Byberry this branch of the Forten family entertained abolitionists and sheltered fugitives. Harriet's elder sister, Margaretta, taught at a black children's school in the city, while her younger sister, Sarah Louise, wrote essays and poems for *The Abolitionist* and for Garrison's *Liberator.*

Hoping to alleviate the growing introversion they witnessed in Charlotte during her largely tutorial schooling in and outside of racially tense Philadelphia, Forten's family arranged to send her in 1853 to study in Salem, Massachusetts. Her father believed that the less discriminatory schools there would prepare her for

teaching, a dependable career that would help her serve her race. In Salem she lived with a noted family of black reformers, Charles Lenox Remond, Amy Matilda Williams (Cassey) Remond, and their children, Sarah Cassey Smith and Henry Cassey. Forten attended Higginson Grammar School, where she became a long-time friend of the principal, Mary Shepard. By May 1854 Charlotte began her journals, devoting her first entry to describing the bright morning, her lessons, her reading of Charles Dickens's *Hard Times* (1854), and tea with friends. But she also detailed with outrage the cases of fugitive slaves such as Anthony Burns. In September 1855 Forten joined the local chapter of the Female Anti-Slavery Society, which brought her closer to the great liberal orators of her age, including Garrison, Wendell Phillips, Ralph Waldo Emerson, Lucretia Mott, Theodore Parker, William Wells Brown, Thomas Wentworth Higginson, and Lucy Stone. At her graduation, Forten's valedictory poem was pronounced the best of the class of 1855. She went on to study at the Salem Normal School and earned a degree and further honors for her poetry in 1856, the year she was appointed to teach at Epes Grammar School. Although bouts of "lung fever" and brutal headaches continually plagued her, Forten dedicated much of her life to teaching.

Forten was exceptionally well educated for any woman of her era, an advantage augmented by her proximity to a cultural center such as Boston. An avid reader, Forten listed historical favorites such as William Shakespeare, Edmund Spenser, and William Cowper among her contemporary preferences such as Dickens, Ik Marvel, and the Brontës. She also read the Bible, Sir Walter Scott, Lydia Maria Child, Madame Anne-Louise-Germaine de Staël, Whittier, Emerson, Maria Edgeworth, Martha Griffith Browne's *The Autobiography of a Female Slave* (1857), Harriet Beecher Stowe, George Eliot, Hannah More, Nathaniel Hawthorne, Henry Wadsworth Longfellow, William Wordsworth, Thomas Carlyle, James Russell Lowell, and Elizabeth Stuart Phelps, among others, including E. D. E. N. Southworth, of whose novel *Retribution* (1849) Forten confessed, "It excited me entirely too much." She idolized Elizabeth Barrett Browning, whose art decried human injustice and celebrated female creativity and love. Browning's "The Runaway Slave at Pilgrim's Point" (1848) especially moved the abolitionist Forten with its dual theme of racial and sexual enslavement. She also loved *Aurora Leigh* (1857), Browning's popular verse novel about a female artist's trials and ultimate triumph. Similarly, natural subjects captivated Forten, and she observed with pleasure subjects ranging from hummingbirds—"our *living breathing moving* flowers"—to Newfoundland dogs. Her keen appreciation for natural detail illuminated her later descriptions of Southern sunsets, azaleas, sand violets, and the moss-draped live oaks in the South Carolina Sea Islands.

While Forten did not produce a volume of poetry in her lifetime, she published close to a dozen individual poems, including several between 1858 and 1860 in *The National Anti-Slavery Standard* and *The Liberator*. Early on Forten sounded hesitant about such public exposure, even though she only had permitted it, not sought publication as her aunts had done. In 1855, questioned by her Aunt Margaretta concerning whether or not a poem to Garrison in *The Liberator* was hers, Forten frowned with self-irony, "If ever I write doggerel again I shall be careful not to sign my own initials." Three years later, when some of her regional sketches appeared in print, she expressed this ambiguity once more: "To my great astonishment see that my poor 'Glimpses [of New England]' are published in the '[National Anti-Slavery] Standard.' They are not worth it." Mary Kelley and Joanne Dobson have shown that nineteenth-century white women who publicly wrote neither out of financial need nor to effect reform could suffer acutely from overstepping the restrained behavioral dictates of the "Cult of True Womanhood." As a writer, even when a fledgling nonprofessional, Forten had to navigate both gender and racial boundaries. She seems to have successfully achieved this negotiation by publishing writing, particularly her poetry, which was moral in purpose, and her geographical independence from her father suggested that she could claim a financial need to earn her own way. Beyond this tension, writing as a vocation for a woman of color during this period may have fostered not only the pride of achievement but also the trepidation of exercising a privilege denied by law to the enslaved members of her race in this country.

In a society in which biculturalism could be a bitter disadvantage, Forten struggled to overcome the many forms of gender and racial oppression she personally and vicariously experienced through others. As Forten wrote in 1854, "hatred of oppression seems to me so blended with hatred of the oppressor I cannot separate them. . . . How *can* I be a Christian when so many in common with myself, for no crime suffer so cruelly, so unjustly?" Even though she grappled with issues of Christian duty, Forten felt bound to serve and continued to follow her father's directive to fulfill her moral obligations through educating others. Brenda Stevenson wonders if Forten did not prefer to imagine herself as a scholar or writer, but she continued teaching as her health permitted. Aside from a few journal references, including those from December 1857 indicating that she had finished a short story, "The Lost Bride," and submitted it without success to *The Home*

(?)

Steamer "United States."

At Sea, Monday, Oct. 27, 1862.

Have been in no condition for writing until to-day. And now, being in a somewhat bewildered state, scarcely know where to commence. It was on Friday, the 24th, that we left N.Y. Enjoyed the sail down the harbor perfectly. The shipping is a noble sight. The sky was blue, the sea calm, the sunlight bright and joyous. Was in good spirits. The sadness that I had felt the night before at leaving some who are dear, was quite gone. One long-cherished wish of my heart was fulfilled at last.— I was southward bound, on the mission to which I have long felt called. Had no symptoms of sea-sickness until night. When, being seated at the supper-table, an inexpressibly singular sensation caused me to make a hasty retreat to the deck, where, seated on a coil of ropes, and keeping perfectly still, managed to spend several hours quite comfortably. My first night at sea. I shall not forget it; the starlight, the solemn stillness, broken only by the sound of the waves, and here and there a solitary lighthouse gleaming through the darkness— for it was very dark although the stars were shining. There was something very wild and strange in it all to me. And I enjoyed it. It gave me a sense of deep, sweet rest and peace, such as I had never felt before. Went below, with into the

Pages from a journal entry Forten wrote while en route to Union-occupied St. Helena Island, South Carolina, where she taught in a school for African Americans (Moorland-Spingarn Research Center, Howard University)

close ladies' cabin, for the night, with much reluc-
tance, and many misgivings which proved not
unfounded, for I had a long night of suffering,
and was not able to re-appear on deck till noon of
the next day. Was at least two hours trying
to dress, and two more trying to get strength enough
to ascend the cabin stairs. What an experience!
Of all dismal, doleful experiences surely sea-
sickness must be the dismalest and dolefulest.
Had a rather miserable afternoon. Scarcely dared to
move – even a finger. There was pleasant talk
going on around me among those passengers
who were so blessed as to be well enough to
talk, to which I'd listen occasionally but
~~that was all. At~~ night felt ~~better~~ and was
able to lean against the ship's side and look
at the phosphorescence in the water. It is a
beautiful sight – the long streak of light in
the wake of the steamer, and the stars and some-
times balls of fire on either side of it, rising, as
if by magic, out of the water. My companion,
Miss Hunn who suffered constantly, d'd enjoy
nothing, and she and I both resolved that
we w'ld not go below and have a repetition of
the agonies of the night before. So we heroically
determined to pass the night on deck. A cosy
little nook was found for us "amidships", and
there, enveloped in shawls and seated in arm-
chairs, we were very comfortably established for

Journal, there is little evidence that Forten attempted to break into the more-lucrative, growing market for fiction. Her preferred modes of writing for the public—poetry, sketches, letters to journals, and essays—suggest that her ambitions as an author did not fix ultimately upon commercial achievement. Teaching supplied her with a more-reliable, if physically taxing, means of self-support, as well as a way to fulfill the moral imperative that her family had instilled in her.

Besides some success in publishing, Forten's late teenage and young adult years included deaths, relocations, and other disruptions—further accounting for the sense of "homelessness" that Peterson identifies as the source of Forten's journal writing. In fall 1855 Robert Forten, his second wife, Mary, and his sons Wendell and Edmund Quincy left the United States for Canada, eventually moving to England in 1858, deepening the estrangement that had begun to develop between father and daughter during her years in Salem. Just prior to the August 1856 publication of Forten's graduation poem in *The Liberator,* Amy Remond, Forten's Salem "mother," died. In January 1857 Forten's uncle Joseph Purvis died in Pennsylvania. That summer Forten went to Philadelphia to recover from a respiratory illness, returning to the Remond home in July to resume teaching at Epes Grammar School. The next month her cousin William Purvis died. In December 1857, with Sarah Cassey Smith, Forten moved to live with the sister of Charles Remond, Caroline, and her husband, James Putnam. On 3 March 1858 health problems forced Forten to resign from Epes Grammar School and to move again to Pennsylvania, where she taught Robert and Harriet Purvis's children at Byberry. In the spring of 1859 the Higginson Grammar School rehired her for the following fall. In September she moved back to Salem to begin teaching, only to resign once more in the spring of 1860, again because of illness. Forten's recuperation took her to Bridgewater and to Dr. Seth Rogers's water-cure facility in Worcester, Massachusetts, where Rogers had also treated his cousin Susan B. Anthony. With abiding affection, Forten pronounced her physician "one of the best and noblest types of manhood." In September 1860 she resumed teaching in Salem only to resign in October and return to Philadelphia. In May 1861 she cared for her cousin Robert Purvis at Byberry, teaching that fall at the Lombard School in Philadelphia run by her aunt Margaretta. Early in 1862 Robert died of consumption, and Forten went back to Salem to teach summer classes at the Higginson Grammar School. During these turbulent years, she made no journal entries between 1 January 1860 and 22 June 1862, not even to note a reaction to the onset of the Civil War.

On 9 August 1862, a day Forten described as "to be marked with a white stone," she and Mary Shepard visited the Whittiers in Amesbury, Massachusetts. During their stay Whittier encouraged Forten to join the Port Royal Experiment, teaching former slaves in the Union-occupied islands off South Carolina, a project that historian Willie Lee Rose calls "a rehearsal for Reconstruction." Earlier that year Edward L. Pierce had been appointed Government Agent in Charge of Plantations and Contrabands of War and had organized a group of teachers, missionaries, and activists to live among and educate the African Americans who remained when plantation owners there had fled the occupying forces. In September 1862 Forten returned to Philadelphia to apply for sponsorship by the Port Royal Relief Association and left in October to teach at Laura M. Towne's school on St. Helena Island. According to Anna Julia Cooper, in a 17 December 1930 letter Francis J. Grimké wrote that when Forten "went South to teach, a small pistol was sent to her by mail from some friend in Boston for self protection in case she should be attacked." Of Forten's part in the Port Royal Experiment, Joanne M. Braxton explains,

> In terms of her inner life, the experiment, viewed romantically as part of her duty to her race (and her transcendental, or higher purpose), promised a political solution to her predicament of isolation, a reconciling of intellect, and a sense of Christian duty, with the . . . Cult of True Womanhood.

Despite the tension of living under military siege, this engagement offered Forten a departure from the life of books and urban teaching that she had led in the North. Teaching in St. Helena seemed to promise a new exotic landscape to study and enjoy, despite ubiquitous fleas and sometimes torrid weather; the unfamiliar customs among the slaves, which she observed with an ethnographer's eye; new friends and travels; a chance to know men whom she considered heroes; personal adventures; and possible romance. For Peterson the journals attest to the "primacy of local place in Forten's imagination." Early in her stay Forten's journal entries supplied the basis for letters north that soon appeared in print. In *The Liberator* on 12 December 1862 she described her first Sea Islands experiences and followed this report in the 19 December issue with "Interesting Letter from Miss Charlotte L. Forten [,] St. Helena Island, Beaufort, S. C.[,] Nov. 27, 1862," which recounted the Thanksgiving holiday there. Elements of these early depictions of her Port Royal experience surface again in her 1864 essay for *The Atlantic Monthly,* "Life in the Sea Islands."

As of 1 January 1863, Forten had been teaching contraband slaves for two months. The holiday marked not only a new year but also the effective date of President Abraham Lincoln's Emancipation Proclamation. During the dizzying celebration, Forten met Colonel Thomas Wentworth Higginson, the Union officer she had long admired as a writer and lecturer. Higginson was commander of the First South Carolina Volunteers, the first authorized regiment of freed slaves. Undoubtedly, Higginson's military rank, his literary celebrity, his renown as a reformer, and the significance of Emancipation Day compounded the awe that the young schoolteacher felt upon meeting him, although Forten was no stranger to literary circles and already had slight connections to the colonel. Her work had appeared in abolitionist journals familiar to Higginson. Moreover, she had secured her Port Royal assignment through the avuncular agency of Higginson's friend Whittier. Nonetheless, when she met Higginson, Forten was starstruck, perhaps because of her impression of his intersecting roles of activist, artist, and moral leader. Attributing Higginson's advocacy of direct action to "the latent ferocity that stimulates the militant moralist," Edmund Wilson pinpoints what may have deepened his appeal for a woman such as Forten as she struggled to channel her own anger, to empower herself both in spite of and in accordance with cultural restrictions on her gender and race.

Wilson summarizes the months of Forten and Higginson's war association as "Spartan . . . and yet so often delightful," and in truth, the war sometimes seems distant from her journal pages during this time. Much as Higginson made literary recommendations to Emily Dickinson, Harriet Prescott Spofford, and other aspiring writers, he read to Forten some Cavalier ballads and Spenser's *The Faerie Queene* (1589) and shared his military writing with her, as well as a darkly ironic consultation about the best way to torch a house. He accompanied her on moonlight rides with the surgeon of the regiment, Dr. Seth Rogers, whom she may have loved, building on their acquaintance from the water cure in Worcester. Rogers, who was married and white, wrote matter-of-fact letters to his family in Massachusetts, in which he mentioned visits to and dinners with "Miss Forten," and on 1 January 1863 he identified her as the "dearest friend" he had found among the revelers on Emancipation Day. More fervently, in her journal for 19 February 1863, Forten thrilled over one late ride she took alone with Rogers, whose "magnetism" she sensed under the "silver bow" of a violet-tinged moon. She was flattered to be invited to serve with Higginson and Rogers in Florida as the teacher of the company, an appointment ultimately lost to the fear of "scandal." To Higginson, Forten became "Daughter of the Regi-

ment," a phrase that once again evokes his genteel paternalism and the dynamic developing between them as would-be patron and protegée, even though they were far removed from the world of belles lettres. Wilson writes, "We can imagine his attitude toward Charlotte Forten: sympathetic, approving, instructive, very sure of his own benevolence," a perspective her clear deference to him undoubtedly enhanced. Forten must have enjoyed such ardent attention from men whom she so deeply esteemed, a group that came to include Colonel Robert Gould Shaw, the son of abolitionists and the young commander of the 54th Massachusetts Regiment of black soldiers from New England.

But the war also proved to be for Forten another period of profound personal loss, moves, and disruptions, as well as of new recognition through her writing. On 20 July 1863 she mourned the devastating loss of Colonel Shaw and much of his regiment at nearby Fort Wagner. Two days later she volunteered as a nurse to treat the survivors of this catastrophic battle. Immediately thereafter she sailed for a two-month vacation in the North, returning to St. Helena on 16 October. In March 1864 Forten's father joined the Union army but died of typhoid in April, the first African American to be buried with full military honors. In May 1864 Charlotte Forten resigned from her Port Royal commitment and returned once again to Philadelphia. At this time Whittier's influence earned her the publication of "Life in the Sea Islands" in *The Atlantic* (May and June 1864); he introduced "Its young author" as "herself akin to the long-suffering race whose exodus she so pleasantly describes." Observing both people and place, Forten sent *Atlantic* readers a postcard from a corner of the war; Whittier called her memoir "graceful and picturesque," despite the occasional hardships she admits. But her description climaxed in the tragedy of Shaw's death, rendering him a martyr for the Union cause and an inspiration for his survivors. Forten concluded by declaring her own related sense of mission: "My heart sings a song of Thanksgiving, at the thought that I am permitted to do something for a long-abused race, and aid in promoting a higher, holier, and happier life on the Sea Islands."

If, as Wilson claims, the war in any sense "saved" Forten, her experience on the Sea Islands had also underlined her difference from both blacks and whites around her, especially in her first encounters with the people of her race who still operated under a plantation hierarchy even though their masters had abandoned the land. The field hands and their children, Forten's unschooled students, spoke Gullah, a Creole dialect alien to her, and the house servants treated her with suspicion. As her supervisor, Laura M. Towne, recalled, "The people on our place are inclined to question a

good deal about 'dat brown gal,' as they call Miss Forten. Aunt Becky required some coaxing to wait upon her and do her room. Aunt Phyllis is especially severe in the tone of her questions. . . . They put on this tone as a kind of reproach to us, I think."

A year later Higginson wrote to his wife of a change in the regard Southern African Americans had toward Forten: "When they heard her *play on the piano,* it quite put them down, and soon all grew fond of her. Miss Towne says she is *the* pet and belle of the island." Her cultural polish expanded Forten's possibilities for self-expression and endeared her to a liberal community that still internalized white superiority, in spite of its promotion of equality. Playing the limited roles of "pet" and "belle" in this light seems an ambiguous attainment, particularly considering Higginson's own professed aims to liberate women.

As the end of the war displaced soldiers from their commitments, it also displaced women such as Charlotte Forten from theirs, and in spite of Whittier's introduction of her to *The Atlantic* and her continued affiliation with Higginson, Forten never sustained a mainstream public authorial presence, in part because of the persistent and complicated racism of the postwar literary marketplace. By October 1865 she had moved to Boston and become the Secretary of the Teachers Committee of the New England Branch of the Freedmen's Union Commission, an appointment that kept her in contact with Higginson. After the war, however, he expressed his radical activism less through action than through language; although the bond he and Forten had forged in South Carolina seemed of mutual importance, the racial tension of Reconstruction, along with Forten's uncertain health, personal modesty, and preferred artistic genres, may have deterred her from the sort of phenomenal literary career he helped promote for the writer Helen Hunt Jackson. Higginson's well-received *Army Life in a Black Regiment,* which appeared first in installments in *The Atlantic Monthly* beginning in 1864 and was later published in a volume in 1870, included many descriptions that parallel Forten's journals. But he mentioned only the "self-devoted and well-educated teachers, mostly women" who served alongside him, not designating Forten by name. In a chapter titled "Negro Spirituals" he credits himself and his men of "iron memory" with the transcription. Forten may have helped him record them as well, as she had offered to transcribe slave hymns for Colonel Shaw after a "Praise House" shout and had included such transcriptions in "Life in the Sea Islands."

Some scholars speculate that Forten's illnesses were symptomatic of the "Victorian malady" that many contemporary women suffered as expressions of sup-pressed anger. Yet, according to Towne, Forten did survive smallpox during her days among the contraband, thus documenting a real, physical cause for Forten's ill health. A postwar letter dated 8 June 1867 from Forten to Lucy Chase, a Quaker abolitionist then teaching in Virginia, indicates that despite her persistent health problems, Forten remained committed to serve her ideals, both troubled by and impatient with her physical frailty:

I dread unspeakably spending another winter here, and if I am well enough to teach, I think I shall try to go to Florida, next year. I long to enter into the work again, & although for some reasons it would be very hard to leave Boston, yet I feel that I ought to go South, if I am able to teach. But the last year of my experience there taught me that it would be folly for me to attempt teaching again, anywhere, until my head should be better. Often, I was haunted by the fear of insanity, & indeed, I think I should have become insane had I continued to teach. Oh, if one could only be well!

In 1865 Whittier wrote to a colleague, hoping to place Charlotte Forten in Dr. Dioclesian Lewis's physical training sessions in Detroit "at reduced price." Apparently she was rejected as "hazardous to the enterprise." One month later, Whittier interceded for Forten, asking *Atlantic* editor James T. Fields for "some employment translating French stories, etc. She is and has been very unwell, and not able [to] write much herself." As Donald Dingledine notes in his introduction to a 1995 edition of Rebecca Harding Davis's novel *Waiting for the Verdict* (1867), Forten on 22 February 1868 published in *The National Anti-Slavery Standard* a critique of unqualified praise of that journal for the "philosophies of blood" in the novel. In 1869 Higginson contributed a preface to Forten's translation of *Madame Thérèse,* a novel about the French Revolution. Not mentioning the translator's name, he concludes, "It remains only to say that the translation has been made with care and conscientiousness, and will be found, it is believed, better than the average of such literary work." The 1869 edition does credit Forten with the translation on the title page, but by 1912 Scribner not only had dropped Higginson's preliminary remarks, but also had effaced the translator's identity altogether.

In 1870 Whittier, Higginson, and other important figures contacted the Boston Public Library about a job for Forten. Instead, in 1871 she moved to Charleston, South Carolina, to teach at the Shaw Memorial School. The next year she relocated to Washington, D.C., where she first taught at what became Dunbar High School and then earned an appointment as first-class clerk in the Fourth Auditor's Office of the U.S. Treasury. In 1872 Forten's two great intercessors corre-

sponded, Whittier writing to Higginson in frustration, proposing a concerned but not surprisingly paternalistic solution: "I am pained to hear of Charlotte Forten's illness. I wish the poor girl could be better situated–the wife of some good, true man who could appreciate her as she deserves." As William Wells Brown wrote about her, "Were she white, America would recognize her as one of its brightest gems." But as a black woman of tentative health whose sporadic work as poet and essayist did not command a remunerative following, Forten was difficult to promote, even for seasoned patrons such as Whittier and Higginson.

Although writing was not Forten's dominant occupation from 1872 to 1876, she did publish several pieces in different genres. One piece was "A Visit to the Birthplace of Whittier" (*Scribner's Monthly,* May 1872), a tribute to her lasting friendship with the Quaker poet. In 1876 she produced several essays, including "The Centennial Exposition," a description of its opening in Philadelphia; the essay ran in the 22 July, 29 July, and 5 August 1876 issues of *The Christian Register.* She also composed "A Summer in Virginia" and "From Washington," two short local descriptions–both collected in Cooper. That same year she published in *The Christian Register* a rebuttal to an article in *Scribner's* that had opposed integration, as well as a scathing letter in the 23 December 1876 issue of *The Commonwealth* that condemned the racist pronouncements of "Mr. Savage's Sermon: 'The Problem of the Hour,'" which had been printed in the same journal. In *The Woman's Journal* for 30 December 1876, Higginson applauded Forten's "calm and courteous reasoning" and the acuity of her argument.

In Washington, D.C., Forten met Francis J. Grimké, who became pastor of the Fifteenth Street Presbyterian Church. Grimké was the son of a slave, Nancy Weston, and Henry Grimké, a brother of white abolitionists Angelina and Sarah Grimké. When Angelina Grimké Weld discovered her brother's transgressions and the related abuses of other family members against her nephews Francis and his brother Archibald, she accepted them as her legitimate kin, extending them gestures of support. Francis Grimké graduated from Lincoln University, attended Howard Law School, and then completed his training in 1878 at Princeton Theological Seminary. In a December 1878 letter to Ednah Dow Cheney, Forten wrote, "I suppose you know that I am to marry a minister. . . . I remember my housekeeping experiences in Charleston with pleasure." While admitting her fatigue, in the same letter she expressed pleasure over the concurrent engagement of Mary Thacher and Thomas Wentworth Higginson, whose first wife had died in 1877. The Grimkés' wedding took place on 19 December 1878. Their only child,

Francis J. Grimké, whom Forten married in 1878

Theodora Cornelia, was born on 1 January 1880 but died within six months. In 1885, because of Francis Grimké's health, the couple moved to Jacksonville, Florida, where he served as minister of the Laura Street Presbyterian Church.

When they returned to Washington in 1889, Grimké resumed duties at his former church. At this time he and Charlotte became central figures in the flourishing black cultural life in the city. Anna Julia Cooper recalled salon-style weekend evenings at the Grimkés' home, which on Fridays they called "The Art Club." Cooper wished that she "could find in the English language a word to express the zest, the stimulating eager sense of pleasurable growth of those days." Dorothy Sterling remarks that Charlotte Forten Grimké lectured on Dante one evening at the Monday Night Literary Club in Washington.

In the 1880s and early 1890s, Forten published several more poems and essays. Her essays explored questions of race relations in the United States; "One Phase of the Race Question" appeared as a letter in the *Commonwealth* (December 1885) and "Colored People in New England" (collected in Cooper), which she sent to the *New York Evangelist* in October 1889. In June 1893 "Personal Recollections of Whittier" appeared in *The New England Magazine.* During these years, she also wrote art criticism such as "The Umbrian and Roman

School of Art," "Midsummer Days in the Capital: The Corcoran Art Gallery," and "The Corcoran Art Gallery in Winter." A lighter fictional piece, "The Flower Fairies' Reception," was published 8 August 1874 in *The Christian Register,* along with a glimpse into the life of a great reformer, "At the Home of Frederick Douglass."

Forten's journals cease in May 1864. But when she resumed her journal writing in November 1885, she spoke in a different voice. During the intervening decades she had occasionally published literary works, held a series of nonliterary jobs in different states, married, and endured the death of an infant and, as always, fluctuating health. In 1885 she wrote as a realist but one still committed to the fight for racial equality, one who did not equivocate about wishing to see her writing in print:

> sent my MS. entitled "One Phase of the Race Question," to Col. Higginson, asking if he thought it possible that I could get it into the "N.[orth] A.[tlantic] Review," & if not whether he could try to get it into the "Congregationalist" for me, or some other Boston paper which Gail Hamilton & other orthodox people could see.

Forten's article objects to the "contagion of color prejudice" that she found in Hamilton's article about intermarriage, "Race Prejudice," in *The North American Review* (November 1884). Evidently, Higginson could only partially fulfill her request, as the essay was printed as a letter to the editor of the Boston *Commonwealth.* Forten's rebuttal demonstrates her confidence not only in taking to task a popular and influential writer such as Hamilton, but in urging that her rejoinder be publicized. Forten had corresponded privately with public figures such as Lydia Maria Child, Harriet Martineau, Wendell Phillips, and Charles Sumner, in addition to Whittier and Higginson, but her stated ambition to have her opinions made public represents a striking transformation from the self-deprecating attitude toward publication that she had recorded in the 1850s.

Despite such an overt wish for visibility, a contemporary biographer of Forten, Lawson A. Scruggs, wrote in 1893:

> Her life in the District has not been an eventful one, much of her time being spent in church work, and therefore she has not done as much literary work as she had hoped to do. She sometimes tries to find consolation in the thought that possibly this is why her long-cherished dreams of becoming an authoress have never been fully realized. Few Afro-American women have been more useful than Mrs. Grimkee [*sic*].

To be sure, Forten's life as a minister's wife entailed commitment to both church and home. Such obliga-

tions grew between 1894 and 1898, when the Grimkés became legal guardians to Francis's niece Angelina Weld Grimké while her father, Archibald Grimké, worked overseas. In 1905 both Angelina and her father moved in with Charlotte and Francis. In the poem "To Keep the Memory of Charlotte Forten Grimké," Angelina Weld Grimké, who became a well-known dramatist and poet, recalled her aunt as a woman of "gentle spirit" who loved the "wonders of dark and day."

Forten continued to serve outside the home as trustee and secretary of the Westborough Insane Hospital. In an 1895 letter Francis Grimké remembered that his wife's "Reminiscences of the South" had been published in the *New York Independent.* In 1896 Charlotte Forten Grimké joined with Frances E. W. Harper, Rosetta Douglass Sprague, Fanny Jackson Coppin, Louisa Jacobs, Ella Sheppard Moore, and younger activists such as Ida Wells Barnett, Alice Moore (Dunbar), and Victoria Earle Mathews to found the National Association of Colored Women, a group at whose first convention Harriet Tubman spoke. Increasingly frail in the last five years of her life, tenderly cared for by her husband, Forten became bedridden in 1913 and died in Washington, D.C., on 23 July 1914.

In an anonymous obituary for Charlotte Forten Grimké published in the October 1914 *A. M. E. Review,* she is introduced as the wife of Dr. F. J. Grimké and the descendant of James Forten, before being acclaimed in her own right for her education, awards, teaching, writing, and publications. Curiously, Forten's eulogist then interjects some romantic speculation into an account of her antislavery work, claiming, "She stood high in anti-slavery circles, so much so that there is a tradition that she might have been Mrs. [Thomas Wentworth] Higginson instead of Mrs. Grimke had she so desired." This "tradition" has not been verified by any of Higginson's or Forten's biographers. The obituary turns immediately from this reference to celebrate the Grimkés as "one of the most devoted couples of human wedlock," a not unexpected detail in a memorial to a woman whose equally esteemed husband had survived her.

The day after Forten died, her husband remembered her as "one of the rarest spirits that ever lived . . . yet with all her sweetness, gentleness, and rare delicacy, she was a woman of great strength of character. She could take a stand and hold it against the world."

Recognized now mostly for her personal writing, Charlotte Forten also maintained a firm, if sporadic, public voice throughout her life, finding outlets for expression in the editorial columns of journals and in her social activism as teacher, minister's wife, and community leader. More of Forten's commentary may yet be recovered from the pages of nineteenth-century peri-

odicals, from others' memoirs, and from examining local or church publications, especially those dating from her years in Washington, D.C. Such a recovery would only add to the self-portrait that Forten's journals render of the life of an exceptional woman, as well as to fill in a broader cultural landscape of her times.

Biography:
Anna Julia Cooper, *Life and Writings of the Grimké Family* (N.p. , 1951).

References:
Joanne M. Braxton, *Black Women Writing Autobiography: A Tradition Within a Tradition* (Philadelphia: Temple University Press, 1989);

"Death in the High Ranks of Afro-America," *A. M. E. Review* (October 1914): 217–218;

Joanne Dobson, *Dickinson and the Strategies of Reticence* (Bloomington: Indiana University Press, 1989);

Tilden G. Edelstein, *Strange Enthusiasm: A Life of Thomas Wentworth Higginson* (New Haven: Yale University Press, 1968);

Francis J. Grimké, *Stray Thoughts and Meditations and Letters,* volumes 3 and 4 of *The Works of Francis J. Grimké,* edited by Carter J. Woodson (Washington, D.C.: Associated Publishers, 1942);

Thomas Wentworth Higginson, *Army Life in a Black Regiment,* volume 3 of *The Writings of Thomas Wentworth Higginson* (Boston: Houghton, Mifflin, 1900);

Mary Kelley, *Private Woman, Public Stage: Literary Domesticity in Nineteenth-Century America* (New York: Oxford University Press, 1984);

Carla L. Peterson, *"Doers of the Word": African-American Women Speakers and Writers in the North (1830–1880)* (New York: Oxford University Press, 1995), pp. 176–195;

Katharine Rodier, "'A Career of Letters': Emily Dickinson, T. W. Higginson, and Literary Women," dissertation, University of Connecticut, 1995, pp. 79–94;

Seth Rogers, *Letters of Maj. Seth Rogers, M. D., Surgeon of the First South Carolina Volunteers, the First Freedmen's Regiment, Thirty-Third U. S. Colored Infantry, 1862–1863* (Boston: John Wilson, 1910);

Willie Lee Rose, *Rehearsal for Reconstruction: The Port Royal Experiment* (New York: Vintage, 1969);

Lawson A. Scruggs, *Women of Distinction: Remarkable in Words and Invincible in Character* (Raleigh, N.C.: L. A. Scruggs, 1893), pp. 193–196;

Joan R. Sherman, *Invisible Poets: Afro-Americans of the Nineteenth Century* (Urbana: University of Illinois Press, 1974), pp. 88–95;

Dorothy Sterling, *We Are Your Sisters: Black Women in the Nineteenth Century* (New York: Norton, 1984);

Henry L. Swint, ed., *Dear Ones At Home: Letters From Contraband Camps* (Nashville: Vanderbilt University Press, 1966), pp. 219–220;

Laura M. Towne, *Letters and Diary of Laura Towne,* edited by Rupert S. Holland (Cambridge, Mass.: Riverside Press, 1912);

Cheryl Walker, *The Nightingale's Burden: Women Poets and American Culture Before 1900* (Bloomington: Indiana University Press, 1982);

John Greenleaf Whittier, *The Letters of John Greenleaf Whittier,* 3 volumes, edited by John B. Pickard (Cambridge, Mass.: Harvard University Press, 1975);

Edmund Wilson, "Northerners in the South: Charlotte Forten and Colonel Higginson," in his *Patriotic Gore* (New York: Oxford University Press, 1962) pp. 239–257.

Papers:
Charlotte L. Forten's manuscripts are part of the Francis J. Grimké Collection in the Moorland-Spingarn Research Center of Howard University. A few of her letters can be found at the Boston Public Library; her letter to Lucy Chase is at the American Antiquarian Society in Worcester, Massachusetts. Documents that may be written in her hand are included in the Thomas Wentworth Higginson Papers at the Houghton Library, Harvard University.

Margaret Fuller

(23 May 1810 – 19 July 1850)

Eric Purchase

See also the Fuller entries in *DLB 1: The American Renaissance in New England; DLB 59: American Literary Critics and Scholars, 1800–1850; DLB 73: American Magazine Journalists, 1741–1850; DLB 183: American Travel Writers, 1776–1864;* and *DLB 223: The American Renaissance in New England, Second Series.*

BOOKS: *Summer on the Lakes, in 1843* (Boston: Little & Brown / New York: C. S. Francis, 1844);

Woman in the Nineteenth Century (New York: Greeley & McElrath, 1845; London: Clarke, 1845);

Papers on Literature and Art, 2 volumes (New York & London: Wiley & Putnam, 1846);

Memoirs of Margaret Fuller Ossoli, edited, with contributions, by Ralph Waldo Emerson, James Freeman Clarke, and William Henry Channing (2 volumes, Boston: Phillips, Sampson, 1852; 3 volumes, London: Bentley, 1852);

At Home and Abroad, or Things and Thoughts in America and Europe, edited by Arthur B. Fuller (Boston: Crosby, Nichols / London: Sampson Low, 1856);

Life Without and Life Within; or, Reviews, Narratives, Essays, and Poems, edited by Arthur B. Fuller (Boston: Brown, Taggard & Chase / New York: Sheldon / Philadelphia: Lippincott / London: Sampson Low, 1860);

Art, Literature, and the Drama, edited by Arthur B. Fuller (Boston: Brown, Taggard & Chase / New York: Sheldon / Philadelphia: Lippincott / London: Sampson Low, 1860);

Margaret and Her Friends, or Ten Conversations with Margaret Fuller upon the Mythology of the Greeks and its Expression in Art Held at the House of the Rev. George Ripley, Bedford Place, Boston, Beginning March 1, 1841, reported by Caroline W. Healey (Boston: Roberts, 1895).

Collections: *The Writings of Margaret Fuller,* edited by Mason Wade (New York: Viking, 1941);

Margaret Fuller: American Romantic. A Selection from her Writings and Correspondence, edited by Perry Miller (Garden City, N.Y.: Anchor/Doubleday, 1963);

Margaret Fuller (engraving after a portrait by Chappel)

The Woman and the Myth: Margaret Fuller's Life and Writings, edited by Bell Gale Chevigny (Old Westbury, N.Y.: Feminist Press, 1976);

Margaret Fuller: Essays on American Life and Letters, edited by Joel Myerson (New Haven, Conn.: College & University Press, 1978);

These Sad But Glorious Days: Dispatches from Europe, 1846–1850, edited by Larry J. Reynolds and Susan

Belasco Smith (New Haven: Yale University Press, 1991);

The Essential Margaret Fuller, edited by Jeffrey Steele (New Brunswick, N.J.: Rutgers University Press, 1992);

The Portable Margaret Fuller, edited by Mary Kelley (New York: Penguin, 1994);

Margaret Fuller's New York Journalism, edited by Catherine C. Mitchell (Knoxville: University of Tennessee Press, 1995).

OTHER: Johann Eckermann, *Conversations with Goethe in the Last Years of His Life,* translated by Fuller (Boston: Hilliard, Gray, 1839);

Günderode, translated by Fuller (Boston: E. P. Peabody, 1842).

"The destiny of each human being is no doubt great and peculiar," wrote Margaret Fuller to James Nathan in May 1845, "but there are also in every age a few in whose lot the meaning of that age is concentrated. I feel that I am one of those persons in my age and sex. I feel *chosen among women*." Her words echo the angel Gabriel's greeting to Mary, "Blessed art thou among women." Fuller felt that she could create the universal human image, not in a book but in the example of her life. A writer by profession, Fuller always sought to transcend the merely literary in order to invent an immediate relationship with the world. Hoping to create a shared awareness of human life in its highest state, she pursued friendships with many of the most prominent writers and thinkers in antebellum America. She tried to practice the ideal friendship imagined by the German Transcendentalists. Though her intensity often disconcerted her friends and her ego sometimes interfered with her relationships, such friendships remained a primary object throughout her life.

Fuller's view of friendship carried over to her writing; she tried to address readers intimately and much of her best writing appears in her surviving private letters, which have been collected in six volumes. Many of her publications also took the form of letters, including *Summer on the Lakes, in 1843* (1844) and the dispatches she wrote for the *New-York Tribune* in 1846–1850. Ultimately, there is little difference between Fuller's personal and public works. Readers should consider her writings as a whole that illustrates a conception of life in which intellect is joined with intimacy and idealism is linked with risk.

Margaret Fuller was one of the brightest and most educated American women of the nineteenth century. She owed her education to her father, Timothy Fuller, a man with a stiff, utilitarian personality, progressive

ideas, and a soft heart for his wife, Margarett Crane Fuller. He became a Unitarian when it was considered a radical theology; he advocated abolition and female education. A Harvard graduate, Timothy Fuller had taught school before studying law and being admitted to the bar in 1804. A supporter of John Quincy Adams, he served in the Massachusetts state senate (1813–1817), the U.S. House of Representatives (1817–1824), and the Massachusetts house of representatives (1825–1828, 1831–1833). When his first child, Sarah Margaret, was born on 23 May 1810, he was practicing law in Cambridge, Massachusetts. The eldest of seven children who survived infancy, Margaret Fuller had one sister, Ellen, and five brothers, Eugene, William Henry, Arthur, Richard, and Lloyd.

As a child Margaret Fuller demonstrated unusual intelligence, and her father began to oversee an exacting course of lessons. She knew the alphabet by age three and soon began to read English. At age five she started studying Latin grammar, which she learned in a few weeks. She later studied Greek, French, Italian, and German. Much of her mature approach to the world and to intellectual work was shaped and limited by her classical education. Learning gave her the ability and confidence to hold her own in dealings with the brightest men of her age. At the same time the classics served as a literary model that Fuller tended to use even when inappropriate. For *Woman in the Nineteenth Century* (1845), for instance, she adopted full periods, declamation, and exempla from Cicero's forensic orations; as a result, her writing was high-toned and earnest but also long-winded and diffuse.

Intense learning at an early age left a lasting effect on Fuller. Every day her father had her memorize a passage from Virgil, which she had to recite perfectly to him after dinner before she was allowed to go to bed for the night. As Fuller commented in "Autobiographical Romance" (written circa 1840): "As he was subject to many interruptions, I was often kept up till very late; and as he was a severe teacher, both from his habits of mind and his ambition for me, my feelings were kept on the stretch till the recitations were over. . . . The consequence was a premature development of the brain, that made me a 'youthful prodigy' by day, and by night a victim of spectral illusions, nightmare, and somnambulism. . . ." This emotionally charged pressure to learn, combined with nearsightedness, gave Fuller chronic headaches and "nervous affections" throughout her life. The symptoms worsened when she was under pressure from deadlines or strained friendships. Nevertheless, Fuller always persisted with her work because, even as a child, reading, writing, and knowledge gave her distinction while satisfying a deep, abiding curiosity about the world.

Fuller's parents, Timothy and Margarett Crane Fuller (from Robert N. Hudspeth, ed.,
The Letters of Margaret Fuller, *volume 1, 1984)*

The Latin classics and the writings of Plutarch gave Fuller a vivid, idealized perception of how one ought to conduct oneself in the world, namely, with noble Stoicism. In "Autobiographical Romance" she wrote, "The genius of Rome displayed itself in Character" and exclaimed, "ROME! it stands by itself, a clear Word. The power of will, the dignity of a fixed purpose is what it utters." Fuller identified her father's commonsensical approach to things with what she termed "Roman virtue," and she often sought this quality in her acquaintances, men and women. Many of her letters remind friends of the noble purposes they share. Many acquaintances disappointed Fuller at some point, such as when her close friend Samuel Ward Gray, whom she called "Raphael," gave up painting to work in his family's bank.

Fuller did not exempt herself from her high standards. As a result, she sought the company of the great and often spoke pompously of herself. For example, on 16 June 1825, the fifteen-year-old wrote a letter to Revolutionary War hero Marie Joseph, Marquis de Lafayette, then on a triumphant tour through the United States, to express her hope of meeting him that evening at a party in his honor: "If I should not be disappointed, the timidity appropriate to youth and the presence of many strangers will probably prevent me from expressing the ardent sentiment of affection and enthusiastic admiration which pervades my soul; I cannot resist the desire of placing my idea before your mind if it be but for a moment; I cannot resist the desire of saying, 'La Fayette I love I admire you. . . .'" Along with the egotistical, inflated rhetoric, the letter expresses her desire to live up to her ideal: "Sir the contemplation of a character such as yours fills the soul with a noble ambition. Should we both live, and it is possible to a female, to whom the avenues to glory are seldom accessible, I will recall my name to your recollection." Fuller's search for heroic purpose continued throughout her life, interspersed with moments when she doubted her ability. She recognized that she might not be the foremost figure of her era; yet, she took herself seriously enough not to subordinate her talent to anyone else's goals.

In adulthood, imagination and emotional frankness tempered Fuller's heroic intellectualism. She later associated the imagination with her mother and her mother's garden, where the young Margaret Fuller

stood at the gate and daydreamed, not daring to enter because she was supposed to be doing her lessons. She linked both qualities with modern authors, especially William Shakespeare, Miguel de Cervantes, and Molière. She recalled that one Sunday *Romeo and Juliet* enchanted her so much that she disobeyed her father's command to read something more appropriate for the Sabbath, such as a book of sermons. Fuller developed these "feminine" qualities in a conscious attempt to make herself more socially adept.

By age ten Fuller had become isolated and somewhat arrogant, a result of several years of demanding study at home under her father's direction. Her work kept her away from other children, in whom she took little interest. In 1821, recognizing her shortcomings, her parents sent her to nearby Boston to attend a school kept by Dr. John Park, where she could receive an education more similar to that of most young girls, though Park's curriculum placed more emphasis on reading and languages than the typical sewing and singing. She quickly worked her way to the head of the class and enjoyed studying social accomplishments such as music and dancing. The other children, however, often made fun of her because she was awkward and pedantic. By late December 1822, Fuller had withdrawn from the school—perhaps because her headaches had worsened— and continued studying at home. Through her father's connections she began to go out into society. Many people disapproved of her because she was not demure, as women were supposed to be, but she also met young men preparing for college, including some who became influential, lifelong friends. They admired her learning, wit, and ability to argue forcefully. In 1824 Timothy Fuller sent Margaret to Susan Prescott's school in Groton, Massachusetts, about forty miles from Boston. He instructed her to think well of the other young women and to be gracious toward them. In 1825, however, Fuller suffered a crisis that was probably the basis for the Mariana episode in *Summer on the Lakes*. Her fellow students sought to humble her pride by a practical joke, which led to a severe bout of her usual ailments. Encouraged by one of her teachers, she learned from this episode that knowledge should not make her complacent about herself but should aid her in pursuing "Truth and Honor."

Fuller spent at least another year in Groton before returning to Cambridge in 1826. The next six years were among the happiest and most important in her life. She became a central figure in a group of young Unitarians who soon became Transcendentalists, including George Ripley, William Henry Channing, James Freeman Clarke, and Frederick Henry Hedge. Hedge later praised her conversational ability: "Though remarkably fluid and select, it was neither flu-

ency, nor choice of diction, nor wit, nor sentiment, that gave it its peculiar power, but accuracy of statement, keen discrimination, and a certain weight of judgment, which contrasted strongly and charmingly with the youth and sex of the speaker." These liberal thinkers appreciated Fuller's intellect. She became a warm, open friend to them and sought—even demanded—warmth in return. Under her friends' influence Fuller's reading expanded to include poets such as John Milton, Dante, and Torquato Tasso as well as modern authors. Hedge inspired Fuller and Clarke to study the German Transcendentalists, especially Johann von Goethe, from whom Fuller adopted many ideas, along with their rhetorical style. The most important projects of Fuller's early career were translations such as Goethe's play *Torquato Tasso* (completed by 1834 and posthumously published in *Art, Literature, and the Drama,* 1860) and Johann Eckermann's *Conversations with Goethe in the Last Years of His Life* (1839), as well as an unfinished biography of Goethe, on which she was working in 1837.

The re-election of Andrew Jackson to the presidency in 1832 spoiled Timothy Fuller's hopes for a diplomatic posting in Europe. When his term in the state house of representatives expired in 1833, he determined to retire to a farm in the country even though his family objected. The Fuller family moved to a small house in Groton, Massachusetts, where Margaret Fuller felt banished from the intellectual life of Boston. She corresponded with her friends, received them in Groton, and sometimes visited Cambridge, but writing and sporadic visits did not alleviate her sense of isolation. Moreover, in Groton much of her time was taken up with housework and the education of her younger siblings. Timothy Fuller died unexpectedly in 1835, leaving the farm and a small legacy, which the executor doled out sparingly. Her father's death forced Margaret Fuller to try to make money by writing, but her first articles and reviews earned her little, and she realized that she would have to teach for a living.

In 1836 she began work in Boston at Bronson Alcott's progressive Temple School, where the instructional method was discussion rather than coercion. At night Fuller taught German and Italian poetry to adult women at fifteen dollars for twenty-four lessons. In 1837 she accepted Albert Gorton Greene's offer of a generous salary of one thousand dollars to teach at his school in Providence, Rhode Island, where Fuller liked her work but longed to return to the Boston area. At the end of 1839, with her family's finances eased and with savings from her pay, she quit her job in Providence and joined her mother. By April they had settled in a new house in Jamaica Plain, near Boston.

Fuller's mature intellectual career started in 1839, when she organized the first of her annual Conversations

Albert Gorton Greene's progressive school in Providence, Rhode Island, where Fuller taught in 1837–1839

(which were held through 1844) and became editor of *The Dial.* In Providence she had been a popular teacher among her older women students, and she exchanged letters with some of them long after she left. Eager to offer more advanced intellectual training than was usually available to women, Fuller planned a series of discussions. As she told Sophia Ripley in a 27 August 1839 letter, Fuller intended these Conversations "to pass in review the departments of thought and knowledge and endeavor to place them in due relation to one another in our minds. To systematize thought and give a precision in which our sex are so deficient. . . ." Each series attracted about two dozen women and featured topics such as poetry, ethics, education, and Greek mythology. Fuller typically began a Conversation with a lecture summarizing the subject and then led a discussion. The women freely contributed whatever they knew or thought, and Fuller challenged them to link their knowledge to their lives. In an unpublished 1839 letter Sarah Clarke recalled Fuller's response to a participant's assertion that a woman had the right to judge by intuition: "'Yes,' says Margaret, gazing full upon her, 'but who are *you?* Were you an accomplished human being, were you all that a human being is capable of becoming, you might

perhaps have a right to say, "I *like* it therefore it is good"– but, if you are not all that, your judgment must be partial and unjust if it is guided by your feelings alone."'

Fuller began her work on *The Dial* when Hedge and Ralph Waldo Emerson wanted to establish a journal to promote Transcendentalism to a national audience but did not want to edit it. Promised two hundred dollars yearly from sales revenues, Fuller tapped her wide circle of friends for literary contributions, often without success. Some did not have the time or inclination; others who held pulpits in less-progressive towns did not want to associate themselves publicly with radical ideas. For example, Hedge refused to contribute anything to the first issue, which appeared in July 1840, even though the journal was originally his idea. Some of Fuller's women friends, such as Caroline Sturgis, agreed to contribute poetry but demanded that Fuller not reveal their identities, even to Emerson and other insiders. As a result, issues appeared late, and she was forced to write much of the material herself. *The Dial* attracted only a few subscribers, so Fuller earned nothing from it. She resigned the editorship in spring 1842, and the magazine ceased publication after the April 1844 issue.

Now established in her career, Fuller again began to consider the higher purpose of her life, trying not to imagine it as a lonely heroism. She believed that she belonged to a select group of souls (the Transcendentalists) who would point society toward a perfect, spiritual state. "A little leaven is leavening the whole mass for other bread," she wrote in *Summer on the Lakes.* An intense religious experience in the fall of 1840 had added a nearly mystical conviction to her belief. The failure of her friends to do anything matching her passionate belief in them did not discourage her. "As they fail to justify my expectation," she wrote Emerson in October 1841, "it only rises them higher and they become dearer as the heralds of great fulfillment." To Fuller this fulfillment could come only in the form of friendships that rose above egoism and rivalry. "But surely there will come a purer mode of being even in the world of Form," she assured Emerson in December 1840, after they had had a disagreement: "We shall move with unerring gentleness, we will read in an eye beam whether other beings have anything for us; on those who have not our only criticism will be to turn our eyes another way." As she became a more committed Christian, she came to desire the spiritual revival of churches, which she thought were diminished by self-serving, bourgeois values.

Still, Fuller remained confused about her role in creating a spiritual society. Before her mystical experience, on 24 February 1840 she wrote Charles King Newcomb that "if the religious sentiment is again to be expressed from our pulpits in its healthy vigor it must be by those who can speak unfettered by creed or covenant; each man from the inner light–." Yet, such utterance seemed beyond her. As she had told James Freeman Clarke in an 8 January 1839 letter, "The moment I lay open my heart, and tell the fresh feeling to any one who chooses to hear, I feel profaned." Sometimes she verged on a kind of quietism, as illustrated in her fable "The Magnolia of Lake Pontchartrain" (*The Dial,* January 1841). There she told the story of an orange tree that enjoyed the good will of humans as long as she bore fruit but was destroyed by them after a frost left her barren. Mother Nature partially granted her wish to withdraw from the earth into the silent spheres of heaven by reincarnating her as a magnolia, virginal "Queen of the South." Fuller saw her own life unfolding in a similar way: having worked hard for others for eight years, she seemed ready to give up writing altogether and to withdraw from the world. "Come what may," she told Channing in October 1840, just before writing this fable, "I do not expect to be the voice of this epoch . . . all my tendency is to the deepest privacy." Within months she reversed her attitude. On 19 February 1841 she wrote to Channing: "Once I was

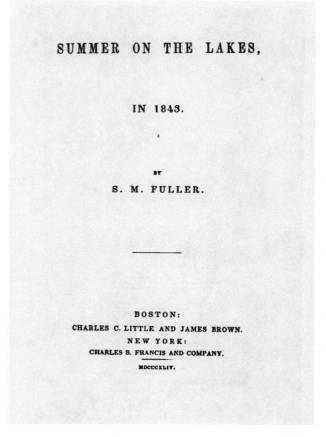

Title page for Fuller's account of her travels through the Great Lakes region with her friend Sarah Clarke

almost all intellect; now I am almost all feeling. Nature vindicates her rights, and I feel all Italy glowing beneath the Saxon crust. This cannot last long; I shall burn to ashes if all this smoulders here much longer. I must die if I do not burst forth in genius or heroism."

The work Fuller did during the rest of her career represents her provisional attempts to realize heaven through the material world. "I agree with those," she had told Channing in 1840, "who think that no true philosophy will try to ignore or annihilate the material part of man, but will rather seek to put it in its place, as servant and minister to the soul." She insisted on the primacy of experience over action or reflection and cited this aphorism from Goethe: "To me it was appointed not to write, or act, but *to live.*" In part she defined her position against Emerson, whom she criticized for his intellectualism. "O these tedious attempts to learn the universe by thought alone," she confided to Sturgis in October 1840. "Love, Love, my Father, thou hast given me.–I thank thee for its pains." During the 1840s Fuller struggled to create the philosophy she intuited by writing out what she experienced in the world,

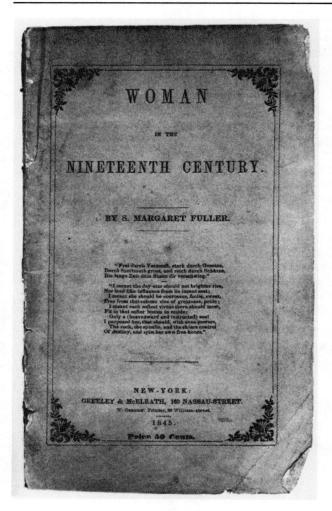

Cover for the feminist work that helped inspire the 1848 women's rights convention in Seneca Falls, New York

not merely her personal thoughts or feelings. Although she could apply to the world a perceptive, critical mind, conceptual thinking for her remained bound with book learning. Her three books, her columns for the *New-York Tribune,* and her personal letters were often an unlikely mixture of transcendental abstraction, literary references, and choice observation.

Fuller most successfully combined diverse experiences with a unitary consciousness in *Summer on the Lakes,* which resulted from a tour through the Great Lakes region with Clarke in 1843. Early nineteenth-century travel writers did not aim to record their impressions of the places they visited so much as to use the occasion of their visits to moralize about history, politics, and art. *Summer on the Lakes* follows this pattern, but Fuller created a rich text by carefully selecting and juxtaposing episodes. Unlike most travel writers of the time, she did not seek to convey "correct" opinions but to express her state of mind at the moment of experience. One idea is

related to the next not through any material connection but through the author's thought process. For example, chapter 5 describes a two-week stay in Milwaukee, at that time a new town. A brief lyrical description quickly turns into digression: Milwaukee "seems to grow before you, and has indeed but just emerged from the thickets of oak and wild roses. A few steps will take you into the thickets, and certainly I never saw so many wild roses, or of so beautiful a red." They remind her of Titian's painting of Venus and Adonis, which she discusses for almost a page.

Fuller next quoted a settler on the justness and inevitability of the Indians' vanishing; he concludes, "They ought not to be permitted to drive away *our* game." Then she recounted staying during a thunderstorm in a temporary "lodge" with some Pottawattomies, one of whom was sick yet insisted on giving up her dry seat to Fuller, who concluded, "They seemed, indeed, to have neither food, utensils, clothes, nor bedding. . . . Little wonder they drove off the game!" She went on to write about an elegant, young European couple, recent immigrants who are isolated and listless on the prairie.

Fuller then devoted some forty pages to a book by Justinus Kerner that she happened to be reading while in Milwaukee. Kerner, a disciple of Franz Mesmer, treated a young woman suffering from what is now called psychosis. Though gifted with imagination, this patient had been scorned and mistreated, and, like Fuller herself, she was a sleepwalker. In that state Kerner's patient suggested effective treatments for her own nervous ailments while, at the same time, she made statements significant for the doctor's soul. Inanimate objects—laurel, grapes, minerals—had magnetic effects on her. (These phenomena anticipate psychological concepts such as transference, compensation, and the collective unconscious.) Fuller eventually returned to Wisconsin and wrote about the Germanic immigrants pouring in there, expressing wonder at the variety of dreams, images, and intuitions their minds must contain. She ended her musing by observing, "There are no banks of established respectability in which to bury the talent" in the West.

In *Summer on the Lakes* Fuller valued forms of perception over the subjects she viewed. She did not state the obvious morals of her work: settlement destroys the natural beauty of the land; Indians deserve justice; people often view others' tragedies as coldly as they do a painting; and the most valuable part of a person is hidden inside. Fuller realized the complexity of the world in flux. She could not reverse the settlement process, even if that were desirable. Instead, she hoped to make people pay attention to what they despised or overlooked in the land, in the Indians, and in themselves.

Page from Fuller's 8 October 1846 letter to writer-reformer Mary Howitt, asking her and her husband, poet-activist William Howitt, to call on Fuller and her traveling companions, the Springs, during their stay in London (Pennsylvania State University Libraries)

Those things and their associated qualities of beauty and compassion are at odds with the dominant, utilitarian mindset, but noticing them opens the way to people's artistic or poetic faculty, with which they could imagine a richer form of civilization in the West.

Fuller's next book, *Woman in the Nineteenth Century,* continued her subtle approach to social injustice. The book is a moderately expanded version of "The Great Lawsuit: Man *versus* Men, Woman *versus* Women," a long essay she wrote for the July 1843 issue of *The Dial.* Fuller changed the title for the book because, she admitted, many readers did not understand the original title; yet, it illustrates Fuller's complex point. She did not argue that men have oppressed women; instead she maintained that the shortsightedness of society and individuals had prevented both men and women from developing their full potentials, thereby preventing them from becoming what Emerson called "Representative" Men or Women: "As men become aware that few men have had a fair chance," she wrote, "they are inclined to say that no women have

had a fair chance." She argued that women must have freedom from household drudgery and the arbitrary controls of husbands, fathers, and brothers. In reply to charges that this liberation would undermine women's indispensable contribution to the stability of the American home, Fuller pointed to popular concerns for the dignity of women expressed in newspapers and linked justice for women to abolition and the larger issue of human rights. Her remedy for women is, therefore, the same as for any human: "What woman needs is not as a woman to act or rule, but as a nature to grow, as an intellect to discern, as soul to live freely and unimpeded, to unfold such powers as were given her when we left our common home."

Fuller did not avoid controversy. She detailed domestic abuse and argued for a higher conception of marriage than the merely utilitarian or sentimental. Above all, she wished for a marriage of souls rather than of hearts or convenience. Fuller also pleaded for society to appreciate women's "magnetic" power, which, she felt, distinguished them from men. Magne-

Giovanni Ossoli in the late 1840s (Houghton Library, Harvard University)

tism, in Fuller's understanding, is not primarily sexuality; it means the libidinous, or erotic, power that attracts people to each other and contributes to creativity. Perhaps referring to herself, Fuller wrote that "women of genius, even more than men, are likely to be enslaved by an impassioned sensibility. The world repels them more rudely, and they are of weaker bodily frame. Those, who seem overladen with electricity, frighten those around them. . . . Sickness is the frequent result of this over-charged existence." This frankness appealed to Horace Greeley when he read "The Great Lawsuit," and he asked Fuller to expand the essay into a book. *Woman in the Nineteenth Century* helped to inspire the July 1848 women's rights convention in Seneca Falls, New York. A second edition appeared in 1855. The book faded from view, however, as the nation became preoccupied by slavery, territorial expansion, and sectional rivalry. Yet, the book earned Fuller the admiration of liberals on both sides of the Atlantic. Greeley asked her to move to New York and become a regular columnist for his *New-York Tribune,* and, when Fuller traveled to Europe in 1846, she found that the book had made her a celebrity in progressive circles.

Fuller moved to New York City in December 1844 and wrote more than two hundred reviews and articles during her twenty months with the *New-York Tribune.* In New York City Fuller confronted crime, poverty, racism, and other societal ills. She visited prisons and asylums; she wrote sympathetically of Irish Americans and African Americans; she spoke out against the gap between rich and poor. In "The Wrongs of American Women" (30 September 1845) she attacked those who criticized "the departure of Woman from her sphere" and claimed that they "can scarcely fail to see at present that a vast proportion of the sex, if not the better half, do not, CANNOT, have this domestic sphere. Thousands and scores of thousands in this country no less than in Europe are obliged to maintain themselves alone." Fuller added that "there is an imperative necessity for opening more avenues of employment to women, and fitting them better to enter them, rather than keeping them back."

Many powerful nineteenth-century journalistic exposés of urban conditions drew their power from detailed recording of life in factories and slums. Fuller's utopianism often kept her from writing effectively about the social wrongs she wished to help remedy. For example, Fuller's essay "What Fits a Man to Be a Voter? Is It to Be White Within, or White Without?" (31 March 1846) has a compelling title, but its point is obscured by an extended allegory involving butternut, chestnut, and walnut trees. Her meaning also becomes lost in character sketches, like those of Theophratus, that she used to discuss the great wealth and poverty of New York: "our ideal poor man needs to be religious, wise, dignified and humble, grasping at nothing, claiming all; willing to wait, never willing to give up; servile to none, the servant of all . . . " ("The Poor Man–An Ideal Sketch," 25 March 1846). The rich man uses his wealth to set a good example for society, as when he builds a house for himself: "It is substantial, for he wishes to give no countenance to the paper buildings that correspond with other worthless paper currency of a credit system" ("The Rich Man–An Ideal Sketch," 6 February 1846). Fuller neglected to offer a bridge between well-established social conditions and the ideal state she desired.

In 1846 Fuller's *Papers on Literature and Art,* a selection of criticism she wrote for *The Dial* and the *Tribune,* was published. She regretted that the collection was not more inclusive, for she had written many reviews of American, English, and European literature along with art and music. *Papers on Literature and Art* includes, among other things, an evaluation of contemporary English poets, a notice of an 1839 exhibition of Washington Allston's paintings, a review of three books about Swedenborgism, and an essay on

the lives of five composers. The most valuable piece for the student of Fuller's writings is "A Short Essay on Critics" (first published in the July 1840 issue of *The Dial*), which describes her critical method. She first strove to understand a work on its own terms. Then, she examined the larger context, the relationship of the work to other things in the world, for which purpose she employed categorical logic. In a review of a new edition of Milton's prose (*New-York Daily Tribune*, 7 October 1845), Fuller laid out three reasons why the work was valuable for her readers: Milton's prose combines the sacred and the profane, ancient and modern; it exercises the reader's "poetic and reflective faculties"; and, as a Puritan, Milton was "emphatically *American.*" Above all, Fuller was judicious. She deprecated work when she thought her judgment was just—even if the author enjoyed a great reputation. Still, she held no work to impossibly high standards and looked for the best each had to offer.

In 1846 Fuller took a long-awaited opportunity to go to Europe, where she became what some critics have called the first American foreign correspondent. Her friends Marcus and Rebecca Spring paid her fare in exchange for Fuller's tutoring their son. Fuller shrewdly put off to the last minute discussing with Greeley compensation for reports from abroad and considered switching to another newspaper; he gave her ten dollars per column, twice the payment other correspondents received. In August Fuller and the Springs landed in Great Britain, where she traveled extensively and sought out significant writers and thinkers. She wrote to Sturgis of her deep regret at not having visited Europe sooner: "It was no false instinct that said I might here find an atmosphere needed to develope [*sic*] me in ways *I* need. Had I only come ten years earlier; now my life must ever be a failure. . . ." In London, Giuseppe Mazzini, an Italian exile, impressed Fuller with his zeal for humanitarian projects and revolutionary movements. Fuller met him again in Rome, where he became a leader of the short-lived Republic. In November 1846 Fuller and the Springs went to Paris, where she became close to Polish expatriate poet Adam Mickiewicz. Unlike her moralistic friends in New England, Mickiewicz confirmed Fuller's belief in magnetic friendship and urged her to pursue her genius without shame.

Mazzini and Mickiewicz gave Fuller a political education that prepared her for Italy, which she reached in March 1847. She soon met a young nobleman, the Marchese Giovanni Ossoli, who became the father of her son, Angelo Ossoli, born in September 1848. Revolutionary European politics heavily influenced Fuller's personal life. The election of the liberal Pope Pius X in 1846 gave Romans the hope of establishing an Italian democracy; the Milanese revolted from Austrian rule,

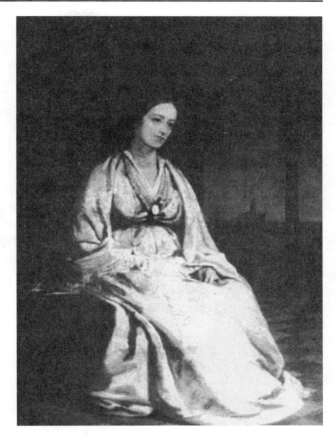

Fuller in Rome while it was under siege by French troops, April–July 1849 (portrait by Thomas Hicks; Houghton Library, Harvard University)

and Giuseppe Garibaldi launched a campaign for a united Italy freed from rule by church, nobility, or foreign powers. In November 1848 the Pope, who had had second thoughts about reform, fled and Rome was declared a republic. The Austrians, however, won a decisive victory in the north, and the French landed in Italy in April 1849 to "liberate" Rome. A committed republican, Ossoli went off to fight while Fuller stayed in Rome. During the French siege of the city in June, Fuller nursed the wounded in hospitals and wrote for the *Tribune*.

In her dispatches from Rome, Fuller used her writing talent and prestige in direct service of her lifelong belief that mankind "beats with one great heart." Her reports on this revolutionary period in Europe are the best sustained writing of her career. Fuller was one of the American intellectuals in Italy who paid attention to politics; for the others, Italy meant past glory and present quaintness, and they barely noticed the political turbulence that preceded the Republic. Fuller's writing in Italy became crisp and powerful, as in her 2 December 1848 account of how an assassin stabbed Pellegrino

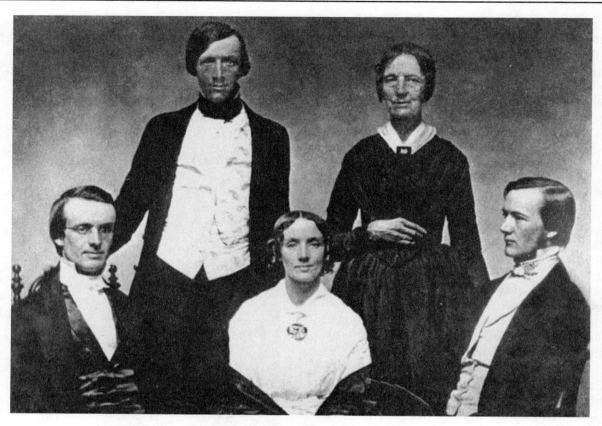

*The Fuller family in the early 1850s: Arthur, Eugene, Ellen, Margarett Crane, and Richard
(from Robert N. Hudspeth, ed.,* The Letters of Margaret Fuller, *volume 3, 1984)*

Rossi, an unpopular government minister appointed by the Pope, as he got out of his carriage in front of the assembly hall: "The horses stopped; he alighted in the midst of a crowd; it jostled him as if for the purpose of insult; he turned abruptly and received as he did so the fatal blow. It was dealt by a resolute, perhaps experienced, hand; he fell and spoke no word more" (*New-York Daily Tribune,* 26 January 1849). Her appeals for help from America were moving and practical: "I see you have meetings, where you speak of the Italians, the Hungarians. I pray you *do something.* . . . Our Government must abstain from interference, but private action is practicable, is due. . . . Send money, send cheer— acknowledge as the legitimate leaders and rulers those men who represent the people, who understand its wants, who are ready to die or to live for its good" (*New-York Daily Tribune,* 11 August 1849). Fuller understood that for democratic leaders to succeed the people's allegiance to them must appear unequivocal. Her plea was calculated to boost the legitimacy of the revolutionary movement and her friends who directed it.

Since 1848 Fuller had been working on a book about the Italian revolution, which was nearly complete when she and Ossoli decided to leave Italy for America. By 1850 Ossoli's family had disowned him, and Italy was not safe for supporters of the failed revolution. Fuller braced herself for a cold reception from her friends in New England and New York, whom she hastened to inform of her child and relationship. After they left Italy in May, the captain of their ship died suddenly. The ocean crossing took two months, at the end of which the captain's inexperienced replacement ran the ship aground off New York's Fire Island in a storm; the ship, as a result, broke into pieces. The Ossolis drowned, and Henry David Thoreau, who was sent to recover their belongings, could find only one trunk that contained some letters and clothes. The manuscript for Fuller's last book was lost.

Margaret Fuller's life and work make her the most important New England Transcendentalist after Emerson and Thoreau. Like Thoreau, she tried not just to write about her ideas, but to enact them in practical ways; writing served as one tool to that end. Fuller believed that she had been given her intellectual and emotional gifts to help lead a spiritual revival of society. She did not want to become the messiah; rather, she hoped to make the "Human Form Divine"

visible through her life. In this ambition Fuller anticipated the giant, prophetic figures in great American epics such as Walt Whitman's *Leaves of Grass* (1855), William Carlos Williams's *Paterson* (1946–1958), and Charles Olson's *Maximus Poems* (1953–1975). In a late *Maximus* poem Olson expressed a similar goal: "It is not I, / even if the life appeared / biographical. The only interesting thing / is if one can be / an image / of man. . . ." Fuller was one of the first American writers to try to enact this possibility.

Letters:

Love-Letters of Margaret Fuller 1845–1846 (New York: Appleton, 1903; London: Unwin, 1903);

Letters of Margaret Fuller, 6 volumes, edited by Robert N. Hudspeth (Ithaca, N.Y.: Cornell University Press, 1983–1994).

Bibliographies:

Joel Myerson, *Margaret Fuller: An Annotated Secondary Bibliography* (New York: Burt Franklin, 1977);

Myerson, *Margaret Fuller: A Descriptive Bibliography* (Pittsburgh: University of Pittsburgh Press, 1978);

Myerson, "Supplement to *Margaret Fuller: An Annotated Secondary Bibliography,*" in *Studies in the American Renaissance* (New York: Burt Franklin, 1984), pp. 331–385;

Robert N. Hudspeth, "Margaret Fuller," in *The Transcendentalists: A Review of Research and Criticism,* edited by Myerson (New York: Modern Language Association, 1984), pp. 175–188;

Myerson, *Margaret Fuller: An Annotated Secondary Bibliography, 1983–1995* (Westport, Conn.: Greenwood Press, 1998).

Biographies:

Julia Ward Howe, *Margaret Fuller (Marchesa Ossoli)* (Boston: Roberts, 1883);

Thomas Wentworth Higginson, *Margaret Fuller Ossoli* (Boston: Houghton, Mifflin, 1884);

Mason Wade, *Margaret Fuller: Whetstone of Genius* (New York: Viking, 1940);

Madeleine B. Stern, *The Life of Margaret Fuller* (New York: Dutton, 1942);

Faith Chipperfield, *In Quest of Love: The Life and Death of Margaret Fuller* (New York: Coward-McCann, 1957);

Joseph Jay Deiss, *The Roman Years of Margaret Fuller* (New York: Crowell, 1969);

Charles Capper, *Margaret Fuller: An American Romantic Life,* volume 1: *The Private Years* (New York: Oxford University Press, 1992);

Donna Dickenson, *Margaret Fuller: Writing a Woman's Life* (New York: St. Martin's Press, 1993);

Joan Von Mehren, *Minerva and the Muse: A Life of Margaret Fuller* (Amherst: University of Massachusetts Press, 1994).

References:

Margaret Vanderhaar Allen, *The Achievement of Margaret Fuller* (University Park: Pennsylvania State University Press, 1979);

Paula B. Blanchard, *Margaret Fuller: From Transcendentalism to Revolution* (New York: Delacorte / Seymour Lawrence, 1978);

Joel Myerson, "Margaret Fuller's 1842 Journal: At Concord with the Emersons," *Harvard Literary Bulletin,* 21 (July 1973): 320–340;

Myerson, ed., *Critical Essays on Margaret Fuller* (Boston: G. K. Hall, 1980);

Leona Rostenberg, "Margaret Fuller's Roman Diary," *Journal of Modern History,* 12 (June 1940): 209–220;

Marie Mitchell Olesen Urbanski, *Margaret Fuller's Woman in the Nineteenth Century: A Study of Form and Content, of Sources and Influences* (Westport, Conn.: Greenwood Press, 1980).

Papers:

The Fuller Family Papers are in the Houghton Library at Harvard University. The Boston Public Library also has an extensive collection.

Sarah Moore Grimké

(26 November 1792 – 23 December 1873)

Shirley Lumpkin
Marshall University

BOOKS: *An Epistle to the Clergy of the Southern States* (New York: American Anti-Slavery Society, 1836);
Letters on the Equality of the Sexes and the Condition of Woman; Addressed to Mary S. Parker, President of the Boston Female Anti-Slavery Society (Boston: Isaac Knapp, 1838).

Edition: *The Public Years of Sarah and Angelina Grimké: Selected Writings, 1835–1839,* edited by Larry Ceplair (New York: Columbia University Press, 1989).

OTHER: Jonathan Dymon, *An Inquiry into the Accordancy of War with the Principles of Christianity,* edited by Sarah and Angelina Grimké, with notes by Thomas S. Grimké (Philadelphia: I. Ashmead, 1834);
Theodore Weld, ed., *American Slavery As It Is: Testimony of a Thousand Witnesses,* includes contributions by Grimké (New York: American Anti-Slavery Society, 1839);
Alphonse-Marie-Louis de Prat de Lamartine, *Joan of Arc: A Biography,* translated by Grimké (Boston: Adams, 1867);
"Letter to Westchester Convention, June 2, 1852," in *History of Woman Suffrage,* edited by Elizabeth Cady Stanton, Susan B. Anthony, and Matilda Jocelyn Gage, 6 volumes (New York: Fowler & Wells, 1881–1922), I: 353–355.

SELECTED PERIODICAL PUBLICATION–
UNCOLLECTED: "A Sketch of Thomas Grimké's Life Written by His Sisters in Philadelphia and Sent to His Friends in Charleston for their Approbation," by Sarah and Angelina Grimké, *Calumet: Magazine of the American Peace Society,* 2 (January–February 1835).

Sarah Moore Grimké (Library of Congress)

Sarah Moore Grimké was the author of the first developed public argument for women's equality in the United States. *Letters on the Equality of the Sexes* (1838) presented Grimké's self-taught feminist perspective on slavery, religion, and the rights of African Americans and women of all classes and espoused a vision of human equality and individual worth. Grimké's beliefs placed her outside the prevailing moral codes of her time and served as the basis for her lifelong struggle to emancipate herself and American society from the bondage of slavery, "unChristian" Christian churches, and prejudice against people of color and white women. An intellectually complex, self-taught, and self-liberating woman, she prefigured in her life and writing the arguments and struggles of late twentieth-century feminists. Her writing and work in the causes of abolition and women of the 1830s gave the nineteenth-century

woman's suffrage workers Abby Kelley, Lucy Stone, Elizabeth Cady Stanton, and Lucretia Mott the political experience, arguments, and ideas they needed to help end slavery and launch the woman's suffrage movement. Despite her groundbreaking work, Grimké is usually an invisible individual hidden behind the study of the "Grimké Sisters."

Born in Charleston, South Carolina, on 26 November 1792 to John Faucheraud Grimké and Mary Smith Grimké, Sarah Moore was the sixth child and second daughter of this socially prominent family. Her father, with his Huguenot heritage, British legal training, and war record as a lieutenant colonel in the Revolutionary army, was a South Carolina Supreme Court judge, a politician, a planter, and the owner of a Beaufort plantation, a Charleston townhouse, and hundreds of slaves. Mary Smith Grimké—allied to many South Carolina planters, slaveholders, politicians, and judges—contributed an equally prominent heritage to the family. Like her fourteen brothers and sisters, Sarah Grimké could have married and assumed a financially secure position in the slaveholding class of Charleston society. From the beginning, however, she separated herself from the assumptions, values, and expectations of her society. She thirsted after learning, attached herself to her father and her brother Thomas, and participated in their readings and arguments. Sarah also studied and read alone, formulating by age thirteen the desire to be a lawyer and envisioning herself standing before the bar at the same time as her brother Thomas. While her father and brother loved her and respected her mind, they, as did her mother, rejected summarily what they saw as her impractical, "unwomanly," and "unseemly" ambition to become an educated lawyer, an impossible goal for any woman in 1804 when no American higher educational institution was open to women.

Calling her early years "lonely" and "marred" by such familial and social rejection of her mind and individuality, Sarah Grimké later said she felt alienated in her youth. She identified the sources of this alienation as her experiences with slavery and as being denied, on the basis of gender, the opportunity for education and significant work. Through her later writing in diaries and letters, and through public testimony, Grimké recorded her youthful inability to see any difference between her position and that of the African Americans who were enslaved; she understood the bitterness of their lot. Such feelings led young Grimké to the illegal act of teaching a young slave to read—an act more radical and dangerous than wanting to be a lawyer. She was caught and severely chastised. She never accepted nor internalized the racial prejudice and assumptions about slavery that characterized the thinking of most nineteenth-century Charlestonians; moreover, her belief in

her inability to change anything led to her further alienation, loneliness, and disappointment.

Only the birth of her youngest sister, Angelina Emily Grimké, the last of the Grimké children, eased Sarah's increasing sense of suffering and difference. In 1805, at the age of thirteen, Grimké made the unusual request to become the godmother of her baby sister, Angelina. After three years devoted to raising "her" baby, sixteen-year-old Grimké entered Charleston society. From 1808 to 1819 she led the typical life of a socially prominent young woman, which focused on parties, clothes, and pleasant conversation designed to attract an acceptable husband. Her diary entries during this period, however, were not typical. Her inner life revolved around agonizing despair and searching. Grimké called her social life heedless, frivolous, and sinful and asked herself repeatedly, "Where are the talents committed to thy charge?" Even though she records that her brother Thomas talked her out of accepting an inappropriate marriage proposal when she was nineteen (an indication of the extent to which she had adhered to social expectations), her diaries show she had not lost her desire to learn, to do good work, and to use her "talents," the gifts of her mind and spirit.

Grimké's father set her upon the path toward final separation from Charleston society and her family. In 1819, when Grimké was about twenty-seven, the terminally ill Judge Grimké asked her to accompany him to Philadelphia and then to New Jersey in search of medical treatment. Alone with her father during his death and burial, she passed through a personal crisis, calling the time she spent with him both "hellish" and the "greatest blessing" she had received from God, next to her conversion. Apparently, although initially distressed and depressed, her experience led her to a stronger sense of independence and moral responsibility than she had ever had before.

On the lonely trip back home Grimké met a Quaker family and received a copy of Quaker John Woolman's journals of 1774. In 1820 she was still so distressed in spirit that her mother sent her to stay with relatives on a plantation in North Carolina to recover. During this period Grimké pondered the meaning of her previous life, her rebuffs, her loneliness, her father's death, the doctrines of Quakerism, and the words of Woolman, who wrote of following one's inner light to find God. Woolman in his journals also stressed his conviction that slavery was an evil institution and should be abolished through each individual's action.

This independent, private self-examination, which occurred while Grimké witnessed the daily workings of the institution of slavery on a North Carolina plantation, led her to pursue actively the life she believed a woman with her talents, and hence responsi-

Grimké's sister Angelina Grimké Weld, who joined her fight for abolition of slavery and for women's rights (Library of Congress)

bilities, should live. She left Charleston in 1821, took up residence in Philadelphia, and joined the Philadelphia Quaker Arch Street Meeting in 1821. While Grimké's actions were considered unusual by any nineteenth-century standard of womanly conduct, from the perspective of her family and Charleston society, her actions verged on lunacy. Thirty and unmarried, Sarah Grimké was living in the North, first with her widowed sister, Anna Frost, and then with a Quaker woman, Catherine Morris. Grimké wore the plain dress and used the speech patterns of Quakers, and she pursued her inner call to be a minister in the Quaker meeting.

For fourteen years, from 1821 to 1835, Grimké struggled to follow her inner light, to do good work, to speak in Quaker meeting, and to be a Quaker minister. Although she was free of her family and Charlestonians' daily judgment, her way was not clear. On 26 September 1826 Quaker Israel Morris, a widower with children, proposed marriage. In the indirect terms characteristic of the nineteenth century, her diaries reveal the strong romantic and sexual feelings she had for Morris, as well as how much she cherished him and relied on his advice, support, and friendship. She could not, however, see her work as being his wife and repeatedly turned down his offers. Instead, she focused on what she saw as her mission: saving Angelina from

the sins and vanities of the world, particularly the slaveholding world of Charleston; extensive reading in the Bible, theology, law, and politics; and trying to testify (to speak when moved to do so) in Quaker meeting. Grimké succeeded in helping her godchild; in November 1829 Angelina joined Sarah in Philadelphia to become another voluntary exile from a slaveholding society, and in March 1831 Angelina joined the Arch Street Quaker meeting. Sarah Grimké was increasingly distressed, however, by her position in the Quaker meeting and her inability to be a Quaker minister. Referring to her experience in Philadelphia in later years as one of "mired conscience," during the early 1830s she recorded in her diary the slights, sneers, and ridicule she felt directed toward her by the Quaker elders whenever she spoke. While she struggled to keep speaking when moved to do so, their disapproval weighed heavily on her, half convincing her that she was not doing God's good work but sinning by speaking. Her inner struggle to understand and to do God's will during this period resulted in intense suffering, leading her to doubt herself and label herself the vilest of sinners and to doubt the Quaker meeting, elders, and principles.

Once again, beloved family members and experiences with African Americans shaped her direction. When brother Thomas visited Philadelphia in September 1834, Sarah, Angelina, and he discussed and debated his principles, particularly those of the Peace Society; then Angelina debated Thomas on the subject of slavery and insisted that the three of them read and take up the issue when Thomas returned. Stimulated by the intellectual discussion and probably feeling like a welcome and equal participant rather than an object of scorn to be silenced as she did in the Quaker meeting, Grimké looked forward to continuing this kind of life. Thomas, however, died suddenly in October 1834. Sarah Grimké tried to carry on Thomas's good work by writing about his life and editing with Angelina the work he had annotated on Jonathan Dymon's Peace Principles and by trying to start a Peace Society among the Quakers. The Quakers rejected her attempt to organize them, just as they rejected her speaking in meetings.

Sarah Grimké's friendship with African American Quakers, especially Sarah Douglass and her mother, Grace, pushed Grimké further away from the Quakers. She was bitterly disappointed that Sarah Douglass was not allowed to be a full participant in the Quaker meeting because of her color. Seeing Douglass and other African Americans relegated to "negro benches" in the back of the meetinghouse and not admitted to "full fellowship" added to Sarah Grimké's growing alienation from the Quakers.

Despite Thomas, Sarah Douglass, and her own doubts, Grimké still struggled to live by Quaker principles and to participate in Quaker meetings and ministry. The final break came through Angelina. Finding herself called to public action on the abolition question, Angelina wrote a letter to William Lloyd Garrison on 30 August 1835. Garrison published Angelina's letter in *The Liberator*. In this letter, Angelina publicly committed herself as an individual and as a member of the Grimké family to the abolition cause. At first Sarah stood with Angelina's Quaker critics, agreeing that the letter was an inappropriate public, political action violating Quaker meeting rules and that Angelina was not following her inner light but rather, as Sarah wrote Angelina, "the voice of the tempter." Sarah even wrote Angelina that the suffering she had brought upon herself was deserved and she must "learn obedience" from her suffering. Angelina was unconvinced by her critics or Sarah's words. Writing Sarah a long letter, Angelina explained her thinking and indicated her intention to become both a writer and a speaker for the antislavery cause. Corresponding with Angelina, Sarah grew more aware of Angelina's thinking and purpose, more concerned about her separation from Angelina, and convinced that Angelina might embark on her antislavery speaking tour alone. Then, on 3 August 1836, Sarah Grimké was interrupted and silenced by Elder Edwards while speaking during a Quaker meeting. Her call to Quaker ministry had met a rejection as devastating as had her desire to become a lawyer—and from the same kind of male authority. Grimké's way became clear to her. She wrote Angelina that she would leave Philadelphia and join in antislavery work.

Sarah Grimké's decision to join Angelina in the late summer of 1836 had multiple causes. The rejection by the Quakers in her call to do good work was certainly one, as was her love for Angelina and her sense of Angelina's determination. Sarah Grimké's lifelong and well-developed feelings against slavery and prejudice also inclined her toward such work. Her practice of coming to a decision through a long process of reading, thinking, praying, reflecting, and exchanging views with Angelina explains how Sarah Grimké could change her position on Angelina's public abolitionist actions. Possibly, Sarah also wanted to support her beloved sister and "daughter" Angelina in what awaited her, since Sarah knew through bitter experience what a woman who rose to speak and write in public faced.

Sarah joined Angelina and accompanied her to the October 1836 convention in New York sponsored by the American Anti-Slavery Society. Sarah became a volunteer agent for the American Anti-Slavery Society and began a two-year period (1836–1838) of intense collaboration in public speaking, writing, thinking, and discussing with Angelina that resulted in the sisters' writing all their major works and doing all their best-known public work.

Sarah Grimké undertook this enterprise with vigorous commitment, leaving behind her earlier reservations and doubts. At the October 1836 Anti-Slavery Society Convention, Grimké and her sister had also been invited by unanimous vote of antislavery men such as William Lloyd Garrison, African American minister Theodore S. Wright, Theodore Weld, and Henry Stanton to participate fully in discussion. Free to speak as well as learn, Grimké felt herself among like-minded people for the first time and wrote in a letter: "It is so good to be here that I don't know how to look forward to the end of such feast." Still smarting from her rejection by the Quakers, Grimké contrasted Anti-Slavery Society conventions and work with the Quaker meetings, pronouncing the antislavery convention "better, far better than any yearly meeting I ever attended." Sarah and Angelina used their training and talents at a series of "parlor meetings" conducted with women in New York and New Jersey under the aegis of the Anti-Slavery Society. Sarah Grimké spoke on the moral and theological grounds condemning slavery and called on all moral agents, including the Church and women, to act toward abolishing slavery.

In 1836, feeling that she had found "a new spring to my existence," Grimké wrote *An Epistle to the Clergy of the Southern States* and volunteered to edit a volume for the American Anti-Slavery Society on the 1832 Virginia legislature slavery debate, which had been prompted by the aftermath of the 1831 Nat Turner rebellion. While the editing project came to naught, her bold address to the clergy of the South was published by the American Anti-Slavery Society. Assuming the authority of a Southerner and a Christian, Grimké called her audience her "Brethren Beloved in the Lord" and presented them with a series of rhetorical questions damning the institution of slavery; biblical, theological, and clerical testimony against slavery; a contrast between the meanings of the Bible and the laws governing slavery; and a chain of logic leading to the inescapable conclusion that the Christian clergy in the South (and by implication in all regions of the United States) must "Repent! Repent! of their slaveholding spirit and support of slavery" if they were to be Christians. Grimké argued forcefully that "if ever there was a time when the Church of Christ was called upon to make an aggressive movement on the kingdom of darkness, this is the time." Grimké called on the clergy to use their position of authority and lead the battle against slavery on one theological ground. All men, she argued, were created in the image of God; therefore, chattel slavery, which reduced "rational and immortal creatures" to things,

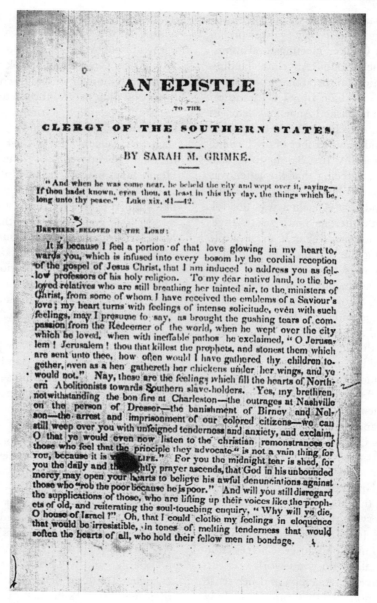

First page of the pamphlet in which Grimké argued that Southern ministers must repent of their stand on slavery if they were to remain Christians

was clearly evil. While her argument against slavery was conventional, the basis for her argument–the equality and therefore rights of all human beings–and her assertion of authority to speak on the principle of being an eyewitness and a moral agent with the right, indeed the duty, to upbraid the ministry for their sins, was not. Nor was her forceful, direct tone and extensive use of irony a conventional style for a woman to use when addressing a male audience in the public sphere. For example, playing on the words "peculiar institution," often used as a euphemism for slavery, Grimké wrote to her clerical (therefore predominantly male)

audience that "God is in a *peculiar* manner the God of the poor and the needy, the despised and the oppressed" and then directly warned them, "And he knows the sorrows of the American slave, and he will come down in mercy, or in judgment to deliver them." Her humble closing, "yours in gospel love and prayer," did not change her assertive tone.

While there is little indication of the intended audience's reception of Grimké's *An Epistle to the Clergy of the Southern States,* the work was crucial in her development as a woman writer and thinker. By directly addressing the clergy–and thus all men in authority,

whom she believed had always oppressed and silenced her–Grimké freed herself from the bondage of silence and created for herself a subtle, authoritative voice, rooted in anger and regret about her long years of spiritual submission. Grimké laid the foundations for all her future arguments for the equality of women in *An Epistle to the Clergy of the Southern States,* and she developed her prose style, using her own conception of her voice, irony, and tightly argued chains of reasoning with proofs drawn from reading and personal experience. While some contemporaries and future scholars judged her prose style "dry" when compared with Angelina's style, analyzing Sarah's writing in the context of her life and her self-education in legal rhetorical strategies leads to the conclusion that she deliberately created a prose style she believed would be an effective weapon in arguing against entrenched public opinions about religion, slavery, human rights, and women.

Grimké was not, however, developing her verbal skills and finding a public voice alone. She collaborated with Angelina through reading and discussion; joint letter writing to mutual friends such as Sarah Douglass, Harriot Hunt, Jane Smith, and Theodore Weld; and responding to her sister's arguments, ideas, drafts of written work, and speeches. These practices gave Sarah Grimké the strength to speak, write, hone her skills, and delight in her own and her sister's work.

As the Grimké sisters' meetings and writings drew more women to the antislavery movement during the early months of 1837, Sarah and Angelina were attacked on the basis of their gender. Considered "unnatural" women for speaking in public on political issues and moving outside a woman's sphere, the sisters were labeled "fanatical women" by Southern papers attempting to discredit them.

Sarah and Angelina were concerned about the "canker" of race prejudice they were finding among their new friends in the Anti-Slavery movement and in the North. They wrote jointly about the need for every Northerner to fight slavery by measuring "men, not by their complexions, but by their intellectual and moral worth" and focused on ensuring that the women in the antislavery movement would provide a model of interracial collaboration in the upcoming Anti-Slavery Convention of American Women held in New York 9–12 May 1837. Seeing Sarah Douglass's experiences with color prejudice as similar to her own and Angelina's experience with the attacks directed at their womanhood, Sarah began to create the connection she and Angelina emphasized throughout 1837: the denial of human rights to African Americans was like the denial of human rights to women and both were equally wrong.

Despite the attacks and because of her public speaking and writing, Grimké felt free for the first time in her life of the "spiritual bondage of being deprived of the right to speak." She tried to act on that freedom and offered Theodore Weld and the American Anti-Slavery Society a manuscript for publication exposing the errors of the Quaker Church on the issues of slavery, prejudice, and discrimination against African Americans and women called to preach. In a response foreshadowing later acts that silenced her, Weld and the Anti-Slavery Society refused to publish the work.

Sarah and Angelina, however, continued to speak out against slavery to increasingly larger meetings consisting of both women and men, referred to in the nineteenth century as "promiscuous audiences." Women addressing a mixed-gender group shocked the general public in 1837. But Sarah and Angelina went even further and publicly debated, before these "promiscuous" audiences, male opponents who questioned their testimony and arguments against slavery. Criticism in the form of attacks on Sarah and Angelina's womanhood increased in frequency and viciousness. Newspapers and common colloquial expressions often referred to both sisters, particularly Sarah, as frustrated spinsters displaying themselves in public to find a husband. One account suggested it would not be surprising to see Sarah Grimké walk naked down the streets in search of any white or even Negro man who would have her.

This kind of criticism based on unexamined assumptions about women rather than on substantive arguments against the Grimké sisters' position and Sarah's love for Angelina and her other women friends led Sarah to more daring public speech and writing in an attempt to reform society. During July 1837 Grimké began to write *Letters on the Equality of the Sexes and the Condition of Woman,* published first as a series of individual letters in *The New England Spectator,* then reprinted in *The Liberator,* and finally issued as a book in 1838.

After the first letter, "The Original Equality of Women," appeared in mid July 1837, the clergymen in New England tried to blunt the sisters' influence by denying them the use of churches and pulpits for their meetings and by issuing a pastoral letter, published in *The New England Spectator* on 12 July 1837. The clergymen's pastoral letter argued that "the appropriate duties and influence of women are clearly stated in the new Testament." Defining these duties as "unobtrusive and private," the clergy asserted that woman's moral influence and power is rooted in "dependence" on men and private actions in the home and Sabbath school. Citing modesty, piety, and love as woman's cardinal virtues, the clergy warned that the character of woman becomes unnatural when she removes herself from the protection of and dependency upon men. The letter ended

with an analogy meant to instruct woman in her appropriate role. A woman, the clergy wrote, should see herself as "the vine, whose strength and beauty is to lean upon the trellis and half conceal its clusters"; if the vine "thinks to assume the independence and the overshadowing nature of the elm, it will not only cease to bear fruit but fall in shame and dishonor into the dust." The clergy implied the Grimké sisters should be considered prime examples of dishonored and unnatural woman, and they proclaimed that the ruin of society would result from woman's assuming "the place and tone of man as a public reformer."

While Sarah Grimké had formulated her thinking before the pastoral letter, she felt compelled to respond publicly in writing and lecture to such ideas, particularly since they came from the clergy. She continued to lecture on the subject and to write her series of *Letters on the Equality of the Sexes*. These letters present the basic arguments for woman's rights that both the nineteenth-century woman's suffrage movement and the twentieth-century feminist movement in politics and literary theory used. Lucretia Mott referred to *Letters on the Equality of the Sexes* as the most important work about women since Mary Wollstonecraft's *Vindication of the Rights of Women* (1792).

Grimké began *Letters on the Equality of the Sexes* by demolishing the scriptural basis for woman's inferiority and limitation to a particular sphere of activity presented by the clergy. Prefiguring by 140 years the "resisting reader" approach of feminist theorist Judith Fetterly (*The Resisting Reader: A Feminist Approach to American Fiction,* published in 1978), Grimké reread the basic texts of nineteenth-century Christian thinking, the Bible and John Milton, using the perspective of gender. From the perspective of an independent thinker, resisting the assumption that literary texts were expressions of universal truths, Grimké argued that the Bible had to be read as a text translated by a group of men and *Paradise Lost* as a text written by a man. Men, she asserted, suffered from the "lust of dominion" that was the first effect of the Fall. Men, she argued, did not write God's truth but ideas that served their own interests and desire to be superior. Unmasking the patriarchal self-interest and bias that shaped these texts, Grimké proclaimed that both works made "woman a means to promote the welfare of man, without due regard to her own happiness." Rather than divine or universal truths, the texts she read with this method revealed what she called the "dogma" that women are inferior and should assume a subordinate position to men in general and husbands in particular. She pointed to Milton's misinterpretation of the creation story in his depiction of Eve as a woman who had just enough graces to "gratify the eye of her admiring husband" and "just intelligence

enough to comprehend her supposed inferiority to Adam and to yield unresisting submission to her lord and master." Grimké called this version of women "much admired sentimental nonsense. . . . fraught with absurdity and wickedness."

Going beyond her claims to authority in *An Epistle to the Clergy of the Southern States,* Grimké asserted her right to come to such conclusions as an independent thinker who sought wisdom and truth alone, not dependent upon male guidance. Grimké advocated that all women ought to do the same and argued that once the male bias in scripture, theology, and texts was exposed, readers would be able to see that man and woman were "created in perfect equality" and "were expected to exercise the viceregency intrusted to them by their Maker, in harmony and love." Then, Grimké reasoned, woman's role as man's "companion, in all respects his equal: one who was like himself a free agent, gifted with intellect and endowed with immortality" and as "a moral and responsible being" would be evident.

Having established woman's true nature and roles, Grimké exposed to public view the evils of woman's present social position, a position that had more in common with the slave than with free men and that created immeasurable suffering of body and soul for women. While Grimké recognized all the differences in kind between the positions of the slave and the free woman, cautioning "I do not wish by any means to intimate that the condition of free women can be compared to that of slaves in suffering or in degradation," still she asserted that the analogy between the two conditions was apt, since the basic deprivation of human rights and equality and the process of reducing the individual to an inferior position and form of servitude were the same.

Using increasingly assertive prose and often relying on irony, Grimké attacked the particular institutions and practices that degraded women. Ridiculing the claim of the pastoral letter to charitable authority, Grimké reread the clergy's "pretty simile" of woman as a vine leaning on the trellis of man's protection. Those women vines, she remarked, often felt what they leaned upon "has proved a broken reed at best, and oft a spear." She asserted that all she wanted from men was "that they will take their feet from off our neck and permit us to stand upright on that ground which God designed us to occupy." Grimké directly attacked the institution of marriage and the laws governing it as oppression designed to reduce women to the status of noncitizens, unable to own property or their own wages and unable to vote, thereby making them objects relegated to the kitchen or the nursery, designed to attract the notice and win the attention of men. Grimké linked husbands with slaveholders, referring to the "peculiar character of husband," echoing the pun she had made

on the "peculiar institution" of slavery in her *Epistle to the Clergy of the Southern States* and labeling their power over women "unlimited and brutal." Equating marriage with slavery through her pun and through her direct statement, Grimké catalogued women's secret sufferings.

Having disposed of the clergy's claims to authority and the institution of marriage, Grimké argued that women were also made inferior to men "by the disproportionate value set on the time and labor of men and of women," citing the different wages earned by men and women, sometimes for the same work. She included slave women in this category, pointing out that they were subject to special oppression as women laborers since they were used as "brood mares" and subjected to the sexual abuse of their masters. Here Grimké made an indirect argument for the sisterhood of all women, regardless of color and status, by remarking that the "colored woman" does not "suffer alone: the moral purity of the white woman is deeply contaminated" by living in "habitual intercourse" with the men who practiced these cruel assaults upon the virtue of colored women with impunity.

Grimké called upon women to unite and liberate themselves. While pointing out how women had been driven to their inferior positions, Grimké expressed her grief that women participated in their own servitude and her conviction that as a free and equal agent under God, woman is accountable only to God for her behavior. She called on women to rise up in their womanhood, to act for their equality and human rights, and to do their moral duty for themselves and their sisters.

Grimké's 1838 *Letters on the Equality of Sexes* was also her personal declaration of independence. Echoing the language of the Declaration of Independence and prefiguring the Declaration of Sentiments at the Seneca Falls Woman's Rights Convention (1848), Grimké declared that since "man and woman were created equal, and endowed by their beneficent Creator with the same intellectual powers and the same moral responsibilities, and that consequently whatever is morally right for a man to do is morally right for a woman to do," she and all women had the right to "preach the unsearchable riches of Christ." Grimké used some of her most scathing irony and devastating logic on the gender issue that had injured her most in her own life: the barring of women from positions of authority to speak as a minister, lawyer, judge, politician, or citizen. Noting that "any attentive observer cannot fail to perceive" that men had deliberately "reserved" all the offices with power, money, and honor for themselves by declaring women by nature unfit for such positions, Grimké used her knowledge of scriptures and theology and her method of independent reading, resisting patriarchal assumptions and biases, to prove that women

Spring Street Church, in New York City, where the Grimké sisters delivered a series of antislavery lectures in 1837

were anointed by the Holy Ghost to preach. She attacked in the strongest language the "educational prejudice" and deliberate attempts that characterized her society to crush the voice of "any woman who needs to speak out." Grimké's last thrust at exposing the contradictions and crushing brutality of such men showed her own doubt that anything would change. Speaking from experience, Grimké observed that men (especially clergymen) seemed, at their worst, willing to let souls perish than to allow the truths of the gospel to be delivered by women. She wondered how any woman could ever rise above the outer and inner circumstances designed to crush her voice.

Grimké called on her sisters to end the silencing and painful bondage of the "tradition of men." First, she said, women must think for themselves, use their own minds, read with the eyes of a woman analyzing the assumptions being made and the values being taught about women in all texts, and refuse to grant divine or universal authority to any male-authored text written from a man's perspective and serving a man's interests.

Grimké insisted secondly that women free themselves from believing the specious assumption that men and women are inherently different and have therefore different natures and responsibilities. Duties, she argued, must be seen as belonging to situations, not to sex. She

called upon women to overcome their fear of people's insolent remarks and criticism and to do whatever the times demanded to bring about moral reformation.

Thirdly, she argued that women had to free themselves from the "unseen fetters of ecclesiastical censure" and emancipate themselves from the opinions of men in any role—husband, father, brother, friend, or minister. Woman cannot see herself as subject to any man and fulfill her duty, Grimké reasoned, especially when her duties are precisely those most men want her to avoid—writing, speaking as ministers or politicians, distributing periodicals, or engaging in petition campaigns. An independent and moral woman must use her talents as she sees fit and through the guidance of her own inner light, Grimké ended, answering, perhaps unconsciously, her own question to herself in her early diaries.

Grimké was willing to acknowledge the difficulty of what she was asking women to do. She acknowledged that the good opinion of men was dear to women and that women who used their talents in public faced fearsome reprisals in speech and actions, as she knew from personal experience. Grimké argued metaphorically that she saw a "root of bitterness" growing up in families and between men and women as the result of the mistaken notion of the inequality of the sexes and that the only way to keep that root from bearing bitter fruit was for men and women to associate upon the grounds of the moral dignity, character, and personal responsibility of equal individuals with the same human rights.

Letters on the Equality of the Sexes bore sweet and bitter fruit. Many women who were to become leaders in the abolition and woman's suffrage movement—such as Abby Kelley, Lucy Stone, and Elizabeth Cady Stanton—took heart from the clarity and power of *Letters on the Equality of the Sexes,* and some women became actively involved with women's causes because of reading them. Some men, such as William Lloyd Garrison, applauded Grimké's reasoning and attacks on the Church and the patriarchy; Garrison reprinted her letters in his antislavery periodical, *The Liberator,* and directly connected the antislavery cause with the cause of women. The ranks of Grimké's opponents, however, swelled to include her and Angelina's closest male friends in the abolition movement, Theodore Weld and John Greenleaf Whittier. Although Sarah wrote the *Letters on the Equality of the Sexes,* Weld and Whittier approached both sisters with their criticism. Weld and Whittier argued that Sarah and Angelina's advocacy of woman's rights damaged the antislavery effort, that they overrated the power of the Northeastern ministry, and that they made unsubstantiated charges about the motives and ideas of antislavery men. Sarah and Angelina stood as one against these attacks, answering letters jointly and honing their arguments together. In an October 1837 letter, Theodore Weld wrote angrily to Sarah and Angelina, contrasting the "busy, honest men" and their good work with the "retired rooms" where women, incapable of analyzing, scanned what men had said and done, and used "Miss Construction" to make up charges of bias against women.

Sarah Grimké's reaction to such criticism from her friends was anger, depression, and concern for her sister Angelina. She wrote to one of her supportive male friends in the antislavery movement, Henry Wright, that "my very soul is sick of the narrow-minded policy of Christians, of abolitionists, trying to keep asunder the different parts of Christianity, as if it were not a beautiful and harmonious system which could not be divided." Admitting that she had never seen Angelina as downcast as she was about the violent criticism, Sarah acknowledged the effects of the men's opinions by writing that it "requires divine assistance to sustain the present pressure of opinion from those we love." Sarah also wrote about her firm intention, based on much past bitter experience, not to "surrender . . . [her] right to discuss any great moral subject." She joined with Angelina to draft a strong reply to the criticism of their friends. The sisters replied that the emancipation campaign was actually being crippled by woman's position; for if the women who had been told that "silence is our province, submission our duty" were supported in asserting their right to labor in the cause, emancipation would be that much nearer. The sisters' parting shot was "Anti-slavery men are trying very hard to separate what God hath joined together."

Weld withdrew somewhat from the public argument, unwilling to damage irreparably his relationship with the sisters (particularly with Angelina) and suggested that they meet to discuss their differences and cease writing about them. Sarah and Angelina asserted their "free agency" as women and their right to speak and act from their own conviction of duty and right. They continued to lecture to large, promiscuous audiences, exposing the brutality of slavery, the moral necessity for emancipation, and the rights of women to speak and act in the cause. Sarah wrote to one of her critics, Amos Phelps, who believed their speaking to be un-Quaker-like and unwomanly, "We believe that this subject of women's rights and duties must come before the public for discussion, and that the Lord will help us to endure the opposition, contumely & scorn which will be cast upon womanhood." She also continued to use logic and her sharp wit to tell audiences that "kindness to slaves is a contradiction in terms" and to ask them to hope that "light may shine out to the glory of God, the ending of slavery and the enfranchisement of women." In the fall of 1837 Sarah and Angelina brought this message to more than forty thousand people.

By November and December 1837, however, Sarah Grimké's mood was somber. She was not doing public speaking but nursing Angelina, ill, probably with typhoid fever. While more convinced than ever that, in her words, "there is no male and female in Christ" and continuing her search for supporting evidence by reading the Bible in Greek to see what it really said on peace, women, the appointment of ministers, the clergy, and Christian duty, Grimké seemed somewhat alienated from the American Anti-Slavery Society's abolition movement and felt a call to preach to African Americans. The truth she wanted to preach, she wrote Weld, was "the whole truth as it is in Jesus, instead of taking one great principle and separating it from the rest of his blessed gospel"—meaning the emancipation of African Americans and women from slavery and prejudice. Despite Weld's injunction not to write further letters on the subject of woman's rights, Grimké continued to debate Weld and attack his position. While firm in her principles and approaches, Grimké did not seem hopeful about success for either cause; she wrote Douglass that "this is the hour and power of darkness, not for the slave but for our country" and wrote Weld that she was "sometimes ready to conclude" that the Lord "will break us in pieces as a potter's vessel" and raise up others more fearless to preach the whole truth.

Perhaps Grimké's mood foreshadowed the coming change in her life. Weld declared his love to Angelina in December of 1837. Suddenly Angelina and Weld were the "kindred spirits," as Grimké wrote to Angelina's friend Jane Smith, rather than Sarah and Angelina. Certainly, Sarah Grimké had her own relationship with Weld; she argued, debated, and discussed with him and demonstrated solicitude for his well-being. She must have known, however, that marriage would permanently alter the relationship among the three of them and the nature of her battle for emancipation.

Both sisters continued to prepare for two important public-speaking events, an appearance before a committee of the Massachusetts house of representatives in February 1838 and a March 1838 series of lectures, arranged by the Boston antislavery women, at the Odeon in Boston. Grimké intended to continue her speaking and writing for the one "Great Cause" of emancipation, and she was trying to become more fearless in her advocacy of emancipation of slaves and women. Illness prevented her from speaking to the legislature in February 1838. In March 1838 she gave the first Odeon lecture on emancipation and included an attack on the governor of Massachusetts for having expressed his willingness to send troops to the South in the event of a slave insurrection. She never again spoke in public for the cause of emancipation, either of slave or woman.

The apparent cause of her silencing was a letter Weld wrote to her after her Odeon lecture. Weld reported

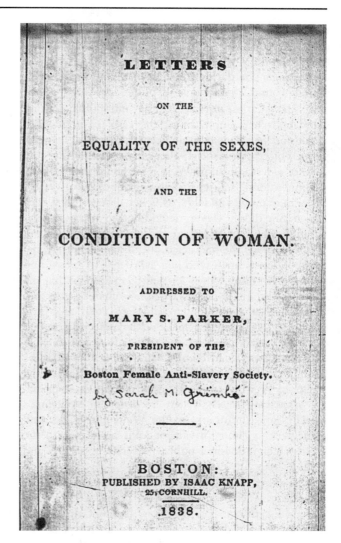

Title page for Grimké's public writings espousing the rights of women and slaves

criticism of Sarah's speaking and praise of Angelina's speaking he had heard from abolition and anti-abolition men. While he emphasized he was writing out of love for her and the cause, he asked Sarah to conceal his letter from Angelina, to consider not speaking again in the Odeon series, and to resign all future public speaking to Angelina, whose effectiveness was apparent. Weld tried to soften the blow by insisting that the heavy and "boring" manner of her speaking, not the matter, was the object of the criticism and by giving Sarah the choice of speaking or turning the lectures over to Angelina. He clearly implied, however, that Sarah damaged the cause of emancipation while Angelina helped it.

Sarah was devastated. Although she had often written her own friends that Angelina was a better speaker and that she was on the lecture circuit to support and relieve Angelina, Sarah knew how important it

was to her own identity as a responsible individual to speak in public. She shared the letter with Angelina and then wrote to Weld that "it seemed as if God rebuked me in anger for daring to set my unhallowed foot on sacred ground." Sarah gave up public speaking.

Her diaries, private letters, and public writing show both her emphasis on the right of women to speak and her own pain at being constantly denied a public voice by her society, her father, her brother, the Quaker elders, and now Weld. Her emotional devastation and internalized sense of unworthiness after Weld's criticism is understandable, as is her decision to silence herself. She did, however, defend herself and assess the situation. She told Weld she did not regret her Odeon lecture because she had acted out of love for Angelina, the abolition women who had asked her to speak, and the cause. In other letters to friends, she hoped that she had passed the role of speaking on woman's rights and abolition to the women around her, such as Maria Chapman, and that "the spark we have been permitted to kindle on the woman question will never go out." How much personal comfort she derived from these thoughts is hard to determine, for from the date of the receipt of Weld's letter in 1838, Grimké became primarily a private letter writer, recorder of Angelina's speeches and the doings of the Weld household, and participant in either private or joint projects with the Welds. Her individual public presence in speech and writing essentially ended.

In May of 1838 Angelina and Weld married; by mutual agreement, Grimké and the Welds set up housekeeping together at Fort Lee, New Jersey. Grimké, like Angelina, turned down repeated requests to speak, the number of requests definitively indicating that not all listeners agreed with the criticisms Weld had reported. Grimké's reply to Anne Warren Weston in July 1838 is typical of her stated reasons for leaving the public-speaking circuit. Saying she did not need to return to speak in Massachusetts, Grimké wrote, "The door is open, and the field has had one ploughing & those who take the plough next will find the soil more yielding, I think. I do not know but my business is simply to open doors, or do the first rough work." Still anxious to support the cause of emancipation, Grimké recommended other women speakers who combined the causes of women and the slave, such as Kelley and Chapman. She also used her love of her "sweet retirement" and her lack of an inner call as reasons to turn down requests to speak in Ohio and Pennsylvania. She seemed to believe she was called to private work as a member of Angelina and Theodore Weld's household; as a circulator of petitions; and as a collector, editor, and writer of her own testimony for Weld's book project for the American Anti-Slavery Society, *American Slavery As It*

Is: Testimony of a Thousand Witnesses (1839). Although devoted to the abolition cause, Weld believed strongly in modesty and criticized "pride" as the worst of sins. He believed an author's attaching his or her name to works appearing in public was sinful pride. Possibly Grimké and Angelina agreed with Weld or perhaps they just followed his ideas on this point, since neither sister's name appears on anything but the testimony each wrote for *American Slavery As It Is.*

Without Weld or the Grimkés' name on the work, *American Slavery As It Is* became a powerful weapon in the arsenal of the American Anti-Slavery Society. When first printed, the work sold one hundred thousand copies and continued to outsell any antislavery work until the appearance of Harriet Beecher Stowe's *Uncle Tom's Cabin* (1852). Sarah and Angelina read thousands of newspaper accounts of slavery, collected and edited testimony, and contributed their own written testimony. Sarah's testimony sprang from the same principles as her previous writing and speaking—the duty to write about and bear witness to the horrors of slavery so that others might plainly see their duty to end slavery and the creation of authority to speak on the basis of her moral duty, personal observation, and firsthand knowledge. In her testimony Grimké again used her contrast of pretensions to goodness and respectability with what an independent analysis of the situation revealed.

Emphasizing that she was telling stories about treatment of slaves by the "men and women of the highest respectability" and of the "first families of South Carolina," Grimké's only concession to family loyalty was to hide that the men and women she described were her own family members and personal friends from her days in Charleston and the North Carolina plantation visit. She was unsparing in her details and described whippings, the use of iron collars, the sexual violation of women slaves, and the deaths of slaves. She was judgmental in her contrast of the behaviors of the men and women who owned and abused these slaves with their reputations as "charitable," "courteous," "benevolent," and "Christian" members of Charleston high society.

Through changes of residence and the opening of the Weld-family-run Belleville, New Jersey, school in the 1840s, Grimké played a central role in the domestic circle of Angelina and Theodore Weld. She mothered her nephew Charles Stuart Faucheraud Weld, born in 1839; her nephew Theodore Grimké Weld, born in 1841; and her niece, Sarah Grimké Weld, born in 1844. While helping to run the household, Grimké also participated in the abolitionist petition campaigns by gathering signatures on petitions to present to John Quincy Adams in the House of Representatives.

Although she was not a part of the 1848 Seneca Falls Women's Rights Convention, Grimké kept in touch

with the cause of women's rights through correspondence with her good friend Harriot K. Hunt, a woman doctor and outspoken advocate of women's civil, social, and educational equality. In June 1852 Grimké wrote a letter read at the first Woman's Rights Convention held in West Chester, Pennsylvania. Almost fourteen years after her *Letters on the Equality of the Sexes,* Grimké took up her public writing again in behalf of women.

This time her audience was limited to the women (and the few men) who attended the convention. Using the metaphor of an insect emerging from a chrysalis, Grimké described woman's present condition as emerging, just at the point of seeing the natural and intellectual world inviting her to enter and possess it. Grimké suggested that woman was in a perilous place, facing the disadvantages and inconveniences of her past, the constraints of her current position, and the advantages of a change. Grimké counseled going calmly forward, guided neither by scorn nor by too narrow a vision of possibilities but by God's wisdom and the expectation that the contradictions would eventually disappear and a perfected individual emerge. This language was quite a contrast to the assertions, ironies, deconstructions of false thinking, and resisting readings of the *Letters to the Clergy of the Southern States* and *Letters on the Equality of the Sexes.*

From 1853 to 1854 Grimké lived apart from the Welds and struggled, as did Angelina, with their relationship. Biographers, with scant evidence, have suggested that Angelina and Sarah became estranged over differences about money and child-rearing practices. The only remaining letter from Angelina to Sarah on the subject was written after Angelina and Theodore Weld decided to dissolve their household and, with their children, join the Raritan Bay Union cooperative in Perth Amboy, New Jersey, and operate the Union's school, Eaglewood. Sarah was against the move, in part because of her attachment to her nephews and niece, whom she referred to as "her children" or "Theodore's children," and her preference for a single household. This disagreement, however, was not central to Angelina's letter. Angelina expressed anguish over Sarah's role in the Weld household. Angelina may have been referring to Sarah's taking over Angelina's role as mother to the children, to Sarah's combining with Theodore to teach Angelina her sins of pride and lack of appropriate motherly feeling, or to Sarah's writing letters criticizing Weld for his temper, careless dress, and inattention to the family's needs. While not naming the actions, Angelina was quite descriptive about the effect on her: "I would not, could not blame you although I have suffered so intensely, that had I not had a pretty well balanced structure, I am sure I should have been a Manaic long ago. . . . the conflicts thro' which I have passed have been terrible." Receiving such a frank description of suffering and being named the cause had a power-

ful effect on Sarah. She knew from Angelina's letter that she was welcome to rejoin the Weld household on a different basis at the Raritan Bay Union, but she looked actively for other options. She wrote her friend Harriot Hunt and inquired about the possibility of studying medicine. She considered rewriting her *Letters on the Equality of the Sexes* and helping the woman's movement by writing articles and pamphlets, compiling the laws pertaining to women in different states and exposing their unfairness, and becoming a spokesperson for the rights of the child. She decided, however, to return to the Weld household because, as she explained in a letter, "At 60 I look back on a life of deep disappointments, of withered hopes, of unlooked for suffering, of severe discipline. Yet I have sometimes tasted exquisite joy and have found solace for many a woe in the innocence and earnest love of Theodore's children." Sarah Grimké's decision to return to private domestic life was final; she chose her relationship to the Weld children above all other callings.

For the next nineteen years, from 1854 to her death in 1873, Grimké played a different role within the Weld household and with the Weld children. While she did not enjoy the Raritan Bay Union or the French teaching she was assigned there, she persevered, taught herself French, and endured teaching others. She moved with the Weld family to Newton, Massachusetts, in 1863. Throughout this period, while teaching and taking on domestic duties, she worked locally in her own neighborhood for her causes. She circulated petitions, collected money for African Americans freed by the Civil War, wrote articles for local newspapers, read, and performed many local charitable and political acts.

In 1868 Grimké learned that she had three additional nephews, the sons of her brother Henry Grimké and his slave Nancy Weston. Along with Angelina, Sarah lived her principles of equality and welcomed her nephews into her home and life, undertaking the task of finding the funds to educate Archibald and Francis Grimké. They both attended Lincoln University, and then Archibald attended Harvard Law School while Francis went to Princeton Theological Seminary. Grimké tried to raise money for the nephews' education by writing a novel about an octoroon marrying a white man. The novel was rejected on the basis of subject matter. She did, however, have a translation of Alphonse-Marie-Louis de Prat de Lamartine's biography of Joan of Arc privately published in 1867, proud of her self-education in French and convinced that the public needed a biography of a great woman.

As her rejected novel and published translation show, Grimké never wholly abandoned her commitment to the cause of human rights. She sold copies of John Stuart Mill's *The Subjection of Women* (1869) in her neighborhood, recognizing that Mill was making

exactly the same arguments, with the exception of the emphasis on the woman as minister, that she had made in *Letters on the Equality of the Sexes,* although neither he nor anyone else seemed familiar with her work. In 1870 she, along with fifty-eight other women and Angelina and Theodore Weld, cast a symbolic ballot in Newton, Massachusetts, to protest women's being denied the vote. Grimké publicized and battled the low wages and working conditions of women, comparing them to the slaves of the antebellum period, and arguing then, as she had earlier, that workers were entitled to the value of their labor. She used her nephews as an example of the absurdity of color prejudice, writing in letters that the so-called illegitimate Grimkés were the most talented of all the Grimké children and that "even my brother Thomas' sons, distinguished as he was, are far inferior to them in intellectual power." She lived her ideas about the equality of human beings, the necessity to see people in terms of their talents and actions, not their color or gender, and human rights in every public and private action until she died on 23 December 1873.

Eulogized and mourned by Weld, Angelina, Garrison, Stone, and others for her love, truth, independence, integrity, moral courage, and sympathy, Sarah Grimké was praised for her commitment and contributions to the abolition and woman's movements. All her 1873 eulogizers also admitted that outside their circle few knew or remembered Sarah Grimké's name, speeches, or written works. She had opened the way for Kelley, Stone, Chapman, and Stanton, who used her cogent written arguments in their campaigns for abolition and woman's rights and her life as an inspiring and instructive example. Although Grimké played an active role through her public speaking and writing in the social reform movements reshaping her society, she suffered the consequences of being a woman in that society. Forced back into an obscure private role through inner doubts, lack of confidence created through a lifetime of criticism, ridicule, pressure to conform, and personal conflict, her life and work were momentarily forgotten. The record of her life and her writing, particularly *Letters on the Equality of the Sexes,* were re-examined in the last half of the twentieth century and provided twentieth-century social activists in the woman and human rights movements with arguments and models for how to reform the perceptions and treatment of race and gender.

Letters:

Gilbert H. Barnes and Dwight L. Dumond, eds., *Letters of Theodore Dwight Weld, Angelina Grimké Weld and Sarah Grimké, 1822–1844,* 2 volumes (New York: Appleton-Century, 1934).

Biographies:

Catherine H. Birney, *The Grimké Sisters. Sarah and Angelina Grimké. The First American Women Advocates of Abolition and Women's Rights* (Boston: Lee & Shepard / New York: C. T. Dillingham, 1885);

Gerda Lerner, *The Grimké Sisters from South Carolina. Pioneers for Womens' Rights and Abolition* (New York: Schocken Books, 1971);

Katharine Du Pre Lumpkin, *The Emancipation of Angelina Grimké* (Chapel Hill: University of North Carolina Press, 1974);

Judith Nies, "Sarah Grimké," in *Seven Women. Portraits from the American Radical Tradition* (New York: Viking, 1977), pp. 3–31.

References:

Larry Ceplair, ed., *The Public Years of Sarah and Angelina Grimké: Selected Writings, 1835–1839* (New York: Columbia University Press, 1989);

Angelina Weld Grimké, "A Biographical Sketch of Archibald Grimké," *Opportunity, A Journal of Negro Life* (3 February 1925): 44–47;

Adrienne Koch, Untitled typescripts, *Maryland Historian,* 3 (Spring 1972): 51–84;

Elizabeth Cady Stanton, "Angelina Grimké, Reminiscences by E. C. S.," in *History of Woman Suffrage,* 6 volumes, edited by Stanton, Susan B. Anthony, and Matilda Joslyn Gage (New York: Fowler & Wells, 1881–1922), I: 392–406;

Theodore Weld, ed., *In Memory of Angelina Grimké Weld* (Boston: George N. Ellis, 1880);

Jean Fagen Yellin, *Women and Sisters. The Anti-Slavery Feminists in American Culture* (New Haven & London: Yale University Press, 1989).

Papers:

Some of Sarah Moore Grimké's papers may be found in the Gerrit Smith Collection of the George Arents Research Library for Special Collections at Syracuse University Library, Syracuse, New York. Miscellaneous letters to, from, or about Angelina Grimké and Sarah Grimké may be found in the Manuscript Division, Library of Congress. Manuscripts are located in the Department of Rare Books and Manuscripts, Boston Public Library; many letters to and from Angelina Grimké, Sarah Grimké, and Theodore Weld or about them, written in the 1830s, 1840s, 1860s, and 1870s may also be found at this location. The Negro Archives Collections of Howard University Library, Washington, D.C., includes many papers. The Weld-Grimké Collection, William L. Clements Library, University of Michigan, Ann Arbor, is the principal source for abundant letters, diaries, and other papers (published and unpublished) of Angelina and Sarah Grimké.

Sophia Peabody Hawthorne

(21 September 1809 – 26 February 1871)

Julie Elizabeth Hall
Sam Houston State University

See also the Nathaniel Hawthorne and Sophia Peabody Hawthorne entry in *DLB 183: American Travel Writers, 1776–1864.*

BOOKS: *Notes in England and Italy* (New York: Putnam, 1869; London: Sampson Low, 1869);
"The Cuba Journal," edited by Claire Badaracco, dissertation, Rutgers University, 1978.

OTHER: Nathaniel Hawthorne, *Passages from the American Note-Books,* 2 volumes, edited by Sophia Hawthorne (Boston: Ticknor & Fields, 1868);
Nathaniel Hawthorne, *Passages from the English Note-books,* 2 volumes, edited by Sophia Hawthorne (Boston: Fields, Osgood, 1870);
Nathaniel Hawthorne, *Passages from the French and Italian Note-books,* 2 volumes, edited by Sophia Hawthorne (Boston: Osgood, 1872);
"A Sophia Hawthorne Journal, 1843–1844," edited by John McDonald, in *The Nathaniel Hawthorne Journal, 1974,* edited by C. E. Frazer Clark Jr. (Englewood, Colo.: Microcard Editions Books, 1975), pp. 1–30;
"With Hawthorne in Wartime Concord: Sophia Hawthorne's 1862 Diary," edited by Thomas Woodson, James A. Rubino, and Jamie Barlowe Kayes, in *Studies in the American Renaissance 1988,* edited by Joel Myerson (Charlottesville: University Press of Virginia, 1988), pp. 281–359;
"Sophia Peabody Hawthorne's *American Notebooks,*" edited by Patricia Dunlavy Valenti, in *Studies in the American Renaissance 1996,* edited by Myerson (Charlottesville: University Press of Virginia, 1996), pp. 115–185.

SELECTED PERIODICAL PUBLICATION–
UNCOLLECTED: "Sophia Hawthorne's Diary for 1861," edited by Thomas Woodson, *Nathaniel Hawthorne Review,* 15 (Fall 1989): 1, 3–5.

Sophia Amelia Peabody Hawthorne, known to many as the wife of Nathaniel Hawthorne, was an art-

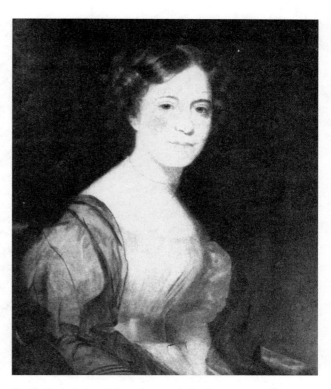

Sophia Peabody in 1830, twelve years before her marriage to Nathaniel Hawthorne (portrait by Chester Harding; from Louise Hall Tharp, The Peabody Sisters of Salem, *1950)*

ist, an intellectual, a lifelong writer of letters and journals, and, late in her life, a published author. Nathaniel Hawthorne once called her the "queen of journalizers" and wrote to his friend and publisher James T. Fields on 28 November 1859 that he had "never read anything so good as some of her narrative and descriptive epistles to her friends." To Fields's partner William D. Ticknor, Hawthorne wrote on 5 June 1857, "her descriptions are the most perfect pictures that were ever put on paper." Yet, recognition from the scholars has been long in coming for Sophia Hawthorne. Early studies of her husband's life and fiction depicted her as the quintessential Victorian female–subservient, prudish, weak, and

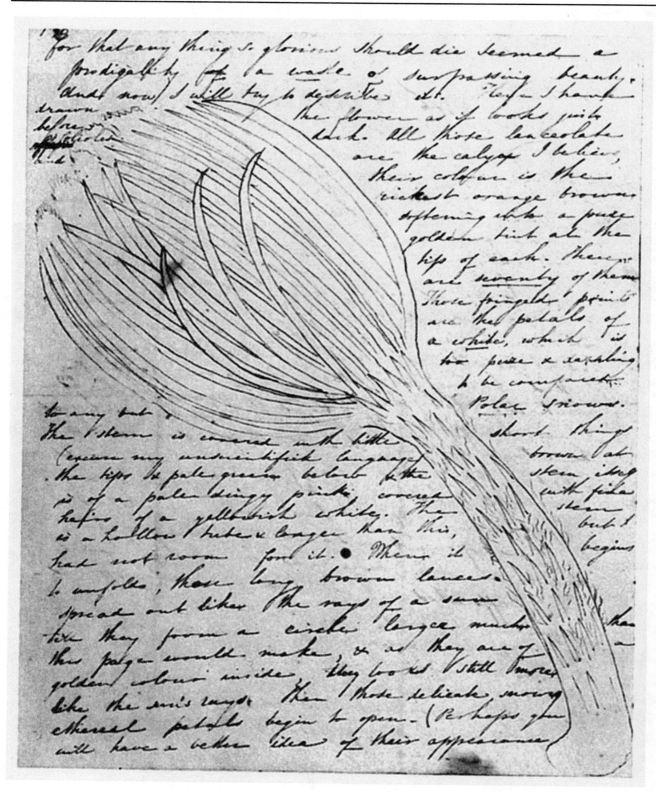

Page from a May 1834 entry in Sophia Peabody's "Cuba Journal," with her sketch of a night-blooming cereus (Henry W. amd Albert A. Berg Collection, New York Public Library, Astor, Lenox and Tilden Foundations)

invalidic–and the characterization has proved so strong that even modern biographers and scholars have difficulty escaping it. Such negative characterizations of Sophia Hawthorne often have been accompanied by dismissals and devaluations of her writings. Yet, she was a talented writer, who–while conforming in many ways to nineteenth-century dictates about a woman's place in society– also worked outside the limited roles prescribed for women. Throughout her life she expressed what she called in a 28 November 1859 letter to Field "the Belleslettres portion of my being" in letters and journals, forms that were culturally approved for the Victorian female because they were essentially "private." But just a few years before her death, Hawthorne became a professional woman of letters when she began editing her husband's notebooks for publication in 1868 and then published her *Notes in England and Italy* (1869), a travel book composed of letters and journals she wrote while the Hawthorne family lived abroad from 1853 to 1860. Travel literature was much in vogue at the time, and *Notes in England and Italy* made a place for itself in the crowded market. Thirteen years after its first appearance, the book was in its eighth edition.

With the exception of *Notes in England and Italy,* none of Sophia Hawthorne's letters or journals was published in her lifetime. Indeed, at the time of her death, Henry Bright, a friend of the family, wrote to Julian Hawthorne, Sophia and Nathaniel's son: "No one has yet done justice to your mother. Of course, she was overshadowed by *him,*–but she was a singularly accomplished woman, with a great gift of expression, . . . she was, too, an artist of no mean quality. Her 'Notes in England and Italy' contain much that is valuable, and much that is beautifully written." Julian and Rose Hawthorne, the Hawthornes' younger daughter, quoted extensively from their mother's writings in their books about their father, and Rose Hawthorne noted in the preface to her *Memories of Hawthorne* (1887) that the volume was "really written by Sophia Hawthorne," for it relied heavily on her letters, which were "so profound in thought and loveliness, that some will of sterner quality than a daughter's must cast them aside." Portions of four journals were published in the twentieth century, and two collections of letters, "The Cuba Journal" (1978) and "Selected Literary Letters of Sophia Peabody Hawthorne, 1842–1853" (1992), have been edited as dissertations. These works are only a portion of the more than 1,500 letters and 19 diaries or journals that Sophia Hawthorne wrote during her lifetime. Taken together, her writings provide a remarkable record of one woman's will to create and her desire to express herself, and of a life that was both singular and representative of women's experience in nineteenth-century America.

Sophia Amelia Peabody was born on 21 September 1809 in Salem, Massachusetts, the third child–and third daughter–of Nathaniel and Elizabeth Palmer Peabody. A graduate of Dartmouth College, Nathaniel Peabody initially made his way in the world as a Latin scholar and teacher. After several teaching jobs, he took up the study of medicine and became a dentist/apothecary. Elizabeth Palmer Peabody was also a teacher, having been employed at Franklin Academy in Andover, Massachusetts, where Nathaniel Peabody, not yet her husband, was preceptor. After their marriage in 1802, Elizabeth Peabody periodically opened and ran home schools to help support the family, for Nathaniel Peabody's business was never financially successful. Although it had fallen on hard times, the Palmer family was illustrious and well connected. Elizabeth Palmer Peabody's grandfather General Joseph Palmer was a member of the Continental Congress, and her father, Joseph Pearse Palmer, took part in the Boston Tea Party (1773) and fought in the Battle of Lexington (1775). According to Louise Hall Tharp, Paul Revere was a member of Joseph's wedding party. One of Elizabeth's sisters, Mary, married lawyer and playwright Royall Tyler, and the son of her youngest sister, Catherine, established the publishing house Putnam and Sons.

Sophia Peabody had two older sisters, Elizabeth Palmer (1804–1894) and Mary Tyler (1806–1887), both of whom, like their sister, became prominent figures in nineteenth-century America. Elizabeth Peabody was part of the Transcendentalist group and a friend and colleague of Ralph Waldo Emerson, Henry David Thoreau, and Margaret Fuller. She opened and ran a Boston bookstore at 13 West Street in Boston, where Fuller held her Conversations, and according to Charles H. Foster, was the first woman publisher in Boston and "probably the nation," publishing three of Hawthorne's children's books and Thoreau's essay "Resistance to Civil Government" in her *Aesthetic Papers* (May 1849). She helped to introduce the kindergarten movement in America and was the author of many books. Mary Peabody married Horace Mann, lawyer, legislator, educational reformer, and first president of Antioch College, the first coeducational college in the country. She wrote the first biography of her husband, *Life and Works of Horace Mann* (1865–1868), for which Sophia drew a portrait of Horace Mann; co-edited the *Kindergarten Messenger* (1873–1875); edited the memoirs of Sarah Winemucca Hopkins, an Indian leader; and at the age of eighty wrote a novel, *Juanita: A Romance of Real Life in Cuba Fifty Years Ago* (1887). Sophia Peabody also had three younger brothers, only one of whom, Nathaniel Cranch (1811–1881), survived past early adulthood.

Like many women of her day, Sophia Peabody was educated almost entirely at home, but as the daugh-

THE GENTLE BOY

The boy had hushed his wailing at once and turned his face upward to the stranger.

Frontispiece by Sophia Hawthorne in the 1839 separate publication of Nathaniel Hawthorne's story "The Gentle Boy"

ter of two teachers, and the sister of two more—both Elizabeth and Mary taught to bolster the family income—she received an education superior to that of most young women of her day. From her father she learned Latin, astronomy, arithmetic, and chemistry. In schools run by her mother, and then under the guidance of Elizabeth Peabody, she read history, literature, philosophy, and religion and studied Greek, Hebrew, German, French, and Italian. A true intellectual, Sophia Peabody possessed a keen mind, a thirst for knowledge, and, from early on, a love of literature and language. She was a prodigious reader all her life. A partial list of her reading in 1862, noted in her journal for that year, includes Thomas Arnold's *History of Rome* (1838–1842), Sir Thomas Browne's *Religio Medici* (1642), William Carpenter's *The Microscope; and its Revelations* (1856), Arthur Hugh Clough's *Poems* (1862), Dante's *Vita Nuova* (circa 1290), Charles Dickens's *Great Expectations* (1860–1861), Victor Hugo's *Les Miserables* (1862), Rebecca Harding Davis's *Margaret Howth* (1862), Samuel Pepys's *Diary* (1825), William Shakespeare's *Hamlet* (1602) and

Julius Caesar (1599), Elizabeth Stoddard's *The Morgesons* (1862), and Alfred, Lord Tennyson's *Idylls of the King* (1859; second edition, enlarged, 1862). In his introduction to the 1862 journal, Thomas Woodson notes that during this year, Fields sent the Hawthornes a copy of any new book published by Ticknor and Fields that might interest the Hawthornes. According to Woodson, Sophia Hawthorne "read them all, and also the *Atlantic Monthly,* from cover to cover."

Sophia Peabody was also a talented artist. First studying drawing at the age of thirteen with her aunt, Amelia Palmer Curtis, she later trained with some of the most notable nineteenth-century American artists: Thomas Doughty, Chester Harding, and Washington Allston. When she was in her twenties, she helped support herself by selling her flawless copies of well-known paintings, and in 1834 she exhibited an original landscape in the Boston Athenaeum. Patricia Dunlavy Valenti maintains that Sophia Hawthorne "should be considered among the earliest serious female painters in America." Several of her works survive. *Landscape* and

Scene near Bristol in England, are housed in the Essex Institute in Salem, Massachusetts. Another, *Flight Into Egypt,* is unsigned but attributed to her and hangs in the House of the Seven Gables in Salem, Massachusetts. Her copy of Chester Harding's portrait of Washington Allston is in the Massachusetts Historical Society; a bas-relief of Charles Emerson, the brother of Ralph Waldo Emerson, which she executed after Charles's death for his fiancée, Elizabeth Hoar, can be seen at the Emerson House in Concord, Massachusetts.

Another important aspect of Hawthorne's life, and one that has factored significantly in historical treatments of her, were the severe, debilitating headaches she struggled with throughout her life and that, during her adolescence and early adulthood, were particularly acute. Julian wrote that his mother's headaches "lasted uninterruptedly from her twelfth to her thirty-first year," and she referred in her journals to the pain that "ached–raged" in her head "for fifteen years." Scholars have speculated about the nature and cause of the headaches, but their onset at puberty and many of her symptoms, including sensitivity to light and noise, suggest severe migraines.

Hawthorne's journals and letters–and the writings of other family members–also give accounts of the "cures" to which she was subjected, providing a fascinating glimpse into the world of nineteenth-century medicine and a case study of nineteenth-century medical attitudes toward, and treatments of, women's illnesses. Julian Hawthorne recorded Elizabeth Peabody's recollection that "the Boston physicians, one after another, tried their hands at curing her, and she went through courses of their poisons, each one bringing her to death's door." Peabody listed mercury, opium, and hyoscyamus as some of the various poisons with which her sister was dosed. Sophia Peabody recorded in her journals that she took arsenic, quinine, and, in 1838, daily doses of morphine. Application of leeches was also tried, as well as diets ranging from total abstinence to potatoes and rice.

During this period of her life, Hawthorne often kept to her chamber for days or even weeks at a time and was accorded the status–and the privileges–of an invalid within the family. After her marriage in 1842, however, although she continued to experience headaches, she led a full life. Nineteenth-century women were encouraged to think of themselves as frail and delicate, and Sophia Peabody's seeing herself as an invalid and adopting that role–as well as the response of the Peabody family–were likely influenced by cultural conditioning.

In 1833, hoping that a warm, humid climate would help to alleviate her headaches, Sophia Peabody journeyed to Cuba, accompanied by her sister Mary. The sisters lived for a year and a half with a wealthy plantation family. Mary served as a governess to earn

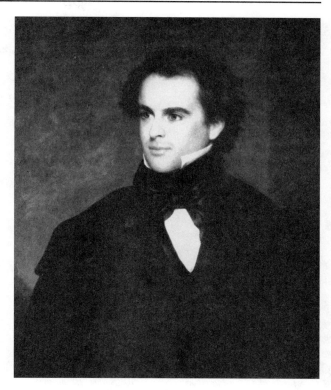

Nathaniel Hawthorne in 1840 (portrait by Charles Osgood; Essex Institute, Salem, Massachusetts)

their keep, and Sophia spent her time resting, writing, drawing, painting, and reading. As she did at other times, she wrote to her family religiously. Travel writing was popular, and her letters were of great interest to those left behind in Massachusetts. The Peabodys bound them in three volumes, called them the "Cuba Journal," and circulated them among family and friends. One admirer of the "Cuba Journal" was Sophia Peabody's husband-to-be, who borrowed the volumes some time after he first visited the Peabody household in Salem in 1837. He seemed captivated by the journal and copied sixteen passages from it into his notebook. (Sophia excised these passages when she edited this notebook for publication, but they are included in Barbara Mouffe's 1978 transcription of the original notebook, *Hawthorne's Lost Notebook, 1835–1841*). One passage he recorded is Sophia's account of cleaning an old picture, which some scholars have identified as the likely germ for his short story "Edward Randolph's Portrait" (1838). He also copied into his notebook her description of a Spanish lady's fancy ball dress, which he appropriated almost wholesale into his short story "Drowne's Wooden Image" (1844). Drowne's image, with many of the markers of Sophia's Spanish lady, is the first of the "dark ladies" that appear in Nathaniel Hawthorne's fiction.

Julian and Una Hawthorne, circa 1850 (Boston Athenaeum)

height and semicircle of eternal green with an emotion of reverence and awe. . . . I saw too, some of those tall delicate trees, which I have seen in engravings of Italian scenery, which look more like dreams than material substances. . . . The fine tracery of their dark tiny leaves and thread-like branches was clearly marked upon the brightest, purest golden and rose coloured sky you ever beheld. I looked at that, and then upon the wild wood at my side with its graceful vines . . . and I could hardly conceal my rapture.

Sophia Peabody returned home in 1835. Two years later she met Nathaniel Hawthorne, and not long after their first meeting she drew an illustration for his short story "The Gentle Boy" (1832), which was engraved as the frontispiece to *The Gentle Boy: A Thrice Told Tale* (1839). She also illustrated the second, 1842 edition of Nathaniel Hawthorne's *Grandfather's Chair* (1841), one of his collections of children's stories.

After a long engagement, Sophia Peabody and Nathaniel Hawthorne were married on 9 July 1842. Traditional views of the marriage as unusually happy have been fostered in part by Julian and Rose Hawthorne's characterizations of the marriage in their books and by Nathaniel Hawthorne's love letters to his wife. (He burned all her "maiden" letters to him before the family left for Europe in 1853.) This view of the marriage has lately been challenged by some scholars, but the love that brought these two artists together seems to have survived whatever difficulties they encountered or created—as is apparent in Sophia Hawthorne's letters to her husband. As late as 1862, only two years before his death, she still addressed her letters to "My dearest husband," and exclaimed on receiving a letter from him, "Your . . . letter has kindled us all up into the lamps of light today."

The happiness of the newly married couple, who settled in Concord in the Old Manse, is revealed in the two journals they kept jointly, one for the years 1842–1843 and the other for 1844–1852. Until the publication of "Sophia Peabody Hawthorne's *American Notebooks*" in 1996, however, only those portions of the journal written by Nathaniel Hawthorne have been available.

During the first ten years of their marriage the Hawthornes' three children were born: Una (3 March 1844 – 10 September 1877), Julian (22 June 1846 – 14 July 1934), and Rose (20 May 1851 – 8 July 1926). Sophia Hawthorne seemed to relinquish any aspirations of becoming a professional artist after she became a mother, but she continued to sketch, draw, paint, and teach her own children these fine arts until the end of her life.

She had at least one occasion to trade on her talents during her marriage. Having been appointed surveyor of the Salem Custom House by President James

The importance of the "Cuba Journal," though, extends beyond Nathaniel Hawthorne's uses of it in his fiction. As Claire Badaracco maintains in the preface to her edition of the "Cuba Journal," it is "an artifact of cultural importance as well." Sophia Hawthorne excelled in creating word pictures, in capturing a scene or a person, and she exercised her abilities in the "Cuba Journal" as she recorded her shipboard journey and her experience of another culture. In Cuba she described and remarked on the life of prosperous Spanish landowners, such as the Morrells with whom she stayed; on her encounters (probably her first) with the slaves who made that prosperity possible; and on the beauty of the Cuban landscape. Her talent for creating a well-turned phrase often combined with her artist's eye for color, shape, and detail to yield lovely passages such as the following:

> We . . . rode through an avenue of palms & oranges, planted alternately at the entrance of which were two trees of marvellous beauty. The leaves grow in separate bunches thus [sketch of the leaves]. . . . The top of the tree was of a rich green, the lower part had changed to a brilliant orange, so that at a distance I thought the golden bunches were the fruit. . . . I have pressed some of the leaves for you to see. The young moon and stars lighted us home. Yesterday afternoon we all went to . . . Marc Antony de Wolfe's estate. . . . One [tree] we passed . . . exceeded any thing I ever conceived of in the way of a production of this earth. It seemed to have more to do with heaven, and I looked up at its giant

K. Polk, a Democrat, in 1846, her husband was ousted from that job in 1849, after President Zachary Taylor, a Whig, took office. Sophia Hawthorne helped to support the family through the sale of hand-painted lampshades and firescreens while her husband returned to the writing he had found almost impossible to accomplish as surveyor. The result was his acknowledged masterpiece, *The Scarlet Letter* (1850), which was followed in quick succession by *The House of the Seven Gables* (1851) and *The Blithedale Romance* (1852).

From this same period also date the letters edited by Nancy Luanne Jenkins Hurst in "Selected Literary Letters of Sophia Peabody Hawthorne, 1842–1853." These letters include Sophia Hawthorne's reflections on her life with Nathaniel, his work, their children, and child rearing, as well as her comments on the many luminaries—literary and otherwise—with whom she and her husband were in regular contact. In 1850, for example, she called the young Herman Melville,

> a man with a true 'warm' heart & a soul & an intellect—with life to his finger-tips—earnest, sincere & reverent, very tender & *modest*—And I am not sure that he is not a very great man—but I have not quite decided upon my own opinion—His nose is straight & rather handsome, his mouth expressive of sensibility & emotion. . . . When conversing, he is full of gesture & force, & loses himself in his subject—There is no grace nor polish—Once in a while his animation gives place to a singularly quiet expression of [his] eyes . . . an indrawn, dim look, but which at the same time makes you feel—that he is at that instant taking deepest note of what is before him—It is a strange, lazy glance, but with a power in it quite unique—It does not seem to penetrate through you, but to take you into himself. I saw him look at Una so yesterday several times.

This description led one of Melville's biographers, Raymond M. Weaver, to call Sophia "one of Melville's most penetrating critics."

In 1853 the Hawthorne family left America for England, where Nathaniel had been appointed U.S. consul to Liverpool by his friend President Franklin Pierce. Hawthorne resigned his consulship in 1857, after the election of James Buchanan to the presidency, and the family moved to Italy for a year, then returned to England for almost another year while he finished his last novel, *The Marble Faun* (1860). On their arrival in the States in 1860, they took up residence in Concord, Massachusetts, at the Wayside, the house they had bought from Bronson Alcott and remodeled before their departure. The next four years appear to have been difficult ones for the family. Una, who had apparently contracted malaria and nearly died in Rome, experienced relapses of the disease; Nathaniel Hawthorne struggled to write another romance, with no suc-

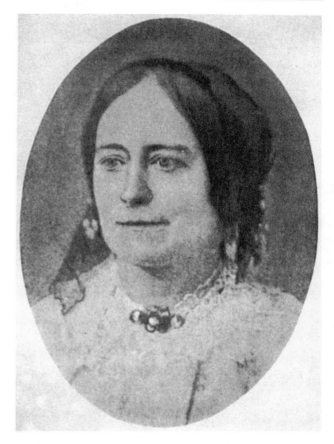

Sophia Peabody Hawthorne, circa 1855 (Essex Institute)

cess. At the same time the United States was experiencing its most severe national crisis—the Civil War. After a period of failing health, Nathaniel Hawthorne died on 19 May 1864, while on a trip with his loyal friend Franklin Pierce. Sophia Hawthorne and the children continued to live at the Wayside, struggling on their dwindling financial resources.

In 1866, at the urging of James Fields, and at least in part because of her family's severe financial straits, Hawthorne agreed to edit her husband's notebooks for publication. The decision was not just economically motivated, though, for she had recognized early on the value of the notebooks and how her husband used them in his literary creations. In an 1849 letter to her mother she had written that he was beginning a new story "from some of his journals (the embryos of his sketches are generally there, I believe–)." The edited passages from the American journals first appeared in twelve installments in *The Atlantic Monthly* (January–December 1866), for which Sophia Hawthorne was paid $100 apiece. *Passages from the American Note-Books* was published in 1868. She also edited *Passages from the English Note-books* (1870) and *Passages from the French and Italian Note-Books* (1872).

Title page for the travel book Hawthorne based on letters and journal entries she wrote between 1853 and 1860, while she and her family were living in Great Britain and Italy

Much has been made of the fact that Hawthorne took liberties with the texts when she edited the notebooks. She changed words that might have offended her Victorian audience's sense of propriety or cast her husband in a bad light and excised some passages entirely—particularly those that mentioned her or the children—marking over them or cutting them out of the original. Thus, Hawthorne may appear as the "bowdlerizer" of her husband's journals. Actually, however, her editing was in every way characteristic of her day, as may be seen if her work is compared to another edition of original papers undertaken in the nineteenth century: *Memoirs of Margaret Fuller Ossoli* (1852), edited by Ralph Waldo Emerson, James Freeman Clarke, and William Henry Channing. As Bell Gale Chevigny, a modern editor of Fuller, points out, these first editors also changed words and phrases, excised passages by marking or cutting them out, and copied letters and journal entries and then destroyed the originals. Hawthorne had an intuitive understanding of the importance and value of Nathaniel Hawthorne's journals,

and her appreciation of his work led her to preserve almost all that was left behind at his death.

In 1868, hoping to stretch her finances, Hawthorne decided to move her family back to Europe—this time, to Dresden, Germany, where Elizabeth Peabody, recently returned from the Continent, had located inexpensive lodgings. This geographical move accompanied an equally important development for Hawthorne. Almost ten years earlier, Fields had expressed interest in publishing the letters and journals she had written in England and Italy. At that time Sophia and Nathaniel Hawthorne had steadfastly refused, but in 1868, shortly after her arrival in Dresden, and immediately after completing work on the *American Note-Books,* Hawthorne turned to her own writings. She copied and edited them just as she had her husband's. *Notes in England and Italy* was published in England and the United States in 1869. Sophia Hawthorne, private belletrist, had become Sophia Hawthorne, published author.

A 549-page work, *Notes in England and Italy* is divided into two parts: the first section is composed of letters written in England and Scotland; the second is extracts from journals kept in Italy. As Mary Suzanne Schriber has noted, travel writing is "historically a remarkably elastic genre . . . something of a literary carpetbag." Hawthorne availed herself of the elasticity of the form when she decided to use both letters and journals in her book. The composition of the volume reveals her primary interests, for although the family lived in England for a total of five years and five months, only 195 pages are devoted to "our old home," while her writings on Italy, where the Hawthornes dwelt for a year and four months, occupy 354 pages. In the sections on England and Scotland, Hawthorne described, with her characteristic felicity of phrasing, visits to cathedrals and literary pilgrimages to homes and haunts of famous authors. The Italian section, though, is almost entirely devoted to her first visits to see the great works of art she had all her life studied and admired. Accounts of many works occupy two or three pages of text, including her description of Guido Reni's *Aurora,* which she had drawn on the headboard of her bridal bed in the Old Manse many years before:

> Finally we entered the central saloon . . . and there, on the ceiling, dawned the world-renowned Aurora, and Apollo rose up in his chariot with the wreath of Hours. I was amazed to see the fresco as brilliant as if painted to-day, unharmed by time and atmosphere. . . . Apollo blazes in a sea of golden light, and the only part of it I do not entirely admire is his hair, which is too pale and short, I think, . . . This truly olympic form bends forward with majestic ease, as he lightly holds the reins of the magnificent horses, swallowing up the darkness with his presence, and filling the dawn with his overflowing day, .

. . Such glorious, fresh, rejoicing movement and outbreak were never painted before. . . . The lovely Aurora, beaming from her violet mantle with reflected joy–the young Morning Star holding on to his kindled torch with a gentle but resolute force, as he endeavors to outstrip the absorbing, fast-rushing god, perhaps with a premonition of his doom: the horses, mottled with a struggling light and shade, purple and pearl–the rainbow richness of the drapery of the Hours, each one so individual in character and expression–the softly-heaped clouds–the deep-blue sea beneath, and mountains beyond, tipped with morning–this is Guido's sunrise in items. . . .

Hawthorne's sensitivity to light, color, form, and space is that of an artist; her knowledge is that of a connoisseur. But her capacity to translate what she saw into beautiful and complete descriptions marks her as a writer. Indeed, her twin abilities of seeing and saying–and the inspiration offered by great art–produce passages of pure poetry in *Notes in England and Italy,* as in this description of the Campanile, or bell tower, designed by Giotto di Bondone in Florence: "Giotto must have diffused his spirit through the stones and lines. One of its bells sang out as we passed–a deep, round, liquid sound. . . . It was music, dropped through water. . . . It was as if the great dome itself had rolled from the soul of its artist, a pure globe of melody, and dropped singing into the sea of space." In publishing *Notes in England and Italy,* Sophia Hawthorne had risked what she called in her preface "the pain it cost me to appear before the public." She was one of a select group of women who did so, for, according to Harold F. Smith, fewer than fifty American women had published book-length travel accounts by the time her volume appeared.

One year after the publication of *Notes in England and Italy,* Hawthorne moved to London with her daughters Una and Rose. (Julian had married and returned to the United States with his wife.) Sophia Hawthorne died on 26 February 1871 of typhoid pneumonia and is buried in Kensal Green, near London.

The author wishes to thank the following libraries for permission to quote from the manuscripts, letters, and journals of Sophia Peabody Hawthorne: the Berg Collection, New York Public Library, Astor, Lenox and Tilden Foundations (journal for 1 April 1829 – 8 August 1831) and the Pierpont Morgan Library, New York (MA 3400: letters to Nathaniel Hawthorne, "Friday 29th, 1862" [SH69], and "August 13[?]" [SH72]).

Letters:

"Selected Literary Letters of Sophia Peabody Hawthorne, 1842–1853," edited by Nancy Luanne Jenkins Hurst, dissertation, Ohio State University, 1992.

Biographies:

Julian Hawthorne, *Nathaniel Hawthorne and His Wife: A Biography,* 2 volumes (Boston: Houghton, Mifflin, 1884);

Louise Hall Tharp, *The Peabody Sisters of Salem* (Boston: Little, Brown, 1950);

Norman Holmes Pearson, "Sophia Amelia Peabody Hawthorne," in *Notable American Women: 1607–1950. A Biographical Dictionary,* 3 volumes, edited by Edward T. James (Cambridge, Mass.: Harvard University Press, 1971), II: 162–163.

References:

Claire Badaracco, Introduction to "The Cuba Journal," edited by Badaracco, dissertation, Rutgers University, 1978;

Bell Gale Chevigny, *The Woman and the Myth: Margaret Fuller's Life and Writings* (Old Westbury, N.Y.: Feminist Press, 1976), pp. 9–10;

Charles H. Foster, "Elizabeth Palmer Peabody," in *Notable American Women: 1607–1950. A Biographical Dictionary,* 3 volumes, edited by Edward T. James (Cambridge, Mass.: Harvard University Press, 1971), III: 31–34;

Julie E. Hall, "A Source for 'Drowne's Wooden Image' and Hawthorne's Dark Ladies," *Nathaniel Hawthorne Review,* 16 (Fall 1990): 10–12;

Nathaniel Hawthorne, *Hawthorne's Lost Notebook, 1835–1841,* edited by Barbara Mouffe (University Park: Pennsylvania State University Press, 1978);

Rose Hawthorne Lathrop, *Memories of Hawthorne* (Boston: Houghton, Mifflin, 1887);

Mary Suzanne Schriber, Introduction to *Telling Travels: Selected Writings by Nineteenth-Century American Women Abroad,* edited by Schriber (DeKalb: Northern Illinois University Press, 1995);

Harold F. Smith, *American Travellers Abroad: A Bibliography of Accounts Published Before 1900* (Carbondale & Edwardsville: Southern Illinois University Press, 1969);

Randall Stewart, *Nathaniel Hawthorne: A Biography* (New Haven: Yale University Press, 1948);

Patricia Dunlavy Valenti, "Sophia Peabody Hawthorne: A Study of Artistic Influence," in *Studies in the American Renaissance, 1990,* edited by Joel Myerson (Charlottesville: University Press of Virginia, 1990), pp. 1–19;

Raymond M. Weaver, *Herman Melville, Mariner and Mystic* (New York, 1921).

Papers:

The most extensive collections of Sophia Peabody Hawthorne's manuscripts are in the Berg Collection at the New York Public Library, the Pierpont Morgan Library in New York City, and the Boston Public Library.

Harriet Jacobs

(1813 – 7 March 1897)

James D. Riemer
Marshall University

BOOK: *Incidents in the Life of a Slave Girl, Written by Herself,* as Linda Brent, edited by Lydia Maria Child (Boston: Published for the Author, 1861); republished as *The Deeper Wrong; Or, Incidents in the Life of a Slave Girl* (London: Tweedie, 1862).

Edition: *Incidents in the Life of a Slave Girl, Written by Herself,* edited by Jean Fagan Yellin (Cambridge, Mass.: Harvard University Press, 1987).

Published in 1861 under the pseudonym Linda Brent, Harriet Jacobs's *Incidents in the Life of a Slave Girl, Written by Herself* is a powerful and complex autobiography in which she recorded and reflected on her life as a slave. Now considered a major work in the slave-narrative tradition, *Incidents in the Life of a Slave Girl* received little scholarly attention from historians and literary critics until 1981, at least in part because modern scholars had doubts about its authenticity and authorship. In 1981, however, drawing on a group of Jacobs's letters as evidence, Jean Fagan Yellin laid to rest any questions about Jacobs's authorship of the text. Then, through extensive research, which she documented in her 1987 edition of *Incidents in the Life of a Slave Girl,* Yellin also established the authenticity of the events Jacobs described in her autobiography. Since that time *Incidents in the Life of a Slave Girl* has attracted increasing critical attention. As scholars place the autobiography in various contexts and examine it from multiple critical perspectives, appreciation of Jacobs's considerable achievement has continued to grow.

Harriet Ann Jacobs was born in Edenton, North Carolina, sometime in the fall of 1813, to Delilah, a slave to John and Margaret Horniblow. Her father, Elijah Jacobs, a carpenter and slave to Dr. Andrew Knox, was most likely the son of one of Knox's white neighbors, Henry Jacobs. Her brother, John S. Jacobs, was born in 1815. When her mother died, the six-year-old Jacobs was taken to live in the household of her mistress, Margaret Horniblow, who treated Jacobs kindly, teaching her to sew, read, and spell.

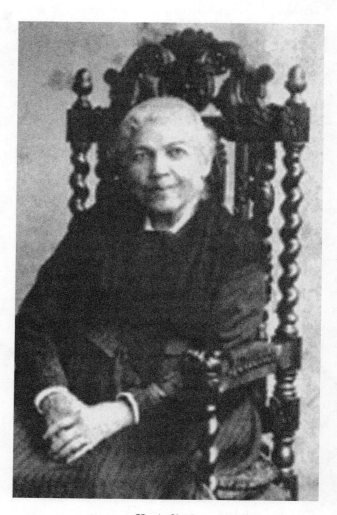

Harriet Jacobs

When Margaret Horniblow died in 1823, however, she did not free Harriet, as her young slave had hoped, but bequeathed her to a three-year-old niece, Mary Matilda Norcom, daughter of Dr. James Norcom. Harriet and her brother then went to live at the Norcom household in Edenton.

Jacobs had served two years in the Norcom household as a domestic slave when she found herself subjected to the sexual advances and harassment of her young mistress's father. Jacobs successfully deflected her master's attentions for several years. Then, when she was sixteen, James Norcom increasingly pressed his suit for her to become his concubine, intending to build a small house for her several miles from town. Wishing to dispel her master's relentless harassment of her, Jacobs began a sexual liaison with a young local white lawyer, Samuel Tredwell Sawyer, by whom she eventually had two children, Joseph (born 1829) and Louisa Matilda (born 1835). She believed that when Norcom learned of the liaison he would be so angry that he would sell her. Instead, when Jacobs revealed that she was pregnant with another man's child, Norcom vowed that he would never sell her. Jacobs then moved in with her grandmother, Molly Horniblow, a freed slave who earned a living as a baker in a house she owned nearby. Based on the account in her autobiography, Jacobs apparently was allowed to remain there in part because Norcom's wife, jealous of his attentions to Jacobs, refused to have her back in the Norcom house.

In 1835 Norcom intensified his pursuit of Jacobs, even though by this time she was the mother of two children, who also lived with Jacobs's grandmother. When Jacobs rejected Norcom's offer to establish her in a small house of her own, he sent her to work on a plantation in nearby Auburn. After six weeks as domestic slave in the great house, she learned that Norcom planned to take her children from her grandmother's home and send them to the plantation as well. Determined to save her children from life as plantation slaves, Jacobs resolved to escape. Thinking that if she were gone, Norcom would find the children too much of a problem and would sell them, Jacobs ran away from the plantation, hoping to escape to the North.

For several months Jacobs was sheltered by sympathetic neighbors. Then realizing that Norcom's vigilance would jeopardize her escape from Edenton for some time, Jacobs hid in an attic crawlspace in her grandmother's house, where she remained for almost seven years, secretly watching over her children. Norcom advertised for her capture, and in an attempt to coerce Jacobs's relatives into revealing her whereabouts, he had her aunt, her brother, and her two children jailed. Shortly thereafter, Norcom sold her brother and her children to a slave trader, who then sold them to Sawyer. He returned Joseph and Louisa to live with Jacobs's grandmother, but he did not free them as he had promised Jacobs.

When Sawyer was elected to Congress in 1837 he took Jacobs's brother with him to Washington, D.C. In the autumn of 1838, while traveling through the North with Sawyer and his new wife, John Jacobs escaped from his master. Two years later Sawyer returned to Edenton and took Louisa with him and his wife to Washington, where she stayed with them and their infant daughter for five months before being sent to live with Sawyer's cousins in New York City.

For almost seven years Jacobs endured the hardship of living in the cramped quarters of her garret retreat, suffering from its extremes of heat, cold, and dampness. During this time she read, sewed, and practiced writing. Believing that she had escaped, Norcom made several trips to New York in the hope of capturing her. From her garret Jacobs encouraged Norcom's belief by arranging to have letters she had written sent from various northern cities.

In 1842 Jacobs finally managed her escape, first to Philadelphia, where she was aided by the Vigilant Committee. From there she traveled to Brooklyn, where she saw her daughter. In New York, Jacobs was employed as a nursemaid by Nathaniel Parker Willis, magazine editor and brother to Sara Payson Willis Parton (Fanny Fern), and his wife, Mary Stace Willis. Learning that Norcom planned to make another trip to New York to look for her, Jacobs went to Boston, where her brother was then living, and arranged for her son, still in Edenton with her grandmother, to be sent to her there.

Leaving her son with her brother, Jacobs returned to New York. When the possibility of capture again arose in October 1844, she revealed to Mary Willis that she was a fugitive slave. Through her employer's aid, Jacobs and her daughter escaped to Boston, where she took a job as a seamstress. After Mary Willis died in the spring of 1845, Jacobs was again employed by Nathaniel Willis, this time accompanying him to England as nursemaid to his daughter. On her return ten months later, Jacobs found that her son had shipped out to sea.

In 1849 Jacobs moved to Rochester, New York, a center of abolitionist activity, in which her brother, John, was an active participant. She worked in an antislavery reading room and bookstore located over the offices of Frederick Douglass's newspaper, *The North Star*. During this time she became acquainted with Amy Post, a Quaker reformer who became a friend and confidante and who urged Jacobs to write a narrative of her experiences as a slave.

In 1850 Jacobs returned to domestic work for the Willis family in New York City, serving as nursemaid to Willis's baby by his second wife, Cornelia

Grinnell Willis. In New York, Jacobs's former mistress, now Mary Matilda Norcom Messmore, and her husband, Daniel Messmore, attempted to seize Jacobs and her daughter. Daniel Messmore argued that since his wife had inherited Jacobs, her father had no right to sell Jacobs's children. Jacobs did not know that because Norcom had replaced Jacobs's children with slaves of equal value, the sale was considered legal, and the Messmores had no claims. Jacobs and her daughter fled to Massachusetts. In 1852 Jacobs became legally free, after Cornelia Grinnell Willis—without Jacobs's prior approval or knowledge—purchased Jacobs from the Messmores for $300 and then freed her, liberating her once and for all from the clutches of the Norcom family. Although Willis's actions brought Jacobs her freedom, Jacobs was angry that to achieve her freedom she had to concede to the concept that she was a piece of chattel that could be bought or sold.

Sometime near the end of 1852 or the beginning of 1853 Jacobs began to entertain seriously the idea of writing a narrative of her life, as Amy Post had suggested several years earlier in Rochester. In a letter to Post written around that time, Jacobs expressed her concerns about making the events of her life available to the public, writing: "Woman can whisper her cruel wrongs into the ear of a very dear friend much easier than she can record them for the world to read." Jacobs specifically acknowledged the conflict between her desire to relate the truth of her past and her hesitation about revealing the details of her sexual history. Although it would mean disclosing her degradation she remarked, "If it could help save another from my fate, it would be selfish and unchristian in me to keep it back." Jacobs's unease about presenting the truth of her life to the public most likely led to her decision to publish her narrative pseudonymously under the name Linda Brent.

Initially, Jacobs had not intended to write the narrative herself. She had hoped to dictate an account of her life to Harriet Beecher Stowe, the celebrated author of *Uncle Tom's Cabin* (1852), who could then transform Jacobs's experiences into a publishable narrative. Learning that Stowe was planning a trip to England, Jacobs thought that if Louisa could accompany Stowe, she could interest the author in her mother's story. In Jacobs's words, Louisa would serve as a "very good representative of the Southern Slave." Apparently Jacobs prevailed on Amy Post and Cornelia Willis to propose the idea to Stowe. Post's letter to Stowe also included a sketch of Jacobs's life, presumably to see if Stowe might be interested in writing an account of it.

The collaboration between Stowe and Jacobs never materialized. A rift developed between the two women, in part because of Stowe's authorial intentions for Jacobs's life story. Responding to Post's sketch of Jacobs's life, Stowe said she was indeed interested in telling Jacobs's story, but as part of her current project, *A Key to Uncle Tom's Cabin* (1853). Stowe intended to include Jacobs's experiences of sexual and psychological abuse and harassment as part of the corroborating documentation about slavery that Stowe was compiling as background and validation for the events in her novel. Jacobs became offended by Stowe's alleged comments that Louisa would be spoiled by the attentions that would be lavished on her if the English found out she had been a slave. In the letter to Post in which Jacobs reacted to Stowe's comments on Louisa, Jacobs also revealed her sense that Stowe had betrayed trust and propriety. Stowe had sent Amy Post's sketch of Jacobs's life to Cornelia Willis for verification, which created a situation that was most likely mortifying for Jacobs, who had kept private the sexual aspects of her slave life. As a result of her disillusionment with Stowe, Jacobs decided to write the narrative of her life herself.

To prepare for writing her autobiography Jacobs honed her writing skills by composing letters about slavery for the newspapers. Jacobs's first publication appeared in the *New York Tribune* on 21 June 1853 as a "Letter from a Fugitive Slave." Anticipating the focus of her autobiography, Jacobs described the sexual oppression and suffering of a young slave girl at the hands of a licentious master and a jealous mistress.

During the five years that she spent writing her narrative, Jacobs continued to work as a nursemaid to the Willis family, then residing on a country estate in Idlewild, New York. In addition to reflecting her misgivings about her writing abilities, Jacobs's letters to Post during this time also voice her frustration that her duties take time away from her writing. The letters also describe her unwillingness to reveal her project to her employers in order to request the time she needed. While working on her autobiography Jacobs continued to write pseudonymous letters to the *Tribune*.

Once she had completed her manuscript in 1858, Jacobs had difficulty finding a publisher. Taking with her letters of introduction from Boston antislavery leaders, Jacobs sailed to London, hoping to secure a publisher there. When her attempts proved unsuccessful, she returned home and began the search for an American publisher. When Phillips and Sampson expressed interest in publishing the work, Jacobs could not willingly agree to their conditions, which made publication conditional on Jacobs's

obtaining a preface from either Stowe or Nathaniel Parker Willis, whom she would not approach because she felt he was decidedly proslavery.

Eventually the Boston firm of Thayer and Eldridge agreed to publish Jacobs's manuscript if she were able to secure an introduction written by Lydia Maria Child, a prominent abolitionist and author. Momentarily hesitant about presenting such a request to a prominent figure whom she did not know, Jacobs sought to meet Child through the help of a friend. Child agreed to write the introduction and to act as editor for the manuscript as well.

In her introduction Child maintained that the changes she made in the manuscript were "mainly for purposes of condensation and orderly arrangement. I have not added any thing to the incidents, or changed the import of her very pertinent remarks. With trifling exceptions, both the ideas and the language are her own. I pruned excrescences a little, but otherwise I had no reason for changing her lively and dramatic way of telling her own story." Child's public claims are borne out and clarified by her private correspondence with Jacobs. In a 13 August 1860 letter to Jacobs, Child praised Jacobs's language, calling it "wonderfully good," and complimented her on the handling of events and remarks. Her changes in the manuscript, Child said, were the "transposing of sentences and pages, so as to bring the story into continuous order, and the remarks into appropriate places." Child went on to make two editorial suggestions that Jacobs apparently followed. She suggested that Jacobs eliminate a final chapter on John Brown so that the narrative would end with the death of Jacobs's grandmother. In following Child's recommendation Jacobs was actually restoring her original ending, for the chapter on Brown had been added sometime after Jacobs was satisfied that the narrative was finished. Child also suggested that Jacobs expand her treatment of the Nat Turner rebellion to include some "striking particulars" of the violence enacted by whites in response to the rebellion. In a letter to a friend, Child commented on her editorial changes: "I abridged, and struck out superfluous words sometimes; but I don't think I altered fifty words in the whole volume."

In September 1860, through the efforts of Child, Thayer and Eldridge agreed to increase the first edition of *Incidents in the Life of a Slave Girl* to two thousand copies, with Jacobs receiving 10 percent of retail as royalties and the prerogative to buy copies at the lowest wholesale price. Although Child signed the contract and had the copyright taken out in her name (presumably because Jacobs wished to remain anonymous), her 27 September 1860 letter to Jacobs emphasized that the manuscript was Jacobs's. In that letter Child requested that Jacobs sign a paper to indicate her permission to have the contract in Child's name. As Child stated, "I want you to sign the following paper, and send it back to me. It will make Thayer and Eldridge safe about the contract in my name, and in case of my death will prove that the book is your property, not mine."

Before Child and Jacobs could meet to discuss the final editing, Thayer and Eldridge went bankrupt. Jacobs was able to buy the printing plates, which had already been made, and to arrange for private publication of her narrative as *Incidents in the Life of A Slave Girl* in 1861. The following year it was published in London as *The Deeper Wrong; Or, Incidents in the Life of a Slave Girl*. Reviews or letters of support for the American edition appeared in *The Liberator,* the *Salem Anti-Slavery Bugle,* the *National Anti-Slavery Standard,* and the *Weekly Anglo-African.* There is no record of how many copies were printed or sold. Jacobs traveled to Philadelphia, where she personally sold fifty copies of her book and the abolitionist Hovey Committee purchased copies with the total value of $100. Most likely, sales were affected by the political climate. As Yellin suggests, with the nation preparing for a war that would determine the fate of slavery, promoting another slave narrative had probably diminished in importance for abolitionists.

In September 1862, with the Civil War well under way, Jacobs went to Washington, D.C., to join in relief work for the growing numbers of so-called contrabands, black refugees from the South who sought shelter and freedom behind Union lines. In January 1863, under the sponsorship of Quaker groups in Philadelphia and New York and the New England Freedmen's Aid Society, Jacobs shifted her relief efforts to Alexandria, Virginia, where she distributed clothing and other relief, helped supply emergency healthcare, and established a free school for contrabands. With the beginning of postwar Reconstruction, Jacobs and her daughter continued their relief work in the South, centering their efforts in Savannah. Twice during this period Jacobs returned to Edenton. During the Civil War and the years immediately after, Jacobs's writing took the form of letters and reports to Northern and English newspapers describing relief efforts on behalf of Southern blacks.

Returning to Boston in 1870, Jacobs ran a boardinghouse for several years. In 1878 she and her daughter moved to Washington, D.C., and in 1892 she sold her grandmother's Edenton house. Harriet Jacobs died in her Washington home on 7 March

1897 and was buried in Mount Auburn Cemetery in Cambridge, Massachusetts.

Since 1987, when Yellin's extensive research established the authenticity of the events Jacobs described in her autobiography, *Incidents in the Life of a Slave Girl* has been accepted as a major addition to the slave-narrative genre, an antebellum literary form in which a former slave gives firsthand testimony about slavery with the intention of soliciting sympathy and support for the abolitionist cause.

In significant respects *Incidents in the Life of a Slave Girl* resembles other accounts in the genre. Like other slave narratives, Jacobs's autobiography testifies to the abuse, oppression, and brutality of slavery. Using the pseudonym Linda Brent, Jacobs recounted in first person the events of her life as a slave, detailing her suffering at the hands of her master and her jealous mistress. As in other slave narratives, she described her rebellion against her condition, chronicling her attempts to seek freedom. Following biographical events, the narrative describes how "Linda" is sheltered by sympathetic neighbors while the vigilance of her master precludes her escape. Later, she hides in her grandmother's garret, where she remains for almost seven years, waiting for an opportunity to flee.

Yet, the importance of *Incidents in the Life of a Slave Girl* as a slave narrative extends beyond its being an excellent example of the genre. The significant ways that Jacobs's narrative departs from the conventions of accepted touchstones such as *Narrative of the Life of Frederick Douglass* (1845) have led to a reshaping of critics' understanding of the genre. The vast majority of extant slave narratives are by men, with only about thirty known narratives by women; thus, prior to the authentication of *Incidents in the Life of a Slave Girl* and the resurgence of interest in the book that followed, the scholarly conception of the slave narrative primarily derived from male-focused plots that incorporated ideals of masculine behavior to indicate that the male slave exhibited qualities valued by white middle-class men. These narratives focus on physical abuse of the slave and present the slave's physical overpowering of his master as an assertion of his manhood and selfhood, a turning point in his journey toward freedom. The formula of the slave narrative based on the male experience also asserts the primacy of literacy in attaining freedom and identity. Literacy is perceived as instrumental in claiming one's humanity and freedom. Narratives by male slaves emphasize the isolated nature of the male slave's existence, and the successful escape to freedom in the North is a solitary achievement of self-reliance.

In its focus on the sexual harassment of a powerless young slave girl and her struggle to retain her virtue, *Incidents in the Life of a Slave Girl* brought to light a new aspect of the slave experience, emphasizing the extent to which a female slave's lot is different from that of a male slave. As Jacobs asserts, her lot is in certain respects worse because of the sexual oppression that she must endure. Whereas male slave narratives depict the hero responding to bodily abuse by assaulting his master physically, Jacobs's narrative focuses on the verbal, psychological abuse and the sexual harassment to which the female slave is subjected. As a result, Linda's resistance to her master and her assertion of her own power takes the form of a war of words and wits and a series of mind games.

Critics have also emphasized that, in contrast to narratives depicting the solitary nature of the male slave's experience and escape, Jacobs's autobiography depicts community and personal relations as a key element in shaping the female slave's experience and escape. Jacobs attributed the success of her escape to a communal effort, but the importance of relationships in her narrative extends beyond this aspect of her story. In placing the slave mother's relation to her children as a central concern in a slave woman's life, the narrative shows that the connection is double-edged. This relationship is the reason Linda does not escape when she might, but later it is the reason she becomes determined to do so.

While literacy plays a significant role in Jacobs's narrative, she does not emphasize the slave's exclusion from literacy or the empowering act of becoming literate, which is central in the male slave narrative. Linda is taught to read and spell by her first mistress early in the narrative. Moreover, her ability to read has more complex consequences than in the male narratives. Her ability to read makes her vulnerable to her master's verbal harassment because he begins pressing his immoral attentions on her through lewd notes, which she pretends not to be able to read. Later, when he believes she has escaped to the North and when in fact she has, Linda's master continues to harass her through letters, sometimes threatening her and other times attempting to lure her into returning to him. While her ability to read makes Linda vulnerable to her master's verbal abuse, it is, nonetheless, a source of power for her, because, while she is still in her grandmother's garret, she can nurture her master's belief that she has escaped to the North by arranging to have letters she has written mailed from several northern cities.

Incidents in the Life of a Slave Girl also departs from the form of most slave narratives because it does not end with its heroine reaching the North. Jacobs's narrative continues after her escape to show how Linda has not yet eluded the impact of slavery on her

life. She is still pursued as a fugitive slave. Only at the end of the narrative, ten years after her escape, does her employer purchase her and set her free.

In addition to examining *Incidents in the Life of a Slave Girl* in the context of the slave-narrative genre, critical attention often focuses on the relationship between Jacobs's narrative and works in other literary traditions, particularly the popular forms of the novel read by antebellum white women: the sentimental novel of seduction and the novel of domesticity. While Jacobs's narrative has generally been perceived as an enriching addition to the slave-narrative genre, its relationships and similarities to these two other nineteenth-century literary traditions have proven problematic and a source of critical disagreement.

Critics agree that *Incidents in the Life of a Slave Girl* fits many of the conventions of the sentimental novel of seduction. In its focus on Linda Brent's struggle to retain her virtue against the persistent sexual harassment of her master, Jacobs's narrative resembles the usual plot of the novel of seduction, in which a young woman confronts the sexual advances of a man of questionable morals who holds a superior social or economic status. In presenting its tale of a heroine who must choose between preserving her virtue and engaging in illicit sex outside marriage, *Incidents in the Life of a Slave Girl,* like the novel of seduction, is characterized by heightened emotions and sometimes melodramatic events. As in that genre, Jacobs renders her heroine's crisis in emotional and stylized language, alluding only in veiled references to the sexual situation that is clearly the center of the story.

The similarities between Jacobs's narrative and the sentimental novel of seduction at first inhibited recognition of her book as an authentic slave narrative. Earlier scholars usually dismissed the narrative as either a highly fictionalized account of Jacobs's life or suspected that it was actually a sentimental novel, possibly written by Child, presented in the guise of autobiography. Even after extratextual evidence validated the authenticity of the events and authorship, Jacobs's reliance on the techniques, language, and situations associated with the novel of seduction has continued to provoke questions about the merits of her book and to contribute to the perception that it is a significantly flawed accomplishment. For example, Valerie Smith believes that the conventions of the sentimental novel that Jacobs used to appeal to Northern white women are "inappropriate" and "inadequate" for her purposes and that their use "trivializes the complexity of her situation." Other critics argue that sentimental conventions emphasizing feminine purity and relying on veiled discourse forced Jacobs to leave out details that were essential to her testimony about the brutality of slavery and its sexual exploitation and oppression of the female slave.

Other critics, however, have tended to view Jacobs's use of sentimental-novel conventions in a more positive light, focusing on the ways Jacobs adapted or modified the genre to her own ends, whether as a means for critiquing the conventions and ideologies that underlie it, or as part of a strategy for appealing to a white female audience. By making use of the situations, language, and characters of the sentimental novel of seduction, with which her contemporaries were familiar, Jacobs encouraged her readers to identify and sympathize with Linda just as they vicariously identified with the heroines of sentimental novels.

At the same time, however, Jacobs used the conventions of the sentimental novel to emphasize the disparity between her situation and that of her readers. Thus, Hazel V. Carby argues that Jacobs was able to "critique conventional standards of female behavior and to question their relevance and applicability to the experience of black women." While Linda's plight recalls the circumstances of many sentimental heroines, Jacobs's narrative makes it clear that the slave woman's "peculiar condition" excludes her from the choice that the sentimental novel inculcates. For the female slave, the choice is not between virtue and a happy marriage on the one hand and sin outside of marriage on the other. When Linda falls in love with a young free black carpenter, who asks to marry her, a legal union is not possible, for the laws give no sanction to such a marriage. As Linda says, "If slavery had been abolished, I also could have married the man of my choice; I could have had a home shielded by the laws." When Linda is harassed by her licentious master, her decision to take another white man as her lover is more complex than a "bad choice" that rejects virtue in favor of illicit sex. Because the choice of virtue and marriage is denied to her, Linda's only avenue for asserting her autonomy lies in the act of choosing. She chooses one illicit union over another, explaining, "It seems less degrading to give one's self, than to submit to compulsion. There is something akin to freedom in having a lover who has no control over you, except that which he gains by kindness and attachment." Linda's lack of choice separates her from the ranks of the sentimental heroine and the ideals of purity that she is supposed to propagate. Unlike the heroines of sentimental novels who would have most likely suffered and died because of their choice, Linda resists becoming a victim. Accepting responsibility for her choice and emphasizing that she "did it with a deliberate calculation," Linda emphasizes that for the slave girl the ideology of virtue and purity that

underlies the sentimental novel is simply not tenable. While she aspires to the same ideals of virtue and purity as her white readers, the conditions of slavery make them unattainable.

Jacobs's complex achievement is evident not only in her adapting the sentimental novel to her purposes but also in her use of the conventions and underlying ideology of a second literary form popular among early nineteenth-century women, the domestic novel, which Nina Baym has labeled "woman's fiction." Typically, the domestic novel depicts the happy home as the source of human contentment. By emphasizing the importance of family and home throughout her narrative, Jacobs connected it to the ideology that underlies the domestic novel, thereby inviting her Northern readers to sympathize with Linda as a woman who shares their values and desires. Jacobs then used this shared ideology as a departure point to emphasize that the happy home and family are also the things from which Linda as a slave and black mother is excluded. Even at the end of the narrative, after Linda is freed, she has not fulfilled her desire for her own home. No longer legally bound to a white master, she feels morally bound to the woman who has bought and freed her, and thus, she remains a domestic servant in another woman's home.

Although it establishes the happy home and family as a cultural ideal, in fact, to a large extent, the domestic novel emphasizes its ideology by depicting the unhappy home as the source of human misery. According to Baym, "There are few intact families in the literature, and those that are intact are unstable or locked into routines of misery . . . family members oppress and abuse each other." In this respect Jacobs's narrative closely resembles the domestic novel familiar to the Northern white female reader she was addressing. Jacobs, however, adapted to her own purposes the technique of invoking the ideal of the happy home by depicting unhappy ones. The typical domestic novel blames character flaws and deficient morals and values of individuals as the causes of family misery and domestic unhappiness. In contrast, Jacobs identified the institution of slavery as the source of misery and indicted it as the primary threat to the ideals of home and family that her readers valued. The threat of slavery to the domestic ideal is most evident in its indifferent dismantling of slave families, separating parents from children for pecuniary gain. At the same time Jacobs described the misery that slavery caused in white slaveholding families, with the licentiousness of the master detracting from the morality and happiness of his entire family. Thus, by employing the conventions of the domestic novel and invok-

ing its underlying ideology, Jacobs dramatized for her female readers how slavery creates and intensifies the situations that women's fiction deplores.

Much of the richness and complexity of *Incidents in the Life of a Slave Girl* derives not only from the manner in which Jacobs adapts the conventions, techniques, and underlying ideologies of individual genres and traditions to her own ends but in the interplay among them. From one perspective this interplay can be understood as a result of the complex personal and cultural contexts within which Jacobs composed her narrative. In a similar sense *Incidents in the Life of a Slave Girl* can be understood as a remarkable reflection of the personal and cultural contexts that shaped the life of Harriet Jacobs.

Letters:
"Correspondence," in *Incidents in the Life of a Slave Girl, Written by Herself,* edited by Jean Fagan Yellin (Cambridge, Mass.: Harvard University Press, 1987), pp. 227–251.

Biographies:
Jean Fagan Yellin, "*Legacy* Profile: Harriet Ann Jacobs," *Legacy,* 5, no. 2 (1988): 55–61;
Yellin, "Jacobs, Harriet Ann (1813–1897)," in *Black Women in America: An Historical Encyclopedia,* edited by Darlene Clark Hine (New York: Carlson, 1993), pp. 627–628.

References:
Nina Baym, *Woman's Fiction: A Guide to Novels by and about Women in America, 1820–1870* (Ithaca, N.Y.: Cornell University Press, 1978);
Joanne M. Braxton, "Harriet Jacobs' *Incidents in the Life of a Slave Girl:* The Redefinition of the Slave Narrative Genre," *Massachusetts Review,* 27 (1986): 379–387;
Braxton and Sharon Zuber, "Silences in Harriet 'Linda Brent' Jacobs's *Incidents in the Life of a Slave Girl,*" in *Listening to Silences: New Essays in Feminist Criticism,* edited by Elaine Hedges and Shelley Fisher Fishkin (New York: Oxford University Press, 1994), pp. 146–155;
Hazel V. Carby, *Reconstructing Womanhood: The Emergence of the Afro-American Woman Novelist* (New York: Oxford University Press, 1987);
John Ernest, *Resistance and Reformation in Nineteenth-Century African-American Literature: Brown, Wilson, Jacobs, Delany, Douglass, and Harper* (Jackson: University Press of Mississippi, 1995);
Frances Smith Foster, "Harriet Jacobs's *Incidents* and the 'Careless Daughters' (and Sons) Who Read It," in *The (Other) American Traditions: Nineteenth-Century*

Women Writers, edited by Joyce W. Warren (New Brunswick, N.J.: Rutgers University Press, 1993), pp. 92–107;

Foster, *Written by Herself: Literary Production by African American Women, 1746–1892* (Bloomington: Indiana University Press, 1993), pp. 95–116;

Deborah M. Garfield, "Speech, Listening, and Female Sexuality in *Incidents in the Life of a Slave Girl,*" *Arizona Quarterly,* 50, no. 2 (1994): 19–49;

Minrose C. Gwin, "Green-eyed Monsters of the Slavocracy: Jealous Mistresses in Two Slave Narratives," in *Conjuring: Black Women, Fiction, and Literary Tradition,* edited by Marjorie Pryse and Hortense J. Spillers (Bloomington: Indiana University Press, 1985), pp. 39–52;

Debra Humphreys, "Power and Resistance in Harriet Jacobs's *Incidents in the Life of a Slave Girl,*" in *Anxious Power: Reading, Writing and Ambivalence in Narrative by Women,* edited by Carol J. Singley and Susan Elizabeth Sweeney (Albany: State University of New York, 1993), pp. 143–155;

Franny Nudelman, "Harriet Jacobs and the Sentimental Politics of Female Suffering," *ELH,* 59 (1992): 939–964;

Valerie Smith, "'Loopholes of Retreat': Architecture and Ideology in Harriet Jacobs's *Incidents in the Life of a Slave Girl,*" in *Reading Black, Reading Feminist: A Critical Anthology,* edited by Henry Louis Gates Jr. (New York: Penguin, 1990), pp. 212–226;

Carolyn Sorisio, "'There is Might in Each': Conceptions of Self in Harriet Jacobs's *Incidents in the Life of a Slave Girl, Written by Herself,*" *Legacy,* 13, no. 1 (1996): 1–18;

Mary Helen Washington, "Meditation on History: The Slave Narrative of Linda Brent," in her *Invented Lives: Narratives of Black Women, 1860–1960* (Garden City, N.Y.: Doubleday, 1987);

Jean Fagan Yellin, "Harriet Jacobs's Family History," *American Literature,* 66 (1994): 765–767;

Yellin, Introduction to *Incidents in the Life of a Slave Girl, Written by Herself,* edited by Yellin (Cambridge, Mass.: Harvard University Press, 1987), pp. xiii–xxxiv;

Yellin, "Text and Contexts of Harriet Jacobs' *Incidents in the Life of a Slave Girl: Written By Herself,*" in *The Slave's Narrative,* edited by Charles T. Davis and Henry Louis Gates Jr. (New York: Oxford University Press, 1985), pp. 262–282;

Yellin, "*Written by Herself:* Harriet Jacobs's Slave Narrative," *American Literature,* 53 (1981): 479–486.

Papers:
Manuscript sources relating to Harriet Jacobs can be found in the Isaac and Amy Post Family Papers at the Rush Rhees Library, University of Rochester; the Norcom Family Papers at the North Carolina State Archives, Raleigh; the Boston Public Library; the Sydney Howard Gay Papers at the Rare Book and Manuscript Library, Columbia University; and the Sophia Smith Collection at Smith College.

Mary Jemison
(circa 1742 – 1833)

Richard V. McLamore
McMurry University

BOOK: *A Narrative of the Life of Mrs. Mary Jemison, who was Taken by the Indians, in the year 1755 when only about twelve years of age, and has continued to reside amongst them to the present time,* by Jemison and James Everett Seaver (Canandaigua, N.Y.: J. B. Bemis, 1824); republished as *Deh-he-wa-mis, or, A Narrative of the Life of Mrs. Mary Jemison: Otherwise Called the White Woman, who was Taken by the Indians, in MDCCLV, and who continued with them seventy eight years* (Batavia, N.Y.: W. Seaver, 1842); republished as *Life of Mary Jemison: Deh-he-wä-mis* (New York & Auburn: Miller, Orton & Mulligan / Rochester: D. M. Dewey, 1856).

Editions: *A Narrative of the Life of Mrs. Mary Jemison,* edited by Charles Delamater Vail (New York: American Scenic & Historical Preservation Society, 1942);

A Narrative of the Life of Mrs. Mary Jemison, edited by June Namias (Norman: University of Oklahoma Press, 1992).

Captured by a Shawnee raiding party in 1758, when she was a teenager, Mary Jemison was adopted into a Seneca family and lived within that culture until her death in 1833. Known in western New York State as the "White Woman of the Genesee," she became one of the best-known American women of the nineteenth century after she spent three days in autumn 1823 recounting her life to James Everett Seaver. The resulting publication, *A Narrative of the Life of Mrs. Mary Jemison* (1824), was one of the best-selling books of the 1820s, as popular as the novels of James Fenimore Cooper. As Charles Delamater Vail has explained, "readers of the period literally wore out the copies of the little 16mo which were frequently carried in the pocket, and more frequently passed from hand to hand, so that only a few have survived." There are only twenty known copies of this edition. Jemison's popularity reveals much about nineteenth-century attitudes toward Native American culture and the inner conflicts experienced by Euramericans who struggled not only to assert legal posses-

sion of Native American territories but also to establish an emotional connection with the land and culture they were appropriating.

Mary Jemison was born onboard the *William and Mary* as it carried her parents, Thomas Jemison and Jane Erwin Jemison, and her three older siblings toward Philadelphia around 1742. It is possible that the Jemisons arrived in Philadelphia as late as December 1742 or January 1743, but Vail concludes that they most likely arrived on 6 October 1742. Jemison's parents had been moderately wealthy Scots-Irish farmers in the Belfast area. The family settled near Marsh Creek, near Gettysburg, in what is now Adams County, Pennsylvania, in 1743. They appear to have thrived, moving into larger quarters and taking in other families and servants shortly before the 1758 raid that devastated the family and surrounding area.

Mary Jemison's memory of early events was uniformly three years off–thus, she said she was captured in early spring 1755, during the sowing of flax seed. Vail, however, quotes a letter published in the 12 April 1758 issue of *The Philadelphia Gazette* that establishes the date of the raid on the Jemison farm as 5 April 1758:

> Three Indians were seen this Day by two Boys near Thomas Jamieson's, at the head of Marsh Creek; upon which they gave the Alarm, when six men went to said Jamieson's House, and found there one Robert Buck killed and scalped; also a Horse killed, that belonged to William Man, a soldier at Carlisle, whose wife and children had just come to live with Jamieson. This woman, and her three Children, Thomas Jamieson, his wife, and five or six children are all missing.

The assault on the Jemison homestead was a consequence of Thomas Penn's "Walking Purchase" of 1737. William Penn's profit-minded son exploited a clause in his father's 1686 treaty with the Lenape (Delaware Indians) that allowed for a second walk to determine the boundaries of the original purchase. Thomas Penn had his agents spend weeks preparing their route and hiring runners. One of these runners, Edward Mar-

shall, managed to cover about sixty-five miles, and Thomas Penn ended up cheating the Lenape out of more than 1,200 square miles of property. Because it dispossessed them of their favorite hunting grounds, this chicanery incensed the Delawares and Shawnees and pushed them into siding with the French in the French and Indian War (1753–1763). As Charles Thomson, who was a clerk for the Delawares during negotiations in 1757 and later became a member of the Continental Congress, explained in *An Enquiry into the Causes of the Alienation of the Delaware and Shawanese Indians from the British Interest* (1759), "how it comes to pass that the English have so few Indians in their Interest, while the French have so many at Command. . . . The Indians themselves, when called upon in a public Treaty, to explain the Motives of their Conduct, declare that the Solicitations of the French, joined with the Abuses they have suffered from the English, particularly in being cheated and defrauded of their Land, have at length induced them to become our Enemies and to make War upon us."

The friction between the Indians and the Anglo-Scots was exacerbated further when the Scots-Irish settlers of the region spread from the already purchased land into Indian lands. Six years after the Walking Purchase, the Jemison family settled themselves on the edge of a particularly rancorous boundary dispute. Jemison recollected that the presence of the Indians had created a sense of danger around the "little paradise" that the Jemison family cleared on "a tract of excellent land lying on Marsh creek." Yet, she was either unaware of the reason for the tension that "excited in my parents the most serious alarm for my safety" or Seaver chose to omit her comments on that subject. As in many other places in Seaver's account of Jemison's narrative, the surface details do not correspond well with the overall pattern and assumptions of the work.

The teenaged Mary Jemison might have been unaware of what motivated the Delaware and Shawnee raids and might well have believed that "The death of the whites, and plundering and burning of their property was apparently their only object." Yet, it is difficult to believe—especially given her later accounts of the maneuvering of New Englanders such as Seaver who occupied Seneca lands—that as an eighty-year-old adopted Seneca she would have been similarly uninformed. Many modern scholars have noticed the contradiction between Jemison's purported lament for the loss "of my childish, happy days" that helped her survive "nearly seventy years, upon the tender mercies of the Indians" and her praise of the "many friends to whom I was warmly attached in consideration of the favors, affection, and friendship with which they had uniformly treated me, from the time of my adoption."

Although it is certainly plausible that Jemison might have held such contradictory notions, her description of the motivation for the raids seems designed to deny any legitimate motivation to the raiders.

Always slightly built—she never grew taller than 4' 6"– Mary Jemison was fifteen years old at the time of her abduction in April 1758. The raiding party—consisting of six Indians and four Frenchmen—"immediately commenced plundering . . . and took what they considered most valuable, consisting principally of bread, meal, and meat." Taking Mary, her parents, two of her brothers, her sister, and some visitors as captives, the raiding party "set out with their prisoners in great haste, for fear of detection." There followed a forced march of 175 miles in five or six days over a difficult, if well-traveled, trail. Although Seaver focuses on Indian atrocities—whippings and forcing little children to drink urine when "they cried for water," the description of this forced march begins a theme within the narrative that asserts the relative strength of women as survivors and sustainers. Providing a fundamental organizing pattern for her tale of strength and persistence, it indicates how thoroughly acculturated to the Senecas' woman-centered culture Jemison had become.

At sunrise of the second day, the prisoners "were halted, and the Indians gave us a full breakfast of provision that they had brought from my father's house." Understandably famished, everyone "partook of this bounty of the Indians, except father, who was so much overcome with his situation—so much exhausted by his anxiety and grief, that silent despair seemed fastened upon his countenance, and he could not be prevailed upon to refresh his sinking nature by the use of a morsel of food." A broken Thomas Jemison spoke nothing more in Mary's hearing, except to point out, probably mistakenly, the name of a small fort along the trail.

In contrast, "Mother, from the time we were taken, had manifested a great degree of fortitude, and encouraged us to support our troubles without complaining; and by her conversation seemed to make the distance and time shorter, and the way more smooth. But father lost all his ambition in the beginning of our trouble, and continued apparently lost to every care—absorbed in melancholy." Correctly guessing that by replacing her shoes and stockings with a pair of moccasins the raiders intended to spare Mary's life, her mother summoned up the courage to implore her daughter to remember her name, her language, and her prayers. In fact, Mary and one of the visitors, a young boy, were the only captives who were not killed. While the next night and day were extremely difficult for Mary, her mother's advice helped her "to endure . . . without complaining" the sight of her family's scalps stretched out to be dried and cleaned. The

A NARRATIVE

OF THE LIFE OF

MRS. MARY JEMISON,

Who was taken by the Indians, in the year 1755,
when only about twelve years of age, and
has continued to reside amongst
them to the present time.

CONTAINING

An Account of the Murder of her Father and his
Family; her sufferings; her marriage to two Indians;
her troubles with her Children; barbarities of the
Indians in the French and Revolutionary Wars; the
life of her last Husband, &c.; and many Historical
Facts never before published.
Carefully taken from her own words, Nov. 29th, 1823.

TO WHICH IS ADDED,

An APPENDIX, containing an account of the tragedy
at the Devil's Hole, in 1763, and of Sullivan's Ex-
pedition; the Traditions, Manners, Customs, &c. of
the Indians, as believed and practised at the present
day, and since Mrs. Jemison's captivity; together
with some Anecdotes, and other entertaining matter.

BY JAMES E. SEAVER.

CANANDAIGUA:
PRINTED BY J. D. BEMIS AND CO.
1824.

*Title page for the narrative of the "White Woman of the Genesee," who
lived with the Shawnees for seventy-five years*

strength of Jemison's mother anticipates the largely woman-centered existence of Seneca village life, as does the ceremony of adoption that occurred when the party reached Fort Duquesne, on the site of modern Pittsburgh.

As Gary L. Ebersole has noted, "Captivity represents an ultimate boundary situation where human existence, identity, and ultimate meaning are called into question as the captive's world is turned topsy-turvy and his freedom and autonomy are stripped from him, along with his social status, clothes, and other cultural accouterments, and markers." In Jemison's case, this stripping away accompanied a process of adoption that granted her a new identity, status, and place within a new community. This process began on her arrival at Fort Duquesne, where Jemison was relieved to be chosen by two women "of the Seneca tribe."

With these women, Jemison left Fort Duquesne for a Seneca town called "She-nan-jee," south of Pitts-

burgh, near present-day Warren, Pennsylvania. Once there, she was ceremonially stripped of her European clothes, which, "though whole and good when I was taken, were now torn in pieces." After undressing her and bathing her, the women dressed her "in complete Indian style . . . and seated me in the center of their wigwam." Shortly thereafter, her adoption ceremony commenced: the townswomen entered the house and lamented the lost relative, a dead brother, whose place Jemison would take in the family. As the women progressed from lamentation to joy at the arrival of the girl whom they named Dehgewamis, they "seemed to rejoice over me as over a long lost child." Indeed, despite her fears that she would "suffer death on the spot," this adoption ceremony conferred upon her the status of "a real sister, the same as though I had been born of their mother." As Dean R. Snow has explained, such "fictive kinship" structures in that matrilineal society "made it possible for the longhouse to survive as a traditional residential form."

The narrative depicts clearly the care that Jemison's new "sisters" took to acculturate Jemison to her new life as a Seneca woman. She cared for children, did housework, and helped hunters bring game in from short hunting trips. Her memories of her family, her old home, and her captivity, however, "destroyed my happiness, and made me constantly solitary, lonesome and gloomy." Although she was warned not to speak English in the hearing of the sisters, Jemison "made a business of repeating my prayer, catechism, or something I had learned in order that I might not forget my own language." At the same time, because of the efforts of the sisters, she learned the Seneca language and customs fairly quickly. Indeed, she appears also to have internalized an Iroquoian system of thought in which "the status of women was derived from their economic importance and from the extension of the kinship system into Iroquois political life." Thus, her adoption is another instance of her guidance by strong women, which she commemorated by telling Seaver that she had "great reason to respect them, though they have been dead a great number of years."

For the next few years Jemison adapted to the routine of living at one town site during the growing season and then moving to the hunting grounds for winter quarters. One indication of her thorough immersion in Seneca life is that she began dating her reminiscences according to these natural cycles—thus, she recalls, "About the time of the corn harvest, Fort Pitt was taken from the French by the English." Another indication of her growing familiarity with Seneca culture rests in her awareness that the spring and summer essentially belong to the women's activities of planting the sacred sisters of "corn, squashes, and beans," while

the winters were given over to the masculine activities of hunting and trapping.

Shortly after returning to the planting grounds on the Scioto River in 1759, the people of her town traveled to Fort Pitt "to make peace with the British." Brought to the fort "to see the white people that were there," Jemison began to wish to return to her friends in white society. The white people at Fort Pitt were surprised to see her with the Indians "and appeared very much interested in my behalf." Alarmed by these developments and fearing that they would lose her, Jemison's adopted sisters "hurried me into the river. . . . So great was their fear of losing me, or of my being given up in the treaty, that they never once stopped rowing till they got home." Her adopted sisters' alarm and hasty retreat reveals that their investment in her was rooted in a communal, rather than commercial, system of values.

Jemison's adopted sisters were understandably alarmed by Jemison's lingering desire to return to white culture and moved to incorporate her more fully into Indian life. They chose a husband for her from the Delawares. Though reluctant, Jemison would not dare to "disobey their commands . . . and Sheninjee and I were married according to Indian custom." Telling this story over several years, Jemison had probably registered the incredulity and disgust this statement provoked from white listeners. When she told her story to Seaver, she stated that "the idea of spending my days with him, at first seemed perfectly irreconcilable to my feelings; but his good nature, generosity, tenderness, and friendship towards me, soon gained my affection; and, strange as it may seem, I loved him."

Her first child—a daughter born in 1760—died after two days. Jemison fell ill and was confined from approximately May until late August—or from "the time that the kernels of corn first appeared on the cob" until "the time that the corn was ripe." In 1762 she bore a son whom she named Thomas Jemison "To commemorate the name of my much lamented father." Her memory "that I had once had tender parents and a home that I loved" was the only thing that marred her happiness.

Sheninjee's kindness, gentleness, and dignity are concrete examples of the humane, loving treatment that eventually led Jemison to bestow on her captors what Seaver termed the "blessings of civilization." When she explained why her anxiety to leave them had disappeared by 1762, she stated, "With them was my home; my family was there, and there I had many friends to whom I was warmly attached." She also included a subtle criticism of the feminine domestic labor necessary to maintain the lifestyle of white civilization in her description of women's work among the Senacas: "Our labor was not severe; and that of one year was exactly similar . . . to that of the others, without that endless variety that is to be observed in the common labor of the white people."

In essence Jemison's tale is a familiar story of the destruction of a shared communal structure by the incursions of commerce. After summing up the kinds of labor performed by the Seneca women, Jemison anticipated the tragic part of her story. No doubt thinking of their effects on her own children, she noted that "the use of ardent spirits amongst the Indians," introduced by whites, and "the attempts which have been made to civilize and christianize them by the white people . . . will ultimately produce their extermination." Lacking Seaver's faith in the "blessings of civilization," Jemison described a life "without any of those jealousies, quarrels, and revengeful battles between families and individuals, which have been common in the Indian tribes since the introduction of ardent spirits amongst them." Despite later attempts by nineteen- and early-twentieth-century editors and retellers of her story to preserve her identity as essentially white and Christian, such comments reveal a woman who had developed a healthy distrust of the culture in which she had lived for the first years of her life. With the exception of sewing, which she learned after the Revolutionary War, Jemison chose to stay ignorant of "the other domestic arts" practiced by white women.

After four years of living at the Wiishto site on the Ohio River, relatives arrived from the tribe's central location on the Genesee River in New York, insisting that Jemison's family go with them to Genishau, near Geneseo, New York. The prospect of this journey may have appealed to Jemison because her two Seneca sisters had gone two years previously. Yet, the 650-mile trip by canoe, horseback, and foot was especially difficult for her because she had to carry her nine-month-old infant. Even though Jemison's party tried to avoid the rainy season by starting early, rains fell throughout the journey, flooding creeks and turning trails into quagmires. As the narrative states, "Those only who have travelled on foot the distance of five or six hundred miles, through an almost pathless wilderness, can form an idea of the fatigues and sufferings that I endured on that journey." Nevertheless, Jemison noted that everyone made the journey in good health and that the warmth of her reception by her Indian sisters "rivetted my affection for them so strongly that I am constrained to believe that I loved them as I should have loved my own sister had she lived, and I had been brought up with her."

Jemison's reunion with her sisters stands in for the return to her white family that never happened. Contrasting the love of these women to abstract notions of white culture, blood kinship, and race, Jemison

seems to have identified herself thoroughly with those people who loved and cared for her tangibly. Such a decision was both fascinating and repulsive to white readers at a time when most American writing represented culturally produced differences as fundamentally unchangeable racial traits. As disturbing as her narrative might have been on first reading, it appealed at a fundamental level to American readers struggling to make sense of the intersection of white and Native American cultures.

Jemison's narrative of her acculturation refutes notions of an unbridgeable racial divide. On her arrival at Genishau, a group of Senecas was preparing to assist the French in an attempt to retake Fort Niagara from the English. They returned with two white prisoners and several oxen. On the feast day appointed to celebrate their triumph and the sacrifice of the two prisoners, Jemison experienced a classic sense of ambivalence, "having never attended an execution, and yet I felt a kind of horrid dread that made my heart revolt, and inclined me to step back rather than support the idea of advancing." This feeling intensified because of her sister's earnest desire to see such a special event. Their mother dissuaded them from going, however, partly because such a sight would torment Jemison by "making her bleed at the wounds which are now but partially healed." Thus, Jemison suggests to her readers that there is more to Indian sensibility than the stereotypical notion of their bloodcurdling savagery.

Moreover, the story demonstrates that the notion of separate spheres for women and men, then dominant in white society, was also current among Native Americans. Their mother's main reason for forbidding Jemison and her sister to witness the executions was that to do so would be "unbecoming the true dignity of our sex." Clarifying the separate roles of men and women, the mother reminds her daughters—including Jemison—"Our task is quite easy at home, and our business needs our attention. With war we have nothing to do: our husbands and our brothers are proud to defend us, and their hearts beat with ardor to meet our proud foes. . . . let our warriors alone perform on their victims their customs of war!"

The rest of Jemison's narrative focuses on how white actions have transformed Seneca culture. In a pattern repeated with the Cherokees, Creeks, and other nations, these cultural changes included redefinition of gender roles among Native Americans. The commercial opportunities afforded Seneca men by white society tended to destabilize Indian communal structures and agricultural practices. These changes came about not only as immediate and local consequences of interactions with fraudulent traders, trappers, and land speculators but also as the result of decisions made by world leaders and financiers in London, Philadelphia, Hartford, and Amsterdam. At the end of the French and Indian War in 1763, Jemison remembered that "the King of England offered a bounty to those who would bring in the prisoners that had been taken in the war, to some military post where they might be redeemed and set at liberty." This concept posed a problem for Jemison when a Dutchman, John Van Sice, who frequented the Genishau town, decided to restore her to white civilization in Niagara and pocket the bounty money. Having "fully determined not to be redeemed at that time, especially with his assistance," Jemison managed to elude his aid, a comical episode in the narrative. The tone turns more somber, however, when "the old king of our tribe" decided that he would take Jemison to Niagara to receive the bounty, notwithstanding an earlier decision that she should not be taken without her consent and that she could stay with them "quietly and undisturbed." Piqued by the king's greedy decision, her brother resolved, said Jemison, that "sooner than I should be taken by force, he would kill me with his own hands!"

Jemison's sister told her to take her child, Thomas, and hide. If the dispute could not be resolved and her brother decided that he must kill Jemison, the sister would place a small cake of corn at the door. When Jemison returned from hiding, the cake was there. Again following her sister's instructions, Jemison took Thomas back into hiding and waited for her sister to send for her. After the king left for Niagara without Jemison, her sister sent the brother to her hiding place to bring her home. This episode further illustrates Jemison's reliance on the traditional woman-centered kinship structures of Seneca culture, and the threat posed to those structures by white incursions—both by whites and by Indian men caught up in the seductions of white ways.

It is impossible to trace whether the emphases of the narrative result from Seaver's rendering of the text or from Jemison's understanding of events. Nevertheless, the story as presented in Seaver's text emphasizes the ways in which white incursions deform, destabilize, and virtually destroy the woman-centered culture and family to which Jemison's affections had become riveted. As evidence of her attachment to an essentially woman-centered culture, one need only note that she says virtually nothing about her second husband, Hiokatoo, except to note their marriage in 1765 or 1766 (after the death of her first husband a few years earlier), the names of their children (named Jane, Nancy, Betsy, Polly, John, and Jesse—again, "principally after my relatives"), and passing comments about Hiokatoo's bravery and decency. In fact, so

glaring is the absence of her comments about her husband that Seaver commented in his introduction to the narrative that she had referred him to her alleged cousin George Jemison for information about Hiokatoo, which Seaver added to the narrative.

Seaver accounts for Jemison's refusal to speak of Hiokatoo's life in terms of her "dread" of his warlike deeds. Yet, twentieth-century studies of the nature of Native American storytelling and autobiography suggest that her reticence had more to do with the fact that Hiokatoo's life was not hers; his deeds were not hers to tell. As Snow has observed, "The village and its surrounding fields was the traditional domain of women. The world of Iroquois men was the forest, where war, trade, and hunting went on." Impossible as it was for Seaver to accept that a woman might think of herself as separate from her husband, Jemison could and did perceive herself as fundamentally separate from Hiokatoo's influence. Furthermore, Jemison also seems to take pride in recounting how she asserted her will, whether or not it conflicted with the wishes of supposed male leaders.

Jemison's account of her dealings with Ebenezer Allen demonstrates her ability to assert and to exercise her will. Usually taken as another of Jemison's descriptions of white atrocities designed to balance the stereotypical presentation of Indians, her account of Allen in chapter 8 of the narrative also emphasizes her role in frustrating Indian and American attempts to capture a notorious Tory who happened to live on her land. Without overtly stating that she considered her land and those living on it to be under her control, Jemison strongly hinted that she believed so. Minimally assisted by her husband, Jemison decided to frustrate any and all attempts to capture Allen:

> Early the next morning, Nettles and his company came in while I was pounding the meal for Allen, and insisted upon my giving him up. I again told them I did not know where he was, and that I could not, neither would I, tell them any thing about him. I well knew that Allen considered his life in my hands; and although it was my intention not to lie, I was fully determined to keep his situation a profound secret. They continued their labor and examined (as they supposed) every crevice, gully, tree, and hollow log in the neighboring woods, and at last concluded that he had left the country, and gave him up for lost, and went home.

The narrative signals her attachment to Allen with a detail whose significance registers fully only for readers who know the central place of corn in Iroquoian culture. Pounding meal for Allen—notwithstanding a white reader's inclination to read the act as a subservient ges-

ture—signified that Jemison has taken responsibility for preserving him.

Jemison's narrative also describes how she asserted and maintained a provisional independence from the white, masculinized ways that shattered Iroquoian culture after the American Revolution. She seems to have understood her narrative in such a framework. To post-Revolutionary life she contrasted the idyllic life of the Indians when "They were temperate in their desires, moderate in their passions, and candid and honorable in the expression of their sentiments on every subject of importance." As many historians have noted, the American Revolution marked a turning point in the development of American culture, and Snow maintains that the war destroyed "the great invisible longhouse of the Iroquois League." As Jemison described it,

> our Indians lived quietly and peaceably at home, till a little before the breaking out of the revolutionary war, when they were sent for . . . by the people of the States . . . in order that the people of the states might ascertain, in good season, who they should esteem and treat as enemies, and who as friends, in the great war which was upon the point of breaking out between them and the King of England.

At that council the Indians agreed to remain neutral. A year or so later, "we, as usual, were enjoying ourselves in the employments of peaceable times, when a messenger arrived from the British Commissioners, requesting all the Indians of our tribe to attend a general council which was soon to be held at Oswego." This meeting continued—without success for the British, Jemison notes—until the commissioners "addressed their avarice" and promised that the Indians "should never want for money or goods." Ironically underscoring how these promises were partially delivered, Jemison observed, "Many of the kettles which the Indians received at the time are now in use on the Genesee Flats."

Snow has pointed out that, as a result of warfare and American depredations such as General John Sullivan's 1779 raids in western New York, "by the end of the war [the Iroquoian] population was halved." Contradicting notions of bloodthirsty savages, Jemison's narrative replays at the personal and communal level the historical devastation of Iroquoian culture. She remembered how she learned of Sullivan's approach with "a large and powerful army of the rebels . . . making rapid progress towards our settlement, burning and destroying the huts and corn-fields; killing the cattle, hogs and horses, and cutting down the fruit trees belonging to the Indians throughout the country." In response to such reports, "Our Indians immediately became alarmed, and suffered

H. K. Bush-Brown's 1910 statue of Mary Jemison, marking her grave at Letchworth State Park in western New York State

every thing but death from fear that they should be taken by surprise, and totally destroyed at a single blow."

Although her townspeople were able to escape Sullivan's army, the town did not:

> Sullivan and his army arrived at Genesee river, where they destroyed every article of the food kind that they could lay their hands on. A part of our corn they burnt, and threw the remainder into the river. They burnt our houses, killed what few cattle and horses they could find, destroyed our fruit trees, and left nothing but the bare soil and timber.

Working to diminish reader outrage at Sullivan's raid, Seaver chose to counter this description with an account of Indian atrocities toward captives, which seems not to have been witnessed by Jemison.

As Snow notes, the Revolution "wrecked Iroquois morale," and he goes on to explain, "While women continued to be economically important in the evolving society, men were stripped of their traditional roles and often derided for their impotence. At the end of the eighteenth

century, the once-proud Iroquois were reduced to a squalid alcoholic existence on small fragments of their former domain." At the same time—and in competition with many Native American men, as well as white speculators such as William Cooper, David Ogden, Robert Morris, and the State of New York—Jemison managed to acquire title to several hundred acres of prime land.

General Sullivan's foray into western New York had prompted Jemison to abandon the Seneca town, which could no longer sustain her family: "The weather by this time had become cold and stormy; and as we were destitute of houses too, I immediately resolved to take my children and look out for myself, without delay. With this intention I took two of my little ones on my back, bade the other three follow, and the same night arrived on the Gardow flats, where I have ever since resided." At the time, the land was inhabited by two runaway slaves, who hired Jemison to help them harvest and husk their corn. Owing to "the most severe winter I have witnessed," which virtually decimated her tribe, Jemison was fortunate to have found a source for "a seasonable supply [of corn that] made my family comfortable . . . through the succeeding winter." She was also deeply amused by the black man's habit of standing guard—gun in hand—while she worked to harvest his corn, "lest I should get taken or injured by the Indians." (Jemison may not have told him that she was an adopted Seneca.)

While she continued to live on the flats, "the negroes left them for a place that they expected would suit them much better." Thus began the process whereby Jemison acquired title to the flats and chose not to return to her white relatives. In her narrative Jemison included notices of the many and tangled cession treaties that papered over the Iroquois lands, recognizing these documents as the instruments that ended the traditional Seneca way of life she had come to call her own. Her account shows the stakes involved in her acquisition and preservation of the Gardow Flats tract.

Jemison's narrative reveals her awareness of ongoing attempts to dispossess the remaining Indians in western New York. These land deals—most of them fraudulent—were inordinately complicated and occasioned enough legal wrangling to keep the practices of several New York City lawyers, including Alexander Hamilton and Aaron Burr, busy for years. While the federal government in 1794 recognized the Senecas' rights to the land they occupied in western New York, the only means for the tribe to provide for its members was to sell the land. In September 1797, at the council of Big Tree, Jemison reported, "the Senecas sold most of their New York land to the Holland Land Company for $100,000." In turn, this Dutch-controlled holding company sold the land to settlers from New England.

It is remarkable that, during this scramble for Indian lands, an illiterate woman could have acquired title to her property, "under the same restrictions and regulations that other Indian lands are subject to." Although opposed by the Seneca chief Red-Jacket at Big Tree and afterward, Jemison acquired the "liberty to lease or let my land to white people to till on shares." She acquired this control, however, after rejecting an offer to let her return to her white relatives. She argued "that I had got a large family of Indian children, that I must take with me; and that if I should be so fortunate as to find my relatives, they would despise them, if not myself; and treat us as enemies; or, at least with a degree of cold indifference, which I thought I could not endure." She did not decide the matter with the consent of all her children. Thomas wanted to return—the first hint that, despite the belief of the chiefs "that Thomas would be a great warrior," he identified himself as at least partially white.

Having reserved "310 square miles in eleven tracts" for themselves, the remaining Seneca found that these reservations soon became the targets for white settlement. Indeed, Jemison appears to have been exploited by George Jemison, who claimed to be her cousin. Taking advantage of her illiteracy, he duped her into signing away four hundred acres of her territory when she thought she was granting him only forty.

The attempts to take Jemison's land reached a peak in 1816, when some of her white friends, "suspecting that some plan was in operation that would deprive me of my possessions," developed a plan to have her naturalized as a U.S. citizen so that she could secure title to her land. In exchange she deeded them in 1817 "the whole of my original reservation, except 4000 acres and Thomas Clute's lot." Finally, in the winter of 1822 and 1823, she agreed to "sell to them all my right and title to the Gardow reservation, with the exception of a tract for my own benefit, two miles long and one mile wide, lying on the river where I should choose it. . . ." Jemison's ability to use her ethnicity and her shrewd bargaining skills allowed her to maintain for several years her ownership of a Seneca reservation, an achievement that makes her the equal of Iroquoian chiefs such as Cornplanter and Red-Jacket.

While Jemison was able to use some aspects of white culture to her advantage, the invasion of white attitudes seems to have been at the base of a murderous series of disputes that resulted in the deaths of all her male children. The hostilities between Thomas and John suggest that the two half brothers had different notions of cultural heritage and identity. From their youth Thomas had accused John of witchcraft, which caused "frequent and severe quarrels between them, and gave me much trouble and anxiety for their safety." Furthermore, Thomas saw John's taking two wives as "a violation of good and wholesome rules in society, and . . . beneath the dignity, and

inconsistent with the principles of good Indians, indecent and unbecoming a gentleman. . . ." Thomas's diatribes against John escalated when Thomas was drunk. Then, Jemison recalled, "he often threatened to take my life for having raised a witch. . . ." Such language—especially from a man who had been made a chief at an early age and been sent "two or three times to Philadelphia to assist in making treaties with the people of the States"—was particularly shocking in Native American culture, which taught children to honor their parents and ancestors.

In 1811 the disputes between brothers—fueled by alcohol and cultural confusion—resulted in John's murder of Thomas in a quarrel "on their old subjects of difference." Next, John conceived a hatred for his younger brother, Jesse, who had begun to shun his older brother after the murder. Like Thomas, Jesse was attracted to white culture and "was inclined to copy after the white people; both in manners and in dress." John killed him in a drunken fit and was subsequently murdered himself as a result of an alcohol-fueled quarrel. The deaths of Jemison's sons confirm Snow's assessment of the devastation alcohol wrought on Iroquois culture: "families fragmented, the mechanism of reciprocal condolence came apart, and Indian society fell into a darkness of mutual suspicion and rumors of witchcraft. . . . Families that had previously been parts of extended matrilinear households had to survive on their own at the very moment at which stress on the traditionally weak marriage link reached its maximum."

Indeed, Jemison's success provoked accusations that she was a witch, which were "believed for a long time, by some of our people . . . but they were unable to prove my guilt, and consequently I escaped the certain doom of those who are convicted of that crime, which, by the Indians, is considered as heinous as murder." Concluding that she would soon die, she stated that her "only anxiety is for my family."

Problems of cultural and physical appropriation are central to Jemison's narrative. Jemison's ethnic heritage—signified by her English name—conflicts with the Senecan cultural identity she adopted—signified by her Iroquoian name of Dehgewamis. In addition to the usual problems of "authorship" that surface in a narrative told by an illiterate Seneca woman to a literate white man, there are those posed by Jemison's potentially ambivalent identifications. Jemison's knowledge of the legal uses to which print could be put to dispossess Indians reveals an understanding of the power of print at odds with the literary and cultural uses that Seaver imagined for his text. Given her experiences with white men's deceptions, it is not surprising that Jemison was suspicious of Seaver, who was one of the horde of whites who had sought control of the land. As Seaver noted in his introduction, she was "so jealous of her rights" that she refused to tell her story unless "in com-

pany with Mr. Thomas Clute, whom she considers her protector."

As H. David Brumble has noted, in "as-told-to autobiographies of the nonliterate. . . . it is the Anglo editor, who decides . . . what is to be the shape of his subject's 'autobiography.'" According to June Namias, "Seaver frequently modified Jemison's words to conform to a sentimental style popular in his day." Seaver conceded as much in his preface, stating that "the greatest care has been observed to render the style easy, the language comprehensive, and the description natural. . . . The line of distinction between virtue and vice has been rendered distinctly visible; and chastity of expression and sentiment have received due attention." In *A Narrative of the Life of Mrs. Mary Jemison,* therefore, editorial and narrative voices clash over the cultural identity that the text is intended to represent. Neither voice succeeds in effacing the other; nor is it possible to decide for certain where one begins and the other leaves off. Still, a careful reader may observe the contrasting voices.

Understandably distrustful of print and certainly aware of how Indians were represented in white culture, Jemison seems to have tried to counter accounts of "The vices of the Indians." Seaver's statement that her "family pride inclined her to withhold whatever would blot the character of her descendants" and his characterization of her conversational style as having "a degree of mildness, candor, and simplicity, that is calculated to remove all doubts as to the veracity of the speaker" suggest a woman who was consciously shaping her narrative as a testament to and defense of Seneca culture. Jemison's narrative does not imply that she was at all interested in "comparing her present situation with what it probably would have been, had she been permitted to have remained with her friends, and to have enjoyed the blessings of civilization." Instead of being concerned with her status as "The White Woman," Jemison's narrative consistently laments the destruction of the traditional, woman-centered Seneca culture into which she had been adopted in 1758.

Nevertheless, Jemison's worldview passed relatively unnoticed among white readers of Jacksonian America. Thus, as Vail has noted, "the First Edition . . . established for the book itself a claim to a place in our English literature as having enriched its permanent stock of great stories, of stories revealing some of the finest traits possible in our human nature."

Still, Jemison's narrative cannot be taken to show—as Lois Lenski wrote in the introduction to her retelling of Jemison's story for children—a thorough "picture of Seneca life from the inside." Either Jemison never fully understood the significance of the rituals and processes of the culture into which she was adopted or Seaver was incapable of or unwilling to register her attempts to explain them. Whatever the case, only rarely—as with the ceremony of her adoption—does the narrative discuss the many rituals and ceremonies that structured her life as a Seneca. On the other hand, the narrative continually reveals a perspective toward Euramerican historical actions that might be termed the vantage point of the oppressed. Jemison rarely knew why such major events as the French and Indian War and the American Revolution happened. Instead, she comprehended the consequences of these events on Seneca life and her own attempt to live with her adopted people.

Jemison lived through the decimation and restructuring of Iroquoian culture. Although she once said that she "did not tell them who wrote it down half of what it was," her narrative reveals the level at which the woman-centered worldview of the Seneca towns had informed her consciousness. Her story also reveals how the extended woman-centered family that had been the mainstay of the Iroquois longhouse had been shattered. This message has perhaps always appealed most to young women readers, and Jemison's story may owe part of its continuing popularity to the way in which it speaks to the desire to evade the drudgery of "women's work" that Jemison came to associate with the "blessings of civilization."

References:

James Axtell, "The White Indians of Colonial America," *William & Mary Quarterly,* third series 32 (Spring 1975): 55–88;

H. David Brumble, *American Indian Autobiography* (Berkeley: University of California Press, 1988);

Gary L. Ebersole, *Captured by Texts: Puritan to Postmodern Images of Indian Captivity* (Charlottesville: University Press of Virginia, 1995);

Annette Kolodny, *The Land Before Her: Fantasy and Experience of the American Frontiers, 1630–1860* (Chapel Hill: University of North Carolina Press, 1984), pp. 68–81;

Lois Lenski, *Indian Captive: The Story of Mary Jemison* (Philadelphia: Lippincott, 1941);

June Namias, *White Captives: Gender and Ethnicity on the American Frontier* (Chapel Hill: University of North Carolina Press, 1993), pp. 145–203;

Karen Oakes, "We Planted, Tended and Harvested Our Corn: Gender, Ethnicity, and Transculturation in A Narrative of the Life of Mrs. Mary Jemison," *Women and Language,* 18, no. 1 (1995): 45–51;

Dean R. Snow, *The Iroquois* (Oxford & Cambridge, Mass.: Blackwell, 1994);

Susan Walsh, "'With Them was My Home': Native American Autobiography and *A Narrative of the Life of Mrs. Mary Jemison,*" *American Literature,* 64 (March 1992): 49–70.

Elizabeth Keckley

(1818? – 26 May 1907)

Barbara McCaskill
University of Georgia

BOOK: *Behind the Scenes. Or, Thirty Years a Slave, and Four Years in the White House* (New York: G. W. Carleton, 1868).

Edition: *Behind the Scenes,* introduction by Dorothy Porter (New York: Arno, 1968); republished with an introduction by James Olney (New York: Oxford University Press, 1988).

Elizabeth Hobbs Keckley's book, *Behind the Scenes* (1868), is a post–Civil War memoir of her enslavement and subsequent service to the Lincoln family. She published her book not only to raise money for herself but also to help her friend and former employer Mary Todd Lincoln, who had incurred a $70,000 debt while her husband's estate was being probated. Exposing white women's cruelty and complicity in slavery, Keckley described her rape, lack of freedom, loss of family during servitude, her eventual emancipation, and her rise to public acclaim as the dressmaker, or modiste, to Mary Lincoln. In Keckley's memoir the events of her life are contrasted to Mrs. Lincoln's highs and lows, including Abraham Lincoln's election to the presidency and Union victory in the Civil War, as well as the deaths of son William and the president and Mary Lincoln's impulsive overspending, disreputable confidantes, scandalous business transactions, and descent into poverty. The former slave and former first lady were diametrically opposed in race, social class, reputation, legal and political rights, and access to civil and patriarchal protection; yet, *Behind the Scenes* united their destinies. The book combines the moral conundrums, industry, and commonsensical wisdom of the eighteenth-century picaro and self-made man with the resourcefulness, sorrows, resilience, and shames of the nineteenth-century fugitive-slave woman and heroine of sentimental fiction.

Behind the Scenes is framed by juvenile and adult memories that connect it to two centuries of slave narratives. Acknowledging a tradition that, according to William L. Andrews, includes the *Narrative of the Life of Frederick Douglass, an American Slave. Written by Himself*

(1845) and Harriet Jacobs's *Incidents in the Life of a Slave Girl. Written by Herself* (1861), Keckley began her book with a paradox: "My life has been an eventful one. I was born a slave—was the child of slave parents—therefore I came upon the earth free in God-like thought, but fettered in action." Beginning with her birth in Dinwiddie, Virginia, in enslavement to the family of Colonel A. Burwell, her reminiscences of childhood are typical of the conventions of this genre. For example, they include the absenteeism of her parents. Her father, George Pleasant, was owned by a different master on another plantation, and he was separated from her and her mother, Agnes Hobbs, when his master relocated to Shelbyville, Tennessee, and thereafter further west.

Separation from her mother came later, when fourteen-year-old Keckley was loaned to her master's son, who took her to live with his family in Hillsboro, North Carolina. In her memoir Keckley wrote about her rebellion against verbal abuse and eroticized beatings at the hands of a Mr. Bingham, the white man who worked for the family as a tutor. When she was about eighteen, she was given to one of her master's friends, Alexander Kirkland, who raped her and compelled her to be his mistress for four years. She bore a son, George, as a consequence of this forced union. In the slave-autobiography tradition, the book juxtaposes the savageries of the southern slaveholding elite with the "God-like" thoughts and deeds of those black chattel who allegedly lack humanity and faith. Keckley recounted witnessing a slave auction, observing the hypocritical Christianity of slaveholders.

Kirkland died when Keckley's son was eighteen months old, and the two slaves were passed on to a Mr. Garland, who had married one of Colonel Burwell's daughters. With her son and mother, Keckley was taken to St. Louis, Missouri. On 13 August 1855, with help from a patron and money earned from work as a seamstress, Keckley was able to purchase freedom for herself and her son from her mistress, Anne Burwell Garland, for $1,200. Her marriage to a fellow slave from Virginia, James Keckley, who had fraudu-

lently represented himself as manumitted, ended in 1860 after eight years.

After leaving her husband, Keckley went to Baltimore and then to Washington, D.C. Like other blacks, Keckley encountered racism as soon as she set foot in the capital city. Not only was she required to show proof of her freedom to any Southerner who demanded to see it, but she also had to find a white person to "vouch to the authorities that I was a free woman." Despite such prejudice, she established herself as a modiste for fashionable society women. Her early clients included the wives of Jefferson Davis, Stephen A. Douglas, and Edwin M. Stanton.

After the Civil War broke out, Keckley's son, George, enlisted in the Union army and died in the Battle of Lexington, Missouri, on 10 August 1861. In 1862 Keckley helped to found the Contraband Relief Association to educate and employ the escaped slaves who streamed into the border states from points further south.

Introduced to Mary Lincoln by the wife of General George McClellan, Keckley soon became the first lady's modiste. After the president's assassination Keckley went with Mrs. Lincoln to Chicago. Although he had been a lawyer–and, according to most of his clients, an exceptional one–President Lincoln had not executed a will. Soon after the assassination, Mary Lincoln found herself in dire financial straits while she waited for his estate to be probated, and she asked Keckley to manage the sale of jewelry and articles of clothing from her wardrobe. Worried about the ethics of the agents Mrs. Lincoln had enlisted to organize this sale, Keckley nonetheless shielded Mrs. Lincoln's delicate business "from the angus-eyed reporters of the press" and enlisted the endorsement of Frederick Douglass. The sale of Mary Lincoln's personal items became heatedly politicized after the agents publicized the sale by publishing letters signed by her that excoriated Republicans for leaving her with no means of support. According to Keckley, the agents had first "proposed to show the letters to certain politicians, and ask for money on threat to publish them if his demands . . . were not complied with." What commenced as a personal appeal concluded as a public travesty. Known as "The Old Clothes Scandal," it ended as a "media circus," says Frances Smith Foster, that in the eyes of the nation "besmirched her [Mary Lincoln's] martyred husband's name and embarrassed the country."

The scandal, and Keckley's account of it, also ended the friendship between Keckley and Mary Lincoln. Keckley's publishers, pressured perhaps by Lincoln's infuriated son Robert, were driven to terminate distribution of her book.

Exiled temporarily from her Washington, D.C., home to a fourth-floor garret at 14 Carroll Place in New York City, Keckley had finished writing *Behind the Scenes* "at the shady side of forty," on 14 March 1868. Describing herself writing alone in her boardinghouse, Keckley ended her story with the familiar slave-narrative themes of nominal northern freedom and contingent, tentative citizenship. Though emancipated, she was impoverished, reduced to surviving on a monthly widow's pension of $12. Her earnings as a seamstress had been diminished for various reasons, including her age, a fickle and seasonal clientele, and the racism, exclusion, exploitation, and lack of welcome that blacks routinely encountered in the nineteenth-century urbanized North. Though surrounded by friends, Keckley was husbandless and childless. Finally, because of gossip and social censure, she had been shunned by her dearest associate, Mary Lincoln. (According to Jessie Carney Smith, Keckley valued Mary Lincoln's friendship so deeply that even after their estrangement, she continued to keep a picture of Mrs. Lincoln in her room.)

Though Keckley's conclusion emphasizes her tentative liberty, it also signals the political willingness of Reconstruction Era African Americans to reconcile with what remained of the southern slaveholding oligarchy and to proceed with uplifting the race and nation. According to Foster, "The nation had no cause to fear that former slaves held grudges or were a threat to safety or security. It was the institution, not the people, that deserved condemnation."

What distinguishes *Behind the Scenes* from many other fugitive-slave narratives is Keckley's subversion of the nineteenth-century sentimental and abolitionist-feminist conventions. Keckley includes a series of scenes in which, as slave or maid, a black woman in some sense exchanges places with a privileged white woman. The defining scene of this sort occurs in the fourteenth chapter, "Old Friends." In the summer of 1868 Keckley visited Rude's Hill, the Lynchburg, Virginia, home of her former mistress Anne Burwell Garland. During this visit Garland told Keckley of a transaction between her mother and Keckley's Aunt Charlotte.

To reconcile with Charlotte after having beaten her, Garland's mother had given her slave her best and only silk dress. Then, Garland said,

> Two weeks afterward mother was sent for to spend the day at a neighbor's house, and on inspecting her wardrobe, discovered that she had no dress fit to wear in company. She had but one alternative, and that was to appeal to the generosity of your aunt Charlotte. Charlotte was summoned, and enlightened in regard to the situation; the maid proferred to loan the silk dress to the mistress for the occasion, and the mistress was only too glad to accept. She made her appearance at the social gathering, duly arranged in the silk that her maid had worn to church on the preceding Sunday.

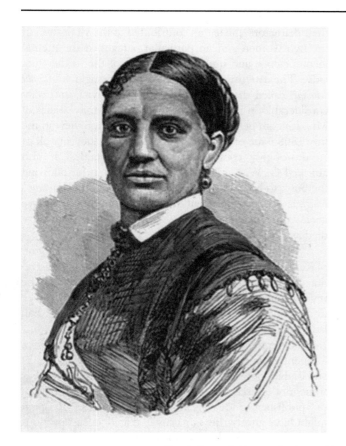
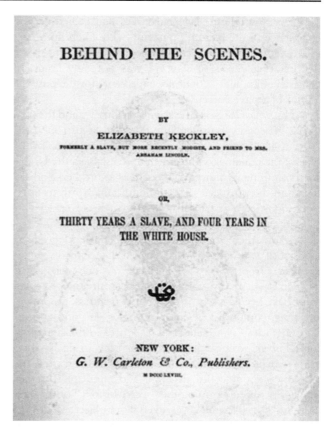

BEHIND THE SCENES.

BY

ELIZABETH KECKLEY,
FORMERLY A SLAVE, BUT MORE RECENTLY MODISTE, AND FRIEND TO MRS.
ABRAHAM LINCOLN.

OR,

THIRTY YEARS A SLAVE, AND FOUR YEARS IN
THE WHITE HOUSE.

NEW YORK:
G. W. Carleton & Co., Publishers.
M DCCC LXVIII.

Frontispiece and title page for the autobiography of Mary Todd Lincoln's dressmaker

This passage must be evaluated in the context of Keckley's earlier statement that "warm is the attachment between master and slave." Garland's story of role reversal suggests the reconciliatory possibilities that Reconstruction offers not only to former slaves and slaveholders but also to prior Confederate and Union foes. Most Confederates resented what they perceived to be the Unionist Republicans' vindictive Reconstruction government, their humiliating election of former slaves to legislate the lives of former masters, their punitive destruction and pillaging of southern homes and property, and their exploitative unleashing of carpetbaggers, con artists, counterfeiters, scalawags, and ne'er-do-wells on what remained of the old antebellum rice, sugar, and cotton empires. Keckley was well aware of these perceptions, having observed firsthand in April 1865 the "desolate appearance—desks broken and papers scattered promiscuously" of the Confederate capitol in Richmond, Virginia, after the surrender. While James Olney says that "Elizabeth Keckley was writing partly within an abolitionist tradition," he adds that "she was also writing within, and simultaneously against, a powerful apologetic tradition, by which I mean a tradition of apology for the South and for the slave system on which the South's economy rested and which determined social structures throughout the Southern states."

Keckley did not overlook the pain of enslavement, excoriating her former mistress in particular for not bothering to educate her. Resentment over the ignorance to which her bondage had confined her had been inspiration for Keckley's role in the Contraband Relief Association during the war. Yet, Keckley bore no ill will against the mistress who withheld education from her. She expressed fondness and affection for "Miss Anne," even to the point of calling their reunion "five of the most delightful weeks of my life."

As Andrews has noted, the apparent contradiction of Keckley's narrative was intended to revise the rhetoric of the antebellum slave's autobiography. Andrews points out that while antebellum narratives "were designed to exacerbate the sectional divisions that would eventually rend the United States into two warring camps," former slaves writing after the war "decided that it was no longer in the best interests of blacks, especially black Southerners, to continue to feed the sectionalism of the past." The aim of these later writers was reconciliation, even to the point of revising "the image of the degenerate slaveholder that

so many antebellum slave narratives had etched on the conscience of the nation." Agreeing with antebellum narratives "that the slave could free him/herself from the degenerating effects of slavery" was not only "morally consistent" but also "politically expedient" for the postwar author of a slave narrative.

In *Behind the Scenes* the slave's reciprocity and the mistress's generosity represent the potential of the South to redeem its dignity by accepting the innate equality of blacks; the potential of the North to re-establish the Union by recognizing its vanquished enemies as brothers and sisters; and the prospects of both South and North to build institutions from which former slaves such as Keckley and Charlotte may benefit.

Ann Allen Shockley has described Keckley in her late sixties as a "tall, stately, always well-groomed woman with scars from slavery on her back." As one who served as mentor to many young black seamstresses, Keckley must have been acutely aware of how neatness, grooming, breeding, comportment, and presenting "a good appearance in society" were effective responses to the stereotyping of black women that had been used to justify their enslavement. Throughout her memoir she contrasted this assurance about codes of dress and etiquette with her ambiguity about exposing the "secret history" of the Lincolns to "gossip-loving" eyes, even if her object were to aid her former employer: "If I have betrayed confidence in anything I have published," she wrote in the preface, "it has been to place Mrs. Lincoln in the better light of the world. A breach of trust—if breach it can be called—of this kind is always excusable." She continued,

> My own character, as well as the character of Mrs. Lincoln, is at stake, since I have been intimately associated with that lady in the most eventful periods of her life. I have been her confidante, and if evil charges are laid at the door, they also must be laid at mine, since I have been a party to all her movements. To defend myself I must defend the lady that I have served.

The nineteenth-century reception of *Behind the Scenes* was unfavorable. As with antebellum slave narratives, white reviewers challenged its authorship, questioned the author's race or gender, compared it unfavorably to works by white writers, or took issue with the veracity of its stories. Contemporary reviewers discussed the book as more Mary Lincoln's story than Keckley's, reproaching both seamstress and first lady for what they considered mortifying glimpses into the private lives of the Lincolns, the Jefferson Davises, and other prominent politicians.

Without consulting Keckley, her publisher, G. W. Carleton, had appended to *Behind the Scenes* lengthy, virtually unedited correspondence between her and Mary Lincoln about the sale of the first lady's clothes and jewelry. Rather than vindicating the beleaguered pair in the eyes of

their detractors, the letters contributed to the vilification of the two women and, in particular, suggested the mental incompetence and questionable ethics of the former first lady. The August 1868 issue of the prestigious *Atlantic Monthly* called the work "both dull and trivial, and only considerable in its effect of dragging the family affairs of Mrs. Lincoln before the public." Similarly, a review in the July 1868 issue of *The Galaxy* dismissed Keckley's book as "a thoroughly contemptible volume of tattle." It also attacked G. W. Carleton and Mary Lincoln for allowing the book to be published. The July 1868 issue of *Putnam's Magazine* stated plainly that the book "ought never to have been written or published." *Behind the Scenes* was soon parodied as *Behind the Seams* (1868), by "Betsey Kickley."

Racism was as much the cause of the poor reception of Keckley's book as the reviewers' perceptions of indiscretion and sensationalism. In dismissing the book the reviewer for *The Galaxy,* for example, described Keckley disparagingly as "a mulatto woman, half dressmaker, half lady's maid."

Over the years critics' assessments of *Behind the Scenes* frequently have been clouded by suspicions regarding its authorship. Some of Keckley's contemporaries, as well as some modern scholars, have speculated that the abolitionist, publisher, and war correspondent James Redpath might have ghostwritten or heavily edited at least portions of the book for Keckley, who admitted to having had no formal education. Having written and edited books on slavery and figures such as Jefferson Davis, John Brown, and Toussaint-Louverture—as well as serving on a postbellum commission in Haiti and founding the Lyceum Bureau, through which he booked lecturers, including Keckley, and managed their tours—Redpath had become well acquainted with the conditions of slavery. He was also well aware of the pitfalls of publishing and adept at identifying the tastes of the predominantly white American readership.

Other African Americans of Keckley's time feared that her unveiling of the Lincolns' private lives would offend the white clients of other black modistes, hurting their trade and tarnishing the reputations of the general ranks of African American working women. Frances Anne Rollin, an African American diarist, said that the book "was well written but not by Mrs. K[eckley] that's clear." A public lecture by Keckley only confirmed to Rollin that the seamstress was incapable of having written *Behind the Scenes* by herself. The reading was "poor to say the least," Rollin wrote. He disparaged her elocution, concluding, "It is too late in the day for her [Keckley] to attempt it especially without a first class teacher."

Since Keckley's authorship has been documented by firsthand observations, claims that Redpath wrote any or all of *Behind the Scenes* seem unfounded. As late as 1982, however, more than a century after its initial publication,

the authorship of *Behind the Scenes* was still being called into question, and it was being attributed to other writers.

Nevertheless, Keckley's book is valued for employing both African American and white American literary traditions and for helping to establish the form, themes, content, and purposes of the postbellum fugitive narrative. To historians, biographers, genealogists, and cultural critics it also is of interest as a repository of information about the lives of freedmen and freedwomen.

Twentieth-century literary critics have been kinder than Keckley's contemporaries. Since the 1980s scholars have assigned *Behind the Scenes* to an important place in the African American and abolitionist-feminist literary canons. Foster and Andrews, for example, have discussed how the book establishes themes, tone, structures, and characterization that distinguish postbellum slave narratives from antebellum ones. *Behind the Scenes* has also been the focus of investigations into how women's slave narratives differ from those written by men—a reappraisal sparked by the feminist movement of the 1960s and 1970s and the subsequent black feminist or womanist movement, which identified the aesthetics and motives of black women writers to be, in many cases, different from those of white women or men of either race.

Behind the Scenes has also been discussed as a template for the success stories of late-nineteenth-century African Americans. In particular, Foster has refocused critical attention on the book away from Mary Lincoln and "The Old Clothes Scandal" and back to Keckley—to her goals, her personality, and her contribution to African American life as well as letters.

After giving up her trade as a seamstress, Keckley taught domestic arts at Wilberforce University in 1892–1894. She died impoverished and alone, after suffering a fatal stroke in her sleep on 26 May 1907 in the Home for Destitute Women and Children, a Washington, D.C., institution that she had helped to found. While her contemporaries censured her, posthumous critical reception of *Behind the Scenes* has redeemed her efforts as a friend, a writer, a citizen, and a representative of her race. Keckley's reputation has benefited from the inclinations of late-twentieth-century critics of American literature to rethink their criteria for canonizing literary works. The re-examination of her work is a noteworthy example of the re-evaluation of a book and author once dismissed as unliterary and minor. Garments designed by Keckley are in the Anacostia Neighborhood Museum, Smithsonian Institution, in Washington, D.C.

Biographies:

John E. Washington, *They Knew Lincoln* (New York: Dutton, 1942);

Bert James Loewenberg and Ruth Bogin, eds., *Black Women in Nineteenth-Century American Life: Their Words, Their Thoughts, Their Feelings* (University Park: Pennsylvania State University Press, 1976);

Dorothy Sterling, ed., *We Are Your Sisters: Black Women in the Nineteenth Century* (New York: Norton, 1984);

Ann Allen Shockley, *Afro-American Women Writers, 1746–1933: An Anthology and Critical Guide* (New York: New American Library, 1988);

Jessie Carney Smith, ed., *Epic Lives: One Hundred Black Women Who Made a Difference* (Detroit: Visible Ink Press, 1993).

References:

William L. Andrews, "The Changing Moral Discourse of Nineteenth-Century African American Women's Autobiography: Harriet Jacobs and Elizabeth Keckley," in *Decolonizing the Subject,* edited by Sidonie Smith and Julia Watson (Minneapolis: University of Minnesota Press, 1992), pp. 225–241;

Andrews, "Reunion in the Postbellum Slave Narrative: Frederick Douglass and Elizabeth Keckley," *Black American Literature Forum,* 23 (Spring 1989): 5–16;

Joanne M. Braxton, *Black Women Writing Autobiography: A Tradition Within a Tradition* (Philadelphia: Temple University Press, 1989);

Frances Smith Foster, "Autobiography After Emancipation: The Example of Elizabeth Keckley," in *Multicultural Autobiography: American Lives,* edited by James Robert Payne (Knoxville: University of Tennessee Press, 1992), pp. 32–63;

Foster, " 'In Respect to Females . . .': Differences in the Portrayals of Women by Male and Female Narrators," *Black American Literature Forum,* 15 (Summer 1981): 66–70;

Foster, *Witnessing Slavery: The Development of the Ante-Bellum Slave Narrative* (Westport, Conn.: Greenwood Press, 1979);

Foster, *Written By Herself: Literary Production by African American Women, 1746–1892* (Bloomington: Indiana University Press, 1993);

Minrose C. Gwin, *Black and White Women of the Old South: The Peculiar Sisterhood in American Literature* (Knoxville: University of Tennessee Press, 1985);

Gwin, "Green-eyed Monsters of the Slavocracy: Jealous Mistresses in Two Slave Narratives," in *Conjuring: Black Women, Fiction, and Literary Tradition,* edited by Marjorie Pryse and Hortense J. Spillers (Bloomington: Indiana University Press, 1985), pp. 39–52;

Barbara McCaskill, "To Rise Above Race: Black Women Writers and Their Readers, 1859–1939," dissertation, Emory University, 1988;

Modiste Elizabeth Keckley: From Slavery to the White House (New York: Black Fashion Museum, n.d.);

Ruth Painter Randall, *Mary Lincoln: Biography of a Marriage* (Boston: Little, Brown, 1953).

Susan Petigru King

(25 October 1824 – 11 December 1875)

Leslie Petty
University of Georgia

BOOKS: *Busy Moments of an Idle Woman,* anonymous (New York: Appleton, 1854);
Lily: A Novel, anonymous (New York: Harper, 1855);
Sylvia's World and *Crimes Which the Law Does Not Reach,* anonymous (New York: Derby & Jackson, 1859);
Gerald Gray's Wife, anonymous (Augusta: Stockton, 1864).
Edition: *Gerald Gray's Wife and Lily: A Novel,* edited by Jane H. Pease and William H. Pease (Durham, N.C.: Duke University Press, 1993).

SELECTED PERIODICAL PUBLICATION–
UNCOLLECTED: "My Debut," *Harper's New Monthly Magazine,* 37 (June–November 1868): 532–546.

In 1993 Duke University Press republished two of Susan Petigru King's novels, *Lily: A Novel* (1855) and *Gerald Gray's Wife* (1864), in one volume, edited by the historians William and Jane Pease. This republication ended more than a century of complete neglect by the literary establishment of this South Carolina writer and is part of a recent resurgence of interest in popular American women writers of the nineteenth century. Unfortunately, with the exception of the introduction written by the Peases for this edition and a few short book reviews written shortly after the publication, little criticism exists of King's work. This lack of attention may in part result from a lack of material: King's other three novels and her final novella have been out of print for years. The oversight, however, may indicate that her novels and short stories do not fit the paradigms of "domestic fiction" outlined by such critics as Mary Kelley and Nina Baym.

Janet Justis, in an October 1994 review for *The North Carolina Historical Review,* observes that King's "novels do not offer a moral blueprint for the reader [as do the works of the 'literary domestics'] but seek to shock or test the reader's perception of the established social conventions of the period." A reviewer for *The Independent Weekly* (June 1994) instead compares King's work, with its aristocratic characters and drawing-room

Susan Petigru King (courtesy of the South Carolina Historical Society)

settings, to Edith Wharton's *The House of Mirth* (1905), saying, "While King's novel is less sophisticated than Wharton's, her characters are just as fascinating." Regardless of the varied comparisons, the consensus of those familiar with King's work is that her novels and stories criticize the institution of marriage as it existed in upper-class antebellum society and satirize the dishon-

esty, jealousy, and banality that permeates the interaction of her aristocratic characters. Critics also note that King chooses to confine herself to the social world of balls and parlors, ignoring completely the explosive political issues during her writing career that culminated during the Civil War.

Although the Civil War dramatically affected King's life, her major themes—the critique of marriage and the satirization of upper-class Southern society—stem from her experiences as a young woman growing up in elite Charleston society. Born Susan DuPont Petigru on 25 October 1824, she was the youngest of the four children of James L. Petigru, a highly respected lawyer and statesman in Charleston, South Carolina, and his wife, Jane Amelia Postell Petigru, a planter's daughter who was a "belle" of Charleston high society. The family was prosperous throughout Susan Petigru's childhood, and she received the traditional education for a female in her societal position—a private school as a young girl and then a finishing school in Philadelphia. There, according to the Peases, Petigru refined her French (which she liberally uses in her fiction) and continued her incessant reading of novels.

The family, however, met with severe financial distress just as Susan was preparing to debut in Charleston society, and because of this decline in fortune, her mother pressured Susan and her sister Caroline to marry wealthy men, regardless of their emotional attachments. After initially resisting this pressure, in 1843 nineteen-year-old Susan Petigru entered into an unhappy marriage with Henry C. King, a wealthy lawyer. Their only child, Adele, was born in 1844. Henry and Susan were never well suited for each other, and they spent a great deal of time apart, Susan King traveling often with her sister and father to Sullivan's Island, Philadelphia, or Saratoga—frequently against Henry's wishes. Her relationship with her parents, like her relationship with her husband, almost certainly contributed both to her subject matter and to her iconoclastic perspective. Interaction with her mother, according to the Peases, became increasingly volatile and strained throughout King's childhood and early adulthood. Her mother's insistence that King marry for position and wealth unquestionably had a negative impact on King's feelings toward her mother and on her views about the institution of marriage. King's relationship with her father, on the other hand, seems to have matured into an affectionate bond based on intellectual compatibility and independent thinking. James Petigru's frequent letters to his younger daughter are kind and confiding. Even when they include a strong note of paternal disapproval, they end with an assurance of devotion and love. Her father's character probably influenced King's propensity for challenging the status quo; as attorney general for the state, Petigru was a firm and vocal Federalist, speaking out against the secession of the Southern states at a time when the popular cry was for civil war.

As a young married woman, King became known as a lavish entertainer with what her husband Henry described as an "almost inordinate love of company." According to her obituaries, King was known "in Charleston and in South Carolina [as] the acknowledged and undisputed leader of fashion, refinement and culture." This assessment may be overly laudatory (as obituaries tend to be); during her lifetime, her reputation was more questionable among the "upper crust" of Charleston. According to the Peases, King was considered an "outrageous flirt"; she was also outspoken and sharp-tongued; and her wit could be withering. One of her contemporaries, Julius Stuart, went so far as to write to his mother in 1855: "Mrs. King, I believe, is a bad woman." While King's intellect never seems to have been questioned, her boldness about publishing (especially when she did not need the money, which was considered a justification for publication by nineteenth-century women writers) certainly contributed to her slightly scandalous reputation.

King began this "bold" literary career in 1854 with the anonymous publication of her first book, *Busy Moments of an Idle Woman*. The book is divided into five sections: the first section, *Edith,* a conventional novella, is by far the longest; the subsequent short sections are the stories "An Everyday Life," "The Widow," "Old Maidism versus Marriage," and "An Episode in the Life of a Woman of Fashion." In *Edith* King chooses as the heroine a popular character type—a young lady who is well bred but orphaned and poor. Edith Millwood works to support herself as a "lady's companion" until she makes a happy and advantageous marriage and is restored to her estranged grandfather, who had disinherited Edith's father, Albert Millwood, when he married without approval. While this story does not include the virulent critiques of marriage and upper-class Charleston society that are the hallmarks of much of King's work, its subplot suggests the author's cynical view of marriage. Mrs. Stockton, the lovely widow for whom Edith works, by the terms of her late husband's will forfeits her entire inheritance if she remarries; thus, she is prevented from marrying the poor man she loves.

The short stories in *Busy Moments* more strongly suggest King's distrust of the "prison house of marriage" and her disgust at the financial and capricious motives that often govern these matches. "An Everyday Life" is a framed narrative in which Mrs. Mordaunt, a worldly wise older woman (a recurring

BUSY MOMENTS

OF AN

IDLE WOMAN.

ROBERT. "Here she comes! [Enter Violante.
VIOLANTE. "I pray you, gentlemen,
 Pass me lightly by : I am too slight a thing
 To dwell on. CHOICE OF A WIFE.

NEW-YORK :
D. APPLETON & COMPANY, 200 BROADWAY
16 LITTLE BRITAIN, LONDON.
185-

Title page for King's first book, a novella and four short stories that reveal her cynicism about the "prison house of marriage"

Perhaps the strongest critique of marriage in King's first published work is the fourth story, "Old Maidism versus Marriage." In this story seven young women vow that in ten years all those who are still unmarried—the old maids—will meet in the same place, while all the others will send letters honestly chronicling their lives as married women. After the ten-year lapse, only one woman, Caroline Bloomfield, now twenty-eight, is unattached. Pursued by Edward Allingham, she awaits the letters before making her decision about marrying him. The majority of the story consists of these "letters," each telling a different tale of woe, ranging from poverty and loneliness to complete self-effacement and self-sacrifice for one's husband and children. Sadly, however, the heroine seems unable to find a preferable alternative to marriage: as Caroline's wise sister-in-law, Dora, advises: "To remain single . . . is all very well so long as, young and beautiful, you have shoals of admirers and crowds of friends; but in ten or fifteen years from now, with your circle scattered, . . . you will find yourself alone, and shut out from many privileges." Better, the story advocates, to "make your choice well" and learn to "bear and forbear."

The final installment in this collection, "The Life of a Woman of Fashion," shows the unfortunate fate of a woman who has not chosen her mate well. Annie Grey, a wealthy, attractive young matron, has married for convenience, but when she meets Mr. Lascelles, a man who falls ardently in love with her, she confronts the emptiness of her life. Part of this emptiness, King's story suggests, results from the contemporary expectations for married women in Charleston society. These women stayed at home at all times; they were not invited to any of the fashionable balls or other society events, since these were places where unmarried males and females went to "make a good match":

> I believe it is a fact no longer to be doubted or disputed, that a young lady's first object is to marry—for this she is born, educated, and introduced—for this papa opens his purse-strings and doles out so many dollars per annum, to be devoted to dressing and party giving—now is it to be borne with, that these same labors should be enjoyed by those who have no right to partake of them?

> If youthful matrons cannot comprehend all this, they must have it lucidly explained to them—if they will not give up society, they must be kic-bowed out of it. It is the old story of the bees and the drones over again.

Mrs. Grey, however, does not follow the "rules" of her societal position, and for this reason, she—much like King—is an anomaly in her culture.

type in King's work) convinces a young girl, Fanny Medwin, to give up her love of a false young man by telling the story of her own disastrous marriage and subsequent flirtations. Mrs. Mordaunt speaks a sentiment echoed throughout King's work: "If love be not there before the knot is tied, small is the chance that capricious blind boy should enter the dwelling afterwards." The next story, "The Widow," tells of the "revenge" of a lovely young widow, Mrs. Templeton Sydney, who runs into a childhood friend of her brother's, Charley Staunton, in Saratoga. When Mrs. Templeton realizes Staunton does not recognize her, she begins an innocent flirtation with him to repay him for an insult to her looks that she overheard him make when they were younger. This story also focuses on the long-term damages of youthful folly.

Busy Moments was received with anger by many of King's contemporaries in Charleston, including members of her family. The Peases note that part of this anger stemmed from the uncomfortable recognition that many of the character studies were based on the lives of prominent Charlestonians. King's mother was one of those most incensed by King's book, and as James Petigru wrote to his daughter, the apology that King sent for shocking her mother was "committed to the flames, in flaming anger." King's father, on the other hand, admits that she "burst upon [him] as an author almost as surprisingly as Miss [Fanny] Burney did on her unsuspicious parent"; nonetheless, he praises her, saying "the dialogue is witty and sparkling, and the descriptions circumstantial and striking." He does, however, realize that King has placed herself in a potentially compromising position by including so many barely concealed portraits of fellow Charlestonians. The postscript to his letter reads, "I believe that the interest would be better kept up by standing in the reserve and making the authorship a sort of secret. It can't be more, considering how many are in the plot." While Henry King's response to his wife's writing is not known, one cannot imagine that the critical treatment of married life in her literature could have improved the conditions of her own marriage.

King's second work, *Lily* (1855), also published anonymously, is her first full-length treatment of the themes of courtship and marriage. Since *Lily* was considered more "subtle" and "proper" than *Busy Moments,* the second work fared better critically among King's contemporaries than the first. Lily is beautiful, sincere, honest, giving, and loving–in other words, the perfect model of the nineteenth-century notion of "true womanhood." Her wealth, however, insures her downfall when she falls in love with and is betrothed to her childhood friend, Clarence Tracy. What the narrator and the reader know–and Lily does not–is that while Clarence is "outwardly refined, delicate, gentle; inwardly, he is sensual, coarse, and violent, unhesitatingly selfish, constitutionally indolent." His affection for Lily is motivated primarily by her great wealth and her childlike devotion to him, while he is more intrigued and captivated by her cruel, cold, attractive cousin, Angelica. Furthermore, a melodramatic plot twist toward the end of the novel reveals that Clarence has a mistress, Lorenza, who, in a fit of jealousy, poisons Lily on the eve of her wedding, thus ending both the heroine's life and the novel. (This final plot twist seems to have been prompted by a Charleston legend of a young bride, Harriett Mackie, who died in 1804.)

Lily, like King's other work, shows the "sinister motivations of cads who toy with women for their own amusement or enrichment." It also shows that even the most perfect women are ultimately defined by and valued for their wealth and position, not for themselves. Furthermore, through the character of Mrs. Clarendon, the book criticizes the woman who devotes herself to her household duties and to the care of her husband and who in turn neglects to guide her daughters and/or wards through courtship rituals and marriage proposals. According to the narrator of the novel, "any woman who fancies that by leaving her young daughters to enter upon the stage of grown-up life without the watchful guard of a parent's eye and presence, is casting away a privilege and disregarding an urgent necessity; . . . there can be no comparison between the relative claims of scrubbing, scolding, and housekeeping, and the care of one's child." One cannot help wondering if King's unbearably strained relationship with her own mother may be reflected in this castigation of Mrs. Clarendon.

In 1859 Derby and Jackson published in one volume two more of King's short novels, *Sylvia's World* and *Crimes Which the Law Does Not Reach.* Each work had been previously serialized in popular magazines; *Sylvia's World* was published under the title, "The Heart History of a Heartless Woman" in *Knickerbocker* during 1859, and the stories from *Crimes Which the Law Does Not Reach* were published chronologically in 1857–1858 in volume 2 of the Charleston-based *Russell's Magazine.* Although the critical notice of the publication of these works in book form was slight, it was laudatory.

Lyle H. Wright's *American Fiction* (1939) attributes King with another anonymously serialized novel, *The Actress in High Life* (1860); however, it is highly unlikely that King wrote this book. It was serialized in *Russell's Magazine* at the same time that *Crimes Which the Law Does Not Reach* was; it lacks King's trademark stylistic flourishes, such as her frequent use of quotation marks and the scattering of French phrases; furthermore, it does not employ King's typically ironic tone.

Sylvia's World is an intriguing study of a psychologically abusive relationship. This work, like King's earlier story "An Everyday Life," is a framed narrative in which an older, wiser, caring woman advises a younger, naive girl about romance and marriage. Sylvia, a disillusioned married woman who is "barely thirty and . . . much admired," spends a rainy evening sharing with her young, "impetuous," unmarried friend, Olivia, a manuscript she has written about a failed romance and deceitful relationships, "The Heart History of a Heartless Woman." This story-within-the-story concerns nineteen-year-old Helen Latimer (whom Olivia and the reader eventually discern is a young Sylvia) and her ardent suitor, Harry Trevor. Mr. Latimer, Helen's father, remembering his other daughter's abusive marriage and subsequent early death, has forbidden the

two to become engaged for four years because he fears for Helen and sees that Trevor's love "promised no abiding happiness to his treasured darling." Trevor is jealous, violent, and possessive, and as his frustration with this restriction on the engagement grows, his petulance and moodiness become stifling. After one of their frequent arguments, Helen and Harry are discovered kissing by some town gossips. As a result, two of Helen's closest friends, including her devious cousin, Claudia Leslie, side with the disapproving members of society and attend parties to which Helen has not been invited because of her indiscretion.

Helen, meanwhile, has been taken under the wing of "saucy" Bertha St. Clair, perhaps the best known of King's wise matrons who "warn the young women [they] befriend against the designing women who would destroy their loves and reputations as well as against duplicitous men." When Harry abruptly ends his relationship with Helen and becomes engaged to Claudia, Bertha is the one who comforts Helen, since Helen's mother blames her daughter, not Harry, for the breakup. Despite Bertha's counseling and warnings, Helen/Sylvia becomes distanced from society, marrying a man that she respects but does not love, because she feels she can never be passionately involved again. The cynical advice that Sylvia gives Olivia reflects the distrust of human nature that permeates this book: "When the lessons of kindred, friends and the world teach you that such as you hoped to find them, they are not, retire within your shell, smother your own feelings, live within yourself, and you will be in the end, more pleasing to them and to yourself." Cold, reserved, pensive Sylvia, who "lives for herself," becomes a much more popular, sought-after "belle" than young, trusting, giving Helen.

Letters written by and about King suggest that in her life she often tried to mentor as did her Sylvia/ Bertha St. Clair characters. In 1855 Julius Stuart (in the same letter in which he calls King a "bad woman") writes of a young girl, Mary Rhett, who "seems fascinated with the company of Mrs. King" and who "talks of nothing else." Stuart saw this attachment to King as dangerous for a young girl; he warned that "if they [Mary and her sisters] go on much longer with Mrs. King, they will compromise the position in society of all three sisters." As late as 1874 King still seems to have been interested in guiding young women, though her reputation seems to have jeopardized her interest in their welfare. The author wrote to her nephew: "I have even lost the little girl whose love for me was such a bright side to my dull life. But her horrible parents have carried her off & poor child as she is but 15 it will be years before the law will set her free." These relationships for King may also have been a way of compensating for her failed relationship with Adele, which became increasingly strained as King's daughter matured. King seems to have been able to guide her real life protégées much less than she was able to help their fictional counterparts.

Like the majority of the stories in *Busy Moments,* the collection of short stories in *Crimes Which the Law Does Not Reach* expose the foibles of human interaction. Published separately in *Russell's Magazine* before their compilation, each one has a title identifying the "crime" played out in the story. The first of the six stories, "No. 1: Gossip," relates the story of fashionable Mrs. Greene and the society women that visit her ostensibly to collect money for the poor; however, the women actually visit to speculate about others' lives and to spread damaging rumors, specifically about a young woman who was seen in a compromising situation. Offended, Mrs. Greene coldly asks the women to leave. At the end of the story Mrs. Greene writes to inform these ladies of the death of the young girl about whom they were gossiping and to accuse them of indirectly causing the girl's death with their maligning tales. "No. II: A Marriage of Persuasion" tells of a mother who goads her unwilling daughter into a lucrative but loveless marriage and does not see how unhappy and cold her daughter's life becomes. "No. III: A Male Flirt" follows the change of Azalea Dudley, a shy, innocent girl who falls in love with Mr. Vernon, the male flirt, who carelessly toys with her emotions when he is engaged to someone else. This experience changes Azalea into a "cruelly self-asserting" woman who becomes the most sought-after woman in society, although her emotions and trust are impenetrable. The final three stories—"No. IV: The Best of Friends," "No. V: A Coquette," and "No. VI: A Man of Honor"—depict the falseness of people who at first seem devoted (romantically or platonically) and then the devastation their duplicity causes when it is discovered. All six stories in this collection show how the "crimes" that humans commit against each other by being manipulative and self-absorbed are the actions that make others also learn to be hardened and self-centered. According to this collection, human nature is embroiled in an unrelenting cycle of disillusionment.

The Civil War followed shortly on the heels of the publication of these two works. The Petigru mansion in Charleston suffered damage during the war, and the family was scattered to various places. Perhaps the most radical consequence of the war for King was the death of her husband Henry at the Battle of Secessionville in 1862. Under these discouraging conditions, King continued to write; she resumed publishing two years after Henry's death with her fifth and final work,

LILY.

A Novel.

BY THE AUTHOR OF

"THE BUSY MOMENTS OF AN IDLE WOMAN."

"She was not very beautiful, if it be beauty's test
To match a classic model when perfectly at rest;
 * * * * * * *
 * * * * * * *
Said I she was not beautiful? Her eyes upon your sight
Broke with the lambent purity of planetary light."
 N. P. WILLIS.

NEW YORK:
HARPER & BROTHERS, PUBLISHERS,
FRANKLIN SQUARE.
1855.

*Title page for the novel in which King attacked the "sinister motivations of cads who toy
with women for their own amusement or enrichment"*

Gerald Gray's Wife (1864). King again ignored the all-consuming politics and battlefield violence and chose instead to mine the familiar territories of Charleston upper-class society, false men and foolish women, and unhappy, money-motivated marriages. However, the heroine of this novel, Ruth Desborough, is unusual in King's canon because she is not a beautiful, naive, trusting girl at the beginning of the story. Instead, Ruth is almost an "old maid" at twenty-six; plain in appearance, her demeanor is reflected in her eyes "so cold, so self-concentrated apparently, so defiant and so distrustful." Ruth's distrust stems from her awareness of her great wealth, which makes her suspect anyone who wants to be her friend or suitor; she

is convinced that everyone is courting the "heiress," not the woman. The distrust is compounded, perhaps, because Ruth is not a born member of Charleston society. Instead, the Desboroughs, although of lower-class origins, have been "admitted" to society because of Mr. Desborough's successful business ventures. Ruth Desborough, then, seems a new creation for the author: a more-mature, worldly wise heroine who has learned before marriage to safeguard herself against the falseness of men and society to which many of King's heroines have fallen prey.

Ruth, however, is not immune to the illusion of romantic love; she only believes that she will never find it. Therefore, when Gerald Gray, born into a

respected family but left poor by fortune, convinces Ruth that he loves her for herself, not her wealth, Ruth blissfully agrees to marry him. The match makes Ruth ecstatically happy, but Gray's attentions are not honest; he fancies himself in love with his vapid cousin, Cissy Clare, and he only weds Ruth for a secure position. Nevertheless, Ruth believes in the façade, and as Gerald Gray's wife, she is physically transformed by her happiness into a beautiful woman, a "magnificent figure, gorgeously arrayed." As Ruth outwardly blossoms, however, she becomes increasingly shallow, insipid, and vain. As the narrator of the novel remarks, "O silly, silly woman's love! Ruth Desborough had more sense than . . . half her sex—Ruth Gray was intensely absurd . . . Ruth Gray looked at everything through her husband's blue eyes and placed her reasoning powers in the alembic of his mind, from which her ideas came as he willed them."

The narrative voice that makes this observation also distinguishes *Gerald Gray's Wife* from King's earlier work. Although some of King's other work has an occasional narrative aside, this novel has a sustained, intrusive, worldly wise narrative presence that frequently interjects biting commentary about Ruth's development, occasionally digressing into long diatribes about the hypocrisy of the Charleston aristocracy and the foolishness and dependence of married women in that society. A similarly opinionated perspective occurs in the novel in a more-familiar character from King's repertoire, Bertha St. Clair, who mentors the younger heroine with a voice of reason and experience, befriending Ruth and staying with her when she discovers Gerald's deceitfulness. Although the blow is devastating, Ruth does not die, as many nineteenth-century heroines do, from a broken heart. Instead, she travels to Switzerland with St. Clair, and the ending of this book, unlike the endings of King's other novels, is guardedly hopeful for Ruth's emotional recovery. The ending, if not happy, has potential for the heroine's happiness after her heartbreak. Now widowed, King may have experienced a corresponding "guarded hopefulness" about her own future as a single woman.

At the end of the war, as a widow with a daughter under her care and little inheritance from Henry's estate, King found herself trying to earn a living in the public sector. She worked for a while in Washington, D.C., as a "translator of foreign documents" in the postmaster general's office. She also continued to write, serializing her novella "My Debut" from June to November 1868 in *Harper's New Monthly Magazine*. This story differs significantly from King's other works. Perhaps the post–Civil War audience was not receptive to a critique of their antebellum upper-class society now that it had been irrevocably transformed; perhaps King herself experienced nostalgia for her lost past, or perhaps her financial considerations made her write a story more conventional and perhaps more palatable to the common reader. Whatever the reason, this novella is more predictable and traditional than almost all of the author's previous writings. First of all, King's heroine, Elizabeth Leighton, and her invalid mother are poor "refugees from that once 'Sunny South'"; once prosperous, they have now fallen on difficult times and moved to New York to seek their fortune. Elizabeth, a young woman teaching school and writing for a local newspaper, is much like the heroine that Nina Baym describes as typical of nineteenth-century women's fiction—an independent young girl who must support herself and possibly others until she has her happy ending, which is invariably marriage to a wealthy suitor.

Again, King's story seems to follow the well-known formula. By chance, Elizabeth finds herself at an elegant party where she encounters Arthur Neville, a gentleman whom she has admired from a distance. A few miscommunications slow the union of the two, but in the end, Elizabeth finds that Mr. Neville was a close friend of her uncle's before he died in the Civil War and the two marry quickly. Elizabeth "cheerfully" becomes mistress of Arthur's household, which includes several orphaned younger brothers and sisters that she takes to raise as her own.

Although on the surface this story displays the more-predictable plotline of many nineteenth-century romance narratives (and to King's own first published work, *Edith*), its sentiments suggest King's further maturation as a writer. First of all, there is a sensitivity to how sheltered the heroine had been as a young woman of privilege. As Elizabeth confesses, "Today I am far more proud of myself than I used to be in the past. I was a giddy, useless woman of fashion; now I am a magnificent 'workey,' condescending to exhibit my talents for these frivolous feminines, who can only dress and dance." Furthermore, King's story comments on the inequality of working women, a subject that is a far cry from the jealousies and injustices of the ballroom and parlor that occupy most of the author's fiction: "To this dead level of presumed inferiority my petticoats alone kept me down. In masculine attire I should have been paid according to my powers; in feminine garb I could form no such pretensions." King, who was forced to work after the war, certainly experienced a similar frustration firsthand. Interestingly, though, neither King nor her heroines ultimately question the larger tenets that structure their gendered lives. Again, Elizabeth's sentiments seem to echo the author's: "In parenthesis, let me pause to say that I neither wish to vote nor preach, nor practice medicine or law, but I should like not to be damned into eternal mediocrity in those few

lines where a woman may modestly assert herself." For those familiar with King's body of work, this return to a "happy ending of marriage" seems too facile. Perhaps at the end of her creative effort, King envisioned a happy marriage because she had experienced how difficult life for a single woman can be when financial concerns make either steady employment or a secure marriage essential to survival, and finding a husband seems more likely than finding a job. (According to most accounts, "My Debut" is King's last published work, although one of her obituaries claims that another work, "Yesterday and To-Day," was published around 1874.)

King's life again changed drastically just two years after the publication of "My Debut." She remarried, this time to Christopher Columbus (C. C.) Bowen, a man even more infamous than Sue King. He was born in Rhode Island, court-martialed by the Confederate Army, and pardoned from a bigamy charge in 1871. When King married him in 1870, he was a Radical Republican serving as a South Carolina congressman. The couple lived in Charleston, but King's life in no way resembled the one she led before and during the war. As Sue King, she had been whispered about but tolerated in Charleston society; as Sue Bowen, wife of a "carpetbagger," she was completely shunned both by her former friends and by most of her family. She did, however, continue to correspond with her sister, Caroline Petigru Carson, and Caroline's two sons, Willie and John. To John she wrote, "I know nothing whatsoever of them [other family members]—never see them—don't hold the faintest communication with one outside drop of my own blood."

King's letters from this time are an eclectic, often contradictory mixture of impassioned political opinions (she wrote animatedly about C. C. Bowen's political career), detailed descriptions of her new luxurious home, disclosures of increased religious fervor (she converted to Catholicism before her death), gay bantering and searing wit, and confessions of her depressing isolation. She writes to Caroline that Adele is now her "bitterest foe," who even keeps the nurse from bringing her grandchildren to visit, and that "the deadly loneliness of [her] existence is hard to stand." For one with an "almost inordinate love of company," being shunned by family and banished from the society in which she thrived even as she satirized it was a devastating blow.

Although King's letters do not reveal much about the nature of her marriage with Bowen, an undercurrent of affection seems present, even though she always refers to him as "Mr. Bowen" and writes about his all-consuming work habits. When she died unexpectedly on 11 December 1875 from typhoid pneumonia, it was a week before Bowen was able to write to his sister-in-law. In the letter he emotionally recounts his final hours with his wife and declares that he has been unable to write because he has been so grief stricken: "I have delayed writing to you til I could bring my mind to more fully realize the sad duty. I could not write but four words for there was nothing else in my mind. My darling is dead." In her last years then, the upper-class Charleston society that King spent her life chronicling and satirizing punished her with its rejection, but she may have found the thing that is so elusive for most of her characters—a sincere, honest marriage with a loving husband.

Ultimately, James L. Petigru's assessment of his daughter's work may be correct: "tho' your performance is indebted for its success to the initiation of temporary evanescent modes of behavior and can hardly be expected to survive the present fashion, it will be remembered longer than anything that any of the rest of us have done." King's work is indebted to a specific cultural, historical, and social milieu, and as such, her work is often limited in scope and perspective. However, her insight into human nature and her portrayal of the difficulties and limitations for nineteenth-century women make her a valuable resource for scholars and others drawn to her satiric wit and her willingness to challenge the status quo.

References:
Jane H. Pease and William H. Pease, *Ladies, Women and Wenches: Choice and Constraint in Antebellum Charleston and Boston* (Chapel Hill: University of North Carolina Press, 1990);

Steven M. Stowe, "City, Country and the Feminine View," in *Intellectual Life in Antebellum Charleston,* edited by Michael O'Brien and David Moltke-Hansen (Knoxville: University of Tennessee Press, 1986).

Papers:
Material relating to Susan Petigru King may be found in the R. F. W. Allston Papers, the James L. Petigru Papers, and the Vanderhorst Papers held by the South Carolina Historical Society, Charleston, South Carolina.

Susan Shelby Magoffin

(30 July 1827 – 26 October 1855)

Deborah J. Lawrence
California State University, Fullerton

BOOK: *Down the Santa Fe Trail and into Mexico: The Diary of Susan Shelby Magoffin, 1846–1847,* edited by Stella M. Drumm (New Haven: Yale University Press, 1926; London: Oxford University Press, 1926).

In June 1846 Susan Shelby Magoffin set out from Independence, Missouri, on the Santa Fe Trail. With her husband, Samuel Magoffin, a veteran Santa Fe trader, she crossed the plains and mountains to Santa Fe, then traveled along the Rio Grande to El Paso Norte, and finally south into Chihuahua. Published in 1926, *Down the Santa Fe Trail and into Mexico* is the earliest narrative about the Santa Fe Trail by an Anglo-American woman. Magoffin recorded a crucial time in the history of the trans–Mississippi West. As a member of her husband's merchant caravan, she saw the trail in one of its busiest years of trade, when more than $1 million worth of goods was hauled more than a thousand miles into the northern provinces of Mexico. She entered Santa Fe only two weeks after the Americans occupied New Mexico during the Mexican War (1846–1848). An eyewitness to General Stephen W. Kearny's conquest of Santa Fe in August 1846, she followed Colonel Alexander W. Doniphan and his Missouri Volunteers down the trail into Chihuahua.

Magoffin was born Susan Shelby on 30 July 1827 at Arcadia, her family's plantation near Danville, Kentucky. Although biographical information concerning Magoffin's parents–Isaac Shelby Jr., and Maria Boswell Warren Shelby–is lacking, her family was prominent and wealthy, and she was born into an atmosphere of ease. Her great-grandfather Evan Shelby (1719–1794) had been a distinguished soldier and a fur trader, and her grandfather Isaac Shelby (1750–1826) was elected the first governor of Kentucky in 1792.

Susan Magoffin was only eighteen years old when she began the record of her journey in 1846 and had been married to Samuel, who was twenty-seven years her senior, since 25 November 1845. Infatuated with her husband's romantic trail career, Magoffin filled her narrative with many personal items and refer-

Susan Shelby Magoffin, 1845

ences to *"mi alma,"* her affectionate name for her husband. For her journal entries from Independence to Bent's Fort, Colorado, she used Josiah Gregg's *Commerce of the Prairies* (1844) as her model. Gregg had traveled the Great Plains four times between the years 1831 and 1840, and his account of the overland trade between the United States and Mexico has been recognized as the definitive description of the trail. Although Magoffin's experiences differed from Gregg's because of the conveniences she had, she, like Gregg, was a keen observer, and her narrative provides one of the most accurate and detailed descriptions of life along the Santa Fe Trail.

Whereas most of the stories of the Santa Fe Trail tell of the experiences of men, Susan Magoffin's eyewit-

ness account of the journey is a rarity. Her 206-page diary illuminates the domestic side of the Santa Fe Trail experience, allowing her readers to share everyday moments on the trail by detailing incidents of a type seldom found in the more formal, public writings by men. Her account does not, however, support the later stereotype of women as "gentle tamers." The assumption that women went west reluctantly, passively taming the wilderness with their civilized presence, was influenced by early works on Western women, beginning with Dee Brown's *The Gentle Tamers: Women of the Old Wild West* in 1958. Magoffin's writing counters this passive image.

Magoffin learned Spanish, helped clerk in her husband's store, and during her husband's absence even became the train leader, a role that gave her authority over Mexican men. She made many friends among the Mexicans, whom she grew to consider generally charming people. A cultivated Kentucky woman, she rethought many assumptions held by her class; the journey through the distinctively new environment of the Southwest required new methods of coping and adapting.

Her increasing references to passages of scripture and reflections on the judgment to come suggest a spiritual change. Magoffin's growth—psychological, emotional, and spiritual—directly related to the narrative movement. Her travels invited her to think differently, to see anew. The geography was a metaphorical precursor of her inner enlightenment.

Magoffin began her diary on 9 June 1846 in Independence, Missouri. As early as 1832 Independence was the main starting point for the Oregon, California, and Santa Fe trails. Travelers, including the Magoffins, gathered in Independence to outfit themselves with equipment and supplies, make up their companies, and take their plunge into the wilderness. The Magoffin caravan consisted of fourteen large ox-drawn wagons filled with trade goods, a Dearborn wagon, a baggage wagon, and a carriage, all drawn by mules. With them were eighteen men under the leadership of Samuel Magoffin and Mr. Hall, the wagon master; Susan's maid; some two hundred oxen; nine mules; two riding horses; and their dog, Ring.

Whereas many women began their westering journals and letters with the details of painful separations and expressions of reluctance or regret, Magoffin started her account with a mood of joyful anticipation. Countering the stereotype of the reluctant and frightened westering woman, dragged off into the terrible frontier, Magoffin anticipated their trip as "an extended honeymoon safari." She wrote that in Independence "the curtain raises now with a new scene." She described herself as between acts. As the curtain rises, her persona moves away from the domestic space and

characteristics of mid-nineteenth-century womanhood and into a series of adventures that lead her farther and farther from home, altering her view of the world and herself. Not only was she about to venture into an unknown geographic landscape of the new republic but also into an unfamiliar cultural frontier. Encountering Mexicans, Hispanic Americans, and Native Americans on the trail, she found her attitudes challenged and her worldview enlarged. In effect, the trail became for her what those in the Southwest call *la frontera,* a borderland of cultures.

Admitting what few women in civilized life might, that her first house after her marriage was a tent, Magoffin readily adapted to their rustic living conditions. In the opening pages of her narrative, she invited her reader inside her canvas home. She described the interior of the tent in detail, from the combs on the little dressing bureau to the carpet on the floor, and the mattress and linen on her bed. The image of the tent as the immediate setting where she lived undercut the notion of house as a place of stability. For her it was the emblem of frequent removals. Her tent home was also a symbol for Magoffin's self. No longer inhabiting the house of civilized and complacent society, she was a subject in transition. Finally, "home" became the worldview that she fashioned in her journal entries.

Expressing dissatisfaction with the trees of eastern Kansas, Magoffin responded to the open and rolling grasslands with delight: "Oh, this is a life I would not exchange for a good deal! There is such independence, so much free uncontaminated air which impregnates the mind, the feelings, nay every thought, with purity. I breathe free without that oppression and uneasiness felt in the gossiping circles of a settled home." Whereas many westering women found the emptiness, the enormity, of Western spaces daunting, Magoffin was the willing inhabitant of an idealized, wild garden. Instead of the conventional catalogue of places and facts, her diary is filled with romantic descriptions of the treeless prairies. Magoffin and her husband "noon it" along gently curving streams, under the shade of cottonwoods or locust trees. On her walks, she delighted in the abundance of flowers, especially the quantities of roses. With the zeal of an amateur naturalist, she described the wild onions, antelope, and birds. The charms of the flowered prairie expanses were sources of happiness for her. In these early pages of her narrative, her persona emerged as a frontier Eve, both adventurer in and assessor of the wilderness paradise: "It is the life of a wandering princess, mine," she concluded after five days on the trail.

After the first few weeks on the trail, however, Magoffin became increasingly anxious, and her depiction of the landscape reflected her fears. The trip from

Lost Spring to Cottonwoods, punctuated by frequent downpours, was an ordeal: the trail became a river of mud and the wagons bogged to their axle hubs. Although Magoffin's rockaway carriage managed to survive the quagmires, when her tent was raised, water covered the floor to a depth of several inches. She described her bed as a boat floating on a pond. The next morning the rain had stopped, and she struggled to regain her balance, describing her sense of accomplishment in coping with the unusual situation. "As bad as it all is, I enjoy it still," she wrote. "I look upon it as one of the 'varieties' of life." Comparing herself favorably to her westering predecessors, she added, "If I live through this—and I think from all appearances now I shall come off the winner—I shall be fit for one of the Oregon Pioneers." Shortly after this storm she attempted to dispel her own forebodings during the terrible journey down the Rio Grande by evoking the image of another persevering woman—her pioneering grandmother Susannah Hart Shelby. Comparing her grandmother's situation in the War of 1812 with her own trials in New Mexico, she concluded without hesitation that her own situation was the more dangerous one.

Despite natural hardships Magoffin lived a pampered life on the trail. Her economic situation provided her with the domestic help that protected her from the fate of many toil-worn westering women. She had a conical tent; her maid, Jane; at least two servant boys to carry out most of the trail chores; a private rockaway; a driver; and an indulgent husband. Whereas in many westering women's writings men are on the periphery of the action, Magoffin depicted her husband, Samuel, as at the core of her experience. As she rode in her rockaway, he was usually on his horse alongside, attempting to shield her from the hardships of the trail. Regardless of her husband's presence, however, Magoffin's account cannot be read as the autobiography of a marriage. She focused instead on herself and on the effects of change wrought by the journey. Despite her husband's attempts to buffer her from the rigors of frontier life, by the time their caravan reached Ash Creek the difficulties of the journey had taken their toll on her buoyant spirit, and she became increasingly cautious as the landscape began to oppress her. In particular Magoffin dramatized the detrimental effects of travel when she described her fall from her carriage at Ash Creek. As she descended the dangerous bank, her carriage turned over and Magoffin was thrown to the ground unconscious. This accident undermined her health and led to her later miscarriage at Bent's Fort.

Ash Creek marks the turning point in her journal. As she became increasingly frail, her ability to withstand the rigors of the trail declined, and her spiritual faith grew. Her diary entries began to reference passages of scripture and to include reflections on the judgment to come and on her sinfulness, especially her failure to "keep the Sabbath." The tone of her narrative became increasingly somber. The downpours, oppressive heat, keening winds, rattlesnakes, and mosquitoes proved too great an ordeal for her, and her journal entries evidenced the kind of mental exhaustion many early travelers felt after having to face the barren stretches along this section of the trail. The landscape was literally marked by the signs of her suffering. "Oh how gloomy the Plains have been to me today!" she complained. "I am sick, rather sad feelings and everything around corresponds with them."

A massive mud structure on the Arkansas River, Bent's Fort was the most renowned landmark on the Mountain Branch of the Santa Fe Trail. Built in 1834, the adobe fort was a private post serving as a center for Indian and fur trade. At her first view of the complex, Magoffin declared that it looked like an ancient castle with its massive earth walls and round-bodied defensive towers. With her keen eye for detail, Magoffin provided her readers with a physical layout of the fort's interior: the wedge-shaped corral, the wagon sheds, the living and workrooms that surrounded the plaza, the well, the billiard room, and the parlor. She described sitting in the fort's parlor with the Mexican wife of George Bent and some other senoritas. Seated on one of the cushions that lined two of the walls—apart from the other women—Magoffin observed their habits. Although the parlor here represented a site of potential interchange between the Eastern white woman and the Mexican women, Magoffin's emphasis on her separateness highlights her distinction from them. With an aloof and somewhat condescending attitude, she noted a bucket of water that stood on the table. To her astonishment, whenever anyone drank from the common dipper, any water remaining in it was tossed onto the dirt floor. She was revolted when one of the Mexican women began to comb her long black hair with so much cooking grease that it dripped. "If I had not seen her at it, I never would have believed it greese, but that she had been washing her head," Magoffin wrote.

On July 30, her nineteenth birthday, Magoffin complained of feeling sick with strange sensations in her head, back, and hips. She grumbled about the din of blacksmith hammers, braying mules, crying children, and quarreling soldiers in the patio outside her room. The next day, she suffered a miscarriage. Grief flooded the poignant entries in this section of her diary. Mainstays of the domestic sphere, children and motherhood, provided the contrast to the unknowns of the American wilderness. But from the onset of her journey, Magoffin had undermined the carefully constructed gendered

Samuel Magoffin in 1845, the year in which he married eighteen-year-old Susan Shelby (portrait on ivory; from Stella M. Drumm, ed.,
Down the Santa Fe Trail and into Mexico:
The Diary of Susan Shelby Magoffin,
1846–1847, *1926)*

ideologies of selfhood that domesticity and adventure represented. Clearly, she crossed the boundaries of normal expectations for young women as she traveled down the Santa Fe Trail.

Undercutting the sentiment of the scene, Magoffin shifted from her private distress to a description of an Indian giving birth to a healthy baby in the room below her. Perceiving a profound difference between her own and the Indian cultures, she wrote, "It is truly astonishing to see what customs will do. No doubt many ladies in civilized life are ruined by too careful treatments during child-birth, for this custom of the hethen is not known to be disadvantageous, but it is a hethenish custom." Instead of exemplifying the popular notion of Native Americans as a "dying" race, incapable of accommodating themselves to changed conditions, the Indian woman, half an hour after she had given birth, walked to the river to bathe herself and her baby while Magoffin was the one who lay passive and weak in her bed. As if to reconcile her sense of obligation with the Eastern social order, Magoffin referred to the Indian woman's way as "hethenish"—in other words, as something other than

the white custom—but she nevertheless recognized it as something advantageous.

On 8 August the Magoffin caravan followed General Kearny's troops toward Santa Fe. Magoffin commented in her diary, "I'm now entirely out of 'the States,' into a new country. The crossing of the Arkansas was an event in my life, I have never met with before; separating me from my own dear native land." Complaining of loneliness and isolation, she conjured up memories of those back home. Her geographical disequilibrium was a rejoinder to her previous disequilibrium of pain, and her miscarriage became a concrete synecdoche for all that was irreplaceable in her pretrail life: "the ruling hand of Providence has interposed and by an abortion deprived me of hope, the fond hope of mortals!" Like many women on overland trails, as she moved into a foreign country, she glanced backward rather than toward the road ahead.

For Magoffin the unpleasantness of the little town of Las Vegas was magnified by the heat and the filth. Unfamiliar with the New Mexican customs, she was openly dismayed by the *nuevomexicanos,* who drank copiously of *aguardiente,* smoked *cigarritas,* and stared at her as an object of curiosity. Magoffin watched them as closely as they watched her. This mutual cross-cultural gaze is doubly significant. The *nuevoamericanos* were interested in Magoffin's habits and dress. Because Anglo migration to New Mexico in the first half of the nineteenth century was predominantly male, Anglo women such as Magoffin were a rarity. In an attitude similar to that of her Mexican counterparts, Magoffin approached them with apprehension, suspicion, and curiosity. The initial impressions she formed in Las Vegas, reflecting many of the racial sentiments of her day, were later modified and in some cases discarded as she came to know individuals and began to understand their culture.

Magoffin's initial impressions centered on the New Mexicans' propensity for smoking and liquor and their lack of modesty. She considered the women's loose, breathable clothing "truly shocking," and she was disgusted by the way they covered their faces with flour paste and painted their lips red. She found the mothers indolent and morally lax. Embarrassed by the naked children, she kept her veil drawn to "protect her blushes." Magoffin also found the food inedible.

On 30 August, only two weeks after General Kearny's occupation, the Magoffins entered Santa Fe. Basking in the pleasure of her accomplishment, Magoffin boasted she was the "first American lady, who has come under such auspices, and some of [the] company seem disposed to make [her] the first under any circumstances that ever crossed the Plains." Evidently it did

not occur to her to include her servant Jane as another first American lady to "come under such auspices."

Samuel Magoffin rented a four-room adobe under the shadow of the colonial San Miguel Chapel, two blocks from the plaza that marked the end of the trail. Glad to be once again in a temporary stopping place on the frontier, his wife began to settle in. She enthusiastically embraced the domestic toils about which men's writings are so consistently silent. She described her daily tasks as "superintending" her housekeepers and haggling for vegetables and fruit in the Santa Fe market. Her bartering in the marketplace created a relationship between herself and the New Mexicans. To negotiate she had to use their language and their pattern of economy. Although she claimed she was simply doing her duty to please her husband, obviously she derived personal satisfaction from her successful interactions in the marketplace and in her ability to fit into the community.

Magoffin's Santa Fe entries are filled with sad yearnings for home and family juxtaposed with her new delight for New Mexico life. She recorded the informal social visits with the Santa Fe women, the formal dinners and dances she attended, and the people she met at them—their clothes and their manners. At Kearny's farewell ball at the Palace of the Governors, she wore a scarlet Canto crepe shawl so that she would "be in trim with the natives." She could even call the native *cuna* a beautiful dance. Also at this farewell ball, she met Dona Gertrudes de Barcelos, familiarly known as "La Tules." One of the most expert monte dealers of her time, Barcelos is an enigmatic figure in New Mexican history. She had amassed a fortune as a proprietor of a prosperous Santa Fe gambling *sala* and bordello and was rumored to have been the former mistress of Armijo. Perpetuating the Anglo perception of Barcelos as a promiscuous rabble-rouser, Magoffin described her as "a stately dame of a certain age, the possessor of a portion of that shrewd sense and fascinating manner necessary to allure the wayward, inexperienced youth to the hall of final ruin." Although Magoffin's Santa Fe entries evidence her increased empathy toward the Mexican and Spanish-speaking American men and women, at this stage of her journey she did not appreciate a woman of such extraordinary independence as Barcelos.

On 7 October the Magoffin caravan left Santa Fe. Magoffin wrote that she was impatient to be on her way. In contrast to her feelings at the start of their journey, in Independence, she was anxious to reach Matamoras and the ship to New Orleans, which would ultimately return her to Kentucky. Her thoughts concerned the future—the establishment of a permanent Kentucky home with her husband and the reconnection

with the family and friends she had left behind. While the final section of *Down the Santa Fe Trail and into Mexico* reveals Magoffin's increased empathy for the Mexicans and their customs, it also emphasizes her growing dislike for the barren landscape. The buoyant and romantic enthusiasm she expressed at her first sight of the prairies was replaced by a realistic assessment of the sterile stretches of desert in the south. In addition, this final section of the journal reflects Magoffin's renewed appreciation for God's mercy in sustaining her through the perils of the road.

Magoffin's journal does not offer a self-conscious account of the process of her initiation into Southwestern life, but it does bear witness to the evolution of her consciousness in several revealing ways. The more she learned about the New Mexicans, the more tolerant she became in her evaluations of their culture. This increased tolerance did not mean that by the time they arrived in Chihuahua she had developed an egalitarian view of humanity; as evidenced by her impression of Dona Barcelos, she was still unable to give up her Eastern standards. But her diary does demonstrate an increased empathy toward people so apparently different from herself and hence suggests that she underwent a considerable growth of mind and perspective during her journey. In Santa Fe she was able to make friends and improve her Spanish. She discovered most of the people as charming and delightful. In addition, she found the charge of cowardice against them inaccurate: "It is a strange people this. They are not to be called cowards; take them in a mass they are brave, and if they have the right kind of a leader they will stem any tide." On their trip to Chihuahua, even though the Magoffin caravan was under constant threat of attack from Mexican forces, and her brother-in-law, James Magoffin, was in jail in Mexico, Magoffin's assessment of the Mexicans remained balanced. In El Paso they took lodging in the house of a priest who was a prisoner of Colonel Doniphan. Magoffin expressed her love for her host family: "Our situations are truly singular; we have a brother prisoner in Chi.[huhua], while they have one *el Senor Cura* [the priest] held as hostage by our army for his safety, and we are here in the same house and as I trust, friends. . . . I shall regret deeply when we have to leave them; twould be injustice to say that I like one more than an other for I love them all."

Her friendship with the Curas is thematically significant. Her "knowledge of these people," she wrote, "has been extended." Whereas in the parlor at Bent's Fort and in Las Vegas she had observed the Mexican people with disapproval, her opinion of them had now changed: she was impressed by the Mexican warmth, hospitality, and cleanliness. Magoffin's increased empathy is illustrated by her altered attitude toward their

food. As she made clear during her dinner in Las Vegas, the Southwest dishes were at first "unaccustomed" to her palate. However, by the time she left Santa Fe and was on the trail toward Chihuahua, not only did she find the food palatable but so delicious that she wanted to learn how to cook it for herself. On 26 November the wife and daughter of the owner of the San Gabriel house the Magoffins took lodging in came with their *mola* stone and corn and taught her how to make tortillas.

As she grew to appreciate the hospitality and kindness of the Mexicans, Magoffin became increasingly critical of the manner of her own countrymen. In Chihuahua, for example, she sympathized with the plight of the residents during the American occupation. In fact, she commented on how Colonel Doniphan and his regiment had complete disregard for the property of the citizens of the town.

Magoffin's changed view accompanied a gradual change in her status. As she began to speak Spanish, to learn how to marshal the camp of their caravan in her husband's absence, and to haggle successfully in the Santa Fe marketplace, she moved into a Southwestern realm of experience and knowledge that was fundamentally different from her previous Eastern ways of thinking. Instead of distinguishing herself from the Southwest, she began to associate herself with her Southwestern surroundings. For example, whereas she was furious when she thought she had been cheated in the Santa Fe markets, she portrayed herself now as a shrewd and experienced businesswoman with the knowledge and skills necessary for successful bartering. While her husband was away, she took his place behind the mercantile counter. Entering the masculine realm, she once again was clearly outside the limited sphere of woman's place (as it was so carefully defined by the cult of true womanhood). In her entry for 15 December she described one customer as particularly challenging—however, Magoffin the shopkeeper was the equal of the other woman and refused to yield even one *pedzao* [bit] in the price. She referred to herself as a "traderess," emphasizing her role in the Magoffin family's business affairs and in the enlarged sphere of social and economic activity as well.

Despite her new status and her changing attitude toward the people and their customs, Magoffin's diary increasingly noted manifestations of her trepidation as they headed toward Chihuahua. The Apaches surrounded them, coming into their camp and driving off their stock. The Mexicans advanced on them from the south. Daily she and her husband heard conflicting rumors about American military defeat. On 28 January 1847 they received news that the Taos people had risen

and murdered the American citizens, including the governor, Charles Bent.

Puritan captivity narratives used the Old Testament type of *Judea capta,* the image of Israel suffering in Babylonian captivity, to illustrate the captive's submission to God's rightful chastening. Magoffin appealed to this image. Mary Rowlandson's narrative *A True History of the Captivity and Restoration of Mrs. Mary Rowlandson* (1682) began the public record of American women's encounters with the New World wilderness landscape. Similarly, by dwelling on her increased physical and emotional frailty and the barrenness of the landscape, Magoffin lay both the emotional and the pictorial groundwork for the biblical type she was about to invoke.

On 1 February the Magoffin caravan was at the mouth of the Jornada del Muerto. Susan Magoffin had by then been eight months on the road. The combination of hazards faced on the strenuous trail, the months of anxiety, the loss of her child, the constant fear of Indian and Mexican hostility, and the guilt in not attending regularly to her religious obligations gave her a continuous sense of fear. Wondering whether she would ever get home again, she began a sober reflection upon the extent and seriousness of her sins, revealing a consciousness of her unworthiness. She compared herself to the biblical prodigal son, and she quoted the words of the prodigal when he realized his error.

Like Rowlandson, Magoffin was physically and psychologically exhausted, and she could no longer enjoy the beautiful, if barren, sights. The river bottoms with their lush green vegetation had provided her imagination some respite from the barren landscape during their trip from Independence to Santa Fe, but from Santa Fe to Chihuahua, they were no comfort. Arriving in Fray Cristobal on 2 February Magoffin wrote that she could say nothing of its beauty. She tried to imagine what the river bottom would look like in summer: "The River bottom is then green; the cotton woods are leaved, the stream, though at all times dark and ugly, is more brisk and lively in its flow. . . ." She had been too long away from the green hills of Kentucky and so she colored the landscape in her imagination in order to come to terms with it. A combination of mental and physical exhaustion brought on by the ordeal of traveling in the starkness of the New Mexico desert had soured Magoffin's perception of the Southwest.

As Magoffin attempted to shut herself off from the arid New Mexico landscape, her diary entries became brief and noncommittal. She made an entry on 5 February at the Laguna del Muerto and then did not write again for three days, when they camped somewhere near Robledo and Dona Ana. In her entry of 14 February she admitted that the road had ceased to

engage her attention. Her closed eyes invited the imagination: her mind was freed from the immediacy of her present condition. She wrote that God "in his infinite mercy has come near unto me, when I was far off, and called me when I sought not after him." She felt him reaching out to her, and she said, "Though I am now in darkness, the Lord has said 'Awake thou that sleepest, and arise from the dead, and Christ shall give thee light.'" The darkness she felt in the Jornada was indistinguishable from the darkness of the soul that had turned from God. Like the captive in the Puritan captivity narrative, Magoffin had been called from the darkness, and as a consequence, the tone of her narrative changed. Magoffin retreated into a world created for her by the religious traditions of Christianity. She was the suffering protagonist who wanted desperately to go home. Although she could not regain her Kentucky home, she could return to her starting point—God's eternity.

One would like to see the story of Magoffin's journal concluded with images of the return to Kentucky and family and friends, but Magoffin ended her journal on 8 September 1847, shortly before she caught yellow fever at Matamoras, during which time she gave birth to a son. The child died shortly afterward. The Magoffins took a vessel from the Mexican coast to New Orleans and returned to Kentucky, to live in Lexington. The rigors of the Mexican trip, however, had ruined Susan Magoffin's health. Her third child, Jane, was born in 1851 without mishap. Susan Shelby Magoffin died on 26 October 1855 at the age of twenty-eight. She was buried in Bellefontaine Cemetery in St. Louis.

In 1926 Stella M. Drumm, librarian of the Missouri Historical Society, convinced Magoffin's daughter to permit publication of the journal. Although some critics regarded the diary as "girlish" and "naïve," scholars immediately recognized its value as a significant addition to Southwestern trail history. Historians such as David Lavender, Howard Lamar, and Annette Kolodny have found Magoffin to be an intelligent, observant, and tolerant narrator. There are two historical novels based on Magoffin's narrative—Shirley Seifert's *The Turquoise Trail* (1950) and Jean M. Burroughs's *Bride of the Santa Fe Trail* (1984). In the 1982 edition of the narrative, historian Howard Lamar's introduction provides an excellent discussion of the dramatic historical events associated with Magoffin's journey. Brigitte Georgi-Findlay's *The Frontiers of Women's Writing* (1996) gives recent critical attention to Magoffin. Although secondary sources on Magoffin are limited, the literature on the Santa Fe Trail is vast. Elemental to serious research on Magoffin's association with the trail is historian Marc Simmons's *Following the Santa Fe Trail* (1984). Read in conjunction with the diary, Simmons's book assists the reader in interpreting the historic sites Magoffin described with the details of the trail today.

Reference:

Brigitte Georgi-Findlay, *The Frontiers of Women's Writing: Women's Narratives and the Rhetoric of Westward Expansion* (Tucson: University of Arizona Press, 1996).

Papers:

The original diary of Susan Shelby Magoffin is in the private possession of the heirs of the late Stella M. Drumm.

Mary Peabody Mann

(16 November 1806 – 11 February 1887)

Deshae E. Lott
University of Illinois at Springfield

BOOKS: *Flower People* (Boston: Ticknor & Fields, 1838);

Primer of Reading and Drawing (Boston: E. P. Peabody, 1841);

Christianity in the Kitchen, A Physiological Cook Book (Boston: Ticknor & Fields, 1857);

Moral Culture of Infancy and Kindergarten Guide with Music for the Plays, by Mann and Elizabeth Palmer Peabody (Boston: Burnham, 1863; revised edition, New York: J. W. Schemerhorn, 1870); revised again as *Guide to the Kindergarten and Intermediate Class and Moral Culture of Infancy* (New York: E. Steiger, 1877);

Life of Horace Mann, volume 1 of *Life and Works of Horace Mann,* edited by Mary Mann (3 volumes, Boston: Walker, Fuller, 1865–1868; 5 volumes, Boston: Lee & Shepard, 1891);

After Kindergarten—What? by Mann and Peabody (New York: E. Steiger, 1878);

Juanita, A Romance of Real Life in Cuba Fifty Years Ago (Boston: D. Lathrop, 1887).

Edition: *Juanita, A Romance of Real Life in Cuba Fifty Years Ago,* edited by Patricia M. Ard (Charlottesville: University Press of Virginia, 2000).

OTHER: John Livingston, *Portraits of Eminent Americans Now Living,* 4 volumes, includes a biography of Horace Mann by Mary Mann (New York: Cornish, Lamport, 1853–1854);

Domingo Faustino Sarmiento, *Life in the Argentine Republic in the Days of the Tyrants or Civilization and Barbarism,* includes a preface and biographical sketch of the author by Mann (New York: Hurd & Houghton, 1868);

Bertha Maria freifrau von Marenholtz-Bülow, *The New Education by Work According to Froebel's Method,* translated by Mann and Leopold Noa (Camden: Philotechnic Institute, 1876);

Marenholtz-Bülow, *Reminiscences of Friedrich Frobel,* translated by Mann (Boston: Lee & Shepard / New York: Dillingham, 1877);

Mary Peabody Mann, circa 1843
(Massachusetts Historical Society)

Erasmus Schwab, *The School Garden,* translated by Mann (New York: M. L. Holbrook, 1879);

Sarah Winnemucca Hopkins, *Life Among the Piutes; Their Wrongs and Claims,* edited, with a preface and afterword, by Mann (Boston: Cupples, Upham / New York: Putnam, 1883).

SELECTED PERIODICAL PUBLICATIONS–
UNCOLLECTED: "The Home," *Kindergarten Messenger* (March 1874);

"Song for the Kindergarten," *Kindergarten Messenger* (May–June 1877);

"German Kindergartens," *Kindergarten Messenger* (November–December 1877);

"Kindergarten Cramming," *Kindergarten Messenger* (November–December 1877);

"Charity Kindergartens and Homes," *Barnard's American Journal of Education,* 30 (March 1880);

"Mary Peabody Mann's short story, 'An Experience'," edited by Megan Marshall, *Proceedings of the Massachusetts Historical Society,* 98 (1986): 78–89.

As a translator, editor, educator, and author, Mary Tyler Peabody Mann advocated education reforms and the abolition of slavery, defended the rights of Native Americans, and called for temperance in food, drink, and attire. Throughout her life she embraced the spiritual mission of the nineteenth-century, middle-class American woman, assuming leadership roles that extended the domestic sphere and facilitated the humanitarian work of more vocal public leaders such as her sister Elizabeth Palmer Peabody; her husband, Horace Mann; President Domingo Faustino Sarmiento of Argentina; and Paiute Indian Sarah Winnemucca Hopkins. Mary Mann published most of her works during the last twenty-five years of her life, after her husband had died and her sons had become young men. These public writing projects, like her earlier private observations in letters and journals, reveal her lifelong commitment to educational, political, and social reforms that supported self-respect and respect for others.

Mann's interest in education and humanitarianism corresponds with the values of her parents, Nathaniel and Elizabeth Palmer Peabody, who met when they were both teaching school in Andover, Massachusetts. After their marriage in 1802, Nathaniel Peabody, a Dartmouth graduate, went on to study medicine and later became a dentist. He guided his children in their studies of Latin and Greek and took them on nature walks, emphasizing different kinds of learning: abstract and cultural as well as concrete and empirical. Education was also important on the maternal side of the family. As a teacher of history, natural science, literature, and biography at private schools for young ladies, Elizabeth Palmer Peabody followed in the steps of her mother, who had been a teacher in the 1780s. At young ages the Peabody children joined their mother's classes. Mary Tyler Peabody, named after her mother's eldest sister, was born on 16 November 1806 in Cambridgeport, where her parents and her elder sister, born in 1804 and named after her mother, were residing while her father was pursuing his medical and dental studies in Boston. A third daughter, Sophia Amelia, was born to the Peabodys in 1809, after the family had settled in Salem, Massachusetts. The sisters were followed by three brothers: Nathaniel Cranch (born 1811), George Francis (born 1813), and Wellington (born 1815).

In her preteen years Mary Peabody tutored her three younger brothers in their lessons for the Salem Latin School. Adhering to the tradition established by the women in her family, by age fifteen she had begun earning an income for teaching, a vocation she followed for sixty years.

Two of Peabody's governess positions afforded her opportunities to accumulate the knowledge of flowers that later she displayed in her first book, *Flower People* (1838). At William Vaughan's Salama estate in Hollowell, Maine, where she worked from April 1824 to April 1825, she spent time in the estate gardens and borrowed books on horticulture and botany from the estate library; she learned the Latin names of many plants and flowers and studied an additional foreign language so that she could read the Vaughans' German books on plants and flowers. When she taught the daughter and two sons of Dr. and Mrs. Morrell at La Recompensa in Havana, Cuba, between December 1833 and May 1835, Peabody learned about Cuban flowers, collected seeds to send her mother, and experienced moments that reinforced her thoughts about how nature reflected God's goodness and instructed individuals. Thus, she based her sketches in *Flower People* on her ability to learn from flowers and her sixteen years of teaching experience, during which she was developing her pedagogical technique of using concrete elements to move toward abstract principles.

Sentimental, fanciful, and didactic, her fictive flower tales for children adhere to genre and gender codes for American antebellum women writers. The stories predate similar uses of flowers for object lessons in Christian conduct, such as Margaret Fuller's "Magnolia of Lake Ponchartrain" (1841) and "Yuca Filamentosa" (1842) and Louisa May Alcott's *Flower Fables* (1854), fairy tales specifically written for a juvenile audience. *Flower People* displays Mary Peabody's liberal Christian upbringing and her familiarity with flowers. Like her mother, she gardened whenever she had a place to do so; and, like her father, she investigated plants scientifically and experimented with homeopathic remedies, sharing her results with others.

Mary Peabody's second book also grew out of her early teaching experience. She had been using the materials in *Primer of Reading and Drawing* (1841) in her private tutoring—such as the lessons she taught at the homes of William Ellery Channing and Josiah Quincy between 1822 and 1839; in her work at Amos Bronson Alcott's Temple School during the summer of 1835; and in the private school that she and her sister Elizabeth had begun on the upper floor of the bookstore Elizabeth had opened at 13 West Street in Boston

in 1840. Published by Elizabeth Peabody from her bookstore, *Primer of Reading and Drawing* offers a more-technical presentation of Mary Peabody's pedagogy than her first book.

The West Street school was not the sisters' first. Ever since April 1822, when the sisters became partners in their first private school, Mary Peabody had typically taught the younger children. Even before her introduction to the influential methods of the German teacher Friedrich Froebel (1782–1852), she cultivated teaching techniques like those he popularized: respecting the individuality and innate ability of each child; creating a happy, harmonious instructional environment; and valuing activity and play as means of assimilating new information. *Primer of Reading and Drawing* outlines some of her methods for teaching those subjects, which involved refraining from criticism and helping children learn to observe things carefully and then showing them ways to represent the objects and the ideas their observations inspired.

Sixteen years elapsed before Mary Peabody published her next book. During the interim, she married, raised her sons, and continued to facilitate her own and others' education. In 1833 she had met her future husband, Horace Mann, at Rebecca Hull Clarke's boardinghouse in Boston, where he was temporarily residing and where Mary and Elizabeth Peabody were living and conducting a private school. Mary Peabody and Horace Mann were both committed to serving the citizens of the Republic, and they came to admire one another's humble, kind, moral, and self-sacrificing natures. In 1833, not long after they met, Horace Mann gave his future wife a tour of an American institution dedicated to educating the blind. When the two were married on 1 May 1843, Horace Mann had already served as a member of the Dedham School Committee (1828–1830, 1832–1833), as legal counsel for the New England Institute for the Education of the Blind (1834), vice president of the Massachusetts Temperance Society (1837), and a Massachusetts state representative (1827–1833) and senator (1833–1837). From June 1835 until June 1837 he had served as president of the senate, and since 1837 he had been the first secretary of the board of education for Massachusetts, a position he held through 1848. Together the couple continued their pedagogical experiments, socially through reform efforts and privately with their sons—Horace Mann Jr. (born 25 February 1844), George Combe Mann (born 27 December 1845), and Benjamin Pickman Mann (born 30 April 1848). George and Benjamin Mann later became educators themselves.

Mary Mann played a significant role in the publication of her husband's highly regarded *Seventh Annual Report to the Board of Education of the State of Massachusetts*

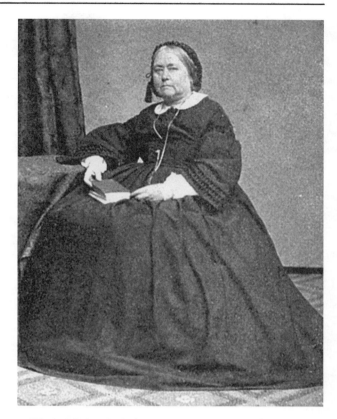

Elizabeth Palmer Peabody, who published her sister's first textbook (from Louise Hall Tharp, Until Victory: Horace Mann and Mary Peabody, *1953)*

(1844), based the newlyweds' observations during their tour of Europe between May and November 1843. The Manns went with another newlywed, reform-minded couple—Samuel Gridley Howe and Julia Ward Howe—to England, Scotland, the German states, Holland, Belgium, France, Ireland, and Switzerland. They toured prisons, reform schools, insane asylums, and institutions for the blind and deaf; and they spoke with Europeans dedicated to educating and reforming individuals. In letters home Mary Mann commented about how much the animated teachers and obedient students, especially those in Hamburg, impressed her. Throughout their travels, she translated conversations and foreign documents. Apparently Horace Mann needed the help, for as his wife wrote her sister Elizabeth in June 1843, he "asked for stewed churches at dinner today, instead of stewed cherries. If the inquisition were in existence, who knows what would be his fate." Between November 1843 and January 1844, after the couple returned to Massachusetts and while Horace Mann drafted the report of their findings, Mary Mann continued to translate for him the foreign documents they had acquired in Europe. In February, Mary and Horace Mann edited his report for publication.

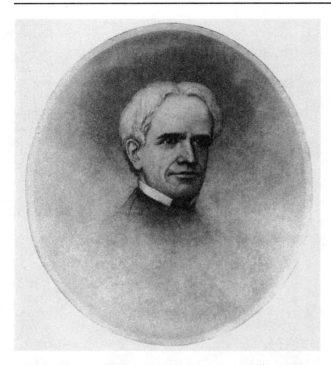

Horace Mann, whom Mary Peabody married in 1843 (mezzotint by John Sartain after a sketch by Sophia Hawthorne)

Though Horace Mann described his job as secretary to the state board of education as that of a "post-rider from county to county" looking after children's welfare by creating ways to establish common national values, his wife characterized his role as that of "high priest of education." Her contributions to his final report in 1848 harmonize with a comment in a letter she wrote to him in 1837, the year he first assumed the post: "How could there be a more beautiful transition of office than yours? After being the breaking up plough of temperance, you are now to tell the people what to do with their soberness. . . . Our country can only prosper by the worth of individuals that compose it and therefore yours is a holy office indeed." She used similar rhetoric in 1848, when she encouraged the antislavery position of her husband, who had just been elected to the U.S. House of Representatives and served there until 1853. Though they had received reprimands for their actions—even from their relatives Nathaniel and Sophia Peabody Hawthorne, who were Democrats rather than Whigs—the Manns had previously welcomed Chloe Lee, a free woman of color, into their home in West Newton after she had been admitted for training at the Normal School and could find no lodging at the local boardinghouses. The Manns believed in the legal and educational rights of all Americans, whatever their religion, race, or gender.

In September 1853 the Manns moved to Yellow Springs, Ohio, where Horace Mann became the first president of the nonsectarian, co-educational Antioch College. In Ohio, Mary Mann observed a need to increase general popular knowledge in matters concerning health and hygiene. While in New England, the Manns had advocated architecture that promoted ventilation; in Ohio, Mary Mann found herself urging people to use soap before handling food. The topic of food and hygiene had long interested her. For a quarter of a century she had been recommending specific diets to help avoid certain ailments.

When her youngest son was nearing his tenth birthday, she began work on *Christianity in the Kitchen, A Physiological Cook Book* (1857). Once again she intertwined pedagogy and practicality, science and spirituality. Unlike her previous writing, however, this book drew on a decade of her experiences as wife and mother and on her scientific inquiries into the rudiments of biochemistry: how specific foods affect one's health. Experiments with dietary approaches such as vegetarianism were not uncommon in New England at the time, and the Manns were among the New Englanders with a puritanical fervor for temperance.

Before writing her book, she consulted with Dr. Griscom and Mr. Hecker of New York, both of whom were considered experts regarding the chemical and physical facts of food and how it affected the human body. In her cookbook Mary Mann shared what she learned from these men as well as from her own kitchen practices. Her thesis is that temperance is Christianity in practice, and the book suggests that it is part of a mother's duty to help keep her family healthy by preparing nutritious meals. Among the proposed foods she deemed "poison" are hot breads; rich, fatty dishes such as plum puddings, wedding cake, and turtle soup; spices; and caffeinated and alcoholic beverages. As Mann explained, "If asked why I pronounce these and similar dishes *unchristian,* I answer, that health is one of the indispensable conditions of the highest morality and beneficence." In the latter part of the nineteenth century other women wrote cookbooks connecting Christianity to consumption, and Fannie Farmer founded a cooking school based on similar principles. Mann, however, was among the first American women to produce a cookbook that included advice on nutrition along with the recipes.

After her husband died on 2 August 1859, Mary Mann and her sons moved back to Massachusetts, residing during September at the Wayside in Concord in the absence of the Hawthornes, who were then in Europe. Next, Mann and her sons moved to Sudbury Street in Boston, where they lived until 1866, when they moved to Follen Street in Cambridge. In Boston,

The Manns' three sons: Benjamin, Horace Jr., and George (from Louise Hall Tharp,
Until Victory: Horace Mann and Mary Peabody, *1953)*

Mann completed several writing projects. She also returned to professional schoolkeeping and, through her correspondence and publications, advocated social reforms more openly than she had in the past. The first English-speaking kindergarten in America opened on Pinckney Street in Boston in 1860. Elizabeth Peabody and Mary Mann were among those who had imagined such a school, and their ensuing efforts helped ensure the development of more such schools throughout the United States. In 1863 Mann and Peabody published *Moral Culture of Infancy and Kindergarten Guide with Music for the Plays.* Several more editions were printed by 1870, when the sisters produced a revised edition after Peabody's investigative trip to Europe. The sisters practiced their pedagogy. For instance, in 1864 Mann taught children of color, hoping that her school would become a model for the rest of the country, and she had free children sign a petition to President Abraham Lincoln, requesting that enslaved children be freed. In 1866 Mann and Peabody opened a kindergarten in Boston, and in 1870—through the support of donations—they opened the first public kindergarten in the United States.

The main change in the 1870 edition of *Moral Culture of Infancy and Kindergarten Guide,* as Peabody's

prefatory remarks in the revised edition establish, is a shift away from respecting each student's individuality above all else. Instead, Peabody followed the increasingly prevalent arguments among educators that it was less important for a school to stress individuality than for it to teach social cooperation that respects the rights of all as a unit, not those of the single, isolated person. Typically, Mann receives credit for *Moral Culture of Infancy,* and Peabody is called the author of *Kindergarten Guide.* Indeed, *Moral Culture of Infancy,* which actually appears second in the book, comprises letters Mann wrote in 1841 through 1843, while she was teaching at the West Street bookstore, to a woman whom she calls Anna. But Mann undoubtedly influenced some of the chapters in *Kindergarten Guide* as well; for the postscript to this section is signed "M.M." Some topics in the *Kindergarten Guide* are in accord with Mann's 1838 and 1841 publications; others express ideas about educating her sons that she related in private correspondence. In her postscript she explained that her authority for knowledge imparted in the book rests on her love of children and schoolkeeping; when *Moral Culture of Infancy and Kindergarten Guide* appeared in 1863, Mann had been teaching children for more than forty years.

The book argues that children dislike school and learning and, thus, deviate from the desired path because of inadequate teaching techniques and environments. Like their contemporary educators, the sisters wanted children to consider duty, loyalty, and conscience; but like the so-called soft-line educators influenced by Romanticism, they also wanted children to love learning rather than to see it as a chore. Thus, they discouraged corporal punishment and advanced the idea that each human being has an inherent ability to learn and, consequently, to approach perfection. These ideas and the elevation of motherhood in the book suggest Mann's philosophy more than that of her elder sister. The arguments for leading children from the concrete to the abstract and against long periods of inactivity are supported by Mann's earlier publications, and the ideas on encouraging children's imagination and independence and on teaching students geography through pictures and descriptions offer a method Mann developed to teach her first son, whom she did not want "to confine his ideas of creation within small boundary lines."

During the early 1860s Mann began a private journal that she titled "Estimate of Horace Mann." It was a tribute to her late husband and a preliminary gathering of ideas for the *Life of Horace Mann,* her book-length biography of her husband that appeared in 1865 as volume one of her husband's works, which she edited. *Life of Horace Mann* was not her first biography of her husband. Later, she had expanded the autobiographical sketch her husband submitted to *The United States Law Magazine* in 1852 for inclusion in *Portraits of Eminent Americans Now Living* (1853–1854). Horace Mann's attributes were lauded by many, and his wife, as she noted in her preface to the 1865 biography, admits that she "tends to idealize" her husband, thus participating in the hagiography common to memoirs written during the middle of the nineteenth century. Along with recording her husband's major activities, Mary Mann presented his personal beliefs, particularly those she valued: for example, his commitment to listening to children's viewpoints, his holding "do unto others as you would have them do unto you" as the central principle of their religion, his faith in the ability of education to elicit a human being's inner nobility, his respect for spiritual subjectivity, and his advocacy of racial equality.

Megan Marshall has convincingly argued that in the early 1860s Mary Mann composed another biographical sketch of her husband in her posthumously published short story, "An Experience" (1986), a work that previously had been categorized as Mann's narrative of a spiritual conversion experience. The new reading positions the text as a fictional account of Mary's meeting Horace Mann and finding that both she and Elizabeth Peabody were attracted to him. Along with Louise Hall Tharp and Robert Lincoln Straker, however, Marshall has demonstrated that a melodramatic interpretation of this fact is unfounded. The story reveals some of Mary Mann's own traits, including her hiding her feelings from her family and friends and her selfless love for others, illustrating how she felt more spiritual when taking nonaggressive and self-sacrificing roles in relationships with her husband, her family, and her God. The story also draws on her investigation of spirit rapping and mesmerism in Concord in August 1863.

In 1865, nearly twenty years after they first met, Mann began corresponding with Domingo Faustino Sarmiento, who was then the Argentinian ambassador to the United States. Sarmiento had served as chief of schools in Buenos Aires and had long been influenced by the work of Horace Mann. Between 1865 and 1884, Sarmiento and Mary Mann wrote approximately two hundred letters to one another. Mann helped recruit seventy American teachers to work in Argentine schools, and she recruited Harvard University astronomer Ben Gould to serve as the first director (1870–1885) of the astronomical observatory in Córdoba, the first observatory in the Southern Hemisphere. In 1868, the year that Sarmiento became president of Argentina, his *Life in the Argentine Republic in the Days of the Tyrants or Civilization and Barbarism* was published in New York, with a preface and a biographical sketch of Sarmiento by Mann. She also contributed "Vida de Horacio Mann" (Life of Horace Mann), a chapter in Spanish about her husband, to Sarmiento's *Las Escuelas: Base de la Prosperidad i de la Republica en los Estados Unidos* (Schools: The Basis of Prosperity and the Republic in the United States, 1873). Through her communications with Sarmiento, Mann transmitted to another continent her and her husband's ideas on education reform. She also continued to work for educational reforms in the United States. In 1872, for example, she and Elizabeth Peabody founded the Kindergarten Association of Boston and opened a kindergarten in Cambridge.

Mann's public support for her husband's ideas on educational reform reflects her continued private idealization of him. In "The Traffords," an unpublished sequel to the novel *The Wooing O'T* (1873), by Mrs. Alexander (Annie French Hector), Mann described the hero as a lawyer-statesman who champions public education. Faced with the possibility of marrying either of two female characters who are good friends, he chooses to marry the one who more closely aligns herself with the Victorian ideals of "True Womanhood." The traits Mann ascribes to the hero's

Mary Mann and her son Benjamin, circa 1860 (from Louise Hall Tharp,
Until Victory: Horace Mann and Mary Peabody, *1953)*

love interest in "An Experience" and "The Traffords" reflect the rhetoric Mann used even to her sister Elizabeth, whose assertiveness and intense intellectual engagement, biographers argue, sometimes disturbed the more conservative Mary Mann. For example, while in Europe with her husband, Mann wrote Elizabeth that hearing Horace and other men "talk and reason" was "a great treat" for "a little while, but weak womankind is not up to the measure of their bent." Moreover, she considered "housekeeping" far preferable to "being in public," which she described as "the one evil in my lot." The stories, written twenty and thirty years after that European journey, may be in part Mann's self-justification for the less-public role she had preferred to pursue during her marriage. Though she had always believed in a woman's right to education, she had done so more along the lines of Mary Wollstonecraft's *A Vindication of the Rights of Woman* (1792), which argued that educated women made better wives and mothers. As the woman's movement gained support in America during the 1870s, Mann publicly defended a woman's right to higher education in a different context, noting her support for the "noble army of unmarried women, who

are often in the respectable ranks of 'spinsterism' . . . out of self respect." Mann's inclusive rhetoric regarding the nobility of women's roles neither abandoned family values nor subscribed to the typical nineteenth-century stereotype of the mothers as the "Angel of the House."

In 1873, to further their educational-reform work, Elizabeth Peabody founded and edited the journal *Kindergarten Messenger,* to which she and Mary Mann contributed often. One article Mann wrote for the magazine, "The Home" (March 1874), expresses the idea that, although they had no role in government, women shape their homes as microcosms of government, influencing how their children will govern in the future. She asserted that mothers teach the moral laws through love of and confidence in their children and that both parents influence their children. These ideas, of course, correspond to the prevalent domestic ideology of Mann's day, but they show an extension of her boundaries. In 1874–1875 the magazine serialized Mann and Leopold Noa's translation of Bertha Maria freifrau von Marenholtz-Bülow's *The New Education by Work According to Froebel's Method*. The work was published as a book in 1876 and was fol-

lowed by Mann's translation of Marenholtz-Bülow's *Reminiscences of Friedrich Frobel* in 1877. In that same year Peabody and Mann founded the American Froebel Union, and Mann contributed three articles to the *Kindergarten Messenger* giving practical advice on kindergarten instruction: "Song for the Kindergarten" (May–June 1877), "German Kindergartens" (November–December 1877), and "Kindergarten Cramming" (November-December 1877). Mann also expanded *Moral Culture of Infancy and Guide to Kindergarten* as *Guide to Kindergarten and Intermediate Class and Moral Culture of Infancy* (1877), covering a longer instructional period. The following year Mann and Peabody produced a text on postkindergarten instruction, *After Kindergarten–What?* (1878).

Mann's next translation project was Erasmus Schwab's *The School Garden* (1879), to which she added a chapter of practical suggestions for applying the theories when instructing children. After the final issue of *Kindergarten Messenger* appeared in 1877, Mann published "Charity Kindergartens and Homes" in the March 1880 issue of *Barnard's American Journal of Education*. Calling for training mothers to improve their homes by creating kindergartens in them, Mann again stressed the need for love in the educational process, asserting that it was a necessary factor in cultivating a child's memory and understanding.

During the last five years of her life, Mann engaged in some of her most radical political work. In 1883 she and Peabody met Princess Sarah Winnemucca Hopkins, who was on a cross-country lecture tour to gain support for her school for Native Americans in Lovelocks, Nevada. The reform-minded sisters, who had second cousins who were the half-Indian children of their Indian princess great-aunt, introduced Hopkins to several national leaders they felt might be sympathetic to her cause. Interested in reaching a larger audience with her personal narrative and campaign for school donations, Hopkins readily accepted Mann's offer to edit *Life Among the Piutes; Their Wrongs and Claims* (1883). In her preface Mann attests to Hopkins's intelligence, noting that she made only ornithological and grammatical alterations to the contents. Mann also added an appendix that includes a series of letters written by political and military leaders to testify to Hopkins's good character. Thus, Mann established Hopkins's credentials in much the same way other editors did with slave narratives. *Life Among the Piutes,* which addresses legal rights and race and gender issues, became the first book by a Native American woman to attack the hypocrisy of settlers and the American government.

Mann's last prose work, *Juanita, A Romance of Real Life in Cuba Fifty Years Ago* (1887), also addresses human hypocrisy. If Mann had published the text fifty years earlier, it might have predated and been as instrumental in abolishing slavery as Harriet Beecher Stowe's *Uncle Tom's Cabin* (1852). Instead, *Juanita* was published just after Mann's death and just before the Cuban emancipation of slaves in 1888. As with her other fictional writings, Mann based her novel on personal experiences. In this case the novel draws on the period in which she served as a governess at a Cuban plantation so that her younger sister Sophia might be a guest there and recover her health in the tropical climate. Mann incorporated into *Juanita* a short narrative that she wrote years earlier: "History of the Doves"; allegorical in nature, it described the death of one of the children's doves and how the death inspired the children to set the other bird free. The event served as one of Mann's object lessons with her students, as a governess and as an author. Mann refused to write the rest of the novel until after the deaths of the plantation owners, thinking it unkind to repay their hospitality with open rebuke. Told from the perspective of Helen Wentworth, the governess, the novel includes detailed descriptions of flowers, birds, people, and customs. Some of the characterizations are melodramatic and sentimental, but others, such as that of Carmillo, the enslaved housekeeper, are especially "round." Though *Juanita* ends optimistically, it shows through a series of tragic relationships how whites enslave themselves by their complicity in maintaining the institution of slavery.

Throughout her life, Mann expressed concern for educating individuals and reforming institutions. She used her knowledge of children, pedagogy, and foreign languages to advance social awareness, particularly in the area of kindergartens but also in the reform of general educational practices, cooking and eating habits, and race relations. Simultaneously orchestrating the roles of teacher, nurturer, gardener, scholar, reformer, writer, wife, and mother, Mann actively contributed to defining national values.

Biographies:

Josephine Elizabeth Roberts, "A New England Family: Elizabeth Palmer Peabody, 1804–1894, Mary Tyler Peabody (Mrs. Horace Mann) 1806–1887, Sophia Amelia Peabody (Mrs. Nathaniel Hawthorne) 1809–1871," dissertation, Case Western Reserve University, 1937;

Roberts, "Horace Mann and the Peabody Sisters," *New England Quarterly,* 18 (1945): 164–180;

Louise Hall Tharp, *The Peabody Sisters of Salem* (Boston: Little, Brown, 1950);

Tharp, *Until Victory: Horace Mann and Mary Peabody* (Boston: Little, Brown, 1953);

Megan Marshall, "Three Sisters Who Showed the Way," *American Heritage,* 38 (September/October 1987): 58–66.

References:

Raymond Benjamin Culver, *Horace Mann and Religion in the Massachusetts Public Schools* (New Haven: Yale University Press, 1929);

Ann Douglas, *The Feminization of American Culture* (New York: Knopf, 1977);

Robert Bingham Downs, *Horace Mann: Champion of Public Schools* (New York: Twayne, 1974);

Pan Eimon, *Triumphant Teacher Triad: The Story of Domingo Faustino Sarmiento of Argentina and of His Boston USA Colleagues Horace Mann and Mary Peabody Mann* (Amarillo, Tex.: Amarillo Branch, American Association of University Women, 1994);

Oliver Burke Gutweiler, "A Study of the Sarmiento–Mary Mann Letters (1865–1884): Some Educational Implications," dissertation, St. Louis University, 1969;

Paul H. Mattingly, *The Classless Profession: American Schoolteachers in the Nineteenth Century* (New York: New York University Press, 1975);

Jonathan Messerli, *Horace Mann: A Biography* (New York: Knopf, 1972);

Bruce A. Ronda, "Print and Pedagogy: The Career of Elizabeth Peabody," in *A Living of Words: American Women in Print Culture,* edited by Susan Albertine (Knoxville: University of Tennessee Press, 1995), pp. 35–48;

Ronda, ed., *Letters of Elizabeth Palmer Peabody, American Renaissance Woman* (Middletown, Conn.: Wesleyan University Press, 1984);

Anne C. Rose, *Transcendentalism as a Social Movement* (New Haven: Yale University Press, 1986);

LaVonne Brown Ruoff, "Early Native American Women Authors: Jane Johnston Schoolcraft, Sarah Winnemucca, S. Alice Callahan, E. Pauline Johnson, and Zitkala-Ša," in *Nineteenth-Century American Women Writers: A Critical Reader,* edited by Karen L. Kilcup (Malden, Mass.: Blackwell, 1998), pp. 81–111;

Robert James Saunders, "The Contributions of Horace Mann, Mary Peabody Mann, and Elizabeth Peabody to Art Education in the United States," dissertation, Pennsylvania State University, 1961;

Stanley K. Schultz, *The Culture Factory: Boston Public Schools, 1789–1860* (New York: Oxford University Press, 1973);

Robert Lincoln Straker, *A Gloss Upon Glosses; Critical Comments on Two Books by Louise Hall Tharp:* The Peabody Sisters of Salem, Until Victory: Horace Mann and Mary Peabody (N.p., 1956).

Papers:

Many of Mary Peabody Mann's letters, journals, and manuscripts for unpublished writings can be found at the Massachusetts Historical Society in the Horace Mann Collection, which in addition to family members' writings includes books from the Peabody family library and family photos. The manuscripts include Mary Mann's "Estimate of Horace Mann" and the short story "Traffords." Other significant collections can be found at the Pierpont Morgan Library, the Henry W. and Albert A. Berg Collection of the New York Public Library (which includes Mann's Cuba journal), and the Mann Manuscripts at the Haverford College Library.

Katharine Sherwood Bonner McDowell
(Sherwood Bonner)
(26 February 1849 – 22 July 1883)

Laura L. Tussey
Marshall University

See also the Bonner entry in *DLB 202: Nineteenth-Century American Fiction Writers.*

BOOKS: *The Radical Club. A Poem, Respectfully Dedicated to "The Infinite." By an Atom* (Boston, 1875);

Like Unto Like (New York: Harper, 1878); republished as *Blythe Herndon* (London: Ward, Lock, 1882);

A Chapter in the History of the Epidemic of 1878 (McComb, Miss.: McComb City Weekly Intelligencer, 1879); revised as "The Yellow Plague of '78: A Record of Horror and Heroism," *Youth's Companion,* 52 (April 1879): 117–119;

Dialect Tales (New York: Harper, 1883);

Suwanee River Tales (Boston: Roberts, 1884);

Gran'mammy: Little Classics of the South, Mississippi (New York: Purdy Press, 1927);

A Sherwood Bonner Sampler, 1869–1884: What a Bright, Educated, Witty, Lovely, Snappy Young Woman Can Say on a Variety of Topics, edited by Anne Razey Gowdy (Knoxville: University of Tennessee Press, 2000).

Edition: *Like Unto Like: A Novel* (Columbia: University of South Carolina Press, 1997).

OTHER: "Gran'mammy," in *Library of Southern Literature,* 17 volumes, edited by Edwin Anderson Alderman and Joel Chandler Harris (Atlanta: Martin & Hoyt, 1907), I: 445–450;

"Yariba," in *Library of Southern Literature,* 17 volumes, edited by Alderman, Harris, and others (Atlanta: Martin & Hoyt, 1907), I: 461–462;

"Decoration Day," in *Dixie Land / Stories of the Restoration Era by Southern Writers,* edited by Henrietta Raymer Palmer (New York: Purdy Press, 1926), pp. 27–33;

"A Volcanic Interlude," in *The Local Colorists: American Short Stories, 1857–1900* (New York: Harper, 1960); also in *Nineteenth-Century American Short Fiction* (Glenview, Ill.: Scott, Foresman, 1970).

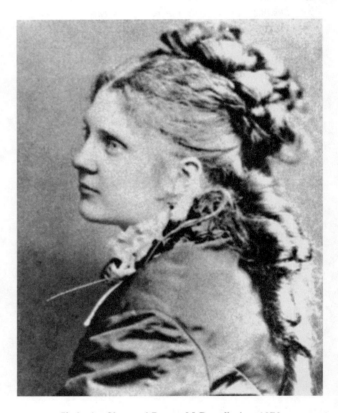

Katharine Sherwood Bonner McDowell, circa 1873

SELECTED PERIODICAL PUBLICATIONS– UNCOLLECTED: "Laura Capello: A Leaf from a Traveler's Note Book," as Clayton Vaughn, *Massachusetts Ploughman and New England Journal of Agriculture* (20 February 1869): 4;

"The Heir of Delmont," anonymous, *Massachusetts Ploughman and New England Journal of Agriculture* (28 August 1869): 4; (4 September 1869): 4;

"Saved," anonymous, *Massachusetts Ploughman and New England Journal of Agriculture* (9 October 1869): 4;

"Dr. J. G. Holland," *Cottage Hearth,* 2 (January 1875): 1–2;

"Miss Willard's Two Rings," *Lippincott's,* 19 (December 1875): 754–761;

"Sherwood Bonner's Letter: Longfellow's Home–Its History," *Memphis Avalanche* (26 December 1875): 2;

"Which Was the Heroine?" *Cottage Hearth,* 3 (January 1876): 24–25; (February 1876): 2–53; (March 1876): 80–81;

"After Thoughts," *Boston Times* (29 October 1876);

"A Page of Poems," *Harper's Young People* (7 September 1880): 661;

"Not in Vain," *Harper's Young People* (7 September 1880): 661;

"One March Day," *Harper's Young People* (7 September 1880): 661;

"Peacock and Monkey," *Harper's Young People* (7 September 1880): 661;

"Three Little Princesses," *Harper's Young People* (7 September 1880): 661;

"Who Knows," *Harper's Young People* (7 September 1880): 661;

"A Page of Poems," *Harper's Young People* (12 October 1880): 741;

"Kate of Myrtle Springs," *Harper's Young People* (12 October 1880): 741;

"The Red Ear," *Harper's Young People* (12 October 1880): 741;

"Song of the Moral Alligators," *Harper's Young People* (12 October 1880): 741;

"The Bat Boy," *Harper's Young People* (12 October 1880): 741;

"The Angel in the Lilly Family," *Harper's Young People* (19 October 1880): 756–757;

"Two Storms," *Harper's,* 62 (April 1881): 728–748; abridged as "The Hoodoo Dance," in *Library of Southern Literature,* 1 (1907): 458–461;

"In Memoriam: Howard Falconer," *Holly Springs Reporter* (7 July 1881): 3;

"The Valcours," *Lippincott's,* new series 2 (September 1881): 243–258; (October 1881): 345–361; (November 1881): 441–462; and (December 1881): 555–570;

"Two Smiles," *Harper's Weekly* (21 July 1883): 458;

"A Longed For Valentine," *Publications of the Mississippi Historical Society,* 2 (June 1898): 54;

William Luke Frank, "Sherwood Bonner's Diary for the Year 1869," in *Notes on Mississippi Writers,* 3 (Winter 1971): 111–130; 4 (Spring 1971): 22–40; 4 (Fall 1971): 64–83.

Katharine Sherwood Bonner McDowell, known to the writing community as Sherwood Bonner, was one of the first female news columnists, local colorists, dialect writers, and novelists of the post–Civil War South to gain literary recognition. McDowell's works, rich with historical ideologies and social detail, describe the complexities, conflicts, and tensions surrounding Southern Reconstruction in the decades following the Civil War. A comprehensive catalogue of McDowell's experimentation in various literary genres includes the novel and novella, compilations of short fiction, journalistic travel letters, celebrity profiles, a satire, autobiographical sketches, and poetry. This range of genres attests to McDowell's versatility, as well as her savvy in anticipating emerging literary trends. With the recent publication of McDowell's previously uncollected works in *A Sherwood Bonner Sampler, 1869–1884: What a Bright, Educated, Witty, Lovely, Snappy Young Woman Can Say on a Variety of Topics* (2000), edited by Anne Razey Gowdy, scholars have been afforded a more in-depth look into a remarkable author who was almost erased from the annals of American literature.

Catherine Sherwood Bonner was born 26 February 1849, the first surviving daughter of a Southern plantation owner in Holly Springs, Mississippi. Her father, Dr. Charles Bonner, an Irish immigrant of Pennsylvania, had taken as his wife Mary Wilson, a native of Holly Springs. A reputedly willful child, young Bonner demonstrated a yearning to move beyond the narrow roles expected of girls in her society. An early example was improving upon her birth name; she signed herself Katharine or "Kate." (Her first name is given as "Katherine" in the Library of Congress catalogue.) Indications of Bonner's early rebellion against gender conventions appear in Jane Turner Censer's account of her desire to drill with a group of girls who emulated Confederate cadets: "Her father's refusal to allow her to participate reduced Kate to tears. Her mother, seeking to console her, made her an apron featuring the Confederate flag." Raised and schooled in her mother's ancestral home, Bonner received early instruction typical for young girls of her era, which centered on subjects related to hearth and home. Bonner was also an avid reader, however, and enjoyed the luxuries of her father's extensive library, as described in her 1878 autobiographical novel *Like Unto Like:* "Their reading was of a good solid sort. They were brought up, as it were, on Walter Scott. They read Richardson, and Fielding, and Smollett, though you may be sure that the last two were not allowed to girls until they were married." During the years 1859–1863 Bonner was enrolled in Holly Springs Female Seminary, where the curriculum included instruction in liberal arts as well as in natural science, mathematics, philosophy, and hygiene.

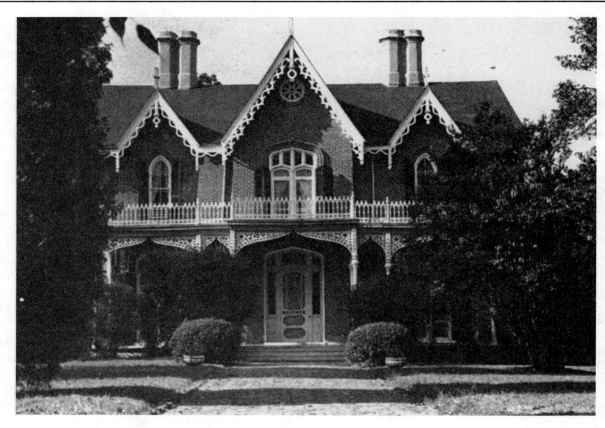

Bonner House in Holly Springs, Mississippi, where McDowell lived for much of her childhood

The Civil War interrupted Bonner's education at Holly Springs Female Seminary. Her parents, fearing for their daughter's safety during the Union occupation of their town, sent Bonner to Montgomery, Alabama, to finish her schooling at the Diocesan Female Seminary, Hamner Hall. At the end of her first year at Hamner Hall, Bonner returned to Holly Springs and did not pursue further schooling except for a year at the Select School for Young Ladies, founded by a prominent family of Holly Springs and taught by their thirty-year-old daughter. This same organization, interested in preserving the fading vestiges of Southern culture, founded The Philomathesian Society, the first literary club in Holly Springs to include women in its membership. There Bonner met and became engaged to her future husband, Edward McDowell.

The years between Bonner's introduction to McDowell and her marriage demonstrate her inner turmoil regarding her cultural "place" as a woman and her desire to carve out a niche for herself professionally in the literary community. In 1869, while studying at Hamner Hall, Bonner published her first short story, "Laura Capello: A Leaf from a Traveler's Note Book,"

a melodramatic two-part quest for British inheritance, in the Boston periodical *Massachusetts Ploughman*. She published this work under the pseudonym Clayton Vaughn and was awarded $20 by *Massachusetts Ploughman* editor Nahum Capen for her contribution. Though 1869 records indicate that Bonner published "The Heir of Delmont" and "Saved" (a bridal dream story, published in *Massachusetts Ploughman*, examining the consequences of choosing the wrong mate), her diary entries for that same year tell of a desire to participate more actively in a culture that seemed to lock women hopelessly in the role of domestic ornament: "I feel sometimes I shall go mad! There is no help for me—none—all I long for is death and annihilation—, but oh! The long long years to come—How can I fill them—How can I crush out the needs of my hungry soul. . . . And from this I turn to the parlour with a smile . . . like one who had never learned to sigh or weep."

Bonner married Edward McDowell on 14 February 1871, and on 10 December of that same year, she bore their daughter, Lilian. Edward, who had a history of being intermittently employed, left his wife and daughter in the care of his family while he followed his

dream of opening a mercantile business in Uvalde, Texas. Katharine McDowell moved to Texas in 1873 in an effort to revitalize their marriage. When it became apparent that Edward could not support her or Lilian, McDowell left on 20 August 1873. With a desire to earn her own way, removed from Edward's financial frivolity, McDowell resolved to separate from him, take Lilian to her family in Holly Springs, and enter college at Vassar. McDowell implored the help of Nahum Capen, publisher of *Massachusetts Ploughman,* who cautioned her against such a brash move, citing possible social disapproval for such actions. Undeterred, McDowell proceeded to Boston alone and was aided by Capen and his family in securing lodging, schooling, and employment. During this time, McDowell supported herself with secretarial work for Capen, for Dr. Dio Lewis, and then for poet Henry Wadsworth Longfellow, who became her literary patron and friend.

Though little is known of the mentor-protégée relationship of Longfellow and McDowell, recent scholarly investigation into their alliance has raised questions regarding the dynamics of the early Boston literary community. Lisa Pater Faranda proposes that omission of McDowell's name by writers in her time was due to an almost conspiratorial cover-up by the Boston literary community. Faranda builds upon an argument posed in *The Prodigal Daughter: A Biography of Sherwood Bonner* (1981) by Hubert Horton McAlexander Jr., who suggested a social resentment of the relationship of Bonner and Longfellow by the "female literary establishment" of Boston: "That group, traditionally a closed shop, had not been kind to Kate in her last years . . . and Kate McDowell was never mentioned in any of their reminiscences of the Boston literary world." Adding to the communal animosity excited by Bonner's nonconventional life was her publication of *The Radical Club. A Poem, Respectfully Dedicated to "The Infinite." By an Atom,* a satirical work printed in the *Boston Times* in 1875, poking fun at an elitist Boston literary club, whose membership boasted such figures as Bronson Alcott, Edna Dow Cheney, Elizabeth Peabody, and John T. Sargent. "The Radical Club" was so popular it was republished in pamphlet form, also in 1875. McDowell's frank parody and unflattering character sketches of the more prominent members of the community earned her their scorn and opened to social scrutiny her relationship with Longfellow, which without such provocation might have been overlooked according to social decorum. Longfellow's own letters have only scant references to McDowell. That McDowell, whom her contemporaries dubbed "Vivien" to Longfellow's "Merlin," was only slightly mentioned in any of Longfellow's journals or correspondence has led to the critical speculation that Longfellow's brother Samuel, embarrassed by the rumors and gossip surrounding the relationship, erased all reference to the "literary adventuress" when the collection came into his possession after Longfellow's death.

While McDowell may have exercised questionable judgment in satirizing her literary peers, the fact remains that she was shrewd in anticipating the literary tastes of her time. She exploited her experiences as a Southerner by writing for Northern periodicals and then reversed this practice by reporting to the *Memphis Avalanche* as a correspondent writing from Boston, the "Hub of the Universe." These correspondent pieces, composed in the style of long letters, focused on a woman's first impressions of Boston and society. Similarly, when she went abroad in 1876, McDowell composed more of the "impression" pieces for newspapers in Boston and Memphis. Many scholars cite Bonner's "Gran'mammy" tales as among the first Negro dialect tales available to Northerners. The character of Gran'mammy, central in many of Bonner's tales published in *The Youth's Companion* and her collection *Suwanee River Tales* (1884), was drawn from Molly Wilson, the African slave who nurtured Bonner and her family for three generations before the Civil War. Bonner wrote of Wilson in "Gran'mammy" that she was the one "to whom we ran to tell of our triumphs and sorrows; she whose sympathy, ash-cakes, and turnover pies never failed us." The literary appearance of the Gran'mammy figure precedes Joel Chandler Harris's Uncle Remus, first appearing in the *Atlanta Constitution* in 1876, and Irwin Russell's dialect poem "Christmas Night in the Quarters" (1878), both landmark works in the genre.

In an 1877 letter to Longfellow, McDowell expressed concern over the rumors surrounding her that affected her work and social esteem. The letter demonstrates McDowell's awareness of her social position and speaks of her regrets: "In the past perhaps there had been something unusual in my position . . . but as a *mother* living in Boston according to her husband's wish for the education of their child, no gossip could touch me. . . . I have lost my taste for Bohemianism. . . . I could even find it in my heart to wish that I had not written 'The Radical Club.'" For a time it seemed that McDowell's social atonement had been sufficient. Despite the rumors surrounding her relationship with Longfellow, in 1878 McDowell's career in the Boston literary circuit reached its high point with the Harper Brothers publication of *Like Unto Like.* The critical reviews of *Like Unto Like* described the work as original and promising. An *American Bookseller* review from 1 October 1878 said, "The book shows so much talent that we would like to know who Sherwood Bonner is." Set during Reconstruction, *Like Unto Like* is atypical of

Edward McDowell in the 1890s

most reconciliation novels of the period. Rather than present a portrait of a Southern beauty who has succumbed to the charms of a Northern hero, McDowell depicted Blythe Herndon, the heroine, as strong, independent, and, by the end of the novel, ultimately alone. *Like Unto Like* was noted for its frank exploration of Reconstruction politics. McDowell described Herndon's steely-eyed grandmother clinging to the memory of her slain husband and the Lost Cause: "[The Yankees] mingle with us to exult over us—to spy out the nakedness of our land. To-morrow they will laugh at the tears that flow"; and she depicts the public scrutiny endured by the Tollivers for boarding Northern tenants: "It soon became the current report in Yariba that the Tollivers had all 'gone' to the Yankees." Ignoring the regional politics present in *Like Unto Like,* feminist scholars have concentrated recently on the gender issues present in the work, noting that its publication predates Kate Chopin's *The Awakening* (1899), a novel well known for dealing with the gender issue, by twenty years. The early feminism in *Like Unto Like* is apparent in the scene in which Blythe becomes enraged at Roger Ellis's defense of General Butler's insulting tactics used to manage the unruly women of occupied New Orleans. When Ellis calls Blythe a "desperate little

rebel," she makes clear to him the reason for her rage: "It is not as a southerner that I resent what you have said, but as a *woman.*"

McDowell returned to Boston after attending to her family in Holly Springs during the 1878 outburst of yellow fever, only to find that, though her novel had received favorable reviews, her literary peers had not forgotten her social affront to them. Though Bonner had written to Longfellow that the success of her novel was a compensation for "having so many cruel and unjust things said of me," she soon learned that the veiled threat made anonymously by a member of "The Radical Club" in response to her controversial poem would be carried out: "'Words' may fall on ears unheeding: / Deeds will stand the final test." Though Bonner continued to publish, she was repeatedly scorned by her literary peers. Even longtime friends Louise Chandler Moulton and Longfellow distanced themselves from Bonner. In an 1879 letter to Longfellow, Bonner expressed concern regarding his distance: "I never see you now-a-days and am trying to accustom myself to the thought that you will soon stop caring for me in the least."

McDowell traveled with her daughter to relatives in southern Illinois to obtain a divorce from Edward in 1880. Though she had been distanced from her mentor Longfellow in the previous months, Bonner still kept a correspondence with him. A letter to Longfellow signed "Your Troubling Kate" and dated 28 April 1880 demonstrates Bonner's resolve to change her circumstances and to regain control over her life: "I shall work furiously this year—if I were happier I should be less ambitious." Indeed, McDowell heeded her resolution, for the fifteen months spent in Illinois were the most productive of her literary career, with the publication of juvenile poems and a story about Lilian's dolls called "The Angel in the Lilly Family" in the September and October issues of *Harper's Young People;* two more Negro dialect tales—"Why Gran'mammy Didn't Like Pound Cake," in the *Wide Awake Pleasure Book,* and "Dr. Jex's Predicament," in *Harper's Weekly* for 18 December; a series of three tales about Cumberland Mountain life—"Jack and the Mountain Pink," "The Case of Eliza Bleylock," and "Lame Jerry"—in the 29 January, 5 March, and 28 May 1881 issues of *Harper's Weekly;* a local-color tale portraying the hypocrisy of a fundamental religious community in Perry County, Illinois, called "Sister Weeden's Prayer" in the April 1881 issue of *Lippincott's;* "Two Storms" in the April 1881 *Harper's;* and her novella, *The Valcours,* modeled after William Makepeace Thackeray's *Vanity Fair* (1847–1848) and published serially in the September, October, November, and December 1881 issues of *Lippincott's.*

McDowell in 1879

McDowell scholars have concentrated on her mastery of humor and strength in re-creating vernacular speech patterns characteristic of such twentieth-century Southern writers as Flannery O'Connor, Eudora Welty, or William Faulkner. Bonner's Cumberland Mountain tales offer readers an uncommon glimpse into her perception of the world of mountain women. "Lame Jerry" depicts sympathetic Cordy, who suffers an unromantic fate at the hands of her father, and "Jack and the Mountain Pink" describes resilient Sincerity

Hicks's aid in moonshiner Jack Boddy's escape from federal agents. Sincerity's help then earns her a cash award from the amused Seldon, and she says, "Guess this 'll be good for some blue beads. . . . I've been a-wantin' some a right smart while." McDowell's trip to the Tennessee Cumberland Mountains in 1879, sponsored by Harper Brothers, enabled her to research these tales as well as two other short stories meant to be included in *Dialect Tales* (1883). Biographer McAlexander praises Bonner's work on these four tales: "No

group of stories by a contemporary writer reflects so well the pattern of development in American literature from the Civil War to the end of the nineteenth century." Scholars have also noted that during her time in Illinois, a pattern emerged in McDowell's work that deals with deceived or abandoned women, as illustrated in "The Case of Eliza Bleylock," "Two Storms," and "On the Nine-Mile" (1882), a tale about an Illinois farm girl who discovers after being maimed in a farm accident that her fiancé no longer wants to marry her. McAlexander states of "On the Nine-Mile": "The depth of feeling in this work may well be traceable to the author's own fear that the divorce had made her 'unsuitable' for marriage."

In August 1881 McDowell noticed an ever-growing lump on her breast, and on 5 May 1882, she traveled to Boston to consult various specialists regarding her failing health. Placing herself under the care of Dr. Richard C. Flower, McDowell found her writing restricted to only three hours a day. Her primary reason for coming north, however, was to collect some of her stories for *Dialect Tales,* and on 18 July 1882, she signed a contract for the publication of her tales with Joseph Harper of Harper and Brothers. On 7 March 1883, shortly after her thirty-fourth birthday, McDowell, with her longtime friend Sophia Kirk, returned to Holly Springs to spend the remainder of her life. Katharine McDowell died on 22 July 1883.

McDowell had named Kirk as her literary executrix. Kirk left Bonner House with several manuscripts written in McDowell's last months, which included a collection of juvenile Christmas tales and, in Kirk's own words, "a book nearly complete—it being so far advanced that another party can complete it." In 1884 Kirk published "Christmas Eve at Tuckeyhoe" (January, in *Lippincott's*), "The Tender Conscience of Mr. Bobberts" (March, in *Harper's Weekly*), "Coming Home to Roost" (May, in *Harper's Weekly*), and Bonner's Christmas collection, which appeared as *Suwanee River Tales.* With the controversial publication of Ellen W. Kirk's *The Story of Margaret Kent* in 1886, however, McDowell's reputation suffered its final blow. The novel was immediately recognized as Bonner's life story, since it describes the trials of a heroine living by writing because her absent, frivolous husband will not support her, as well as her risqué associations with a renowned poet of seventy, Herbert Bell. That *Margaret Kent* was written by Sophia Kirk's stepmother—and that the novel described in detail real life incidents in McDowell's life Ellen W. Kirk could not have known—has given rise to the speculation by modern scholars that the work was composed almost entirely by Bonner's own hand. *Margaret Kent* became an immediate best-seller, its success hinging on its exploitation of the thinly veiled relationship of McDowell and Longfellow. According to McAlexander, the Boston literary society, disdainful that Kirk would capitalize on the memory of the revered Longfellow, responded "not with outrage, but with a profound silence . . . and the almost complete obliteration of Kate McDowell's memory there began immediately after the great success of *Margaret Kent*." So thorough was her erasure from the notes and letters of the Boston literary society and from Longfellow's personal papers that staff at Longfellow House had not heard of Katharine McDowell or Sherwood Bonner as late as 1978. That McDowell died of breast cancer in 1883 at age thirty-four in the midst of what should have been productive years is a disappointment to scholars who until recently had only scant artifacts from the writer.

McDowell's works have been included in anthologies of humor, women's writing, Southern literature, local-color writing, and in anthologies of American literature. Although she was a controversial figure in her quest to earn a literary name for herself, McDowell was also a witty and talented observer of the American landscape. Her work revealed insight into the mechanics of its people and the literary trends during central periods in American history. McDowell's candid views of her America provide readers a different perspective on gender mechanics and regional differences at the turn of the nineteenth century.

Letters:

Jean Nosser Biglane, "An Annotated Indexed Edition of the Letters of Sherwood Bonner," M.A. thesis, Mississippi State University, 1972.

Bibliographies:

Thomas McAldory Owen, "A Bibliography of Mississippi," *Annual Report of the American Historical Association,* 1 (1900): 654;

Jean Nosser Biglane, "Sherwood Bonner: A Bibliography of Primary and Secondary Materials," *American Literary Realism,* 5 (Winter 1972): 38–60.

Biographies:

Alexander Bondurant, "Sherwood Bonner–Her Life and Place in the Literature of the South," *Publications of the Mississippi Historical Society,* 1 (1899): 43–68;

Dorothy Gilligan, "The Life and Works of Sherwood Bonner," M.A. thesis, George Washington University, 1930;

William Luke Frank, "Catherine Sherwood Bonner McDowell: A Critical Biography," dissertation, Northwestern University, 1964;

Hubert Horton McAlexander, *The Prodigal Daughter: A Biography of Sherwood Bonner* (Baton Rouge: Louisiana State University Press, 1981).

References:

Nash Kerr Burger, "Katherine Sherwood Bonner: A Study in the Development of Southern Literature," M.A. thesis, University of Virginia, 1935;

B. M. Drake, "Sherwood Bonner," in *Southern Writers: Biographical and Critical Studies,* 2 (1903): 97–98;

Lisa Pater Faranda, "A Social Necessity: The Friendship of Sherwood Bonner and Henry Wadsworth Longfellow," in *Patrons and Protégées: Gender, Friendship, and Writing in Nineteenth-Century America,* edited by Shirley Marchalonis (New Brunswick, N.J.: Rutgers University Press, 1994), pp. 184–211;

Wade Hall, *The Smiling Phoenix: Southern Humor from 1865–1914* (Gainesville: University of Florida Press, 1865);

Ellen W. Kirk, *The Story of Margaret Kent* (Boston: Ticknor, 1886);

Hubert McAlexander Jr., "Sherwood Bonner," *American Literary Realism,* 8 (1975): 202–204;

Rayburn S. Moore, "Merlin and Vivien? Some Notes on Sherwood Bonner and Longfellow," *Mississippi Quarterly,* 28 (1975): 181–184;

Moore, "Sherwood Bonner's Contributions to *Lippincott's Magazine* and *Harper's New Monthly,*" *Mississippi Quarterly,* 17 (Winter 1963–1964): 226–230;

Darlene Pajo, "The Woman Question in the Life and Fiction of Sherwood Bonner," M.A. thesis, University of Louisville, 1989;

Robert C. Pierle, "Sherwood Who? A Study in the Vagaries of Literary Evaluation," *Notes on Mississippi Writers,* 2 (1969): 18–22;

George W. Polhemus, "Longfellow's Uncompleted Review of *Like Unto Like,*" *Notes and Queries,* 6 (February 1959): 48–49;

Moody L. Simms Jr., "Sherwood Bonner: A Contemporary Appreciation," *Notes on Mississippi Writers,* 2 (Spring 1968): 25–33;

Daniel E. Sutherland, "Some Thoughts Concerning the Love-Life of Sherwood Bonner," *Southern Studies: An Interdisciplinary Journal of the South,* 26 (Summer 1987): 115–127;

Edward Wagenknecht, *Longfellow: A Full-Length Portrait* (New York: Longmans, Green, 1955).

Papers:

The Houghton Library at Harvard University houses the most extensive compilation of Katharine Sherwood Bonner McDowell's personal correspondence and includes fifty-four letters from McDowell to Longfellow. Mississippi State University in Starkville also holds several letters, as well as the following artifacts: a penned account of her dinner with the Ingersolls, her last will and testament, copies of various short stories, the poem "The Radical Club," the unpublished poem "The Judge," the unfinished story "A Heroine of the Last Century," and various *Memphis Avalanche* articles. Other collections of letters are housed in the special collections department at the library of the University of Mississippi in Oxford.

Maria Jane McIntosh

(1803 – 25 February 1878)

Jennifer Hynes

BOOKS: *Blind Alice; or, Do Right If You Wish to Be Happy,* as Aunt Kitty (New York: Dayton & Saxton, 1841); republished as *Blind Alice and Her Benefactress* (London: T. Nelson, 1849);

Florence Arnott; or, Is She Generous? as Aunt Kitty (New York: Dayton & Saxton, 1841; London: Nelson, 1850);

Jessie Graham; or, Friends Dear, but Truth Dearer, as Aunt Kitty (New York: Dayton & Saxton, 1841);

Ellen Leslie; or, The Reward of Self-Control, as Aunt Kitty (New York: Dayton & Newman, 1842);

Grace and Clara; or, Be Just as Well as Generous, as Aunt Kitty (New York: Dayton & Saxton, 1842; London: T. Nelson, 1850);

Conquest and Self-Conquest; or, Which Makes the Hero? anonymous (New York: Harper, 1843; London: Bruce & Wyld, 1844);

Woman an Enigma; or, Life and Its Revealings, anonymous (New York: Harper, 1843; London: N. Bruce, 1843); republished as *Louise de la Vallière: A Tale* (London: T. Nelson, 1854);

The Cousins: A Tale of Early Life, as Aunt Kitty (New York: Harper, 1845); republished as *The Cousins; or, Mary Mowbray and Lucy Lovett: A Tale of Early Life* (London: T. Nelson, 1850);

Praise and Principle; or, For What Shall I Live? anonymous (New York: Harper, 1845; London: Routledge, 1850);

Two Lives; or, To Seem and To Be (New York: D. Appleton / Philadelphia: G. S. Appleton, 1846); republished as *Grace and Isabel; or, To Seem and To Be* (London: Routledge, 1852);

Aunt Kitty's Tales, as Aunt Kitty (New York: D. Appleton, 1847);

Charms and Counter-Charms (New York: D. Appleton, 1848; London: Routledge, 1849);

Woman in America: Her Work and Her Reward (New York: D. Appleton, Philadelphia: Geo. S. Appleton, 1850);

Evenings at Donaldson Manor; or, The Christmas Guest (New York: D. Appleton, 1851); republished as *Annie*

Courtesy of the American Antiquarian Society

Donaldson; or, Evenings at the Old Manor House (London: T. Nelson, 1853);

Letter on the Address of the Women of England to Their Sisters of America. In Relation to Slavery (New York: T. J. Crowen, 1853);

The Lofty and the Lowly; or, Good in All and None All-Good (New York: D. Appleton, 1853); republished as *Alice Montrose; or, The Lofty and the Lowly; Good in All and None All Good* (London: R. Bentley, 1853);

Emily Herbert; or, The Happy Home (New York & London: D. Appleton, 1855);

Rose and Lillie Stanhope; or, The Power of Conscience (New York: D. Appleton, 1855; London: Routledge, 1855);

Violet; or, The Cross and the Crown (Boston: John P. Jewett, 1856); republished as *Violet; or, Found at Last* (London: Routledge, 1856);

Meta Gray; or, What Makes Home Happy (New York: D. Appleton, 1859);

A Year With Maggie and Emma: A True Story (New York: D. Appleton, 1861; London: D. Appleton, 1861);

Two Pictures; or, What We Think of Ourselves, and What the World Thinks of Us (New York: D. Appleton, 1863);

Violetta and I, as Cousin Kate (Boston: Loring, 1870);

The Children's Mirror: A Treasury of Stories, as Cousin Kate (New York: T. Nelson, 1887; London: T. Nelson, 1887).

After beginning her literary career publishing children's books pseudonymously, Maria Jane McIntosh turned in the 1840s to writing moral tales for adults. Categorized by modern critics as a creator of what Nina Baym calls "woman's fiction," McIntosh wrote from the perspective of a Southern woman. In both fiction and nonfiction she defended the system of slavery as a Christian institution, eventually publishing twenty-four books. Although much of McIntosh's adult fiction followed formulaic—if fairly complex—plot structures, her ability to depict characters' psychological lives sets her apart from other popular sentimental writers.

McIntosh was born in 1803 in Sunbury, on the coast of Georgia, to Mary Moore (Maxwell) and Lachlan McIntosh; it was the fifth marriage for her father, a wealthy and distinguished lawyer and plantation owner. The prominent Scottish McIntosh family boasted of General William McIntosh of the Highland troops and Captain John More McIntosh, one of the first settlers of Georgia and founder of McIntosh County. Family pride in this Scottish ancestry later surfaces in McIntosh's novel *Two Pictures* (1863), in which Georgia plantation owner and attorney Hugh Moray seeks a male heir to carry on his legacy. Following her father's death when she was three years old, McIntosh was raised by her invalid mother. The spacious mansion and beautiful grounds of the family plantation appear in several of McIntosh's novels, including *The Lofty and the Lowly* (1853) and *Two Pictures.* She was educated at home by her mother and at two schools—a coeducational academy in Sunbury and Baisden's Bluff Academy in McIntosh County. Later she recalled the headmaster of the Sunbury academy, Presbyterian clergyman Dr. McWhir, as a teacher who urged his female students to compete with the male students and to excel academically, even if in somewhat different fields.

In 1823 McIntosh's mother died, leaving the twenty-year-old to manage the plantation, which she did for a dozen years. McIntosh sold the property in 1835, investing her fortune in securities and moving to New York to live with a half brother, naval Captain James McKay McIntosh. The Panic of 1837 changed McIntosh from a wealthy heiress into a struggling spinster when her fortune was lost. She then turned to writing, as did many other nineteenth-century middle-class women—both real and fictional—when faced with financial trouble.

McIntosh began her literary career by attempting moral juvenile fictions in the style of popular children's writer Samuel Griswold Goodrich, who published under the name "Peter Parley." Selecting the pseudonym "Aunt Kitty," she began her first such book, *Blind Alice; or, Do Right If You Wish to Be Happy,* in 1838, although it did not appear until 1841. In McIntosh's children's books she often used contrasting pairs of characters to prove her lesson; she later paired heroes or heroines in her adult fiction. For example, the juvenile *Ellen Leslie; or, The Reward of Self-Control* (1842) contrasts the young title character, a spoiled, sensitive girl who has difficulty controlling her temper, with her sister, the calm, patient Mary. Only after Ellen suffers for her quick temper does she learn the habit of Christian self-control and submission, thus earning her the reward of a happy home life. Likewise, the title characters of *Rose and Lillie Stanhope; or, The Power of Conscience* (1855) are a pair of sisters—pretty, spoiled Rose and unselfish, honest Lillie. After suffering for her weaknesses, Rose learns the same Christian strength that keeps her sister content. Notably, this novel also includes a plug for the moral publications of the Sunday-School Union; McIntosh even reproduces a fourteen-page extract, "The Happy Garden," which teaches the power of conscience. Her other books for juveniles teach similar lessons: *Jessie Graham; or, Friends Dear, but Truth Dearer* (1841), the importance of truth; *Florence Arnott; or, Is She Generous?* (1841), the difference between true generosity and a desire for praise; and *Grace and Clara; or, Be Just as Well as Generous* (1842), the need for fairness. Because she was writing tales for children, McIntosh made certain that her lessons were clear and unambiguous. Her early pseudonymous children's tales (*Blind Alice, Florence Arnott, Jessie Graham, Ellen Leslie,* and *Grace and Clara*) were collected in *Aunt Kitty's Tales* (1847). Although nineteenth-century biographical dictionaries claim that McIntosh's juveniles were published as a set in England, no evidence attests to this occurrence.

When McIntosh turned to writing for adults, she at first maintained both her anonymity and her habit of using paired characters to illustrate her moral points. Her first novel for adults was *Conquest and Self-Conquest; or, Which Makes the Hero?* (1843), a moral tale for young men that pits the honest, upright, abste-

mious Frederic Stanley against his more easygoing, self-indulgent friend. Frederic is rewarded with money, love, and honor for his good character. The novel reflects knowledge of life on board a naval ship, which McIntosh must surely have gained from her half brother, Captain McIntosh. Similarly, the anonymous *Praise and Principle; or, For What Shall I Live?* (1845) is a didactic work that repeats the formula of rewarding hard work and honesty while punishing sloth, in this instance focusing on two law students. Although McIntosh experimented with complex plots in these early adult works, the obvious parallels and overpowering didactic content make them less interesting to modern readers than her later works.

When McIntosh turned to writing fiction that focused on female characters, she retained the didactic messages of her earliest fiction. The anonymous *Woman an Enigma; or, Life and Its Revealings* (1843) was McIntosh's first foray into the realm of Baym's "woman's fiction." Baym argues that this mode, popular among women writers between 1820 and 1870, focuses on the trials and triumphs of a young heroine who loses her traditional supports and must learn to fend for herself emotionally and economically. Indeed, *Woman an Enigma* follows its young heroine, Louise de la Vallière, who, raised in a French convent, enters the world as a naive girl of seventeen. Although she is not orphaned, as is typically the case for heroines in the tradition of woman's fiction, Louise is a kind of de facto orphan because of her weak, powerless mother and her father, who hopes to become wealthy by marrying off his beautiful daughter. Having been betrothed to an older man, the Duc de Montreval, Louise spends a season in Paris attempting to acquire the social polish that he expects from her. But when Montreval sees Louise in Paris, he believes that she has turned into a dangerous flirt and calls off the engagement. Having placed all her hopes on this attachment, Louise is emotionally disappointed—she has yet to learn the lesson of the novel, the need for female independence. She retains her pride, however, and rather than accept the financial trust Montreval leaves her, she supports herself and her mother with needlework, music, and teaching. By proving to herself and the world that she can be financially independent, Louise also learns the emotional independence that allows her to mature. When she meets Montreval years later, they have both grown. Thus, the love that accompanies their marriage later in life is mature and equal, not that of a father figure and submissive child.

Besides fitting into the realm of woman's fiction, *Woman an Enigma* also is an attempt at historical fiction. Woven into the narrative of Louise's growth and independence are events of the French Revolution.

Because she is from an aristocratic family, Louise's life and property are in danger. Her father, along with a second suitor, whom Louise does not accept, attempts to take the money that Montreval has left in trust and flee to Geneva, leaving Louise alone to sustain her mother in the Paris of the French Revolution. Conveniently, Louise is relatively unharmed by historical events. By the end of the novel she earns both fortune and true love. McIntosh's paradoxical message seems to be that only by working toward emotional and economic independence can a woman find happiness in a dependent marriage.

McIntosh's next novel, *Two Lives; or, To Seem and To Be* (1846), was the first to which she signed her name. Baym claims that this novel began the wave of popular women's novels, paving the way for Susan Warner's *The Wide, Wide World* (1851), Maria Susanna Cummins's *The Lamplighter* (1854), and dozens of other best-sellers. In *Two Lives* McIntosh returns to the use of parallel characters that had been so dominant in her children's works and early adult fiction. Her contrasting female characters, cousins Grace Elliott and Isabel Duncan, both exhibit traits of a fictive heroine. Motherless, they are raised by Grace's father until his death, when they must leave their rural home to be educated and introduced into New York society. Interestingly, the petite, blond Grace and the tall, brunette Isabel reverse the traditional contrast of dark and light heroines. Blonde Grace is weak and flirtatious, not pure and pious; her dark cousin is strong-willed but giving, revealing a Christian faith atypical of the "dark lady" with a tinge of sin in her blood and in her past.

Both heroines have their faults; Grace is flighty, impulsive, and excessively eager to please others while the analytical Isabel, absolutely unswayed by others, allows her excessive pride to make her act harshly. Having promised to take care of her cousin, Isabel refuses to marry the man she loves because she believes that Grace loves him also. But Grace becomes engaged to somebody else, revealing Isabel's principle to be nothing more than pride. Grace's lack of decision scares off her suitor, leaving her to marry a wealthy rogue and to become the most admired belle in Paris. While showing lavish, detailed scenes of fashionable society, McIntosh preaches against involvement with such frivolous, often scandalous, lifestyles; but such scenes allow readers vicarious glimpses into the lives of the wealthy and privileged. While Grace seems to enjoy her reign in Paris, Isabel lives by her principles until her uncle loses his money and she must support the family by teaching. McIntosh's contrast at this point is obvious: Grace is unhappy and disillusioned in Paris, while Isabel is fulfilled by doing her duty. When Isabel marries her early love and

WOMAN IN AMERICA:

HER WORK AND HER REWARD.

BY

MARIA J. McINTOSH,

AUTHOR OF "CHARMS AND COUNTER-CHARMS," "TO SEEM AND
TO BE," ETC. ETC.

"The ancients looked towards the land of the setting sun as to a land of
promise, where the earth puts forth fruits for eternal life; and surely the home
of the Hesperides must have features and beauty of its own, and a calling not
known to the old world."

F. BREMER.

NEW YORK:
D. APPLETON & COMPANY, 200 BROADWAY.
PHILADELPHIA:
GEO. S. APPLETON, 164 CHESNUT-STREET.
M DCCC L.

Title page for the book in which McIntosh argued that, although women and men are not equal, only women can "rectify the error of American society" caused by too great a focus on business matters and too much imitation of European society

makes a home for the abandoned Grace, the moral contrast of the two lives is complete. Independent Isabel, after learning the need for flexibility and concern for others, wins the day over dependent, flighty Grace. This message of the importance of independence for women recurs in several of McIntosh's later novels.

Having made a name for herself with *Two Lives,* McIntosh continued writing woman's fiction. *Charms and Counter-Charms* (1848) was McIntosh's most popular work, selling approximately one hundred thousand copies and spreading her fame as a writer. As the title might indicate, this novel includes parallel characters, both heroes and heroines. Cousins Mary Raymond and Evelyn Beresford love the same man, the exemplary Everard Irving. Early in the story Mary learns the major lesson of the novel (excess dependence on a man leads to misery for a woman), gives up Everard to her cousin, and settles in to enjoy a useful, independent life. Mary's reward for her hard work and self-control is, according to formula, an upright and loving husband, Everard.

What no doubt made the novel so successful, however, is not Mary's stable course but Evelyn's more sensational path, that takes up most of the book's four hundred pages. After her cousin gives up the good Everard to her, Evelyn becomes fascinated by the unattainable—the older Euston Hastings. Evelyn's infatuation flatters Euston into a shortsighted romance that leads to marriage. Evelyn expects that each will be all

the other needs. Instead, her demands drive Euston away from home and into an affair with the married woman who had introduced the couple.

In her characterization of both Euston and Evelyn, McIntosh shows her ability to create deep, psychologically realistic personalities. A heroine with some self-control might have given up her wayward husband, but Evelyn follows him to Europe, where he has given up his affair, and begs him to love her again. Here the most sensational episodes begin: Euston allows his wife to stay with him, but only if she plays the role of his mistress, giving up all social position. Evelyn agrees, but in this position of isolation and shame she begins to understand the dangers of her dependence. Eventually, Evelyn's newfound self-respect and Christian faith cause Euston to mend his ways and become a loving husband. With its message of female emotional independence and Christian love, *Charms and Counter-Charms* offers a sensational twist to the traditional plot of the woman's novel.

In a 1990 doctoral dissertation, "Maria Jane McIntosh, A Woman in Her Time: A Biographical and Critical Study," Bashar Akili asserts that McIntosh took a middle position in the nineteenth-century debate over women's rights, urging women to prove their worth in modern society while warning them against an excess of independence and the forwardness associated with early feminists. Indeed, her one full-length nonfiction work, *Woman in America: Her Work and Her Reward* (1850), articulates the tenets of domestic feminism that characterized the work of Catharine Beecher. In this 155-page discussion, McIntosh asserts that women's proper role in American society is to ensure that the economic, political, and social advances of the age do not infringe on the strength of "Christian civilization." She writes that although women and men are definitely not created equal, women alone can "rectify the errors of American society" brought about by excess attention to business and the effort to mimic European society. Thus, women are to seek out useful work—not avoid it—and to take their proper place in raising children, nursing the sick, and maintaining the hearth fires of Christianity. McIntosh sees women as having several specific roles defined by their regions: Southern women should take the lead in missionary work that targets the slave population; Western women should steer the developing society in such a way that immigrants are properly Americanized; and Eastern women should provide a stable, upright home life that offers men a safe haven from the lures of moneymaking. Her argument, with its pro-American and anti-Catholic perspective, seems intended for a middle- and upper-class white Protestant audience.

Indeed, McIntosh relies heavily on the Bible in making her argument, assuming that her readers will follow the logic of expecting a purpose for all creatures, a season for all things. With other fairly conventional thinkers of her era, McIntosh relies on the weight of tradition as evidence that men and women have always fulfilled the positions for which they were created. But remarkably, while she asserted the dangers of women's independence in *Woman in America,* she wrote in her fiction of women's need for self-sufficiency and proved in her life that women were quite capable of supporting themselves.

Critic Elizabeth Moss argues that McIntosh, along with other Southern women writers of her generation such as Caroline Hentz and Augusta Jane Evans, used their fiction to defend their region against the political, social, and economic encroachment of the North. Indeed, McIntosh takes up the cause of the South in both fiction and nonfiction, most strongly after Harriet Beecher Stowe brought the attention of the world to the issue of slavery with *Uncle Tom's Cabin* (1852). McIntosh directly addressed the arguments of abolitionists in her 1853 pamphlet, *Letter on the Address of the Women of England to Their Sisters of America. In Relation to Slavery,* which was reprinted from *The New York Observer.* This pamphlet answered an earlier essay, "An Affectionate and Christian Address of Many Thousands of Women of Great Britain and Ireland to Their Sisters the Thousands of Women of the United States of America," which had been written, signed, and entrusted to Stowe, along with a hefty monetary donation, by a group of British women during her 1853 tour of England. In her essay McIntosh argues against the abolitionist claim that slaves had been removed from a happy family life in Africa to be abused and overworked in Southern plantations. Rather, the Southern apologist argued that life in Africa was a barbaric, unhappy existence, gladly thrown over for relative prosperity and security in America. McIntosh claims that well-behaved slaves could ensure a happy, healthy existence under a paternal plantation system run by nurturing, humane Christians.

McIntosh again directly addresses Stowe's abolitionist writing with her novel *The Lofty and the Lowly; or, Good in All and None All-Good* (1853). Apparently a play on Stowe's subtitle, "Life Among the Lowly," McIntosh's work actually deals with the economically disadvantaged of both North and South. This lengthy work contrasts a vicious, exploitive system of Northern factory labor, which uses up and spits out its employees with no concern for their well-being, with a family-centered plantation economy that values slaves throughout their lives and teaches them the importance of Christian principles. McIntosh shows her fictional slaves mourn-

ing the death of their owner, caring for their young white charges with more concern than they take for their own children, and relinquishing legal freedom to support a young mistress during financial crisis. Thus, slave owning is painted as missionary work, while Northern capitalism appears as a selfish moneymaking system. But McIntosh argues that capitalism can be made into a Christian institution if factory owners will take responsibility for workers and their families, building them sanitary housing and providing free schooling—conditions similar to those on her ideal plantation.

The Lofty and the Lowly, however, is not a simple proslavery tract. By this time in her career McIntosh was adept at weaving together complicated plots involving many characters. This novel follows the struggles of a Boston widow and her two children, Alice and Charles Montrose Jr.; their wealthy Georgia cousins, Isabelle and Donald Montrose; and the hardworking engineer and inventor Robert Grahame. Various economic and moral troubles beset all of the major characters, allowing McIntosh to show the values of both hard work and good family character. Not surprisingly, McIntosh again pairs characters as a way of differentiating between regions and between types of female beauty. The virtues of the "chivalrous South" appear through the easygoing, generous Charles and the gracious Isabelle, while the positive traits of the "enterprising North" are shown through hardworking, self-sacrificing Robert Grahame and quiet, angelic Alice Montrose. In this instance, McIntosh relies upon the standard contrast of dark and light heroines when she paints the brunette Isabelle as a proud, fashionable woman with a passionate temper, while blonde Alice is a delicate, obedient, sincere Christian.

As Baym points out, *The Lofty and the Lowly* fits into the realm of woman's fiction, dealing as it does with young, displaced heroines who must learn to make their way in the world both financially and morally. When the novel first appeared in Britain, its title was changed to *Alice Montrose; or, The Lofty and the Lowly,* suggesting an emphasis on one of the heroines who does not figure prominently in the first half of the novel. But the nearly six-hundred-page novel develops yet another major theme—economic responsibility. Having suffered economic losses during the Panic of 1837, McIntosh involves her female characters in the same kinds of trials that she had experienced. She also depicts in detail the hardships brought on a family by a son's gambling debts, expecting readers to share her interest and understanding of the discussion. Although she repeatedly argued to maintain separate, gendered spheres, McIntosh did not expect women to be ignorant of financial matters.

A prolific writer, McIntosh continued to write domestic fiction that featured innocent heroines who must find their way in the world but that also tended to include sensational elements that retained readers' attention. *Emily Herbert; or, The Happy Home* (1855) and *Meta Gray; or, What Makes Home Happy* (1859) both fit into the genre of woman's fiction, while *Violet; or, The Cross and the Crown* (1856) includes pirates, a shipwreck, and mistaken identity along with its standard orphaned heroine. Such elements of intrigue, along with McIntosh's occasionally deep insight into the psychology of her characters, set her work apart from other works of sentimental fiction.

Having criticized the early women's rights movement with *Woman in America,* McIntosh expanded on this theme in her last novel, *Two Pictures; or, What We Think of Ourselves, and What the World Thinks of Us* (1863). The main character, the orphaned Augusta Moray, is the heir apparent to an expansive Georgia seacoast plantation (similar to McIntosh's own early home). McIntosh brings the title of the novel to life when she allows Augusta to tell her own biography for the first chapter, then switches to an omniscient narrator for all but the final chapter, which resumes Augusta's voice. Through this device, McIntosh attempts to show that, while others see Augusta as a haughty woman, her pride owes in part to insecurity and a retiring nature. But Augusta's pride and self-control cause her to endanger her romantic happiness and financial security; thus, the main message of *Two Pictures* seems to be the danger of excessive independence for women.

Not surprisingly, McIntosh includes a pair of contrasting male characters between whom Augusta must choose. When her uncle Hugh Moray, a lawyer who owns the plantation on which Augusta has been raised, seeks a male heir to carry on his name, he finds two young male relations in New York. Charles Moray, a fun-loving son of a wealthy and fashionable widowed mother, seems born to enjoy the outdoor amusements of a Southern gentleman but has little education and no ambition. His cousin, Hugh Moray, the quiet, thoughtful son of a navy captain, puts himself through school while helping to support his mother and sisters. Although Augusta and Hugh become attached in their youth, a complex series of incidents ensues—involving harmful gossip, lies, and a forged will—threaten to separate them. By the end of the novel Charles has ruined his family with heavy gambling debts while Hugh has assisted his father in fighting a naval battle off the coast of Mexico, has been elected a U.S. senator, and saves his uncle's plantation from Charles's creditors before inheriting it. After demonstrating she can support herself as a gov-

erness, Augusta realizes she needs Hugh's strength and happily settles for his protection.

Although *Two Pictures* appeared during the Civil War, it expands on the proslavery message McIntosh had articulated in *The Lofty and the Lowly*. In her later work McIntosh argues that a truly Christian master can give slaves a happy, comfortable existence that they would not enjoy were they free. Ever the upright man, Hugh works with the plantation minister to expand religious services for the slaves and provide positive incentive for their good behavior: separate, independent houses are given to loyal slaves. In a lengthy speech late in the novel, Hugh expounds on the message that slave owning must be a form of missionary work:

> In the essential features, the dependence of the slave, the rule and authority of the master, I believe it to be divinely appointed for the noblest ends. Woe be to him who makes it minister to his selfishness—to his degrading sensualities! Woe to him who is indifferent to its grand responsibilities! Ham was to be a servant of servants; but it was to be "to his BRETHREN," through whom he would still be united to their common Lord.

As in McIntosh's earlier proslavery novel, slaves do not complain of their treatment but praise and thank their masters for kindness. Augusta similarly enjoys the life-long devotion and love of the only maternal figure she has ever known—her slave mammy, Charity.

McIntosh never married, and while earning enough to support herself by writing, she made her home with various relatives. In 1859 she traveled to Geneva, Switzerland, with the family of John Elliott Ward, a nephew. After returning to New York, McIntosh became a teacher at Henrietta B. Haines's school. Finally settling in to the role of the comfortable maiden Southern gentlewoman, McIntosh in her later years in New York held a salon where she entertained guests with dramatic readings and discussions. She spent her last months living with her niece and namesake, Maria McIntosh Cox (also a writer), in Morristown, New Jersey. She died there on 25 February 1878 after a year-long illness.

Biographies:

Sarah Josepha Hale, "Maria Jane McIntosh," in *Woman's Record* (New York: Harper, 1855), II: 468–469;

Julia Keese Colles, "Miss Maria McIntosh," in *Authors and Writers Associated with Morristown. With a Chapter on Historic Morristown,* second edition (Morristown, N. J.: Vogt, 1895), pp. 174–176.

References:

Bashar Akili, "Maria Jane McIntosh, A Woman in Her Time: A Biographical and Critical Study," dissertation, University of Technology, Loughborough, U.K., 1990;

Nina Baym, "Maria McIntosh," in her *Woman's Fiction: A Guide to Novels by and about Women in America, 1820–70,* second edition (Urbana & Chicago: University of Illinois Press, 1993), pp. 86–109;

Mary Kelley, *Private Woman, Public Stage: Literary Domesticity in Nineteenth-Century America* (New York & Oxford: Oxford University Press, 1984);

Elizabeth Moss, *Domestic Novelists in the Old South: Defenders of Southern Culture* (Baton Rouge: Louisiana State University Press, 1992);

Sara Elizabeth Moss, "Our Earnest Appeal: The Southern Domestic Novelists and Their Literary Defense of Southern Culture, 1833–1866," dissertation, Washington University, 1989.

Lucretia Mott

(3 January 1793 – 11 November 1880)

Jennifer Margulis
Mount Holyoke College

BOOKS: *A Sermon Delivered in the Unitarian Church in the City of Washington . . . First Month 15, 1843* (Salem, Ore.: Davis & Pound, 1843);

The Liberty Bell (Boston, 1846);

Sermon to the Medical Students Delivered at Cherry Street Meeting House, Philadelphia, on First-day evening, second month 11th, 1849 (Philadelphia: Merrihew & Thompson, 1849);

Discourse on Woman, Delivered at the Assembly Buildings, December 17, 1849 (Philadelphia: T. B. Peterson, 1850);

Slavery and "the woman question": Lucretia Mott's Diary of Her Visit to Great Britain to Attend the World's Anti-Slavery Convention of 1840, edited by Frederick B. Tolles (Haverford, Pa.: Friends' Historical Association, 1952);

Lucretia Mott: Her Complete Speeches and Sermons, edited by Dana Greene (New York: Edwin Mellen Press, 1980);

Lucretia Mott Speaking: Excerpts from the Sermons and Speeches of a Famous Nineteenth Century Quaker Minister and Reformer, compiled by Margaret Hope Bacon (Wallingford, Pa.: Pendle Hill Publications, 1980).

Lucretia Mott became a figure of national importance in the abolition and women's rights movements of the mid nineteenth century. A prominent woman in the public domain and the mother of six children, Mott contributed Quaker ideals of nonviolence and simple living in accordance with moral beliefs to the abolition and the women's rights movements. While Mott gained fame as an orator, she tended not to supplement her generally extemporaneous speeches with written words. Indeed, Mott always found writing difficult, and—aside from a brief autobiography, diary entries, and letters to her family and friends (which she found so burdensome that she often delegated the task to her husband)—she did not leave behind a significant body of written work. This fact perhaps explains why, although prominent in the nineteenth century, Lucretia Mott is today less well

Lucretia Mott (courtesy of the Friends Historical Library of Swarthmore College)

known than other antislavery and women's rights activists.

Lucretia Coffin was born on the island of Nantucket on 3 January 1793. Her ancestors had helped establish the first white settlement on Nantucket in 1659. Her father, Thomas Coffin, was a direct descendant of Tristram Coffyn Sr. and Thomas Macy, the two original purchasers of the island. Her mother, Anna Folger Coffin, descended from the earliest Martha's Vineyard families and was also distantly related to Tristram Coffyn. Mott's parents, who married in 1779,

213

were both Quakers; they, like their forefathers of several generations, were faithful members of the Society of Friends. Nantucket at this time was a prosperous island and the point of origin for many whaling and East Indian expeditions. Thomas Coffin was a sailor, reported to be intelligent in appearance rather than handsome, and Anna Coffin was an energetic, keen-witted woman.

When Lucretia was four years old, the family moved to Fair Street in the town of Nantucket. While her father went on long sea voyages, her mother ran a small shop selling East Indian wares. The second of six children and the eldest of the five girls, Lucretia was often left in charge of her younger sisters while her mother went to the mainland to buy goods for the shop. Raised with a strong sense of the Quaker religion, the children learned to observe Quaker tradition, to attend meetings regularly, to sit quietly, and to appreciate the value of silence. An active child, quick-tempered and impatient with others, Lucretia struggled to follow Quaker principles. In an autobiographical sketch she wrote later in life, she remembered that "in childhood . . . [I] tried to do right, praying for strength to overcome a naturally hasty temper."

The family moved again when Lucretia was eleven years old, this time to Boston. Her parents sent the children to public school, fearing that the select private school would foster class prejudice and pride. Public school in Boston, where Mott later explained that she "mingled with all classes without distinction," allowed her to meet children from poor families. She later remembered her early schooling as one of the many sources of her compassion for the less fortunate: "My sympathy was early enlisted for the poor slave, by the class-books we read in our schools, and the pictures of the slave-ships, as published by Clarkson." When she was thirteen years old, Lucretia and her younger sister Elizabeth went to the Friends' Nine Partners School in New York, where she first met her future husband, James Mott. Since boys and girls were kept strictly apart at the school, Lucretia did not meet the nineteen-year-old teacher from Nine Partners School until she accompanied James's sister, Sarah, home to Cowneck on a school vacation. James worked at the school as a teacher until 1809 during which time Lucretia was promoted first to assistant teacher and then to full teacher. On 4 April 1811 James Mott and Lucretia Coffin were married.

During her adolescence Lucretia had become aware of the injustices that women and enslaved people faced. She learned that even though tuition at the Nine Partners School was the same for boys and girls, male teachers made twice as much money as women teachers. She also learned about the transatlantic slave trade and the debased position of Africans in America. At both inequities, even as a young girl, she was outraged. Of the disparity between men's and women's salaries Mott wrote, ". . . the injustice of this distinction was so apparent, that I early resolved to claim for myself all than an impartial Creator had bestowed." Of the sufferings of slaves Mott asserted even more forcefully: "the millions of down-trodden slaves in our land being the greatest sufferers, the most oppressed class, I have felt bound to plead their cause . . . to endeavor to put my soul in their souls' stead, and to aid . . . in every right effort for their immediate emancipation."

Despite her early awareness of injustice, Mott's growing family kept her busy. She gave birth to her first child, a girl named Anna, on 6 August 1812. In July 1814, she had a son, Thomas, who died three years later. In 1818 she gave birth to another daughter, Maria, followed by another son in 1823, whom she also named Thomas, and subsequently by two more girls—Elizabeth in 1825 and Martha in 1828. While her children were small, Mott assiduously read the works of William Penn and the Bible, committing much of what she read to memory. Her public speeches abound with references to Penn's writing and to scripture. In her many scriptural references used to reinforce her arguments, Mott often signaled the positive depiction of independent women, the compassion of Jesus, and the conviction of the Apostles even in the face of opposition, emphasizing the authority of the Bible and truth over the authority of accepted interpretations of the Bible.

The Motts' early married life was marked by financial difficulties and strain. Having left teaching, James Mott pursued various commercial undertakings with differing degrees of success, becoming, finally, a partner in Lucretia's father's business. When Thomas Coffin died of typhus fever in February 1815, he left both his family and his son-in-law's family impoverished. Following Lucretia's mother's example, Lucretia and James Mott opened a small store in Philadelphia. Their business venture, however, quickly proved unsuccessful, and the failure led James to leave his family to seek work as a bank clerk in New York.

Offered a job as bookkeeper in Philadelphia by John Large, James hurried back to the city where his wife and children were living with family. At the same time, Lucretia Mott decided to augment the family income by opening a school. Under the guidance of the Pine Street Monthly Meeting, a small school was opened in 1817, with Rebecca Bunker as principal. Although Lucretia Mott withdrew from the school as a teacher while pregnant with her third child, she did not devote herself solely to her domestic life. Instead, she spoke more and more often at Friends' meetings and

came to be regarded as an excellent preacher. At the age of twenty-five, in 1818, she delivered her first public sermon to a Meeting of Friends. Her dignified presence and engaging manner impressed many of the listeners, and she soon became an active preacher and contributor to the Quaker ministry.

The Motts' financial difficulties returned when John Large's once-prosperous business fell into financial ruin, and James Mott was forced to find other employment. From 1822 to 1830 James's business included the buying and selling of domestic commodities, including cotton. With a growing consciousness among the Quakers about the evils of slave labor, however, and the influence of the convincing preaching of Elias Hicks, Quakers began to eschew products made by slaves. Lucretia Mott was concerned about the ethics of her husband's business, and James, even more cautious than his wife, decided in 1830 after long deliberation to give up his prosperous enterprises and enter the wool business instead. Part of this decision was propelled by the Motts' desire, in keeping with the Quaker ideal, for simple living in accordance with moral beliefs, an ideal Lucretia Mott returned to in her sermons and public lectures. Later, when antislavery activists advocated other means of emancipating slaves, she insisted that the economic refusal to buy goods made by slaves was the most effective step toward abolition.

In 1827 the Quaker church in Pennsylvania split into Orthodox Friends and Hicksites, less conservative Quakers who believed that the Orthodox disciplining of the outspoken Elias Hicks was unjust. Because of her growing prominence in the Society of Friends and her obvious talents as a speaker, Lucretia Mott's decision to follow the Hicksites was especially significant. After some hesitation, she left the Orthodox Friends and joined with the Cherry Street Meeting House, deciding also to devote her life to the abolition of slavery and the promoting of women's rights, nonresistance, temperance, and universal peace. The subsequent infighting between the two Societies of Friends deeply disturbed the Motts, who feared that these squabbles did not reflect the fundamental spirit of Quakerism.

In 1833 Lucretia Mott began her public speaking career against slavery at an antislavery convention held in Philadelphia for the purpose of forming an abolition society. In her speech she cautioned against gradual emancipation. "If our principles are right," she said in her deliberate, captivating voice, "why should we be cowards?" Inspired by the convention, the Philadelphia Female Anti-Slavery Society formed under the leadership of Esther Moore, with Lucretia Mott as one of its founding members. For the first time in Philadelphia, black and white women united together, sat together, and fought together for a common cause. Among the members were Abba Alcott, Charlotte and Margaretta Forten, Hattie Forten Purvis, Sarah McCummel, and Grace Bustill Douglass. Unaccustomed to separate women's organizations, the Anti-Slavery Society called on James McCrummel, a man of color, to preside at the first meeting. Although many of the Anti-Slavery Society's members were Friends, the Quaker church grew increasingly hostile to Mott's outspoken stance against slavery and was embarrassed by the public agitation of antislavery activists.

While the Society of Friends encouraged silence, the abolition movement throughout the United States was gaining momentum. Now that her older children were in their teens, Lucretia Mott had more freedom to travel and preach. Although many of her sermons concerned religious issues, she put forward an antislavery agenda as well. Speaking to an audience in Boston in 1841, Mott insisted on Northern compassion for the Southern slave: "Let us look to the souls who are led into hopeless captivity, deprived of every right," she urged. Mott's public denunciation of slavery became increasingly dangerous. In 1838, when Philadelphia Hall was burned to the ground by a mob of proslavery Southerners and anti-abolition Northerners, several witnesses reported that the angry mob decided to continue to the Motts' residence and burn that as well. Distracted by the idea of destroying an orphanage for African American children, the mob did not disturb the Motts' house, although many other violent threats and actions were taken to intimidate Lucretia Mott and to harass her colleagues into silence. Isaac Roach, mayor of Philadelphia, asked Mott to refrain from walking and mingling in public with African American women at the 1839 Anti-Slavery Convention of American Women. Mott refused to comply with Roach's request.

In 1840 Lucretia and James Mott, together with William Lloyd Garrison, traveled to London as delegates to the British and Foreign Anti-Slavery Society Convention. Before this journey, abolitionists had split between those led by Garrison, who believed in immediate emancipation and equal participation of women in the movement and those such as Theodore D. Weld, James G. Birney, and Arthur and Lewis Tappan, who advocated gradual emancipation and thought the presence of women weakened the abolitionist cause. Influential in New England and a long-standing personal friend of the Motts, Garrison championed the right of women to participate in the movement. After the split of the Anti-Slavery Society into two separate national bodies, Lucretia Mott, Lydia Maria Child, and Maria Weston Chapman became increasingly identified as Garrisonians.

Mott's brief diary of her trip to Great Britain to attend the world antislavery convention was later pub-

Pages from the journal Mott kept during her 1840 trip to London to attend the British and Foreign Anti-Slavery Society Convention (courtesy of the Friends Historical Library of Swarthmore College)

lished under the title *Slavery and "the woman question": Lucretia Mott's Diary of Her Visit to Great Britain to Attend the World's Anti-Slavery Convention of 1840* (1952); Mott's writing style in the diary is highly individualistic, abbreviated, and idiosyncratic. Commenting on peculiarly English customs, she delighted in recognizing her Nantucket ancestry in an English kitchen, where she found "old furniture like Grandfather Folgers, Jack for roasting—large bellows, 3 cornered chairs, large andirons—pipe box, iron and brass candlesticks, etc." Mott described how on reaching London, she and the other women delegates, in accordance with the anti-Garrison abolitionist faction in the United States, were barred from fully participating in the convention and escorted to the back of the convention hall. Angered by this decision, Mott and Sarah Pugh drafted a letter of protest from the American Women Delegates to the World Convention, insisting that the exclusion of women went against the concept of Universal Liberty. When Garrison arrived and learned of the discrimination against the women, he refused to take part actively in the convention. James Mott referred to his wife's diary while writing *Three Months in Great Britain* (1841), a sober book that detailed both their experiences abroad and the ongoing schism in the Society of Friends.

Although disappointed during much of the trip to Great Britain, Lucretia Mott met Elizabeth Cady Stanton there for the first time and became convinced of the urgency of championing women's rights alongside the antislavery cause. News of Mott's treatment abroad brought her into the national spotlight in America, where after the convention she gained status as a public figure. During the Motts' absence from the United States, both the abolition movement and the tension about Quaker involvement had fermented. The Orthodoxy of the Society of Friends talked of Lucretia Mott's interpretation of religion as heresy, and even the Hicksites sought to quiet her.

In 1841 the Monthly Meeting of Friends arraigned three of its members—Charles Marriott, Isaac T. Hopper, and James S. Gibbons—for promoting discord among the Quakers by helping to publish the *Anti-Slavery Standard,* an abolitionist newspaper. Contributors to the paper included authors Lydia Maria Child, Edmund Quincy, James Russell Lowell, and J. Miller McKim. The decision to disown the Friends was upheld at the New York Yearly Meeting in May 1842. Always more determined and deliberate in the face of opposition, Mott spoke against slavery to the Delaware, Pennsylvania, and New Jersey legislators and preached at Friends' Meetings with renewed vigor, traveling with her husband to some of the slaveholding states to preach there as well.

Mott's petite form, stately bearing, and deliberate presence brought recognition from some of the most famous literary men and women of her day—including Margaret Fuller, Frederick Douglass, Ralph Waldo Emerson, and Henry David Thoreau. Emerson remarked that Mott's speaking startled men, even those who disagreed with her opinions, into silence, "like the rumble of an earthquake." In a letter to his wife written after dining with the Motts, Emerson notes, "I do not wonder that they are too proud of her and too much in awe of her to spare her, though they suspect her faith." Although impressed with Mott's manner and intelligence, Emerson complained that she was not philosophical enough in her speeches and that "her will is more illuminated than her mind." For her part, Mott was "greatly pleased" to attend Emerson's public lectures, though she disagreed with Emerson's all-encompassing definition of nature. She objected to Emerson's "making Nature utilize everything—the bad as well as the good. That may be in the animal economy—but in morals, I told him, wickedness works only evil."

To raise money for the antislavery movement, Mott helped organize antislavery fairs, in which members sold donated wares, paintings, clothes, and baked goods. Although the Society of Friends disapproved of this money-raising activity, the fairs were held yearly around Christmas time. One year the Motts housed the fair in their own parlor because goods to sell had been too late in arriving to do otherwise. For this action and for allowing engravings with her portrait on them to be sold, Mott was severely rebuked by the Friends. She did not openly explain her actions to the Friends, considering it "time poorly spent in trying to disabuse such minds," as she wrote in a 13 March 1843 letter to Cyrus Pierce. In that letter she described the urgency of her work: "Of the good that has been accomplished on behalf of the stricken and the suffering slave, let an awakened conscience, a growing public sentiment in favor of emancipation, and thousands of liberated fugitives in Canada, testify."

Lucretia and James Mott's doors were as open as their words, and their large family often had other visitors. They participated in the Underground Railroad—giving shelter, clothing, and food to fugitive slaves. Abolitionists from overseas, traveling Friends, and antislavery speakers on the lecture tour often spent the night under the Motts' roof. While vehemently criticized in public for acting in an unwomanly manner, Lucretia Mott steadily devoted time and energy to domestic household concerns and to raising her children. In her biography, her granddaughter Anna Davis Hallowell portrays her as an excellent cook and indefatigable housewife. In explaining why a member of the family compiled her life and letters,

Hallowell wrote in the preface, ". . . it was finally decided that only a member of the family could undertake the proper delineation of a character whose domestic life was hardly less important than the more widely known events of her public career."

While in Great Britain in 1840, Lucretia Mott and Elizabeth Cady Stanton pledged to organize a woman's rights convention together, asserting the necessity of starting a national movement. Eight years later, their plans materialized. After James and Lucretia Mott visited an Indian reservation, they stopped in Auburn, New York, to visit with family. There with her sister, Martha C. Wright, Lucretia Mott, Jane Hunt, Elizabeth Cady Stanton, and Mary Ann McClintock resolved to hold the convention in Seneca Falls, New York, at Wesleyan Chapel in July 1848. James Mott presided at the two-day meeting at which Lucretia Mott's voice was the most often heard. In her inaugural speech Mott criticized women's social and political degradation and emphasized the need for a progressive movement to advance women's equality with men.

The Women's Rights Convention adopted a Declaration of Sentiments, modeling its language after the Declaration of Independence. The Declaration of Sentiments insisted on the equality of men and women and called for an end to the injurious history of male domination over women. When, at the same meeting, Stanton suggested to Mott the importance of women's suffrage, the usually radical Quaker reformer was initially taken aback, perhaps fearing that including a demand to give women the right to vote would undermine unanimous endorsement of the declaration. After the meeting, newspaper articles around the country ridiculed the proceedings, poking fun in particular at Mott. Despite the unsympathetic press, however, other conventions followed across the United States, and the women's rights movement later traced its origins to Seneca Falls.

Mott delivered her most famous, and perhaps most eloquent, speech on women's rights, "Discourse on Woman," in response to Richard Henry Dana, author of *Two Years Before the Mast* (1840). Criticizing Mott's outspoken stance on equal rights for women, Dana had argued in a public lecture in Philadelphia that the women's rights movement threatened conventional society. On 17 December 1849 she responded. Citing Exodus, the laws revealed to Moses on Mt. Sinai, and the precepts of Jesus, Mott insisted upon the equality of men and women in the Bible and in the eyes of God: she said that to underestimate the importance of women in the Bible is to misread the Scriptures. Mott then emphasized the importance of women in contemporary society, explaining to her

James and Lucretia Mott

audience that women need not lose their womanliness nor neglect their domestic duties in order to become more equal with men. Woman, said Mott, "asks nothing as a favor, but as right; she wants to be acknowledged a moral, responsible being. She is seeking not to be governed by laws, in the making of which she has no voice. . . ."

Translating her rhetoric about women's rights into action, Mott helped found two seminal institutions for women's education—the School of Design for Women in Philadelphia and the Female Medical College of Pennsylvania, opened in 1850. Widespread public disapproval of women's entering the medical profession made the education of women doctors extremely difficult. Despite the hecklers, however, Mott presided over public health and hygiene lectures by Dr. Hannah Longshore, one of the graduates of the Female Medical College of Pennsylvania. Mott also chose Dr. Ann Preston, another graduate and later founder of Woman's Hospital in Pennsylvania, as her personal physician.

The passage of the Fugitive Slave Act (1850), including its accompanying punishment of up to six months in prison or a thousand-dollar fine for those who helped fugitive slaves, intensified the difficulties

of the antislavery movement. In January 1851, at the age of sixty-two, James Mott retired from the wool business, and the family moved into a larger house on 3378 Arch Street. This house became a gathering place for abolitionists, and, despite boisterous mob violence against them, the Motts continued to help runaway slaves. One celebrated case involved Jane Johnson, a slave to John W. Wheeler, ambassador to Nicaragua, and Johnson's two children. When Quaker abolitionist Passmore Williamson and black abolitionist William Still informed Johnson that Philadelphia law stipulated that a slave who resided there for more than six months was free, she decided to avail herself of the law. The Motts gave her and her two children shelter. The furious ambassador had Williamson, Still, and five others arrested for aiding a fugitive. During the trial the Motts helped to sneak Jane Johnson into the courtroom to testify that she had left her master of her own accord.

In 1857 the Motts moved out of their city house on Arch Street into a house in the country outside of Philadelphia called Roadside. The long ride out to the house did little to deter callers, and the Motts continued to entertain family, Friends, abolitionists, and other visitors. As in the city, destitute callers and people raising money for charitable organizations came often to their door looking for Mott, who was known for her generous giving.

In 1859 when John Brown and eighteen followers, including his two sons, stormed Harpers Ferry, Lucretia Mott admired Brown's actions though she was chagrined at his use of violence. Although John Brown's widow stayed at Roadside during the trial, Mott dogmatically insisted upon nonresistance and nonviolence. Mott asserted to the Pennsylvania Anti-Slavery Society in October 1860 that nonviolence was not equivalent to passivity: "I have no idea, because I am a Non-Resistant, of submitting tamely to injustice inflicted either on me or on the slave. I will oppose it with all the moral powers with which I am endowed." In the same year that she and James celebrated their fiftieth wedding anniversary, the Civil War erupted. While the Motts' old friends rejoiced at President Abraham Lincoln's use of force, Lucretia remained circumspect and conflicted about the war. Several of her nephews served in the Union army and Mott herself, throughout the war, helped organize an ongoing fund-raising for the freedmen.

Mott did not share Garrison's belief that the end of the Civil War would bring about an end to racial prejudice in the United States. During the war itself, she saw firsthand Northern prejudice against African American soldiers. After Camp William Penn, a black military training camp, was established not far from Roadside, conductors of horse-drawn cars would not let black visitors ride in the same cars as whites. On one occasion a conductor ordered an elderly black woman to ride outside in the cold rain. Enraged, Mott took a seat beside the black woman. A protest ensued against the conductor, and the two women were allowed back inside the car. The problem of discrimination led to the formation of a committee, the Friends Association for the Aid and Elevation of the Freedmen, in which both James and Lucretia Mott took part.

Lucretia Mott long suffered from dyspepsia and in her later life was often doubled over in pain because of it. Despite failing health, throughout the war and after, she continued active in both the women's rights and the abolition movements. With the financial difficulties of the postwar United States and the new influxes of freedmen to Philadelphia, she continued to organize and preach on behalf of helping the less fortunate. At the same time, however, some of her rhetoric had begun to change. In her more advanced years she became less tolerant and less concealing of her anger and dislike toward those whose views she found in opposition to her ideals.

Although advancing in years, the Motts actively participated in reconstructing America after the Civil War. In 1864 James Mott received his first traveling minute, which allowed him to speak as a representative of the Friends about the importance of education and the establishment of Swarthmore College. Now that the Civil War was over, the new generation of Quakers treated James Mott with great honor and respect. Swarthmore College was successfully chartered on 1 April 1864. The Motts' daughter Ann Hopper sat on the board of managers. Lucretia Mott spoke at the inauguration of the college in 1869 to an audience of more than one thousand people.

The assassination of President Abraham Lincoln (1865) and the death after a long battle with cancer of her eldest daughter, Elizabeth (1866), as well as the burying of many other close friends and relatives, left Lucretia Mott desolate for a time. In 1868 she suffered an even harder loss: her husband and companion of more than fifty years died of pneumonia at the end of January. Two years later her sister and constant companion, Eliza, also died. Although she had been sure that her husband would outlive her because she was much frailer than he, Mott rallied her energy after his death and continued to espouse the causes they had long fought for. She steadfastly attended pacifist meetings of the Pennsylvania Peace Society, the Yearly Friends' Meetings, and some of the subsequent women's rights conventions. She served as an adviser and friend of the younger generation of women's

rights advocates and frequently consulted with Elizabeth Cady Stanton, Susan B. Anthony, and others. Mott was displeased at the increasing quarrels in the fledgling women's rights movement and at Stanton's racist remarks in 1867 that only the women's vote could insure the safety of the Union from the ignorance, poverty, and vice that would result from freed slaves' voting.

Mott's fame in her advanced years did not decrease; her calm, deliberate, steadfast demeanor and angelic, simple appearance had helped make her into a saintly figure in the public eye. She was reportedly once toasted as "the black man's Goddess of Liberty," a name that was often repeated. Many associations and individuals were named after her, including one society called "The Rising Sons and Daughters of Lucretia Mott." In 1870 she visited and preached at Philadelphia's African American churches. At the centennial anniversary of the Old Pennsylvania Abolition Society her brief speech drew a standing ovation.

Obituaries flooded the newspapers of the nation, and memorial services were held in several states after Lucretia Mott died on 11 November 1880. She had witnessed tremendous changes in the United States during a life that spanned the early days of the antislavery and women's rights movements, the Civil War, and Reconstruction. In her eulogy, preacher Samuel Longfellow remembered her fortitude in the face of injustice and fear, her commitment to ending slavery and prejudice, and her deep conviction that women had the same rights as men to speak out in public and to participate in government. Lucretia Mott was one of the most remarkable women of the nineteenth century: she was indefatigable, committed, and compassionate. From the beginning of her life on the island of Nantucket to the end of her life as a famous, well-respected Quaker activist, Lucretia Mott contributed significantly to the radical changes in American society.

Letters:

James and Lucretia Mott. Life and Letters, edited by Anna Davis Hallowell (Boston: Houghton, Mifflin, 1884).

Biographies:

Mrs. Joseph H. Hanaford, *Lucretia the Quakeress or, Principle Triumphant* (Boston: J. Buffim, 1853);

Lloyd Custer Mayhew Hare, *The Greatest American Woman, Lucretia Mott* (New York: American Historical Society, 1937);

Otelia Cromwell, *Lucretia Mott* (Cambridge, Mass.: Harvard University Press, 1958);

Dorothy Sterling, *Lucretia Mott* (Garden City, N.Y.: Doubleday, 1964);

Gerald Kurland, *Lucretia Mott, Early Leader of the Women's Liberation Movement* (Charlotteville, N.Y.: SamHar Press, 1972);

Margaret Hope Bacon, *Valiant Friend: The Life of Lucretia Mott* (New York: Walker, 1980).

References:

Hugh Barbour, ed., *Slavery and Theology: Writings of Seven Quaker Reformers, 1800–1870* (Dublin, Ind.: Prinit Press, 1985);

Henrietta Buckmaster, *Let My People Go: The Story of the Underground Railroad and the Growth of the Abolition Movement* (Columbia: University of South Carolina Press, 1992);

Maureen Graham, *Women of Power and Presence: The Spiritual Formation of Four Quaker Women Ministers* (Wallingford, Pa.: Pendle Hill Publications, 1990).

Papers:

Lucretia Mott's papers—including letters, a diary, obituaries, sermons, speeches, and sound recordings—are scattered throughout library collections in the Northeast. The largest collection is held at the Friends Historical Library at Swarthmore College in Pennsylvania. A large collection of letters is with the William Lloyd Garrison papers in the Sophia Smith Collection at Smith College. There are also miscellaneous papers at the Quaker Collection at Haverford College, the Nantucket Historical Society, the American Antiquarian Society, the Historical Society of Pennsylvania, the Boston Public Library's Department of Rare Books and Manuscripts, and elsewhere.

Elizabeth Oakes Smith

(12 August 1806 – 15 November 1893)

Timothy H. Scherman
Northeastern Illinois University

See also the Smith entry in *DLB 1: The American Renaissance in New England.*

BOOKS: *Riches Without Wings or, The Cleveland Family* (Boston: G. W. Light, 1838);

The Western Captive, or The Times of Tecumseh: A Tale (New York: J. Winchester, 1842);

The Sinless Child and Other Poems (New York: Wiley & Putnam; Boston: W. D. Ticknor, 1843);

The Poetical Writings of Elizabeth Oakes Smith (New York: J. S. Redfield, 1845);

The Dandelion (New York: Saxton & Miles; Boston: Saxton & Kelt, 1846;

The Moss Cup (Boston: Saxton & Kelt, 1846);

Rosebud, or The True Child (New York: Saxton & Miles; Boston: Saxton & Kelt, 1846);

The Salamander: A Legend for Christmas, found amongst the papers of the late Ernest Helfenstein, edited by E. Oakes Smith (New York: Putnam, 1848); republished as *Hugo: A Legend of Rockland Lake, found amongst the papers of the late Ernest Helfenstein,* Ed. by E. Oakes Smith (New York: J. S. Taylor, 1851); republished as *Mary and Hugo: or, The Lost Angel: A Christmas Legend* (New York: Derby & Jackson; Cincinnati: H. W. Derby, 1857);

The Keepsake: A Wreath of Poems and Sonnets (New York: Leavitt, 1849);

The Lover's Gift, or, Tributes to the Beautiful: American Series, ed. By Mrs. E. Oakes Smith (Hartford: J. S. Parsons 1850);

Woman and Her Needs (New York: Fowler & Wells, 1851); republished in *Liberating the Home* (New York: Arno, 1974);

Hints on Dress and Beauty (New York: Fowler & Wells, 1852);

Shadow Land, or, The Seer (New York: Fowler & Wells, 1852);

Old New York, or Democracy in 1689: A tragedy in five acts (New York: Stringer & Townsend, 1853);

The Newsboy (New York: J. C. Derby; Boston: Phillips, Sampson, 1854);

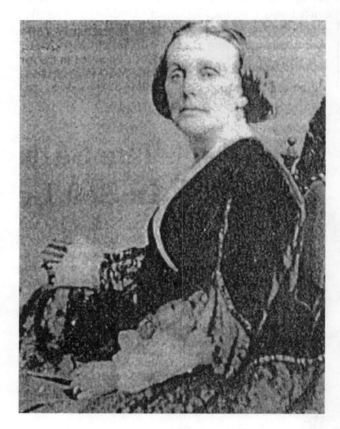

Elizabeth Oakes Smith (The Schlesinger Library, Radcliffe College)

Bertha and Lily, or The Parsonage of Beech Glen: A Romance (New York: J. C. Derby; Boston: Phillips, Sampson, 1854);

Bald Eagle, or The Last of the Ramapaughs: A Romance of Revolutionary Times (New York: Beadle & Adams, 1867);

The Sagamore of Saco (New York: Beadle & Adams, 1868).

Edition: *Selections from the Autobiography of Elizabeth Oakes Smith,* edited by Mary Alice Wyman (Lewiston, Me.: Lewiston Journal Company, 1924).

OTHER: *The Mayflower for MDCCCXLVII*, edited, with contributions, by Oakes Smith (Boston: Saxton & Kelt, 1846);

"Beloved of the Evening Star: An Indian Legend," in *The Opal for 1847* (New York: J. C. Riker, 1846), pp. 45–59;

The Mayflower for MDCCCXLVIII, edited, with contributions, by Oakes Smith (Boston: Saxton & Kelt, 1847);

Joy Wiltenburg, "Excerpts from the Diary of Elizabeth Oakes Smith," *Signs: A Journal of Women in Culture and Society,* 9, no. 3 (1984): 534–548.

SELECTED PERIODICAL PUBLICATIONS–
UNCOLLECTED:
FICTION

"The Lover's Talisman, or The Spirit Bride," *Southern Literary Messenger* (July 1839): 465–469;

"The Opal Ring," *Godey's Lady's Book* (January, February 1840): 12–16, 58–60;

"Gems and Reptiles," *Godey's Lady's Book* (February 1841); republished in *New World* extra series nos. 27/28 (27 October 1842): 46–48;

"Leaves by the Wayside," *Godey's Lady's Book* (July–December 1842): 94, 149;

"Bud and Blossom," *Graham's Magazine* (August 1842): 61–63;

"The Christian Sisters," *New World* extra series nos. 27/28 (27 October 1842) 39–46;

"Lunacy, or Fanny Parr," *Godey's Lady's Book* (January 1843); republished in *Rover* 2/21 (1843): 321–324;

"The Witch of Endor," *Graham's Magazine* (April 1843): 225–227; republished in *Rover* 2/2 (1843): 42–44;

"Hobomok: A Legend of Maine," *Rover* 2/2 (1843): 175–176;

"The Unrequited," *Godey's Lady's Book* (May 1843);

"The Miser's Wife," *Rover* 1/20 (1843): 313–314;

"Coming to Get Married," *Graham's Magazine* (July 1843): 52–56;

"Not Sure About That Same," *Godey's Lady's Book* (July 1844);

"The Sentiment of Self-Sacrifice," *Graham's Magazine* (February 1845): 90–91;

"The Interrupted Letter," *Godey's Lady's Book* (April 1845);

"The Sagamore of Saco," *Graham's Magazine* (July 1848): 47–52.

NONFICTION

"Characterless Women," *Graham's Magazine* (October 1842): 199–200;

"A Word Upon Conceitedness," *Graham's Magazine* (October 1843): 203–204;

"A Card from Mrs. E. Oakes Smith," *New York Tribune,* 31 December 1852;

"Letters from Mrs. E. O. Smith," *New York Tribune,* 15 January 1853;

"Divorce," *New York Tribune,* 4 February 1853;

"Marriage and Divorce," *New York Tribune,* 23 February 1853;

"Reply to P. T. Barnum," *New York Tribune,* 5 May 1855;

"Men and Women," *Emerson's Magazine and Putnam's Monthly* (1857): 83–86;

"A Happy New Year," *Emerson's Magazine and Putnam's Monthly* (1857): 87–88;

"Writing in New York," *Emerson's Magazine and Putnam's Monthly* (1857): 88–89;

"Power and Genius," *Emerson's Magazine and Putnam's Monthly* (1857): 312–313;

"The Weaker Vessel," *Emerson's Magazine and Putnam's Monthly* (1857): 319–320;

"Button-Holes and Babies," *Emerson's Magazine and Putnam's Monthly* (1857): 320–321;

"Women Voting," *Emerson's Magazine and Putnam's Monthly* (1857): 417;

"New York State Teachers' Convention: Protest of a Lady Member," *Emerson's Magazine and Putnam's Monthly* (1857): 517–519;

"Alice Carey," *Emerson's Magazine and Putnam's Monthly* (1857): 520–521;

"Womanly Perception," *Emerson's Magazine and Putnam's Monthly* (1857): 529–530;

"Books," *Emerson's Magazine and Putnam's Monthly* (1857): 591–592;

"Who Are Our Educators?" *Emerson's Magazine and Putnam's Monthly* (1857): 636–638;

"Bankruptcy and Dress," *Emerson's Magazine and Putnam's Monthly* (1857): 746–747;

"Fashions and Fashion Plates," *Emerson's Magazine and Putnam's Monthly* (1857): 764;

"The Sewing Machine," *Emerson's Magazine and Putnam's Monthly* (1858): 101–102;

"Sarah Helen Whitman," *Emerson's Magazine and Putnam's Monthly* (1858): 115;

"Poverty a Producer," *Emerson's Magazine and Putnam's Monthly* (1858): 174–176;

"Private Insane Hospitals," *Emerson's Magazine and Putnam's Monthly* (1858): 214–215;

"Burning Libraries," *Emerson's Magazine and Putnam's Monthly* (1858): 324–325;

"Virtue Rewarded," *Emerson's Magazine and Putnam's Monthly* (1858): 431–433;

"Women as Physicians," *Emerson's Magazine and Putnam's Monthly* (1858): 433–434;

"The Ragpickers of New York," *Great Republic Monthly* (January 1859): 133–139;

"The Newsboys of New York," *Great Republic Monthly* (February 1859): 242–248;

"The Firemen of New York," *Great Republic Monthly* (March 1859): 357–363;

"The Tombs, The Great City Prison," *Great Republic Monthly* (March 1859): 364–368;

"The Carmen of New York," *Great Republic Monthly* (April 1859): 486–490;

"The Sewing Girls of New York," *Great Republic Monthly* (May 1859): 568–576;

"Autobiographic Notes," *Beadle's Monthly* (1867): 30–33, 147–156, 220–225, 325–329, 437–442, 538–549;

"The Puritan Child, Being an Autobiography," *Phrenological Journal of Science and Health,* 72 (1881): 188–192, 304–309;

"The Puritan Child," *Phrenological Journal of Science and Health,* 73 (1881): 72–78, 241–248;

"The Puritan Child," *Phrenological Journal of Science and Health,* 74 (1882): 80–86;

"Reminiscences and Reflections," *Phrenological Journal of Science and Health* (September 1890): 105–106.

Elizabeth Oakes (Prince) Smith was one of the first American women to earn a national reputation as a fiction writer. In her mid forties she abandoned that career to work as an advocate for labor reform, temperance, and women's rights, becoming the first woman to lecture nationally on the lyceum circuit. Though much of her work remains uncollected and unpublished at the turn of the twenty-first century, the thousands of pages of writing she produced over a career spanning eight decades—letters, editorials, poetry, stories, lectures, novels, essays, memoirs, and autobiography—provide an unparalleled cultural and political record of the nineteenth-century woman's experience.

Elizabeth Oakes Prince was born near North Yarmouth, Maine, on 12 August 1806, to Sophia (Blanchard) and David Prince, a merchant seaman. When her father died at sea in 1809, Smith's two grandfathers—starkly contrasting in religious and social temperaments—filled paternal roles, creating a division in Smith's personality traceable throughout her life and writing. From the stern Calvinist David Prince Sr., she learned selflessness and an almost aristocratic pride in her family's heritage, while in the liberal Universalist Seth Blanchard she found both a sense of self-worth and a taste for the exotic.

As a teenager she planned to take in "scholars" and thereby earn money enough to board with a college professor at Bowdoin College and "learn all the lessons the young men learn," but her mother objected, fearing that if her daughter did not marry young she would remain a spinster all her life. Thus, instead of continuing her education, on 6 March 1823 Elizabeth was married to Seba Smith, a balding news-

paperman twice her age, known later for his humorous political satire. There is ample evidence in personal letters that Oakes Smith's married life was not an unhappy one; yet, most of her novels and virtually all of her feminist writings directly attack the marriage institution as it existed in her day.

Over the next ten years, Oakes Smith's primary work was motherhood (of her six sons, four lived to adulthood). Seba Smith's position as editor and proprietor of a weekly newspaper, *The Eastern Argus,* and later the daily *Portland Courier,* enabled her to combine her domestic duties with an exposure to professional writing. Both papers were run as cottage industries, whose printing operation and business office were run out of the Smiths' home, and thus in addition to feeding and clothing her own sons and her business family (including six apprentices), Smith found herself supplying poems, sketches, and editorials to help fill the columns of her husband's newspaper ventures, either anonymously or over the signature "E."

As contemporary critics later noted, the economic crisis of the mid 1830s transformed Elizabeth Oakes Smith into a professional writer. Taken by the fever for land speculation in Maine, Seba Smith had brought his family to financial ruin by 1838. As Oakes Smith recorded later in her autobiography,

> We were writers, and [impractical] in many ways. . . . I saw the shipwreck before us, but made the best of it, and it was nothing I could in any way prevent. Internally I vented my spleen upon the false position held by women, who seemingly could do nothing better than suppress all screaming and go down with the wreck.

During the Panic, Seba Smith spent some time surveying the land he had bought with a mortgage near Monson, Maine (then known as Township "Number 8"), and Oakes Smith's letters to him in this period provide a fascinating glimpse of a woman living both inside and outside a volatile economic environment. Alongside her report of daily business failures, mental breakdowns among property owners, and eventual eviction from their home, is a request for her husband to bring back "one great bear's foot" for stew.

Yet, while her husband despaired of his losses, Oakes Smith began testing the broader literary market anonymously with a poem in John Neal's *Boston Galaxy.* She received enough critical praise to convince her that her writing might succeed in a broader public forum than her husband's newspapers. Soon after, she wrote and sold a novel, *Riches Without Wings* (1838), which targeted children (and presumably their reading parents) as victims of the Panic. Setting

Page from a letter Oakes Smith wrote to Seba Smith in 1837 (Manuscripts Division, University of Virginia Library)

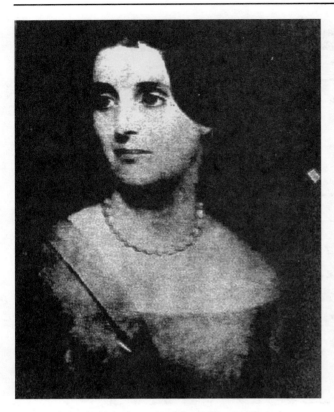

Oakes Smith in the 1840s (Maine Historical Society)

out to instill in both audiences an appreciation for riches beyond a material wealth, the plot describes the moral education of a young girl, Mary Cleveland, as she is instructed by her mother in the superiority of the natural and spiritual over the material world. Oakes Smith later dismissed the work as a "poor but pious" "Sunday School" book, but its extensive sales brought her far more money than what she called her later "more pretentious enterprises" and drew the attention of publishers such as Louis A. Godey, who solicited her work for his *Lady's Book.*

Arriving in New York in 1839, Oakes Smith and her husband boarded with cousins and set to work as professional writers. She submitted her work under several names—Mrs. Seba Smith, E. Oakes Smith, and a male pseudonym, "Ernest Helfenstein,"—which enabled her to sell multiple pieces for individual issues. In January 1842 the appearance of her poem "The Sinless Child" in the *Southern Literary Messenger* drew the notice of several New York and Philadelphia critics, notably Rufus Griswold, soon to be preeminent arbiter of popular literary taste in the country with his *Poets and Poetry of America* (1842), and already editor of *Graham's Magazine,* the most popular literary magazine of the period. With support from Griswold, Park Benjamin, John Keese, and others,

Oakes Smith's reputation soared. The only question was, as Charles F. Hoffman wrote to Griswold in 1843, whether Oakes Smith's "constitution be strong enough for the necessary mechanical labor of triumphant authorship." No complete bibliography of Oakes Smith's work has been compiled, but even a list of her known work answers Hoffman's question. In the 1840s she published two novels, three books of children's stories, and two volumes of poetry, edited two giftbooks, and contributed scores of stories and sketches to popular journals, who soon paid her competitive rates. Testament to Oakes Smith's writing pace came definitively in an 1849 letter from the notoriously prolific Lydia Sigourney, who marveled, "how many hours out of twenty-four do you write? And when are your thinking times?"

Oakes Smith's novels of the 1840s were her best. *The Western Captive* (1842) was one of the first paperback books published in the United States, printed as an "extra" edition of Park Benjamin's mammoth newspaper, *The New World.* By far the most successful (and topical) of Oakes Smith's Indian novels—the other two, *Bald Eagle* (1867) and *The Sagamore of Saco* (1868) were published late in her career in Beadle's New Dime Novels series—its historic background is Tecumseh's attempt to unite Native American tribes against Harrison's army in the aftermath of the treaty of Fort Wayne. Sold to Benjamin and advertised as an "American" novel without irony, the book's two themes are the U.S. government's tradition of hypocrisy in Native American affairs and the "natural" but forbidden union between white and Native American cultures. Incorporating patterns of Oakes Smith's precursors, James Fenimore Cooper and Catharine Maria Sedgwick, the book features both a white scout raised among Indians (Henry Mansfield, who is much like Cooper's Natty Bumppo) and sisters reunited years after an Indian raid on their settlement. Like her precursors, Oakes Smith used stilted dialogue and descriptions many times overblown, but her plot and characterization bring new perspectives to the genre. The woman Swaying Reed, an abducted white woman raised by her Shawnee captors, not only refuses to be rescued by Mansfield but manages to restore her sister Alice, who had also been taken captive, to the white settlement. More significantly, by denying what Mansfield sees as her "natural" place among whites, she resists the prejudices of white society, insisting on her identity as a white woman steeped in Native American culture. If the conventions of the work and the demands of the market allowed only a limited critique of racism in the novel, Oakes Smith's feminist position emerges, not only in her characterization of

the fiercely independent Swaying Reed but in the novel's self-reflexive dedication "to those of her sex whom the desire for utterance, or the necessities of life have called from the sanctity of womanly seclusion."

The quality of Oakes Smith's sketches and short fiction during the 1840s is mixed, but one longer story, "The Defeated Life" (1846), deserves special mention. Published in *The Mayflower,* the story begins as a sketch of the "Old Meeting House," the social and religious centerpiece of a community near North Yarmouth, Maine, in the early nineteenth century. Gradually it develops into a transparently autobiographical tale of a young woman "given" in marriage in that church, on a rainy spring day, to a balding man nearly twice her age. When some years later the trials of her marriage have driven the young woman into a hopeless stupor, her mother is called and finds a diary in which her daughter's mental dissolution is recorded in a manner prefiguring Charlotte Perkins Gilman's "The Yellow Wallpaper."

Into the late 1840s, Oakes Smith had been satisfied to maintain the distance between her public figure—a literary reputation largely produced and maintained by male editors, publishers, and critics—and her private identity as a woman struggling to support her family. In *The Salamander: A Legend for Christmas, found amongst the papers of the late Ernest Helfenstein* (1848), Oakes Smith casually declared the death of her "male" pseudonym. She was aware of the professional risks of such a move and never wrote a more complex allegory than *The Salamander.* Set in the Ramapo Valley southwest of the Hudson in colonial times, the novel takes its title from a legend circulated by the ironworkers of the region, claiming that unless the fire of a blast furnace were extinguished once every seven years, a flaming creature—the Salamander—would emerge to pursue the workmen and consume them in his grasp. The novel describes the quest of the Salamander, allegorically a "Lost Angel"—and in human form, Hugo's son, who disappears mysteriously as a child—with the aid of women in the community (named "Margery" and "Mary") to obtain the promise of his own salvation by leading the novel's characters toward unearthly goodness and truth. Having taken on the material form of man in order to ensure the salvation of all, the Salamander can only recover his unity with the spiritual realm by passing the "veil of fire"—a violent and painful martyrdom preordained by both the novel's Christian allegory and the legend that gives the novel its title.

E. P. Whipple and other critics declared the novel Oakes Smith's best work, and some observed that it showed "unmistakable evidence of being drawn from the writer's own life and mental experiences." But none seemed to note the possibility that Oakes Smith was allegorically contemplating her own role as a woman, who, by passing into a new career as a feminist, would undergo a painful public martyrdom for the salvation of her society.

Whatever her initial misgivings—or perhaps because of them—Oakes Smith found her decision to declare herself publicly a feminist liberating. As she recalled in her autobiography, "I had so much to renounce, and so much to do, that I almost danced over my freedom." In the late 1840s she began to turn down offers for literary work and wrote to her friends of her intentions to devote herself to the cause of women. Discarding her traditional summer clothing, she experimented with the Bloomer costume and other less restrictive styles, writing a conservative critique of women's fashion in *Hints on Dress and Beauty* (1852). Overcoming at last what she called an early "prejudice" against political solutions to the problems facing women, she found her greatest inspiration at the first National Women's Rights Convention in Worcester, Massachusetts, in October 1850. When she returned to New York, where the merits of the convention and the women's rights movement were hotly debated, she began a series of ten articles titled *Woman and Her Needs,* written to explode accepted limitations for women in education, professional opportunity, and law.

Printed in a revised form by Fowler & Wells in 1851, *Woman and Her Needs* ran as a series of essays in Horace Greeley's *New York Tribune* between 21 November 1850 and 19 June 1851. These articles were distinguished from other feminist works of Oakes Smith's day by her position in the debate over women's rights and her rhetorical approach to it. Because Oakes Smith was already widely known, yet not identified with the volatile social issues like abolition that had silenced or distanced precursors such as Angelina Grimké and Lydia Maria Child, she brought a large audience with her. If many of Oakes Smith's arguments were known to the Boston elite who had attended Margaret Fuller's "conversations" in the 1840s, they were not yet familiar—much less acceptable—to the much larger and varied readership of Greeley's *Tribune* in 1850.

Oakes Smith's rhetorical strategy in *Woman and Her Needs* and elsewhere has perhaps wrongly earned her the reputation of a temperate feminist. In an approach that recalls the subtle irony of Ralph Waldo Emerson's Transcendentalism (which she greatly revered), characteristically she would begin by defending a position widely accepted in bourgeois society. But by identifying contradictions or inconsis-

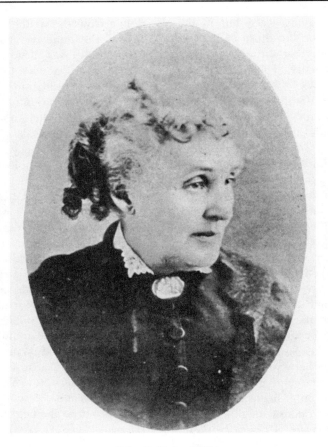

Oakes Smith late in life

tencies underlying that position, or between social theory and practice, she would lay the ground for a reversal of the status quo. Hence when Oakes Smith reveals "marriage" as the central subject of *Woman and Her Needs,* and begins by defending its "sanctity," her feminism looks "temperate" indeed. More radical, however, was her contention that the debasement that marriage brings begins in education, where girls are trained to be dependent, "to gain a position by marriage, or have none." Prepared for no other station in life, a woman without fortune too often does not marry but "is taken" in marriage, as a species of exchange or barter by which she becomes "the reflex glory of another," or in worse cases, a recipient of all her husband's "meanness, debasement, and disgrace."

Characteristically, as her radical position rose to the surface of her argument—or when her description of woman's sufferings began to sound too much like autobiography—Oakes Smith took a step backward. Admitting that many are content to view the marriage relation "as a commercial relation or one of social convenience only," she claimed not to attack "existing relations," but only asked that "humanity [be] coura-

geously truthful in its vocabulary"—that if marriage is seen as a commercial relation, then "the marriage contract [should] be put on the same base with other contracts." She pointed out that "the very nature of a contract presupposes equality." Thus, she argued, even in its basest material form, the marriage contract implied the necessity of improving women's position. Only when the element of compulsion in such a contract was removed by allowing women the right to own property, the right to labor for her own wages, and the education or training that would prepare her for employment would her "holiest attributes" become a "free-will offering" and the sanctity of marriage be preserved. Later she would wryly remark that she was only reminding men of what they already knew, "helping our Brothers to consistency."

Apart from the work she published with Greeley (who in his own editorial pages severely limited the ensuing dialogue), Oakes Smith found it difficult to place her feminist work in widely read journals. So in 1851 she began spreading her message in professional lectures. Though she had no formal training in public speaking, and continued efforts to publish,

Oakes Smith adapted her life and work to a lecture career. By September she had written a short lecture series, "Manhood," "Womanhood," and "Our Humanity," and had begun to book appearances for herself at lyceums, mercantile associations, and churches along the eastern seaboard. By February of the following year she had already addressed audiences in Brooklyn, Lynn, Concord, Worcester, Philadelphia, Providence, and on Nantucket, and had begun to lecture extempore. By June 1852 she had addressed audiences as large as two thousand (one gathered for another National Women's Rights Convention), and as far west as Chicago, expanding her western "tour" each year to include the cities of Cincinnati, Toledo, Cleveland, Louisville, St. Louis, and several smaller towns in Upstate New York.

Payments for her lectures varied. In some cases her letters home show that her share of receipts had only cleared expenses for travel and lodging, but many others report profits, along with instructions to her husband and sons on how the money should be spent. Evidence of payments made to men with whom she shared the lecture platform indicate that Oakes Smith enjoyed nearly equal pay for her labors in the lecture field. Since her career was best sustained in local appearances in New York City and the surrounding area—Brooklyn, Poughkeepsie, Yonkers—that reduced travel expenses, she expanded her repertoire as much to accommodate return appearances as to expand on and illustrate the principles set out in *Women and Her Needs*. Topics for 1852 included "Cleopatra and the Egyptians," "Woman the Inferior," and "The Dignity of Labor"; for 1853, "Madame Roland and the French"; and for 1854, "Margaret Fuller."

Apart from her lecture career and several frustrated efforts to inaugurate a feminist journal, *Egeria,* in the early 1850s Oakes Smith managed to publish two novels, *The Newsboy* (1854) and *Bertha and Lily* (1854). In keeping with her new career, the message of social reform predominates over attempts at artistry. George Ripley, writing in *Putnam's Monthly,* gave these works a fair assessment:

> Mrs. Smith has poetic sensibility, and a strong feeling of the sufferings of her sex . . . but as an artist she is deficient. She wants unity in the structure of her plots, and simplicity in everything. Her characters are generally too high strung, and would be better with a little more common sense. In the use of language, too, she is inflated. Instead of saying "it snowed" or "snow covered the ground," she says "The earth assumed its ermine mantle;" and this is characteristic of many of her descriptions. At the same time, it is proper to add, that she writes with such evident sincerity of conviction, that it is impossible not to get interested in one of her stories.

The Newsboy is a sentimental novel aimed at labor reform. Oakes Smith published it anonymously. The plot involves the rise of a newsboy, Robert Seaborn, from the abject poverty of street-corner vending to a successful position in the merchant class. As Nina Baym has suggested, the novel may have been a model for Horatio Alger; still, in Oakes Smith's refusal to "marry" her hero into the bourgeoisie, *The Newsboy* remains more realistic than works such as William Dean Howells's *The Rise of Silas Lapham* (1885). More successful than any element of her unlikely plot was Oakes Smith's attempt to expose her bourgeois audience to the living conditions of the working class in the city of New York, a project she continued in a series of articles for *Great Republic Monthly* in 1859.

Of all Oakes Smith's works, *Bertha and Lily* has received the most attention in recent years, most likely for its feminist subject. Critically successful in its day, it is not Oakes Smith's best novel and presents her feminist positions in an unsuitable fictional context. The protagonist Bertha takes refuge in the village of Beech Glen after a mysterious crisis. There she becomes for most—and especially the local minister, Ernest Helfenstein—a model of feminine wisdom while some others see her as a threat. Scholars have noted the autobiographical cast of Bertha's character—much of her dialogue is taken directly from Oakes Smith's lectures. More surprising in the novel is the revelation that the "crisis" driving Bertha to Beech Glen was her seduction, and the loss of her child, Lily, in a period of "madness" that followed. In an unlikely series of wish fulfillments, Lily is eventually restored to her, and in her union with Helfenstein Bertha finds the marriage of true equals she has until then only theorized. Bertha's dual nature as ideal and fallen woman remains the most radical stroke in any of Oakes Smith's fictions.

As the Civil War approached, Oakes Smith found fewer lecture engagements and began to devote herself to writing essays and editorials for *Emerson's Magazine and Putnam's Monthly,* a journal advertising a circulation of forty thousand. Her contributions are not signed, but her hand is unmistakable in hundreds of pages. In a casual and occasionally witty style recalling that of her best lectures, she addressed subjects both characteristic of her feminist work (women's suffrage, the abuses of private insane hospitals, women physicians) and tangential to women's rights (the advent of the sewing machine, public and private schooling, women writers). In 1859 Oakes

Smith and her husband, working with their sons, formed Oaksmith and Co. and purchased the magazine, which they published as *Great Republic Monthly*. It featured both Oakes Smith's own series on the working poor of New York City and travel articles on the South and West. Their effort to reach a national market was ill-timed, however, and the journal died after only eleven issues.

At the onset of the war, the family left New York for rural Patchogue, Long Island. Restless in genteel retirement (their home, named The Willows, included a billiard room and an aviary), Oakes Smith started a lyceum series at the Patchogue theater and lectured occasionally in the conservative village to unenthusiastic audiences. By 1865 she confessed in her diary that she felt as cut off from the world as she had in 1823, at the time of her marriage. In a series of tragedies in the 1860s—the deaths of her husband and two sons, and the mysterious indictment and exile of her eldest living son, Appleton, for war crimes—Oakes Smith's religious and political will was tested. (Appleton was pardoned by President Ulysses S. Grant in 1872.) While she continued to write and lecture on women's rights and other reforms through the 1880s, Oakes Smith spent much of her remaining years in self-reflection, publishing and revising portions of an autobiography that was never completed.

By the time Oakes Smith died in Hollywood, North Carolina, on 15 November 1893, she had outlived any connection to her original audiences—her family, her literary generation, and the first wave of the women's movement. As a result her work was quickly forgotten. In her time a celebrated poet, fiction writer, and a renowned feminist (a "household name" according to Elizabeth Cady Stanton), she was buried without ceremony in Long Island. Sure sign of her powerful presence in life, at her death the

Patchogue *Advance* vented its resentment of her radical positions on temperance and women's rights in a dismissive obituary, describing Oakes Smith generally as "a woman of surpassing talent not always dedicated to noble ends" who "never lost her queenly bearing, even though her throne was nothing but a soapbox." In the late twentieth century, however, several scholars began to re-examine Smith's writing. Cheryl Walker has singled out Smith's verse as representative of a broad class of American women poets, and other critics have placed her novels within the main currents of sentimentalist fiction.

Biography:
Mary Alice Wyman, *Two American Pioneers: Seba Smith and Elizabeth Oakes Smith* (New York: Columbia University Press, 1927).

References:
Cameron Nickels and Timothy H. Scherman, "Elizabeth Oakes Smith: The Puritan as Feminist," in *Femmes de conscience: aspects du feminisme americain (1848–1875),* edited by Susan Goodman and Daniel Royot (Paris: Presses de la Sorbonne Nouvelle, 1994), pp. 109–126;

Cheryl Walker, *The Nightingale's Burden: Women Poets and American Culture Before 1900* (Bloomington: Indiana University Press, 1982);

Walker, ed., *American Women Poets of the Nineteenth Century: An Anthology* (New Brunswick, N.J.: Rutgers University Press, 1992).

Papers:
The two principal collections of Elizabeth Oakes Smith's papers are at The Alderman Library, University of Virginia, and the New York Public Library, which holds "A Human Life," the complete manuscript for her autobiography.

Sara Payson Willis Parton
(Fanny Fern)
(9 July 1811 – 10 October 1872)

Joyce W. Warren
Queens College, City University of New York

See also the Parton entries in *DLB 43: American Newspaper Journalists, 1690–1872* and *DLB 74: American Short Story Writers Before 1880.*

BOOKS: *Fern Leaves from Fanny's Port-Folio* (Auburn, N.Y.: Derby & Miller / Buffalo: Derby, Orton & Mulligan, 1853; London: N. Cooke, 1853);

Little Ferns for Fanny's Little Friends (Auburn: Derby & Miller, 1853);

Fern Leaves from Fanny's Port-Folio, Second Series (Auburn & Buffalo: Miller, Orton & Mulligan / London: Low, 1854); republished as *Shadows and Sunbeams: Being a Second Series of Fern Leaves from Fanny's Port-Folio* (London: Orr, 1854);

Ruth Hall (New York: Mason Brothers, 1855 [i.e., 1854]; London: Houlston & Stoneman, 1855);

Rose Clark (New York: Mason Brothers, 1856);

Fresh Leaves (New York: Mason Brothers, 1857)— includes Fern's novella *Fanny Ford;*

The Play-Day Book (New York: Mason Brothers, 1857);

Fresh Leaves (New York: Mason Brothers, 1857);

A New Story Book for Children (New York: Mason Brothers, 1864);

Folly as It Flies (New York: Carleton / London: Low, 1868);

GingerSnaps (New York: Carleton / London: Low, 1870);

CaperSauce (New York: Carleton / London: Low, 1872);

Ruth Hall and Other Writings, edited by Joyce W. Warren (New Brunswick, N.J.: Rutgers University Press, 1986).

PERIODICAL PUBLICATIONS:
Fern wrote weekly columns for the *Boston Olive Branch,* 28 June 1851 – 25 June 1853; the *Boston True Flag,* 29 November 1851 – 23 April 1853; the *New York Musical World and Times,* 9 October 1852 – 19 November 1853; the Philadelphia *Saturday Evening Post,* 7 January 1854 –

Sara Payson Willis Parton (Fanny Fern), circa 1868

1 April 1854; and the *New York Ledger,* 5 January 1856 – 12 October 1872.

Sara Payson Willis Parton, known to her readers as Fanny Fern, was the first American woman newspaper columnist and the most highly paid newspaper writer of her time. Her popular columns appeared regularly for twenty-one years and were reprinted throughout the United States and Great

Britain. She was also the best-selling author of two novels, six books of essays, a novella, and three collections for children. In 1853 she originated the now-familiar saying, "The way to a man's heart is through his stomach." A pioneer in the use of the vernacular and understatement, writing in a frank, satirical style that defied convention, Fern was acclaimed by *Harper's New Monthly Magazine* in 1854 as the welcome harbinger of a new writing style, which, the editors hoped, marked the end of the "stilted rhetoric" and "parade and pomp" of literature. Stripping the facade of convention from some of society's most sacred institutions, Fern wrote fearlessly on such taboo subjects as venereal disease, prostitution, birth control, and divorce. She expounded ideas on education and child rearing that have become accepted practice today; she questioned male authority and conventional marriage patterns; she condemned narrowness in religion; she urged prison reform; she criticized platitudinous religious reformers and sought real solutions for poverty and crime. The underlying theme in all her work, however, was her concern for women's rights, particularly her advocacy of economic independence for women, a revolutionary concept at the time.

Born Sarah Payson Willis on 9 July 1811, she was the fifth of nine children of Nathaniel and Hannah Parker Willis. When Sara was an infant (she later dropped the "h" in her name), the family moved from Portland, Maine, to Boston, Massachusetts, where in 1816 her father founded *The Recorder,* the first religious newspaper in the United States, and eleven years later, *The Youth's Companion,* the first juvenile newspaper. Having undergone a religious conversion in 1807, Nathaniel Willis was a deacon of the Park Street Church and a strict Calvinist, who worried that his spirited and rebellious daughter Sara was not sufficiently fearful of God's wrath. Hannah Willis was as warm and cheerful as Deacon Willis was sober and distant. Throughout her life Fern remembered her mother with admiration and warmth. In 1864 she wrote in "A Story about Myself" that any talent she had for writing she had inherited from her mother.

Young Sara attended several boarding schools, her father hoping that one of them would bring her to a religious conversion. Although her brother and sisters experienced conversions when they were in their teens, Sara refused to be converted. Years later Fanny Fern criticized the "grim creed" of Calvinism in her newspaper columns, insisting that children should not be "fettered" with "chains of fear." From 1828 to 1831 Sara was a student at Catharine Beecher's Female Seminary in Hartford, where she received as close to a college education as was available for women at the time. Harriet Beecher Stowe, who was a pupil teacher in her sister's school, remembered Sara's "irrepressibility" and described her as "Sister Katy's best-loved pupil, her torment and her joy." Stowe's brother, Henry Ward Beecher, who went on clandestine horseback rides with Sara while she was at his sister's school in Hartford, described her thus: "She was a blonde, had a very fair face and flowing flaxen hair. She was quite a bewitching little creature. One of the prettiest girls in Hartford."

In 1831 Sara came home to Boston, as she later said, to learn the "lost arts" of "bread-making and button-hole stitching" and prepare herself for a domestic career. She also wrote articles and did proofreading for her father's periodicals, work for which she received no remuneration or recognition and which she did to help out her father, with no thought of preparation for a career. On 4 May 1837 she married Charles Eldredge, a cashier at the Merchant's Bank of Boston, who was called "Handsome Charlie" by his friends. They had three daughters, Mary (1838), Grace (1841), and Ellen (1844). The next two years brought the deaths of four people who were very close to her. In 1844 her mother and sister died, and on 17 March 1845 her seven-year-old daughter Mary died. The following year, on 6 October 1846, her husband died of typhoid fever. Charles Eldredge had been involved in a long lawsuit that he had lost on appeal just prior to his death. The result was that when he died he was heavily in debt, and all of his property was sold to pay his creditors.

Sara Eldredge was left without resources and with two children to support. Her father urged her to remarry, and ultimately she took his advice. In January 1849, she married Samuel Farrington, a widower with two children. The marriage proved to be "a terrible mistake," as her daughter Ellen later said. Farrington was violently jealous, abusive, and apparently also sexually repulsive to Sara. She left him in January 1851, and Farrington and his brother retaliated by spreading malicious stories about her, claiming that she was sexually promiscuous. His brother later retracted his statements, admitting that they were false. Her family, however, was scandalized that she had left her husband, and her father refused to help financially, hoping to force her to return to Farrington. Her father-in-law changed his will, disinheriting her two daughters unless she agreed to give him and his wife sole custody of the girls.

Determined to keep her children and equally determined not to return to Farrington, Sara needed

Parton's parents, Nathaniel and Hannah Parker Willis (left: Houghton Library, Harvard University; right: portrait by Chester Harding, Collection of Mr. And Mrs. Edward William Carter)

to earn money of her own. She worked as a seamstress, but only earned 50¢ a week; she took the Boston teacher's exam, but, lacking influence, she did not get an appointment. Then she tried writing articles for the newspapers. She sent some of her articles to her brother Nathaniel Parker (N. P.) Willis, poet and editor of *The New York Home Journal,* but he refused to help her. He criticized her articles for what he called their "vulgarity" and "indecency" and advised her to write for the religious papers—which, as he well knew, would not pay her much. That he would not help her was surprising since he had helped other women writers at the beginning of their careers. His own tastes, however, were more genteel than his sister's (he regarded her frank prose as vulgar), and, as a social climber, he probably did not want to be associated with a sister who had left her husband. Perhaps also he was jealous of his sister's writing (critics later compared his work unfavorably with hers).

After her brother's dismissive response, Sara was even more determined to succeed on her own. Taking her little daughter Ellen by the hand, she tramped the streets of Boston attempting to sell her articles under various pseudonyms. Finally the Bos-

ton *Olive Branch* bought "The Model Husband" for 50¢ and published it on 28 June 1851. The next day it was reprinted in a major paper, and, although Sara received no additional money, the fact that a prominent paper had reprinted the article was encouraging to her. The *Olive Branch,* and soon the *True Flag,* bought all the articles she could write, and the circulation of the two papers soared. Three months after she began publishing her articles, she decided on the pen name Fanny Fern. Her identity was a well-kept secret, and readers began asking "Who is Fanny Fern?" A popular theory was that she was a man, one editor declaring that no woman could write with such "power" and "courage."

When Fern adopted the name Fanny Fern, she did so partly as a spoof, signing her bold satires with the kind of alliterative, flowery name used by genteel lady writers. But her pseudonym was also an assertion of independence. She said she took the name "Fern" because her mother loved the sweet fern of New England, a hardy, self-reliant shrub that grows in sandy soil and windswept locations where more delicate plants cannot survive. Fanny Fern adopted the name as a pseudonym, but gradually it became her name in both her public and her private life. In a

Sara Payson Willis as a young woman (portrait by E. D. Marchant; from Joyce W. Warren, Fanny Fern: An Independent Woman, *1992)*

sense she renamed herself, exchanging the male patronym—her father's or her husbands' names—for the matrilineal Fern.

Within a year after she began to write, the name Fanny Fern was ubiquitous. In the summer of 1852 the editor of the New York *Musical World and Times,* Oliver Dyer, contacted Fern through the *Olive Branch* and offered to pay her double her combined earnings from the two Boston papers if she would write for his paper. Then in early 1853 she received a letter from James Derby of the publishing firm of Derby and Miller offering to publish a collection of her newspaper articles. *Fern Leaves from Fanny's Port-Folio* was published in June 1853 and was an immediate best-seller. In 1853 it sold 70,000 copies in the United States and 29,000 in England.

Meanwhile, Samuel Farrington had obtained a divorce in Chicago on grounds of desertion. Fern's publisher's lawyer went to Chicago to investigate the divorce and wrote to her that the divorce was final and that Farrington had no claim to her "person or property"—which was fortunate for her because at

that time a married woman's earnings were legally the property of her husband, and if he had not obtained a divorce, Farrington would have had the right to all of her considerable earnings as Fanny Fern.

In early June, Fern moved from Boston to New York. She was glad to see her younger brother, Richard Storrs Willis, a musician and later the composer of the music for the Christmas carol "It Came Upon a Midnight Clear." She had not applied to him for assistance when her first husband died since he would have been in no position to help her. He had been studying music in Germany when Charles Eldredge died, and when he returned, he was struggling to support himself as a musician. Fern refused to speak to her older brother, N. P. Willis, the well-to-do New York poet and editor who had refused to help her when she was living in poverty, and they remained estranged for years. For the remainder of 1853 she wrote a weekly column for Dyer's *Musical World and Times,* where Richard Willis wrote a music column. Then, between January and April 1854 she wrote regularly for *The Saturday Evening Post.*

In February 1854 Fern signed a contract with Mason Brothers to write a novel. The publishers did not require that Fern submit a prospectus or even indicate what the novel would be about, yet they offered to use "extraordinary exertions" to promote the book "to make it exceed the sale of any previous work." In effect, Mason Brothers was promising to make the book a best-seller, even before it had been written, solely on the basis of Fanny Fern's name—an indication of how popular she had become in just two and a half years. Fern's novel, *Ruth Hall,* published in December 1854, is autobiographical, although she shaped the material, changing significant aspects of her life. For example, she left out her siblings except for N. P. Willis; she changed her brother-in-law to a cousin; she did not discuss her first husband's financial dealings; and she omitted entirely the story of her second marriage. Otherwise, the novel follows the outlines of her life. When Ruth Hall's beloved husband, Harry, dies, she is left penniless with two children; her relatives refuse to help her; she works as a seamstress and tries to get a teaching position in Boston; she begins writing for the newspapers under a pseudonym; her articles are very popular, and a publishing company publishes a collection of her articles. At the end of the novel she has become independently wealthy and is about to leave for New York.

Ruth Hall satirizes Fern's father and brother, her in-laws, and the editors who had exploited her. One of the editors, William Moulton of the *True Flag,*

incensed at her unflattering portrait of him as Mr. Tibbetts of *The Pilgrim,* revealed her identity, and the novel became recognized as a roman à clef. Sales climbed to seventy thousand copies, with readers particularly eager to see the author's portrait of her famous brother, Nathaniel Parker Willis, in Ruth's foppish brother, Hyacinth Ellet. The novel was translated into French and German; stores advertised the "Ruth Hall bonnet, in elegant black gauze"; the composer Louis Jullien wrote "The Ruth Hall Schottische"; and a popular song, "Little Daisy," was based on the death of Ruth Hall's daughter. Although many critics praised *Ruth Hall* for its "powerful satire," "originality," "insight into character," and "unaffected style," others—including those who praised other aspects of the novel—castigated Fern for her "unfeminine" writing and her "unfilial" portrayal of her male relatives. The novel was called "monstrous," "abominable," "evil," "overflowing with an unfemininely bitter wrath and spite." The review for the *True Flag* (13 January 1855) summed up this criticism with the exclamation, "O, Goneril! O, Regan!" It is clear that much of the criticism derived from the fact that Fanny Fern was a woman. The reviewer for *The New York Times* on 20 December 1854 declared that if Fern had been a man, the revenge that she sought in satirizing her relatives would have been excusable, but in a woman it was reprehensible: "We cannot understand how a delicate, suffering woman can hunt down even her persecutors so remorselessly. We cannot think so highly of [such] an author's womanly gentleness." A vituperative pseudobiography appeared anonymously in March 1855, *The Life and Beauties of Fanny Fern.* Apparently written by William Moulton, the editor who was angered by Fern's portrayal of him in *Ruth Hall,* the book was a vindictive attempt to injure Fern's reputation and was filled with innuendoes and false statements designed to raise questions about her morals and her integrity.

In a mock review of one of her own books in 1857, Fern satirized the stereotypical male criticism of her work:

> We have never seen Fanny Fern, nor do we desire to do so. We imagine her, from her writings, to be a muscular, black-browed, grenadier-looking female, who would be more at home in a boxing gallery than in a parlor—a vociferous, demonstrative, strong-minded horror,—a woman only by virtue of her dress. . . . Thank heaven! there are still women who *are* women—who know the place Heaven assigned them, and keep it.

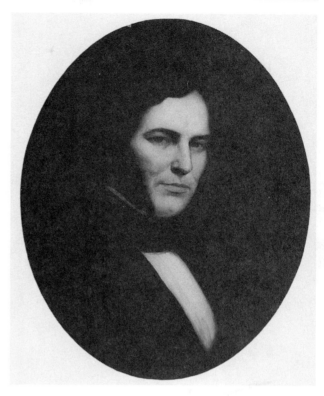

Charles Harrington Eldredge, who married Sara Willis in 1837 (portrait by Albert Gallatin Hoit; Collection of James Parton II)

It was Fern's refusal to be bound by the restrictions of conventional femininity that drew criticism; yet, it is this very defiance of convention that gives *Ruth Hall* its power. A British review of *Fern Leaves* praised Fern's work because she was "totally without that affectation of extreme propriety which is popularly attributed to the ladies of the New World" (*The Living Age,* 19 November 1853). Nathaniel Hawthorne, also writing from abroad, wrote to his publisher in February 1855 that after reading *Ruth Hall* he wanted to qualify his earlier criticism of the "damned mob of scribbling women":

> In my last, I recollect, I bestowed some vituperation on female authors. I have since been reading "Ruth Hall"; and I must say I enjoyed it a good deal. The woman writes as if the devil was in her; and that is the only condition under which a woman ever writes anything worth reading. Generally women write like emasculated men, and are only distinguished from male authors by greater feebleness and folly; but when they throw off the restraints of decency, and come before the public stark naked, as it were—then their books are sure to possess character and value. Can you tell me anything about this Fanny Fern? If

RUTH HALL:

A

DOMESTIC TALE

OF

THE PRESENT TIME

BY

FANNY FERN.

NEW YORK:
PUBLISHED BY MASON BROTHERS
1855.

Title page for autobiographical novel in which Fern based the foppish Hyacinth Ellet on her brother Nahaniel Parker Willis and the honest Horace Gates on James Parton, who became her third husband in 1856

you meet her, I wish you would let her know how much I admire her.

Not only did Fern refuse to conform to the restrictions of conventional femininity in her novel, but thematically *Ruth Hall* was a revolutionary book. The threat posed by the novel was its insistence that women should be economically independent. Nineteenth-century society stressed American individualism and self-reliance, but all of the societal assumptions and the literature—the rags-to-riches novels and the preaching of the pundits—were directed at white male Americans. The career of Ruth Hall or of Fanny Fern herself provided a rare role model for nineteenth-century women: the example of a woman who had achieved financial independence solely on her own. The novel ends, not with the traditional wedding but with Ruth Hall about to

go off to conquer new worlds, and the last pages of the novel reproduce, not a handsome male face or a wedding dress, but a certificate of bank stock.

Fern was impatient with her society's economic double standard that praised men for self-reliance but required that women be passive and dependent. It was considered indelicate or vulgar for "respectable" women to be concerned about money. Fern wrote in 1861:

> There are few people who speak approbatively of a woman who has a smart business talent or capability. No matter how isolated or destitute her condition, the majority would consider it more "feminine" would she unobtrusively gather up her thimble, and, retiring into some out-of-the-way place, gradually scoop out her coffin with it, than to develop that smart turn for business which would lift her at once out of her troubles; and which, in a man so situated, would be applauded as exceedingly praiseworthy.

Fern's main argument in favor of economic independence for women derived from her own experience in being coerced into marriage as a means of support. Marriage, she insisted, should not be seen as a way of "getting a living." No way of getting a living, she said, was harder. She wrote in 1869–1870: "Why shouldn't women work *for pay*? Does anybody object when women *marry for pay*?—without love, without respect, nay with even aversion? . . . How much more to be honored is she who, hewing out her own path, through prejudice and narrowness and even insult, earns honorably and honestly her own independence. . . . I want all women to render themselves independent of marriage as a mere means of support. . . . Sweet is the bread of independence." The independent woman would not need to be driven to marry someone she did not love and respect, Fern said, urging that all avenues of employment be opened to women as they were to men and that women receive equal pay for equal work. Her descent into poverty had showed her the hypocrisy behind the facade of society's claims of male protection of women. In effect, Fanny Fern was radicalized by her widowhood and the ensuing circumstances. As long as she was dependent upon her male relatives, she realized, she was powerless to determine her own fate or the fate of her children.

After the publication of *Ruth Hall,* Fanny Fern was what one might call a "hot commodity." In early 1855 Robert Bonner, the enterprising editor of *The New York Ledger,* was determined to persuade Fern to write for his paper. He offered her $25 a column. When she refused, he raised his price until she accepted the unprecedented offer of $100 a column

and agreed to write a serialized story for the *Ledger*. Before Fern's story, *Fanny Ford,* appeared, Bonner announced his coup, printing weekly announcements and ultimately confirming the unprecedented price that he was paying for the tale.

Fanny Ford, which appeared during the summer of 1855, tells a story that begins with Jacob Ford, the owner of a sweatshop that exploited poor seamstresses. His wife, Lucy, who had been one of the seamstresses, comes to feel that their money is ill-gotten. She fears "retribution," and the apparent retribution comes when their daughter Mary's fiancé, Percy Lee, is imprisoned for embezzlement. The shock throws Mary into a stupor-like depression, and Jacob dies. Tom Shaw, a rival of Percy's, marries Mary in order to spite Percy, but soon tires of her. Mary dies in childbirth, leaving an infant daughter, Fanny. Lucy cares for little Fanny, working as a seamstress, until she dies. Percy Lee, released from prison, takes over the care of Fanny, educating and ultimately marrying her.

The story, which spans eighteen years in less than one hundred pages, uses the same abbreviated style and sudden scene shifts that Fern had developed in *Ruth Hall*. The tone throughout is world-weary, often cynical, undercutting the conventional language and stereotyped situations of the sentimental story. An understanding of this technique helps to explain why some of the characters seem to be turned inside out. The "heroine," Mary Ford, is beautiful and good, but she turns into a zombie—the passive heroine carried to a grotesque extreme. The "hero," Percy Lee, is handsome and kind, but he is a crook. Jacob Ford is a loving father, but he is a cruel exploiter—even murderer—of poor seamstresses. Fern's portrayal of these characters suggests that such duality is not uncommon in life; that in romanticized stories, perhaps, it is simply hidden from us. An important aspect of *Fanny Ford* is its social criticism. Fern portrays the plight of underpaid seamstresses, the need for prison reform, the need for improved child-rearing and educational methods, the social causes of prostitution, the disparity between the haves and the have-nots, the wastefulness of the fashion-conscious, and the injustices in the marriage relationship.

After the success of *Fanny Ford,* Bonner signed Fern to an exclusive contract, and within a year after Fern began writing for the *Ledger,* the paper's circulation rose to more than 100,000. Encouraged by his success with Fern, Bonner acquired other celebrity writers, and by the fall of 1856 the circulation of the *Ledger* had reached 180,000, the highest circulation

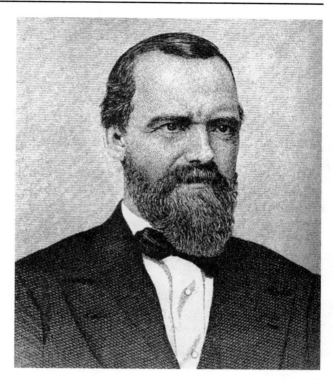

Robert Bonner, editor of The New York Ledger, *who hired Fanny Fern as a columnist in 1855 at the unprecedented salary of $100 per column*

ever reached by any American paper to the time, and continued to climb to a peak of 400,000.

Fern's first regular article appeared in the *Ledger* on 5 January 1856. That was also the date of Fern's wedding to her third husband, James Parton, who later became the well-known biographer of such figures as Horace Greeley and Andrew Jackson. Parton had been the editor of N. P. Willis's *Home Journal* at the beginning of Fern's career. Unaware that Fanny Fern was his boss's estranged sister, Parton, like editors all over the country, had been reprinting Fern's articles. Willis was out of town at the time, but when he returned and discovered what Parton had been doing, he forbade him to reprint any more articles by Fanny Fern. Parton refused to comply, and when Willis insisted, Parton resigned. Parton believed that Fern's articles were brilliant and had praised her originality in a review of her first book in the *Home Journal* on 4 June 1853, declaring, "Fanny Fern is a voice, not an echo." Parton, who was eleven years younger than Fern, had asked Oliver Dyer to introduce him to her when she came to New York in 1853, and he became her steady escort. Fern used him as the prototype of the honest Horace Gates in *Ruth Hall*. Before they were married, however, Parton signed a prenuptial agreement stating that any

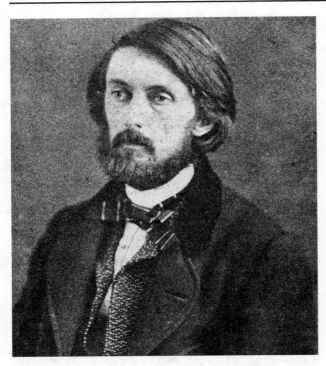

James Parton at about the time of his marriage to Fanny Fern

money Fern earned before or after their marriage would be hers.

Fern's second novel, *Rose Clark* (1856) includes the story of her second marriage, left out of *Ruth Hall*. After the criticism she received for her creation of an independent heroine in *Ruth Hall,* Fern in this novel created two heroines: the gentle Rose is balanced against the strong-minded Gertrude. Rose is introduced as a child in the orphanage, where she is victimized by Mrs. Markham. When Rose moves to her Aunt Dolly's home, she is no better off, for Dolly is cruel and selfish. After Rose has a child, she and her young son are abandoned by the man who is apparently her husband, though they may in fact not be married. Rose refuses to believe ill of him, however, and travels to New Orleans to find him. In New Orleans she meets Gertrude, whose story parallels the facts of Fern's marriage to Farrington: Gertrude's first husband had died and she had married John Stahle, who proved to be abusive. She separated from him and was driven to support herself and her son. Whereas Fern and Ruth Hall earned their independence through writing, Gertrude is a successful artist.

The novel, which takes place over a period of sixteen years, is structured like a five-act play. Each act ends with a death, except act 3, which ends with the sisterly embrace of Rose and Gertrude *and* the

"Satanic laugh" of Anne Cooper, the only principal evil character in the book who is not punished at the end of the novel. That Fern ends the central act with Cooper's vindictive speech undercuts the idealistic implications of the two protagonists' embrace and undermines the faith in a beneficent universe that is suggested by the ending of the novel. In *Rose Clark* Fern constructed a novel with an apparently symmetrical design and an ostensibly happy ending. Built into this ordered structure, however, is a disconnectedness that implicitly questions the order and provides an important indication that the religious ending represents an ideal, not a realistic conclusion to the experiences related in the book.

Rose Clark was a best-seller, although it did not sell as well as the sensational *Ruth Hall.* Critics who had heaped criticism on Fern for her portrayal of the independent Ruth Hall and for the bitter tone of the former book, praised Fern's portrayal of the sweet and gentle Rose Clark and liked what they believed to be the more charitable tone of the novel. *The New York Tribune,* for example, called Rose Clark "the most attractive character" Fern had created (6 December 1855), and the *New York Mirror* in November 1855 praised the "general tone and sentiment of the book." Although some reviewers responded positively to Fern's portrayal of Rose and took the novel at face value as a work with a noble purpose, other reviewers focused on the less-gentle aspects of the novel. In a scathing review, *The New York Times,* for example, criticized all of the aspects of the novel that the modern reader finds most appealing: the satirical portrayals of Mrs. Markham and Aunt Dolly, the frank portrayal of the independent Gertrude, and Fern's use of down-to-earth language. Pronouncing the novel a "failure," the reviewer expressed disgust with a woman writer who would portray ordinary people as despicable and who would use words that are not "delicate." The most revealing aspect of the review is its denunciation of Fern's portrayal of Gertrude, who confides to Rose the horror of being used sexually by a husband who degraded her and for whom she felt neither love nor respect.

Rose Clark was Fern's last novel. In the United States in the 1850s the boundaries for women novelists were too tightly drawn to suit her. During the remainder of her career, Fern was outspoken and satirical—but only in the essay where the boundaries were her own.

In 1861 Fern's daughter Grace married Mortimer Thomson, a newspaper writer who was known by his pseudonym, Q. K. Philander Doesticks, P. B. In 1861 and 1862 Grace wrote a column for *The New York Ledger* under the pen name Mrs. George Wash-

ington Wyllys. The style and subject matter of her columns were similar to those of her mother. On 1 December 1862 Grace gave birth to a daughter, Grace Ethel. Three weeks later Grace died. After Grace's death, the infant "Effie" was brought up by her grandmother and James Parton. Fern was devastated by the death of her daughter, but young Effie brought joy to her and Parton.

Fanny Fern wrote a regular column for the *Ledger* for sixteen years. Although her columns sparkled with a sharp humor, she was motivated to write because of her social concerns. In a column printed in the *Ledger* on 2 February 1867 she described her motivation:

> What if you are so constituted that injustice and wrong to others rouses you as if it were done to yourself? What if the miseries of your fellow beings, particularly those you are powerless to relieve, haunt you day and night? . . . Rather than be that torpid thing [a man who "turns a deaf ear" to society's abuses], and it a *man,* I would rather be a woman tied hand and foot, bankrupt in chances, and worry over what I am powerless to help. At least I can stand at my post, like a good soldier, because it *is* my post; meantime—I had rather be taken off that by a chance shot, than rust in a corner with ossification of the heart.

Fern's readers responded warmly to her empathetic writings and her honest cry for justice in society and in the marriage relation. A practical feminist, Fern used her satire to expose male tyranny and social inequities, particularly those that affected women. She urged women to speak up, to use their female voices to critique injustice from their own point of view.

Fanny Fern received widespread recognition during her lifetime. During the early years of her career, she was reviled by conventional critics who were shocked at the "unfeminine" frankness of her satire and the "vulgarity" of her unadorned prose. Her works, however, were enthusiastically received by both men and women, rich and poor, the cultured and the uncultured. She was deluged with unprecedented amounts of fan mail, letters from admirers and from people asking for help and sympathy. She was dogged by the press in the way that celebrities are today.

During the first three quarters of the twentieth-century, however, Fanny Fern seemed to be forgotten. Her books were out of print and she was rarely anthologized. She was seldom mentioned by literary critics, and then only dismissively as one of the sentimental "scribbling women," as, for example, in Fred

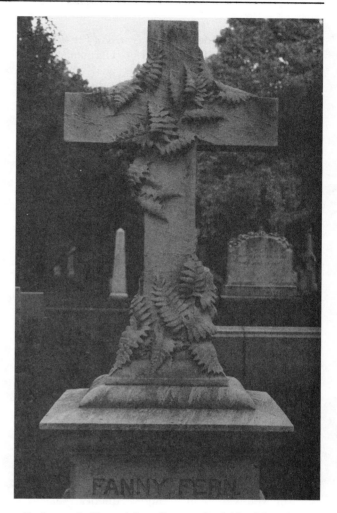

Fern's grave in Mount Auburn Cemetery, Cambridge, Massachusetts

Lewis Pattee's *The Feminine Fifties* (1940). Her work was rediscovered in the last two decades of the twentieth century, and modern readers have found much to admire and relate to in the works of Fanny Fern. Fern's ability to transcend convention makes her writing still valuable today. Her ideas are relevant, and she speaks to modern readers as forcefully as she did to nineteenth-century readers. In addition, she writes in a pungent, unforgettable idiom that renders her work powerful and unique.

Fern's last article appeared on 12 October 1872, two days after her death from breast cancer. She was buried in Mount Auburn Cemetery in Cambridge, Massachusetts, next to her first husband and her daughters Mary and Grace. Her tombstone is in the form of a giant marble cross, decorated with fern leaves. It bears the simple inscription, FANNY FERN. Her contemporaries believed she needed no other identification.

Biographies:

Florence Bannard Adams, *Fanny Fern, or a Pair of Flaming Shoes* (West Trenton, N.J.: Hermitage Press, 1966);

Joyce W. Warren, *Fanny Fern: An Independent Woman* (New Brunswick, N.J.: Rutgers University Press, 1992).

References:

Anonymous, *The Life and Beauties of Fanny Fern* (New York: H. Long & Brother, 1855);

Nina Baym, *Woman's Fiction: A Guide to the Novels by and about Women in America, 1820–1870* (Ithaca, N.Y.: Cornell University Press, 1978), pp. 251–252;

Lauren Berlant, "The Female Woman: Fanny Fern and the Form of Sentiment," *American Literary History,* 3 (Fall 1991): 429–454; republished in *The Culture of Sentiment: Race, Gender, and Sentimentality in Nineteenth-Century America,* edited by Shirley Samuels (New York: Oxford University Press, 1992), pp. 265–281;

James C. Derby, *Fifty Years among Authors, Books and Publishers* (New York: Carleton, 1884), pp. 208–220;

Robert P. Eckert Jr., "Friendly, Fragrant Fanny Ferns," *Colophon,* 18 (September 1934);

Milton E. Flower, *James Parton: The Father of Modern Biography* (Durham, N.C.: Duke University Press, 1951);

Linda Grasso, "Anger in the House: Fanny Fern's *Ruth Hall* and the Redrawing of Emotional Boundaries in Mid-Nineteenth-Century America," *Studies in the American Renaissance* (1995): 251–261;

Grace Greenwood (Sara Lippincott), "Fanny Fern–Mrs. Parton," in *Eminent Women of the Age,* edited by James Parton (Hartford: S. M. Betts, 1868), pp. 66–84;

Philip F. Gura, "Poe, Hawthorne, and One of Those 'Scribbling Women,'" *Gettysburg Review,* 6 (Winter 1993): 38–45;

Kristie Hamilton, "The Politics of Survival: Sara Parton's *Ruth Hall* and the Literature of Labor," in *Redefining the Political Novel: American Women Writers, 1797–1901,* edited by Sharon M. Harris (Knoxville: University of Tennessee Press, 1995), pp. 86–108;

Susan K. Harris, "Inscribing and Defining: The Many Voices of Fanny Fern's *Ruth Hall,*" *Style,* 22 (Winter 1988): 612–627; republished in her *19th-Century American Women Writers: Interpretive Strategies,* (New York: Oxford University Press, 1990), pp. 111–127;

Linda Huf, "*Ruth Hall* (1855): The Devil and Fanny Fern," in her *A Portrait of the Artist as a Young Woman: The Writer as Heroine in American Literature,* (New York: Ungar, 1983), pp. 16–35;

Mary Kelley, *Private Woman, Public Stage: Literary Domesticity in Nineteenth-Century America* (New York: Oxford University Press, 1984);

Anne Scott MacLeod, "Fanny Fern and the Culture of Poverty," in *Cross-Culturalism in Children's Literature: Selected Papers from the Children's Literature Association* (New York: Pace University, 1988), pp. 57–60;

Patricia McGinnis, "Fanny Fern, American Novelist," *Biblion,* 2 (1969): 2–37;

Helen Papashvily, *All the Happy Endings: A Study of the Domestic Novel in America; the Women Who Wrote It, the Women Who Read It, in the Nineteenth Century* (New York: Harper, 1956), pp. 123–125;

Ethel Parton, "Fanny Fern at the Hartford Female Seminary," *New England Magazine,* 24 (March 1901): 94–98;

Parton, "A Little Girl and Two Authors," *Horn Book Magazine,* 17 (March–April 1941): 81–86;

Parton, "A New York Childhood: The Seventies in Stuyvesant Square," *New Yorker* (13 June 1936): 32–39;

James Parton, *Fanny Fern: A Memorial Volume* (New York: Carleton, 1873);

Ishbel Ross, *Ladies of the Press* (New York: Harper, 1936);

Elizabeth Bancroft Schlesinger, "Fanny Fern: Our Grandmother's Mentor," *New York Historical Society Quarterly,* 38 (October 1954): 501–519;

Schlesinger, "Proper Bostonians as Seen by Fanny Fern," *New England Quarterly,* 27 (March 1954): 97–102;

Nicole Tonkovich, *Domesticity with a Difference: The Nonfiction of Catharine Beecher, Sarah J. Hale, Fanny Fern, and Margaret Fuller* (Jackson: University Press of Mississippi, 1997);

Nancy Walker, *Fanny Fern* (New York: Twayne, 1993);

Joyce W. Warren, "Domesticity and the Economics of Independence: Resistance and Revolution in the Work of Fanny Fern," in *The (Other) American Traditions: Nineteenth-Century Women Writers,* edited by Warren (New Brunswick, N.J.: Rutgers University Press, 1993), pp. 73–91;

Warren, "Fanny Fern, Performative Incivilities, and Rap," *Studies in American Humor,* 3 (1999): 17–36;

Warren, "Fanny Fern's *Rose Clark,*" *Legacy,* 8 (Fall 1991): 92–103;

Warren, "Fracturing Gender: Woman's Economic Independence," *Nineteenth-Century American Women Writers: A Critical Reader,* edited by Karen Kilcup (Cambridge, Mass.: Blackwell, 1996);

Warren, "The Gender of American Individualism," in *Politics, Gender, and the Arts,* edited by Ronald Dot-

terer and Susan Bowers (Selinsgrove, Pa.: Susquehanna University Press, 1991), pp. 150–157;

Warren, "A Profile of Fanny Fern," *Legacy,* 2 (Fall 1985): 54–60;

Warren, "Subversion versus Celebration: The Aborted Friendship of Fanny Fern and Walt Whitman," in *Patrons and Protégées,* edited by Shirley Marchalonis (New Brunswick, N.J.: Rutgers University Press, 1988), pp. 59–93;

Warren, "Text and Context in Fanny Fern's *Ruth Hall:* From Widowhood to Independence," in *Joinings and Disjoinings: The Significance of Marital Status in America,* edited by JoAnna S. Mink and Janet D. Ward (Bowling Green, Ohio: Popular Press, 1991), pp. 61–76;

Warren, "Uncommon Discourse: Fanny Fern and the New York Ledger," in *Social Texts: Nineteenth-Century American Literature in Periodical Contexts,* edited by Susan Belasco Smith and Kenneth Price (Charlottesville: University of Virginia Press, 1995), pp. 51–68;

Ann Douglas [Wood], "The 'Scribbling Women' and Fanny Fern: Why Women Wrote," *American Quarterly,* 23 (September 1971): 3–24;

Ning Yu, "Fanny Fern and Sui Sin Far: The Beginning of an Asian American Voice," *Women and Language,* 19 (Fall 1996): 44–47.

Papers:

Fanny Fern's papers are in the Sophia Smith Collection at Smith College. They include personal letters, business papers, and an informal manuscript biography by her granddaughter, Ethel Parton. Other letters and documents relating to Fern are in various collections throughout the United States. Of particular note is the James Parton Collection at the Houghton Library, Harvard University.

Ann Plato

(1824? – ?)

Katharine Capshaw Smith
Florida International University

BOOK: *Essays; Including Biographies and Miscellaneous Pieces, in Prose and Poetry* (Hartford: Printed for the author, 1841).

Edition: *Essays; Including Biographies and Miscellaneous Pieces, in Prose and Poetry,* edited by Kenny J. Williams (New York: Oxford University Press, 1988).

"My authoress is a colored lady, a member of my church, of pleasing piety and modest worth," wrote James W. C. Pennington, one of the most celebrated African American ministers and abolitionists in Hartford, Connecticut. That statement in his preface to Ann Plato's *Essays; Including Biographies and Miscellaneous Pieces, in Prose and Poetry* (1841) provides nearly all the available biographical information about her. Ann Plato was the first African American to publish a collection of essays, and the twenty works in her only book, on topics such as "Religion," "Education," "Diligence and Negligence," and "Obedience," offer little specific biographical information. As Kenny J. Williams attests in her introduction to the modern edition of Plato's volume, "[I]n the absence of contemporaneous documents, attempting to reconstruct a life is as difficult as trying to find the proverbial needle in a haystack."

Ann Plato likely belonged to what Barbara Jean Beeching calls "the heart of Hartford's black elite," a community of free blacks whose autonomy and education enabled them to prosper socially and economically. Although Williams asserts that "several Plato families lived in the Hartford area for a number of years," in fact only one nuclear family of Platos appears in early-nineteenth-century census and city records. The family was headed by Henry Plato (1801–1859), alternately referred to in city records as a "farmer" or "gardener," who was born in New York State, possibly in East Hampton on Long Island. Henry moved to Hartford and owned land within the city limits as early as 1828. He married Deborah Freeman (1802–1888), a native of Montville, Connecticut, on 6 May 1824. When Henry died of "Congestion [of the] Brain" in 1859, he left some $4,000 in real estate, an impressive estate for an antebellum African American.

Ann Plato may well have been the eldest daughter of Henry and Deborah. If so, she would have been about sixteen or seventeen years old when her book was published. In the poem "Lines, Written Upon Being Examined in School Studies for the Preparation of a Teacher," she wrote, "Now fifteen years their destined course have run, / In fast succession round the central sun" (an allusion, as Williams points out, to a similar passage in Phillis Wheatley's poem "On Recollection"). In the census of 1830, when Ann would have been five or six, Henry is reported as having two daughters and one son, all under the age of ten.

There are also suggestions within *Essays* that Henry Plato is Ann's father. Throughout the book Plato refers to her father's gardens and land; in "Lessons Drawn from Nature," an essay, Plato describes the "vines which clime my father's bowers"; similarly, in "The Residence of My Father" she describes her pleasant home, its "Delightful garden," exclaiming "Heaven bless you, O ye *groves,* / Of which my father knows." Recognizing Plato's religious convictions as a Congregationalist, the "father's garden" could, of course, refer to the Garden of Eden, or to any other biblical garden. But the repetition of the image, as well as the poem's personal approach, both suggest an allusion to Henry Plato, the gardener and farmer. Additionally, in the poem "I Have No Brother," Plato mourns the death of her younger brother, in terms which may allude to the Hartford Plato family: "The image of my Henry dear, / A sister has wept below." Not only was the gardener and farmer named Henry, but his wife's father was also named Henry, suggesting that Henry was a Plato family name.

Ann Plato's association with Hartford's black churches and schools anchors her text. In 1841 there were two major African American churches in Hartford. Pennington suggests that Plato belonged to the church he pastored, the African Congregational Church on Talcott Street, established in 1826. In response to widespread racism in Hartford's integrated public schools, black leaders petitioned in 1830 for a segregated facility. Pennington's church housed Hartford's first all-black school,

called the North African School. Plato may have been educated by Pennington or by minister Amos G. Beman at this institution. By 1840, a second facility, the South African School, had opened on the premises of Hartford's other major black church, the Elm Street Zion Methodist Church. Plato assumed the position of head teacher at the South African School at its inception in 1840. In fact, the most compelling evidence of a familial relationship between Ann and Henry Plato surfaces in documents describing the establishment of this second school. Seth Terry, a notary public and man of some prominence in Hartford, kept records of money exchanged between himself and "The African Religious Society and School Districts" for many years. On several occasions Terry distributed money to Henry Plato, who appears to have administered the African School's resources from 1840 until 1842. Katherine Clay Bassard, using the 1830 census and city directories, also concludes that Henry and Deborah were Ann's parents.

Plato addresses her essays and poems to Hartford's African American community. As Pennington states, "our young authoress justly appeals to us, her own people, (though not exclusively), to give her success." The essays and poems address an even more specific component of her community, young women. She explains her motivation for writing her book in the poem "Advice to Young Ladies": "And then I think I will compose / And thus myself engage – / To try to please young ladies [sic] minds, / Which are about my age." Pennington explains, "This book has a claim upon our youth, and especially those of the writers [sic] own sex. She has a large heart full of chaste and pious affection for those of her own age and sex; and this affection is largely interspersed over the pages of her book." In fact, many of her works speak directly to the concerns of the female youth in this increasingly affluent population. In the biographical essay "Louisa Sebury," for example, Plato cautions her audience against affectation: "For empty ceremony and ostentious fashion, she had neither time nor taste."

Plato was a devout Christian and she felt an obligation to profess her faith. Pennington wrote in his introduction: "I know of knothing [sic] more praise-worthy than to see one of such promise come before the public, with the religion of Christ uppermost in her mind." The volume's first essay, "Religion," presents her orthodox belief in the power of Christianity; Plato asserts that "From a supreme love to God, and from a full persuasion of his perfect benevolence and almighty power, springs *confidence*–a trusting in him for protection, for safety, for support, and for final salvation." Faith in God, moreover, animates Plato's narrative voice, providing her with the authority and resolution to speak definitively about theology, education, and social mores.

Elm Street Zion Methodist Church in Hartford, where Ann Plato became head teacher of the South African School in 1840 (The Connecticut Historical Society, Hartford, Connecticut)

While Plato puts her faith in Christ, and encourages her youthful audience to do the same, she also suggests that young people should value obedience in its abstract sense. In the essay "Obedience" Plato explains, "in whatever situation of life a person is placed in, from the cradle to the grave, a spirit of obedience and submission, pliability of temper, and humility of mind, are required from them." While she instructs her young audience to submit to the rules of educators and parents, throughout *Essays* Plato also emphasizes the value of active engagement with the social world. Her essays reflect an eighteenth-century sensibility, which emphasizes practicality and the ability of young people to craft their own identities through hard work and attention to social and religious rules: "The young are not apt to value the importance of time. They forget that time is money!" In fact, throughout *Essays* Plato encourages her audience to take responsibility for making the most of their abilities and opportunities in order to become the most pious and productive citizens possible.

Plato's faith in children's ability to succeed emerges from her optimistic perspective on social relations in nineteenth-century Connecticut, a reflection of her status as a free black in the North, who presumably had little direct experience with slavery. She does, however, reveal her awareness of the country's racial situation in her biographical essay on her affluent black friend Eliza Loomis Sherman. Plato writes that "had she wished for shelter beneath a Georgian clime, that privilege would not have been granted her, on account of the laws." Additionally, in the poem "To The First of August," Plato celebrates

ESSAYS;

INCLUDING

Biographies and Miscellaneous Pieces,

IN

PROSE AND POETRY.

BY ANN PLATO.

HARTFORD.
PRINTED FOR THE AUTHOR.
1841.

Title page for Plato's advice book for young black women, the first book of essays by an African American (The Connecticut Historical Society, Hartford, Connecticut)

the 1838 abolishment of slavery in the British West Indies.

While explicit references to ethnicity, slavery, and prejudice are few, according to Bassard race is "the suppressed discourse" in Plato's work. In fact, Plato asserts her belief in the equality of the races several times through the course of *Essays*. In "Benevolence" Plato instructs her audience to "impress yourselves with a deep sense of the original and natural equality of men." Similarly, in "Lessons from Nature" a character explains that "'Although there are many nations, and many stations in life, yet he watches over us, he has given us immortal souls. Some have white complexions, some are red, like our wandering natives, others have sable or olive complexions.' 'But God hath made of one blood all who dwell upon the face of the earth.'" Plato directs her audience to take action in cultivating themselves, to assume responsibility for the citizens they will become.

Plato's observations about education are particularly interesting, since she became head teacher at a new school the year before her essays were published. In "Education" she asserts that a "society or people are always considered as advancing, when they are found paying proper respect to education. The observer will find them erecting buildings for the establishment of schools, in various sections of their country." Plato trusts in the power of the written word to transform the individual, asserting that "these silent teachers address all ages and all nations" while "Oral instructions can benefit but one age and one set of hearers." Her own learning is impressive; in the essay "Decision of Character" alone, Plato alludes to Christopher Columbus, Pompey, Robert Fulton, Demosthenes, and Robert Bruce.

In essays such as "Diligence and Negligence" and "Two School Girls," Plato asserts her belief in "strength of intellect," which "is acquired by conquering hard studies. . . . knowledge painfully gained [is] not easily lost." She optimistically believes that education and strength of mind enable young people to change their circumstances, even to change their constitution. In "Decision of Character" Plato claims: "The use of decision will raise you to elevated stations—its neglect will sink you to ruin." In "Eminence from Obscurity" Plato articulates her faith that young blacks can use knowledge and discipline to surmount their circumstances. She asserts, "Dear youth of my country, her pride and her hope, catch the spirit of well done Philanthropy. If you cannot surpass the great and the good who have gone before you, study their excellences, walk in their footsteps, and God give you grace to fill their places well, when they are mouldering into dust." Similarly, in "Reflections Upon the Close of Life," Plato addresses the grave of an "aged sire," exclaiming, "Thou wast becoming a stranger amidst a new succession of men. A race who knew thee not, had arisen to fill the earth."

Plato was a teacher, and her book reveals her own sense of agency and power. The poem "Lines, Written Upon Being Examined in School Studies for the Preparation of a Teacher" frames her commitment to teaching as a vital religious mission: "Oh, grant me active days of peace and truth, / Strength to my heart, and wisdom to my youth, / A sphere of usefulness—a soul to fill / That sphere with duty, and perform thy will." In "The Infant Class" Plato describes her satisfaction at the children's "prayerful voices" which "say what I do teach," for only when "adorn'd" with her lessons are the children "full of music each." Plato envisions her role as a teacher critical, for she works, both in *Essays* and in her classroom, to instruct and to inspire black children to become American civic leaders.

In fact, her leadership of the Elm Street South African School was at times both spiritually satisfying and emotionally trying. A brief but telling glimpse of Plato's schoolroom emerges in the notes of Thomas Robbins, a

N.D.

There will be a public Exhibition of the Second colored School in Elm. St. church on wednesday evening. Doors open at half past six, o. clock. Exercises commencing at seven.

In connection with this, there will be an Examination in the vestry of said church, on said day; commencing at half past ten in the morning.

Dr Robins is respectfully invited to attend.

By order of the committee

A. Plato. Teacher.

N.D.

Dr Robins —

Is very respectfully invited to attend the Examination of the South District School, under the colord church in Elm street, tomorrow morning at eleven o'clock.

The Exhibition will occur in the evening.

Ann Plato. Teacher

Notes in which Plato invited Thomas Robbins to visit her classroom (The Connecticut Historical Society, Hartford, Connecticut)

Congregational minister and member of Hartford's School Society, who visited Plato's school four times during 1844 and 1845. His portrait reveals the arduous conditions under which she labored: books are scarce, the classroom shabby, and attendance often spotty. Yet, Robbins's notes also reveal Plato's determination to educate Hartford's black children, and her frustration with her circumstances.

> March 22.d [1845]. Second Coloured School; Elm Street. Miss Ann Plato. Whole numbers, Males 26; Females 24=50. Average attendance as stated, 40. Present, an unfavorable day, 22 [students]. Quite a deficiency of Books. Much idleness. The teacher takes pains & is pretty well qualified. She has taught some time. Some of them read well. The spelling was passable. A few recited a Geography lesson pretty well. The scholars appeared fond of their school. Prayer by the Teacher.

In later visits Robbins notices that "The room is much in need of improvement" and that "Attendance [is] irregular," but also concedes that the students' "[m]anners [are] good for the circumstances." In one telling entry, Robbins reveals his tendency to minimize his depiction of the school's hardship, while Plato expresses exasperation at being evaluated under such trying conditions.

> July 3.d [1845]. . . . Whole number 45. Average 35. Present, wet day, 31. The absentees mostly girls. Upper classes read and spell; they spell long words, with syllabication. Good order in school. Twelve writing books, some of them look very well. A good examination in the first rudiments of Arithmetic & Geography. The Teacher well qualified, with some want of patience. Religious exercises. They sing like blackbirds. –

Plato had twelve books total, and only a few in satisfactory condition, with which to teach writing to some forty-five students. No wonder she showed "some want of patience" when this distinguished white elder appeared to evaluate her teaching.

Her sense of calling, paired with a faith in God and belief in the necessity of action, enables Plato to resist limitations on women's public roles. Plato, who Bassard calls "unapologetically *ambitious*," claims a place alongside Phillis Wheatley as an official voice of African American people. While she herself alludes to Wheatley's "On Recollection," Pennington's introduction situates Plato as the heir to Wheatley, saying "My authoress has followed the example of Philis Wheatly [*sic*]" and "She, like as Philis Wheatly [*sic*] was, is passionately fond of reading, and delights in searching the Holy Scriptures." In contrast to the common belief that Plato faded into obscurity after publication of her book, Barbara Beeching records that

Plato's influence was felt regionally in the second half of the nineteenth century by women such as African American educator Rebecca Primus, who imitated Plato's poetry. Plato also encourages women to write in "Advice to Young Ladies," when she states that "The greatest word that I can say, – / I think to please, will be, / To try to get your learning young, / And write it back to me." *Essays* itself is a kind of "writing back" to the culture of free blacks in Hartford.

After 1847, the last year Plato taught at Hartford's South African School, no records remain of her life. Certain of her works suggestively linger on the fear of early death, as in biographies of friends who died young, in essays which describe tours of graveyards, and in "Death of the Christian," "Life is Short," and "Reflections Upon the Close of Life." Plato also appears conscious of her literary legacy in poems such as "Author's Farewell" and "Forget Me Not," where she asserts, "While thou art searching stoic page, / Or listening to an ancient sage, / Whose spirit curbs a mournful rage, / Forget me not." Plato may have died young, like the friends her essays describe, or she may have married or moved out of Hartford. Apart from Plato's text, and a few contemporaneous documents, most of the life of this first African American essayist remains a mystery, although her voice endures within the pages of *Essays*.

References:

Katherine Clay Bassard, "Spiritual Interrogations: Conversion, Community, and Authorship in the Writings of Phyllis Wheatley, Ann Plato, Jarena Lee, and Rebecca Cox Jackson," dissertation, Rutgers University, 1992;

Barbara Jean Beeching, "The Primus Papers: An Introduction to Hartford's Nineteenth-Century Black Community," M.A. thesis, Trinity College, 1995;

Bert James Lowenberg and Ruth Bogin, eds., *Black Women in Nineteenth-Century American Life: Their Words, Their Thoughts, Their Feelings* (University Park: Pennsylvania State University Press, 1976);

William H. Robinson Jr., ed., *Early Black American Poets: Selections with Biographical and Critical Introductions* (Dubuque: Wm. C. Brown Company, 1969);

Joan R. Sherman, *Invisible Poets: Afro-Americans of the Nineteenth Century* (Urbana: University of Illinois Press, 1989);

Sherman, ed., *African American Poetry of the Nineteenth Century: An Anthology* (Urbana: University of Illinois Press, 1992);

David O. White, "Hartford's African Schools, 1830–1868," *Connecticut Historical Society Bulletin,* 39, no. 2 (April 1974): 47–53.

Margaret Junkin Preston

(19 May 1820 – 29 March 1897)

Marcy L. Tanter
Tarleton State University

and

S. Diane Wellman
Marshall University

BOOKS: *Silverwood: A Book of Memories,* anonymous (New York: Derby & Jackson, 1856);

Beechenbrook: A Rhyme of the War (Richmond: J. W. Randolph, 1865);

The Young Ruler's Question (Philadelphia: Presbyterian Board of Publication, 1869);

Old Song and New (Philadelphia: Lippincott, 1870);

Cartoons (Boston: Roberts, 1875);

Centennial Poem for Washington and Lee University, Lexington, Virginia, 1775–1885 (New York & London: Putnam, 1885);

A Handful of Monographs: Continental and English (New York: A. D. F. Randolph, 1886);

For Love's Sake; Poems of Faith and Comfort (New York: A. D. F. Randolph, 1886);

Colonial Ballads, Sonnets, and Other Verse (Boston & New York: Houghton, Mifflin, 1887);

Chimes for Church-Children (Philadelphia: Presbyterian Board of Publication and Sabbath-School Work, 1889);

Semi-Centennial Ode for the Virginia Military Academy, 1839–1889 (New York & London: Putnam, 1889);

Aunt Dorothy: An Old Virginia Plantation Story (New York: A. D. F. Randolph, 1890).

OTHER: "President George Junkin D.D., 1848–1861," in "The Presidency of Washington College," edited by Henry A. White, *Proceedings of the Scotch-Irish Congress 1895* (Nashville, 1895).

SELECTED PERIODICAL PUBLICATIONS–
UNCOLLECTED: "Magazine Literature," *Christian Parlor Magazine,* 9 (1852): 27–30;

"The Literary Profession in the South," *Library Magazine of American and Foreign Thought,* 8 (1881): 60–74;

"Paul Hamilton Hayne," *Southern Bivouac,* 2 (September 1886): 222–229;

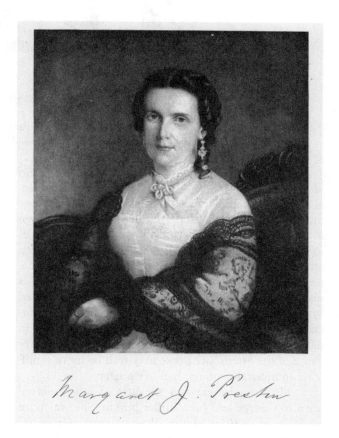

Margaret J. Preston

"Personal Reminiscences of Stonewall Jackson," *Century,* 32 (October 1886): 927–936;

"The General's Colored Sunday School," *Sunday School Times,* 29 (3 December 1887): 771–772;

"General Lee After the War," *Century,* 38 (June 1889): 271–276;

"Giving Children Right Impressions of Death," *Sunday School Times,* 33 (7 November 1891): 707–708.

A mid-nineteenth-century photograph of the president's house at Washington College, where Margaret Junkin lived from 1848 until her marriage to John Preston in 1857 (Michael Miley Collection, The University Library, Washington and Lee University)

Known as the "Poetess of the South" during and after the Civil War, Margaret Junkin Preston influenced a generation of Southerners with her writings on life in the Confederacy. Although primarily known as a poet, Preston also wrote a novel and other books in prose, as well as reviews, essays, columns, and letters, publishing them widely in journals and newspapers. At a time when literature from the South was discounted or ignored by Northerners, Preston argued for the recognition of Southern letters and the importance of their contribution to American literature. In part because she employed it to champion the literary cause of the South, her prose may well be more significant to modern readers than her poetry.

Margaret Junkin was the first of nine children born to George and Julia Miller Junkin. She was born on 19 May 1820 in Milton, Pennsylvania, where her father was minister of the Associate Reformed Presbyterian Church. Homeschooled by her well-educated parents, Margaret Junkin, known to her family as "Maggie," received a rigorous classical and biblical education. At the age of six she learned the Greek alphabet and Latin grammar, and she soon mastered both well enough to study Greek and Latin works in the original. Maggie Junkin was especially close to her vivacious sister Eleanor, or "Ellie," who was five years younger. Maggie's earliest poems describe afternoons she and Ellie spent exploring nature, while some of her later poetry and prose uses archaic language influenced by her extensive knowledge of the Bible.

After two years in Germantown, Pennsylvania (1830–1831), where he was principal of the Manual School, George Junkin moved the family to Easton, Pennsylvania, where he became president of Lafayette College. Margaret Junkin flourished in this new intellectual atmosphere, and over the next sixteen years she wrote hundreds of poems and became skilled at painting and sketching. Her verses appeared in local and national publications, gaining her a reputation that continued to grow.

After living briefly in Oxford, Ohio, where George Junkin served as president of Miami University (1841–1844), the family returned to Easton, where he once again became president of Lafayette College. There, in 1845 at the age of twenty-five, Margaret Junkin was struck with rheumatic fever, a near-fatal form of rheumatoid arthritis. The illness left her with permanently stiff joints, blinding headaches, and severely weakened eyesight. For the next eight years her doctors ordered extreme restrictions on the use of her eyes, forcing her to abandon much of her reading and writing and all her painting. Ultimately,

this prescription had little benefit. Her headaches and joint pain recurred unexpectedly and randomly for the rest of her life.

In 1848 George Junkin became president of Washington College, now Washington and Lee University, in Lexington, Virginia. The Junkin family relocated to Virginia, where Margaret Junkin lived for the next forty-four years. That same year, her brother Joseph Junkin was diagnosed with a pulmonary condition for which the only known treatment was moving to a warm climate. Having little money, the Junkins made sacrifices to pay for his journey to Florida, where he died within months of arrival.

To help with family finances, Margaret Junkin began writing stories that were serialized in magazines. One such story, "The Step-mother!" centers on a young woman who is courted by a rich, handsome widower. His desire for her is not based on love, but on his need to find a mother for his seven orphaned children. After they marry, the woman gradually, and gracefully, wins the affection of her husband and his children.

Feeling more confident, and grateful for regular paychecks, Junkin began writing in earnest, publishing her work in the prestigious journals such as *Southern Literary Magazine* and the *Eclectic Magazine*. In another early work, the essay "Magazine Literature," published in an 1852 issue of the *Christian Parlor Magazine,* she wrote: "Woman's rights in the department of literature are . . . infringed. When she only has love stories . . . she *ought* to have the discriminating review, the vivid sketch of travel."

Also in 1852, the Junkin family met Thomas Jonathan Jackson, who had moved to Lexington the previous summer to teach military tactics and natural philosophy at Virginia Military Institute (and who later distinguished himself as General "Stonewall" Jackson in the Civil War). He and Ellie Junkin became engaged and were married in 1853. The following year, Margaret's mother died, and Ellie and her baby died during childbirth. Grief-stricken, Margaret Junkin and Thomas Jackson turned to each other for comfort, forging a deep friendship that lasted for the rest of their lives.

Margaret Junkin wrote her only novel, *Silverwood* (1856), to "embalm the characters of dear mother, Ellie, and brother Joe," as well as to find solace for her painful losses. The main characters are the Irving sisters: Zilpha, a self-confident artist, and Edith, a shy author who is forced to write stories to support her family. After a fire destroys their old home place, they move with their widowed mother and younger siblings to a country estate called Silverwood. Then their brother Lawrence becomes ill and goes to the West

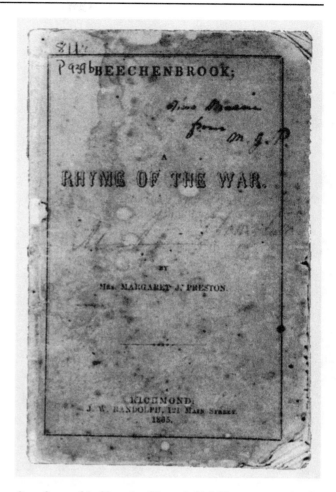

Cover for one of the fifty copies of Preston's Civil War poem to survive the burning of Richmond in April 1865 (Special Collections, The University Library, Washington and Lee University)

Indies in an unsuccessful attempt to restore his health. While chronicling a series of courtships involving Zilpha and Edith, the novel also portrays women taking part in domestic duties with little complaint; the older women are resigned to their fates, while the younger ones are seeking husbands. In many ways a typical "woman's novel," with conventional settings and topics of conversation, *Silverwood* includes an entire chapter, "Breakfast Table Talk," in which women discuss the women's rights movement, about which the narrator reaches no conclusions.

Despite a positive review in the *Southern Literary Messenger* (January 1857), whose reviewer called the novel a "charming series of sketches, pleasant and mournful to the soul," the 405-page *Silverwood* was neither financially nor critically successful. Junkin insisted that the novel be published anonymously, even after her publishers, Derby & Jackson, offered her an additional $200 to put her name on the title

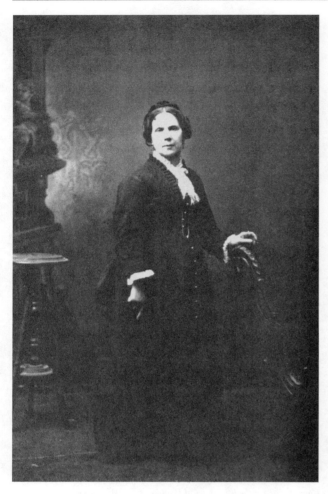

Margaret Junkin Preston after the Civil War

page. As Mary Price Coulling surmises, "Either she had temporarily yielded to Lexington's conservative views concerning women writers, or, more likely, she felt that her novel was so autobiographical that it required anonymity."

In January 1856, after the completion of *Silverwood,* Margaret Junkin's close friend Sally Preston died in childbirth. Her husband, Major John Preston, was a successful lawyer who had founded Virginia Military Institute in 1839. Classically educated and a close friend of Jackson and George Junkin—as well as Edgar Allan Poe—John Preston began courting Margaret. On 3 August 1857 thirty-seven-year-old Margaret Junkin married the rich, handsome Preston, who was nine years her senior and had seven children.

After her marriage, Margaret Preston's life changed dramatically. Within the next three years she gave birth to two sons, and her quiet routine of writing and studying was replaced by the responsibilities of running a home, which included nine children and

several slaves. Although her husband appreciated her literary talent, he was not supportive of her publishing her work. Consequently, for the first five years of their marriage, Margaret Preston put writing aside and dedicated herself to domesticity. According to Coulling, Preston "might never have written again if it had not been for the Civil War."

By the winter of 1860–1861 Preston was faced with conflicting loyalties. Her father sided with President Abraham Lincoln and the Unionists, while Major Preston "held that he owed allegiance first to his sovereign state, Virginia." After the Civil War broke out in April 1861, George Junkin and his daughter Julia went to live in the North, while, according to Elizabeth Preston Allan, Margaret Preston "unhesitatingly accepted her husband's views, and his people became her people." During the war she kept a journal and wrote letters to her husband, who became a colonel and served under General Jackson in the Confederate Army.

Preston's journal and the letters, many of which were published in *The Life and Letters of Margaret Junkin Preston* (1903), chronicle the daily lives of the families left behind while the men were away at war. In her journal Preston wrote about the shortages of dry goods and provisions such as coffee and wheat, as well as the suffering of wives and mothers who heard of battles but received no word of their husbands and sons who fought in them. There are brief, intense reports of war news as she heard it and descriptions of events that touched her at home, such as the arrival of Union troops at Lexington, having to give up their horses to the Union army, and the temporary occupation of their home by Union soldiers. Preston's journal is a significant firsthand account. It is free of romantic notions of war and does not attempt to glamorize any aspect of it. As she wrote on 3 April 1862, "Darkness seems gathering over the Southern land; disaster follows disaster; where is it all to end? My very soul is sick of carnage. I loathe the word—*War.*"

In addition to letters Preston also sent her husband *Beechenbrook: A Rhyme of the War,* a poem about the effects of war on the life of a family. The work so impressed him that he had it printed as a book in 1865. Only fifty copies of the first edition survived the burning of Richmond in April 1865, but when it was republished in Baltimore in 1866, *Beechenbrook* became a best-seller, going through eight printings. It was the only one of Preston's books that made a profit.

Although John Preston had come to approve of his wife's writing for publication, she insisted that her true role should be that of wife and mother and that her writing should be of secondary importance to her domestic duties. As she wrote to W. M. Baskerville on

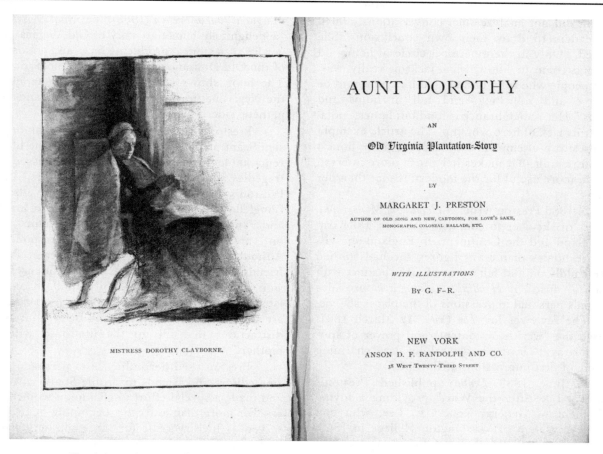

AUNT DOROTHY

AN

Old Virginia Plantation-Story

BY

MARGARET J. PRESTON

AUTHOR OF OLD SONG AND NEW, CARTOONS, FOR LOVE'S SAKE,
MONOGRAPHS, COLONIAL BALLADS, ETC.

WITH ILLUSTRATIONS

BY G. F–R.

NEW YORK

ANSON D. F. RANDOLPH AND CO.

38 WEST TWENTY-THIRD STREET

MISTRESS DOROTHY CLAYBORNE.

Frontispiece and title page for Preston's 1890 book, a dialect story about plantation life before the Civil War

21 March 1889, "I think I can truly say that I never neglected the concocting of a *pudding* for the sake of a *poem* or a *sauce* for a *sonnet!* Art is a jealous mistress— and I have only served her with my left hand, because I have given my right hand to what has seemed more pressing and important." Nonetheless, Preston's diary illustrates that she found little satisfaction in domesticity and was continually frustrated because her literary pursuits were curtailed.

Throughout her prose writings Preston seldom commented on African Americans. The Prestons owned slaves, and she relied on them for help during the war. A short chapter in *Silverwood* is devoted mostly to a monologue in which a slave tells one of his young mistresses that "his people" should be "returned" to Africa. This idea recurs in some of her poetry. On 10 April 1862 Preston recorded in her journal, "One thing surprises me very much in the progress of this war; and I think it is a matter of general surprise—*the entire quietness and subordination of the negroes.*" Coulling points out that despite Preston's

empathy for the slaves' desire for freedom, "she would not listen to abolitionist arguments and believed *Uncle Tom's Cabin* to be a 'one-sided book.'"

After the war Preston wrote a memorable essay on Jackson, who had been killed in the war. Published in the October 1886 issue of *Century*, "Personal Reminiscences of Stonewall Jackson" is a touching memoir that avoids sentimentality and creates a true portrait of the man she knew. Preston could have romanticized Jackson as the great hero, but instead she described his human traits while making plain her utmost respect for him as man and soldier. For example, after describing an event in which Jackson opened fire on a street full of people in Mexico during the Mexican War, Preston wrote,

"And had you no compunctions," I asked, with a woman's feeling of horror at the devastation, "as you thought of this multitude being hurried into eternity through your agency?" "None whatever," was his instantaneous rejoinder. "What business had I with results? *My* duty was to obey orders."

Preston did not analyze such conversations, allowing readers to draw their own conclusions. She claimed, "Only in the innermost circle of home did any one come to know what Jackson really was. With people who fully understood him he would be sportive and rollicking, and full of quips and pranks." Her remembrance is fond but honest, notable for its lack of hero worship. The article exemplifies Preston's attempt in all her prose to be honest yet fair, a trait that makes her prose more interesting and more useful for the modern reader than her poetry.

In 1886 Preston wrote *A Handful of Monographs,* a series of sketches to commemorate her 1884 trip to England and the Continent. In England she visited the homes of literary figures she had studied since childhood and felt "every foot is instinct with immortal dust." *A Handful of Monographs* provides Preston's personal impressions of the places she visited. The reviewer for *The Critic* (12 March 1887) praised the "wealth of contents and power of spirited portrayal" in the book, calling it a "charming volume of first impressions of Europe."

In June 1889 *Century* published Preston's "General Lee After the War," providing a loving assessment of General Robert E. Lee, who had become president of Washington College in 1865. This portrait is gentler than Preston's assessment of Jackson, but it still avoids glorification. In fact, Preston recorded Lee's "unwillingness to be made a hero of anywhere. . . . 'Why should they care to see me,' he would say, when urged to appear on the platform of the train—'I am only a poor old Confederate.' This feeling he carried with him to the latest hour of his life." Perhaps less significant because Preston was not close to Lee and did not know him as well as she had known Jackson, this article demonstrates Preston's loyalty to the South and to the man who fought so hard for it. This devotion is important for understanding the popularity of Preston's poetry among Southern readers. In a 13 December 1887 letter to Preston, Maurice Thompson, an Indiana writer who fought for the Confederacy, called her "the strongest and best of our living Southern poets" and "the best living woman poet in America."

Aunt Dorothy: An Old Virginia Plantation Story (1890) was published toward the end of Preston's life. A humorous dialect story set before the war, it is mostly formulaic and does not seek to clarify her views on slavery. While *Aunt Dorothy* was reviewed by *The Critic* as "ordinary" (31 January 1890), James Harrison of the University of Virginia wrote, in his appreciation of Preston for *The Life and Letters of Margaret Junkin Preston* (1903), that *Aunt Dorothy* was "a delightfully humorous story of Old Virginia plantation life . . . a story reproducing faces and atmosphere of the Old Dominion long years ago 'befo' de wah.' The book shows Mrs. Preston's understanding of the Negro nature both on its humorous and on its pathetic sides."

Preston's letters should be counted among her significant prose works. They chronicle the life of a remarkable woman who achieved success despite tragedies and setbacks throughout her life. Among Preston's correspondents were Henry Wadsworth Longfellow, John Greenleaf Whittier, Jean Ingelow, and Paul Hamilton Hayne. She and Hayne carried on a prolific eighteen-year correspondence. Although they never met, the two became faithful friends, exchanging criticisms and confidences. Preston wrote to Hayne on 11 July 1869, "Congratulate yourself, my dear sir, that you are a *man,* and are thus free from the thousand petty housewifely distractions that fill up the life of a wife and mother!"

Preston used her influence to persuade magazine editors and friends to profile Southern writers and made a special effort to champion women writers. For more than a decade, beginning in 1870, she served as literary critic for three southern papers, reviewing hundreds of books with complimentary copies as her only pay. As she wrote in her diary on 3 December 1870, "Surely my little critiques amount to something! This is better than making puddings, and so much more agreeable." In an undated letter to G. Watson James, she expressed her pleasure at being able "to do anything, however little, toward helping forward the recognition of Southern literature."

Widowed at seventy, Preston soon suffered a stroke, which left her unable to walk without assistance. She died on 29 March 1897 at the age of seventy-seven.

In "The Literary Profession in the South" (1881), Preston envisioned the future of Southern literature:

A bright and attractive future, then, we believe is about to open before those among us who may hereafter give themselves to letters. With the possession of genius, which nature has not made a matter of geography; with the full equipment which a thorough culture demands; with the priceless inheritance of the richest historic associations; with a marvelously picturesque past, whose local coloring is the fairest which this transatlantic land affords; with the material prosperity which in time must come . . . what is there to hinder this wide, vast

South from taking its position as a leader in the world of letters, as the equal and peer of the North?

Margaret Junkin Preston did not live to see her vision for Southern literature come to fruition, but in her prose she helped to lay the foundation for that "bright and attractive" future.

Biographies:

Elizabeth Preston Allan, *The Life and Letters of Margaret Junkin Preston* (Boston & New York: Houghton, Mifflin, 1903);

Mary Price Coulling, *Margaret Junkin Preston: A Biography* (Winston-Salem, N.C.: John F. Blair, 1993).

References:

James A. Harrison, "Margaret Junkin Preston: An Appreciation," in *Life and Letters of Margaret Junkin Preston* (Boston & New York: Houghton, Mifflin, 1903), pp. 341–378;

Rayburn S. Moore, "'Courtesies of the Guild and More': Paul Hamilton Hayne and Margaret Junkin Preston," *Mississippi Quarterly,* 43 (Fall 1990): 485–493.

Papers:

The largest collection of Margaret Junkin Preston's papers remains in private hands. Other significant holdings are in the Southern Historical Collection at the University of North Carolina at Chapel Hill and at the library of Washington and Lee University.

Nancy Gardner Prince

(15 September 1799 – ?)

Darcy A. Zabel
Friends University

BOOKS: *The West Indies: Being a Description of the Islands, Progress of Christianity, Education, and Liberty Among the Colored Population Generally* (Boston: Printed by Dow & Jackson, 1841);

A Narrative of the Life and Travels of Mrs. Nancy Prince (Boston: The Author, 1850); revised as *A Narrative of the Life and Travels of Mrs. Nancy Prince, Written by Herself* (Boston: The Author, 1853).

Edition: *A Black Woman's Odyssey Through Russia and Jamaica: The Narrative of Nancy Prince* [1856 edition], introduction by Ronald G. Walters (New York: Markus Wiener, 1990).

Freeborn but troubled by poverty most of her life, Nancy Gardner Prince labored as a domestic, seamstress, and when need be, an itinerant jack-of-all-trades to support herself and the causes in which she believed. Respected in her own time as a social activist interested in children's welfare programs and in abolition, Prince is best remembered today as the author of a largely autobiographical travel narrative. By observing and experiencing the social and economic climates of nineteenth-century Russia, the British-controlled West Indies, and several parts of the United States, including the South, Prince came to view racism, sexism, poverty, and political struggle as universal problems and not peculiar to any one country or race of people.

Little is known about Prince apart from the information she provides in *A Narrative of the Life and Travels of Mrs. Nancy Prince, Written by Herself* (1850). Born on 15 September 1799 in the seafaring town of Newburyport, Massachusetts, Prince was never a slave. She emphasizes that her relatives who had been slaves earned or won their freedom through acts of bravery or daring. Prince's maternal grandfather, Tobias Worton, was born free in Africa but then sold as a slave in Massachusetts prior to the Revolutionary War. He was freed as a reward for his loyal participation in the Battle of Bunker Hill on the side of the Americans. Once freed he married a Native American woman formerly enslaved by the English who was also freed following the Battle of

Bunker Hill. Although Prince's paternal grandparents were brought from Africa to the Americas as slaves, Prince's father, Thomas Gardner, was freeborn. A sailor, he died at sea when Prince was three months old.

Prince's stepfather, Money Vose, though not fond of Prince, had a great impact on her material, emotional, and imaginative life. Born in Africa, Money Vose had been captured by sailors but escaped while the slave ship on which he was transported docked at an eastern port. Prince retells the story of her stepfather's escape in her narrative, providing a detailed account of Vose's swim for freedom. She begins with his capture in Africa while selling baskets in a market, and ends by describing the sea plants that pricked at the soles of his feet as he waded out of the sea to the Massachusetts shore. She celebrates his daring then and his industry later. Unable to make a living for himself or his family on shore, Vose turned to the sea. For twelve years he made a good living as a sailor, traveled the world, and came home with detailed observations and stories. His financial success provided Prince with a sense of security and pride while his stories fired her imagination. Captured by an English warship, Vose died at sea. His death marks her entrance into the adult world of financial deprivation, familial duty, and spiritual uncertainty, perhaps explaining Prince's selection of this event to begin the action of her autobiography.

Details about Prince's life outside those she herself provides in her autobiography are scant. She was baptized in Boston in May of 1819, shortly before her twentieth birthday, by the Reverend Thomas Paul. Five years later, in February of 1824, she married Nero Prince, an African American who served as a dress doorman and guard for the czar's court in Russia. The Princes arrived in Russia shortly before the St. Petersburg flood of 1824, a disastrous event that killed hundreds of people and destroyed many parts of the city. A year later, both were on hand for the death of Czar Alexander I in 1825 and subsequent military uprising, the Decembrist Revolt. Political reform in Russia crumbled, the power of the state increased, and many per-

sonal and religious freedoms were curtailed. Whether for these reasons or for her health, as she claims in her narrative, Prince booked passage on a ship and returned to America in 1833, leaving her husband behind to complete the terms of his contract with the Russian court. He died of unknown causes before the year was out.

That same year, Britain passed its Emancipation Act for the eventual end of slavery in the colonies, set to take effect on 1 August 1834. According to the guidelines established by the act, former slaves would serve as unpaid "apprentices" until the year 1840. Domestic slaves would receive manumission in 1838 and all children under the age of six were freed immediately. This event filled American abolitionists with hope for an end to slavery throughout the Americas. The events of Jamaica were closely studied and hotly debated by those for and against the cause of abolition. The apprentice system failed and in 1838 Britain officially freed all African Jamaicans. Missionaries flocked to the island, often returning to the states to give lectures. These lectures became popular forms of education and fund-raising. Prince's first efforts at public discourse are a product of the popularity of these lectures. Recently returned from Russia, she drew on her travels for lecture material.

Her name first appeared in print in the 8 March 1839 issue of the antislavery publication the *Liberator*. Between a notice announcing the "Annual Sermon in behalf of the Samaritan Asylum for indigent colored children" and a notice to all *Liberator* correspondents of "Colonization Colonized, a letter from C. W. Denison" appeared a two-paragraph advertisement for the sale of tickets at three different Boston shops for a lecture "to be delivered by Mrs. Nancy Prince on the manners and customs of Russia." Promising that "some drawings of the cities of Gronstault and Petersburg will be exhibited," the advertisement stated that Prince had resided in Russia for ten years and could thus be expected to "give an account of many interesting events which transpired during that time," referring, no doubt, to the St. Petersburg flood of 1824, the death of Czar Alexander I in 1825 and consequent Decembrist Revolt, and the eventual coronation of Nicholas I as the new emperor of Russia. No mention of this lecture is made in Prince's autobiography. She does mention, however, her efforts to solicit funds to establish an orphanage in Boston such as the one she had formed in St. Petersburg, so the lecture may have been related to her fund-raising efforts. Prince did manage to establish her asylum and to personally care for eight children, but her orphanage did not continue to attract donations or receive funds and the project failed within three months.

Frustrated, she turned her attention back to the cause of abolition and the support of established societies for social reform. For a brief stint, she aligned herself with William Lloyd Garrison and his Anti-Slavery Society until contention broke out among the members about the role of women in the group, which combined with disagreements about how the society should participate in instigating or inspiring social change. While some members of the group favored institutional or political change through legal venues and social protest, others preferred action with direct impact on the lives of individual people. Prince seems to have aligned herself with the latter group, asserting that "there has been a great change in some things, but much remains to be done; possibly I may not see so clearly as some, for the weight of prejudice has again oppressed me." Prince felt disenfranchised from the group and left, joining forces with an evangelical Protestant group dedicated to performing good works abroad. Her previous experiences as a traveler made her eager to serve as a missionary. In 1840 Prince set sail for Jamaica. She hoped to make herself useful as both a teacher and a spiritual guide in the newly freed "black man's" country, never realizing how much this trip would change the course of her life.

The West Indies: Being a Description of the Islands, Progress of Christianity, Education, and Liberty Among the Colored Population Generally (1841) is a sixteen-page political, social, and spiritual message about the universal need for morally inspired political management of social structures. Written specifically for a New England audience, part 1 is primarily a physical description of the general region and its climate, portions of which may have been culled from other accounts. Of particular interest is the way Prince blends this first section on the geography of the islands, particularly Jamaica, into part 2, the political history of Jamaica and its people. Her account of this history begins in earnest with English imperialism; she compares the colonization of Jamaica to that of Ireland. Prince blames the ill-treatment of the thousands of black slaves shipped yearly to the West Indies from Africa to replace those who died in service of the British Empire. She bluntly criticizes the British practice of exporting the people she calls "the dregs of the English nation, and the refuse of the jails of Europe" as colonizers for the Crown. She asserts that England's plan for Jamaica is the same as its plan for Ireland—usurpation of land and resources at the expense of people the Crown views as disposable. The third part of the text addresses the current state of affairs in Jamaica and the aftermath of the 1834 Act of Emancipation that abolished slavery throughout the British Empire. Prince was appalled by the large-scale corruption that blossomed in freedom's wake. To forewarn American readers, she targets two fraudulent schemes used by corrupt

missionaries to lure African Americans immigrating to the West Indies with false promises about the quality of life.

Prince deplored the religious corruption that occurred under the guise of missionary work. In particular she decried the work of black missionaries who took advantage of blacks by selling Bible subscriptions at inflated prices, offering up life after death and a place in heaven–for a stiff fee. Showing how the money sent by well-meaning Christians from abroad was squandered by the missionaries on the islands, Prince hoped to demonstrate the importance of contributing funds to someone who personally would attend to the problems in Jamaica. She demonstrated that money proffered without sound management may well increase corruption rather than decrease it. Prince commends the newly freed African Jamaicans for their desire to improve their schools, churches, and markets; she faults the foreign-funded missionaries for the corruption that spread in the wake of emancipation. Prince argued that Jamaica and its people were worthy of investment, provided that the management of the funds rested in the hands of a morally inspired Christian authority without mercenary interests.

Prince also addressed the widespread notion that following the Jamaican Emancipation of 1834, African Americans should follow what some white Americans suggested as a solution to the American Negro Problem: to leave the United States to be with "their own kind" in Jamaica. Prince cautions black readers in the United States to be wary of those who offer them free passage to the islands, warning that many are incarcerated upon reaching the island and forced to sell their labor to pay for passage. Many of the black Americans whom Prince met living in Jamaica, she says, were poor and discontent, "rueing the day they left the country, where, notwithstanding many obstacles, their parents had lived and died, [and] which they had helped to conquer with their toil and blood." Prince thus positions herself and people like her as true Americans, despite social injustice and financial and political struggles. National allegiance, not color, becomes the determining factor of origin and identity for Prince; the blood offered up in the toil of building the country, not race, is what makes an American. Prince describes herself and her family, therefore, as laborers who have earned the right to their nationality. She concludes her book on the West Indies by reminding people that the only real purpose for going to Jamaica is for what one can honestly bring to it, not take from it. In fact, she offers to solicit aid in the states to establish an educational home for orphans and outcasts and then return to Jamaica herself to manage the home. She urges "the colored people of these United States who are induced to

A
NARRATIVE
OF THE
LIFE AND TRAVELS
OF
MRS. NANCY PRINCE.

WRITTEN BY HERSELF.

SECOND EDITION.

BOSTON:
PUBLISHED BY THE AUTHOR.
1853.

Title page for the autobiography of an African American woman who spent nine years of her life at the courts of Alexander I and Nicholas I of Russia

remove to Jamaica, in consequence of the flattering offers made to them," to consider the dangers of emigration and to research the true state of affairs in Jamaica, for, "knowing the truth, they may no longer be deceived."

Upon returning to the United States in 1841, Prince threw herself into the cause of abolition in her own country. In an anecdote about the role that women played in the "Abolition Riots" of 1847, printed in "Women's Era," his 1894 recollection of the Boston Female Anti-Slavery Society, Thomas B. Hilton describes Nancy Prince as "a colored woman of prominence in Boston" who together with "the assistance of the colored women that had accompanied her" rescued a runaway slave from a paid slave catcher. He recalls that Prince ordered her followers to attack the "kidnapper" and "pelt him with stones and anything you can get a hold of." Prince herself does not mention this event.

A Narrative of the Life and Travels of Mrs. Nancy Prince, published in 1850 and copyrighted in the clerk's

office of the District Court of Massachusetts, is her best-known work. It includes a revised version of *The West Indies*. Prince tells the story of both her travels and her purpose in traveling. The text went through three editions (1850, 1853, and 1856), and Prince made few revisions from edition to edition. The 1853 edition contains more autobiographical material and several of Prince's corrections, including the spelling of her maiden name, Gardner, from the original misspelling in the 1850 edition, where her father's name is listed as Gardener. The 1856 third edition includes no new material. Prince paid for the publication of all three editions.

Before moving into the history of her own personal experiences, Prince discusses her personal geographical and genealogical heritage as an African- and Native-American New Englander. Following an account of the death of her stepfather, Money Vose, Prince describes the financial problems that threatened her future. Whereas Prince's mother looked to marriage as her sole source of financial and physical security, marrying four times and producing eight children, Prince wanted a freer life. The summer after Money Vose died, Prince and her younger brother George pooled their resources to support their mother and siblings. The two "gathered berries and sold them in Gloucester; strawberries, raspberries, blackberries, and whortleberries, were in abundance, in the stony environs, growing spontaneously. With the sale of these fruits, my brother and myself nearly supported my mother and her children, that Summer." But their mother remarried and the older Gardner and Vose children once again returned to domestic service.

The early part of Nancy Prince's autobiography deals with financial concerns and family matters: her struggles to support her mother and her siblings, her mother's "insanity" and bad choices concerning matrimony, and Prince's sister's prostitution. As she recounts the early part of her life, Prince details what it cost to keep her family supplied with shelter and food at the various foster homes and "situations" in which she placed her brothers and sisters. Her baptism by the Reverend Thomas Paul in May of 1819 brings her spiritual and emotional comfort, but does not materially change her life. After accounting for her family's whereabouts and exactly what it had cost her, dollar for dollar, to settle them, Prince ends that chapter of her life asserting that she discovered within herself a "determination to do something for myself," which she links to leaving her place as a domestic and learning a trade. In 1822 she found herself with "a determination to do something for myself; I left my place after three months, and went to learn a trade; and after seven years of anxiety and toil, I made up my mind to leave my country. September 1st, 1823 Mr. Prince arrived from Russia. February 15th, 1824, we were married."

Her husband, Nero Prince, was a much older man and a former sailor once acquainted with her mother and deceased stepfather, now serving as a doorman and guard at the Russian imperial court. Prince found, at the age of twenty-five, that she had to leave her country in order to pursue the American Dream.

The Russian section of Prince's autobiography is a strange blend of ethnography and a record of personal growth and delight. Prince observes that in Russia, "there was no prejudice against color; there were all casts, and the people of all nations, each in their place." Difference was marked by something Prince identified as "standard," not by color, a change she found invigorating. Her first day at court, Prince was introduced to the Emperor Alexander and Empress Elizabeth, given a gold watch, and made to feel welcome, both as the wife of Nero Prince and as a new member of the court. By her third week in Russia, Prince opened her own business making baby linen and children's clothing. Patronized by the empress and ladies of the court, Prince found her work so popular in the city of St. Petersburg that she was forced to hire a journeywoman and take on several apprentices in order to meet the demands for her wares. She conducted much of her business in French, rather than English or Russian.

Prince remained in Russia for almost ten years. Toward the end of her time there she began working with a Protestant missionary named Kenell, distributing Bibles and pamphlets with information about Protestantism. According to Prince, in response to this Protestant threat the bishop of the Orthodox Church petitioned the emperor to order that anyone found distributing free Bibles or Protestant tracts be severely punished. Prince records that "many were taken and imprisoned, two devoted young men were banished; thus the righteous were punished, while evil practices were not forbidden, for there the sin of licentiousness is very common."

Immediately following this revelation, Prince mentions for the first time that she has a lung condition, and then says it was on "the advice of the best physician that I had better not remain in Russia during another cold season. However painful it was to me to return without my husband, yet life seemed desirable, and he flattered me and himself that he should soon follow. It is difficult for anyone in the Emperor's employ to leave when they please. Mr. Prince thought it best for me to return to my native country, while he remained two years longer to accumulate a little property, and then return." Whether it was the physical climate or religious climate that Prince found chilling, she closed down her business, abandoned her Russian missionary

work, and set sail for the United States, never to return to Russia or to the status she had enjoyed there.

Her autobiography glosses over her six-year struggle for financial independence and personal security once back in the United States, noting only that "the old church and society was much in confusion" and that the "sins" of her "beloved country are not hid" from God's notice. She launches into an extended account of her travels to and through Jamaica in the aftermath of emancipation, and of the good work she hoped to do there. Added to her 1841 description of Jamaica is a new section on miscegenation and mulattoes and a brief history of the people she calls the original Jamaicans, the Maroons, who were destroyed or banished from the island when not confined to reservation-like territories. At a time when virtually all the major Native American Indian societies east of the Mississippi and those formerly living in the southern states had been forcibly removed to the western United States to make room for white settlement, the Seminoles in Florida, joined by a group of runaway black slaves, successfully staged a similar uprising that lasted well into the 1850s. Stories of successful rebellion abroad served as models to Jamaicans for resistance to American nationalism and domestic imperialism.

The last section of Prince's autobiography is one that some readers find troubling and that others find the most riveting. According to her narrative, Prince departed Jamaica for New York in 1842 but found herself a potential victim of kidnapping as the unscrupulous captain set sail for Key West, where he hoped to lure Prince and four other black passengers ashore where he could sell them. Trapped onboard ship without fresh water, Prince and the other four passengers heard the captain and his compatriots laughingly discussing whether they will get the $600 as promised, presumably their share for the sale of the five African Americans onboard. A law had just been passed to incarcerate every free person of color coming ashore. The ship was blown off course and ended up somewhere off the coast of Texas. While the ship was docked for repairs, Prince was approached three times by crowds of men desiring to sell her into slavery. But she knew the law and refused to leave ship. When the captain and his men realized she had no intention of stepping foot onshore, they attempted to bully her. Prince writes that she "found it necessary to be stern with them; they were very rude; if I had not been so, I know not what would have been the consequences." The first time they attempted to force her to leave ship, she warded them off by revealing her father's name. One of her tormentors remembered having sailed with Thomas Gardner and turned supporter instead of antagonist. The second time, she was permitted a form

of diplomatic immunity because she did not discount a rumor that she would be protected because of her association with the Russian government. The third time her tormentors approached, however, she appealed to religious rather than political or personal authority. She took as her weapon her ability to quote Scripture cogently. Thus, she assaulted her persecutors with the lines from Revelations 18:15 and 20: "The merchants of these things which were made rich by her, shall stand afar off, for the fear of her torment, weeping and wailing. For strong is the Lord God who judgeth her."

Finally, the ship set sail. The captain sailed close by a slave ship and then threatened to set Prince down on such a vessel instead of taking her to New York unless she gave him money. She refused, reminding him that she had already paid for safe passage to New York and that as yet he had not fulfilled his duty or his word. On 3 October, exactly one month after setting sail for New York, Prince again found herself in Key West. Again she was unable to get off the boat during the four-day layover in Comet, Florida. As the ship finally set sail for New York, the captain informed her that John and Lucy Davenport of Salem, Massachusetts, had offered $100 to anyone who could have gotten her off the ship in Florida because "they intended to beat you."

At last, on 19 October 1842, Prince arrived, without luggage, in New York. She spent the winter there, "poor in health, and poor in purse." For almost two years, she worked at several different occupations, primarily sewing, and accumulated enough capital to go into business for herself again. Subsequently robbed by the people she rented rooms from and by those she hired, she became disenchanted with those whom she once "mostly sympathized, and shared in common the disadvantages and stigma that is heaped upon us, in this our professed Christian land." This misfortune, she concludes, had been her "lot."

The narrative ends with Prince's recording of another bout of illness. Prince writes that in 1848 and 1849 she experienced a complete physical breakdown and was too ill to work or care for herself. Her illness became the impetus for this longer second publication, which she refers to only as her narrative. Prince hoped that the publication and sale of the text would provide her with financial support during her illness. Ironically, her physical illness provided the physical time off from her usual manual labors necessary to write. Meanwhile, unnamed patrons, people she calls new friends, provided shelter, support, and relief. At the close of the 1853 edition, Prince celebrates these friends and hopes that her text will provide her with the financial support she needs so that she may support herself instead of relying on their kindness or charity. The prose portion

of her narrative concludes with a poem, "The Hiding Place," in which the narrator longs for the safety and power of life in heaven, rejecting the charms, wealth, honor, and noise of the physical world.

The poem provides a bittersweet ending to an autobiographical narrative largely framed by a series of voyages, suggesting that Prince finds herself in the process of preparing for one last and final trip. Each time Prince left home, however, she had a purpose. At first, her purposes were always financial as she hired herself to one family or another, but each time out ended in physical exhaustion rather than financial success or spiritual salvation. Her journey to Russia in quest of a better life ended in heartache, just as her travels to the West Indies left her disappointed in her fellow man. Her accidental trip to the South only reconfirmed in her mind that there was no safe place for a woman of color in nineteenth-century America. Calling on the Lord to guide her on the final portion of her journey, she longs to "enter safe my hiding place."

Yet, Prince was never a fugitive. Despite the tone of this last poem, her prose indicates that regardless of how much Prince might have desired to run away from conflict or hardship, her journeys were never undertaken simply as a mode of escape. Each leave-taking enacted a conscious decision to embark on a journey toward a known goal, with the intention of returning to her original point of departure. A traveler, Prince used her experiences abroad to confirm her belief that identity was a matter of national and personal history and collective experience, and that just as one's point of origin was conditioned by the changing countenance of one's country, so too was one's destiny. Understandably, therefore, Prince's experiences as an activist, missionary, teacher, traveler, and author differ greatly from many of her white or black counterparts.

There is no record of Nancy Prince's life after 1856. No one knows when, where, or how she died.

Although her name appears in Thomas B. Hilton's 1894 account of the heroic actions of the Boston Female Anti-Slavery Society, no mention was made of what became of her in later years. After the publication of her 1856 third edition, Prince, at the age of fifty-seven, slipped from the public record just prior to the advent of the Civil War. Forgotten for years, she is remembered now as a representative voice of a different kind of African American ancestor. A writer, a speaker, a teacher, a missionary, a domestic, a seamstress, a shop owner, an independent businesswoman, a daughter, a wife, and a foster mother, Nancy Prince was many things to many people, but she was never a slave. Prince's writing adds depth and detail to our understanding of what it meant to be black, female, and free in nineteenth-century antebellum America, and the world beyond.

References:

Frances Smith Foster, "Adding Color and Contour to Early American Self-Portraitures: Autobiographical Writings of Afro-American Women," in *Conjuring: Black Women, Fiction, and Literary Tradition,* edited by Marjorie Pryse and Hortense J. Spillers (Bloomington: Indiana University Press, 1985);

Thomas B. Hilton, "Women's Era," in *We Are Your Sisters: Black Women in the Nineteenth Century,* edited by Dorothy Sterling (New York: Norton, 1984);

Carla L. Peterson, *"Doers of the Word": African-American Women Speakers & Writers in the North (1830–1880)* (New York: Oxford University Press, 1995);

Ann Allen Shockley, *Afro-American Women Writers 1746–1933* (Boston: G. K. Hall, 1988);

Ronald G. Walters, Introduction to *A Black Woman's Odyssey Through Russia and Jamaica: The Narrative of Nancy Prince* (New York: Markus Wiener, 1990).

Catharine Maria Sedgwick

(28 December 1789 – 31 July 1867)

Patricia Larson Kalayjian

California State University, Dominguez Hills

See also the Sedgwick entries in *DLB 1: The American Renaissance in New England; DLB 74: American Short-Story Writers Before 1880;* and *DLB 183: American Travel Writers, 1776–1864.*

BOOKS: *A New-England Tale; or, Sketches of New-England Character and Manners,* anonymous (New York: Bliss & White, 1822; London: Miller, 1822); enlarged as *A New England Tale and Miscellanies* (New York: Putnam, 1852);

Mary Hollis: An Original Tale, anonymous (New York: New York Unitarian Book Society, 1822);

Redwood, A Tale, anonymous, 2 volumes (New York: Bliss & White, 1824);

The Travellers: A Tale, Designed for Young People (New York: Bliss & White, 1825);

The Deformed Boy (Brookfield: E. & G. Merriam, 1826);

Hope Leslie; or, Early Times in the Massachusetts, 2 volumes (New York: White, Gallagher & White, 1827);

Clarence; or, A Tale of Our Own Times, 2 volumes (Philadelphia: Carey & Lea, 1830);

Home (Boston & Cambridge: Monroe, 1835);

The Linwoods; or, "Sixty Years Since" in America, 2 volumes (New York: Harper, 1835);

Tales and Sketches (Philadelphia: Carey, Lea & Blanchard, 1835);

The Poor Rich Man and The Rich Poor Man (New York: Harper, 1836);

Live and Let Live; or, Domestic Service Illustrated (New York: Harper, 1837);

A Love Token for Children (New York: Harper, 1838);

Means and Ends, or Self-Training (Boston: Marsh, Capen, Lyon & Webb, 1839);

Stories for Young Persons (New York: Harper, 1840; London: Tilt & Bogue, 1840);

Letters from Abroad to Kindred at Home, 2 volumes (London: Moxon, 1841; New York: Harper, 1841);

Tales and Sketches. Second Series (New York: Harper, 1844);

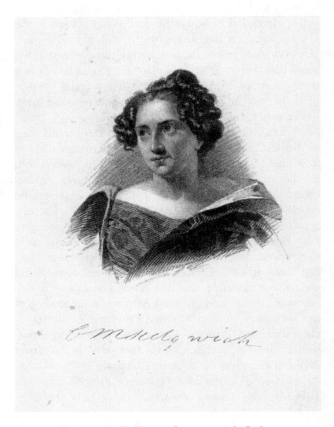

Engraving by F. Halpin after a portrait by Ingham

Morals or Manners; or, Hints for Our Young People (New York: Wiley & Putnam, 1846; London: Wiley, 1846);

Facts and Fancies for School-Day Reading (New York & London: Wiley & Putnam, 1848);

The Boy of Mount Rhigi (Boston: C. H. Pierce, 1848);

Tales of City Life. I. The City Clerk. II. "Life Is Sweet" (Philadelphia: Hazard & Mitchell, 1850);

Married or Single? (1 volume, London: Knight, 1857; 2 volumes, New York: Harper, 1857);

Memoir of Joseph Curtis, A Model Man (New York: Harper, 1858);

Life and Letters of Miss Sedgwick, edited by Mary E. Dewey (New York: Harper, 1871);

The Power of Her Sympathy: The Autobiography and Journal of Catharine Maria Sedgwick, edited by Mary Kelley (Boston: Massachusetts Historical Society, 1993).

Editions: *Hope Leslie; or, Early Times in the Massachusetts,* edited by Mary Kelley (New Brunswick, N.J.: Rutgers University Press, 1987);

A New-England Tale (New York: Oxford University Press, 1995);

Hope Leslie; or, Early Times in the Massachusetts, edited by Carolyn L. Karcher (New York: Penguin, 1998).

OTHER: "Le Bossu," in *Tales of Glauber-Spa,* 2 volumes, edited by William Cullen Bryant (New York: Harper, 1832), I: 25–108;

"A Memoir of Lucretia Maria Davidson," in *Lives of Sir William Phips, Israel Putnam, Lucretia Maria Davidson, and David Rittenhouse,* volume 7 of *The Library of American Biography,* edited by Jared Sparks (Boston: Hilliard, Gray / London: Kennet, 1837), 219–294;

"Old Maids," in *Old Maids: Short Fiction by Nineteenth-Century U.S. Women Writers,* edited by Susan Koppelman (Boston: Pandora, 1984): 8–26;

"Cacoethes Scribendi," in *Provisions: A Reader from 19th-Century American Women,* edited by Judith Fetterley (Bloomington: Indiana University Press, 1985): 49–59.

Catharine Maria Sedgwick was considered by readers and critics of antebellum America to be a key figure in the establishment of the national literature. Her fiction is particularly American in subject and setting, and Sedgwick modestly considered her work to be a small contribution to the larger political effort of national improvement. As the author of six novels, multiple didactic fictions for adults and children, travel letters, and dozens of short fictions, Sedgwick seemed secure in her literary historical position. Years of derogation and misrepresentation in literary histories followed her death, however, and despite some earlier efforts, Sedgwick remained an out-of-print, literary footnote until the feminist movement of the 1980s. Since then, the high quality of her fictions (especially *Hope Leslie; or, Early Times in the Massachusetts* [1827]), her wide-ranging stylistic and cultural interests, and the alternative ideological positions she espoused (regarding, for example, marriage and race relations) have brought about the reintegration of her work into the American literary scene.

Born 28 December 1789 in Stockbridge, Massachusetts, Catharine Maria Sedgwick was the sixth of seven surviving children and the youngest of three daughters in one of the most important families of western Massachusetts. Her mother, Pamela Dwight Sedgwick (1753?–1807), was the daughter of a "river god," an appellation accorded wealthy families who held sway politically and financially in the Connecticut River Valley. The background of her father, Theodore Sedgwick (1746–1813), was less prestigious, but his law practice and active political life brought him early into the arenas of power; he served in both state and national legislatures and rose to the position of Speaker of the House of Representatives during George Washington's presidency. An ardent Federalist, Theodore Sedgwick eventually fell from political favor, but he remained a determined aristocrat even as his children began to embrace the more democratic principles of the early nineteenth century.

Catharine's parents seemed to have a marriage based on mutual affection and respect; however, the union was not without conflict between the public and domestic spheres—conflict that almost certainly contributed to Catharine's own complicated attitude toward marriage. Her father was often absent while performing his public duties in Philadelphia, occasions that left her mother isolated and lonely. Pamela Sedgwick's letters and the recollections of her children reveal a woman who, true to the gender roles of the times, submitted to her husband's desires by effacing her own. Sedgwick asserted in her autobiography that she believed her mother's recurrent and debilitating mental illness to have been caused by "a sensitive and reserved temperament, a constitution originally delicate, and roughly handled by the medical treatment of the times, and the terrible weight of domestic cares." Theodore Sedgwick was not immune to concern about his wife's illness, but his commitment to the new republic took first priority.

Much of the responsibility for Catharine's upbringing fell to Elizabeth Freeman, affectionately known to the Sedgwicks as Mumbet or "Mah Bet." In 1781 Freeman, then a slave, heard the Declaration of Independence read aloud and desired her own freedom. She requested the assistance of Theodore Sedgwick, who served as her counsel; she won her suit and thereby established a precedent leading to the end of slavery in Massachusetts. Upon gaining her freedom, Freeman entered into service with the Sedgwick family and remained their housekeeper until 1808 and a friend until her death on Catharine Sedgwick's fortieth birthday in 1829. Catharine Sedgwick highly valued Mumbet's integrity, strength, and virtue and memorialized this surrogate mother in an 1853 story, "Slavery in New England." Mumbet's influence probably also con-

A NEW-ENGLAND TALE;

or,

Sketches of
New-England Character and Manners

But how the subject theme may gang,
Let time and chance determine;
Perhaps it may turn out a sang,
Perhaps turn out a sermon.
 BURNS

NEW-YORK:
PUBLISHED BY E. BLISS & E. WHITE, 128 BROADWAY.
1822.
J. Seymour, Printer.

Title page for Sedgwick's first novel, which James Fenimore Cooper
compared favorably to the works of Henry Fielding

tributed to Sedgwick's literary interest in racial issues. Her journal records Mumbet's assertion: "I would have been willing if I could have had one minute of freedom—just to say *'I am free'* I would have been willing to die at the end of that minute." This impassioned sentiment is echoed by Africk in *Redwood, A Tale* (1824) and in *The Linwoods; or, "Sixty Years Since" in America* (1835) by Rose, who finds even a seemingly benevolent enslavement "a yoke [that] binds."

Sedgwick's older sisters, Eliza and Frances, also served as surrogate mothers until their own marriages. Sedgwick's brief autobiography, recorded for a favorite grandniece in 1853, recites twice within a few pages the nearly identical story of Eliza's marriage. Sedgwick was seven, and during the wedding ("the first tragedy of my life"), she was overcome with a sense of loss that made her sob and leave the room. Her new brother-in-law, Thaddeus Pomeroy, came to comfort her: "how well I remember recoiling from him and hating him when he said to me, 'I'll let your sister stay with you this sum-

mer.' He let her! . . . I cried myself to sleep and waked crying the next morning, and so, from that time to this, weddings in my family have been to me days of sadness. . . ." She later recorded that neither of her sisters had particularly happy marriages. Eliza had twelve children, and hers was a "life of trial, of patient endurance, of sweet hopes, keen disappointments, harsh trials," while Frances "endured much heroically" in an abusive relationship from which the laws of the day precluded any escape. Customs of the late eighteenth and early nineteenth centuries made gaining a substantial education difficult for women, and Sedgwick complained even late in her life that she suffered from a lack of systematic educational training. Some of her early letters are reports to her father on the progress of her education, which, while desultory by the standards of today, was exceptional for a girl of her era. She attended a variety of schools in Stockbridge, Albany, New York City, and Boston as her family looked for ever more challenging curricula. If Sedgwick's education lacked order and rigor, it had range, and she enjoyed the freedom to pursue her interests, which included a love of nature. She lovingly recorded her childish delight in nutting, climbing trees, and exploring the countryside. But she felt that her greatest education came from the love of reading she acquired early and the exceptional intellectual vigor of her family. Although her younger brother, Charles, did not attend a university, her older brothers, Theodore Jr., Henry (Harry), and Robert all graduated from nearby Williams College before pursuing their law careers.

Sedgwick certainly, if indirectly, benefited from the intellectual pursuits of her brothers, as she did from their brotherly affections for her. Her choice to remain single in a culture designed to discourage that decision was, in large part, enabled by her supportive brothers and their understanding wives. After their father's death in 1813, Sedgwick never had a home of her own but lived with one or another of her brothers, either in the Berkshire neighborhoods of their childhood or in New York City—generally, the former in summer and the latter in winter. But more than physical shelter, Sedgwick's brothers offered her emotional support and practical advice; they encouraged her as a writer both through praise of her work and by serving as her business agents. She counted their wives among her closest friends, and she was a motherly aunt to their children. If Sedgwick periodically was distressed by her position as "first to none," her brothers proved the most able to ameliorate that unavoidable correlative to spinsterhood.

Her brothers' enthusiasm and influence prompted Sedgwick to pursue publication of her first novel, *A New-England Tale; or, Sketches of New-England*

Character and Manners, which appeared anonymously in 1822. Sedgwick had begun what she intended as a religious tract in celebration of her conversion to Unitarianism but then developed the story into a longer fiction. The intensity of feeling about religious matters in the early republic became the backdrop for Sedgwick's story of an orphaned girl, Jane Elton, whose liberal religious beliefs center on the practice of Christianity manifested through the disinterested performance of good works. After her parents die, Jane is taken in—and used as a domestic servant—by her aunt, Mrs. Wilson; Mrs. Wilson's orthodox Calvinism and her belief that she is among the elect dictate that she need do nothing of merit on the earth. In contrast to Jane's wisdom and goodness (obvious since childhood), Mrs. Wilson does everything wrong as a result of her self-delusion and egocentricity. Her failure to guide her children appropriately leads one to die of drink; another to become a seducer, gambler, and thief; and a third to elope into what promises to be a disastrous misalliance with a foreigner.

A New-England Tale is, however, more than a celebration of liberal theology (embodied in this instance not by a Unitarian but by a sympathetic Quaker who becomes Jane's suitor). The book is also, as its subtitle suggests, comprised of sketches of New England character and manners, and its pages crackle with lively descriptions of the physical and social geography of the region, as well as its moral one. The remote Berkshire village of _____ , with its dance master and its subscription school, appears highly cultured when artfully contrasted with the comfortless life of a crippled mountaineer and his large family of fantastically named progeny, who scrape a subsistence living from the untamed, rugged terrain. This mountaineer, John of the Mountain, his wife, Sarah, and the Elton's housekeeper, Mary Hull, suggest the scope of the working classes of the region, while Jane; the Wilson family; the Quaker, Mr. Lloyd; and another suitor, Edward Erskine, form the aristocracy of the area. On the fringes of both worlds flits crazy Bet, the first of several of Sedgwick's characters who suffers from various forms of mental derangement.

Bet was singled out for praise as an unusual and realistic representation by one well-known critic, James Fenimore Cooper. In his review of the novel for *Repository* (May 1822), Cooper also found *A New-England Tale* admirable for its accurate and felicitous descriptions of nature and society. He favorably compared the anonymous author to Henry Fielding in terms of the generosity of spirit and fine feeling required to reproduce sympathetically such observations of the world. Cooper did, though, express reservations about fiction that used the contemporary world as its setting rather than

reaching for the epic grandeur of "fantasy"; however, he hastened to add that "we love the artist who enters into the concerns and sufferings of the humble, whose genius condescends to men of low estate. . . ." Other critics, both domestic and British, were pleased by this slim volume as well, generally admiring its high moral purpose and its interesting portrayals of uniquely American characters, while puzzling over charges of sectarianism aimed at Sedgwick by angry Calvinists, among whom were many of her own relatives. Today the novel is cited by scholars of nineteenth-century women's writing as having originated the urplot of much of the domestic fiction of the century. In *Woman's Fiction,* Nina Baym identifies this plot as having as its core the story of a young girl, orphaned or abandoned, who must find her own way through the world, facing and overcoming many trials, until she attains independence, at which time she will be guaranteed the successful outcome of the traditional heroine—marriage to a highly eligible suitor. If the previous fictive template for women's fiction had been the seduction tale (of which a remnant remains in this work in the person of Mary Oakley), women writers now found Sedgwick's primary plot a more satisfactory model on which to elaborate. Jane Elton, who cannot depend on either her unprincipled businessman father or her good but passive mother to raise her, must work her way through domestic drudgery to the freedom of an education and a career as a teacher. She must also realize the false allure of the handsome face and fine manners that camouflage Erskine's selfish, coarse, and unethical heart before she can grant her love to the benevolent Quaker widower, Mr. Lloyd.

Sedgwick's self-described "humble tale" met with sufficient critical approbation to encourage her to continue writing prose fiction, and she followed the success of her first attempt with a novel of grander vision and proportion. *Redwood, A Tale* appeared anonymously in 1824. Once again, the setting is contemporary, and the heroine, Ellen Bruce, is a young woman living in a small town in New England. Her mother has died, leaving her in the care of a close friend; of her father, Ellen knows only that his identity may be secreted in a box that her mother left her but forbade her to open until some future date. The possibility that she is illegitimate leaves Ellen in an insecure social position, but, like Jane Elton, morally grounded. Ellen enjoys an upbringing that fuses the sturdy Puritan values and practical wisdom of Mrs. Allen, wife of an unsuccessful yeoman farmer of the Jeffersonian mold, with the more-refined attributes of Mrs. Harrington, whose intelligence and sensitivity had been sorely tried by a bad marriage to a man whose high social standing was not matched by mental or moral acuity. Indeed, from *Redwood* on, Sedg-

wick's novels, although each moves inexorably toward marriage for the heroine, present backgrounds littered with such unequal and disappointing unions. Women too passive or submissive to assert their moral strength over husbands of limited virtue, women who are morally and intellectually superior to their mates, and even one husband who meets his unhappy fate by settling for second best when spurned by a worthy love—these characters serve to dispute the social prescription of marriage as necessary for a woman's fulfillment.

Sedgwick, at age thirty-five, began to depict in her fiction women who, like herself, choose spinsterhood. The first of these women is Debby Lenox, maiden aunt of the Lenox family with whom Ellen currently abides. Large, bony, independent, and outspoken, Debby becomes the prototype for such characters later familiar, if not almost predictable, to readers of the domestic and New England regional literature of the nineteenth century. She arrives first to doctor a seriously injured traveler, Henry Redwood, who appears with his daughter, Caroline, and her maid, Lilly, at the Lenoxes' door. Redwood, a widower, is a Southern slave owner who has been traveling with his daughter in the hope of improving her character, marred by the indulgence of her Charlestonian grandmother, who has raised her.

Issues of character as determined by region, religion, and education form the central tension of *Redwood.* If Ellen possesses all the virtues developed by hard work, intellectual endeavor, and moral rectitude, Caroline fails on all scores: she is indolent, vain, self-centered, and preoccupied with social status. Some of Caroline's flaws seem linked to her Southern origins, from which, Sedgwick suggests, she learned lessons taught indirectly by slavery. Caroline has no interest in physical or mental labors and finds the Northerners' treatment of their help indulgent. Debby tellingly observes that Ellen is a natural creature who is the subject of her own text ("she never seems to think anyone is looking at her"), while Caroline is a culturally constructed object, a "heathen idol."

Mr. Redwood also has substantial failings, but his are the results of his advanced education. In a flashback, Sedgwick acquaints her readers with Mr. Redwood's past, including his relationship as a youth with Mr. Westall, a plantation owner who freed his slaves, and with Africk, a slave who so craved freedom that he killed his own son rather than see him abused by Redwood's father. Despite these positive influences, while at college Redwood fell under the influence of an unprincipled older student, as well as the corrupting philosophies of Voltaire and David Hume; he is now without religion and, therefore, without either the moral grounding or comfort it affords. As in *A New-England Tale,* religion is important to *Redwood,* and Ellen represents the perfection of proper religious precepts against not only Mr. Redwood's hedonistic secularism but also the lure of religious cultism, represented in this work by the Shakers (a sect with which Sedgwick was familiar because of the proximity of Hancock). Like Sedgwick's future heroines, Ellen, while domestically competent, is not confined to the woman's sphere but acts vigorously in the world by traveling with Debby to rescue a reluctant Shaker, Emily Allen, from an unscrupulous charlatan who has gained power within the Shaker community.

The novel resolves with Mr. Redwood revealed as Ellen's true father, who had married her mother secretly but abandoned her without knowing she had a child; the mother had kept Ellen's father's identity a secret from her daughter to protect her from his anti-Christian sentiments. Caroline marries the fortune hunter she deserves, and Ellen wins the heart of Charles Westall, the son of Redwood's late neighbor. Lilly, Caroline's slave, runs away to freedom, and Mr. Redwood has a religious conversion. Although *Redwood* shares some of the moralistic tones of *A New-England Tale,* this novel more importantly critiques the character of the New Englander in comparison to that of the Southerner and therein displays an awareness of the arguments against slavery that dominated the discourse of the next decades: slavery is a moral assault on both slave and owner, leading to deceitfulness and degradation for the enslaved and indolence, cruelty, arbitrariness, and moral decay for the enslaver.

Redwood was well received, and the anonymity of the author remained only as a fiction; Sedgwick was becoming the public person so alien to women of this era. William Cullen Bryant, a close friend, was both the dedicatee of the novel and one of its more-thorough reviewers; critics in the United States and abroad, moreover, mixed praise of *Redwood* with acknowledgments that such domestic fictions, or novels of manners, could not compete with works that were considered the real stuff of literature—war and adventure. Bryant himself suggested that works on the forefathers of America were the suitable matters for fiction about the United States, an observation Sedgwick must have taken to heart as she turned to historical fiction in two of her next three novels.

Whether this new fame or the social position of her large family elicited the invitations, Sedgwick enjoyed an active social life that included bids from the political elite to celebrate the fiftieth anniversary of the signing of the Declaration of Independence in July of 1825. Perhaps Sedgwick was reminded that the promise of freedom and equality was not yet achieved, for her next novel, *Hope Leslie,* critiques more than celebrates the Puritan settlement of the New World. Sedgwick fol-

lows Bryant's dictum regarding the appropriate subjects of American fiction, and, on this literary and geographic frontier, she discovers themes and characters that illuminate the past and present of America. Displaying both a technical and stylistic ability and a cultural insight vastly more acute than in her earlier work, she adapted the historical-romance formula and uncovered literary possibilities denied by contemporary protorealism. Sedgwick's authorial maturity and confidence appeared in a variety of ways. One was the wryly humorous voice of the narrator, whose tone is one not unlike Sedgwick's own in her many letters to her nieces and nephews. It has the edge of experience without the didactic parental tone and an awareness of both the dictates of society and the arbitrary nature of social practice.

Like most of her literary world, Sedgwick admired Sir Walter Scott, but she drew from his work different lessons from those, such as the apology of progress, commonly traced to his influence. She was more intrigued by his exceptional outsiders, individuals from despised races who rise to brave acts, and by his heroic unmarried women, such as Flora MacIver and Rebecca. In *Hope Leslie,* these figures merge in the character of Magawisca, a Pequod Indian who experienced, as a child, the slaughter of her tribe (known to Anglo-European America as the Pequod War of 1637). Magawisca lives with the Fletcher family in a frontier outpost and later is imprisoned by the Puritans; however, she saves the lives of her Puritan enemies before she disappears into "the far western forests." Magawisca is the dark-skinned double of the titular heroine of the novel, but, more importantly, she is the moral center of the novel. Hope, an exceptional young woman in her own right, has one flaw from which she must be cured by the end of the novel: she must recognize and dispel her racial prejudice by accepting the miscegenational marriage of her sister, Faith, to Magawisca's brother, Oneco.

Sedgwick's preface may be said to announce these notable changes. Whereas she had used her two earlier prefaces to beg forgiveness for her inadequacies and tolerance for her "humble effort," in this preface she directs her readers' approach to the novel, asserting that she depicts Native Americans as human beings and insisting that her readers reconsider received racial ideas. By asking her readers to reexamine familiar events through the eyes of an Indian, Sedgwick invokes the subjectivity of history and calls into question the authority of Anglo-American texts. The complex, multivoiced novel holds many challenges and surprises for the reader familiar only with traditionally authoritative texts, for Sedgwick uses and then defuses language. Both the narrative voice and other characters employ common epithets such as "savage" in reference to Native Americans, but Sedgwick contradicts these designations by illustrating the savagery of the whites. White men slaughter women and children in the Pequod massacre; in revenge, Magawisca's father, Mononotto, murders Mrs. Fletcher and her children, takes young Faith Leslie captive, and attempts to kill the teenage Everell Fletcher in retribution for his own son's death. Magawisca rescues Everell but loses her arm protecting him. Women (referred to as "the weaker sex" and the "inferior vessels"—but in action shown to be neither) in *Hope Leslie* are peacemakers, negotiators, nurturers, healers, protectors—never associated with violence or revenge, force or dominance, as are men of both races.

Hope Leslie begins in England during the early days of the Puritan migration, advances another dozen years to eastern Massachusetts in 1637, and then comes to rest there another decade later. At each of these moments, Sedgwick emphasizes the oppressive nature of patriarchy and implicates the Puritan fathers in the reinstitution of such oppression in the New World, where Native Americans must submit, be demonized, or die. In more-traditional texts, strong heroines such as Hope and Magawisca, who think and act in contradiction to the established order, might be expected to be punished or die for their rebellious and assertive behavior. Instead, Hope and Everell free Magawisca from an unjust imprisonment by Puritan Governor Winthrop after a trial in which Magawisca echoes sanctified American political rhetoric, saying, "I demand of thee death or liberty." Magawisca gets her freedom and the respect of her own people as well as the adoration of her white friends; Hope demonstrates her moral and intellectual superiority to the patriarchs who would control and mold her and marries the only man worthy of her. Moreover, *Hope Leslie* also contradicts the apologist notion that contact with white culture corrupts Native Americans, who can exist as noble savages only in their precontact state or as lackeys to the superior whites. Magawisca, Everell, and Hope all expand their views through interracial contact.

Despite the seemingly inevitable marriage of the heroine and Everell, matrimony is not the subject of the novel; it is, however, a significant subtext. The ill-fated Mrs. Fletcher is aware she is her husband's second choice as a mate; she runs the frontier outpost of the family while Mr. Fletcher stays too long in Boston, and she dies with her infants in an Indian attack for which she fails to prepare in passive deference to her husband's near arrival home. Mrs. Winthrop, wife of the colonial governor, is described as "a horse easy on the bit," an "inferior animal" who occasionally has the illusion of freedom. When Governor Winthrop worries

THE POOR RICH MAN,

AND

THE RICH POOR MAN.

BY THE AUTHOR OF

"HOPE LESLIE," "THE LINWOODS," &c.

" There is that maketh himself rich, yet hath nothing : there is that maketh himself poor, yet hath great riches."

NEW-YORK:

HARPER & BROTHERS, CLIFF-STREET.

1836.

Title page for one of Sedgwick's popular works of didactic fiction, a novel she disparaged as "suited to the market, the thing wanted"

about Hope's being too "lawless," he suggests that marriage to Sir Philip Gardiner (the villain of the novel) will serve to "put jesses [restraints] on this wild bird while she is on our perch."

As in *Redwood,* there is a mute chorus of women suppressed and restricted by apparently "good" men. Sedgwick can arrive at marriage for Hope only through a series of significant conditions. First, Everell must come to realize that only someone as free and natural as Hope can contest the social norms and perform the moral acts necessary for the resolution of the problems presented in the novel. His attempts to persuade his fiancée, Esther, acknowledged as the perfect Puritan woman, to help free Magawisca fall on deaf ears. Secondly, Everell must be Hope's "brother," that is, her companion rather than her superior. Lastly, Esther must choose to remain single after she and Everell break their engagement; then, her role as a culturally

endorsed female becomes an advantage when she decides to share her talents with the world rather than with an individual in marriage.

Critical reaction to *Hope Leslie* generally centered on whether such a Native American woman as Magawisca could possibly exist; the consensus ranged from unlikely to impossible. The implicit racism of such arguments is matched by the manner in which Sedgwick's gender is highlighted. In the *Western Monthly Review* (September 1827), Timothy Flint stated that Sedgwick "appears to move onward, with becoming modesty; and if her track is not distinguished by splendor . . . it will at least lead no one astray." Despite Flint's condescension, *Hope Leslie* had multiple editions, and decades later the *North American Review* (January 1849) called it "the only really successful novel . . . founded on the history of Massachusetts." Sedgwick wrote to her brother Robert on 6 July 1827 that she heard "from all quarters what honestly seems to me very extravagant praise" of *Hope Leslie,* and this unusual frontier romance remains her most highly acclaimed work.

Her 1830 novel, *Clarence; or, A Tale of Our Own Times,* was in many ways a new venture for Sedgwick. It is an attempt at a novel of manners set in New York City and other fashionable locales. Sedgwick lived most winters with one of her brothers, either Harry or Robert, in New York City, and her widely recognized talents brought them social prestige. But her conservative New England upbringing shows through in the distrust of money, position, and ostentatious display and in the implicit endorsement of thrift, plainness, and religious values. The tale begins with several chapters in which a background of greed, betrayal, abandonment, infidelity, and even fratricide accompanies the acquisition and then loss of wealth and family. The struggling Carroll family discovers they are really Clarences and heirs to a fortune, but the court battle required to inherit inadvertently results in the death of the angelic only son, Frank. Guilt over Frank's death makes the family realize that money can corrupt, and, as years pass, Mr. Clarence and his remaining child, Gertrude, live modestly and use their fortune to benefit others.

Gertrude is "a fit heroine for the Nineteenth Century; practical, efficient, direct, and decided—a rational woman—that beau-ideal of all devotees to the ruling spirit of the age—utility," but she is saved from being a drudge by her romantic imagination. If Gertrude is fundamentally competent (whereas Hope Leslie is never depicted as domestic), she wastes no energy on womanly tasks. Raised in the country to avoid the pitfalls of urban society, Gertrude feels the obligations of her wealth to be of service to others. *Clarence* includes a telling critique of middle-class womanhood, for whom life

all too often becomes a pointless routine of conspicuous consumption and vicarious leisure activities.

The principal plotline involves Gertrude in the rescue of a naive young girl, Emilie Layton, whose parents represent the worst of contemporary high society. Mrs. Layton is a woman of fashion, an aging belle who is dissatisfied with her marriage and carries on flirtations with younger men. Mrs. Layton is an unusually complex character for early American literature; she has enormous wit and intelligence but wastes her gifts in a pointless search for entertainment rather than enrichment. Her husband is a speculator and gambler, and both spend money unwisely and ignore their debts. When Mr. Layton cheats at cards, he is discovered by the villainous Pedrillo, who loans Layton money and then blackmails him into arranging a marriage to Emilie.

Gertrude, with the help of her fortune and the aid of Gerald Roscoe, prevents Emilie from being sold into marriage with this unscrupulous man, but not before duels are fought, secret identities are uncovered, and fancy dress balls are attended. Although *Clarence* suffers from a superfluity of characters and plot twists, it can be admired for its attempt to critique the new American society in which the obsessions of money, position, and power replace the older Puritan values. If *Clarence* is not completely successful at its complex aspirations, Sedgwick is prescient regarding the transformation of the United States. The effects of capitalism and the industrial revolution and the poverty as well as the potential of urban life did not receive further serious consideration until late in the century. Few American authors of Sedgwick's time spoke with such intimate knowledge of the cultural and financial elite of New York City. *Clarence* attracted little notice, however; only *North American Review* (January 1831) offered an appraisal, generally admiring the work but chastising Sedgwick for attempting topics requiring "masculine talent."

The late 1820s and early 1830s were years of change, both losses and new beginnings, for Sedgwick. Her sister Eliza and Mumbet died, as did Henry, who of all her brothers had most actively encouraged and supported her writing career; moreover, Henry's death involved an agonizing loss of mental stability. Partially filling the emotional gaps these deaths occasioned was Sedgwick's friendship with the English actress Fanny Kemble, who maintained a home in the Stockbridge-Lenox area and joined Sedgwick's sisters-in-law, Elizabeth and Susan, as part of the writer's inner circle of friends. As Sedgwick's fame grew, she welcomed to her salons the intellectual elite of the nation and made the Berkshires a stop for literary travelers from America and abroad—including Harriet Martineau, Frederika Bremer, and Jean Charles Sismondi. Nathaniel Hawthorne and Herman Melville first met at one of Sedgwick's parties in 1850. She, in turn, was the guest not only of the literati but also of politicians—including Daniel Webster, Chief Justice John Marshall, Martin Van Buren, and Andrew Jackson—and religious notables, such as the Reverend Henry Ware and William Ellery Channing. Ware was instrumental in redirecting Sedgwick's literary output by requesting, in January 1834, her aid in a project to illustrate "the practical character and influences of Christianity" in "a series of narratives between a formal tale and a common tract"; for Ware's project, Sedgwick wrote three popular didactic fictions—*Home* (1835), *The Poor Rich Man and The Rich Poor Man* (1836), and *Live and Let Live; or, Domestic Service Illustrated* (1837).

The year 1835 was significant for Sedgwick; in addition to publishing *Home,* she also brought out a collection of her short fiction, *Tales and Sketches,* and the last novel she produced for more than two decades, *The Linwoods.* Sedgwick had been a regular contributor to periodicals, gift books, and annuals, and her first collection offered the author an opportunity to gather together her most successful short works. *Tales and Sketches* includes "A Reminiscence of Federalism," "The Catholic Iroquois," "The Country Cousin," and "Old Maids" and illustrates both the range and quality of Sedgwick's short fiction. Topics on which she expanded in her long fiction appear in this collection—national and regional politics, the New England character, race relations, American history, marriage, and spinsterhood—sometimes with solemnity and occasionally as melodrama but most often carefully crafted with her familiar humor and wit. "Old Maids" affirms marriage as women's best state at the same time as it presents positive images of spinsterhood and decries unions formed from desperation: "It is a fearful fate," comments a married woman, "to be yoked in the most intimate relation of life, and for life, to a person to whom you have clung to save you from shipwreck, but [with] whom you would not select to pass an evening." "A Reminiscence of Federalism" recalls the combative divide between Federalists and Democrats that characterized Sedgwick's own childhood.

The most artful and challenging fiction to appear in *Tales and Sketches* was "Cacoethes Scribendi" (the irresistible desire to write), which originally appeared in *The Atlantic Souvenir* for 1830 and is one of Sedgwick's few short stories currently anthologized. The scene is a New England village, "H," from which men have virtually disappeared, and in which women live in a utopia of sisterhood. On the edge of the village lives the only available "beau," a handsome young farmer named Ralph, whose virtues include not only the competent maintenance of his farm but also singing, violin mak-

MARRIED OR SINGLE?

BY THE AUTHOR OF
"HOPE LESLIE," "REDWOOD," "HOME," ETC., ETC.

"Seven generations, haply, to this world,
To right it visibly a finger's breadth,
And mend its rents a little."
AURORA LEIGH.

IN TWO VOLUMES.

VOL. I.

NEW YORK:
HARPER & BROTHERS,
FRANKLIN SQUARE.
1857.

Title page for the first American edition of Sedgwick's last novel, in which she warns that it is better for a woman to "maintain her dignity" as a spinster than to "submit to those little domestic wrongs and tyrannies" of an unhappy marriage

ing, and taming squirrels. He appears to be the perfect male. His aunt, Mrs. Courland, is taking up writing as a profession, while her daughter, Alice, desires neither to write nor to be the subject of her mother's texts. The tensions maintained in this wryly sophisticated story include not only the question of female authorship and authority, but also questions of the proper subject of fiction, the effect writing has on the writer and on the community, and whether reality or fancy is the more satisfying source of fiction. "Cacoethes Scribendi" is metafiction at both its most amusing and its most complex, and the story bears surprising similarities—especially in its parody of a fairy-tale setting—to postmodern fictions.

For her 1835 novel, *The Linwoods,* the intersection of the political and the familial forms the central conflict. The time is 1775; the place is New York City and

environs; and the American Revolution divides the Linwood family between loyalist father and rebel son. Loving both father and brother and attempting to bridge the gulf between them is the heroine, Isabella (Belle). In Belle, Sedgwick returns to the independent and fearless heroine she introduced with Hope Leslie, although Belle is not as nearly perfect as Hope. If Hope must learn to suppress her racist impulses and accept her sister's interracial marriage, Belle must experience a rebirth in which she rejects the politics of her father and affirms the new order—symbolically represented by her brother and his peers—an action that parallels the political course of the new nation. When she dismisses the suit of her father's favorite, a high-born but opportunistic loyalist named Jasper Meredith, Belle shows the superiority of American values over those of the hierarchical Old World. The aristocratic Belle's re-formation as a patriot is also paralleled by her increasing attraction (and eventual marriage) to Eliot Lee, son of a New England farmer, one of "nature's aristocracy." Herbert's marriage to Lady Anne, an English peeress, confirms the liberal, democratic politics of the novel: the union of the three families effectively erases middle- and upper-class demarcations in the new United States.

The Linwoods reiterates other Sedgwick themes as well. It raises, for example, the issue of race and freedom for African Americans in the person of Rose. Rose's personal nobility and high ethical standards provide important instruction to the headstrong Belle, whose own mother offers the child no guidance. Mrs. Linwood is the only Sedgwick heroine's mother to survive the opening pages, but she is described as a "conjugal nonentity" by the narrator and a "poor, subservient, domestic drudge" by her own husband. Belle's strength of character is illustrated by an exchange with Rose when Belle is eight. Rose, then a slave, asserts that she can never be entirely happy knowing that she "can be bought and sold like the cattle"; Rose "would die tomorrow to be free today." So impressed is little Belle that she begs her father to free Rose; he refuses. Undaunted, Belle finds another way to win Rose's freedom. Mr. Linwood offers Belle anything she asks if she wins a French contest at school. Although a poor student of French, Belle applies herself and, with much effort, wins the contest and claims Rose's freedom as her prize.

Rose is certainly a fictive version of Elizabeth Freeman, but this episode also illustrates Sedgwick's own contradictory attitudes toward slavery. In her journal of 29 November 1829, she described Massachusetts blacks as being "restored to their natural rights—declared free" by Freeman's 1781 suit. Yet, Sedgwick described Freeman in her autobiography as a "remarkable exception to the general character of her race." Sedg-

wick's sympathetic portrayal of slaves desiring a freedom rightfully theirs is frequently adjacent to paternalistic depictions and racist stereotypes. As her friends and acquaintances became active in abolitionism, Sedgwick favored the movement but was timid in her support. Nevertheless, in *The Linwoods,* Sedgwick suggested that the freedom of slaves is the business of women, because, while men like Mr. Linwood offer sophistic intellectual justifications for slavery, women's emotional relationships enable them to comprehend better the need of all individuals for personal autonomy.

Famous personages of the Revolutionary period—including George and Martha Washington, General Israel Putnam, Sir Henry Clinton, and the Marquis de Lafayette—are characters in *The Linwoods,* as is a lesser known hero, a New York shopkeeper and spy named Lizzie Bengin. Bengin's appearance in the novel affirms Sedgwick's desire to illustrate the historical contributions of women. Fictively, the women of the novel conspire together to free Herbert from prison; Belle, Lady Anne, Lizzie, and Rose all assist in his escape by sea, with the ever-competent Lizzie at the helm. Women's active participation in the public world is affirmed when Belle's assertiveness attracts the heroic Yankee revolutionary, Eliot; she observes that "you like me for what most men like not at all—my love of freedom and independence of control." The narrative voice expresses the opinion that, if women devoted some of the time they wasted on "dress, gossip, and light reading, to the comprehension of the constitution of their country, and its political institutions," they would be no less interesting companions for men.

Sedgwick's status was quite elevated by the mid 1830s. Edgar Allan Poe proclaimed in the *Southern Literary Messenger* (December 1835) that she deserved a place "upon a level with the best of our native novelists. Of American female writers we must consider her the first." As attractive as Belle is within the frame of the novel, Poe was particularly taken with another, more vulnerable female character—Bessie Lee, Eliot's sister. Bessie "was of earth's gentlest and finest mould [*sic*]—framed for all tender humanities, with the destiny of woman written on her meek brow. 'Thou art born to love, to suffer, to obey,—to minister, and not to be ministered to.'" Bessie's ill-fated love for the unworthy Jasper Meredith, who dallies with her to feed his vanity, drives her mad; she wanders in a daze through the countryside to find him and return the trinkets she has cherished. Crazy Bet (in *A New-England Tale*), Louis Seton (in *Clarence*), as well as Bessie, are all characters demented by unrequited love, while another character from *The Linwoods,* Kisel, is mentally retarded. Bet stays mad; Seton dies; but Bessie survives, heals, and becomes the ideal woman she was destined to be; she also chooses to remain single. Con-

temporary readers found Sedgwick's ability to represent mental derangement fascinating, and her interest in the subject and in portraying people afflicted by such disorders brought an appreciation of human psychology to her work that was unusual among her peers.

The choice to marry and the responsibilities marriage and family entail are the topics of Sedgwick's other 1835 original work, *Home.* Like the other didactic fictions that followed it, *Home* directed Sedgwick's literary purpose away from the art toward which it had increasingly aspired and back to the moral and social responsibility with which she had begun *A New England Tale.* The didactic trilogy is far less complex than her novels in terms of structure and characterization, and Sedgwick clearly intended these works to reach a different audience, one comprised of common folk, whose lives, she believed, could be improved by modeling their behavior on that of rural New Englanders who improved themselves as vigorously as they improved their land. She confided to her niece Kate (8 March 1837) that *The Poor Rich Man and The Rich Poor Man* "is, like bread-stuff, or like the satinets and negro-cloths, to be a little more modest in my comparison, suited to the market, the thing wanted." For these modest commodities, Sedgwick received great praise from individual readers and religious mentors alike. William Ellery Channing wrote (19 August 1837) that thousands "will be the better and happier for it [*Live and Let Live*]; thousands, as they read it, will feel their deficiencies, and resolve to do better." All of her advice books achieved multiple editions—twenty for *Home.* Sedgwick confided to Channing (24 August 1837): "I thank Heaven that I am not now working for the poor and perishable rewards of literary ambition . . . there is an immense moral field opening, demanding laborers of every class." In this field she went to work, replacing the ambition she acknowledged and simultaneously abjured with a disinterested service to the literate but unenlightened working-class readers she aspired to raise to good health, good habits, good manners, and, hence, responsible citizenship in the republic.

Sedgwick continued to be an active and popular contributor of short fiction to annuals, gift books, and magazines over the next decades; her second collection of these stories, *Tales and Sketches. Second Series,* appeared in 1844. As a novelist, however, she remained inactive for more than twenty years. She traveled to Europe in 1839–1840 with her brother Robert and his family. As a celebrated writer, she was welcomed, and she energetically explored the cultures and the landscapes. Her correspondence was published in 1841 as *Letters from Abroad to Kindred at Home.* The trip was intended to improve Robert's health after he suffered a stroke, but it failed to accomplish its goal; Robert died soon after returning home. Theodore had died in 1839, and Sedgwick's only

LIFE AND LETTERS

OF

CATHARINE M. SEDGWICK.

EDITED BY

MARY E. DEWEY.

NEW YORK:
HARPER & BROTHERS, PUBLISHERS,
FRANKLIN SQUARE.
1871.

THE SEDGWICK HOUSE AT STOCKBRIDGE.

Frontispiece and title page for the posthumously published volume that includes Sedgwick's autobiography

remaining sister, Frances, died in 1842. Only Charles remained in her immediate family. Sedgwick, who never lived for any length of time outside her brothers' homes, felt their loss profoundly. "God only knows," she wrote a friend in September 1841, "how I have loved my brothers—the union of feeling, of taste, of principle, of affection I have had with them. No closer tie has weakened that which began with my being." An additional blow came when her favorite niece, Kate, married in 1842 and moved away, a reminder of Sedgwick's "sense of sadness" at family weddings.

Her interest in marriage had made that institution a subtext in all of her novels, but it moved to center stage in *Married or Single?* (1857), Sedgwick's last major work. Circling the central theme are insights into the events of the mid 1850s in New York and New England. The Fugitive Slave Act brings bounty hunters; a psychic holds a seance; prisons for men and women are visited;

ramshackle tenement housing is criticized; and immigrants are patronized. But it is the question of marriage that is debated and explored. The principal players are Grace and Eleanor Herbert, orphaned sisters who live with their widower uncle, William (survivor of a bad marriage to a woman obsessed with fashion), and widowed Aunt Sarah, recently released from an asylum where she was recuperating from the deaths of her children and husband. Despite this grim marital backdrop, Eleanor falls in love with a young minister, Frank Esterly, and marries him. Grace takes a less romantic view of marriage and plans a future as a single woman, a plan interrupted only at the closing moments of the novel by a worthy young lawyer, Archibald Lisle.

The union of Frank and Eleanor is the only marriage of young people in any of Sedgwick's novels, although the Barclays are idealized as the perfect family in *Home*. The Esterlys face a rockier future in *Married or*

Single? Grace witnesses an exchange between Frank and Eleanor in which he berates her for the state of his laundry. Eleanor is self-effacing and understanding, but Grace forces a more-critical look at Frank's behavior. She believes that Eleanor is "too unresisting, almost impassive." When, she asks, "was there anything gained in this world by inert submission?" After disparaging women who are part of the women's rights movement (a point of view shared by the author), Grace asserts that she "would have every woman, in her own place, maintain her dignity, and not submit to those little domestic wrongs and tyrannies of your 'very good men,' which are vestiges of the dark ages." Just such a man is Frank. When he loses his faith and, thus, his calling to the ministry, he indulges in self-pity and leaves his wife and children to make their way alone while he goes on a journey of self-discovery. Left to support herself, Eleanor struggles but survives.

As a long-term guest in the homes of her married sisters and brothers for decades, Sedgwick had opportunity to witness much. Yet, she still maintained that "good brothers make good husbands" and had Grace marry Lisle. But the preface of the novel, as well as the last paragraph, reminds readers that an excellent marriage may be a woman's greatest source of happiness, but anything of even slightly lesser quality more likely insures a wretched union from which there is little likelihood of escape. Moreover, Sedgwick argues, women must not view marriage as a form of rescue from an absurd or useless fate as a spinster; women can and do lead happy and fulfilled lives alone. When she died in 1867 at the age of seventy-seven, Sedgwick was still the welcome guest of her family members (particularly her niece, Kate Sedgwick Minot) and a celebrity whose work was in print, if not as popular as in decades past.

Despite Sedgwick's resistance to organized women's rights groups (or to the more-activist aspects of abolitionism), she never endorsed the qualities admired by the Cult of True Womanhood. Indeed, Sedgwick appears to have disputed the kind of woman admired by women's fiction during this period. Not one of her heroines allowed her "self" to be subdued as did Ellen Montgomery in Susan Warner's *The Wide, Wide World* (1850) or silenced as was Hester Prynne in *The Scarlet Letter* (1850). In her decades of fiction writing, Sedgwick offered her readers a remarkable range of women characters, from assertive do-gooders to frightened child-women; from belles of New York society to Native American princesses; and from bad wives of good husbands to good wives of weak or evil men. She also presented spinsters of all ages, shapes, and sizes; wives, widows, lovers loved and unrequited; real women and fictive ones; farmers, shopkeepers, frontiers-

women, and bluestockings; religious hypocrites, cultists, and occultists; black, red, and white.

Her accomplishments, however, are not limited to her female characters any more than her works should be classified only as women's fiction or study of her work confined to *Hope Leslie.* Sedgwick turned the focus of American fiction on women, but she also raised many of the themes most central to American literature as it was evolving, themes equally important today—racism, religious precepts and practice, regionalism, urban and rural issues, consumerism and capitalism, and social welfare. Because she did not always subscribe to the politics or ideology of the majority, her novels and other fictions offer insight into conflicts reformed by canonical representations into consensus. Moreover, she was innovative in style as well as subject. She experimented in the historical romance, in local-color realism, and in the novel of manners, as well as in forms of short and didactic fiction. She often abjured the omniscient narrator and opted instead for multiple narrators—such as the wryly amused voice of a friendly aunt, the voice of the moral arbiter, or the defender of the oppressed. As an increasing number of scholars are discovering, Sedgwick's work offers the student of American literature a different literary and political viewpoint from the usual of the early years of the nation.

Letters:
Life and Letters of Miss Sedgwick, edited by Mary E. Dewey (New York: Harper, 1871).

Biographies:
Gladys Brooks, *Three Wise Virgins* (New York: Dutton, 1957), pp. 53–63;
Mary Kelley, "A Woman Alone: Catharine Maria Sedgwick's Spinsterhood in Nineteenth-Century America," *New England Quarterly,* 51 (June 1978): 209–225;
Kelley, *Private Woman, Public Stage* (New York: Oxford University Press, 1984);
Kelley, "Profile: Catharine Maria Sedgwick (1789–1867)," *Legacy,* 6 (Fall 1989): 43–50;
Kelley, "Negotiating a Self: The Autobiography and Journals of Catharine Maria Sedgwick," *New England Quarterly,* 66 (September 1993): 336–398;
Kelley, "Introduction," *The Power of Her Sympathy: The Autobiography and Journal of Catharine Maria Sedgwick* (Boston: Massachusetts Historical Society, 1993).

References:
Barbara Ann Bardes and Susanne Gossett, *Declarations of Independence: Women and Political Power in Nine-*

teenth-Century American Fiction (New Brunswick, N.J.: Rutgers University Press, 1990);

Erica R. Bauermeister, "*The Lamplighter, The Wide, Wide World,* and *Hope Leslie:* The Recipes for Nineteenth-Century American Women's Novels," *Legacy,* 8 (Spring 1991): 17–28;

Nina Baym, *Woman's Fiction: A Guide to Novels by and about Women in America, 1820–1870,* second edition (Urbana: University of Illinois Press, 1993);

Alide Cagidemetrio, "A Plea for Fictional Histories and Old-Time 'Jewesses,'" in *The Invention of Ethnicity,* edited by Werner Sollors (New York: Oxford University Press, 1989), pp. 14–43;

Christopher Castiglia, "In Praise of Extra-Vagrant Women: *Hope Leslie* and the Captivity Romance," *Legacy,* 6 (Fall 1989): 3–16;

Victoria Clements, ed., "Introduction," *A New England Tale* (New York: Oxford University Press, 1995), pp. xi–xxvii;

Judith Fetterley, "Introduction to 'Cacoethes Scribendi,'" in *Provisions: A Reader from 19th-Century American Women,* edited by Fetterley (Bloomington: Indiana University Press, 1985), pp. 41–49;

Thomas H. Fick, "Catharine Sedgwick's 'Cacoethes Scribendi': Romance in Real Life," *Studies in Short Fiction,* 27 (Fall 1990): 567–576;

Edward Halsey Foster, *Catharine Maria Sedgwick* (New York: Twayne, 1974);

Gregory T. Garvey, "Risking Reprisal: Catharine Sedgwick's *Hope Leslie* and the Legitimation of Public Action by Women," *American Transcendental Quarterly,* 8 (December 1994): 287–298;

Philip Gould, "Catharine Sedgwick's 'Recital' of the Pequod War," *American Literature,* 66 (December 1994): 641–662;

Susan K. Harris, *19th-Century American Women's Novels: Interpretive Strategies* (New York: Cambridge University Press, 1990);

Carol Holly, "Nineteenth-Century Autobiographies of Affiliation: The Case of Catharine Sedgwick and Lucy Larcom," *American Autobiography: Retrospect and Prospect,* edited by Paul John Eakin (Madison: University of Wisconsin Press, 1991), pp. 216–234;

Patricia Larson Kalayjian, "Cooper and Sedgwick: Rivalry or Respect," *James Fenimore Cooper Society Miscellany,* 4 (September 1993): 4–19;

Kalayjian, "Revisioning America's (Literary) Past: Sedgwick's *Hope Leslie,*" *NWSA Journal,* 8 (Fall 1996): 63–78;

Maria LaMonaca, "'She Could Make a Cake as Well as Books . . .': Catharine Sedgwick, Anne Jameson, and the Construction of the Domestic Intellectual," *Women's Writing,* 2 (1995): 235–249;

Dana Nelson, "Sympathy as Strategy in Sedgwick's *Hope Leslie,*" in *The Culture of Sentiment: Race, Gender, and Sentimentality in Nineteenth-Century America,* edited by Shirley Samuels (New York: Oxford University Press, 1992), pp. 191–202;

Cheri Louise Ross, "(Re) Writing the Frontier Romance: Catharine Maria Sedgwick's *Hope Leslie,*" *CLA Journal,* 39 (March 1996): 320–340;

Carol J. Singley, "Catharine Maria Sedgwick's *Hope Leslie:* Radical Frontier Romance," *Desert, Garden, Margin, Range,* edited by Eric Heyne (New York: Twayne, 1992), pp. 110–122;

Sandra A. Zagarell, "Expanding 'America': Lydia Sigourney's *Sketch of Connecticut,* Catharine Sedgwick's *Hope Leslie,*" *Tulsa Studies in Women's Literature,* 6 (Fall 1987): 225–245; republished in *Redefining the Political Novel: American Women Writers, 1797–1901,* edited by Sharon M. Harris (Knoxville: University of Tennessee Press, 1995), pp. 43–65.

Papers:

Catharine Maria Sedgwick's papers are located primarily at the Massachusetts Historical Society in Boston.

Lydia Huntley Sigourney

(1 September 1791 – 10 June 1865)

Paula Kot
Niagara University

See also the Sigourney entries in *DLB 1: The American Renaissance in New England; DLB 42: American Writers for Children Before 1900; DLB 73: American Magazine Journalists, 1741–1850;* and *DLB 183: American Travel Writers, 1776–1864.*

BOOKS: *Moral Pieces, in Prose and Verse* (Hartford: Sheldon & Goodwin, 1815);

The Square Table, anonymous (Hartford: Samuel G. Goodrich, 1819);

No. II. The Square Table, or the Meditations of Four Secluded Maidens Seated Around It, anonymous (Hartford, 1819);

Traits of the Aborigines of America, A Poem, anonymous (Cambridge, Mass.: Harvard University Press, 1822);

Sketch of Connecticut, Forty Years Since, anonymous (Hartford: Oliver D. Cooke & Sons, 1824);

Poems (Boston: Samuel G. Goodrich / Hartford: H. & F. J. Huntington, 1827);

Female Biography; Containing Sketches of the Life and Character of Twelve American Women, anonymous (Philadelphia: American Sunday-School Union, 1829);

Memoir of Phebe P. Hammond, a Pupil in the American Asylum at Hartford (New York: Sleight & Van Norden, 1833);

Evening Readings in History: Comprising Portions of the History of Assyria, Egypt, Tyre, Syria, Persia, and the Sacred Scriptures; With Questions, Arranged for the Use of the Young, and of Family Circles, anonymous (Springfield, Mass.: G. & C. Merriam, 1833; London, 1834);

Letters to Young Ladies, anonymous (Hartford: Printed by P. Canfield, 1833; revised edition, Hartford: William Watson, 1835; revised again, New York: Harper, 1837; revised again, London: Jackson & Walford / Edinburgh: W. Innes, 1841; New York: Harper, 1842);

How to Be Happy. Written for the Children of Some Dear Friends, anonymous (Hartford: D. F. Robinson, 1833);

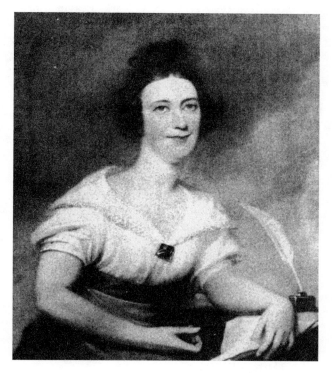

Lydia Huntley Sigourney, 1838 (portrait by John Trumbull; The Wadsworth Atheneum)

Biography of Pious Persons; Abridged for Youth, 2 volumes, anonymous (Springfield, Mass.: G. & C. Merriam, 1833);

The Farmer and the Soldier. A Tale, as L. H. S. (Hartford: Printed by J. Hubbard Wells, 1833);

A Report of the Hartford Female Beneficent Society (Hartford: Printed by Hanmer & Comstock, 1833);

The Intemperate, and The Reformed. Shewing the Awful Consequences of Intemperance and the Blessed Effects of the Temperance Reformation, by Sigourney and Gerrit Smith (Boston: Seth Bliss, 1833);

Sketches (Philadelphia: Key & Biddle, 1834);

Poetry for Children (Hartford: Robinson & Pratt, 1834); enlarged as *Poems for Children* (Hartford: Canfield & Robbins, 1836);

273

Poems (Philadelphia: Key & Biddle, 1834; enlarged, 1836);

Lays from the West, edited by Joseph Belcher (London: Thomas Ward, 1834);

Tales and Essays for Children (Hartford: F. J. Huntington, 1835);

Memoir of Margaret and Henrietta Flower, anonymous (Boston: Perkins, Marvin, 1835); republished as *The Lovely Sisters, Margaret and Henrietta* (Hartford: H. S. Parsons, 1845); republished again as *Margaret and Henrietta* (New York: American Tract Society, 1852);

Zinzendorff, and Other Poems (New York: Leavitt, Lord / Boston: Crocker & Brewster, 1835);

History of Marcus Aurelius, Emperor of Rome (Hartford: Belknap & Hamersley, 1836);

Olive Buds (Hartford: William Watson, 1836);

The Girl's Reading-Book; in Prose and Poetry, for Schools (New York: J. Orville Taylor, 1838; revised, 1839); republished as *The Book for Girls* (New York: J. Orville Taylor, 1844);

Letters to Mothers (Hartford: Printed by Hudson & Skinner, 1838; London: Wiley & Putnam, 1839; revised edition, New York: Harper, 1839);

Select Poems (Philadelphia: F. W. Greenough, 1838; enlarged edition, Philadelphia: E. C. Biddle, 1842; enlarged again, 1845);

The Boy's Reading-Book; in Prose and Poetry, for Schools (New York: J. Orville Taylor, 1839); expanded as *The Boy's Book* (New York: Turner, Hughes & Hayden / Raleigh, N.C.: Turner & Hughes, 1843);

Memoir of Mary Anne Hooker (Philadelphia: American Sunday-School Union, 1840);

Pocahontas, and Other Poems (London: Robert Tyas, 1841; republished, with differing contents, New York: Harper, 1841);

Poems, Religious and Elegiac (London: Robert Tyas, 1841);

Pleasant Memories of Pleasant Lands (Boston: James Munroe, 1842; revised, 1844);

Poems (Philadelphia: John Locken, 1842);

The Pictorial Reader, Consisting of Original Articles for the Instruction of Young Children (New York: Turner & Hayden, 1844); republished as *The Child's Book: Consisting of Original Articles, in Prose and Poetry* (New York: Turner & Hayden, 1844);

The Peace Series No. 3: Walks in Childhood (London: Gilpin, 1844);

Scenes in My Native Land (Boston: James Munroe, 1845; London: Clarke, 1845);

Poetry for Seamen (Boston: James Munroe, 1845); enlarged as *Poems for the Sea* (Hartford: H. S. Parsons, 1850); republished as *The Sea and the Sailor* (Hartford: F. A. Brown, 1857);

The Voice of Flowers (Hartford: Henry S. Parsons, 1846);

Myrtis, With Other Etchings and Sketchings (New York: Harper, 1846);

The Weeping Willow (Hartford: Henry S. Parsons, 1847);

Water-drops (New York & Pittsburgh: Robert Carter, 1848);

Illustrated Poems . . . With Designs by Felix O. C. Darley, Engraved by American Artists (Philadelphia: Carey & Hart, 1849); republished as *The Poetical Works of Mrs. L. H. Sigourney,* edited by F. W. N. Bayley (London: Routledge, 1850);

Whisper to a Bride (Hartford: H. S. Parsons, 1850);

Letters to My Pupils: With Narrative and Biographical Sketches (New York: Robert Carter, 1851);

Examples of Life and Death (New York: Scribner, 1851);

Olive Leaves (New York: Robert Carter, 1852);

The Faded Hope (New York: Robert Carter, 1853);

Memoir of Mrs. Harriet Newell Cook (New York: Robert Carter, 1853);

The Western Home, and Other Poems (Philadelphia: Parry & McMillan, 1854);

Past Meridian (New York: Appleton / Boston: Jewett, 1854; London: Hall, 1855; enlarged edition, Hartford: F. A. Brown, 1856; revised and enlarged again, Hartford: Brown & Gross, 1864);

Sayings of the Little Ones, and Poems for Their Mothers (Buffalo: Phinney / New York: Ivision & Phinney, 1855);

Examples from the Eighteenth and Nineteenth Centuries (New York: Scribner, 1857);

Lucy Howard's Journal (New York: Harper, 1858);

The Daily Counsellor (Hartford: Brown & Gross, 1859);

Gleanings (Hartford: Brown & Gross / New York: Appleton, 1860);

The Man of Uz, and Other Poems (Hartford: Williams, Wiley & Waterman, 1862);

The Transplanted Daisy: A Memoir of Frances Racillia Hackle (New York: Printed by Sanford, Harroun, 1865);

Letters of Life (New York: Appleton, 1866);

Great and Good Women; Biographies for Girls (Edinburgh: W. P. Nimmo, 1866).

OTHER: *The Writings of Nancy Maria Hyde, of Norwich, Conn. Connected with a Sketch of Her Life,* edited anonymously by Sigourney (Norwich, Conn.: Printed by Russell Hubbard, 1816).

"Have I imparted to others, a single pious sentiment, or moral precept for the direction of conduct?"– Lydia Howard Huntley Sigourney once wrote in "Self-Examination," an 8 April 1821 letter held at the Connecticut Historical Society. Sigourney believed that her moral development was inextricably bound to her ability to impart moral sentiments to others. Though twentieth-century critics have derided her writing as

excessively sentimental and moralistic, a valid assessment of her prose must consider her self-proclaimed goals. Sigourney's belief in self-examination reveals that she imagined her life as a female version of Benjamin Franklin's. Like Franklin, she believed that her own betterment led to the betterment of the nation, or, as she put it, the United States "has been uplifted by her self-made men." Like Franklin too, she used the printed word to gain respectability, wealth, and fame. Of humble birth and limited formal education, Sigourney used her talents to re-invent herself as a writer, educator, philanthropist, and self-conscious role model for women. Critics have attacked Sigourney for her "ruthless ambition" as an author, but she availed herself of one of the few opportunities for women to rise in the world of the nineteenth century. Labeled "The Sweet Singer of Hartford," she was arguably the most famous American woman writer of the antebellum period. Sigourney is best known as a poet, but her prose works, which include educational volumes, history, travel literature, temperance tracts, fiction, and advice manuals, represent the bulk of her published writing. Scholars are re-evaluating her contribution to American literary history as they re-examine the values and practices of sentimental writers and the problems associated with being a woman writer in the nineteenth century.

Born in Norwich, Connecticut, on 1 September 1791, Lydia Howard Huntley was the only child of Ezekiel Huntley and his second wife, Zerviah Wentworth Huntley. Lydia maintained a close relationship with her parents throughout her life and attributed to them what she perceived as the most important aspects of her identity—creativity and patriotism. Though Zerviah Huntley was not well educated, she was an avid reader who encouraged her daughter's reading and writing. In her autobiography, *Letters of Life* (1866), Sigourney later described her mother as possessing an "intellect of no common order, rapid perceptions, strong retentive powers, facility of seizing knowledge almost by intuition, and a command of language comprising somewhat of histrionic force." Lydia was particularly devoted to her father. As she put it, "Methinks the love of a daughter for a father is distinct and different from all other loves." She was proud of her father's participation in the American Revolution and of the fact that his father had fought in the French and Indian War.

Ezekiel Huntley was employed as gardener-handyman to the widow of Dr. Daniel Lathrop, Jerusha Lathrop, who was a member of one of the first families of Norwich and a daughter of a former governor of Connecticut. While Lydia's parents taught her industry, order, and obedience, Mrs. Lathrop, "a lady of noble bearing, cultivated intellect, and eminent piety," repre-

Charles Sigourney, who married Lydia Huntley in 1819

sented the model of philanthropy: the transmission of Christian and republican values extending beyond the nuclear family. Mrs. Lathrop devoted herself to Lydia, encouraging her precocity in reading and writing. When she was on her deathbed, Mrs. Lathrop often asked Lydia to read aloud to her. Lydia was fourteen when her mentor died, and overcome with grief, she was sent to visit Mrs. Lathrop's relatives, the Wadsworths of Hartford, Connecticut. Though she was anxious about being away from her parents, the trip was one of the most important of Lydia's life. Mrs. Lathrop's nephew, Daniel Wadsworth, introduced her into Hartford society, invited her to open a school in Hartford for the daughters of his friends, served as a mentor and later as a patron of her writing.

In *Letters of Life* Sigourney recalled that her "earliest promptings of ambition were, not to possess the trappings of wealth or the indulgences of luxury, but to keep a school." As a child, she had transformed her dolls into pupils, and then "talked much and long to them, reproving their faults, stimulating them to excellence, and

enforcing a variety of moral obligations." Lydia Huntley's first effort to establish herself as a teacher, by opening a school in her parents' home, failed because she could find only two students. She then decided to open a girls' school with her friend Nancy Maria Hyde. Hoping to attract more pupils, they decided to travel to Hartford, where they could study the "ornamental branches" of women's education: painting, embroidery, filigree work, and "other things" that Huntley felt were equally "tedious." In 1811 the two young women established a girls' school in Norwich. Then, in 1814 Daniel Wadsworth offered Huntley the opportunity to live in Hartford with his mother and to open a girls' school in his home. Huntley was delighted to find that Wadsworth agreed with her progressive educational philosophy. She could ignore the ornamental branches of women's education and devote more time to the disciplines that encouraged intellectual and moral development: reading, arithmetic, penmanship, geography, rhetoric, history, and natural and moral philosophy. In *Letters of Life* she described how important this school was for her and her students: "It is more to us than the Fourth of July was to our fathers. It began for us a new life." Her attempt to engage the intellects of her students and release them from the burden of women's ornamental education did indeed offer them a new life. Though Miss Huntley's School closed four years later when she married Charles Sigourney, she remained significant in these young women's lives. She and her graduates continued to hold reunions for almost half a century. Her relatively brief tenure as a respected teacher to the children from the elite families of Hartford enabled her to succeed as a leader and role model for young women.

Lydia Huntley's role as an educator led to her career as a published author. She had begun keeping a journal when she was eleven years old, using it to record her studies and quickly realizing that her writing was "conducive to improvement." On her thirteenth birthday she received another journal, which served as "a sort of companion and confidant." She used this journal to develop her skills, composing "serious Essays, or Meditations" that mixed piety and nationalism and addressed topics such as the dangers of pride and ambition. She also included poetry and recitations. She eventually showed these journals to Daniel Wadsworth, seeking his advice as to whether these pieces were appropriate as reading exercises for her students. Wadsworth confirmed her judgment and even suggested that her poems should reach a wider audience. He edited them, read the proofs, wrote the preface, and gathered subscriptions from the first families of several Connecticut and Massachusetts towns for the volume that was published as *Moral Pieces, in Prose and Verse* (1815). Wadsworth also assuaged her fears about the propriety of publishing her work, assuring her in a 27 August 1814 letter that "the result will be to you both profitable and honorable." He was able to sell almost one thousand volumes at one dollar per copy and presented her with "a larger pecuniary amount than had been anticipated." With his help she progressed toward her goal of economic self-reliance and the ability to contribute to the support of her parents.

Wadsworth's influence on Huntley's career extended beyond the physical production of the book. He also played a vital role in the creation of her image as the ideal female author by associating her personal achievements with the virtues she sought to inculcate in others. When Wadsworth wrote to Huntley on 9 November 1814 to describe the preface he was writing for her book, he started to create the identity that would last her lifetime:

> Nothing would be necessary but for the purpose of letting the Public know, that the Author has not had the advantages of Affluence, *& life of education,* among those, whose literary taste, knowledge of the world, & elegant accomplishments, might render her acquirements only a matter of course. . . . It is but justice to yourself, that the Public should have some sense of how entirely all you possess of literature has been from your own exertions.

Though the published advertisement did not mention her poverty, reviewers were made aware of her humble origins. The critic who reviewed *Moral Pieces* for *The North American Review* (May 1815), for example, felt it noteworthy that she had "emancipated herself from the humblest penury." In the advertisement Wadsworth also claimed that her writing "arose from the impulse of the moment, at intervals of relaxation from such domestic employments, as the circumstances of the writer, and her parents, rendered indispensable." Wadsworth echoed the classic defense of women's writing, that the pious young woman and dutiful daughter never neglected her domestic responsibilities, and he ascribed to her the virtues of industry and domestic economy. In *The Female Prose Writers of America* (1852), John S. Hart reiterated this defense, asserting that she "sacrificed no womanly or household duty, no office of friendship or benevolence for the society of the muses. That she is able to perform so much in so many varied departments of literature and social obligation, is owing to her diligence. She acquired in early life that lesson—simple, homely, but invaluable—to make the most of passing time." Throughout her career Sigourney accepted and participated in the idealization of her identity, describing her writing as "originating in impulse." In *Letters of Life* she explained, "my literary course has been a happy one. It commenced in impulse, and was continued from habit. Two principles it has ever

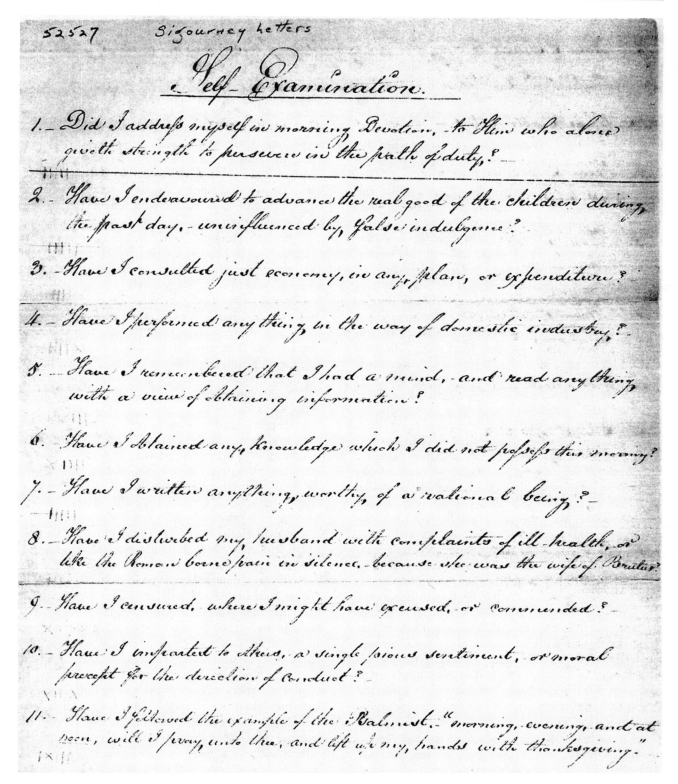

52527 Sigourney Letters

Self - Examination.

1.— Did I address myself in morning Devotion, — to Him who alone giveth strength to persevere in the path of duty? —

2.— Have I endeavoured to advance the real good of the children during the past day, — uninfluenced by false indulgence?

3.— Have I consulted just economy, in any plan, or expenditure?

4.— Have I performed any thing in the way of domestic industry?

5.— Have I remembered that I had a mind, — and read any thing with a view of obtaining information?

6.— Have I obtained any knowledge which I did not possess this morning?

7.— Have I written anything worthy of a rational being? —

8.— Have I disturbed my husband with complaints of ill health, or like the Roman borne pain in silence, because she was the wife of Brutus?

9.— Have I censured, where I might have excused, or commended?

10.— Have I imparted to others, a single pious sentiment, or moral precept for the direction of conduct?

11.— Have I followed the example of the Psalmist, — "morning, evening, and at noon, will I pray, unto thee, and lift up my hands with thanksgiving."

Page from an 8 April 1821 letter in which Sigourney examined her duties to her family and her readers
(The Connecticut Historical Society, Hartford, Connecticut)

kept in view—not to interfere with the discharge of womanly duty, and to aim at being an instrument of good."

Moral Pieces, in Prose and Verse introduces the theme that dominated Sigourney's writing and her understanding of her rise in the world: the power of language to shape reality. Yet, she did not trust that the written word would automatically lead to moral improvement, for she had absorbed from her culture a distrust of imaginative fiction. She revealed this distrust in *Letters of Life* when she recalled the "surreptitious satisfaction" and "remorse" she experienced when first reading "that fearful fiction-book" Ann Radcliffe's *Mysteries of Udolpho* (1794). For Sigourney's American contemporaries, as in earlier eras, fiction was widely believed to addle readers' minds, as it had Don Quixote's, rendering them unable to distinguish between the imaginary world and reality. Women's imaginations were believed to be particularly susceptible to this kind of moral confusion. One way authors responded to warnings about the dangers of delusive fiction was to write didactic prose. Since Sigourney often wrote specifically for a female audience, she was constantly mindful of these warnings. Accordingly, the title of her first collection of prose and verse announces that it has a moral intent.

Moral Pieces, in Prose and Verse delivers lessons on happiness and composition, counseling that happiness can be achieved through the development of one's mind. The book also educates students on the dangers and advantages of reading. Reading can be "either salutary, or pernicious, according to the choice we make of our books." To demonstrate the pernicious effects, one piece charts the fall of a young woman who reads the wrong kind of books: "her mind enervated, her wishes uncertain and contradictory, her temper capricious and whimsical, and her views of life so incorrect and extravagant, that in the world where it must still be her fate to live, she sees nothing but what is offensive, because it is unlike the visionary world she has formed in her own imagination." Thus, novel reading can sap a young woman's energies and sever her from participation in the world around her. Sigourney imagined her own prose and verse as an antidote. Her intent was not merely to reverse the impressions formed by readings with bad moral subject matter, replacing them with pious admonition. Rather, she sought to stimulate her readers to reflect actively on the world around them.

In *Moral Pieces* and throughout her writings, Sigourney hoped to integrate her female readers into the body politic. Whether she was writing reading exercises, conduct manuals, travel sketches, or temperance tracts, she believed that the best writing offered "an excellent moral lesson," inculcating wisdom, patience, and sobriety. Although the rhetoric of separate spheres excluded women from direct participation in government, her prose educated women in patriotism, republican values, and civic virtue. In *Letters to Young Ladies* (1833), an enormously popular advice book that was in its sixteenth edition by 1849, she reminded women that "the nature of our government demands our energies." She wrote, "to a republic, whose welfare depends on the intelligence, and virtue of the people, the character and habits of every member of its family are of value." According to Sigourney, young women were the daughters of a republic whose opinions would influence the public sphere and who would eventually educate the next generation of citizens. Their participation in government might be less visible than their male counterparts' direct participation, but it would nevertheless have far-reaching effects.

Zerviah Huntley's fear that her daughter's love of books "might become extravagant or morbid" and distract her from the important matter of marriage, however, was to some degree well founded. She married later than most women of her time. When Lydia Huntley wed Charles Sigourney on 16 June 1819, she was twenty-seven years old and "a quiet school-dame" who was "most happy with her scholars and friends." By marrying this respectable, wealthy, conservative, and older man, she secured a role in Hartford society and, at least initially, economic stability. At first glance Lydia and Charles Sigourney may have seemed well suited for one another. Contemporaries described him as "a leading merchant of Hartford, and a gentleman of education and literary taste." In addition to his hardware business, he served as president of the Phoenix Bank, warden of Christ Church, and trustee of Trinity College. He built for his bride the stately Sigourney Mansion, which served as the model for the Connecticut House at the Louisiana Purchase Exposition in St. Louis (1904). From the beginning, however, Lydia Sigourney was anxious about her role as his second wife and stepmother to his son and two daughters—and about her rise in class status. She had first met Charles Sigourney in the company of his first wife, an exemplary woman who later died of consumption. In *Letters of Life* Lydia later recalled that, when she married Charles and took charge of his home, "in this new sphere I could scarcely hope to equal my predecessor—who was a model of elegance." Sigourney assumed responsibility for a large and well-established household that included not only her husband and stepchildren but also her predecessor's unmarried sister, clerks from her husband's store, and servants. She worried that she had been too suddenly "initiated into the science of housekeeping, with the shell of the school-mistress still on my head."

At the time of their engagement Charles had asked Lydia to close her Hartford school. Initially he respected his new wife's interest in literature. He

My beloved wife,

I came to you in the spirit of deep self abasement. I come to you in the spirit of kindness, & conjugal affection. I came to you, my wife, in the spirit of prayer; for on my knees have I implored, and repeatedly, the direction & blessing of the Almighty on the application I am about to make to you. ____ But looking back on the past, & forward to the future, my soul sinks within me, and I feel a bitterness of disappointment; & an agony of unhappiness & depression, which admits not of description. What is to become of me, Oh my God!, & what is to become of my beloved wife? Oh! then my wife; listen, but with softened feelings, to what I may say. Ponder it in your heart. And then determine what it is, ____ bound together as we are by a tie of God's holy ordinance which cannot, & must not be severed, ____ what it is that a regard to our united happiness requires to be done. ____

The first years of our marriage (still may it yet be blessed) you may remember that, in addition to the sentiments of love & esteem I entertained for you, I took a pride in admiring the talents with which your mind was adorned, & the efforts, then only occasional, of your poetical imagination. You may remember too, not only my admiration of the powers of your mind, but the satisfaction, & patience with which I cooperated with you in preparing your "Traits," & your "Sketch", & the pleasure with which, in the former work, I anticipated, what did not follow, an honourable, & successful sale. This, my wife, pardon me if I say it, was the more meritorious as; in both cases, I surrendered my own opinions, as regarded the publication of the works, to your wishes. Nevertheless, our minds, to a certain degree, to the period of the publication of the "Traits," were one, & I endeavoured, by every means in my power, not merely to uphold your character, but to extend your reputation. But to this time, however, you restrained, within the limits of what I deemed propriety, your love of publick attention. But, when afterwards, I began to perceive your great susceptibility of praise, and, as I thought, your passion for literary distinction increasing, I perceived also that it led you occasionally, without any motive I agree beyond self-gratification, & thinking no evil, into conduct I could not reconcile with my ideas of the delicate propriety which should ever mark the female character; — that, at first it occupied, as appeared to me, too large a share of your thoughts, — then excluded other duties & feelings as of inferior importance, — and, finally, growing by what it fed on, usurped, & engrossed your whole mind. Then it was that I, by degrees,

Page from one draft of the October 1827 letter in which Charles Sigourney expressed his inability to reconcile his wife's conduct as an author with his "ideas of the delicate propriety which should ever mark the female character" (The Connecticut Historical Society, Hartford, Connecticut)

added the scholarly notes and helped her to publish anonymously *Traits of the Aborigines of America, A Poem* (1822), but he became increasingly uncomfortable with her growing fame and monetary success. Early in the marriage Sigourney had to resort to subterfuge to avoid his displeasure about her publication. She asked her publishers to send all of her correspondence to her father. Since she used the money earned from her writing to support her parents, Charles's prohibitions against publication threatened both her sense of self-reliance and her ability to help her parents in their old age. He forced her to choose between filial responsibility and her duty as a wife to submit to her husband's leadership. The breakdown of the Sigourneys' marriage emphasizes how difficult it was for Lydia Sigourney to balance the different facets of her identity as the ideal, self-made woman and writer.

Sigourney was committed to the business aspects of publication. She arranged her own business and publishing affairs and managed to carry on a personal and business correspondence of some 1,300 to 1,500 letters per year. She also kept track of all aspects of publication, including how volumes would be bound and illustrated. Sigourney often repackaged her old writing in new books. Moreover, her skills as an entrepreneur dovetailed with her role as an educator. For example, she arranged for *The Girl's Reading-Book* (1838) and *The Boy's Reading-Book* (1839) to be adopted in area schools and, of course, she received large royalties on the sales. Within one year *The Girl's Reading-Book* went into its ninth edition.

Charles Sigourney believed that the tensions in their marriage developed from the widening gap between the idealized identity she and others created in print and the self-reliant businesswoman with whom he actually lived. These tensions were demonstrated most clearly in a fourteen-page letter he wrote her in 1827, eight years after their marriage. The letter reveals his enormous anger at his wife, an anger that survived more than one draft of the letter, and his conservative attitude toward women writers. He resented most that her ambitions as an author led her "into conduct I could not reconcile with my ideas of the delicate propriety which should ever mark the female character" and that she had become indifferent toward him. He accuses her of being "seduced by the celebrity of talents" and becoming "intoxicated by success, and flattery." Essentially, Charles Sigourney described his wife's violation of woman's sphere and participation in the public sphere as a form of prostitution: He asked her, "Who wants, or would value, a wife who is to be the public property of the whole community?" He concluded his litany of objections by urging her to "be content to move in your proper sphere" and by using her own words against her. He would allow her to continue to write and publish, he wrote, but only in modera-

tion and provided that she publish anonymously. He advised her to remain, "as your simile expresses it, 'like the sun behind a cloud, yourself unseen.'" Ten months after Charles wrote this letter, after three earlier babies had died in infancy, Lydia Sigourney gave birth to Mary Huntley Sigourney. Within two years she had also borne a son, Andrew Maximilian Sigourney. Though Sigourney continued to publish her writings, her husband's letter nonetheless had a profound influence on her authorship. She spent the rest of her life writing in spite of his recriminations and insisting that her identity as the ideal female writer was true. While he accused her of transgressing the domestic sphere, she continued to use her work to position herself within it.

Early in the relationship Sigourney recognized her marriage constituted a threat to her identity. In her autobiography, written years after Charles Sigourney's death, she turned back to her journal entry for 27 January 1819 to recapture her first feelings on her marriage. The passage is remarkable because it records both her sense of unworthiness and loss of identity: "I feel almost astonished as I write the words. I am no more mine own, but another's. Last evening I promised to do all in my power to advance the happiness of a man of the purest integrity, sensibility, and piety." Sigourney's later description of the ceremony further illuminates the tensions in the relationship. In *Letters of Life* she added that during the ceremony, "my lips gave no sound. The power of articulation fled. The presence of the throng had no influence. It did not enter my mind. I seemed wrapped in a dream, and to have no personal identity with surrounding things." She represented her wedding ceremony, ostensibly the culminating moment of her life, as a nightmarish case of writer's block.

Sigourney detailed the tensions in her marriage in a series of letters to her editor, Theodore Dwight Jr. In 1830 Dwight encouraged her to discontinue publishing anonymously, explaining that she could increase sales by using her own name. Sigourney replied on 2 November: "My husband has often expressed his decided aversion to this step, even when he warmly patronized my intellectual pursuits, and now that he has become their opposer, it would of course, create violent displeasure." She desired to submit to her husband, but she also felt that she could not do so without "utterly burying in the earth those 'few talents' for which I am responsible to their Giver and Judge." In 1835 Sigourney decided to publish the second edition of *Letters to Young Ladies* under her own name. As Dwight had predicted, the volume sold remarkably well and increased the sales of her other publications. On 27 October 1834 Sigourney explained to Dwight that her perspective on publishing had changed with the changes in her husband's fortune: "as my husband has

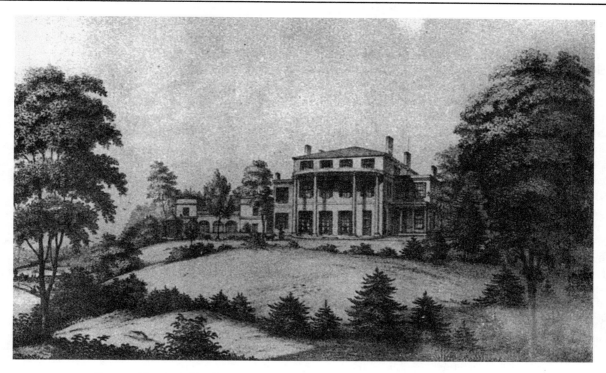

Sigourney Mansion in Hartford, where Lydia and Charles Sigourney lived from 1819 until 1838
(The Connecticut Historical Society, Hartford, Connecticut)

not recently been prosperous in his business, I have felt it my duty to aid him, by pursuing more as a trade, what had previously been only a recreation or solace. It is now considerably more than a year, since I have supplied all my expenses of clothing, charity, literature, etc, besides paying the wages of a woman, who relieves me a part of the day from household care, and I take great pleasure in doing it. I also educate my little children, & take unspeakable delight in their daily lessons." Sigourney attempted to negotiate the conflicting demands of career and marriage. She admitted that she wrote for money, but she also asserted that she sought to assist her husband, not to supplant him. She could afford to relieve herself of household duties, but she retained the role of educator of her children, a role that filled her with "unspeakable delight."

Charles Sigourney's discomfort with his wife's success most likely was exacerbated by the reversal of his fortunes in the late 1830s. He accused his wife of unbridled ambition, but his extravagant design for the Sigourney Mansion had cost more than he had estimated and far exceeded what he could afford. Soon after their marriage he had informed Sigourney that "a system of retrenchment would be expedient, perhaps imperative." In 1838 the family was forced to sell it and move to a more modest home in Hartford. Charles Sigourney implicitly blamed his wife when he explained that they had lost their home because of a "lax system

of domestic economy." From his perspective, the woman who wrote about the home neglected her duties there.

Sigourney's marriage and home life deteriorated to the point that she sought, unsuccessfully, to separate from Charles. But she continued to write books and periodical essays that advised women on marriage, the home, and motherhood. *Whisper to a Bride* (1850), a popular gift book for brides, treated what Sigourney called "the most important era in the life of woman." The book, bound in white, is remarkable for the way it illuminates the tensions in Sigourney's marriage. She urged women to embrace the virtues of cheerfulness, industry, charity, and "forgetfulness-of-self," and to abandon vanity, for "it will disturb thy peace." Yet, she also advised women to develop their accomplishments even after marriage: "If thou hast accomplishments, lay them not aside. For in so doing, thou art unjust to the state of matrimony which God hath ordained." In an essay written in 1860 for the *Home Monthly,* Sigourney likewise sought to promote women's "accomplishments" and to reconcile women's seemingly passive role with her own view of women as agents of social change. In this essay she defended the concept of separate spheres and cautioned her readers on the dangers of overstepping prescribed bounds. She recognized that women might "sometimes covet a more lofty or exposed position" within the public sphere, but she asserted that home is "committed" to

women "as our own sphere." Through a series of rhetorical questions, Sigourney asked her readers why she and they would want to "forfeit things of peculiar value to ourselves, for the uncertain acquisition of those that are not?" She defended women's concern with home, children, and servants, arguing that it was not an indication of intellectual weakness but a decision made by women to transcend the seemingly meaningless strife of the public sphere and concentrate on matters of true value. Far from endorsing a passive role for women, Sigourney argued that women who respected the concept of separate spheres would remain free of the taint of political maneuvering. From this protected and privileged vantage, women could raise a wiser generation of patriots.

Sigourney's *Letters to Mothers* (1838; revised, 1839) advises women how to take an active role within the "body politick" while avoiding the conflicts created by men. She asserted that the body politic has become "diseased" through several influences: "The influx of untutored foreigners, [who are] often unfit for its institutions"; the "inordinate desire of wealth" that is a particular failing of Americans; and masculine conflict, which defined the political arena. She represented republican motherhood as the cure, counseling women, who are "secluded . . . from any share in the administration," that the legitimate exercise of their patriotism is to educate the next generation in republican values through their example of civic virtue: "The degree of her diligence in preparing her children to be good subjects of a just government, will be the true measure of her patriotism." Though women will be working from within the domestic sphere, their influence will extend into and heal the public sphere. Sigourney's model of the bridge between private and public spheres empowers women. In fact, she believed that through their selfless model, women could assume an unbounded power over home and government that would set them "next to the Creator . . . in point of precedence." If women are raising future statesmen, they can determine the proper values for their sons to enact as policy. Sigourney's perception of women's responsibilities toward the nation, as well as her corresponding distrust of men's contributions, creates a vision of the ideal nation as female, for women embody all that is best about it: wisdom, integrity, and peace. At the height of her fame in the 1840s and 1850s, Sigourney's Hartford home attracted hordes of travelers seeking out celebrities.

In the semi-autobiographical *Lucy Howard's Journal* (1858) Sigourney continued her role as an educator, in this case, by providing young women with a model of good behavior. Lucy Howard is pious, virtuous, humble, and patient. She also enjoys writing poetry (though realizing others say it is a waste of time), respects her elders, and understands the importance of good chirography, or

penmanship. Since readers most likely would have recognized the similarities between Lydia Howard Sigourney and her character, Lucy Howard, Sigourney also used this putative work of fiction to continue constructing her own idealized life. Lucy Howard derives her chief happiness through the acquisition of knowledge and does not want to be hurried into womanhood, which she believes will effectively end her education. When Lucy's grandfather, a Revolutionary War veteran like Sigourney's father, implies that women's education is dangerous—injuring their health and distracting them from their role as housekeepers—Lucy's comical rejoinder voices Sigourney's own girlhood frustration at having to quit her schooling: "I don't see why their [women's] housekeeping, or their health either, should be helped by being dunces." Lucy practices Christian resignation and accepts her fate, but she also seeks a way to continue improving her mind, albeit through the new medium of domestic economy. Thus, she treats domestic science as "any other science" and compares learning new recipes to learning a new language. Lucy finally discovers that "female domestic occupations" are not "unfavorable to mental improvement."

Within the plot of the novel, Lucy's marriage to Henry Howard enabled Sigourney to recraft for public consumption her own troubled marriage and to assert the privileges of woman's sphere. While Charles Sigourney had viewed his wife's writing and publication as a threat to their marriage, Lucy's husband encourages her poetic talents. In fact, when Henry realizes that she does not write as much after marriage as she had before, he blames himself. Henry "is troubled" because "he fancies he had checked [my] taste for writing poetry." Sigourney had to give up educating girls when she married, but Lucy opens a school for poor girls after marriage. Henry allows Lucy to realize her essential identity as a poet and educator, but Lucy still espouses conventional attitudes about women's role. When the couple travels to Washington, D.C., and witnesses political strife, Lucy asserts, "One of the privileges of our sex is that they may keep clear of such matters. Our wisdom, even if we were not Christians, is to be peace-makers." Lucy also bows to Henry's desire to settle in the West. Furthermore, Lucy embraces motherhood, but like Sigourney, seeks to widen its scope beyond the natural family; even after she bears a child, Willie, she reaches out to nurture other children as well, including an orphaned Native American girl, Orra.

Sigourney's *Letters of Life* (1866) represents her last attempt to define herself as the ideal woman of the nineteenth century. Though she had spent most of her life educating others in Christian and republican values, she was criticized—by her husband and the general public—

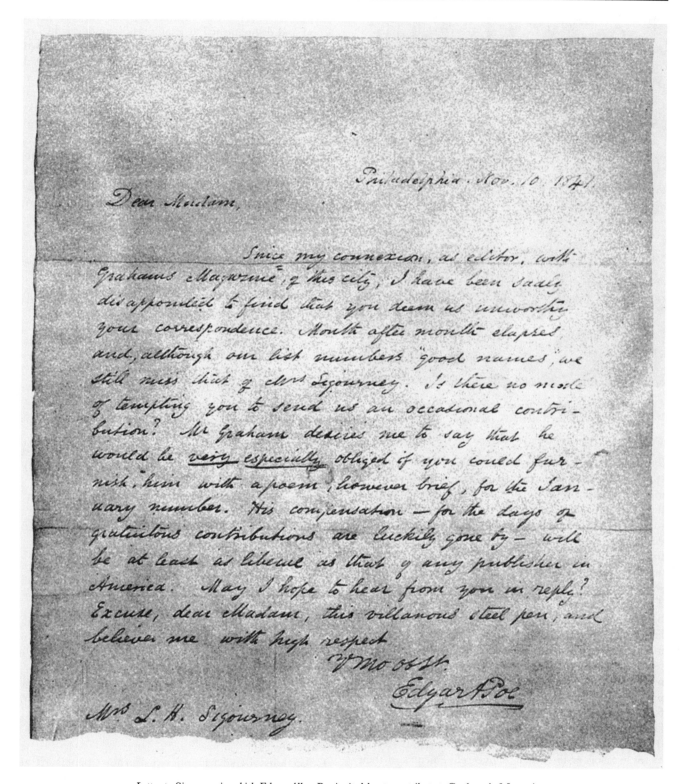

Letter to Sigourney in which Edgar Allan Poe invited her to contribute to Graham's Magazine
(The Connecticut Historical Society, Hartford, Connecticut)

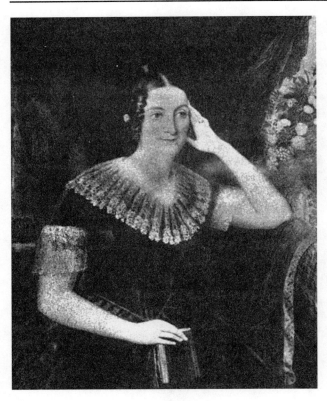

*Sigourney in 1842 (miniature by George Freeman;
The Wadsworth Atheneum)*

for ambitiously overstepping the bounds of woman's sphere. There is no question that Sigourney had engaged in questionable professional conduct. She had published her son's journals after Andrew's death in 1850, even though he had tried to prevent her from doing so by destroying many of them. She had published excerpts from private letters without the consent of the writers and used them to imply that she had developed friendships with famous writers whom she barely knew. Toward the end of her life, the public echoed her husband's earlier accusation: she had made the private public. Sigourney's response in her autobiography was to insist that she had always respected woman's role. She recalled that she had needed a great deal of encouragement to publish her first book since she was wary of stepping "into regions then seldom traversed by the female foot." She asserted that she had never been motivated by fame and was "exceedingly sensitive to aught that bore the appearance of forwardness in my own sex. It seemed to me treason against their native refinement and their allotted sphere."

Throughout her career Sigourney used biographies of famous people as a vital component of her educational mission. For example, she compiled *Female Biography* (1829) because she "had been led to attach

increasing importance to biographical sketches of the good and distinguished as examples of conduct." In *Letters of Life* she set forth "a particular account of my own life"—not to add to her fame—but because she believed "there is no earthly pilgrimage, if faithfully portrayed in its true lights and shadows, but might impart some instruction to the future traveller." Like Benjamin Franklin, her model is meant to demonstrate that "comfort and respectability . . . flow from a life of industry, frugality, and piety" and thereby encourage civic morality. Sigourney could not actively participate in politics, but in her prose she sought to bridge the private and public spheres in such a way as to allow women to exercise their patriotism and affect the political process.

Biography:
Gordon Sherman Haight, *Mrs. Sigourney: The Sweet Singer of Hartford* (New Haven: Yale University Press, 1930).

References:
Nina Baym, *American Women Writers and the Work of History, 1790–1860* (New Brunswick, N.J.: Rutgers University Press, 1995);

Baym, "Reinventing Lydia Sigourney," *American Literature,* 62 (September 1990): 385–404;

Alice DeLana, *Lydia Huntley Sigourney in the Bacon Collection* (Hartford: Hartford Public Library, 1986);

DeLana and Cynthia Reik, eds., *On Common Ground: A Selection of Hartford Writers* (Hartford: Stowe-Day Foundation, 1975);

Joanne Dobson, "Reclaiming Sentimental Literature," *American Literature,* 69 (June 1997): 263–288;

Rufus W. Griswold, *The Female Poets of America* (Philadelphia: Carey & Hart, 1849);

Griswold, *Poets and Poetry of America* (Philadelphia: Carey & Hart, 1842);

John S. Hart, *The Female Prose Writers of America* (Philadelphia: Butler, 1852), pp. 76–83;

Ann Douglas Wood, "Mrs. Sigourney and the Sensibility of the Inner Space," *New England Quarterly,* 45 (June 1972): 163–181;

Sandra Zagarell, "Expanding 'America': Lydia Sigourney's *Sketch of Connecticut,* Catharine Sedgwick's *Hope Leslie,*" *Tulsa Studies in American Literature,* 6 (1987), 225–246.

Papers:
Collections of Lydia Huntley Sigourney's papers are at the Connecticut Historical Society, the Connecticut State Library, the Hartford Public Library, Trinity College, the Huntington Library, the Schlesinger Library at Radcliffe College, the New York Historical Society, and the Boston Public Library.

E. D. E. N. Southworth

(26 December 1819 – 30 June 1899)

Joanne Dobson
Fordham University

and

Amy E. Hudock
University of California, Berkeley

BOOKS: *Retribution; or The Vale of Shadows: A Tale of Passion* (New York: Harper, 1849; London, 1860);

The Deserted Wife (New York: Appleton, 1850; London: Clarke, 1856);

Shannondale; or the Three Beauties (New York: Appleton, 1850); republished as *Winny Darling; or, the Three Beauties of Shannondale* (London, 1857); republished as *The Three Beauties of Shannondale* (Philadelphia: Peterson, 1878);

The Mother-in-Law; or The Isle of Rays (New York: Appleton, 1851; London, 1853);

Virginia and Magdalene; or The Foster Sisters (Philadelphia: Hart, 1852); republished as *The Two Sisters* (Philadelphia: Peterson, 1858; London, 1860);

The Discarded Daughter; or the Children of the Ilse: A Tale of the Chesapeake, 2 volumes (Philadelphia: Hart, 1852);

The Curse of Clifton (Philadelphia: Hart, 1853; London: Beeton, 1853); republished as *Fallen Pride; or, The Mountain Girl's Love* (Philadelphia: Peterson, 1868); republished as *The Tide of Fate; or, The Curse of Clifton* (London: Nicholson, 1885);

Old Neighborhoods and New Settlements (Philadelphia: Hart, 1853; London, 1853); revised as *The Wife's Victory; and Other Novelettes* (Philadelphia: Peterson, 1854);

Mark Sutherland; or Power and Principle (London, 1853); republished as *India: The Pearl of Pearl River* (Philadelphia: Peterson, 1856);

The Lost Heiress (Philadelphia: Peterson, 1854; London: Ward & Lock, 1855);

The Missing Bride; or, Miriam the Avenger (Philadelphia: Peterson, 1855); republished as *Miriam, the Avenger* (Philadelphia: Peterson, 1874); republished as *The Missing Bride; or, Miriam the Avenger* (London, 1878);

Ever Your Friend
E. D. E. N. Southworth

Vivia; or The Secret of Power (Philadelphia: Peterson, 1857);

The Island Princess: or, the Double Marriage (London, 1858); republished as *The Lady of the Isle: A Romance from Real Life* (Philadelphia: Peterson, 1859); also published as *The Arrested Bride; or, The Lady of the Isle* (London: Milner, n.d.);

The Hidden Hand (London, 1859; New York: Dillingham, 1888); part 2 republished as *Capitola the*

Madcap (New York: Hurst, n.d.); republished as *Capitola's Peril* (New York: Sears, 1923);

The Haunted Homestead and Other Nouvellettes. With an Autobiography of the Author (Philadelphia: Peterson, 1860);

The Gipsy's Prophecy: A Tale of Real Life (Philadelphia: Peterson, 1861); republished as *The Gipsy's Prophecy; or, The Bride of an Evening* (Philadelphia: Peterson, 1886); republished as *The Bride of an Evening* (London: Modern, 1935);

Hickory Hall; or The Outcast: A Romance of the Blue Ridge (Philadelphia: Peterson, 1861); republished as *The Prince of Darkness* (Philadelphia: Peterson, 1869); republished as *The Bride's Dowry* (Chicago: Donohue, n.d.);

Astrea, or the Bridal Day (London, 1862); republished as *The Fortune Seeker; or, The Bridal Day* (Philadelphia: Peterson, 1866; London: Milner, 1878);

The Broken Engagement; or, Speaking the Truth for a Day (Philadelphia: Peterson, 1862);

Love's Labor Won (Philadelphia: Peterson, 1862);

The Fatal Marriage; or the Doom of Deville (Philadelphia: Peterson, 1863; London: Milner, 1878); republished as *The Doom of Deville* (New York: Street & Smith, n.d.; Chicago: Donohue, n.d.);

The Bridal Eve; or Rose Elmer (Philadelphia: Peterson, 1864; London: Milner, 1878);

Allworth Abbey; or Eudora (Philadelphia: Peterson, 1865); republished as *Eudora; or, The False Princess* (New York: Lupton, 1894?);

The Widow's Son (Philadelphia: Peterson, 1867);

The Bride of Llwellyn; Sequel to "A Widow's Son" (Philadelphia: Peterson, 1866 [i.e., 1867?]);

The Coral Lady; or The Bronzed Beauty of Paris (Philadelphia: W. C. Alexander, 1867);

Fair Play; or The Test of Lone Isle (Philadelphia: Peterson, 1868; London: Milner, 1878);

How He Won Her: A Sequel to Fair Play (Philadelphia: Peterson, 1869; London: Milner, 1878); republished in part as *Elfie's Vision* (New York: Street & Smith, n.d.);

The Changed Brides (Philadelphia: Peterson, 1869; London: Milner, 1878);

The Bride's Fate: A Sequel to "The Changed Brides" (Philadelphia: Peterson, 1869; London: Milner, 1878);

The Family Doom; or The Sin of a Countess (Philadelphia: Peterson, 1869);

The Maiden Widow: A Sequel to the "Family Doom" (Philadelphia: Peterson, 1870);

The Christmas Guest; or, The Crime and the Curse by Mrs. E. D. E. N. Southworth; and Stories by Her Sister, Mrs. Frances Henshaw Baden (Philadelphia: Peterson, 1870);

Cruel as the Grave (Philadelphia: Peterson, 1871);

Tried for Her Life (Philadelphia: Peterson, 1871);

The Artist's Love by Mrs. E. D. E. N. Southworth; and Stories by her Sister, Mrs. Frances Baden (Philadelphia: Peterson, 1872);

The Lost Heir of Linlithgow (Philadelphia: Peterson, 1872);

A Noble Lord: The Sequel to "The Lost Heir of Linlithgow" (Philadelphia: Peterson, 1872);

A Beautiful Fiend; or, Through the Fire (Philadelphia: Peterson, 1873); republished with *Victor's Triumph* in *Between Two Loves; or, The Slave to Woman's Beauty* (London, Milner, n.d.);

Victor's Triumph: The Sequel to "A Beautiful Fiend" (Philadelphia: Peterson, 1874); republished with *A Beautiful Fiend* in *Between Two Loves; or, The Slave to Woman's Beauty* (London, Milner, n.d.);

The Spectre Lover by E. D. E. N. Southworth; and Other Stories by Her Sister, Mrs. Frances Henshaw Baden (Philadelphia: Peterson, 1875);

Ishmael; or, In the Depths (Philadelphia: Peterson, 1876); republished as *Ishmael; or, The Bride Elect* (London: Milner, n.d.);

Self-Raised; or, From the Depths: A Sequel to "Ishmael" (Philadelphia: Peterson, 1876);

The Bride's Ordeal: A Novel (New York: A. L. Burt, 1877);

Her Love or Her Life: Sequel to "The Bride's Ordeal: A Novel" (New York: A. L. Burt, 1877); republished as *Erma; the Wanderer* (New York: Street & Smith, n.d.);

The Fatal Secret by E. D. E. N. Southworth; and Other Stories by Her Sister, Mrs. Frances Henshaw Baden (Philadelphia: Peterson, 1877);

The Red Hill Tragedy: A Novel (Philadelphia: Peterson, 1877); republished as *Broken Pledges* (Philadelphia: Peterson, 1891);

The Phantom Wedding; or, The Fall of the House of Flint by E. D. E. N. Southworth; and Other Stories by Her Sister, Mrs. Frances Henshaw Baden (Philadelphia: Peterson, 1878);

Sybil Brotherton: A Novel (Philadelphia: Peterson, 1879);

The Trail of the Serpent; or, The Homicide at Hawke Hall (New York: A. L. Burt, 1880);

Why Did He Wed Her? (New York: A. L. Burt, 1884);

For Whose Sake? A Sequel to "Why Did He Wed Her?" (New York: A. L. Burt, 1884);

The Rector's Daughter; Sequel to "For Whose Sake?" (New York: Street & Smith, n.d.);

A Deed Without a Name (New York: A. L. Burt, 1886);

Dorothy Harcourt's Secret: Sequel to "A Deed Without a Name" (New York: A. L. Burt, 1886);

To His Fate: A Sequel to "Dorothy Harcourt's Secret" (New York: A. L. Burt, n.d.);

When Love Gets Justice: A Sequel to "To His Fate" (New York: Street & Smith, n.d.);

A Leap in the Dark: A Novel (New York: Bonner, 1889; London: Milner, n.d.);

Unknown; or the Mystery of Raven Rocks (New York: Bonner, 1889; London: Milner, n.d.);

Mystery of Raven Rocks; A Sequel to "Unknown" (Chicago: Donohue, n.d.);

Nearest and Dearest: A Novel (New York: Bonner, 1889; London: Milner, n.d.);

Little Nea's Engagement: A Sequel to "Nearest and Dearest" (New York: A. L. Burt, 1889);

For Woman's Love: A Novel (New York: Bonner, 1890; London: Milner, n.d.);

An Unrequited Love: a Sequel to For Woman's Love (New York: A. L. Burt, 1890);

The Lost Lady of Lone (New York: Bonner, 1890); republished as *The Mistaken Bride; or, Lost Lady of Lone* (London: Milner, n.d.);

The Unloved Wife: A Novel (New York: Bonner, 1891);

When the Shadow's Darken: A Sequel to the Unloved Wife (New York: Street & Smith, n.d.);

Lilith: A Sequel to "The Unloved Wife" (New York: Bonner, 1891);

Gloria: A Novel (New York: Bonner, 1891); republished as *"Will You Marry Me?"; or, Maria Gloria de la Vera* (London: Milner, n.d.);

David Lindsay: A Sequel to Gloria (New York: Bonner, 1891); republished as *'I Will Marry You'; or, David Lindsay* (London: Milner, n.d.);

A Love Lost and Won; a sequel to "David Lindsay" (New York: Street & Smith, n.d.);

"Em": A Novel (New York: Bonner, 1892);

Em's Courtship (New York: Street & Smith, n.d.);

Em's Husband (New York: Bonner, 1892);

The Mysterious Marriage: A Sequel to "A Leap in the Dark" (New York: A. L. Burt, 1893);

A Skeleton in the Closet: A Novel (New York: Bonner, 1893);

Brandon Coyle's Wife: A Sequel to "A Skeleton in the Closet" (New York: Bonner, 1893);

When Love's Shadows Flee; A Sequel to Brandon Coyle's Wife (New York: Street & Smith, n.d.);

Only a Girl's Heart: A Novel (New York: Bonner, 1893; London: Milner, n.d.);

The Rejected Bride; Only a Girl's Heart, Second Series (New York: Bonner, 1894; London: Milner, n.d.);

Gertrude Haddon: Only a Girl's Heart, Third Series (New York: Bonner, 1894);

The Struggle of a Soul: A Sequel to "The Lost Lady of Lone" (New York: A. L. Burt, 1904);

Sweet Love's Atonement: A Novel (New York: A. L. Burt, 1904);

Zenobia's Suitors: Sequel to Sweet Love's Atonement (New York: A. L. Burt, 1904);

A Tortured Heart ("The Trail of the Serpent") Second Series (New York: Street & Smith, 1907);

The Test of Love; Being the Third and Last Part of "The Trail of the Serpent" (New York: A. L. Burt, 1907);

Love's Suspense; Sequel to A Tortured Heart (New York: Street & Smith, n.d.);

Her Mother's Secret (New York: A. L. Burt, 1910);

Love's Bitterest Cup: A Sequel to "Her Mother's Secret" (New York: A. L. Burt, 1910);

When Shadows Die: A Sequel to "Love's Bitterest Cup" (New York: A. L. Burt, 1910);

When Love Commands (New York: A. L. Burt, n.d.);

Fulfilling Her Destiny: A Sequel to When Love Commands (New York: A. L. Burt, n.d.);

The Initials: A Story of Modern Life (Philadelphia: Peterson, n.d.);

The Three Sisters; or, New Year in the Little Rough-Cast House (New York: Street & Smith, n.d.).

Editions: *The Curse of Clifton* (New York: AMS Press, 1970);

The Hidden Hand, or Capitola Madcap, edited by Joanne Dobson (New Brunswick, N.J.: Rutgers University Press, 1988);

The Hidden Hand, introduction by Nina Baym (Oxford & New York: Oxford University Press, 1997).

SELECTED PERIODICAL PUBLICATIONS–
UNCOLLECTED: "The Irish Refugee," *Baltimore Saturday Visitor* (1846);

"The Better Way; or the Wife's Victory," *National Era* (1847);

"The Thunderbolt to the Hearth," *National Era* (1847);

"The Wife's Mistake," *National Era* (1847);

"The Temptation; or Sybil Brotherton," *National Era* (1847–1848);

"Neighbors' Prescriptions," *National Era* (1848);

"Captain Rock's Pet," *London Journal* (1861–1862).

Emma Dorothea Eliza Nevitte Southworth, who published many of her books under the name Mrs. E. D. E. N. Southworth, was one of the most popular fiction writers in the United States during the mid nineteenth century. Beginning in 1846, she published her novels regularly in newspapers and magazines. When these novels were later published as books, they often bore new titles, and sometimes one serial was published as two or three separate novels. Later editions, both authorized and unauthorized, were frequently retitled again, creating a tangle of interrelated books. Scholars are still attempting to compile a definitive bibliography of Southworth's works, which include at least sixty novels and eight collections of short stories.

Although she wrote almost exclusively for a popular audience, Southworth was respected by critics in

THE MISSING BRIDE;

OR,

MIRIAM, THE AVENGER.

BY

MRS. EMMA D. E. N. SOUTHWORTH.

AUTHOR OF "THE LOST HEIRESS," "THE WIFE'S VICTORY," "CURSE OF CLIFTON," "THE DISCARDED DAUGHTER," ETC.

A dancing Shape—an Image gay
To haunt, to startle, and waylay.

A Being breathing thoughtful breath,
A Traveler between life and death.
The reason firm, the temperate will,
Endurance, foresight, strength, and skill;
A perfect woman, nobly planned,
To warn, to comfort, and command;
And yet a Spirit still, and bright
With something of angelic light.—WORDSWORTH.

Philadelphia:
T. B. PETERSON AND BROTHERS,
306 CHESTNUT STREET.

Frontispiece and title page for Southworth's 1855 novel, which was republished at least a dozen times by the early twentieth century

her day. Her books were read on both sides of the Atlantic and enjoyed as much for their moral overtones as for their energetic characters and lively adventures. Among her literary friends she counted such well-known and well-respected writers as Harriet Beecher Stowe and John Greenleaf Whittier.

Emma Dorothea Eliza Nevitte was born in Washington, D.C., on 26 December 1819. She was the first child of Captain Charles Le Compte Nevitte, a merchant from Alexandria, Virginia, and Susannah Wailes Nevitte of St. Mary's County, Maryland. At the time of her marriage Susannah Wailes was fifteen years old, and Charles Nevitte was a forty-five-year-old widower. Susannah was so young that her mother was asked to live in the newlyweds' household. Southworth remembered her grandmother as the dearest friend of her unhappy childhood. "I was a child of sorrow from the very first year of my life," she later wrote in an autobiographical sketch for John Seely Hart's *Female Prose Writ-*

ers of America (1852). A solitary, dreamy child, she felt herself to be "a weird little elf," scorned and neglected by her family.

When Emma Nevitte was four years old, her father died, and the sensitive child sank into a state of depression: "For months and even years after, I ruminated on life, death, heaven, and hell, with a painful intensity of thought, impossible to describe." Her father's death began the financial hardship that plagued her for many years. The family of women—the young mother, the grandmother, Emma, and her younger sister, Charlotte—were left unsupported in an era when few means of employment were available for middle-class women. They lived frugally on the grandmother's small income in an elegant house, which had been rented on a long-term lease by Charles Nevitte and in which her grandmother attempted to establish a boardinghouse.

When Emma was six her mother married Joshua L. Henshaw of Boston. The marriage began a period of

profound unhappiness for Emma and Charlotte. In an undated letter to her daughter, Lottie, Southworth wrote of the "sad time I and my Sister Charlotte had when we were children," explaining: "we would be left to play in a freezing garret and driven away from the fire in the parlor, and never allowed to come to the table until every body else had done & there was very little left for us, hardly ever having a kind word given to us."

At the school Henshaw opened in Washington, Emma soon became head scholar in her class and developed into an ardent reader. Her active imagination was further nourished by long talks with the family's African American servants, whose ghost stories, legends, and tales of the family's wealthy past absorbed her attention and later surfaced in her fiction. Frequent visits to her mother's home county, St. Mary's, gave her an enduring love for and fascination with the wooded, mountainous countryside of Maryland and Virginia, and she set many of her novels in that terrain.

At the age of sixteen Southworth graduated from Henshaw's school and began a career as a teacher in the public schools of Washington, D.C. In 1840 she married Frederick Hamilton Southworth, an inventor from Utica, New York, and moved with him to Prairie du Chien, Wisconsin. Details about the marriage are sparse. It is known that Emma Southworth returned to Washington from Prairie du Chien in 1844—pregnant, with her small, sickly son, Richmond, in hand, and without her husband.

After the birth of her second child, Charlotte Emma (called Lottie), Southworth returned to teaching in the Washington public schools, earning the inadequate salary of $250 a year. To supplement her income, she began writing short pieces for newspapers, the first of which, "The Irish Refugee," was published in the *Baltimore Saturday Visitor* in 1846. Her first full-length novel, *Retribution,* was published serially in the *National Era* from 12 April through 3 June 1849, and was published as a book later that year by Harper and Brothers in New York.

Southworth's fiction deals melodramatically with the ramifications of women's legal and economic subordination to men and comically with the absurdity of contemporary gender stereotypes and expectations. In her early novels especially, she adeptly and energetically manipulated cultural conventions, particularly as they relate to the deprived lives of women. She peopled her novels with displaced and abused women and pompous, self-interested, ludicrous men. Her female protagonists are deserted wives, discarded daughters, lost heiresses, and missing brides. Tragic as they are, however, these women are for the most part strong, or learning to be strong. While her male characters are occasionally heroic, she more often satirized them for their stereotypical masculine traits.

With her earliest novels Southworth began an ongoing investigation of unconventional strengths and ambitions in a range of female characters. Although they are often either good or evil, her women, especially in her early fiction, do not fit neat patterns. Larger-than-life characters appear as early as Southworth's third book, *The Mother-in-Law* (1851), serialized in the *National Era* in November 1849 – July 1850, but such characters are less typical than her conventionally altruistic, less flamboyant, but nonetheless powerful, heroines.

In *Retribution* the plain, mild-mannered, consumptive heiress, Hester Dent, is a young woman with an abiding sense of integrity and responsibility, whose primary concern is the manumission of her slaves. A foil to Hester, the beautiful, tempestuous, and scheming Juliette Summers seduces Ernest Dent, Hester's husband. On her twenty-first birthday, Hester frees her slaves and then dies. Ernest marries Juliette Summers and lives with her in Europe until Juliette runs off with an aristocrat.

The story of Minny Dozier, a beautiful and talented mulatto daughter of a West Indian sugar planter, who has neglected to free her from slavery, provides a subplot paralleling the primary storyline of masculine self-interest and the consequent suffering of women. A "tragic mulatto" figure predating Harriet Beecher Stowe's Cassie in *Uncle Tom's Cabin* (1852), Minny Dozier is a fascinating and individual character. Most of Southworth's characters—black and white—are stock figures straight from the cultural repertoire of nineteenth-century America. Although an abolitionist and ardent supporter of the Union during the Civil War, Southworth created African American characters who fit the racial stereotypes of her era.

Powerful and malevolent women characters such as Juliette Summers abound in Southworth's work, but she did not believe that the possession and use of power is inappropriate for women. She deplored the abuse of power, particularly when it deprives others of the exercise of free will. In *Retribution* she called these abuses "intangible crimes—sins against mind, heart, or happiness."

In *The Mother-In-Law* Southworth investigated the disastrous effects of a domineering woman's attempts to "gain a life-long ascendancy over the heart and mind" of her daughter and force her daughter's "absolute subjection to her will." Southworth's concern is with the negation of self brought about by unthinking obedience. The daughter, Louise Armstrong, becomes less than human in her obedience to her mother's will, immobilized by her mother's power.

ISHMAEL;

OR,

IN THE DEPTHS.

BY

MRS. EMMA D. E. N. SOUTHWORTH.

AUTHOR OF "THE MISSING BRIDE," "THE CHANGED BRIDES," "A BEAUTIFUL FIEND,"
"HOW HE WON HER," "A NOBLE LORD," "TRIED FOR HER LIFE," "DESERTED WIFE,"
"FATAL MARRIAGE," "LADY OF THE ISLE," "BRIDAL EVE," "CRUEL AS THE GRAVE,"
"THE WIDOW'S SON," "VIVIA," "THE LOST HEIRESS," "FAMILY DOOM,"
"THE ARTIST'S LOVE," "GIPSY'S PROPHECY," "HAUNTED HOMESTEAD,"
"FALLEN PRIDE," "VICTOR'S TRIUMPH," "THE CURSE OF CLIFTON,"
"SPECTRE LOVER," "MAIDEN WIDOW," "FORTUNE SEEKER,"
"THE TWO SISTERS," "FAIR PLAY," "ALLWORTH ABBEY,"
"PRINCE OF DARKNESS," "THE BRIDE'S FATE,"
"MOTHER-IN-LAW," "THREE BEAUTIES," "INDIA,"
"DISCARDED DAUGHTER," "WIFE'S VICTORY,"
"LOVE'S LABOR WON," "RETRIBUTION,"
"THE LOST HEIR OF LINLITHGOW,"
"THE BRIDE OF LLEWELLYN,"
"CHRISTMAS GUEST," ETC.

We almost fancy, that the more
He was cast out from men,
Nature had made him, of her store
A worthier denizen;
As if it pleased her, to caress
A plant grown up so wild
As if his being parentless
Had made him more her child.—R. M. MILNES.

PHILADELPHIA:
T. B. PETERSON & BROTHERS;
306 CHESTNUT STREET.

Title page for one of Southworth's 1876 books, her personal favorite among her novels

The fettering of individuality was Southworth's enduring concern, and tampering with personal freedom provides the locus of evil not only for female but for male characters. Serialized in *The Saturday Evening Post* in 1849 and published as a book in 1850, *The Deserted Wife* is a study of the deliberate, calculated attempt of a man to destroy the independence of a high-spirited, passionate woman by marrying her and using her love for him to bring her to a state of humiliation and dependency. "I wish you joy of your automation!" snaps Hagar Churchill to her new husband, Raymond Withers, who induces a wifely "docility" that proves neither profound nor permanent.

In 1856 Southworth, who was overwhelmed by what she later described as "the combined effect of overwork, and under pay, of anxiety and of actual privation," was approached by Robert Bonner, editor of *The New York Ledger,* with an offer she could not resist: "My own belief," Bonner wrote on 10 October 1856, "is that there is no female author either on this or the other side of the Atlantic, who can write so excellent a story." On 22 October, after receiving Southworth's response to his solicitation, he replied, "*I want to secure all you write . . . and I am willing to pay you your own terms; or double as much, at least, as you have ever received from any other newspaper publisher*" [italics in original]. The enterprising Bonner gave Southworth a generous contract for exclusive rights to her novels, an arrangement that continued for the next thirty years of her professional life. Southworth profited financially from the arrangement, which also made money for Bonner and his paper. The circulation of the *Ledger,* the most popular of the weekly American story papers, is said to have doubled when Southworth began to write for it.

Of all the Southworth novels published serially in the *Ledger,* the most popular was *The Hidden Hand* (serialized in 1859 and not published as a book in the United States until 1888). Furthermore, of all her strong female characters, its heroine, Capitola Le Noir, known as Cap Black, is the most enticing. An irreverent ruffian

in her early teens, Cap describes herself as "a damsel-errant in quest of adventures." Kidnapped as an infant, Cap has spent her childhood years in Rag Alley, a New York City slum, and her early adolescence in fending for herself on the streets. When her guardian finds her there, she is disguised as a boy, selling newspapers and running odd jobs. As a street boy, she has "never been taught obedience or been accustomed to subordination." After she is "rescued" and taken back to her ancestral Virginia, she finds a conventional woman's life stultifying. She is "bored to death" she says, "decomposing above ground for want of having my blood stirred," and goes "in quest of adventures." With insouciance and style she rescues damsels in distress, captures bandits, and fights duels.

The Hidden Hand captivated the popular imagination. The entire novel was republished in the *Ledger* in 1868–1869 and in 1883 and was dramatized in forty stage versions. An unauthorized edition of the novel appeared in London in 1859, and the eventual authorized book publication came after years of requests from book publishers for publication rights. *The Hidden Hand* is the only one of Southworth's novels currently in print. With her implicit critique of conventional gender definitions, Cap fascinated Southworth's contemporaries—and continues to interest readers. Cap attacked the great humbug that limited the lives of nineteenth-century women—the cultural ethos of feminine obedience and subordination.

Southworth wrote prolifically, often staying awake until late at night to finish her weekly installment by the light of a kerosene lamp. At times she sent Bonner forty to sixty pages a week, and she habitually began a new novel as soon as the previous one was finished.

Southworth was a popular writer in the most accurate sense of the term. Not only did her work find continued favor with an enormous popular audience, but she herself wrote from the vantage point of the people, always bearing in mind the desires and preferences of her audience. Conventional pieties, personal passions, and radical departures from gentility intermingle in Southworth's work, reflecting not only her intimate involvement with the values of her society, but also the complexity and self-contradictions inherent in that culture.

Southworth's personal favorite of her novels was *Ishmael* (1876), serialized in 1863–1864 as "Self-Made, or Out of the Depths." Investigating what Southworth saw as the ideal masculine character, this novel is the story of a boy born into poverty and disgrace. Believed to be illegitimate, he rises to great heights without compromising his moral integrity. The memory of his dead mother and his reverence for women motivates Ish-

mael, characterizing his life and great public service. The novel stresses the femininity of Ishmael's character; he is pious, altruistic, and emotional—qualities Southworth obviously thought men should learn from women.

Southworth's *Fair Play* (1868) and *How He Won Her* (1869), serialized together in 1865–1866 as "Britomarte, the Man-Hater," have a feminist protagonist. Britomarte Conyers has renounced marriage until such time as society has corrected the inequitable relationship between man and woman. Nonetheless, Britomarte—"the man hater, the woman's champion, the marriage renouncer . . . magnificent in the sense of conscious strength, ardor and energy with which she impressed all"—ends up on a desert island and on a Civil War battlefield with the man she loves. Like Capitola, Britomarte dresses and acts like a man. She is a woman who "if law and custom had allowed her freer action and a fairer field, . . . would have influenced the progress of humanity and filled a place in history."

At the height of Southworth's career she was earning about $6,000 a year, but she maintained this comfortable income by arduous toil and at the cost of physical health. She suffered from the weight, she told Bonner, of having had "the life long double burden of man and woman laid upon me." At the end of her life she was in straitened financial circumstances and had little to show for her labors.

Southworth was a popular novelist whose strength lay in her ability to render cultural fantasies in all their fascinating and self-contradictory complexity. Especially in the early years of her career, when her writing was at its liveliest, her many readers were not unanimously approving. Many felt a disquieting sense of anxiety about her idiosyncratic vision of life. Although her contemporaries—such as Sarah Josepha Hale, the influential editor of *Godey's Lady's Book*—praised Southworth for her passion and imagination, some—including Hale—were also uneasy about the bold energy of Southworth's depictions of human behavior. Hale accused Southworth of a "freedom of expression that almost borders on impiety" and was critical of her "enthusiasm for depicting character as it is actually found . . . beyond the limits prescribed by correct taste or good judgement." Henry Peterson, her editor at *The Saturday Evening Post* in the early 1850s, chastised her repeatedly for her literary freedom, urging her to "keep up the noble and Christian elements of the story," and to "avoid that vein I so much dislike and fear." "I stand between you and literary perdition," he warned. In an era of severe constraints on the expression of women and on the depiction of female characters, Southworth often crossed the invisible boundaries of strict propriety, depicting women who challenge the restraints

placed on them by the prevailing ideal of white, genteel womanhood.

Although Southworth's novels have feminist implications, her books do not campaign for the rights of women in the political manner usually defined as feminist. Rather, she felt and recorded a deep personal sense of outrage at the oppression and deprivation in her own life and in the lives of women she saw around her. For more than forty years Southworth's protagonists defined independence, integrity, and personal strength as central to a woman's existence, and, as a widely read writer, she inevitably helped to shape the popular perception of women.

Biography:

Regis Louise Boyle, *Mrs. E. D. E. N. Southworth, Novelist* (Washington, D.C.: Catholic University of America Press, 1939).

References:

Nina Baym, *Women's Fiction: A Guide to Novels by and about Women in America, 1820–1870* (Ithaca, N.Y.: Cornell University Press, 1978);

Herbert Ross Brown, *The Sentimental Novel in America: 1789–1860* (Durham, N.C.: Duke University Press, 1940);

Lynette Carpenter, "Double Talk: The Power and Glory of Paradox in E. D. E. N Southworth's *The Hidden Hand*," *Legacy,* 10, no. 1 (1993): 17–30;

Alexander Cowie, *The Rise of the American Novel* (New York: American Book Company, 1948);

Joanne Dobson, "The Hidden Hand: Subversion of Cultural Ideology in Three Mid-Nineteenth Century American Women's Novels," *American Quarterly,* 38, no. 2 (1986): 223–242;

Dobson, Introduction to *The Hidden Hand, or Capitola the Madcap,* edited by Dobson (New Brunswick, N.J.: Rutgers University Press, 1988);

Alfred Habegger, *Gender, Fantasy, and Realism in American Literature* (New York: Columbia University Press, 1982);

Habegger, "A Well-Hidden Hand," *Novel,* 14 (1981): 197–212;

Susan K. Harris, "The House That Hagar Built: Houses and Heroines in E. D. E. N. Southworth's *The Deserted Wife*," *Legacy,* 4, no. 2 (1987): 17–29;

James D. Hart, *The Popular Book* (New York: Oxford University Press, 1950);

John Seely Hart, *Female Prose Writers of America* (Philadelphia: E. H. Butler, 1852);

Amy Hudock, "Challenging the Definition of Heroism in E. D. E. N. Southworth's *The Hidden Hand*," *American Transcendental Quarterly,* 9, no. 1 (1995): 5–20;

Hudock, "No Mere Mercenary: The Early Life and Fiction of E. D. E. N. Southworth," dissertation, University of South Carolina, 1993;

Mary Kelley, *Private Woman, Public Stage: Literary Domesticity in Nineteenth-Century America* (New York: Oxford University Press, 1984);

Ann Merrill, "The Novels of E. D. E. N. Southworth: Challenging Gender Restrictions and Genre Conventions," dissertation, Emory University, 1993;

Frank Luther Mott, *Golden Multitudes: The Story of Best Sellers in the United States* (New York: Macmillan, 1947);

Helen Waite Papashvily, *All the Happy Endings: A Study of the Domestic Novel in America, the Women Who Wrote It, the Women Who Read It, in the Nineteenth Century* (New York: Harper, 1956);

Fred Lewis Pattee, *The Feminine Fifties* (New York: Appleton, 1940).

Papers:

There are collections of E. D. E. N. Southworth's papers in the Library of Congress and in the William R. Perkins Library at Duke University.

Maria W. Stewart

(?1803 – December 1879)

Robin M. Dasher-Alston

BOOKS: *Religion And The Pure Principles of Morality, The Sure Foundation On Which We Must Build* (Boston: Garrison & Knapp, 1831);

Meditations From The Pen of Mrs. Maria W. Stewart (Boston: Garrison & Knapp, 1832); revised and expanded as *Meditations from The Pen of Mrs. Maria W. Stewart, (Widow of the late James W. Stewart), Now Matron of the Freeman's [sic] Hospital, and Presented in 1832 to the First African Baptist Church and Society of Boston, Mass., First Published by W. Lloyd Garrison and Knap [sic], Now most respectfully Dedicated to the Church Militant of Washington, D.C.* (Washington, D.C., 1879);

Productions of Mrs. Maria W. Stewart, Presented to the First African Baptist Church and Society, of the City of Boston (Boston: Published by Friends of Freedom and Virtue, 1835).

SELECTED PERIODICAL PUBLICATION–UNCOLLECTED: "Cause for Encouragement," *Liberator* (14 July 1832).

Maria W. Stewart was an abolitionist, a foremother of the women's rights movement, and an advocate for African American self-determination. In 1831 and 1832 she published two short works, a compilation of devotional meditations and essays and a pamphlet that demonstrated an evolving synthesis between religious fervor and social activism. In 1832 and 1833 she delivered four public lectures, including what women's studies scholars call the first by a black woman to a mixed-gender audience, a 21 September 1832 political address on the abolition of slavery, women's rights, racial pride, and the empowerment of the disenfranchised. In 1835 a collection of her speeches and essays was published, and in 1879, just months before her death, she expanded and republished the 1832 collection of meditations. Limited information about her life was known before Marilyn Richardson's biography, *Maria W. Stewart, America's First Black Woman Political Writer* (1987). Her literary contributions, her evolution

as a public figure, her role in paving the way for reformers such as Sojourner Truth, Frederick Douglass, and Frances Ellen Watkins Harper, among others, was not recognized until 108 years after her death.

Maria W. Stewart (née Maria Miller) was born in Hartford, Connecticut, in 1803. Little is known about her early years in Connecticut, except that she was orphaned at an early age and was "bound out" to a clergyman from the age of five until she was fifteen. She continued to work as a domestic servant until her marriage in 1826 to James W. Stewart, a member of Boston's burgeoning African American middle class. At a time when most free African American men worked as laborers, James Stewart owned his own business, outfitting boats and ships. Maria Stewart assumed the middle initial "W" at her husband's request shortly after their marriage.

James Stewart died in 1829, after less than four years of marriage, and his assets were appropriated by the unscrupulous machinations of several white businessmen. Grief-stricken and destitute, Maria W. Stewart experienced a religious conversion that inspired her to express her strong convictions by writing about the social, political, and economic oppression experienced by African Americans, free and slave alike. Having received no formal educational instruction as a child, she learned to read and write while attending Sabbath classes as an adult. The Sabbath schools of the nineteenth century often combined secular educational instruction with religious teachings.

Stewart was profoundly influenced by the writings and actions of David Walker (1785–1830). Walker, who also lived in Boston, was a businessman who vocally advocated the abolition of slavery. In 1829 he wrote and published a pamphlet titled *Walker's Appeal, In Four Articles; Together With A Preamble, To The Colored Citizens of The World, But In Particular, and Very Expressly, To Those Of The United States of America,* a work radical for its time because it not only called for the abolition of slavery but urged African Americans actively to resist racism and oppression. Walker was a deeply

religious man who peppered his liberationist rhetoric with religious and biblical references. He was blamed for inciting the 1831 slave revolt in Virginia led by Nat Turner. Walker died under mysterious circumstances less than one year before Stewart's emergence into the public arena, but she felt his influence, as she readily acknowledged in *Religion And The Pure Principles of Morality,* first published in the 8 October 1831 issue of *The Liberator* about two months after Turner's rebellion:

> Many will suffer for pleading the cause of oppressed Africa, and I shall glory in being one of her martyrs; for I am firmly persuaded, that the God in whom I trust is able to protect me from the rage and malice of mine enemies, and from them that will rise up against me; and if there is no other way for me to escape, he is able to take me to himself, as he did the most noble, fearless, and undaunted David Walker.

Emboldened by her religious beliefs, Stewart "made a public profession of [her] faith in Christ" and embarked on a crusade against racial injustice. She recalled in *Religion And The Pure Principles of Morality,* "From the moment I experienced the change, I felt a strong desire, with the help and assistance of God, to devote the remainder of my days to piety and virtue, and now possess that spirit of independence that, were I called upon, I would willingly sacrifice my life for the cause of God and my brethren."

In 1831 Stewart, then a young widow of twenty-eight, approached William Lloyd Garrison with her first manuscript. Garrison, the publisher of the abolitionist newspaper *The Liberator* and later one of the most influential members of the abolitionist movement in the United States, was sufficiently impressed by her work to publish it first in his paper, then as a pamphlet, *Religion And The Pure Principles of Morality, The Sure Foundation On Which We Must Build* (1831).

The tract was significant for two reasons. It was written by a woman of color in the early 1800s, when women in general were relegated to the domestic sphere, and when African American women were viewed, if their plight was contemplated at all, with a mix of contempt and indifference. In addition, the sociopolitical message of *Religion And The Pure Principles of Morality* was directed primarily at the free African American community. During the early years of the abolitionist movement, most white abolitionists rallied against slavery on purely philosophical and/or religious grounds. Few believed that African Americans were inherently equal or possessed the potential to become full and active citizens in American society.

Stewart challenged African Americans, particularly African American women, to pursue their quest for liberation from oppression. She believed that Afri-

can American women had a particular responsibility for the betterment of the race. As she wrote in *Religion And The Pure Principles of Morality,* "O, ye daughters of Africa, awake! Awake! Arise! No longer sleep nor slumber, but distinguish yourselves. Show forth to the world that ye are endowed with noble and exalted faculties."

Throughout Stewart's brief public career she would use the secular lectern and the printed page of *The Liberator* to spread the word of God with the righteous zeal of a missionary. She wrote in *Religion And The Pure Principles of Morality*: "Finally, my heart's desire and prayer to God is that there might come a thorough reformation among us. Our minds have too long grovelled in ignorance and sin. Come, let us incline our ears to wisdom, and apply our hearts to understanding; promote her, and she will exalt thee; she shall bring thee honor when thou dost embrace her." According to Marilyn Richardson, Stewart's writings "synthesi[ze] . . . religious, abolitionist, and feminist concerns. . . ."

Several of the essays Stewart wrote between 1831 and 1833 were published by Garrison in *The Liberator.* Garrison's newspaper provided an important public platform for Stewart's feminist and abolitionist writings because it gave her credibility within the abolitionist community, provided a readership that extended beyond Boston, and exposed her work to an integrated audience of African Americans and whites of both sexes. The successful publication of her essays further encouraged her to accept invitations to lecture publicly.

Both the publisher and the newspaper proved to be influential in Stewart's evolution as an activist and advocate for human rights. In 1832 Garrison attended the Second Annual Convention of the People of Color in Philadelphia. While there, he was invited to attend a meeting of the Female Literary Association and later wrote in the 30 June 1832 issue of *The Liberator* that the meeting ". . . was one of the most interesting spectacles he had ever witnessed. If traducers of the colored race could be acquainted with the moral worth, just refinement, and large intelligence of this association, their mouths would hereafter be dumb." Stewart was so taken by his account of the convention that she was inspired to write an essay, "Cause for Encouragement," published in the 14 July 1832 issue of *The Liberator,* where she proclaimed, "The day-star from on high is beginning to dawn upon us, and Ethiopia will soon stretch forth her hands unto God. These Anti-slavery societies, in my opinion, will soon cause many grateful tears to flow, and desponding hearts to bound and leap for joy." The essay also provided an opportunity for Stewart to urge African Americans to develop the "moral worth" and "excellence of character" needed to persevere and become "worthy of imitation."

The concerns that Maria Stewart expressed about the "fair daughters of Africa" were exemplified in a speech she delivered on 21 September 1832 at Franklin Hall. She began the lecture with an explosive question directed squarely at the free African American community in Boston: "Why sit ye here and die?" One theme that readers will find throughout Stewart's essays and lectures is the obligation that people of color have to become self-reliant and to struggle against degradation: "Yet, after all, methinks were the American free people of color to turn their attention more assiduously to moral worth and intellectual improvement, this would result: prejudice would gradually diminish, and the whites would be compelled to say, unloose those fetters." Confident in her actions, she offered herself as an exemplar of self-determination when she asked "[w]ho shall go forward, and take off the reproach that is cast upon the people of color? Shall it be a woman? And my heart made this reply—If it is thy will, be it even so, Lord Jesus!"

As a passionate advocate of women's rights, Stewart was forthright in expressing her dismay that white women were not inclined to link their struggle against oppression to that of "Afric's daughters." Accordingly, she urged, "O, ye fairer sisters, whose hands are never soiled, whose nerves and muscles are never strained, go learn by experience! Had we the opportunity that you have had, to improve our moral and mental faculties, what would have hindered our intellects from being as bright, and our manners from being as dignified as yours?"

In the spring of 1832 Stewart was invited to serve as the anniversary speaker at the Afric-American Female Intelligence Society of America. By this time, the cries of her critics were loud and insistent. She was determined that "[t]he frowns of the world shall never discourage me, nor its smiles flatter me; for with the help of God, I am resolved to withstand the fiery darts of the devil, and the assaults of wicked men. The righteous are as bold as a lion, but the wicked fleeth when no man pursueth. I fear neither man nor devils; for God in whom I trust is able to deliver me from the rage and malice of my enemies, and from them that rise up against me." Yet, she continued to forge ahead, solid in her belief "that God has fired my soul with a holy zeal for his cause." She reproached her fiercest critics in the African American community of Boston for failing to recognize the righteousness of her efforts.

And why is it, my friends, that we are despised above all the nations upon the earth? Is it merely because our skins are tinged with a sable hue? No, nor will I ever believe that it is. What then is it? Oh, it is because that we and our fathers have dealt treacherously with one

The African Meeting House in Boston, where Stewart delivered one of her first speeches, as it appeared before 1850

another, and because many of us now possess that envious and malicious disposition, that we had rather die than see each other rise an inch above a beggar.

Stewart believed that free African Americans had not taken advantage of the opportunities available to build a mutually cooperative and self-reliant community. In a lecture delivered at the African Masonic Hall on 27 February 1833, she explained that "it was our gross sins and abominations that provoked the Almighty to frown thus heavily upon us, and give our glory unto others." She believed that once African Americans demonstrated their true moral character, society certainly would not be able to ignore their collective value as a people.

Stewart did not ignore the efforts of whites to deny the "sons and daughters of Africa" the social and political rights of citizenship. When the movement to colonize Liberia and to repatriate African Americans to Africa was under way—touted as a way to resolve the "Negro problem"—Stewart struck forcefully: ". . . now that we have enriched their soil, and filled their coffers, they say that we are not capable of becoming like white men, and that we can never rise to respectability in this country. They would drive us to a strange land. But before I go, the bayonet shall pierce me through."

Her literary efforts were, on one hand, full of hope, understanding, and expectation; yet they also seemed admonitory. In response to her detractors who were offended at the thought that an African American woman would emerge, without apologies, into the public sphere, she stated in "An Address Delivered At the African Masonic Hall" (*The Liberator*, 2 March 1833),

"Had those men among us who had an opportunity, turned their attention as assiduously to mental and moral improvement as they have to gambling and dancing, I might have remained quietly at home and they stood contending in my place."

By 1833 Stewart had grown tired of the constant criticisms that she received as a result of her public lectures. She delivered what was billed as her farewell address to the people of Boston on 21 September 1833, explaining what led her to step into the public arena. Stewart exclaimed "[w]hat if I am a woman. . . ? . . . [H]oly women ministered unto Christ and the apostles; and women of refinement in all ages, more or less, have had a voice in moral, religious and political subjects." Moreover, she declared ". . . I am about to leave you, perhaps never more to return. For I find it is no use for me as an individual to try to make myself useful among my color in this city. It was contempt for my moral and religious opinions in private that drove me thus before a public."

Following Stewart's departure from Boston, she moved to New York, then to Baltimore and on to Washington, D.C. Her continued involvement with women's literary societies, such as the New York Ladies Literary Society, proved instrumental to her development as an educator. She taught in New York and Baltimore, founded a private school in Washington, D.C., and, toward the end of her life, became a matron of the Freedmen's General Hospital and Asylum in Washington. The hospital served as a medical facility, a settlement for former slaves, a school, and a mutual aid society. Stewart remained in Washington, D.C., until her death in December 1879. She did not lecture publicly again after leaving Boston, but her connection to the city was not completely severed. In 1835 a collection of her speeches was compiled and published under the title *Productions of Mrs. Maria W. Stewart*. It included *Religion And The Pure Principles of Morality* (1831), along with the lectures she delivered between 1832 and 1833. She continued active participation in the abolitionist movement and attended the 1837 national convention of the antislavery societies.

In 1878 Stewart received a much-needed pension as a result of her deceased husband's service in the War of 1812, which enabled her to expand and republish the 1832 version of *Meditations From The Pen of Mrs. Maria W. Stewart*. The book contained not only her previously published collection of essays and lectures, but introductory letters from friends and colleagues, a biographical sketch, and a brief memoir covering some of the major events of her life. The autobiographical portion of *Meditations* was aptly titled "Sufferings During the War." Published just months before her death, the book serves as a fitting tribute to her life.

Maria Stewart's role as a public figure was relatively brief. Yet, the scholarship of the last twenty years has positioned her as a foremother of the black and white activists who emerged some years later, such as Sarah and Angelina Grimké and Sojourner Truth. As Garrison stated almost fifty years after first meeting Stewart, "[y]our whole adult life has been devoted to the noble task of educating and elevating your people, sympathizing with them in their affliction, and assisting them in their needs. . . ."

Biography:
Marilyn Richardson, ed., *Maria W. Stewart, America's First Black Woman Political Writer, Essays and Speeches* (Bloomington & Indianapolis: Indiana University Press, 1987).

References:
Ernest G. Bormann, ed., *Forerunners of Black Power: The Rhetoric of Abolition* (Englewood Cliffs, N.J.: Prentice-Hall, 1971), pp. 174–197;

Paula Giddings, *When and Where I Enter: The Impact of Black Women on Race and Sex in America* (New York: Morrow, 1984), pp. 49–54, 195, 99–100;

Darlene Clark Hine, *Hine Sight: Black Women and the Re-Construction of American History* (Brooklyn, N.Y.: Carlson, 1994), pp. 9, 50–51;

Gerda Lerner, ed., *Black Women in White America: A Documentary History* (New York: Pantheon, 1972), pp. 83–85, 526–530, 563–566;

Bert James Loewenberg and Ruth Bogin, eds., *Black Women in Nineteenth-Century American Life: Their Words, Their Thoughts, Their Feelings* (University Park: Pennsylvania State University Press, 1976);

Lillian O'Connor, *Pioneer Women Orators: Rhetoric in the Ante-Bellum Reform Movement* (New York: Columbia University Press, 1954), pp. 42, 43, 53–55, 126, 137, 142, 145, 146, 167, 169, 178, 179, 192, 215, 229;

Benjamin Quarles, *Black Abolitionists* (New York: Oxford University Press, 1969), pp. 7, 50, 192;

Dorothy Sterling, ed., *We Are Your Sisters: Black Women in the Nineteenth Century* (New York & London: Norton, 1984), pp. 153–159;

Emilie M. Townes, ed., *A Troubling In My Soul: Womanist Perspectives on Evil and Suffering* (Marynoll, N.Y.: Orbis, 1993), pp. 2, 13, 14–16, 21–32, 182;

Jean Fagan Yellin and John C. Van Horne, eds., *The Abolitionist Sisterhood: Women's Political Culture in Antebellum America* (Ithaca, N.Y. & London: Cornell University Press, 1994), pp. 1–19, 119–137, 139–158.

Lucy Stone

(13 August 1818 – 18 October 1893)

Katharine Rodier
Marshall University

See also the Stone entry in *DLB 79: American Magazine Journalists, 1850–1900.*

BOOKS: *Proceedings of the Anti-slavery Convention of American Women, Held in Philadelphia, May 15th, 16th, 17th, and 18th, 1838* (Philadelphia: Merrihew & Gunn, 1838);

Proceedings of Woman's Rights Convention Held at Worcester, October 23 and 24, 1850 (Boston: Prentiss & Sawyer, 1851);

Proceedings of Woman's Rights Convention Held at Worcester, October 23 and 25, 1850 (Boston: Prentiss & Sawyer, 1851);

Proceedings of the Second Woman's Rights Convention Held at Worcester, October 15th and 16th 1851 (New York: Fowler & Wells, 1852);

Proceedings of Woman's Rights Convention, held at West Chester, Pa., June 2d and 3d, 1852 (Philadelphia: Merrihew & Thompson, 1852);

Proceedings of the Third Woman's Rights Convention (Syracuse, N.Y.: J. E. Masters, 1852);

Proceedings of Woman's Rights Convention held at the Broadway Tabernacle, in the City of New York, on Tuesday and Wednesday, Sept. 6th and 7th, 1852 (New York: Fowler & Wells, 1853);

Proceedings of the Fourth Woman's Rights Convention (New York: Fowler & Wells, 1853);

The Whole World's Temperance Convention, Held at Metropolitan Hall in the City of New York . . . Sept. 1st and 2nd, 1853 (New York: Fowler & Wells, 1853);

Proceedings of the World's Temperance Convention, Held at Metropolitan Hall, in the City of New York, September 6, 1853 (New York: Printed by S. W. Benedict, 1853);

Proceedings of the National Woman's Rights Convention, Held at Cleveland, Ohio, on Wednesday, Thursday, and Friday, October 5th, 6th, and 7th, 1853 (Cleveland, Ohio: Gray, Beardsley, Spear, 1854);

Woman's Rights Tracts, Nos. 1–5 (Rochester, N.Y.: Steam Press of Curtis, Butts, 1854);

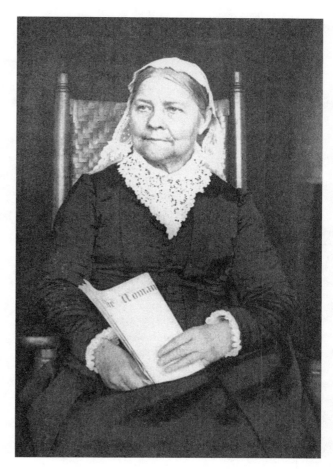

Lucy Stone in the 1880s

Speech Delivered Feb. 13, 1856. Concerning Her Desire that a Knife Might Be Given to the Slave-mother in the Cincinnati Slave Case (New York?, 1856);

Proceedings of the Seventh Woman's Rights Convention (New York: Edward O. Jenkins, 1856);

The Woman's Rights Almanac for 1858. Containing Facts, Statistics, Arguments, Records of Progress, and Proofs of the Need of It (Worcester, Mass.: Z. Baker, 1857?);

Proceedings of the Ninth Woman's Rights Convention Held in New York City, Thursday, May 12, 1859 (Rochester, N.Y.: A. Strong, 1859);

Proceedings of the Tenth Woman's Rights Convention (Boston: Yerrinton & Garrison, 1860);

Proceedings of the Eleventh Woman's Rights Convention (New York: Robert Johnston, 1866);

Proceedings of the First Anniversary of the American Rights Association (New York: Robert Johnston, 1867);

Woman Suffrage in New Jersey (Boston: C. H. Simonds, 1867);

Reasons Why the Women of New Jersey Should Vote, as Shown from the Constitution and Statutes of New Jersey (Vineland, N.J.: C. B. Campbell, 1868);

To the Constitutional Conventions of the Four New States (United States, between 1869 and 1890);

Woman Suffrage Convention (Washington, D.C.: Chronicle Print, 1871);

Constitution of the American Woman Suffrage Association and the History of its Formation: With the Times and Places in Which the Association Has Held its Meetings up to 1880 (Boston: G. H. Ellis, 1881);

A Woman Suffrage Catechism (Boston: American Woman Suffrage Association, 1888);

Questions for Remonstrants (Boston: American Woman Suffrage Association, 1889);

Some Things the Massachusetts Legislature of 1889 and 1890 Did for Men, Who Have Votes, Contrasted with What it Did for Women, Who Have No Votes (Boston, 1890);

The Gains Forty Years at the Fortieth Anniversary of the First National Woman's Rights Convention, Celebrated in Boston, Mass., Jan. 27 and 28, 1891 (Boston: Woman's Journal, 1891);

Hearing of the Woman Suffrage Association Before the Committee on the Judiciary, Monday, January 18, 1892 (Washington, D.C.: Government Printing Office, 1892).

Better known as an orator than as a literary figure, reformer Lucy Stone was nonetheless prominent in the world of nineteenth-century American letters—as a self-publisher who circulated printed versions of her speeches on abolition and woman's rights; as the subject of others' editorials, tributes, and lampoons; and as the cofounder and editor of the *Woman's Journal,* a weekly newspaper dedicated to women's issues that by 1875 drew subscribers from all states and thirty-nine countries. She once claimed, "There was a good farmer spoiled when I went into reform" and first became noted for her speeches against slavery. She also stood with Susan B. Anthony and Elizabeth Cady Stanton as one of the most influential crusaders for women's equality. Stone's biographers contend that disagreements among the three led Stanton and her staff to

downplay Stone's contributions to their cause in their monumental *History of Woman Suffrage* (1881–1921), leading in turn to her virtual erasure from the public record that celebrated the others' achievements. Only recently have scholars begun to reappraise Stone's larger importance both as an activist and as a considerable presence in the history of women's publishing.

Stone's own characteristic diffidence, combined with her moral rectitude, undoubtedly contributed to her partial exclusion from the historical limelight. In 1876 when Stanton, Anthony, and Matilda Joslyn Gage asked Stone for information for their project, she admitted,

> I have never kept a diary or any record of my work, and so am unable to furnish you the required dates . . . I commenced my regular public work for anti slavery and woman's rights in 1848. I have continued it to the best of my ability ever since, except when the care of my child, and the war prevented. . . . I cannot furnish a biographical sketch, and trust you will not try to make one.

To others she confided that she felt "more than content to be left entirely out of any history that those ladies may publish of the suffrage work," and elaborated, "It is a shame to publish such a one sided history—But the good work exists all the same and will just as truly have done its part in the great movement." The "good work" of reconstructing Stone's biography has owed primarily to her letters; to the memoirs and written accounts by contemporaries and fellow reformers, including her daughter, Alice Stone Blackwell; and to the print legacy of Stone's years with the *Woman's Journal,* from 1870 to the end of her life.

Lucy Stone was born on 13 August 1818 to a farming family in Brookfield, Massachusetts. Her parents—Francis Stone, formerly a tanner and briefly a teacher, and Hannah Bowman Matthews Stone—had settled at their Coy's Hill farm two years before their daughter's birth. As the eighth of nine children, three of whom were girls, Stone grew up under her parents' abolitionist ideals. Her father opposed advanced schooling for women, even as he wholeheartedly advocated higher education for his sons. Stone later said he "had the Puritan idea that women were to be governed." In response, she found academic opportunities on her own, relying on her brother's textbooks after her father declined to pay further for hers. Eventually she and other young people nearby banded together to hire their own tutor. Stone grew up reading texts such as the Bible, William Guthrie's *A Geographical, Historical, and Commercial Grammar of the World* (1815), *The Worcester Spy,* and other periodicals, including borrowed copies of *The Youth's Companion* and Susanna Rowson's caution-

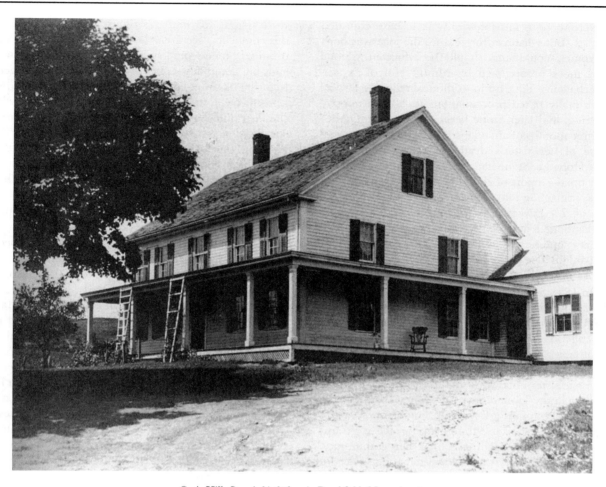

Coy's Hill, Stone's birthplace in Brookfield, Massachusetts

ary *Charlotte Temple* (first published as *Charlotte: A Tale of Truth,* 1791), although her parents generally judged novels to be abominable. One early account of Stone's defiant streak details the discovery of her secret reading of *The Children of the Abbey* (1796) by Regina Maria Roche, a popular favorite that her parents denounced as scandalous. Her mother finally permitted her willful daughter to finish it on condition that she read no other such works.

As a teenager, Stone joined the West Brookfield Congregationalist Church, soon protesting the interpretation of the church that women's public speech was against scripture. Because of the activities of outspoken reformers such as the Grimké sisters, the Congregational ministers of Massachusetts in 1837 issued a pastoral letter, the "Brookfield Bull," decrying the "mistaken conduct of those who encourage females to bear an obtrusive and ostentatious part in measures of reform, and countenance any of that sex who so far forget themselves as to itinerate in the character of public

lecturers and teachers." Rather than heed such admonitions, Stone saw the Grimkés' example as inspiration. Having heard abolitionist Abby Kelley Foster lecture in 1838, Stone voted soon thereafter against a move to censure the church's pastor for his antislavery leanings. Although nominally a full church member, Stone found her vote was ignored because of her sex, much to her mounting outrage against the treatment of women by her culture. During this time she began to suffer the migraine headaches that troubled her much of her life, as did spells of depression.

Nevertheless, Stone redoubled her efforts to advance her education, attending briefly Quabog Seminary in Warren, Massachusetts, and the Wesleyan Wilbraham Academy in Wilbraham, Massachusetts. After teaching in the local common schools to help defray the debt of the farm and to finance her brothers' university educations, she secured her father's conditional permission to enroll at Mount Holyoke Female Seminary. As Stone described founder Mary Lyon's goals: "The men

who were to go as missionaries were to have educated wives. . . . But whatever the reason, the idea was born that women could and should be educated." Stone proved more preoccupied by Mount Holyoke's academic challenge than by its orthodox religious fervor; her spiritually based proclamations took on a nonsectarian ring, and later Stone became a Unitarian. After only three months of attendance, she left school in 1839 because of her sister's death. In that short time at Mount Holyoke, Stone had become known as a radical for her open support of abolition and Garrisonian sympathies, smuggling into the seminary reading room the copies of *The Liberator* that her brother had sent her. Lyon cautioned her: "Now the slavery question is a very great question, and a question on which the best people are divided." But Stone expressed no such moral equivocation on the issue.

In 1843 Stone carried her convictions to Oberlin Collegiate Institute in Ohio, the first four-year college in the United States to admit women. At Oberlin her radical agenda further encompassed woman's rights, a commitment also espoused by fellow student Antoinette Brown, who became Stone's dear friend as well as her sister-in-law and the first woman ordained a minister in the United States. Despite Oberlin's relatively liberal support of women and blacks, Stone's fervent advocacy of social reform for these groups again set her apart from much of her community. With Brown she organized a secret debating society at Oberlin, and the two women became officers in the Oberlin Female Reform Society. Stone also taught in area schools for free blacks, delivering a speech at a rally to celebrate West Indian emancipation. After Foster and her husband, Stephen, visited the college in 1846, Stone became an agent for *The Anti-Slavery Bugle* of Salem, Ohio, contributing an article opposed to the proslavery element of the local church. Upon her graduation in August 1847, she was invited to write a commencement essay for her class, but as only males in her program were allowed to read their statements publicly, she declined the ostensible honor.

By 1848 Stone had started a bold career lecturing for her concerns, her primary occupation for the next decade. After returning to Massachusetts from Oberlin to teach for a term to repay loans, she gave her first public talk on women's rights at her brother's church. In June 1848 she joined Foster as an agent for the Massachusetts Anti-Slavery Society (MASS). Inclined to infuse her passion for women's rights into her abolitionist lectures, Stone met resistance from MASS officials, who urged a more singular focus on their stated cause. She initially replied, "I was a woman before I was an abolitionist. I must speak for the women. I will not lecture any more for the Anti-Slavery Society, but will

work wholly for woman's rights." Not wishing to lose this compelling lecturer, the Society worked out a compromise: Stone would speak for their agenda on weekends but could devote her own time during the week to lecturing on other concerns. After her appearances, versions of her lectures circulated as printed tracts, which she distributed, or in newspaper reprints, even though she made her speeches largely without written scripts. Touring several states until her daughter's birth in 1857, she met crowds as likely to call her a "raving she hyena" and to burn pepper in her face, spit or throw hymnbooks at her, or douse her through an open church window, as to embrace her eloquent but plain-spoken message of equality.

Stone had fervent supporters as well, from people in the crowd to literary and intellectual luminaries. The vast admiration of Thomas Wentworth Higginson for Stone began when he met her early in her speaking career while he was a minister in Newburyport, Massachusetts. His various writings about her supply a not-unbiased record of her complex appeal as a liberal persona. To his mother, he reported, "A most charming individual has been here in the shape of a female Anti-Slavery lecturer—Miss Lucy Stone by name—a little meek-looking Quakerish body, with the sweetest, modest manners and yet as unshrinking and self-possessed as a loaded cannon." Stone, who was instrumental in organizing the first Woman's Rights Convention in Worcester in 1850, as well as similar following events, appeared in another letter that Higginson wrote to his mother regarding the 1853 Woman's Suffrage Convention in New York: "Lucy Stone of course was the real presiding genius, dear little stainless saint that she is." Prior to her lecture in Brattleboro, Vermont, soon thereafter, he proclaimed, "Lucy Stone . . . is simply one of the noblest and gentlest persons whom I know; with . . . her little Bloomerized-Quakerish person—and her delicious voice." Obviously Higginson delighted in the incongruities between Stone's demure appearance and her hard convictions. Such apparent tensions may have enhanced what Andrea Moore Kerr identifies as the dialectical thrust of Stone's rhetoric.

But the way that Higginson savored Stone's "delicious voice" seemed a matter of consensus, not solely an expression of one smitten colleague's pleasure. Stone's daughter, Alice Stone Blackwell, remembered the "transparent sincerity, simplicity, and intense earnestness" of her mother's "musical" voice. As Blackwell elaborated in a 1930 memoir, "It was said of her voice—that voice that swayed thousands and started the suffrage movement toward the victory that she didn't live to see—that it was never loud to the nearest nor faint to the farthest." Julia Ward Howe recalled her own conversion:

Page from a letter Stone sent to Henry Browne Blackwell a few months before their marriage on 1 May 1855 (from Elinor Rice Hays, Morning Star:
A Biography of Lucy Stone, 1818–1893, *1896)*

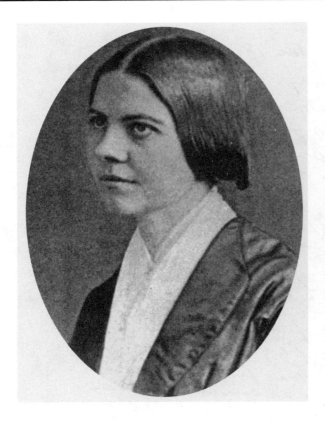

Lucy Stone and Henry Blackwell

[Stone] had long been one of my imaginary dislikes. As I looked into her sweet, womanly face and heard her earnest voice, I felt that the object of my distaste had been a mere phantom, conjured up by senseless and silly misrepresentations. Here stood the good woman, pure, noble, great-hearted, with the light of her good life shining in every feature of her face. . . . When they requested me to speak . . . I could only say, "I am with you."

Higginson cited the similar experience of his friend and protégée, Helen Hunt Jackson:

Professedly abhorring woman suffrage, [Jackson] went with me to a convention on the subject in New York, under express contract to write a satirical report in a leading newspaper; but was so instantly won over—as many another has been—by the sweet voice of Lucy Stone, that she defaulted as a correspondent, saying to me, "Do you suppose I ever could write against anything which that woman wishes to have done?"

Another critic attributed to Stone the voice and concomitant power of an "angel."

To effect her conversions of political and moral opponents, Stone used her "female" resources—her "delicious" voice and diminutive stature—to advantage in her preferred forum, the lecture hall, confounding those antagonists who charged that Stone's reform activities "unsexed" her. Although the approval of male colleagues certainly helped validate her work, for Stone to earn the public eye she needed essentially to appear, face the commotion, and speak, unlike women writers at the time who sought males as intermediaries between them and the ideologically "separate" public sphere that included authorship. Because of her unimposing presence and lilting eloquence, Stone retained what her audience read as femininity and paradoxically could influence her listeners *as a woman*. Once she had "unsexed" herself by braving the crowds, she essentially "resexed" herself before their eyes, parlaying her cause with her gentle voice and manner. While relying on male colleagues to help her effect a community of reform, Stone also understood that she could make her own headlines, disarming opponents with her capacity to broadcast herself and her accompanying message as, ultimately, unthreatening.

While Stone moved many to convert, she also inspired detractors. In 1855 the pseudonymous Fred Folio satirized her reform efforts by linking them to

other enthusiasms of the era in "A Book for the Times," *Lucy Boston; or, Woman's Rights and Spiritualism: Illustrating the Follies and Delusions of the Nineteenth Century* (1855). In private conversations Stone might become the topic of rude doggerel. One anti-Stone rhyme concluded,

> A name like Curtius's shall be his,
> On fame's loud trumpet blown,
> Who with a wedding kiss shuts up
> The mouth of Lucy Stone.

In fact, Stone had resolved that she would never marry, to the consternation of Henry Browne Blackwell, whom she had met in Ohio in 1850. Blackwell, brother of pioneering women physicians Elizabeth and Emily Blackwell, was himself sympathetic to reform issues. A would-be entrepreneur, he had persisted in courting Stone across several states, despite her protestations against matrimony. Thanks to Blackwell's perseverance, Stone decided by 1854 to marry after all.

Yet, another interpretation of Stone's complex personal charisma surfaces in Higginson's description of her 1855 wedding to Blackwell, a ceremony that Higginson performed. Higginson's colorful memoir of the event, held at Stone's family home in Brookfield, once again figured Stone as both commanding and dear, stalwart and sentimental:

> We went in to tea at a great table; Lucy presided and cared for everybody . . . piloting us, and looking to see that the fire and water and all were right. She took such care of everybody that I felt as if some one else in the family were to be married, and she was the Cinderella. . . . Presently in came the small lady and with her the bridegroom; he in the proper white waistcoat, she in a beautiful silk *ashes-of roses* color. They stood up together and they read their *protest* . . . and then my usual form of the service proceeded. She . . . expressed her purpose to "love and honor" (not obey) very clearly and sweetly, and he as bridegroom should; and I have to add with secret satisfaction that, after this, Lucy, the heroic Lucy, *cried* like any village bride. . . . [She] soon swallowed her tears and gave others tea to swallow and we plunged into a hasty breakfast. And I record for posterity that Lucy was presently heard to say quietly, "And is n't the bride to have any breakfast?"

Shortly thereafter Higginson recast the sentimental elements of his tribute to publicize for *The Worcester Spy* the six-point "protest" Stone and Blackwell had lodged against contemporary marriage laws. Stone also sent this piece to *The Liberator*. As she and Blackwell argued:

We protest specially against the laws which give to the husband—

1. The custody of his wife's person;
2. The exclusive control and guardianship of their children;
3. The sole ownership of her personal and use of her real estate, unless previously settled upon her, or placed in the hands of trustees, as in the case of minors, lunatics, and idiots;
4. The absolute right to the product of her industry;
5. Also against laws which give to the widower so much larger and more permanent an interest in the property of his deceased wife than they give to the widow in that of her deceased husband;
6. Finally, against the whole system by which "the legal existence of the wife is suspended during marriage," so that in most States she neither has a legal part in the choice of her residence, nor can she make a will, nor sue or be sued in her own name, nor inherit property.

We believe that personal independence and equal human rights can never be forfeited, except for crime; that marriage should be an equal and permanent partnership, and so recognized by law; that until it is so recognized, married partners should provide against the radical injustice of present laws, by every means in their power. . . .

Thus reverencing Law, we enter our earnest protest against rules and customs which are unworthy of the name, since they violate justice, the essence of all Law.

While the substance of the protest itself provoked controversy, perhaps its most remarked outcome was that Lucy Stone did not change her last name to her husband's, a detail that even Susan B. Anthony found difficult to apprehend.

After their marriage, Stone and Blackwell moved to Cincinnati, but Stone soon returned east to lecture in Saratoga and in September 1855 to visit Boston with Anthony. Stone continued to travel widely for lecture appearances, often apart from Blackwell; during the 1850s they relocated many times, moving back and forth from the Midwest to the Northeast. When Stone returned to Cincinnati in 1856, she demonstrated a further perspective on woman's capability, appropriating a form of the maternal ideal of her era to speak for Margaret Garner, a fugitive slave who had killed one of her children rather than see her returned to a Kentucky slave owner. Like Harriet Beecher Stowe, who began *Uncle Tom's Cabin* in 1850, and others, Stone used her relative privilege as a free and literate white woman to speak on Garner's behalf, since Garner herself was denied the chance:

> The faded faces of the negro children tell too plainly to what degradation female slaves submit. Rather than give her little daughter to that life, she killed it. If in her deep maternal love she felt the impulse to send her

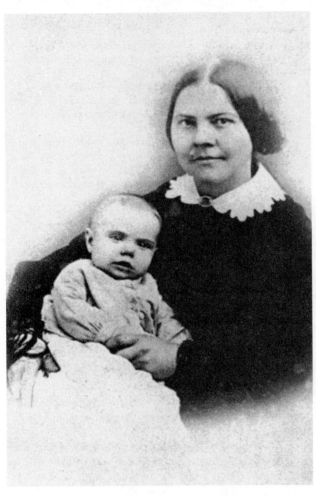

Stone and her daughter, Alice Stone Blackwell, born 14 September
1857 (Library of Congress)

her supporter Stanton never really bridged this rift with Stone. Later that year, when her daughter Alice was a newborn, Stone refused to pay taxes on her residence, claiming the property tax was mandated by a legislature that she was not enfranchised to elect. When authorities seized her possessions for auction, including paintings of reformers Salmon P. Chase and William Lloyd Garrison, Higginson tried to cheer his longtime friend: "The selection of these portraits will be so melodramatic for your biography that I suspect you of having bribed the sheriff to seize them." In fact, Stone's biographers note that her gesture was more significant as publicity than as any finally devastating loss for the protester.

Stone devoted much of the next decade to motherhood, retiring temporarily from many of her previous public commitments. Despite her relative retreat from active reform, her name continued to appear in contemporary written accounts. In "Ought Women to Learn the Alphabet?" first printed in *The Atlantic Monthly* in February 1859, Higginson recalled her inspiring example: "In how many towns was the current of popular prejudice against female orators reversed by one winning speech from Lucy Stone! Where no logic can prevail, success silences. First give woman, if you dare, the alphabet, then summon her to her career. . . ." He wrote this tribute to women orators after planning with Stone *The Woman's Rights Almanac for 1858. Containing Facts, Statistics, Arguments, Records of Progress, and Proofs of the Need of It* (1857?), which Mary Thacher Higginson's bibliography lists as a collaboration. At the time, Stone pragmatically cited a lack of funds as her reason for shelving *The Woman's Rights Almanac* project, although Elinor Rice Hays proposes that personal tension and Stone's pregnancy contributed to its eventual production by Higginson alone. Yet, Hays concludes that Higginson could not have been gravely perturbed by Stone's defection, for he published in *The Woman's Rights Almanac* her address on the women's progress from the Seventh Annual Woman's Rights Convention.

During the next few years Stone suffered several personal losses—a miscarriage in 1859 and the deaths of both of her parents. Shortly, the cataclysm of the Civil War and the ensuing upheavals of Reconstruction splintered countless antebellum political affiliations, especially in the controversy over whether the long-vexed "woman question" demanded priority over suffrage for freedmen. The Fourteenth Amendment, proposed in June 1866, decreed full citizenship for blacks, but its language specified protection for the rights of males, implying women's exclusion. Advocates insisting upon suffrage for women feared that yoking the urgent needs of freed blacks with the persistent women's issue might

child back to God to save it from coming woe, who shall say she had no right to do so? That desire had its root in the deepest and holiest feelings of our nature—implanted alike in black and white by our common Father. With my own teeth would I tear open my veins and let the earth drink my blood rather than wear the chains of slavery. How then could I blame her for wishing her child to find freedom with God and the angels, where no chains are?

Through this identification with Garner, Stone's impassioned appeal radically transformed contemporary sentimental domestic ideals into clear urgency, prefiguring as well her dedication to her own concerns as a mother over the next few years.

The year 1857 was one of exceptional conflicts for Stone. The increasingly influential Anthony frowned upon Stone's pregnancy that year and her investment in a new home in New Jersey as betrayals of her commitment to women's suffrage. Anthony and

doom both causes. Unwilling to subordinate their women's cause to any other, Anthony and Stanton called for educated suffrage, which would grant most white women the vote ahead of unschooled former slaves. Lamenting, "I will be thankful if *any* body can get out of the terrible pit," Stone left for Kansas in 1867 to fight for a dual referendum that would strike "male" and "white" restrictions from that state's voting standards. Conditions in Kansas pushed her toward Anthony's camp: "The negroes are all against us. These men ought not to be allowed to vote before we do because they will be a dead weight to lift."

After both Kansas referenda failed, Stone concluded that Anthony and Stanton's absolutism may have damaged their campaign. She also thought that their support of and funding by the flamboyant Democrat George F. Train, opponent of black voting rights, betrayed both moral principles and Republican loyalty. Rejoining former abolitionists such as Higginson, Garrison, Phillips, and Frederick Douglass, Stone helped win ratification in 1869 of the Fifteenth Amendment, which denied race as a voting standard. She also supported the universal suffrage stance of the New England Woman Suffrage Association (NEWSA), formed partially in dissatisfaction with the existing American Equal Rights Association (AERA), which Anthony and Stanton dominated. NEWSA called for an organizing meeting for a new national woman's association to be held in Cleveland in November 1869. Writing to Antoinette Brown Blackwell in October of that year, Stone foreshadowed the more definitive split between women's rights proponents that occurred after the Cleveland rally: Anthony and Stanton's National Woman's Suffrage Association (NWSA) formed in contention with her own somewhat more conservative American Woman's Suffrage Association (AWSA).

In her letter to Antoinette Brown Blackwell, Stone also outlined her plans for a publication:

> Harry will join me at Newburyport, and we shall set to, to raise $10,000 to start a paper. I suppose you know the N.E. Woman Suffrage Association propose to take the "Agitator"–call it the "Woman's Journal," with Mrs. [Mary] Livermore, Mrs.[Julia Ward] Howe, T. W. Higginson & Mr. [William Lloyd] Garrison as Editors–*If we can raise the money*. If we do I shall try and work through the paper, for the future, and quit this lecturing field nearly altogether.

Envisioned as a substitute for her brilliant but exhausting career as an orator, an increasingly demanding undertaking as Stone grew older, the *Woman's Journal* functioned essentially as a "diary of [her] public life." To found and to maintain, the *Woman's Journal* required a huge financial investment for Stone and her

family; she came to refer to the journal as "a big baby which never grew up and always had to be fed." To designate its editorial board required of her a matching emotional and professional trust. Among the important figures who contributed to Stone's *Woman's Journal,* only Higginson, who became the weekly newspaper's lead writer, was offered a regular salary, an even more significant distinction after the Panic of 1873 and the ensuing five-year depression shook the country's financial foundation and the economic future of the *Woman's Journal.*

As a forum for the AWSA, which welcomed men into its ranks as the NWSA did not, the *Woman's Journal* purported to "champion the passage of the Fifteenth Amendment, to defend the family, and to preserve the institution of marriage." Focusing on local and state suffrage campaigns rather than on the federal battle, the *Woman's Journal* promoted expanded roles for women within fundamentally conventional settings and muted discussion of current controversies over divorce, adultery, infanticide, and free love that raged in NWSA circles. It proclaimed itself "Devoted to the interests of woman, to her educational, industrial, legal and political equality, and especially to her right of suffrage" but reflected little sustained commitment to social issues such as labor struggles or the burgeoning unemployment of the 1870s. Men and women collaborated in its production, and what Stone saw as its ideologically compatible staff grew to include not only her husband and former abolitionist allies such as Higginson and Garrison, but also her own daughter, Alice. Important contributors included Louisa May Alcott, the younger Elizabeth Stuart Phelps, Rebecca Harding Davis, and Harriet Beecher Stowe.

Publishing literary reviews, social tidbits, poetry, fiction, and ads for sarsaparilla and the "Emancipation Waist"–a "strictly hygienic dress reform garment"–along with its editorials and suffrage news, the *Woman's Journal* did not sell itself as a radical publication. In 1876 Stone summarized its perspective by paraphrasing Higginson: "we dont [*sic*] think women are better than men, or that their suffrage will bring the millennium." As *Woman's Journal* chief editor, Stone relied on the versatility of her staff and appreciated their dedication to the ideals they shared. Published every Saturday in Boston and Chicago, and later in St. Louis, the *Woman's Journal* featured columns such as "What Women Are Doing," "Suffrage Items," foreign correspondence, and "Just For Fun," which included jokes such as "A sick young lady in Worcester, Mass., has been attended by thirteen physicians, and still lives." Stone's own contributions to the first issues ran a range from the sober "Laws in Relation to the Property Rights of Married Women in Massachusetts" to a

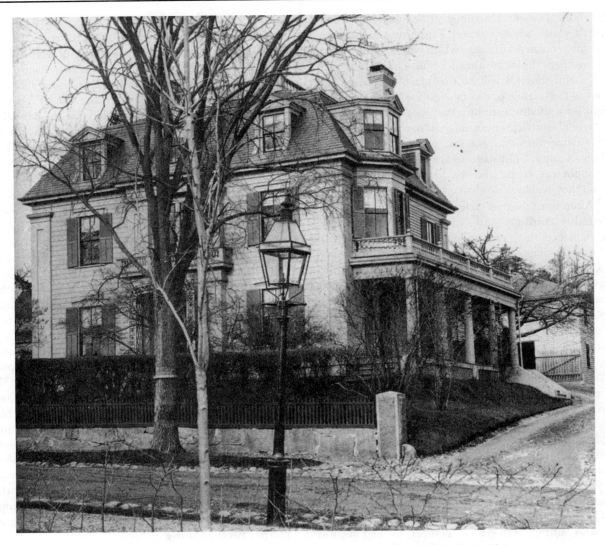

Pope's Hill, the house in Dorchester, Massachusetts, that Stone and Blackwell bought in 1870

profile of "Our Office." Beginning with a charming description of the work space and its furnishings, the latter piece concluded with no uncertain call for active support:

To this office the friends of the cause are always welcome. Through it we hope not only to make acquaintances all over the country, who have common interest with us in our work, but who will cooperate actively with us in extending the circulation of our journal, who will take responsibility in carrying tracts and petitions to every house in the neighborhood, who will open the way for lectures, and by every just means induce all the friends of the cause to unite in the long, strong pull, which is necessary to take woman above the political level she now shares with idiots, lunatics, paupers, felons, and unpardoned rebels, and to put her on the same plane with other decent tax-paying citizens.

Regularly, the *Woman's Journal* also printed the AWSA Constitution and the names of its officers, many of which not surprisingly appeared also on the newspaper's masthead.

In Higginson's *Common Sense About Women,* an 1881 compilation of his essays first published in the *Woman's Journal,* Stone remained an informing literary presence for him, if not touted as a writer herself, or as an editorial arbiter of his work. She appears throughout as an advocate of a mother's rights to her children, as an international force in securing married women's property rights, and as a homespun commentator on human nature:

Lucy Stone tells a story of a good man in Kansas who, having done all he could to prevent women from being allowed to vote on school questions, was finally com-

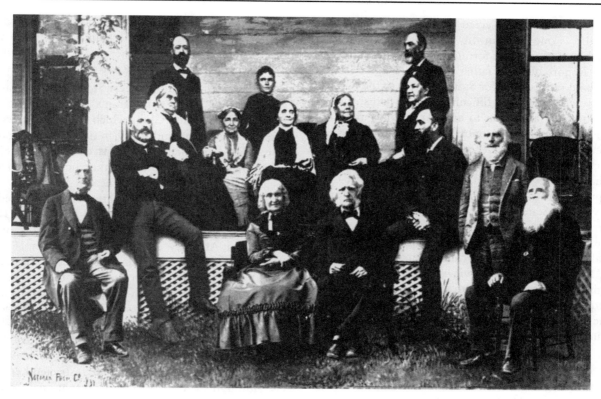

Abolitionist reunion at Pope's Hill, 1886: (in front of porch) Samuel May, Harriet W. Sewall, Samuel Sewall, Henry Blackwell, and Theodore D. Weld; (seated on porch) William Lloyd Garrison Jr., Elizabeth B. Chace, Sarah H. Southwick, Abby Kelley Foster, Lucy Stone, Zilpha Spooner, and Wendell P. Garrison; (standing on porch) Francis J. Garrison, Alla Foster, and George T. Garrison (Sophia Smith Collection, Smith College)

forted, when that measure passed, by the thought that he should at least secure his wife's vote for a pet school-house of his own. Election day came, and the newly enfranchised matron . . . made breakfast as usual, went about her housework, and did on that perilous day precisely the things that her anxious husband had always predicted that women never would do under such circumstances. . . . nothing short of the best pair of horses and the best wagon finally sufficed to take the farmer's wife to the polls.

The anecdote may have had a personal resonance: only a few years earlier, Stone could not register with other women newly permitted to vote in Massachusetts school elections because she did not share her husband's last name. Higginson's writing further perpetuated his friend's own claim for the divine sanction of her work: "Woman's nature was stamped and sealed by the Almighty, and there is no danger of her unsexing herself while his eye is watching her."

But in 1883 Higginson confronted another aspect of Stone when he opposed her support of Democrat Benjamin Butler in the Massachusetts governor's race. Carol Lasser and Marlene Deahl Merrill explain that for Higginson, Butler's shady business dealings, shifting party allegiances, and opposition to temperance legisla-

tion all raised doubts about his political program. Stone and Henry Blackwell, on the other hand, backed Butler when the state Republican Party abandoned its commitment to woman suffrage, and the Democrats, under Butler's prodding, added it to their platform.

Higginson supported candidate Robert Bishop, partly out of Republican loyalty, but more for his advocacy of civil service reforms. Looking ahead to a votership overwhelmingly—and vulnerably—expanded by woman suffrage, Higginson thought policies should first be mandated to preclude electoral corruption. The *Woman's Journal* published the ongoing disagreement between Stone and Higginson, prefiguring their far more serious quarrel during the next presidential election. As Butler took office, Stone and Blackwell printed in the *Woman's Journal* a "biting reply" to Higginson's attacks, followed by the lead writer's brief vacation from its pages.

In the 1884 presidential election, Higginson joined Independent Republicans, or Mugwumps, to side against mainstream Republican James G. Blaine. Higginson's cousin, Democrat Grover Cleveland, owned an impressive service record as mayor of Buffalo, New York, and appealed to Higginson's sense of

civic reform. Stone objected to Cleveland on moral grounds: as one letter in the *Woman's Journal* alleged, he had been accused of forming "an irregular connection." Reportedly the father of an illegitimate son, Cleveland represented for Stone a threat to the family, whose own sometimes difficult marriage had survived her husband's attraction to another woman in 1869. Publicly Stone rallied support in the *Woman's Journal,* writing in one pronouncement, "Women must be opposed at all cost, to that which is the destruction of the home. They know with an unerring instinct that the purity and safety of the home means purity and safety to the State and Nation." As the election drew closer, Higginson and Stone faced off once more in columns of the *Woman's Journal,* each claiming superior moral ground for his or her candidate, and by implication, for his or her ethical views. According to Hays, Higginson intimated that both men and women might be equal partners in any sexual question, whereas Stone asserted woman's purity as an absolute unless violated by man's lechery.

Their exchange of 9 October 1884 suggests the crux of their opposition. In his weekly commentary, Higginson argued in Cleveland's case for the authority of public opinion. "L. S." coolly countered:

> If, by testimony of credible witnesses, it is clear that he is a man of dissolute life, as is affirmed, then he should be dropped at once. If such testimony is not found, there will be no need of apology or excuse for Grover Cleveland. But there should be no doubt in the case.

Despite such open doubts, Cleveland won the election, an outcome Stone blamed on "the need of a moral force in politics that can come only when women have their equal political rights." As Stone urged women even more strongly to seek the ballot, implying it was their moral imperative, Higginson withdrew his contributions as the regular head writer of the *Woman's Journal.*

Apparently, though, Higginson had not irrevocably offended the moral but business-minded Stone, as his work soon reappeared in the *Woman's Journal,* excerpted from *Harper's,* although not as reliably as before the Cleveland contretemps. A 15 March 1887 letter from Stone to her husband indicates her continued exasperation by Higginson's vanity, in this case over his request for an elaborate layout for an article. As an enduring composite of its staff's commercial, political, social, aesthetic, and philanthropic perspectives, the *Woman's Journal* undoubtedly signified a different personal territory for each contributing editor. If Stone saw the weekly as a substitute for her lecture career, any such tension must have touched her individually as well as professionally, as her miffed private

remarks attest. But as a woman powerful enough to control her own weekly publication, Stone stood in a rare position to criticize a writer and personality whom many other women had looked to as a mentor.

Despite their differences, Stone and Higginson continued to share political involvements such as Boston's Nationalist Club, which they supported to promote American industrial nationalization against unregulated competition. But as early as the 1870s, Stone had begun to suffer further health problems, including rheumatism and repeated infections, that worsened in the 1880s. Hostilities also continued to flare between Stone, Anthony, and Stanton. In 1886 Stanton reportedly called Stone a liar and a hypocrite; after Anthony and Stone had met in 1887 to discuss working out their differences, the latter revealed, "I dread to try to work with these women." Despite such doubts, the two factions reestablished a formal union in February 1890 as the National American Woman Suffrage Association (NAWSA), with Stone serving as its executive committee chairperson for the final years of her life. Avowing in 1887, "I am an old woman," Stone restricted her travels, although she did attend the International Council of Woman meeting in 1888 to celebrate the fortieth anniversary of the Seneca Falls Convention. In 1892 she helped organize the General Federation of Women's Clubs and visited the World's Columbian Exposition in Chicago in 1893. Delivering "The Progress of Fifty Years" speech at the NAWSA session, she wished to return in August to speak to the Woman Suffrage Department of the World Congress on Governments. But in the interim *The Boston Globe* began to carry updates on her seriously failing health. Stone died at her home in Dorchester, Massachusetts, on 18 October 1893; she was the first person in New England to be cremated.

Earning national news coverage and drawing more than 1,100 mourners, Lucy Stone's funeral on 21 October 1893 suggested in its scope the magnitude of her stature as a public citizen. At the service in Boston, Thomas Wentworth Higginson served as one of her twelve pallbearers—six men, six women—and observed, "It is something to have known, in this vast and perplexing life, one perfectly single-minded human being," having himself stood as ally and, more recently, as opponent to her fierce convictions. In 1894 Antoinette Brown Blackwell spoke at a memorial service for the woman she called "friend and sister," recalling as well how Stone "went forward confidently, wrapped in . . . sustaining conviction." As Alice Stone Blackwell continued into the twentieth century her mother's work at the *Woman's*

Journal, she reminded others of Lucy Stone's last exhortation: "Make the world better."

Letters:

Loving Warriors: Selected Letters of Lucy Stone and Henry B. Blackwell, 1853 to 1893, edited by Leslie Wheeler (New York: Dial Press, 1981);

Friends and Sisters: Letters Between Lucy Stone and Antoinette Brown Blackwell, edited by Carol Lasser and Marlene Deahl Merrill (Urbana: University of Illinois Press, 1987).

Biographies:

Alice Stone Blackwell, *Lucy Stone* (Boston: Woman's Journal, 1893);

Blackwell, *Lucy Stone: Pioneer of Woman's Rights* (Boston: Little, Brown, 1930);

Elinor Rice Hays, *Morning Star: A Biography of Lucy Stone 1818–1893* (New York: Harcourt, Brace & World, 1961);

Andrea Moore Kerr, *Lucy Stone: Speaking Out for Equality* (New Brunswick, N.J.: Rutgers University Press, 1992).

References:

Ellen Carol DuBois, *Feminism and Suffrage: The Emergence of an Independent Women's Movement in America, 1848–1869* (Ithaca, N.Y.: Cornell University Press, 1978);

Tilden G. Edelstein, *Strange Enthusiasm: A Life of Thomas Wentworth Higginson* (New Haven: Yale University Press, 1968);

Blanche Glassman Hersh, *The Slavery of Sex: Feminist-Abolitionists in America* (Urbana: University of Illinois Press, 1978);

Mary Thacher Higginson, *Thomas Wentworth Higginson: The Story of His Life* (Boston: Houghton Mifflin, 1914);

Thomas Wentworth Higginson, *Carlyle's Laugh and Other Surprises* (Boston: Houghton Mifflin, 1909);

Higginson, *Common Sense About Women* (Boston: Lee & Shepard, 1881);

Higginson, *Letters and Journals of Thomas Wentworth Higginson, 1846–1906,* edited by Mary Thacher Higginson (Boston: Houghton Mifflin, 1921);

Higginson, *The Writings of Thomas Wentworth Higginson, Volume I: Cheerful Yesterdays, Volume II: Contemporaries, Volume IV: Women and the Alphabet* (Boston: Houghton, Mifflin, 1900);

Howard Meyer, *Colonel of the Black Regiment: The Life of Thomas Wentworth Higginson* (New York: Norton, 1967);

Robert Taylor, "The Fight for Woman's Vote Spearheaded by Rabid Radicals," *Boston Sunday Globe,* 15 December 1968, p. A25;

James W. Tuttleton, *Thomas Wentworth Higginson* (Boston: Twayne, 1978);

Cynthia Griffin Wolff, "Margaret Garner: A Cincinnati Story," *Massachusetts Review,* 32 (Fall 1991): 417–424;

Jean Fagan Yellin, *Women and Sisters: The Antislavery Feminists in American Culture* (New Haven: Yale University Press, 1989).

Papers:

Lucy Stone's papers are located primarily in the Blackwell Family Collection at the Library of Congress. Other collections are in the Boston Public Library, the Sophia Smith Collection at Smith College, and in the Schlesinger Library at Radcliffe College.

Harriet Beecher Stowe

(14 June 1811 – 1 July 1896)

John Gatta
University of Connecticut

See also the Stowe entries in *DLB 1: The American Renaissance in New England; DLB 12: American Realists and Naturalists; DLB 42: American Writers for Children Before 1900; DLB 74: American Short-Story Writers Before 1880;* and *DLB 189: American Travel Writers, 1850–1915.*

BOOKS: *Primary Geography for Children, on an Improved Plan,* by Harriet Beecher and Catharine E. Beecher, as C. and H. Beecher (Cincinnati: Corey & Fairbank, 1833);

Prize Tale: A New England Sketch (Lowell, Mass.: Gilman, 1834);

The Mayflower; or, Sketches of Scenes and Characters among the Descendants of the Pilgrims (New York: Harper, 1843; London: Hodson, 1852); enlarged as *The Mayflower and Miscellaneous Writings* (Boston: Phillips, Sampson, 1855); republished as *Tales and Sketches of New England Life: Comprising "The May Flower," and Other Miscellaneous Writings* (London: Sampson Low, Son, 1855);

Uncle Tom's Cabin; or, Life among the Lowly, 2 volumes (Boston: Jewett / Cleveland: Jewett, Proctor & Worthington, 1852; London: Clarke, 1852);

Earthly Care, a Heavenly Discipline (Boston: Jewett / Cleveland: Jewett, Proctor & Worthington, 1853 [i.e., 1852]);

The Two Altars; or, Two Pictures in One (Boston: Jewett, 1852);

A Key to Uncle Tom's Cabin: Presenting the Original Facts and Documents upon Which the Story Is Founded. Together with Corroborative Statements Verifying the Truth of the Work (London: Sampson Low, 1853; Boston: Jewett / Cleveland: Jewett, Proctor & Worthington / London: Sampson Low, 1853);

Uncle Sam's Emancipation; Earthly Care, A Heavenly Discipline; and Other Sketches (Philadelphia: Hazard, 1853); enlarged as *Uncle Sam's Emancipation; Earthly Care a Heavenly Discipline; and Other Tales and Sketches* (London: Nelson, 1853);

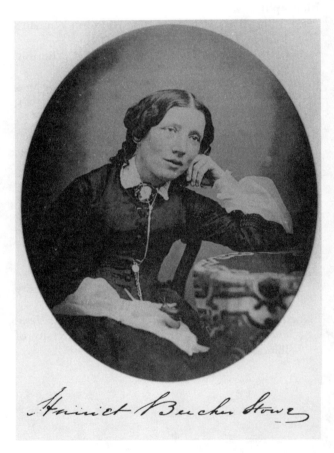

Sunny Memories of Foreign Lands, 2 volumes (London: Sampson Low, 1854; Boston: Phillips, Sampson / New York: Derby, 1854);

First Geography for Children, edited by Catharine E. Beecher (Boston: Phillips, Sampson / New York: Derby, 1855); revised as *A New Geography for Children: Revised by an English Lady* (London: Sampson Low, 1855);

Dred: A Tale of the Great Dismal Swamp, 2 volumes (London: Sampson Low, Son, 1856; Boston: Phillips, Sampson, 1856); republished as *Nina Gordon: A Tale of the Great Dismal Swamp,* 2 volumes (Boston: Ticknor & Fields, 1866);

Our Charley and What to Do with Him (Boston: Phillips, Sampson, 1858; London: Routledge, 1859);

The Minister's Wooing (London: Sampson Low, 1859; New York: Derby & Jackson, 1859);

The Pearl of Orr's Island: A Story of the Coast of Maine (2 parts, London: Sampson Low, 1861, 1862; 1 volume, Boston: Ticknor & Fields, 1862);

Agnes of Sorrento (London: Smith, Elder, 1862; Boston: Ticknor & Fields, 1862);

A Reply to "The Affectionate and Christian Address of Many Thousands of Women of Great Britain and Ireland, to Their Sisters, The Women of the United States of America" (London: Sampson Low, 1863);

House and Home Papers, as Christopher Crowfield (Boston: Ticknor & Fields, 1865; London: Sampson Low, Son & Marston, 1865);

Stories about Our Dogs (Edinburgh: Nimmo, 1865);

Little Foxes; or, The Insignificant Little Habits Which Mar Domestic Happiness (London: Bell & Daldy / Sampson Low, Son & Marston, 1866); republished as *Little Foxes,* as Crowfield (Boston: Ticknor & Fields, 1866);

Religious Poems (Boston: Ticknor & Fields, 1867); republished as *Light after Darkness: Religious Poems* (London: Sampson Low, Son & Marston / Bell & Daldy, 1867);

The Daisy's First Winter, and Other Stories (Edinburgh: Nimmo, 1867);

Queer Little People (Boston: Ticknor & Fields, 1867; London: Sampson Low, Son & Marston, 1867; enlarged edition, New York: Fords, Howard & Hulbert, 1867 [i.e., 1881]);

The Chimney-Corner (London: Sampson Low, Son & Marston / Bell & Daldy, 1868; as Crowfield, Boston: Ticknor & Fields, 1868);

Men of Our Times; or, Leading Patriots of the Day: Being Narratives of the Lives and Deeds of Statesmen, Generals, and Orators (Hartford: Hartford Publishing Co. / New York: Denison / Chicago: Stoddard, 1868); enlarged as *The Lives and Deeds of Our Self-Made Men* (Hartford: Worthington, Dustin / Cincinnati: Queen City Publishing Co. / Chicago: Parker, 1872);

Oldtown Folks (3 volumes, London: Sampson Low, Son & Marston, 1869; 1 volume, Boston: Fields, Osgood, 1869);

The American Woman's Home; or, Principles of Domestic Science: Being a Guide to the Formation and Maintenance of Economical, Healthful, Beautiful, and Christian Homes, by Stowe and Catharine E. Beecher (New York: Ford / Boston: Brown, 1869);

Lady Byron Vindicated: A History of the Byron Controversy, from Its Beginning in 1816 to the Present Time (Boston:

Fields, Osgood, 1870; London: Sampson Low, Son & Marston, 1870);

Little Pussy Willow (Boston: Fields, Osgood, 1870; London: Sampson Low, Son & Marston, 1870);

Pink and White Tyranny (London: Sampson Low, Son & Marston, 1871); republished as *Pink and White Tyranny: A Society Novel* (Boston: Roberts, 1871);

My Wife and I: or, Harry Henderson's History (New York: Ford, 1871; London: Sampson Low, Marston, Low & Searle, 1871);

Oldtown Fireside Stories (London: Sampson Low, Marston, Low & Searle, 1871; Boston: Osgood, 1872); enlarged as *Sam Lawson's Oldtown Fireside Stories* (Boston: Osgood, 1872; enlarged again, Boston: Houghton, Mifflin, 1881);

Palmetto-Leaves (Boston: Osgood, 1873; Sampson Low, Marston, Low & Searle, 1873);

Woman in Sacred History: A Series of Sketches Drawn from Scriptural, Historical, and Legendary Sources (London: Sampson Low, Marston, Low & Searle, 1874; New York: Ford, 1874; enlarged edition, New York: Ford, 1874); original edition republished as *Bible Heroines: Being Narrative Biographies of Prominent Hebrew Women* (New York: Fords, Howard & Hulbert, 1878);

We and Our Neighbors; or, The Records of an Unfashionable Street: A Novel (London: Sampson Low, Marston, Low & Searle, 1875); republished as *We and Our Neighbors; or, The Records of an Unfashionable Street. (Sequel to "My Wife and I.") A Novel* (New York: Ford, 1875);

Betty's Bright Idea. Also, Deacon Pitkin's Farm, and the First Christmas of New England (New York: Ford, 1876 [i.e., 1875]; London: Sampson Low, Marston, Low & Searle, 1876);

Footsteps of the Master (New York: Ford, 1877; London: Sampson Low, Marston, Low & Searle, 1877);

Poganuc People: Their Loves and Lives (New York: Fords, Howard & Hulbert, 1878; London: Sampson Low, Marston, Low & Searle, 1878);

A Dog's Mission; or, The Story of the Old Avery House. And Other Stories (New York: Fords, Howard & Hulbert, 1880; London: Nelson, 1886);

Nelly's Heroics by Harriet Beecher Stowe. With Other Heroic Stories (Boston: Lothrop, 1883);

The Writings of Harriet Beecher Stowe, Riverside Edition, 16 volumes (Boston & New York: Houghton, Mifflin, 1896);

Regional Sketches: New England and Florida, edited by John R. Adams (New Haven: College & University Press, 1972).

Editions: *Uncle Tom's Cabin: Authoritative Text, Backgrounds and Contexts, Criticism,* edited by Elizabeth Ammons (New York: Norton, 1994);

The Oxford Harriet Beecher Stowe, edited by Joan D. Hedrick (New York: Oxford University Press, 1999).

SELECTED PERIODICAL PUBLICATIONS—
UNCOLLECTED: "Immediate Emancipation: A Sketch," *New York-Evangelist,* 16 (2 January 1845): 1;

"The Freeman's Dream: A Parable," *National Era,* 4 (1 August 1850): 121;

"An Appeal to the Women of the Free States of America, On the Present Crisis in Our Country," *Independent,* 6 (23 February 1854): 57;

"Who Shall Roll Away the Stone from the Door of the Sepulcher?" *Independent,* 9 (3 September 1857): 1;

"Sojourner Truth, the Libyan Sibyl," *Atlantic Monthly,* 11 (April 1863): 473–481;

"How Shall I Learn to Write?" *Hearth and Home,* 1 (16 January 1869): 56;

"What Is and What Is Not the Point in the Woman Question," *Hearth and Home,* 1 (28 August 1869): 520–521;

"The Blessed Woman," *Christian Union,* new series 2 (6 August 1870): 66–67;

"A Look beyond the Veil," *Christian Union,* new series 2 (5 November 1870): 277.

Greeted in her own time with vast popular acclaim in the Northern states—and with disdain by Southern slaveholding interests—Harriet Beecher Stowe remains widely known today. Yet, her reputation rests mainly on a single book—*Uncle Tom's Cabin; or, Life among the Lowly* (1852)—and, still more, on the role that book played in the antislavery agitation leading to the Civil War. The book remains controversial, but for different reasons than those originally raised. Some readers, including James Baldwin, have deplored Stowe's image of "Uncle Tom" for its influence in sanctioning racial stereotypes of docility and passivity demeaning to African Americans. Others have found artistic faults in the novel or disparaged its appeal to bourgeois sentiments and values. More recently, however, Stowe's work has drawn new respect from critics who appreciate its ability to highlight the power of feminine piety and redemptive love—and, above all, the saving force of maternity. Within the limits of her domestic feminism, Stowe dramatized the deep affinity between antislavery sentiment and the emerging women's movement. Transforming and adapting the spiritual legacy of Calvinist-evangelistic piety, she produced in *Uncle Tom's Cabin* a passionate masterwork of rhetoric. If not a well-wrought novel in strictly belletristic terms, the book achieves its hortatory aim by combining the language of feeling familiar in sentimental domestic fiction with the apocalyptic urgency of conversion preaching.

Among the novels, essays, nonfiction, and children's stories that form the rest of Stowe's large corpus of prose writings, the four novels set in preindustrial New England present the strongest claim to extend Stowe's literary reputation beyond the authorship of *Uncle Tom's Cabin.* Mingling autobiography, nostalgia, social criticism, and history, these works offer valuable impressions of a vanishing regional culture. In contrast to the heroic individualism typically celebrated in masculinist fiction, *The Minister's Wooing* (1859), *The Pearl of Orr's Island: A Story of the Coast of Maine* (1861, 1862), *Oldtown Folks* (1869), and *Poganuc People: Their Loves and Lives* (1878) uphold matrifocal and collective values and can be regarded as narratives of community. Though less successful, Stowe's New York novels—*Pink and White Tyranny* (1871), *My Wife and I; or, Harry Henderson's History* (1871), and *We and Our Neighbors; or, The Records of an Unfashionable Street* (1875)—must also be counted as falling within the scope of her lifelong reflection on marriage and nineteenth-century womanhood, as must her essays on domestic topics collected from *The Atlantic Monthly* as *House and Home Papers* (1865), *Little Foxes; or, The Insignificant Little Habits Which Mar Domestic Happiness* (1866), and *The Chimney-Corner* (1868), as well as her later contributions to *Hearth and Home,* a magazine she co-edited in 1868–1869.

Born in Litchfield, Connecticut, on 14 June 1811, Stowe was the seventh of the eight children of Lyman and Roxana Foote Beecher. (An earlier child named Harriet had died in infancy.) Her father later rose to national prominence as an evangelical preacher; her mother, who died when Harriet was five, became so sanctified in family memory that the surviving children thought of her (according to Harriet's brother Henry Ward Beecher) as equivalent to "what the Virgin Mary is to a devout Catholic." The emotionally intense, public-spirited family in which "Hatty" Beecher was raised fostered in her certain anxieties, as well as expectations of capability and a strong sense of loyalty toward her siblings. Lyman Beecher regarded his daughter as a "great genius," though he wished she had been born male. He remarried in 1817, and he and his new wife, the former Harriet Porter, had four children.

Steeped in the Calvinist legacy of Jonathan Edwards and ever mindful of Lyman Beecher's formidable influence, Harriet underwent a conversion experience at age thirteen while studying at her older sister Catharine's Hartford Female Seminary; she became a teacher there in 1827. Visits to her maternal relatives in Nutplains, near Guilford, Connecticut, exposed her to a less-severe Episcopal religious tradition than that espoused by her father. Excluded from ordination

because of her sex, Harriet Beecher seems to have regarded her writing as a vocational equivalent to the clerical ministry exercised by her father and all seven of her brothers.

In 1832 Lyman Beecher moved his family to Cincinnati, where he had been named president of Lane Theological Seminary. In this border region convulsed by race riots Harriet Beecher met fugitive slaves and former slaves, encountered fierce debates over slavery, and visited a Kentucky plantation. Her first publications included sketches for periodicals, *Primary Geography for Children, on an Improved Plan* (1833), and a volume of fifteen sketches collected as *The Mayflower* (1843).

On 6 January 1836 Beecher married Calvin Stowe, a widower who was professor of biblical studies at Lane. Bearing seven children by 1850, she quickly became engulfed by domestic concerns. Though she extolled the idea of woman's care for the home, she found the actual experience of running a household and raising children burdensome. Yet, the strain of supporting their large family on Calvin's modest salary gave her a strong incentive to write for money. She was determined, she told a friend in a letter of 8 December 1838, "not to be a mere domestic slave."

In 1850 the Stowes moved to Brunswick, Maine, where Calvin had accepted a position at Bowdoin College. There Harriet was inspired to write *Uncle Tom's Cabin* by passage of the Fugitive Slave Law; by displaced grief and anger over the death from cholera of her infant son, Charley; and by a vision of a beaten, dying slave—the original of Uncle Tom—that appeared to her while she was sitting at the communion table of Brunswick's First Parish Church in 1851. She began to write the work at the urging of a sister-in-law but also, she later claimed, under a divine imperative. Having had a second conversion experience in the 1840s, she composed the novel, she reported, with her "heart's blood."

The case for immediate emancipation that Stowe presses in *Uncle Tom's Cabin* is addressed mainly to Northern readers—above all, to white middle- or upper-class mothers. This audience, which for Stowe comprised the keepers of the nation's conscience, could not easily ignore vivid demonstrations of the way in which "the peculiar institution" brutalized individual human beings, thereby degrading both blacks and whites. The episodes of flogging, murder, suicide, infanticide, and sexual assault in the novel contribute to this indictment. Northerners are shown to be complicit in the evil of slavery through the New England origins of the tyrannical overseer Simon Legree. But Stowe recognized that her readers would be most deeply moved by witnessing slavery's destruction of families. The union of the nation—if not its very soul—was threatened by a

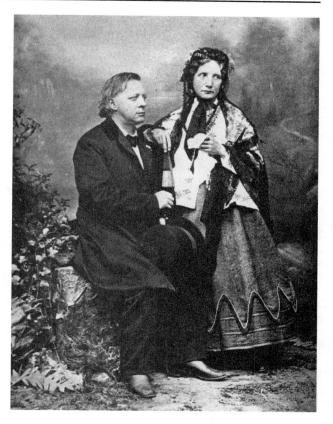

Stowe and her brother Henry Ward Beecher, 1868 (Sophia Smith Collection, Smith College)

system that could legally put asunder wives from their husbands and children from their mothers. An emotionally charged episode early in the work shows Eliza Harris, child in her arms, desperately fleeing across ice floes in the Ohio River to save her son Harry from bondage and separation.

In *Uncle Tom's Cabin* Stowe meant, above all, to convince readers that slavery was sin—and, therefore, absolutely intolerable. Understood as sin rather than social ill, crime, or political aggravation, slavery must be expunged totally and immediately. The original sin of American slavery not only divided slave families but also separated free citizens from their God, a God whose wrath and justice would bring cataclysm unless the nation repented speedily. Thus, Stowe's novel combines a heartfelt sermon to the congregation of America with an epic tale of escape to freedom. For the author, two different but affiliated orders of personal conversion were required to avoid national peril: religious conversion of heart to Christian faith and moral conversion to the political cause of emancipation.

In this drama of salvation Tom and Little Eva qualify as "saints" who are regenerate in both senses.

Part of the 1st Chapter of Uncle Toms Cabin
1st Draught

they are to be a fancy article entirely to sell for waiters to rich folks what can pay for a very handsome article — It sets off one of these stylish establishments you know — a handsome boy to open the door & wait & tend & all that — & they fetch a good round sum I can tell you —

I would rather not sell him said Mr Selby thoughtfully the fact is — I'm a humane man & I hate to take the boy from his mother Sir —

— Oh you do — law sakes! — well it is unpleasant the fuss these women make about their children — I always hate these scratching screaming times they have & as I does business I commonly avoids em Sir — Cant you get the woman off for a day or two, for an errand or visit or some such & then the thing can be done quietly — your wife might buy her a new gownd & some ear rings or some such trap to make it up with her —

I'm afraid not —

Lor yes — bless you these creaturs ant like folks you know — they gets over things — that is to say if you know how to manage them — Now they say my kind of trade is hardening to the felins — but I never found it so — I never could do things up in the high

Pages from the first draft for Uncle Tom's Cabin *(Manuscripts Division, University of Virginia Library)*

handed sort of way that some fellows manage
the business — I've seen em as would pull away
a womans baby out of her arms & set him up
to sale — & she screeching like mad — so that it most
take two or three to hold her — bad policy that —
damages the article — makes em quite unfit for
service sometimes — I knew a real handsome girl
once as was entirely ruined by this kind of proceeding
— the fellow that was a waiting for her of course didn't
want her baby & she was one of you real high sort
when her blood was up — & she squeezed her child
in her arms & talked reale awful — it kinder
makes my blood run cold to think on't — & when
they pulled away the baby & locked her up
she just went ravin mad — & died in a week
— a clear waste sir of two thousand dollars —
just for want of a little management —
~~Well Mr Stimpson said Mr Shelby rising Il~~
~~think em matters & let my wife decide~~
And did you find that your way of managing
did the business any better said Mr Shelby —
— Certainly — to be sure — get em out of the
way — out of sight out of mind — & when the
things clean done & cant be helped & they
know it they naturally gets used to it — folks
can get used to any thing when they must —

Tom, a feminized and maternal Christ figure, fosters new birth in others, as does the child-saint Eva through her early death, which is recounted with every adornment of nineteenth-century sentimentality. Modeled in part on an escaped slave, the Reverend Josiah Henson, Tom admittedly betrays some traits—and Stowe's minor black characters do so to an even greater degree—that have given rise to the epithet "Uncle Tom" to refer to an obsequious black person. Stowe writes from a white perspective, viewing African Americans through the favorable yet patronizing lens of what George M. Fredrickson has termed "romantic racialism." Still, Tom's role as saintly hero gains validity when considered in opposition to what Ann Douglas calls "the masculine hubris endemic to Western capitalism and imperialism." It is notable that Tom, in his defiant love, refuses to flog a fellow slave and dies rather than betray the fugitive slaves Cassy and Emmeline; his response makes possible both their escape and the liberation of the slaves on the Shelby estate in Kentucky.

In stark contrast to Tom and Eva, the story's confirmed reprobates include the slave traders Haley, Loker, and Marks; the falsely maternal Marie St. Clare; and the infamous Legree. A third group of characters, occupying a middle station with strong dramatic interest, are neither saints nor hardened sinners: the white planter Augustine St. Clare and the black fugitive George Harris are examples of what Calvinism would term "natural men"; they are sympathetic characters ripe for conversion. Indeed, the religiously rebellious Harris, whose anger is more appealing to modern readers than Tom's self-sacrificing resignation, is already convinced of his need for liberation, if not for God. But St. Clare never gains full conversion of heart as regards either emancipation or the saving goodness of God. The author concludes Uncle Tom's Cabin with a jermiad, warning of the divine wrath to come unless her readers seize the "day of grace," denounce the "accursed traffic" of slavery, and thereby hastening the millennialistic renewal of God's kingdom that will enable "this Union" of states "to be saved."

The work was published in installments in the National Era from June 1851 to April 1852 before appearing in book form. Sales surged past three hundred thousand the first year; presses in England and the United States could scarcely meet the demand. No book except the Bible surpassed it in sales in the United States for the rest of the nineteenth century. The novel was also translated into more than fifty languages. Stowe defended the accuracy of her sources in A Key to Uncle Tom's Cabin (1853).

Although Stowe had settled for a 10 percent royalty arrangement on Uncle Tom's Cabin, the huge sales of the book brought her financial freedom, international fame, and three trips to Europe with her husband. She wrote about the first of these trips, taken in 1853, in the two-volume guidebook Sunny Memories of Foreign Lands (1854), in which she takes evident pleasure in introducing innocent Americans to the cultural and aesthetic riches of Europe. She revisited the theme of slavery in her novel Dred: A Tale of the Great Dismal Swamp (1856), but neither it nor any of her subsequent work approached the success of Uncle Tom's Cabin.

Published in 1859, The Minister's Wooing, the first of Stowe's New England historical novels, is set in Newport, Rhode Island, during the early years of the republic. The central historical figure in the book is the Reverend Samuel Hopkins, an antislavery preacher and exponent of the Calvinist New Divinity initiated by Jonathan Edwards. Hopkins's patriarchal authority over his parishioners recalls that exercised over Stowe by her father. The story involves a love quadrangle in which three men—Hopkins, Aaron Burr, and James Marvyn—vie for the affection of Mary Scudder, who is repeatedly likened to the Virgin Mary. Although Marvyn's suit is weakened by his inability to claim any clear experience of religious conversion, he enjoys a vast advantage over Hopkins by virtue of his youth, energy, and charm. When it appears that he has perished at sea, Mary, after grieving his loss, agrees to wed the scholarly preacher; but she breaks off the engagement when Marvyn returns. Hopkins accepts his loss graciously. Mary is able to awaken Marvyn's religious feelings before she marries him and even succeeds in "wooing" the learned doctor from an overly cerebral, self-tormenting Calvinism toward a Christianity that allows greater scope for beauty and divine compassion. Mary thus displaces Hopkins as the theological center of the novel.

In The Minister's Wooing Stowe rejects austere Calvinism with its monarchical God, its obsessive search for evidences of election, and its radical split between nature and grace. She proposes, instead, a "feminized" Christianity that stresses the motherly compassion of Jesus. Her growing conviction that "true love is a natural sacrament" encompasses both the charitable and the erotic varieties of love. In place of Calvinism's unmediated, all-or-nothing theory of conversion and true virtue, she envisions "a ladder to heaven, whose base God has placed in human affections."

Stowe's repudiation of Calvinist demands for a discrete moment of conversion can best be seen in her treatment of Marvyn. Though he had failed to produce visible evidence of his salvation before his apparent death at sea, he clearly arrives at last within the embrace of God's mercy and love. His story reflects the crisis Stowe had endured after the drowning of her eldest son, Henry, in the Connecticut River in 1857:

Henry had failed to reach any decisive experience of salvation; was he, therefore, damned? Stowe refused to believe so. In *The Minister's Wooing* the black housekeeper, Candace, asserts, on the grounds of her womanly "spirit wisdom," that "Mass'r James is one o' de 'lect and I'm clar dar's considerable more o' de 'lect than people tink." Candace's healing influence is also crucial when she ministers to Marvyn's grief-stricken mother after he is lost at sea. For Stowe, the charismata displayed by unordained women such as Candace and Mary Scudder represents a priesthood whose power derives from personal knowledge of affliction and from identification with "the bleeding heart of the Mother of God." Stowe's fascination with the Madonna, unlikely for someone of her Protestant training, reveals her attraction to a more-feminine religious symbology than that which she inherited in the Puritan scheme of Lyman Beecher. She later displayed this fascination most explicitly in the nonfiction writings collected in *Woman in Sacred History: A Series of Sketches Drawn from Scriptural, Historical, and Legendary Sources* (1874) and *Footsteps of the Master* (1877).

In *The Pearl of Orr's Island: A Story of the Coast of Maine,* published in 1861, Stowe presents another saintly, motherly maiden who helps to rescue a man from his impetuous instincts. Mara, the "pearl" of the title, is raised by her grandparents, Zephaniah and Mary Pennel, after the deaths of her parents. Zephaniah and Mary also adopt Moses, so named because he is rescued from stormy waters off the Maine coast. Moses is less spiritual and reflective than Mara; but despite his headstrong character, religious skepticism, and Spanish and Catholic origins, love develops between the two. Stowe's tale, however, has less to do with private romantic love than it does with nurture and moral redemption in a community. Mara ministers in a maternal way toward "this brother who was not a brother": she prays for him, saves him from bad companions and reckless ways, and shares with him her faith in a God who is "like a dear and tender mother." Sexual complications of the relationship are avoided by Mara's saintly demise from consumption. Predictably, her death chastens and ennobles Moses. The endorsement of community values is reinforced by the presence in the novel of such characters as Aunt Roxy and Aunt Ruey Toothacre, who are "nobody's aunts in particular" but are available as aunts to all.

For some years Stowe had attended Episcopal services. In 1862 her three daughters—Georgiana and the twins, Harriet and Eliza—were confirmed in the denomination, and at some time between 1864 and 1866 Stowe became a formal church member in Hartford. That same year Stowe tried, with limited success, to evoke Europe's exotic appeal in *Agnes of Sorrento* (1862),

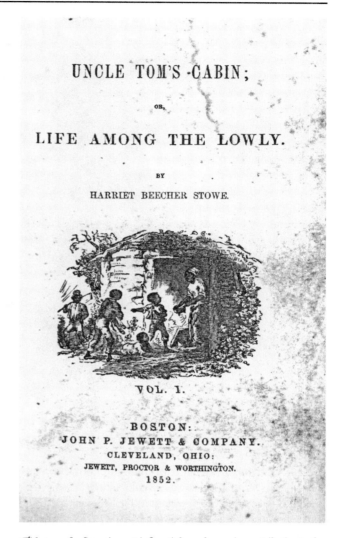

Title page for Stowe's most-influential novel, a major contribution to the abolitionist agitation leading to the Civil War

a romance of fifteenth-century Italy featuring yet another "prayerful maiden." Though this antipapal novel reflects the parochial outlook of a Protestant New Englander, it transcends the virulent anti-Catholicism that Lyman Beecher espoused.

Stowe's role as the family breadwinner was confirmed when her husband retired from teaching in 1863. In 1864 she built a comfortable residence, Oakholm, in Hartford, Connecticut. By 1873 the family had moved to a house on Forest Street in the Nook Farm neighborhood of Samuel Langhorne Clemens (Mark Twain). Between 1867 and 1884 Stowe and her family made annual winter visits to Mandarin, Florida, a haven she describes in the nonfiction collection *Palmetto-Leaves* (1873).

Oldtown Folks, published in 1869, is Stowe's longest fictional account of New England culture in the "ideal" era before the advent of railroads and steamships. Narrated by

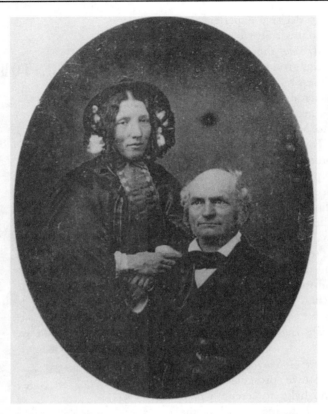

Harriet and Calvin Stowe in 1853 (Schlesinger Library, Radcliffe College)

Horace Holyoke, this gentle, meandering book combines the author's knowledge of local color and customs with childhood recollections contributed by her husband. Sam Lawson, introduced early in the novel, is a New England character type whose folksy storytelling and pungent dialect are more fully displayed in *Sam Lawson's Oldtown Fireside Stories* (1872), fifteen sketches collected from *The Christian Union* and *The Atlantic Monthly.*

In *Lady Byron Vindicated: A History of the Byron Controversy, from Its Beginning in 1816 to the Present Time* (1870) Stowe defends Anne Isabella Milbanke, Lady Byron, for divorcing her husband, the poet George Gordon, Lord Byron, by revealing Byron's alleged incestuous relationship with his half sister, Augusta. Despite her enduring status as a national celebrity, Stowe began to lose popular favor after the publication of this controversial work. Her professional problems were compounded by personal woes: her second son, Frederick, had been wounded in the Civil War and never recovered from the psychic trauma he suffered from combat at Gettysburg. He became an alcoholic; by 1871 he had disappeared and was presumed dead.

Stowe's novels of society set in fashionable New York are even less commonly read today than her New England novels. *Pink and White Tyranny,* which warns against over-hasty marriage through the character of flirtatious Lillie Ellis, appeared in 1871. The loosely plotted, moralistic *My Wife and I: or, Harry Henderson's History* of 1871 and its sequel, *We and Our Neighbors; or, The Records of an Unfashionable Street,* which appeared in 1875, were calculated to edify readers of *The Christian Union,* where the works were first serialized. Henry James, who reviewed *We and Our Neighbors* in *The Nation* (22 July 1875), found nothing to praise in the book.

These novels are, however, worth reading for what they reveal about Stowe's attitudes toward issues of the day involving marriage and the status of women. In *My Wife and I* she combines a conventional marriage plot with commentaries on wealth and fashion as her journalist narrator, Harry Henderson, succeeds in wedding the affluent Eva Van Arsdel and settling down with her to a life of virtuous genteel poverty. Although Harry is described as "a champion of the modern idea about women," the author uses him to present largely conservative responses to the woman question. Women represent humanity's "finer self," Harry says, a point ignored by "the very alarmingly rational women-reformers" who promote unisex standards of dress. Eva declares that woman's peculiar "genius" and "mission" is "to make life beautiful; to keep down and out of sight the hard, dry,

prosaic side, and keep up the poetry." Another character suggests that woman suffrage will arrive at some future time when women have gained enough education to vote wisely. Stowe's position on the suffrage issue was shifting and ambivalent: she had argued in "What Is and What Is Not the Point in the Woman Question" (*Hearth and Home,* 28 August 1869) that the Declaration of Independence already granted women the right to vote.

Stowe's suspicion of radical feminist leaders is evident in her satiric portraits of Miss Audacia Dangereyes and Mrs. Cerulean. Dangereyes reflects the author's abhorrence of Victoria Woodhull, whose advocacy of free love–linked, in Stowe's mind, with modern French communist ideology–threatened to discredit more moderate arguments for women's rights. Clearly, Stowe was disturbed by the danger she thought some feminists posed to marriage, motherhood, sanctity of the home, and Christianity. At the same time, she supported the women's movement to the extent of insisting on abolition of the double standard in sexual behavior, on women's claim to equal rights in marriage, and on more freedom for women in choosing occupations. Thus, along with more conservative pronouncements, *My Wife and I* includes arguments in favor of women's rights to speak freely in public, to remain unmarried, to seek higher education, or to pursue professions such as medicine. Harry Henderson praises the "unconventional freedom" of manners and social possibility afforded women in the United States as compared with Europe. The novel also draws sympathetic portraits of Harry's cousin Caroline and sister-in-law Ida, self-reliant women who refuse to accept conventional social roles.

The year after the novel appeared, Woodhull publicly accused Stowe's beloved brother Henry Ward Beecher, who had achieved his own fame as a Congregational preacher, writer, and lecturer, of committing adultery with one of his parishioners; he was cleared of all charges after two trials. The scandal distressed Stowe greatly; even more upsetting to her was the fact that her half sister, Isabella Beecher Hooker, failed to defend Henry or to disassociate herself from Elizabeth Cady Stanton's National Woman's Suffrage Association, which supported Woodhull's position in the controversy.

Stowe's final New England novel, *Poganuc People: Their Loves and Lives,* published in 1878, is the most autobiographical of her works. It is set in her birthplace, Litchfield, and features a protagonist, Dolly Cushing, whose father is a Calvinist clergyman. There are some outward deviations from the author's life: Dolly marries an English cousin and settles in Boston. Yet, Dolly's inward journey of faith and her questions about Christian denominational differences are concerns that Stowe

Stowe and her husband, Calvin, at their house in Mandarin, Florida, circa 1880 (Stowe-Day Foundation, Hartford, Connecticut)

had sustained for years. By this time the maternal, Nutplains side of her childhood experience, with its festive Christmas celebrations and liturgy from the Book of Common Prayer, had taken precedence over the more fearful versions of Beecher Calvinism. Still, *Poganuc People* gives the evangelical tradition its due. The Reverend Dr. Cushing is portrayed in relatively favorable terms, particularly when he preaches on a favorite Stowe theme, "Jesus as the soul-friend offered to every human being." Saintly Mary Higgins, who remains within the Congregational fold, is allowed to assume the familiar sentimental role of consumptive angel in her "triumphant death." Yet, Dolly, through personal appeal to a gospel of love and trust, succeeds better than her Congregationalist father in leading Mary's widower to faith. The nostalgia of *Poganuc People* is marred by nativist regret that New England's villages are no longer populated by "people of our own blood and race" after the arrival of "the pauper population of Europe."

Stowe's husband died in 1886. Her daughter Georgiana, who had become addicted to morphine, died in 1887 at forty-four. By the time of her own death in Hartford on 1 July 1896, Stowe had suffered several years of mental decline. She was buried in the Andover Chapel cemetery.

Assessment of Stowe's literary standing is complicated by her own reluctance to think of her writing in literary terms. Although she was frequently eloquent, she wrote copiously and usually in haste, with little regard for standards of form or craft, and she rarely bothered to revise her work. Her conceptual categories were sometimes simplistic and her plots formulaic. The

sentimentality that suffuses her work can be defended only so far. Though she produced some noteworthy novels after *Uncle Tom's Cabin,* her career as a fiction writer shows no clear pattern of maturation beyond 1852. Yet, the moral passion that enlivens Stowe's best writing, particularly *Uncle Tom's Cabin,* once captured the nation's imagination to an unprecedented degree and still has the power to move readers. If she was not an artist by formalistic criteria, she excelled in the art of persuasion and must be judged successful by the standards she set for herself. In at least one crucial way *Uncle Tom's Cabin* sustains the New Light evangelism of Jonathan Edwards, who believed preachers had to learn to move the affections if they wanted to release the grace of conversion preceding change of heart.

Inevitably, present-day evaluations of Stowe are tied to judgments about her attitudes toward race, gender, and class. Her understanding of racial matters was certainly limited, but incidents such as her somewhat patronizing responses to Frederick Douglass must be weighed against her continuing and authentic zeal to promote the welfare of African Americans. Up to a point, one can blame the later profusion of popular "Tom shows" and "Tom plays" for shaping more offensive images of blacks than those presented in *Uncle Tom's Cabin.* More troubling, perhaps, are the colonialist views she expressed toward the end of the novel: unlike more-radical abolitionists, Stowe believed at the time that most blacks would end up resettling in Africa after emancipation because the United States could not change sufficiently to become a genuinely multiracial society. Viewed within her historical and cultural context, however, and in relation to her father's gradualist stance toward abolition, her antislavery credentials look more impressive. Like its author, *Uncle Tom's Cabin* embraces a peculiar blend of conservative popular sentiment and prophetic challenge. Had Stowe written a book reflecting more-radical politics and egalitarian racial views, she probably would have lost the broad readership through which she achieved her purpose. Conservative and progressive tendencies likewise vied for dominance when Stowe considered women's proper role in society.

In contrast to the iconoclastic, countercultural disposition of many leading figures in the American literary canon, Stowe enjoyed a mass-market appeal in her own time that, for some, only increases doubts about the seriousness with which her writing should be regarded today. A large share of her output was casual journalism written for mass consumption, and almost all of her novels were first serialized in periodicals. As Jane P. Tompkins has suggested, though, Stowe's attraction to popular domestic sentimental fiction is no reason to scorn what she managed to achieve within the form. The singular status accorded to *Uncle Tom's Cabin* can obscure Stowe's affinities with other widely read nineteenth-century women writers, such as Catharine Maria Sedgwick, Lydia Sigourney, and Lydia Child. Also, modern readers may fail to appreciate Stowe's religious piety; yet, her neo-evangelical conviction that some form of individual conversion is needed to bring about full-scale regeneration of society remains a key article of American belief, even when it is formulated in thoroughly secular terms.

Literary history often assigns Stowe to the realist school of fiction, in a separate category from male symbolic romancers such as James Fenimore Cooper, Nathaniel Hawthorne, and Herman Melville. Yet, the mythical reach of *Uncle Tom's Cabin* toward archetypes of exodus liberation and passover may be said to raise the book above mere propaganda. Elements of the symbolic romance also figure in the New England novels, though here they may be mixed with shades of local color allied to fictional realism.

Perhaps the strongest indication that *Uncle Tom's Cabin* retains its standing as a classic is the way in which it continues to elicit strong reactions. That the book can still provoke creative rebuttal is shown, for instance, by *I Ain't Yo Uncle,* the revisionist play that the African American playwright Robert Alexander composed from a nineteenth-century stage adaptation. Opening with the author of *Uncle Tom's Cabin* being dragged on stage by her characters to confront angry charges of "creatin' stereotypes," Alexander's play was performed in 1995 by the Hartford Stage Company, within a stone's throw of Harriet Beecher Stowe's former home.

Bibliographies:
Margaret Holbrook Hildreth, *Harriet Beecher Stowe: A Bibliography* (Hamden, Conn.: Archon, 1976);
Jean W. Ashton, *Harriet Beecher Stowe: A Reference Guide* (Boston: G. K. Hall, 1977).

Biographies:
Charles Edward Stowe, *Life of Harriet Stowe Compiled from Her Letters and Journals* (Boston: Houghton, Mifflin, 1889);
Annie Fields, *Life and Letters of Harriet Beecher Stowe* (Boston: Houghton, Mifflin, 1898);
Forrest Wilson, *Crusader in Crinoline: The Life of Harriet Beecher Stowe* (Philadelphia: Lippincott, 1941);
Edward Wagenknecht, *Harriet Beecher Stowe: The Known and the Unknown* (New York: Oxford University Press, 1965);
Joan D. Hedrick, *Harriet Beecher Stowe: A Life* (New York: Oxford University Press, 1994).

References:
John R. Adams, *Harriet Beecher Stowe,* revised edition (Boston: G. K. Hall, 1989);

Elizabeth Ammons, "Heroines in *Uncle Tom's Cabin*," *American Literature,* 49 (1977): 161–179;

Ammons, ed., *Critical Essays on Harriet Beecher Stowe* (Boston: G. K. Hall, 1980);

James Baldwin, "Everybody's Protest Novel," *Partisan Review,* 16 (June 1949): 578–585;

Gillian Brown, "Getting in the Kitchen with Dinah: Domestic Politics in *Uncle Tom's Cabin*," *American Quarterly,* 26 (Fall 1984): 502–523;

Lawrence Buell, "Calvinism Romanticized: Harriet Beecher Stowe, Samuel Hopkins, and *The Minister's Wooing*," *ESQ: A Journal of the American Renaissance,* 24 (1978): 121;

Buell, "Hawthorne and Stowe as Rival Interpreters of New England Puritanism," in his *New England Literary Culture: From Revolution through Renaissance* (New York: Cambridge University Press, 1986), pp. 261–280;

Alice Crozier, *The Novels of Harriet Beecher Stowe* (New York: Oxford University Press, 1969);

Laurie Crumpacker, "Four Novels of Harriet Beecher Stowe: A Study in Nineteenth-Century Androgyny," in *American Novelists Revisited: Essays in Feminist Criticism,* edited by Fritz Fleischmann (Boston: G. K. Hall, 1982), pp. 78–106;

Josephine Donovan, Uncle Tom's Cabin: *Evil, Affliction, and Redemptive Love* (Boston: G. K. Hall, 1991);

Ann Douglas, *The Feminization of American Culture* (New York: Knopf, 1977), pp. 244–255;

Douglas, "Introduction: The Art of Controversy," in *Uncle Tom's Cabin,* by Harriet Beecher Stowe (New York: Viking Penguin, 1981), pp. 7–34;

Charles Foster, *The Rungless Ladder: Harriet Beecher Stowe and New England Puritanism* (Durham, N.C.: Duke University Press, 1954);

George M. Fredrickson, *The Black Image in the White Mind: The Debate on Afro-American Character and Destiny, 1817–1914* (New York: Harper & Row, 1971), pp. 97–129;

John Gatta, "The Anglican Aspect of Harriet Beecher Stowe," *New England Quarterly,* 73 (September 2000): 412–433;

Gatta, "Calvinism Feminized: Divine Matriarchy in Harriet Beecher Stowe," in his *American Madonna:*

Images of the Divine Woman in Literary Culture (New York: Oxford University Press, 1997), pp. 53–71;

Thomas F. Gossett, Uncle Tom's Cabin *and American Culture* (Dallas: Southern Methodist University Press, 1985);

Thomas Graham, "Harriet Beecher Stowe and the Question of Race," *New England Quarterly,* 46 (December 1973): 614–622;

Alex Haley, "In 'Uncle Tom' Are Our Guilt and Hope," *New York Times Magazine,* 1 March 1964, pp. 23, 90;

E. Bruce Kirkham, *The Building of* Uncle Tom's Cabin (Knoxville: University of Tennessee Press, 1977);

Mason Lowance, Ellen E. Westbrook, and R. C. De Prospo, eds., *The Stowe Debate: Rhetorical Strategies in* Uncle Tom's Cabin (Amherst: University of Massachusetts Press, 1994);

Thomas P. Riggio, "*Uncle Tom* Reconstructed: A Neglected Chapter in the History of a Book," *American Quarterly,* 28 (Spring 1976): 56–70;

Cushing Strout, "*Uncle Tom's Cabin* and the Portent of Millennium," *Yale Review,* 57 (Spring 1968): 375–385;

Eric J. Sundquist, ed., *New Essays on* Uncle Tom's Cabin (New York: Cambridge University Press, 1986);

Jane P. Tompkins, *Sentimental Designs: The Cultural Work of American Fiction, 1790–1860* (New York: Oxford University Press, 1985), pp. 123–146;

Edmund Wilson, *Patriotic Gore: Studies in the Literature of the American Civil War* (New York: Farrar, Straus & Giroux, 1962), pp. 3–11.

Papers:

Major holdings of Harriet Beecher Stowe's correspondence, family papers, and manuscripts are at the Stowe-Day Library in Hartford, Connecticut, and the Schlesinger Library at Radcliffe College in Cambridge, Massachusetts. Other repositories include the Barrett Library at the University of Virginia; the Beinecke and Sterling Libraries at Yale University in New Haven, Connecticut; the Boston Public Library; the Cincinnati Historical Society; the Clements Library at the University of Michigan; the Houghton Library at Harvard University; the Huntington Library, San Marino, California; the Rutherford B. Hayes Library in Fremont, Ohio; and the New York Public Library.

Celia Laighton Thaxter

(29 June 1835 – 26 August 1894)

Lori Beste
University of Connecticut

BOOKS: *Poems* (New York: Hurd & Houghton, 1872; expanded edition, New York: Hurd & Houghton, 1874);

Among the Isles of Shoals (Boston: Osgood, 1873);

Drift-Weed (Boston: Houghton, Osgood, 1879);

Poems for Children (Boston & New York: Houghton, Mifflin, 1884);

The Cruise of the Mystery and Other Poems (Boston & New York: Houghton, Mifflin, 1886); published in two editions: Edition de Luxe, with twenty-four poems, republished as *Verses* (Boston: Lothrop, 1891), and Regular Edition, with twelve poems;

Idyls and Pastorals: A Home Gallery of Poetry and Art (Boston: Lothrop, 1886);

Salutation! (Boston: L. Prang, 1887);

The Yule-Log (Boston: L. Prang, 1889);

My Lighthouse and Other Poems (Boston: L. Prang, 1890);

An Island Garden (Boston & New York: Houghton, Mifflin, 1894);

Stories and Poems for Children, edited by Sarah Orne Jewett (Boston & New York: Houghton, Mifflin, 1895);

The Poems of Celia Thaxter, edited by Sarah Orne Jewett (Boston: Houghton, Mifflin, 1896);

The Heavenly Guest With Other Unpublished Writings, edited by Oscar Laighton (Andover, Mass.: Smith & Coutts, 1935).

SELECTED PERIODICAL PUBLICATIONS—

UNCOLLECTED: "The Sandpiper's Nest," *Our Young Folks,* 3 (1867): 433–434;

"The Spray Sprite," *Our Young Folks,* 5 (1869): 377–381;

"A Memorable Murder," *Atlantic Monthly,* 35 (May 1875): 602–615;

"The Bear at Appledore," *St. Nicholas,* 3 (1876): 602–605;

"Willie's Wonderful Flight," *St. Nicholas,* 3 (1876): 522–523;

"Madame Arachne," *St. Nicholas,* 15 (1882): 521–524;

"Peggy's Garden and What Grew Therein," *St. Nicholas,* 12 (1885): 886–895;

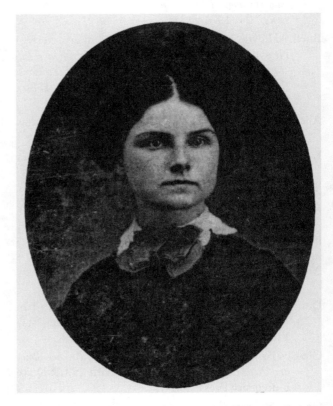

Celia Laighton Thaxter, circa 1860 (Isles of Shoals Collections, University of New Hampshire)

"Some Polite Dogs," *St. Nicholas,* 14 (1887): 543–545;

"Cat's Cradle," *St. Nicholas,* 15 (1888): 582–588;

"Almost a Tragedy," *St. Nicholas,* 16 (1889): 890–893.

Celia Thaxter, one of the most popular American poets of the late nineteenth century, lived on the Isles of Shoals off the coast of Maine and New Hampshire. Nathaniel Hawthorne called her the "Island Miranda," a reference perhaps to both William Shakespeare's *The Tempest* (circa 1611) and Margaret Fuller's *Woman in the Nineteenth Century* (1845). Lucy Larcom called her an "enchantress." Most people who met her

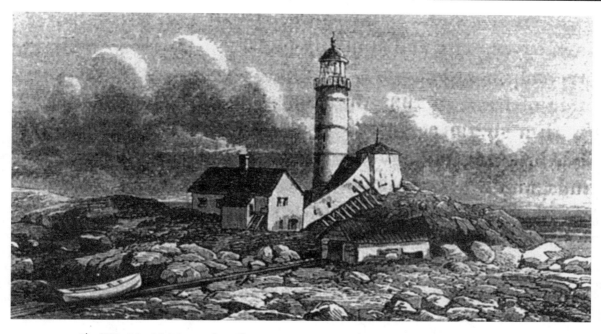

The White Island lighthouse, where Thaxter spent her childhood (engraving from Samuel Adams Drake,
Nooks and Corners of New England Coast, *1876)*

remarked upon her striking beauty, gracious manner, and captivating conversation. Among her friends were many of the famous literati of New England, including John Greenleaf Whittier, Sarah Orne Jewett, Annie Fields, and her husband, publisher James Fields. Thaxter's life and her writing career, like those of many nineteenth-century women, were simultaneously inhibited and propelled by her domestic and financial responsibilities. She managed to support herself through writing and achieved recognition for her poetry. Though she was known primarily as a poet and often dismissed her ability to write prose, her poetic ability enabled her to write prose that confronts and describes the beauty and horrors of human experience with a realistic forthrightness and an elegant attention to detail.

Thaxter's poetry has a lyrical style with conventional end rhymes, popular during her day, but often dismissed by modern critics. Her poetry appeared frequently in the pages of popular periodicals such as *The Atlantic Monthly* and *Harper's*. Both her poetry and prose address complex themes about human suffering, God's indifference, and moral ambiguity. She always resisted sentimentality and asserted a strong realistic vision. In a 10 April 1889 letter to a friend, she wrote, "To be perfectly direct and clear as daylight is absolutely necessary to my peace of mind!" Sometimes her directness, especially when it addressed topics of human tragedy, caused nineteenth-century critics to

accuse her of a lack of cheerfulness. Yet, this lack of cheerfulness and her preference for realism over sentimentalism seem to be the qualities that appealed to the late-twentieth-century critics who have reconsidered Thaxter's work.

Jane Vallier, whose 1982 biography is the most significant work to date on Thaxter's life and poetry, defends the importance of Thaxter's poetry through a careful biographical and historical reading. In her introduction Vallier fittingly compares Thaxter to Fuller and discusses the many parallels between their lives. Like Fuller, Thaxter struggled to balance the societal expectations of women and her own expectations of herself as an intellectually independent and creative individual. Though full of burdens and adversities, Thaxter's life was rich and fascinating—she, as James Freeman Clarke said of Fuller, "might furnish the material for a hundred biographers."

Celia Laighton was born 29 June 1835 to Thomas B. and Eliza Laighton in Portsmouth, New Hampshire and spent most of the formative years of her life on the wind- and sea-swept, rugged islands of the Isles of Shoals. In 1839, after becoming disgruntled by the American political process, Celia's father moved the family to White Island, where he assumed a position as lighthouse keeper. In the 1830s White Island was the most developed island among the Shoals, supporting the fishing village of Grosport with a population of approximately 150 people. Thomas

Laighton purchased Appledore, Smutty-nose, Malga, and Cedar Islands from Captain Sam Haley, whose family had owned these essentially undeveloped islands since the seventeenth century. In 1847 Laighton moved his family to the rocky isle of Appledore, where he had constructed a hotel. The Appledore Hotel changed this peaceful fishing outpost into a lively vacation resort for wealthy New Englanders desiring the benefits of fresh air and sunshine, which were not readily available in the manufacturing towns of the northeast.

Celia Laighton's childhood on the islands was marked by isolation and solitude, which she later recounted in her book *Among the Isles of Shoals* (1873). Her younger brothers, Oscar and Cedric, were her only playmates, and she sought solace in nature and work. She wrote, "But the best balanced human mind is prone to lose its elasticity, and stagnate, in this isolation. One learns immediately the value of work to keep one's wits clear, cheerful, and steady." Living on the islands, Celia became conscious of the forces of nature, weather, plants, and animals. This consciousness of nature's destructive power and beauty would become more fully revealed in her prose and poetry.

Initially, Thomas Laighton assumed the responsibility of educating his children at home. As they grew, however, he realized they needed more formal instruction, and the demands of running the new hotel increasingly distracted him from his children's studies. The obvious choice for a tutor was Levi Thaxter, whom Laighton had known for years and who had helped finance the Appledore hotel. As a visitor to the islands, he had impressed Laighton with his gentlemanly manners and Harvard education. He became Celia's tutor in 1847, and by the spring of 1851 she wrote to a friend that she would probably marry him in the fall. Little is known of the courtship between Levi and Celia, as only a few letters exist from this period of her life. Despite her father's disapproval, they were married on 30 September 1851 in the front parlor of her family's home on Appledore Island. They settled for a time on White Island, where Levi accepted a position of pastor at a small church, but this position did not last long, and the couple endured a series of moves before finally settling in Newtonville, near Boston, in 1855.

Shortly after she turned eighteen, Thaxter gave birth to her first son, Karl, on 24 July 1852. The birth was difficult, and Karl was born with a permanent mental and emotional disability. Thaxter never discussed the disability in detail, but Karl remained in his mother's care for all of her life. Although he later developed an ability to read and interact socially with others, Thaxter always feared her firstborn son would

be forced into a mental institution if she did not care for him. His violent temper and physical aggression, especially against his younger brother John, was a constant source of stress to her. The Thaxters had two more sons: John was born 29 November 1854, and Roland, the youngest, was born 28 August 1858. Since Thaxter was so occupied with raising Karl, Levi helped with the other boys when they were older. Any youthful idealism Thaxter may have had about marriage and family, however, was certainly destroyed by the actual responsibilities of caring for raucous sons and an indolent husband.

After barely surviving a treacherous shipwreck in 1855, Levi had enough of island life and vowed never to return. His conviction against travel to the Isles of Shoals became one of many obstacles in their marriage. Levi sold his portion of Appledore Island to his father-in-law, and he let his father help him purchase the Newtonville house for the young family. Thaxter's letters to her friends during this time suggested that she was more isolated in her Newtonville home than she had ever been on Appledore. Levi was unrelenting in his demands about housework, but they could not afford to hire help. Never providing his wife and children with a steady income, he moved from job to job, unable to commit himself to any permanent occupation.

Despite Thaxter's remarks about Levi's insensitivity and demands, she seemed to have found some joy with him during the early years of her marriage. She wrote of Levi's reading John Ruskin's essays, Elizabeth Barrett and Robert Browning's poetry, and other works to her in the evenings, while she sewed. In Boston, Thaxter made several lifelong friends who helped initiate her writing career and later visited her on the Isles of Shoals throughout her life—most significant were James Fields of the publishing house Ticknor and Fields and his wife, Annie. The Fields's home was a place where authors dined and conversed on a variety topics. The Thaxters were frequent guests during their early years in Boston. Among the writers Thaxter met there were Charles Dickens, Ralph Waldo Emerson, Oliver Wendell Holmes, and Henry Wadsworth Longfellow. During this time Thaxter was learning a great deal about poetry from Levi and from the lively, distinguished company into which her husband introduced her.

Thaxter's first poem, "Land-locked," was published in the March 1861 issue of *The Atlantic Monthly*. This poem subtly reveals some of her desire to escape domestic tension and return to a freer existence on Appledore. Without her knowledge, Levi sent a copy of this poem to his friend James Russell Lowell, then editor of *The Atlantic Monthly*. The poem was published

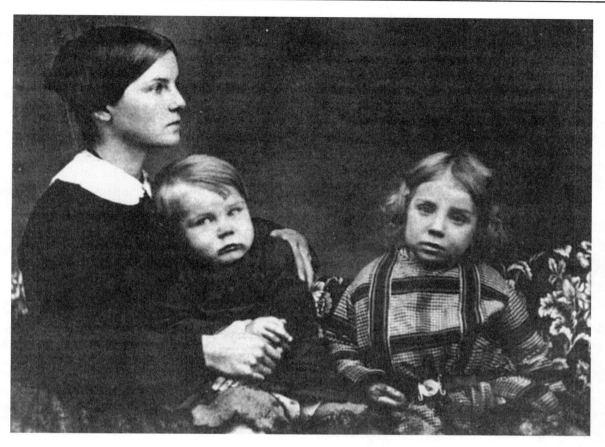

Thaxter and her sons John and Karl, circa 1856 (Isles of Shoals Collections, University of New Hampshire)

anonymously, but Thaxter was surprised and elated to discover her poem in print. According to her letters, the Thaxters only discussed the poem briefly after she received a ten-dollar check for it from Ticknor and Fields. Levi never mentioned the poem, and she did not ask for his opinion. She wrote, "I know very well what he would say if I asked him if he liked it. Yet I think he is pleased." She had always been his star pupil, and he may have had a solemn confidence in her ability. As several biographers have suggested, however, Levi's indifference most likely resulted from his jealousy toward his wife's success. He had given up a career in the theater once he married and essentially abandoned all of his youthful aspirations for a literary career. He did teach Thaxter about poets and poetry, and he encouraged her writing to some degree during the 1860s. After he helped finance her first book of poems published in 1872, however, he did not offer her the intellectual and critical support she desperately sought. As his health problems and other events

of their lives drew them apart, Thaxter looked to her friends and editors for support and criticism.

Thaxter lacked self-confidence in her writing ability, despite her popularity with the reading public. Vallier contends that Thaxter's lack of a formal education caused her to doubt her ability and concludes that her dependence on editorial advice limited her ability to grow artistically. In her letters to periodical editors, she pleaded for their critical commentary, yet adamantly resisted advice that altered her poetic intentions. When James Fields made such suggestions, she wrote a letter that stated her intentions and then with self-deprecating excuses about her untutored willfulness, she asked his forgiveness for her stubborn refusal to comply with his advice. She often sent Mary Mapes Dodge, editor of the children's magazine *St. Nicholas,* stamped envelopes with her submissions so that Dodge could return her editorial suggestions more quickly. When John Greenleaf Whittier, whom Thaxter met during the 1860s, wrote in 1874 asking about an autobiographical novel he had encouraged

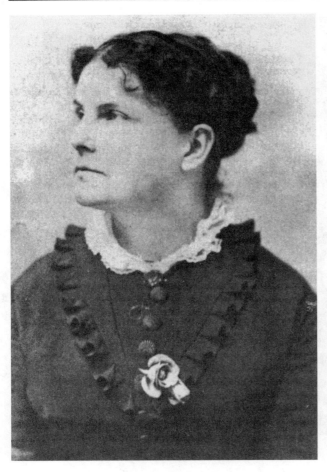

Thaxter, circa 1873 (Portsmouth Public Library)

as if I don't know the King's English." Her friends, however, repeatedly praised her powers of storytelling and admired her talent for description. Jewett, who affectionately referred to Thaxter as "Sandpiper," praised her prose style. In a letter to a friend Jewett wrote, "I ought to be Sandpiper to properly enumerate and describe."

During the 1860s Whittier offered Thaxter some of the encouragement she sought, and he might have been largely responsible for inspiring her to write her first, and perhaps most important, prose piece. Many years before Thaxter granted his wish, Whittier began suggesting that she write an account of the Shoals. In January 1864 he wrote to her "Where is that paper for the *Atlantic* upon Star Island and its inhabitants? . . . If it is only half as good as thy verbal account of that remarkable settlement it will be well worth reading." In 1866 he again chided her, "I wish thee would write out for the *Atlantic* some of the good things thee know of the Shoals and Shoalers. I have never heard anything in dramatic effect to thy stories one evening in thy parlor at Appledore." Several years later Thaxter wrote her first major prose piece about the Isles of Shoals as a four-part series for *The Atlantic Monthly* (August 1869–May 1870). The public praised these essays about the Shoals, and the pieces firmly established Thaxter's capability as a local historian and ethnographer. While chronicling the Shoals' geology, horticulture, climate, history, and folklore, she wrote vivid descriptions of the landscape's beauty and desolation and the inhabitants' isolation and resilience.

During the fall of 1869, while Thaxter was writing *The Atlantic Monthly* series about the Isles of Shoals, Levi became seriously ill and was eventually diagnosed with rheumatism. This incident marked the beginning of a series of illnesses and complications that kept Levi separated from Thaxter throughout most of the remaining years of their marriage. His doctor recommended that Levi travel south to relieve some of his symptoms. Because of Karl's behavior problems Thaxter thought their eldest child should not travel. Levi took Roland and John with him to St. Augustine, Florida, during the winter of 1870. Thaxter and Karl went to the Isles of Shoals that winter, and the family did not live together with any semblance of domestic stability until 1881, when Levi purchased the Champernowne Farm on Kittery Point, Maine, where Celia and Levi lived at times with their sons.

As the series on the Shoals appeared in *The Atlantic Monthly,* Whittier wrote encouraging comments to Thaxter about his conversations in Amesbury with people who had inquired about the essays. He suggested to Thaxter that the series should be published

her to write, she replied with frustration, "Twice I essayed to begin, wrote a chapter and flung it to the four winds, in wrath and scorn. . . . I am not to be the author of the Novel, par excellence, of America, that is certain." She continued in this letter to express her desire for someone who could really help her develop and edit her work. Though Whittier, Dodge, Fields, and others attempted to provide the assistance Thaxter longed for, she did not find her ideal mentor and editor until 1893 when she worked on *An Island Garden* with Sarah Orne Jewett, whom she had met in the early 1880s.

According to her letters, poetry came more naturally to her than her prose. In 1889 she wrote, "The first verses I remember to have written sang themselves, a spontaneous expression of my homesickness for my islands after my marriage, when I left them for the first time." She continued to explain that after she wrote a few poems, "verses were always weaving themselves into my brain." In 1867 she wrote to Dodge, "I'm entirely unused to writing prose, and feel

as a book with illustrations by Harry Fenn, who had often illustrated Whittier's poems. Nearly three years after *The Atlantic Monthly* series, Houghton, Mifflin published Thaxter's work *Among the Isles of Shoals* with illustrations by Fenn. More than 2,000 copies of the book were printed in May 1873; these sold quickly during the first three months of publication, so a second printing of 1,030 copies followed in July 1873. This work continued to be reprinted by Houghton, Mifflin throughout Thaxter's life.

Her next prose piece, "A Memorable Murder," was published in the May 1875 issue of *The Atlantic Monthly* and retold the story of a gruesome murder that occurred on Smutty-nose Island on 6 March 1873. The sordid details of this crime made national headlines for several years until the murderer was hanged in Portsmouth in 1875. Thaxter personally knew all of the characters: the victims—two Norwegian women, Karen Christensen and her sister-in-law Anethe; the sole survivor, Maren Hontevet, who managed to escape; Anethe's and Maren's husbands; and the notorious murderer, the axe-wielding Louis Wagner. Thaxter had employed Karen at the hotel, knew the families on Smutty-nose as her neighbors, and had met Wagner when he worked for Anethe's husband. Thaxter, like the popular press, pieced together an account of events from the testimony of Maren Hontevet, from the women's husbands who had seen Wagner earlier the night of the murders, and from details concerning Wagner's whereabouts and actions before and after the murders. Thaxter's approach, however, differs from other reports. As a result of her ties to the people involved, Thaxter's account is more merciful and astute than most. She had been on the crime scene the day after the murder, and she knew the people and places involved much better than the average reporter. The public, anxious for news of the crime, was enthralled with Thaxter's story.

Thaxter attempted to render the humanity of the victims, the enigmatic character of the murder, and the indifference of Nature in order to evoke a more sympathetic response from the public. She recalls the details with a fearless honesty and remonstrates that she, too, had been taken in by Wagner's seemingly benign character. Her story examines Wagner's inhumanity and Nature's indifference. She describes the women's characters and speculates about the conditions that enabled Wagner's evil Nature to triumph over the women's goodness. She describes Nature as an accomplice to the crime and asks why a typical March storm had not raged that night to thwart the villain's plans. Her story, though it has an appeal as a crime drama, also addresses questions of ontology,

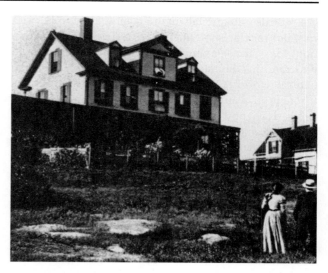

Thaxter's house and garden on Appledore Island, where she resided from the 1870s until her death in 1894 (Isles of Shoals Collections, University of New Hampshire)

moral ambiguity, and transcendentalist views of nature.

Throughout her life Thaxter's poetry and short stories consistently appeared in children's magazines, such as Lucy Larcom's *Young Folks* and Dodge's *St. Nicholas*. Though she often trivialized this work in her letters, her stories and poems appeared alongside other famous writers, such as Louisa May Alcott and Mark Twain. This writing provided her with a fairly reliable income, and she seemed to have been able to depend on Dodge to give her work whenever she needed it. Her letters to Dodge were often friendly, but some harbored a desperate tone as Thaxter practically begged Dodge to consider her work for publication. In 1882 she concluded her letter to Dodge, "And let me hear from you *soon?* And give me all the work you can. I am sure you will! Nobody needs it more." Thaxter complained to Whittier of the tediousness of writing for *St. Nicholas;* in some letters she expressed a slight embarrassment about the nature of the stories, yet she needed the financial benefits this writing provided.

Despite her own reticence about her children's poetry and prose, her juvenile literature demonstrated her marked preference for realism over sentimentalism. Her stories addressed young audiences with an adult sensibility and stressed that children could make contributions to their families and society, typical elements of children's literature at the time. Yet, Thaxter continued to reveal her sense of humankind's relationship to nature and examined complex moral questions similar to her prose pieces published in *The Atlantic Monthly*.

Birds and animals figure prominently in her stories, but they are not fanciful creatures of the imagination. She used animal and human characters to illustrate that human action can negatively affect the natural world. Occasionally an individual triumphs through an animal's assistance, but generally her stories resist happy endings. Frequently, the animals suffer as a result of human foolishness, and the innocent or beloved animal often dies in her story. Thaxter did not shelter her young readers from the harsh realities of an adult world. "The Bear at Appledore," published in *St. Nicholas* in 1876, for example, is about a Georgia bear brought from the mountains to the Isles of Shoals. A conflict develops regarding the bear's inability to adapt to the new island environment. Taking the bear from his natural home proves to be a disaster for all involved, and in the end the bear has to be shot. By creating sympathy for the bear the story presents a moral about the tragedy of humankind's disruption of nature.

Some of her children's stories also have an autobiographical quality, such as "Spray Sprite" published in *Young Folks* (1869) and "Peggy's Garden and What Grew Therein" published in *St. Nicholas* (1885), a tale of a young girl who grows a lovely flower garden on an island and sells the flowers to guests of the nearby hotel so that her family can buy food. Though Thaxter's family never knew the kind of poverty described in the story of Peggy's garden, the parallels to Thaxter's life are obvious. In the story, the father, basically a good man, suffers from rheumatism and is unable to work. Thaxter's father and her husband, Levi, suffered from rheumatism. Like Peggy, Thaxter derived much of her personal fulfillment from her garden. The story stresses the young girl's faith and ingenuity as well as her natural beauty in contrast to the women at the hotel, who are artificial, made-up beauties with affected manners. A kindly, wealthy, elderly woman recognizes Peggy's true beauty and becomes her benefactress and promises in her heart to provide for the young woman. It is a story of universal charity, for inasmuch as Peggy gains from the kindness of those who buy her flowers, Peggy also enriches their lives.

Though Thaxter never wrote in support of women's rights, her children's prose describes a feminine-centered world and emphasizes that young women should cultivate a serious, not frivolous, attitude. She attempted to show her young readers that women could care for themselves through their hard work, their intelligence, and their ability to sympathize with the natural world.

Stories and Poems for Children (1895), a collection of Thaxter's work, was edited by Jewett after Thaxter's

death; 2,065 copies were printed in 1895, and this volume, still in print, continues to delight children.

In addition to writing two major prose pieces during the 1870s, Thaxter continued writing poetry for popular periodicals; she spent most of her time on Appledore Island caring for her aging mother while Levi traveled around the United States and the West Indies. In 1877 Eliza Laighton died, causing Thaxter great emotional and psychological turmoil. She had been extremely close to her mother and grieved over her death for many years. During this time of grief Thaxter became especially interested in spiritualism and read many books on mediums and mysticism. Along with her friends Annie Fields and Jewett, Thaxter attended séances where she tried to contact her mother. Eventually this interest passed, but she continued to explore mysticism and various religions, including Buddhism and Christianity. She had not been raised to believe in a particular religion and never fully embraced the tenets of one spiritual tradition. Yet, throughout her life she maintained an unconventional spirituality, which became especially evident in her later works.

From the 1880s until her death Thaxter's home on Appledore was a favorite summer retreat for artists, musicians, and writers. Her parlor, immortalized in the paintings of Childe Hassam, was open to all who appreciated beauty, poetry, art, music, and conversation. She devoted a section of her book *An Island Garden* (1894) to describing her decorating choices for the parlor and explaining the aesthetic effects she created. Nearly every space of the parlor's walls was adorned with photographs and paintings by her artist friends, such as Hassam, J. Appleton Brown, and Ellen Robbins. She carefully arranged bouquets of flowers that sat atop all available surfaces in the rooms. Her friends gave recitals of Ludwig van Beethoven and Robert Schumann; she gave poetry readings and often told stories about the Shoals to the delight of her audience.

Thaxter's last published work, *An Island Garden,* is a blend of practical horticultural advice and personal wisdom. In this work she discusses various types of flowers and their care. She details her techniques of cultivating her garden on Appledore Island and of decorating her home. Advice on how to control garden pests and propagate plants is juxtaposed with revelations on how the garden speaks to the soul. Though the book has a factual basis, her elegant prose reads much like a poetic catalogue from Walt Whitman's *Leaves of Grass* (1855). In many ways this work is her attempt to render all the details of her garden, to count each specific flower in all of its beauty, and to reveal its relationship to her life. Of the lilies she

wrote, "And in the garden they are planted especially to feast the eyes of the souls that hunger for beauty, and within doors as well as without they 'delight the spirit of man.'"

More than one thousand copies of *An Island Garden* were printed during the spring of 1894. A second printing of one thousand copies was published in November 1894. It featured a gold-stamped cover designed by Sarah Whitman and numerous illustrations by Childe Hassam of Thaxter and her garden. In her review for the June 1894 issue of *The Dial*, Sarah Hubbard described Thaxter's work in the garden as "heroic" and called attention to her descriptions of flowers. That fall a critic in the November issue of *New England Magazine* claimed that Thaxter's flower commentary placed her among men such as Wordsworth, Emerson, Thoreau, Lowell, and Burns, all who had made flora and fauna subjects in their writing. Since its publication horticulturalists, naturalists, and gardening enthusiasts have shown a continued interest in *An Island Garden*.

Thaxter suffered poor health while writing this work. She had experienced some sort of heart attack in 1887 and, for the rest of her life, occasionally complained of neuralgia. In one letter to Jewett, Thaxter contrasted the melancholy and physical discomfort she had been feeling during the winter she spent writing *An Island Garden* with joy she felt while writing *Among the Isles of Shoals*. Of her mood she wrote, "I was so happy when I wrote the Shoals book—it wrote itself. . . . But now the shadows are so long, and it grows so lonesome on this earth." Such a comparison in her mood is ironic because *An Island Garden* contains sweet and soulful musings about the pleasures of gardening, birdwatching, decorating, aesthetics, and private contemplation, while *Among the Isles of Shoals* is full of rough and violent images of the islands and their inhabitants, all threatened by destruction at any moment should a strong enough storm appear.

Celia Thaxter died on 26 August 1894, six months after the publication of *An Island Garden*. Shortly thereafter Annie Fields and Rose Lamb began collecting and editing Thaxter's letters and published a selection of them in 1895. Thaxter's letters, prized and praised by her friends, are worth reading for the poetic descriptions and revealing details of an artistic woman's life in nineteenth-century America. Though they edited in the cut-and-paste style typical of the time, Fields and Lamb's book is the only collected edition of Thaxter's letters to date. In the July 1895 issue of *The Bookman* reviewer Bliss Carman criticized Thaxter's correspondence for lacking introspection and blamed this

Thaxter in her garden on Appledore Island (frontispiece to Letters of Celia Thaxter, *1895)*

defect on the editors who omitted her most personal and philosophical thoughts. To some degree this criticism is true; yet, even this published volume has an appeal for its vivid descriptions of her domestic, artistic, and personal joys and struggles. Her letters that have been published in later biographies and those that remain in archives and special collections are worth reading for their candor and wisdom.

Barbara White and Vallier have considered the way Thaxter's life and work typify what women in nineteenth-century America could and could not accomplish. Thaxter's poetic ability was certainly inhibited by personal conflicts and societal forces; she struggled against familial responsibilities and her own self-doubts. Hers may have been a natural talent, one born of "instinct," rather than training as she herself often claimed. Yet, she thought deeply about the world she knew, and her thoughts and questions are beautifully expressed in her work. Her

prose, poetry, and life resonate in the line from her poem "Dust," featured in the preface of *An Island Garden:* "how much / it hides and holds that is beautiful, bitter, or sweet."

Letters:

Letters of Celia Thaxter, edited by Annie Fields and Rose Lamb (Boston: Houghton, Mifflin, 1895).

Biographies:

Rosamund Thaxter, *Sandpiper: The Life and Letters of Celia Thaxter,* revised edition (Francestown, N.H.: Marshall Jones, 1963);

Jane E. Vallier, *Poet on Demand: The Life, Letters, and Works of Celia Thaxter* (Camden, Me.: Down East, 1982);

Julia Older, *The Island Queen: A Novel* (Hancock, N.H.: Appledore, 1994).

References:

Richard Cary, "The Multicolored Spirit of Celia Thaxter," *Colby Library Quarterly* (December 1964): 512–536;

David Park Curry, *Childe Hassam: An Island Garden Revisited* (Denver: Denver Art Museum / New York: Norton, 1990);

Sarah Orne Jewett, *Letters of Sarah Orne Jewett,* edited by Annie Fields (Boston: Houghton Mifflin, 1911);

Wilma Stubbs, "Celia Thaxter, 1835–1894," *New England Quarterly,* 8 (December 1947): 518–533;

Perry D. Westbrook, "Celia Thaxter: Seeker of the Unattainable," *Colby Library Quarterly* (December 1964): 501–511;

Westbrook, "Controversy with Nature: Celia Thaxter," in his *Acres of Flint: Sarah Orne Jewett and Her Contemporaries,* revised edition (Metuchen, N.J.: Scarecrow Press, 1981): 105–127;

Barbara A. White, "Legacy Profile: Celia Thaxter (1835–1894)," *Legacy,* 7 (Spring 1990): 59–64;

John Greenleaf Whittier, *The Letters of John Greenleaf Whittier,* 3 volumes, edited by John B. Pickard (Cambridge, Mass.: Belknap Press / Harvard University Press, 1975).

Papers:

The Portsmouth Atheneum in Portsmouth, New Hampshire, has a file of Celia Laighton Thaxter's papers along with other items about the Shoals in the "The Isles of Shoals" collection, formerly held by the Portsmouth Public Library. Thaxter's letters also can be found in special collections held by the Boston Public Library, Colby College, Harvard University, Yale University, Princeton University, the University of Virginia, and the University of New Hampshire.

Sojourner Truth

(?1797 – 26 November 1883)

Martin Japtok
West Virginia State College

BOOK: *Narrative of Sojourner Truth, A Northern Slave, Emancipated from Bodily Servitude by the State of New York, in 1828,* told to and edited by Olive Gilbert (Boston: For the Author, 1850); expanded as *Narrative of Sojourner Truth: A Bondswoman of Olden Time, Emancipated by the New York Legislature in the Early Part of the Present Century; with a History of her Labors and Correspondence Drawn from her "Book of Life,"* edited by Gilbert and Frances Titus (Battle Creek, Mich.: For the Author, 1878).

Sojourner Truth is one of the most enduringly popular American nineteenth-century historical figures. Born into slavery from which she was not released until she was thirty years old, Sojourner Truth, uneducated and illiterate, is remembered for the enormous power and influence of her oratory. Her 1851 "Ar'n't I a Woman?" speech delivered at a women's conference in Akron, Ohio, is regarded as a masterly expression of feminist thought and contributes to her image as a near-mythical symbol of African American womanhood. She embroiled herself in the great struggles of her century—abolition, women's rights, and Reconstruction—drawing force from the strength of her religious beliefs. Her narrative and her "Book of Life," recorded and edited by Olive Gilbert, provide a record of a woman who was, by all accounts, one of the most charismatic orators of her time.

Born about 1797 in Ulster County, New York, the daughter of Betsey (Elizabeth) and James, Sojourner Truth's original name was Isabella. Her parents were slaves of the Hardenberghs, a Dutch-speaking family, which may account for Truth's distinct pattern of speech. She did not begin learning English until she was about nine and lived under hostile circumstances with a succession of severe slave masters in a region where she probably heard Dutch on a regular basis. Nell Irvin Painter surmises in her biography of Truth, that "she lost neither the

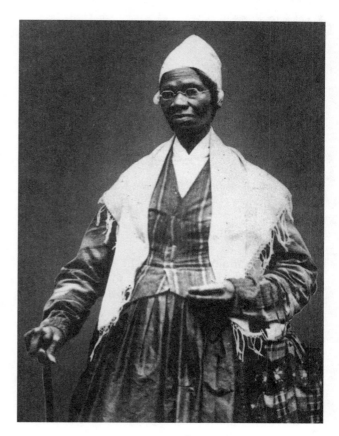

Sojourner Truth

accent nor the earthy imagery of the Dutch language that made her English so remarkable."

Isabella was married to a slave named Thomas, and they had several children. In the fall of 1826 Truth left the Dumont family to whom she had been sold in 1810, though she would have been legally free on 4 July 1827 by the terms of a New York state law abolishing slavery. Dumont had reneged on his

The earliest known portrait of Truth, an engraving published as the frontispiece to the 1850 edition of her Narrative

promise to manumit her, and she walked away in protest, leaving her husband and children with Dumont. In a typical passage from *Narrative of Sojourner Truth* (1850), Olive Gilbert quotes Truth's recollection of this time: "'Ah!' she says, with emphasis that cannot be written, 'the slaveholders are TERRIBLE for promising to give you this or that, or such and such a privilege, if you will do thus and so; and when the time of fulfillment comes, and one claims the promise, they, I forsooth, recollect nothing of the kind. . . .'" In the Rochester *Evening Express* of 17 April 1871 she is quoted as saying she "did not run off, for I thought that wicked, but I walked off, believing that to be all right." She wanted to give Dumont a chance to find her, which he did, living with a friendly family, the Van Wagenens, who had provided her shelter. They bought her from Dumont and set her free. She adopted the name Isabella Van Wagenen.

During the years 1827–1828, Truth enlisted the help of lawyers to retrieve her son Peter, who had been illegally sold to a slaveholder in Alabama. In her narrative she says, "I was sure God would help me get him. Why, I felt so *tall within*—I felt as if the *power of a nation* was within me!" Jeffrey C. Stewart, in his introduction to the 1991 edition of the 1878 version of her narrative, comments that both "religious faith and a belief that she was part of a larger struggle of a 'nation' of black people empowered her to act on behalf of her son." Despite overwhelming odds and a lack of financial resources, she was successful.

Following the retrieval of her son, Isabella moved to New York City in 1829, where she participated in various religious communities. She joined a religious commune run by a self-proclaimed prophet named Robert Matthews, later accused of murder and of exploiting his followers. He changed his name to Mathias and founded the Kingdom of Mathias, which had only one black member, Isabella Van Wagenen. Commenting on Gilbert Vale's *Fanaticism: Its Source and Influence, Illustrated by the Simple Narrative of Isabella* (1835), Truth's biographer Victoria Ortiz says the author "praised the black woman's integrity and openness and declared that 'she had shrewd common sense, energetic manners, and apparently despises artifice.'"

Isabella Van Wagenen left New York in 1843 in order to become a traveling preacher and evangelist, and at that time she adopted the name Sojourner Truth, breaking "with two traditions at once," according to Stewart: "the tradition of former slaves taking their master's names and that of married women taking their husband's names." In her narrative, she tells the reader that New York City "was no place for her; yea, she felt called in spirit to leave it, and to travel east and lecture." By becoming an evangelist Truth took on "one of the few leadership roles outside the home that was open to women, both black and white," as Carleton Mabee observes in his biography of Truth. Evangelizing at camp meetings, she drew on her own theological views, the elaboration of which makes up a significant part of the 1850 narrative.

According to Margaret Washington, Truth's religious beliefs reflect the influences of West African spirituality, influences that might have come to her through her mother and African Dutch traditions in the Hudson Valley. Dutch Protestantism and the various millennial communities–communities expecting the imminent second coming of Christ–influenced Truth throughout her life. Much of her narrative is a personal spiritual history–an account of how she gained her faith, of her trials and tribulations in overcoming doubt and temptation, and of her certainty of God's presence and power in her life. Gilbert reports Truth's theology, even if at times with disapproving comments. On the relationship between Christ and God, Truth comments on one of her visions, "'Of that I only know as I saw. I did not see him to be God; else, how could he stand between me and God?

I saw him as a friend, standing between me and God, through whom, love flowed as from a fountain.'" One might argue that her isolation from mainstream Protestantism in her early years, her mother's influence, various idiosyncratic millennialists she encountered, and her own visions forged an intensely personal religious thought system, always expressed in vivid, concrete imagery, which sustained her throughout her life. All her reform activity was heavily intermixed with evangelism, and the singing of hymns was one of her trademarks.

Indeed, the *Narrative* often mentions her singing, and Gilbert, Frances Titus, and Harriet Beecher Stowe, as well as many newspaper articles, comment on her remarkable singing ability. Mabee, in his 1993 biography of Truth, explains that in hymns she often composed herself, she captured something larger than her own emotions: "Like many blues singers, however, Truth sang not only out of her own experience but out of the experience of blacks at large. She sang especially of the agony of herself and others as slaves." Singing also served as one of her main conduits of spirituality and religious expression, and she was reported singing in public until her death.

In 1844 Truth joined a utopian community in Northampton, Massachusetts—a fateful choice, since it brought her into contact with many of the most famous abolitionists of the time, including William Lloyd Garrison and Frederick Douglass, as well as Gilbert, her editor and collaborator. The 1850 edition of Truth's narrative relates an event reflective of that power. At a camp meeting in Northampton a few months after her arrival there in 1844, Truth witnessed the gathering threatened by a mob of unruly young men. After overcoming her initial fear through calling on her faith in God, she positioned herself on a hill and "commenced to sing, in her most fervid manner, with all the strength of her most powerful voice, the hymn on the resurrection of Christ. . . . All who have ever heard her sing this hymn will probably remember it as long as they remember her. . . . when sung in one of her most animated moods, in the open air, with the utmost strength of her most powerful voice, [the hymn] must have been truly thrilling." The hymn attracted the attention of the mob, which gathered around her, and she addressed them: "'Well, there are two congregations on this ground. It is written that there shall be a separation, and the sheep shall be separated from the goats. The other preachers have the sheep, I have the goats. And I have a few sheep among my goats, but they are *very* ragged.' This exordium produced great laughter." After more singing and preaching, she was able to pacify and disperse the mob. Witty use of her biblical

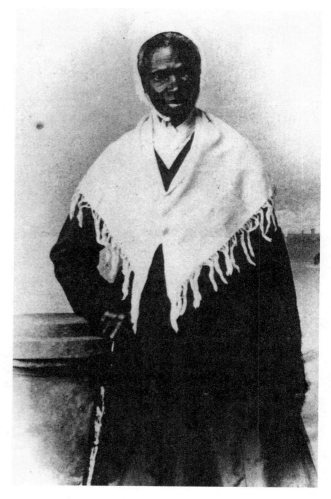

Truth in 1864 (photograph by Randall, Detroit)

knowledge, humor, fearlessness, and song comprised her trademark style which, as these events show, appears to have been remarkably effective.

Truth's first recorded public appearance explicitly as a reformer, rather than as an evangelist, was in fall 1850. Events after that year are recorded in her "Book of Life," published in one volume with the 1878 edition of the *Narrative*. She spoke in support of women's rights and became a traveling speaker in the cause of abolition at the invitation of Garrison and George Thompson, a British member of Parliament. In May 1851 Truth gave her most famous speech, usually referred to by the refrain "Ar'n't I a Woman?" Upset at the comments of white preachers who denied that women had equal rights, Truth took the speaker's podium, turning on people in the audience who protested her appearance as a speaker. She said: "I have plowed and planted and gathered into

Truth's house in Battle Creek, Michigan, where she lived from 1867 until her death in 1883
(*from the* Chicago Semi-Weekly Inter-Ocean, *25 September 1893*)

barns, and no man could head me—and ar'n't I a woman? I could work as much and eat as much as a man (when I could get it,) and bear de lash as well—and ar'n't I a woman? I have borne thirteen chilern, and seen 'em mos' all sold off into slavery, and when I cried out with a mother's grief, none but Jesus heard—and ar'n't I a woman?" The text of the speech is disputed. Marius Robinson, present at the Akron convention, published a version of the speech in the 21 June 1851 *Anti-Slavery Bugle* in Salem, Ohio. However, the best-known version of her remarks was not published until 23 April 1863 when Frances Dana Gage, who had presided over the women's rights convention at which the speech was given, published a mannered transcription in the New York *Independent* that attempted with more attention to effect than accuracy to record Truth's vernacular dialect. Possibly reacting to "The Lybian Sibyl," an influential

article in the April 1863 *Atlantic Monthly* by Harriet Beecher Stowe that described Truth as speaking the language of a former slave from a Southern plantation, Gage gave her the speech patterns of a rural Southern black. Repeatedly newspaper accounts testify to Truth's "originality," her "sharp wit," and her sarcasm and irony. They describe her as "peculiar," "unique," and "imaginative," as "indescribable" and "powerful"—but not Southern. An 1864 newspaper article reprinted in "Book of Life" reported: "She would never listen to Mrs. Stowe's 'Libyan Sibyl.' 'Oh!' she would say, 'I don't want to hear about that old symbol; read me something that is going on *now,* something about this great war.'"

In another of her best-known public appearances, around 1852, she shared the speakers' podium with Frederick Douglass. When Douglass, discounting the possibility that white Americans would ever

abolish slavery, proposed that African Americans take matters into their own hands and resort to armed struggle, Truth responded, "Frederick, *is God-dead?*" Wendell Phillips reported, "The effect was perfectly electrical, and thrilled through the whole house, changing as by a flash the whole feeling of the audience. Not another word she said or needed to say; it was enough." As with other circumstances of Truth's life, Stowe's "Libyan Sibyl" popularized the event, emblematic both of Truth's forceful presence and of her solid faith.

During the Civil War, Truth put those powers into the service of new causes, particularly supporting freed slaves in Washington, D.C. She visited Abraham Lincoln at the White House on 29 October 1864, a visit documented by a signature in the autograph section of her "Book of Life." In 1865 in Washington, D.C., Sojourner Truth agitated for the integration of public transportation. As with abolitionism and women's rights, she used her most powerful tool: her voice. In "Book of Life" she recounts that after several streetcars had passed by, despite her being in her late sixties and signaling her wish to board, she took action: "She then gave three tremendous yelps, 'I want to ride! *I want to ride!!* I WANT TO RIDE!!!' Consternation seized the crowd—people, carriages, go-carts of every description stood still. The car was effectually blocked up, and before it could move on, Sojourner had jumped aboard. Then there arose a great shout from the crowd, 'Ha! ha! ha!! She has beaten him,' &c."

Truth energetically engaged in speaking tours for various causes during the last two decades of her life. Her "Book of Life" reprints several newspaper articles announcing or reporting on her speaking appearances for the cause of resettlement of the destitute freed people living in makeshift housing in the District of Columbia, having fled there during the Civil War. Truth was successful in securing employment for freed slaves in Rochester, New York. Her campaign took her to more than a dozen states and lasted almost until the end of her life. During this time she is repeatedly depicted both as a "representative for her race" and as its leader. In Frances Titus's words, "Sojourner, robbed of her own offspring, adopted her race." She envisioned land set aside for African Americans in Kansas, creating a territorial base for a nation within a nation, but despite a petition drive and her 1879 visit to Kansas to witness the arrival of southern African Americans, the plan of public land donations was never realized.

In 1878 an expanded version of her *Narrative* was published, now including her "Book of Life," a collection of autographs, newspaper articles, letters

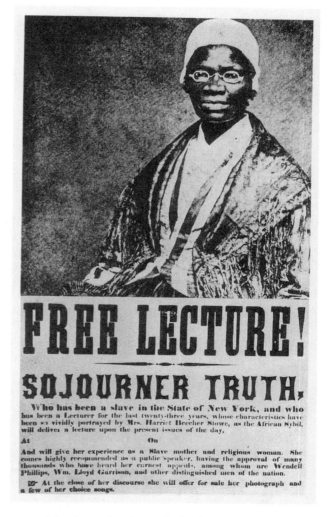

Advertisement for a lecture Truth delivered in the 1870s (State Archives of Michigan)

to her, and biographical entries, including direct quotations from her, all of it edited by Titus, a friend from Battle Creek, Michigan, where Truth had moved in 1867. Though there is evidence that Titus tampered with the documents provided to her by Truth, as Mabee has noted, one regrets that Titus did not edit the 1850 edition of the *Narrative*, which the 1878 edition reprints unchanged, because she is a less-obtrusive presence than Gilbert, who comments at length on Truth's theology and the appropriateness of Truth's judgments. Titus's presence in the text is subtler. She took as her main task to select which of the materials collected by Truth should appear in the "Book of Life": In the biographical portions of the "Book of Life," Truth is rendered in lengthy direct quotations, and, in general, Titus

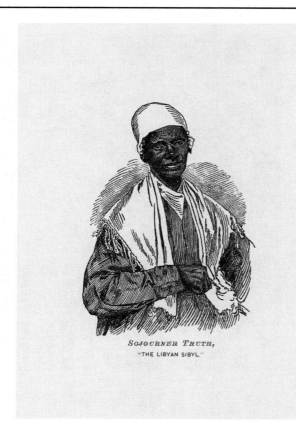

Frontispiece and title page for the second, enlarged edition of the life story of one of the most influential American orators of the nineteenth century

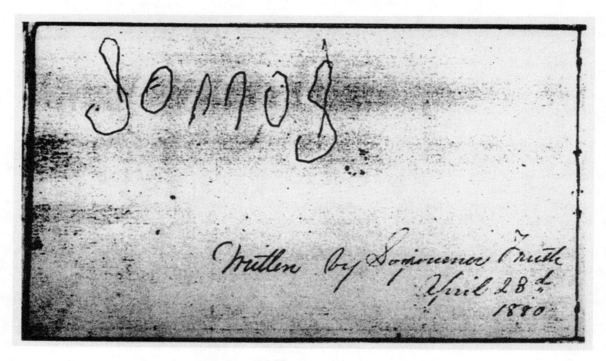

The only known signature of Sojourner Truth (Battle Creek Historical Society)

refrains from editorializing. The 1850 edition was published to promote abolitionism. Titus's purpose for the 1878 edition was to obtain revenues for an aging Truth, then in her eighties.

During 1880–1881 Sojourner Truth traveled for her last speaking tour in Indiana, Illinois, and Michigan. Since the 1870s she had become an important speaker for temperance, a cause shared by many feminists, not least because alcohol was seen as one of the major causes of abuse of women. On this tour, which included an address to the Michigan legislature in Lansing in 1881, Truth spoke for temperance and against capital punishment.

Sojourner Truth died on 26 November 1883 in Battle Creek, Michigan, after having been ill for about two months, despite efforts to cure the ulcers on her leg. Resilient to the last, she sang a hymn to her last public visitor, a reporter from Grand Rapids, and encouraged him to continue the project most important to her during her last two decades, the resettlement of African Americans on western lands.

Biographies:

Hertha Pauli, *Her Name Was Sojourner Truth* (New York: Camelot/Avon, 1962);

Victoria Ortiz, *Sojourner Truth, A Self-Made Woman* (Philadelphia: Lippincott, 1974);

Carleton Mabee, with Susan Mabee Newhouse, *Sojourner Truth: Slave, Prophet, Legend* (New York: New York University Press, 1993);

Nell Irvin Painter, *Sojourner Truth: A Life, a Symbol* (New York: Norton, 1996).

References:

Kathleen Collins, "Shadow and Substance: Sojourner Truth," *History of Photography,* 7 (July-September 1983);

Jeffrey C. Stewart, Introduction to *Narrative of Sojourner Truth, A Bondswoman of Olden Time, With a History of Her Labors and Correspondence Drawn from her "Book of Life"* (New York: Oxford University Press, 1991);

Margaret Washington, Introduction to *Narrative of Sojourner Truth* (New York: Vintage Classics, 1993).

Papers:

Important collections of papers related to Sojourner Truth are in the Bernice Lowe Collection at the Bentley Historical Library, University of Michigan, Ann Arbor, and at the Burton Historical Collection housed in the Detroit Public Library in Detroit, Michigan. Other resources are the Sojourner Truth Collection of the Library of Congress, Washington, D.C., the Willard Public Library in Battle Creek, Michigan, and the Sophia Smith Collection at Smith College, Northampton, Massachusetts.

Susan Bogert Warner
(Elizabeth Wetherell)
(11 July 1819 – 17 March 1885)

Laurie Ousley
State University of New York at Buffalo

See also the Warner entries in *DLB 3: Antebellum Writers in New York and the South* and *DLB 42: American Writers for Children Before 1900.*

BOOKS: *The Wide, Wide World,* 2 volumes, as Elizabeth Wetherell (New York: Putnam, 1851[i.e., 1850]; London: J. Nisbet, 1851);

American Female Patriotism: A Prize Essay, as Wetherell (New York: E. H. Fletcher, 1852);

Queechy, 2 volumes, as Wetherell (New York: Putnam, 1852; London: Nisbet, 1852);

Carl Krinken: His Christmas Stocking, by Susan Warner and Anna Warner, anonymous (New York: Putnam, 1854 [i.e., 1853]; London: Nisbet, 1854);

The Hills of the Shatemuc, 2 volumes, as the author of "The Wide, Wide World" (London: Sampson Low, Son, 1856; New York: Appleton, 1856); republished as *Rufus and Winthrop; or, The Hills of the Shatemuc* (London: Simpkin, Marshall, 1857); republished as *Rest, or, The Hills of the Shatemuc* (London: Milner & Sowerby, 1860); republished as *Hope's Little Hand* (London: Routledge, 1877); republished as *Hope and Rest* (London: Ward, Lock, 1890);

Say and Seal, 2 volumes, by Susan Warner and Anna Warner, as the author of "Wide, Wide World, and "Dollars and Cents" (London: Bentley, 1860; Philadelphia: Lippincott, 1860);

The Golden Ladder: Stories Illustrative of the Eight Beatitudes, by Susan Warner and Anna Warner, as the authors of "The Wide, Wide World" (London: Nisbet, 1863 [i.e., 1862]; New York: Randolph, n.d.); republished in 8 volumes, as:

The Two School Girls and Other Tales, by Susan Warner, anonymous (New York: Carlton & Porter, Sunday-School Union, 1862 [i.e., 1863]; London: Routledge, 1864);

Althea. "Blessed Are They that Mourn: For They Shall be Comforted," by Susan Warner and Anna Warner, anonymous (New York: Carlton & Porter, Sunday-School

Susan Bogert Warner

Union, 1862 [i.e., 1863]); republished as *The Widow and Her Daughter* (London: Routledge, 1864);

Gertrude and Her Cat. "Blessed Are the Meek: For They Shall Inherit the Earth," by Susan Warner, anonymous (New York: Carlton & Porter, Sunday-School Union, 1862 [i.e., 1863]); republished as *Gertrude and Her Bible* (London: Routledge, 1864);

The Rose in the Desert. "Blessed are They Which Do Hunger and Thirst after Righteousness: For They Shall See God," by Susan Warner and Anna Warner, anonymous (New York: Carlton & Porter, Sunday-School Union. 1862, [i.e., 1863]; London: Routledge, 1864);

The Little Black Hen. "Blessed are the Merciful: For They Shall Obtain Mercy," by Susan Warner and Anna Warner, anonymous (New York: Carlton & Porter, Sunday-School Union, 1862 [i.e., 1863]; London: Routledge, 1864);

Martha's Hymn. "Blessed Are the Pure in Heart: For They Shall See God," by Susan Warner, anonymous (New York: Carlton & Porter, Sunday-School Union, 1862, i.e., 1863); republished as *Martha and Her Kind Friend Rachel* (London: Routledge, 1864);

The Carpenter's House. "Blessed are the Peacemakers: For They Shall be Called the Children of God," by Susan Warner, anonymous (New York: Carlton & Porter, Sunday-School Union, 1862 [i.e., 1863]); republished as *The Carpenter's Daughter* (London: Routledge, 1864); republished as *Little Nettie; or Home Sunshine* (London: Warne, 1872);

The Prince in Disguise. Blessed are They which Are Persecuted for Righteousness' Sake. For Theirs Is the Kingdom of Heaven, by Anna Warner, anonymous (New York: Carlton & Porter, Sunday-School Union, 1862 [i.e., 1863]);

The Old Helmet, 2 volumes (New York: Carter, 1864 [i.e., 1863]; London: Nisbet, 1863);

Melbourne House, 2 volumes, as the author of "The Wide, Wide World" (New York: Carter, 1864; London: Nisbet, 1864);

The Word. Walks from Eden, as the author of "The Wide, Wide World" (New York: Carter, 1866 [i.e., 1865]; London: Nisbet, 1865);

The Word. The House of Israel. A Sequel to "Walks from Eden," (New York: Carter, 1867; London: Nisbet, 1867);

Daisy: Continued from "Melbourne House," 2 volumes, as the author of "The Wide, Wide World" (Philadelphia: Lippincott, 1868; London: Nisbet 1868);

Daisy in the Field, as the author of "The Wide, Wide World" (London: Nisbet, 1869); republished as *Daisy. Continued from "Melbourne House,"* as the author of "The Wide, Wide World" (Philadelphia: Lippincott, 1869);

"What She Could," as the author of "The Wide, Wide World" (New York: Carter, 1871; London: Nisbet, 1871); republished with *Opportunities* (London: Nisbet, 1871);

Opportunities. A Sequel to "What She Could," as the author of "The Wide, Wide World" (New York: Carter, 1871; London: Nisbet, 1871); republished with *"What She Could"* (London: Nisbet, 1871);

The House in Town. A Sequel to "Opportunities," as the author of "The Wide, Wide World" (New York: Carter, 1872 [i.e., 1871]; London: Nisbet, 1871);

Lessons on the Standard Bearers of the Old Testament. Third Grade for Older Classes (New York: Randolph, 1872; London: Nisbet, 1873);

"Trading." Finishing the Story of The House in Town (New York: Carter, 1873 [i.e., 1872]; London: Nisbet, 1873);

The Little Camp on Eagle Hill (London: Nisbet, 1873; New York: Carter, 1874); republished as *Giving Honour* (London: Nisbet, 1876);

Willow Brook: A Sequel to "The Little Camp on Eagle Hill," as the author of "The Wide, Wide World" (New York: Carter, 1874; London: Nisbet, 1874);

Sceptres and Crowns, as the author of "The Wide, Wide World" (Nashville: Publishing House of the Methodist Episcopal Church, South, Barber, and Smith, 1874; London: Routledge, 1875); republished with *The Flag of Truce* (London: Nisbet, 1875);

The Flag of Truce, as the author of "The Wide, Wide World" (New York: Carter, 1875); republished with *Sceptres and Crowns* (London: Nisbet, 1875);

Giving Trust. I. Bread and Oranges. II. Rapids of Niagara, as the author of "The Wide, Wide World" (London: Nisbet, 1875);

Bread and Oranges, as the author of "The Wide, Wide World" (New York: Carter, 1875);

The Rapids of Niagara, as the author of "The Wide, Wide World" (New York: Carter, 1876);

Wych Hazel, by Susan Warner and Anna Warner, as the author of "The Wide, Wide World" (London: Nisbet, 1876; New York: Putnam, 1876);

The Gold of Chickaree, by Susan Warner and Anna Warner (New York: Putnam, 1876; London: Nisbet, 1876);

Pine Needles, as the author of "The Wide, Wide World" (London: Nisbet, 1877; New York: Carter, 1877); republished as *Needles and Old Yarns* (London: Simpkin, 1878); republished as *Pine Needles and Old Yarns* (Wakefield: Nicholson, 1878);

Diana (New York: Putnam, 1877; London: Nisbet, 1877);

The Kingdom of Judah, as the author of "The Wide, Wide World" (New York: Carter, 1878; London: Nisbet, 1878);

The King's People, 5 volumes (New York: Carter, 1878)—comprises *Walks from Eden, The House of Israel, The Kingdom of Judah,* and *The Broken Walls of Jerusalem,* all by Susan Warner, and *The Star of Jacob,* by Anna Warner;

The Broken Walls of Jerusalem and the Rebuilding of Them, as the author of "The Wide, Wide World" (New York: Carter, 1879; London: Nisbet, 1879);

My Desire, as the author of "The Wide, Wide World" (New York: Carter, 1879; London: Nisbet, 1879);

The End of a Coil, as the author of "The Wide, Wide
World" (New York: Carter, 1880; London: Nisbet, 1880);
The Letter of Credit, as the author of "The Wide, Wide
World" (London: Nisbet, 1881; New York: Carter, 1882);
Nobody (London: Nisbet, 1882; New York: Carter, 1883);
Stephen M.D., as the author of "The Wide, Wide
World" (New York: Carter, 1883; London: Nisbet, 1883);
A Red Wallflower, as the author of "The Wide, Wide
World" (New York: Carter, 1884; London: Nisbet, 1884);
Daisy Plains, begun by Susan Warner and completed by
Anna Warner, as the author of "The Wide, Wide
World" (New York: Carter, 1885; London: Nisbet, 1885).

Edition: *The Wide, Wide World,* edited by Jane Tompkins
(New York: Feminist Press of the City University
of New York, 1987)—includes the previously
unpublished final chapter.

OTHER: "How May an American Woman Best Show
Her Patriotism?" *Ladies Wreath: An Illustrated
Annual,* edited by Mrs. S. T. Martyn (New York:
J. M. Fletcher, 1851);
The Law and the Testimony, extracts from the Bible
arranged by Susan Warner and Anna Warner
(New York: Carter, 1853); republished as *The Law
and the Testimony: Christian Doctrine* (London: Nisbet, 1853).

SELECTED PERIODICAL PUBLICATIONS—
UNCOLLECTED: "Melbourne House," 46 parts, *Little American,* 1 (1 and 15 October 1862; 1 and 15
November 1862; 1 and 15 December 1862; 1 and
15 January 1863; 1 and 15 February 1863; 1 and
15 March 1863; 1 and 15 April 1863; 1 and 15
May 1863; 1 and 15 June 1863; 1 and 15 July
1863; 1 and 15 August 1863; 1 and 15 September
1863; 1 and 15 October 1863; 2 and 15 November 1863; 1 December 1863; 15 January 1864; 1
and 15 February 1864; 1 and 15 March 1864; 1
and 15 April 1864; 1 and 15 May 1864; 1 and 15
June 1864; 1 July 1864; 15 August 1864; 1 September 1864; 1 October 1864; 1 December
1864);
"Iceland," 5 parts, *Little American,* 1 (1 October 1862; 1
December 1862; 15 February 1863; 1 March
1863; 1 April 1863);
"The Seven Fairies," 5 parts, *Little American,* 1 (1 October 1862; 15 November 1862, 15 January 1863; 1
May 1863; 15 August 1863);

"Pigeontown," *Little American,* 1 (1 October 1862);
"Josie's Letters," 8 parts, *Little American,* 1–2 (1 October
1862; 1 and 15 December 1862; 1 October 1863;
2 and 15 November 1863; 1 December 1863; 1
February 1864);
"The Breakfast Table," 7 parts, *Little American,* 1–2 (1
October 1862; 15 November 1862; 1 January
1863; 1 February 1863; 1 April 1863; 15 November 1863; 1 December 1863);
"Little Lights," *Little American,* 1 (1 October 1862);
"The Chevalier Bayard," *Little American,* 1 (15 November 1862);
"The Grasses," 2 parts, *Little American,* 1 (15 November
1862; 15 March 1863);
"I Know How," *Little American,* 1 (1 December 1862);
"The Great Serpent," *Little American,* 1 (1 December
1862);
"Gates," *Little American,* 1 (15 December 1862);
"Children All Over the World," 4 parts, *Little American,*
1 and 2 (15 December 1862; 1 June 1863; 2
November 1863; 1 April 1864);
"The Old Man with the Two Flutes," *Little American,* 1
(15 December 1862);
"Bethlehem," *Little American,* 1 (1 January 1863);
"The Children's Dream," *Little American,* 1 (1 January
1863);
"The Ugly Knight," *Little American,* 1 (1 January 1863);
"The Experiences of the Rush Family," 6 parts, *Little
American,* 1–2 (15 January 1863; 1 and March
1863; 15 June 1863; 15 October 1863; 15 February 1864);
"The Midnight Alarm," *Little American,* 1 (15 January
1863);
"A Roseleaf," *Little American,* 1 (15 January 1863);
"The Strange Little Boy," *Little American,* 1 (1 February
1863);
"Mamma's Dressing Room," 2 parts, *Little American,* 1–2
(1 February 1863; 1 October 1863);
"The Wonderful Serpent," *Little American,* 1 (15 February 1863);
"The Black Art," *Little American,* 1 (15 February 1863);
"A Talking Party Among the Parrots: The Cockatoo,"
Little American, 1 (1 March 1863);
"Ready for Duty," *Little American,* 1 (15 March 1863);
"Chinese Visits," *Little American,* 1 (1 April 1863);
"The Robin's Breakfast," *Little American,* 1 (1 April
1863);
"Watch and Ward," *Little American,* 1 (15 April 1863);
"Mrs. Wren is Obliged to Build," *Little American,* 1 (15
April 1863);
"The Water-Cress Market," *Little American,* 1 (15 April
1863);

"Lamplighters of the World," 2 parts, *Little American,* 1 (1 May 1863; 1 June 1863); "May," *Little American,* 1 (1 May 1863);

"An Earl Who Loved His Country," *Little American,* 1 (1 May 1863);

"A Chinese Feast," *Little American,* 1 (1 June 1863);

"Truth," *Little American,* 1 (15 June 1863);

"A Concert–Beginning at Three, A. M." *Little American,* 1 (15 June 1863);

"Workers in Wood," 4 parts, *Little American,* 1 (1 July 1863; 1 and 15 August 1863; 1 September 1863);

"Spring Doings," *Little American,* 1 (1 July 1863);

"The Indian Goose-Driver," *Little American,* 1 (1 July 1863);

"Feathers," *Little American,* 1 (1 August 1863);

"Shahweetah," 5 parts, *Little American,* 1 and 2 (1 August 1863; 15 October 1863; 15 January 1864; 1 February 1864; 1 October 1864);

"Distinguished," *Little American,* 1 (1 August 1863);

"Three French Knights," *Little American,* 1 (15 August 1863);

"The Fairy Greymantle," *Little American,* 1 (1 September 1863);

"The Seed-Bearing Grasses," *Little American,* 1 (1 September 1863);

"How People Live," 2 parts, *Little American,* 1–2 (1 September 1863; 15 June 1864);

"The Ship Worm," *Little American,* 1 (15 September 1863);

"The Sparrow," *Little American,* 1 (15 September 1863);

"The Flower-Girl," *Little American,* 1 (15 September 1863);

"The Ringing of Bells," *Little American,* 1 (15 September 1863);

"Mice!" *Little American,* 2 (1 October 1863);

"Masons of the World," 11 parts, *Little American,* 2 (1 and 15 October 1863; 2 and 15 November 1863; 1 December 1863; 15 January 1864; 1 and 15 March 1864; 15 April 1864; 15 May 1864; 1 September 1864);

"Moss," *Little American,* 2 (1 October 1863);

"The Link of Gold," *Little American,* 2 (15 October 1863);

"Deacon Broderick's House: Chapter 1," *Little American,* 2 (2 November 1863);

"Thanksgiving," 2 parts, *Little American,* 2 (15 November 1863; 1 December 1863);

"Christmas Eve," *Little American,* 2 (15 January 1864);

"Little Hands," *Little American,* 2 (15 January 1864);

"The Grain-Bearing Grasses," 4 parts, *Little American,* 2 (1 February 1864; 1 April 1864; 1 May 1864; 1 October 1864);

"Great Deeds," *Little American,* 2 (1 February 1864);

"Natural History," 4 parts, *Little American,* 2 (15 February 1864; 15 March 1864; 15 May 1864; 15 September 1864);

"History of a Needle," 5 parts, *Little American,* 2 (1 and 15 March 1864; 1 and 15 April 1864; 1 May 1864);

"The Sheep," *Little American,* 2 (1 March 1864);

"Safe–For Evermore," *Little American,* 2 (15 March 1864);

"Town Mouse and Country Mouse," 5 parts, *Little American,* 2 (15 April 1864; 1 and 15 May 1864; 1 and 15 June 1864);

"The Bouquet," *Little American,* 2 (1 May 1864);

"Thistle Work," *Little American,* 2 (15 May 1864);

"Dolls," *Little American,* 2 (1 June 1864);

"The Trumpets," *Little American,* 2 (1 June 1864);

"The Swans at a Watering Place," *Little American,* 2 (15 June 1864);

"Shadows," *Little American,* 2 (15 June 1864);

"Sheep Folds," *Little American,* 2 (1 July 1864);

"The Story of Hercules and Minerva," 4 parts, *Little American,* 2 (1 July 1864; 15 August 1864; 1 September 1864; 1 December 1864);

"Soldier Stories," 2 parts, *Little American,* 2 (1 July 1864; 15 August 1864);

"Shepherds," *Little American,* 2 (15 August 1864);

"Evening Prayer for the Children," *Little American,* 2 (15 August 1864);

"Gifts," *Little American,* 2 (1 September 1864);

"The Dove of Pompeii," *Little American,* 2 (1 October 1864);

"Fishers of the World: The Barnacle," *Little American,* 2 (1 November 1864);

"Shepherds in Larly Times," *Little American,* 2 (1 November 1864);

"The Little Pilgrim," *Little American,* 2 (1 November 1864);

"The Little China Asters," *Little American,* 2 (1 November 1864);

"War in Old Times," *Little American,* 2 (1 December 1864).

Susan Bogert Warner, who wrote under the pseudonym Elizabeth Wetherell, wrote twenty-seven novels, four volumes of biblical history, one biblical study, various religious tracts, a prize-winning essay on patriotism, and, with her sister, Anna Bartlett Warner, two collections of stories and four novels. In addition, the sisters wrote and edited a children's magazine. Susan Warner was certainly prolific, but because much of her tract and magazine writing was published anonymously, scholars may never know the precise number of pieces she wrote. Warner's enormous popularity was unprecedented in American literary history. Her novels, most

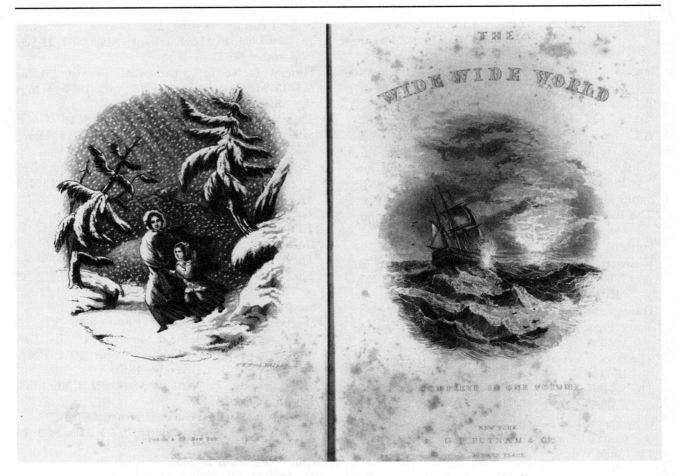

*Frontispiece and title page for Warner's first novel, about a young heroine whose mother dies
and leaves her daughter at the mercy of a miserly and mean-spirited aunt*

often referred to as either "sentimental" or "domestic,"
appealed to her readership for their religious, patriotic,
and personal themes. She was, until recently, known by
literary scholars primarily as a children's writer and as a
local colorist. She has become significant to scholars of
women writers for her vast and long-lived appeal to
women readers, beginning with her first and most
famous novel, *The Wide, Wide World* (1851).

The elder of the two surviving daughters of
Henry Whiting Warner and Anna Marsh Bartlett
Warner, Susan Bogert Warner was born 11 July 1819 in
New York City. Her mother was a wealthy socialite
from Long Island, New York. Anna, the mother, did not
greatly influence either of her daughters. She died in
1828 while the sisters were still young children. After
his wife's death, Henry brought his sister, Frances
(Aunt Fanny), to live with the small family, run the
household, and mother the children. She remained with
them until her death in 1885. Henry Warner, a prosper-
ous lawyer, was raised in Canaan, New York. The sis-
ters often spent summers at their grandfather's house in

Canaan, where many of their novels were subsequently
set. Warner's childhood and youth were marked by
affluence, and she acquired the accomplishments of a
wealthy American girl in search of a suitable husband.
She was tutored in Greek, Latin, French, Italian, and
German; received piano, voice, drawing, and painting
lessons; studied history, literature, arithmetic, and bot-
any; and was immersed in the conversation of New
York society.

The family began its dramatic decline into pov-
erty in the Panic of 1837, when Henry Warner lost
much of the family fortune in a real estate investment.
Warner's sister, Anna, reports in her biography, *Susan
Warner ("Elizabeth Wetherell")* (1909), that Henry's
brother Thomas, who apparently developed difficul-
ties with officials at West Point, where he was chap-
lain, played a role in the family's decline by failing to
act as witness for his brother—instead leaving for
Europe, where he remained. Henry continued to lose
money in litigation, and by 1846 the family had lost
their New York properties and moved permanently to

their summer house at Constitution Island, opposite West Point, the place the family called home for the remainder of their lives.

Henry Warner continued to support the family, but the sisters began writing out of financial necessity in the mid 1840s, when they were most destitute. Susan began her first novel, *The Wide, Wide World,* in the winter of 1847. Anna recounts the origin of the novel in her biography: "Aunt Fanny spoke. 'Sue, I believe if you would try, you could write a story.' Whether she added 'that would sell' I am not sure; but of course that was what she meant." The novel was completed in 1849, and Henry Warner took charge of finding a publisher. The book was rejected by many, but G. P. Putnam published *The Wide, Wide World* in December of 1850, despite Putnam having already been advised not to take on the novel. As George Haven Putnam recalled in his speech to the Martelaer's Rock Association in 1923, "Father had the manuscript at his home on Staten Island, where his mother, an earnest Christian woman, happened to be visiting him. He handed the manuscript to her for an opinion. Her report was, in substance: 'George, if you never publish another book, you must make "The Wide, Wide World" available to your fellow men. . . . Whatever the business difficulties, I feel sure that Providence will take care of this book.'" He took her advice, and the novel proved to be enormously popular, going into fourteen editions by 1852, to his great surprise. He arranged to have one of his London correspondents, James Nisbet, publish a British edition, which also sold remarkably well. In fact, the novel was in print in England until the 1950s. It was also included on the Baptist ministers' first list of books designated as appropriate for Sunday School libraries because "It presents the teaching of the Lord."

The Wide, Wide World chronicles the relationship between a young girl, Ellen Montgomery, and her pious, loving, but consumptive mother. Mother and daughter are cruelly separated by the cold and domineering Captain Montgomery, who has lost much of the family fortune in a bad business deal and taken a position in Europe. Mrs. Montgomery's physician, who knows that she cannot survive the voyage, orders her to follow her husband overseas. Sent to live with her father's sister, Miss Fortune Emerson, Ellen, as her father has arranged, journeys to her Aunt Fortune's farm in the company of distant acquaintances. When Ellen arrives, she learns that her father had neglected to inform Miss Emerson of her niece's arrival and indefinite stay. Not the warm and loving guardian Ellen has wanted, the aunt is cold, miserly, and generally mean-spirited. Although Ellen has been a pampered child, she is a good, well-behaved little girl. Ellen, however, must learn, with the help of her neigh-

bors and spiritual advisers, Alice Humphreys and her father Reverend Humphreys, to break her own will, submitting without question to the will of God and to the will of the aptly named Miss Fortune. Along the way, Ellen inspires and converts many of those she meets, including her aunt's future husband, Mr. Van Brunt, a good man who provides Ellen the only comfort she can expect in that home. When her friend Alice becomes sick, Ellen obtains permission to live with and care for her and the Reverend Humphreys. There Ellen meets her future husband and Alice's brother, John, a minister in training.

After Alice's death, Captain Montgomery takes charge of his daughter once again, sending her to her mother's relatives, the Lindsays, in Scotland. There Ellen faces a challenge even greater than that presented by Aunt Fortune; she must give up her American identity, a strong and self-conscious aspect of her character, as well as her devout religious beliefs, the same beliefs that allowed her to tolerate her American aunt's cruelties. Ellen does not compromise when it comes to her Christian devotions, though she does learn to submit to all of the other psychic cruelties heaped upon her. Finally, John Humphreys pays a visit to the Lindsays, making his presence and intentions known to Ellen, promising her a life of comfort and safety, both financial and emotional, when she comes of age. The final chapter of the novel, not published until Jane Tompkins's edition in 1987, portrays Ellen's return to America as Mrs. John Humphreys, touring the home in which she had been so happy before her friend's death. The final chapter, in short, represents the happy ending only promised in the earlier editions of the novel.

The Wide, Wide World and Warner's other novels appeal to modern critics for their descriptions of New England farm life as well as for indications of American culture and social mores of the period. Though modern readers often find the emotion in these novels excessive and the religion distasteful and overpowering, the religion appealed to Warner's readers. Each of Warner's heroines and heroes is or must become a devout Christian. A large part of each of Warner's novels chronicles the conversion of these characters and then illustrates the behavior of the true Christian after that conversion, leading Tompkins to refer to these novels as "training narratives." Significantly, while modern readers consider the descriptions of the farm life and people to be realistic, and the descriptions of the genteel and pious Humphreys idealistic and therefore not consistent with realism, contemporary readers did not make this distinction. In fact, many readers wrote to Warner praising the realism of characters such as Ellen Montgomery and of scenes such as Alice Humphreys's tremendously idealized Christian death. Caroline Kirkland, in "Nov-

Warner's sister and frequent collaborator, Anna Bartlett Warner

els and Novelists: *The Wide, Wide World, Queechy,* and *Dollars and Cents,*" in *North American Review* (January 1853), comments that she actually does not like the American scene in contemporary novels or what she sees as Warner's overuse of dialect in the conversations of the lower classes. Kirkland does, however, celebrate the "democratic principles" and "religious intention" of *The Wide, Wide World* and *Queechy* (1852).

Warner's own conversion in the winter of 1840–1841 changed her life drastically. It marked the beginning of her new purpose in life: to worship God, to spread His message, and to uplift the lives and spirits of others using that message. In *Say and Seal* (1860), Warner's first collaboration with her sister, Mr. Endecott Linden and Miss Faith Derrick, the future Mrs. Linden, spend almost all of their spare time helping the poor and sick in Pataquasett, the fictional setting for most of the novel. They distribute food and necessities, as well as tracts and Bibles, to those they visit, actively trying to convert the unconverted, and helping them, whenever possible, to become independent.

In *Wych Hazel* (1876) and its sequel *The Gold of Chickaree* (1876), another collaboration with Anna, the hero and heroine, both devout, use their fortunes to better the lives of those around them. They send much-needed supplies to ministers and their families on the frontier and become captains of the textile industry in the Northeast, not to increase their fortunes but to bring hope, education, and good health care to the mill-workers. The last chapter, in fact, is a portrait of a Christian utopia in the mill town.

Warner was not as financially successful as her heroines. The royalties earned on the sale of *The Wide, Wide World* had yet to make their way to the young writer, and the family was nearly destitute, having little even to eat. When she did finally receive the much-needed money (she earned, according to James D. Hart in *The Popular Book: A History of America's Literary Taste* [1950], approximately $4,500 semi-annually), her father essentially squandered it on his endless lawsuits in attempts to regain his lost fortune. The commercial success of the novel in England did not assist the family's finances much because copyright laws did not guarantee American writers any of the profits from the sale of their novels. Warner did, however, receive at least one royalty payment from Nisbet. At least four British publishing houses, however, pirated her books, and she never benefited from those sales. Warner did not sell the copyrights to her earlier novels as literary historians often claim, though she and Anna both did so with their later writing because they could not wait for royalties.

Warner's second novel, *Queechy,* also sold well—ten thousand copies in one London train station alone. It was well under way before Putnam even accepted *The Wide, Wide World,* but the initial encouragement prompted her to work in earnest. *Queechy* is the story of an orphan, Elfeda Ringgan, who lives with her grandfather, Elzevir Ringgan, an aging Revolutionary War veteran and a noble Christian gentleman. Upon his death she is escorted by the hero, Mr. Carleton, a young Englishman who has inherited a large estate, to the home of her Aunt Lucy and Uncle Rolf Rossitur in France, where she meets her young cousin Hugh. There the family lives happily, eventually deciding to return to New York. Life continues pleasantly until Uncle Rolf loses the family fortune in a bad business deal; they then must move to the homestead and farm in Queechy where, coincidentally, Fleda had lived with Grandfather. There Fleda and Hugh take over the care of the family from the uncle, who later leaves for the West in shame. Always sickly, Hugh eventually dies under the strain, and his death marks the beginning of Aunt Lucy's conversion. Fleda and Mr. Carleton, in spite of several misunderstandings caused by many

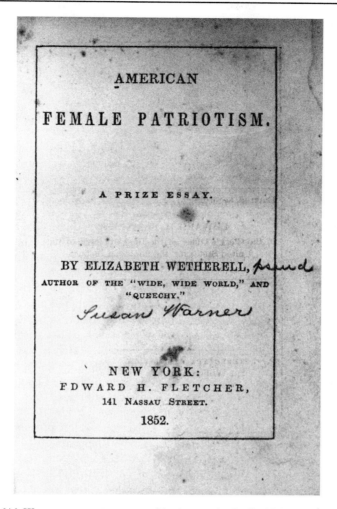

Title page for essay with which Warner won a contest sponsored by the magazine Ladies' Wreath *(American Antiquarian Society)*

unthinking and insensitive people, marry and move to the Carleton estate in England, with the promise of planting the seeds of Christianity and republicanism in the aristocratic mother country.

The plots of *The Wide, Wide World* and *Queechy* are similar, though Ellen must learn to be a proper Christian, and Fleda has this knowledge at the outset of *Queechy*. Ellen, as part of her Christian training, must learn to submit to God and to her aunt through the vehicle of learning various domestic chores. Fleda, already devout, knows how to make a house a home and the art of managing both servants and family; in addition, she learns the typically masculine tasks of managing a farm and business interests. The piety of Warner's heroine often brings her wealth if she is not already wealthy and attracts an equally pious hero, with whom she will advance the word of God. *Queechy,* significantly, deals directly with the issues of American identity and politics that are so important to Warner and her work, as first men-

tioned in *American Female Patriotism: A Prize Essay* (1852), which Warner wrote for *Ladies Wreath: An Illustrated Annual,* answering the question "How may an American woman best show her patriotism?"

Warner wrote the essay after she had finished writing *The Wide, Wide World* but before the novel was published. In her essay she said that women must be American, Christian, and enlightened patriots in their own right. She stressed the importance of Christianity as well as education to the republican citizen, saying that women are responsible to "extend the sway of religion" within American borders in order to ensure the virtue and moral foundation of the country. The republic, according to Warner's line of argument, is a specifically Christian construction, following biblical dictates. In their own lives Susan and Anna Warner managed to combine their Christian mission with what they saw as their patriotic duty by offering Bible lessons to the West Point cadets on Sunday afternoons; writing and distributing religious tracts; and,

briefly, collecting for evangelical missions. Both sisters maintained a considerable correspondence with domestic and foreign missionaries, giving when they could, and with several of their West Point students who wrote from army posts throughout the country and from as far away as Japan. Anna Warner, less than four years after Susan Warner's death, received a letter from Mark L. Hersey, one of the cadets, stating "Your class indeed extends from the Atlantic to the Pacific. Hardly an Army Post but what has some officer who has been under your tuition as a cadet."

Warner's third novel, *The Hills of the Shatemuc* (1856), sold ten thousand copies on its first day of sale. It is the story of Winthrop Landholm and his brother Rufus, modeled on Henry and Thomas Warner. The brothers' father serves in the New York legislature, and their mother is a strong Christian woman. Although born into a farming family, the boys envision a professional life away from the farm. Both brothers prove to be superlative students, and both, overcoming many obstacles, mostly financial, try their fortunes in the big city. They move to "Manahatta," Manhattan—Winthrop to study law and Rufus to study engineering. The brothers have entirely different personalities—Winthrop is patient and methodical, Rufus restless and irresolute. Both men are popular; Rufus is charming and an accomplished conversationalist, while Winthrop wins many allies with his dependability and strong morality. The brothers meet the Hayes, a family living in the city. The eldest daughter, Elizabeth, a spoiled and self-involved aristocrat, has taken control of her widowed father's household. Rose, Mr. Haye's ward, lives with them and is Elizabeth's constant if unwelcome companion. Elizabeth's growing respect for Winthrop, in spite of his meager beginnings, marks the commencement of her moral and republican education. Mr. Haye and Rose eventually marry, much to his daughter's chagrin and to the surprise of all who know them. Winthrop comforts Elizabeth after the marriage and helps her to recover from her indignation. Almost in spite of herself, she develops an attraction to Winthrop, but she cannot hope to win his affections until she becomes a true Christian. Winthrop teaches her to be Christian and humble, and when she learns this lesson, they marry.

Education takes a prominent role in most of Warner's novels. Many pages are dedicated to recounting the volumes read, studied, and enjoyed by the heroes and heroines and even by the secondary characters, such as Mr. Herder in *The Hills of the Shatemuc*, who seems to be based on Louis Agassiz, the Swiss-born American naturalist. *Say and Seal,* for example, describes the wonders of chemistry, biology, botany, and natural science. A microscope offers Faith Derrick an evening of wonders, and she studies French, science, and history, as well as the Bible. Fleda, of *Queechy,* reveals a remarkable reading list, and Winthrop, of *The Hills of Shatemuc,* is actually characterized by his continuous and methodical study of law and the Bible. The Warners' own reading lists were admirable, and the value they placed on study and knowledge is revealed in their writing.

Warner's later novels did not sell nearly as well as *The Wide, Wide World* or *Queechy,* which in 1893 were still requested by 44 and 25 percent respectively of library patrons, as reported in *The Forum*. George Haven Putnam noted in *George Palmer Putnam: A Memoir* (1912) that "Miss Warner had retained her reading public for a longer period of years than was the case possibly with any other American writer of fiction whose work had begun as early as 1849. Fifty years later there is still continued demand not only for the first book, *The Wide, Wide World,* but for nearly the entire series." Heroines of other novels of the period read and enjoyed Warner's novels: Jo March of Louisa May Alcott's *Little Women* (1868, 1869) is described as reading *The Wide, Wide World,* and Hope of Hannah Bradbury Goodwin's *Sherbrooke* (1866) likes *Queechy* "more than any story I've ever read." Pride in the presentation of their town in Warner's fiction prompted the officials of Canaan to change the name of Whiting Pond, called so for Warner's ancestors, to Queechy Lake. The popularity of *The Wide, Wide World* was not limited to English-speaking lands; it was translated into at least three languages, including French, German, and Dutch. Though Warner's name is known only to literary scholars today, she had a tremendous impact on her readers and other writers of the period.

Letters:

Letters and Memories of Susan and Anna Bartlett Warner, edited by Olivia Egleston Phelps Stokes (New York: Putnam, 1925).

Bibliographies:

Mabel Baker, *The Warner Family and The Warner Books* (West Point, N.Y.: Constitution Island Association, 1971);

Dorothy Hurlbut Sanderson, *They Wrote for a Living: A Bibliography of the Works of Susan Bogert Warner and Anna Bartlett Warner* (West Point, N.Y.: Constitution Island Association, 1976).

Biographies:

Grace Overmeyer, "Hudson River Bluestockings—The Warner Sisters of Constitution Island," *New York History* (April 1859): 137–158;

Anna Warner, *Susan Warner ("Elizabeth Wetherell")* (New York: Putnam, 1909);

"Susan and Anna Warner: 'The Brontë Sisters of America,'" *Constitution Island. Compiled for the Meeting of The Garden Club of America* (West Point, N.Y.: Constitution Island Association, 1936);

Mabel Baker, *Light in the Morning: Memories of Susan and Anna Warner* (West Point, N.Y.: Constitution Island Association Press, 1978).

References:

Mabel Baker, *The Warner Family and the Warner Books* (West Point, N.Y.: Constitution Island Association Press, 1971);

Erica R. Bauermeister, "*The Lamplighter, The Wide, Wide World,* and *Hope Leslie:* Reconsidering the Recipes for Nineteenth-Century American Women's Novels," *Legacy,* 8 (Spring 1991): 17–28;

Nina Baym, *Woman's Fiction: A Guide to Novels by and about Women in America, 1820–1870* (Ithaca, N.Y.: Cornell University Press, 1978);

John A. Calabro, "Susan Warner and Her Bible Classes," *Legacy,* 4 (Fall 1987): 4–5;

Donna M. Campbell, "Sentimental Conventions and Self-Protection: *Little Women* and *The Wide, Wide World,*" *Legacy,* 11 (1994): 118–129;

Edward Halsey Foster, *Susan and Anna Warner* (Boston: Twayne, n.d.);

Susan K. Harris, "Decoding the Exploratory Text: Subversions of the Narrative Design in *Queechy,*" in her *Nineteenth-Century American Women's Novels: Interpretive Strategies* (New York: Cambridge University Press, 1990), pp. 78–110;

Mary P. Hiatt, "Susan Warner's Subtext: The Other Side of Piety," *Journal of Evolutionary Psychology,* 8 (August 1987): 250–261;

Grace Ann Hovet and Theodore R. Hovet, "Identity Development in Susan Warner's *The Wide, Wide World:* Relationship, Performance and Construction," *Legacy,* 8 (Spring 1991): 3–16;

Mary Kell, *Private Woman, Public Stage: Literary Domesticity in Nineteenth-Century America* (New York: Oxford University Press, 1984);

Caroline Kirkland, "Novels and Novelists: *The Wide, Wide World, Queechy,* and *Dollars and Cents,*" *North American Review,* 76 (January 1853): 104–153;

D. G. Meyers, "The Canonization of Susan Warner," *New Criterion,* 7 (December 1988): 73–78;

Nancy Schnog, "Inside the Sentimental: The Psychological Work of *The Wide, Wide World,*" *Genders,* 4 (March 1989): 11–25;

Veronica Stewart, "Mothering a Female Saint: Susan Warner's Dialogic Role in *The Wide, Wide World,*" *Essays in Literature,* 22 (Spring 1995): 58–74;

Stewart, "The Wild Side of *The Wide, Wide World,*" *Legacy,* 11 (1994): 1–16;

Jane Tompkins, Afterword, *The Wide, Wide World* (New York: Feminist Press, 1987);

Tompkins, *Sensational Designs: The Cultural Work of American Fiction, 1790–1860* (New York: Oxford University Press, 1985);

Isabelle White, "Anti-Individualism, Authority, and Identity: Susan Warner's Contradictions in *The Wide, Wide World,*" *American Studies,* 31 (Fall 1990): 31–41;

Cynthia Schoolar Williams, "Susan Warner's *Queechy* and the Bildungsroman Tradition," *Legacy,* 7 (Fall 1990) 3–16;

Susan S. Williams, "Widening the World: Susan Warner, Her Readers, and the Assumption of Authorship," *American Quarterly,* 42 (December 190): 565–586.

Papers:

The Constitution Island Association Archives is the primary location of Susan Warner's papers–housing manuscripts, Sunday school notes, journals, scrapbooks, and correspondence. Special Collections at the Cadet Library at the United States Military Academy houses another important collection of her correspondence. The manuscript for *The Wide, Wide World* is at the Huntington Library.

Emma Willard

(23 February 1787 – 15 April 1870)

Richard V. McLamore
McMurry University

BOOKS: *An Address to the Public, Particularly to the Members of the Legislature of New-York, Proposing a Plan for Improving Female Education* (Albany, N.Y.: Printed by I. W. Clark, 1819);

Ancient Geography, As Connected with Chronology, and Preparatory to the Study of Ancient History (Hartford: Oliver D. Cooke, 1822); republished in *Universal Geography, Ancient and Modern; on the Principles of Comparison and Classification,* by Willard and William Channing Woodbridge (Hartford: O. D. Cooke, 1824); republished as *Woodbridge and Willard's Universal Geography* (Hartford: Belknap & Hamersley, 1842);

Geography for Beginners (Hartford: O. D. Cooke, 1826);

Ancient Atlas, to Accompany the Universal Geography (Hartford: O. D. Cooke, 1827);

History of the United States, or Republic of America: Exhibited in Connexion with its Chronology and Progressive Geography; by means of A Series of Maps (New York: White, Gallaher & White, 1828; revised, 1829);

A Series of Maps to Willard's History of the United States (New York: White, Gallaher & White, 1828; revised, 1829?);

The Fulfilment of a Promise (New York: White, Gallaher & White, 1831);

Abridgement of the History of the United States; or, Republic of America (New York: White, Gallaher & White, 1831); republished as *Abridged History of the United States; or Republic of America* (Philadelphia: Barnes, 1843; enlarged edition, New York: A. S. Barnes / Cincinnati: H. W. Derby, 1849);

Advancement of Female Education; or, A Series of Addresses, in Favor of Establishing at Athens, in Greece, a Female Seminary, Especially Designed to Instruct Female Teachers (Troy, N.Y.: N. Tuttle, 1833);

Journal and Letters, from France and Great-Britain (Troy, N.Y.: N. Tuttle, 1833);

A System of Universal History, in Perspective: Accompanied by an Atlas, Exhibiting Chronology in a Picture of Nations, and Progressive Geography in a Series of Maps (Hartford: F. J. Huntington, 1835);

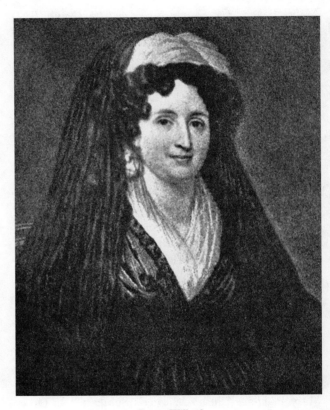

Emma Willard

A Treatise on the Motive Powers Which Produce the Circulation of the Blood (New York & London: Wiley & Putnam, 1846);

An Appeal to the Public, Especially Those Concerned in Education, Against the Wrong and Injury Done by Marcius Willson, in His Pamphlet Entitled "Report on American Histories, etc." (New York: A. S. Barnes, 1847);

Respiration, and its Effects; More Especially in Relation to Asiatic Cholera, and Other Sinking Diseases (New York: Huntington & Savage, 1849);

Last Leaves of American History; Comprising Histories of the Mexican War and California (New York: Putnam, 1849);

Guide to the Temple of Time; and Universal History, for Schools (Willard's Historic Guide) (New York: A. S. Barnes / Cincinnati: H. W. Derby, 1849);

Astronography; or Astronomical Geography, with the Use of Globes (Troy, N.Y.: Merriam, Moore, 1854);

Late American History: Containing a Full Account of the Courage, Conduct, and Success of John C. Fremont (New York: A. S. Barnes, 1856);

Morals for the Young (New York: A. S. Barnes, 1857);

To the Senate and Representatives of the United States of America in Congress Assembled (Washington, D.C., 1861);

Via Media: A Peaceful and Permanent Solution of the Slavery Question. (Washington, D.C.: C. H. Anderson, 1862).

Described after her death "as a beacon light in the path of female education," Emma Willard distinguished herself as a notable and influential educator, historian, travel writer, and public figure in the antebellum United States. Willard was born Emma Hart, the ninth child of Captain Samuel and Lydia (Hinsdale) Hart of Berlin, Connecticut. Captain Hart, a liberal Republican in a state dominated by conservative Federalists, represented Berlin in the Connecticut State Assembly and served in other local offices during his life. During his tenure as treasurer of the First Congregational Church of Berlin, he gained notoriety by opposing the Puritan-era law that required townspeople to pay taxes to support the Congregationalist Church. Captain Hart resigned his office and withdrew entirely from the church as a result of this dispute; he also provided his daughter Emma with other compelling examples of acting on one's beliefs.

Captain Hart readily encouraged Emma to develop her intellect. He presided over fireside evenings during which the Hart family read aloud from and debated the merits of a broad spectrum of philosophical, political, and religious texts; he also discussed with Emma notable passages he had come across in his reading during the day. Thus encouraged at home in her thinking, Emma had exhausted the meager possibilities offered by the Berlin district school by her fifteenth birthday. Yet, if the school failed to challenge one of its most illustrious pupils, it did inspire her to become a teacher. Acting on this wish, Emma prevailed upon her parents to let her attend the academy opened in Berlin by a Dr. Miner, a Yale graduate. She left Dr. Miner's academy after two years to open a village school during the summers. Hoping to further her training as a teacher, in 1805 she moved to Hartford, where one of her brothers lived, and attended an "advanced" school for young women. During this period, when she was allowed to study and maintain her own school, Willard first discovered the energy and drive that sustained her throughout her career.

Called to take charge of the Berlin district school in 1806, Hart developed a reputation for excellent teaching that spread throughout New England. Thus, at age twenty she was courted by schools in Westfield, Massachusetts; Middlebury, Vermont; and Hudson, New York. She chose the Westfield school because it was closer to her home in Connecticut but discovered that neither the salary nor the duties she was to perform matched her expectations. She left and assumed a position at the school in Middlebury, Vermont. In Middlebury Hart was not only courted by the proprietors of the school but also by the widowed marshal of the State of Vermont, Dr. Jonathan Willard. Finding him to be "In several respects . . . a man peculiarly calculated to gain a woman's affection," Hart married Dr. Willard on 10 August 1809 and resigned her teaching position. Their only child, John Hart Willard, was born in 1810.

Unfortunately for the Republican Willards, New England in the years immediately preceding the War of 1812 did not favor that party affiliation. Even in Vermont, which generally supported the Jeffersonian Republicans, Republican officials bore the brunt of public dissatisfaction with the restrictions of the federal government on trade with England and Canada. Accordingly, Dr. Willard was removed from his office as marshal in 1813, as much for his political affiliation as for his alleged financial improprieties and drinking. At any rate, Jonathan Willard's removal from office threatened financial ruin for the family.

Emma Willard's return to teaching was prompted by the political and financial woes that beset her husband during the war years. Although the circumstances that drove her to return to teaching were relatively common, the boarding school for young ladies she established was not. On opening the Middlebury Female Seminary in her home in 1814, Willard began to develop a curriculum that largely abandoned the courses in landscape painting, knitting, and other such cultivated trifles then deemed suitable for young ladies. Instead, guided by the sense of intellectual delight and awakening she experienced while reading the texts her husband's nephew, who lived in the home with them, was studying at neighboring Middlebury College, she began to prepare courses in philosophy, science, and mathematics. Willard asked permission to attend either classes or commencement exercises at Middlebury College, but her requests were denied. Despite the rebuff, Willard made her school successful. Fueled by the energy she devoted to mastering the texts and ideas necessary to teach her courses, her school soon attracted seventy students.

Willard began to envision an ideal academy or seminary that would educate young women to become fit teachers, wives, and mothers for the republic. As she

continued to plan her ideal school for women, Willard became convinced that such an institution would need government funding. She began drafting a proposal, therefore, for the legislative support of her female seminary. Carefully written, closely argued, and widely circulated, *An Address to the Public, Particularly to the Members of the Legislature of New-York, Proposing a Plan for Improving Female Education* marked Willard's first appearance in print when it was published in 1819.

Throughout her life Willard sought to distance herself from the more politically and morally radical visions of gender relationships that emerged during her lifetime. She viewed Mary Wollstonecraft as an unfortunate and deluded apostate from the true cause. Willard's *Plan for Improving Female Education* owes more to the work of moderate figures such as the American physician and philosopher Dr. Benjamin Rush and the examples of conservative English moralists and writers such as Hannah More and Maria Edgeworth. By basing her plan on arguments echoing those advanced by Rush in his 1787 *Thoughts upon Female Education*, Willard found acceptable grounds within Republican ideology to justify women's education.

Although her plan refers to Rush's earlier observations, Willard plainly draws on her reading of John Locke's *An Essay concerning Humane Understanding* (1690) to develop her major premise:

> Unprovided with the means of acquiring that knowledge which flows liberally to the other sex–having our time of education devoted to frivolous acquirements, how should we understand the nature of mind, so as to be aware of those early impressions, which we make upon the minds of our children?–or how should we be able to form enlarged and correct views, either of the character, to which we ought to mould them, or of the means most proper to form them aright?

In accordance with this vision of mothers as the fundamental agents of the reproduction and production of the nation's culture, Willard reminds her legislative audience that "we have the charge of the whole mass of individuals, who are to compose the succeeding generation; during that period of youth, when the pliant mind takes any direction, to which it is steadily guided by a forming hand." She leaves it for her audience to imagine the potential consequences for the republic–and the legislators' own families–if the children of the nation are essentially held hostage during their formative years by ill-educated mothers.

Reasoning from this cultural centrality of mothers as the success of a republican form of government, Willard deduced several reasons why the government should fund education for women. First, Willard exposed the defective nature of an unfunded and unregulated system of education for women. She then discussed the principles on which education should be regulated, sketched her plan for a properly funded and regulated "Female Seminary," and, lastly, envisioned the benefits society would receive from the existence of such institutions for women. Drawing an analogy from commerce, she explained that unlike the case of trade, which is capable of regulating itself, "civilized nations have long since been convinced, that education, as it respects males, will not . . . regulate itself; and hence, they have made it a prime object, to provide that sex with every thing requisite to facilitate their progress in learning: but female education has been left to the mercy of private adventurers; and the consequence has been to our sex, the same as it would have been to the other, had legislatures left their accommodations and means of instruction, to chance also." Beyond making the obvious point that education for women had been neglected, Willard's analogy skillfully portrayed it as virtually having been hijacked by potentially merciless and mercenary "adventurers."

Being left to the questionable mercies of "adventurers" led to further disadvantages of the education for women, according to Willard. She suggested, no doubt from personal experience, that being wholly "dependent on their pupils for their support . . . [they] are consequently liable to become the victims of their caprice." In the absence of state support and regulation, Willard continued, even well-intentioned schools lacked the resources to provide suitable housing, libraries, and "other apparatus necessary to teach properly the various branches in which they pretend to instruct." Driven by the need to make money "to teach their pupils showy accomplishments rather than those which are solid and useful," teachers of women necessarily provide an education of a temporary value, at best. Thus, when the fashions change, argued Willard, the education of these young women will also, "and no benefit remain to them, of perhaps the only money, that will ever be expended on their education." Of course, given a laissez-faire approach to education for women, parents must exercise the same practice of caveat emptor that they would in an unregulated marketplace. Willard wrote that "the public are liable to be imposed upon both with respect to the character and acquirements of preceptresses."

Her plan was well-received by Governor De Witt Clinton and other politicians, but the New York legislature did not appropriate funds for her planned female seminary. Encouraged to believe that if she implemented her plan successfully she might receive state aid, Willard moved to Waterford, New York, and opened the Waterford Academy, which received a charter–but no funds–from the New York legislature

in 1819. Greatly disappointed by this turn of events and nearly ruined financially, Willard feared total failure. However, the citizens of Troy, New York—then a burgeoning and fashionable manufacturing center—were impressed enough by Willard's plan, her efficiency in implementing it, and the favorable reports it received from state examiners that they offered to provide a building for her seminary if she would move to Troy. Willard opened the Troy Female Seminary in 1821. Propelled by her curricular innovations and energetic teaching, the school quickly proved successful and influential.

This success prompted the beginning of Willard's literary career. Since no textbook existed for teaching students the geography of ancient lands according to the method she later called "Progressive Geography," Willard set about developing one. Published in 1822, *Ancient Geography, As Connected with Chronology, and Preparatory to the Study of Ancient History* included several of the teaching tools and directed exercises that sprang from Willard's experiments in the classroom. On theoretical and practical grounds, Willard made the study of geography a prerequisite exercise for the study of history. As she explained in the preface to the *History of the United States, or Republic of America: Exhibited in Connexion with its Chronology and Progressive Geography* (1828), "the true mnemonics of history is to associate the event and its date with the geographical representation of the place where it occurred . . . the event fixes the recollection of the place, no less than the place the event . . . it is difficult to say which is the more important." Although Willard had adapted her text on ancient geography for inclusion in William Channing Woodbridge's *Universal Geography, Ancient and Modern; on the Principles of Comparison and Classification* (1824), even then she had seen the necessity of producing a textbook of American history that made use of the geographical plan of teaching history she had developed.

Unfortunately, as she declared in the preface to the second edition of *Universal Geography Ancient and Modern,* since she was burdened "with the care of an extensive institution, [she] deemed it impossible . . . to write" a book. Always resourceful and inventive, however, Willard hit on the notion of piecing out the various parts of her planned history to "certain of my former pupils, now my intimate friends. . . . I procured the standard authors on American history, laid down my plan, and employed my assistants in its execution; reserving to myself the entire liberty of adding, subtracting, or altering either in style or matter, whatever I should think proper." Despite having spent more time and effort on the project than she had planned, Willard felt uneasy enough about

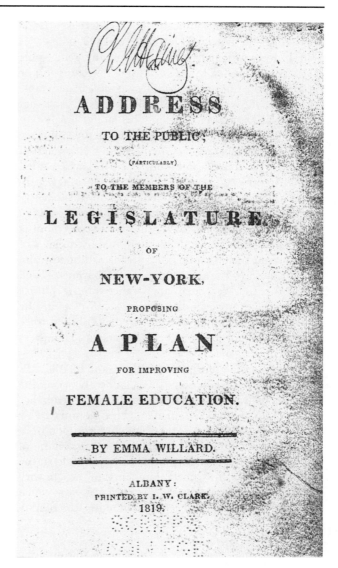

Title page for Willard's first publication, an effort to obtain public funding for a girls' school that would provide females the same level of education as males

claiming authorship for the entire work to have written to Edward Everett for advice.

Willard was also concerned about "how awfully responsible is the task of making the historical record of the actions of men." Reverting to a metaphor at once geographic and historic, Willard explained that until about the time of the War of 1812, "the history of America seems mostly settled; and the compiler . . . has only to choose good historians, select, and arrange." Confessing that "Since that period, my guides seem almost to have deserted me, and I [was] left, in some measure to find my way alone," Willard viewed her task as a historiographer as akin to the efforts of the

United States to domesticate the "wilderness" lands acquired by the Louisiana Purchase of 1803.

Indeed, Willard tended to mark the geographic progress of America by its successive dispossession or extermination of various tribes of Native Americans. Her assertion—written at virtually the same time that Andrew Jackson was pursuing his policy of Indian Removal regardless of the decision of the Supreme Court—that "Here are no demoralizing examples of bold and criminal ambition, which has 'waded through blood to empire'" illustrates the nineteenth-century view that all territorial expansion was divinely ordained. Her account of King Philip's War in 1675 represents the campaign as a contest between colonists in peril and genocidal Indians "withheld by no laws of religion, and their customs of war, instead of restraining, led them to the most shocking barbarities." Well before the first recorded appearance of the phrase "Manifest Destiny" in the *Democratic Review* in the 1840s, Willard thought that her students should trace the westward progress on their maps, so as to impress it better in their memories.

Although not the predominant strand of Willard's account of the revolution, this conflict between the forces of civilization and barbarism also appeared in her emphasis upon "the demoniac cruelties" committed by the bands of Indians and Tories who preyed upon frontier settlements. On the whole, however, her account of the American Revolution portrays the fortitude of the patriots. One of the finest moments of her history occurs in her description of "the patience with which these votaries of freedom endured" the horrors of Valley Forge:

> To go to battle, cheered by the trumpet and the drum, with victory or the speedy bed of honour before the soldier, requires a heroic effort; much more to starve, to freeze, and to lie down and die, in silent obscurity. Sparta knew the names of the three hundred who fell for her at the pass of Thermopylæ; but America knows not the names of the hundreds who perished at the camp of Valley Forge.

Among the heroes of the American Revolution, Willard also admired the Marquis de Lafayette. In fact, during his triumphal tour of the United States in 1824 in commemoration of the fiftieth anniversary of the beginnings of the revolution, Willard had labored strenuously and successfully to attract the French patriot and his family to Troy and her Female Seminary. While in Troy, Lafayette and his family were feted and lauded on a par with the enthusiasm of the other stops on his tour. In her history Willard devoted more space to his tour through the United States in 1824 and 1825 and "the warm feeling of gratitude which pervaded the whole nation" than she did either to the events and deliberations that precipitated the Missouri Compromise of 1820 or to the near simultaneous deaths of John Adams and Thomas Jefferson on the fiftieth anniversary of independence on 4 July 1826.

Possibly as a direct result of the expansionist sentiments that inform her historiography, the much-reprinted, revised, and abridged *History of the United States* eventually secured a place as—according to Nina Baym's estimate—possibly the second best-selling American history text in the thirty years after American history became a school subject in the 1820s. Willard not only became rich from her discovery of an emergent niche in the literary and academic marketplace, but she also secured an influential position in an era during which most Americans relied heavily on these textbooks for their knowledge of the history of the United States. Since a fair percentage of the students of the Troy Female Seminary went on to teach in schools throughout the United States, Willard's textbooks and the ideology of history they included were disseminated throughout the country.

Along with the success of Willard's textbooks and the continuing expansion of the Troy Female Seminary, which had become the school of choice for, among other Americans, the nieces of Washington Irving, Willard also had to contend with the death of her husband in 1825 and the cumulative effects of several years of extreme stress and effort. Her family and friends urged her to take a break from her duties to recover her strength and health. During the first part of this respite from her duties she assembled and published *The Fulfillment of a Promise* (1831), a small volume of poems she had promised herself, her sister Almira Phillips, who was coprincipal of the Troy Female Seminary, and her mother. With the exception of "Rocked in the Cradle of the Deep," which, set to music, became one of the most reprinted poems of the century and influenced Walt Whitman's "Out of the Cradle Endlessly Rocking," the poems in this volume have been forgotten.

Of more literary importance, however, was her decision to extend her vacation with a journey to France and England. Her narrative of these travels, *Journal and Letters, from France and Great-Britain* (1833), is the most readable and entertaining of all her writings. Willard's travels coincided with the French Revolution of 1830 in which Lafayette figured significantly. Equally fortuitously, her visit to England coincided with the resurgence and popularization of the reform movement. Beyond that, her position as an internationally recognized authority on education for women and American historians gave her access to, among other famous people, the Lafayette family and women's rights activist Bessie Raynor Parkes Belloc; American authors James

Fenimore Cooper and Irving; and, in perhaps the most entertaining passage in the narrative, social reformers Frances Wright and Robert Owen.

Willard published her letters as part of a plan to establish a seminary to train female teachers in Greece. After her return to Troy from Europe, Willard was approached by a group of men and women who sought to aid the cause of liberty in Greece. Well aware of the irony of turning to a woman of Troy to aid Greece, Willard noted in *Advancement of Female Education; or, A Series of Addresses, in Favor of Establishing at Athens, in Greece, a Female Seminary, Especially Designed to Instruct Female Teachers* (1833) how the event upends an old story: "in the ancient story we are told that one of our sex remaining in Troy wrought harm to the Greeks. In modern recital may it be said, that women of *American* Troy have done them lasting good." Beyond much behind-the-scenes effort in lining up potential teachers and missionaries for the project, Willard also volunteered to "give a manuscript of my European Journal, which, when printed . . . will sell for a dollar a copy," to help raise the three thousand dollars needed to finance the project.

Willard's invocation of epic precedent signals the lofty tone of her plainest statement in favor of "the future accomplishment of what has long been the leading motive of my life." Her own perspective expanded geographically and ideologically by her recent travels, Willard saw a sign of a coming "renovation" in the mission to establish a female seminary in Greece upon the model of the Troy Female Seminary:

> Justice will yet be done. Woman will have her rights. I see it in the course of events. Though it may not come till I am in my grave—yet come it will; for men of the highest and most cultivated intellect, of the purest and most pious hearts, now perceive its necessity to the well being of a world, where it is their glory to be workers together with God, to produce a moral renovation.

Advancement of Female Education advances the strongest expression, in fact, of what one could call Willard's feminist sentiments.

Her encounters with such radicals as Wright and Owen, however, disturbed Willard, as did the decadence she perceived in English and French society and their lax methods of educating women. Accordingly, Willard not only asserted the moral and cultural superiority of America to England and France but also claimed that "American women do hold in this country, a condition of companionship with men, superior to the generality of our sex in England, and this is both the consequence, and the cause of moral elevation." Willard demonstrated this cultural superiority by drawing "a comparison between American and English authors." The centerpiece of this comparison is an audacious feminist deconstruction of John Milton's representation of Eve's submissive "what thou bid'st / Unargued I obey; so God ordains" to Adam in *Paradise Lost* (1667):

> To divest this passage of the charm it derives from being connected with some of the most exquisite poetry ever written, let us change the phraseology and put it into the mouth of Adam. We shall then know how to appreciate its morality and the bearing of its sentiments on the character and condition of women. . . . What! Shall a Christian teach us that man, not God is our author? That we are to look to him, as the ruler of our destiny and our final disposer? Shall he go further, and deny that God is a law to us? *Shall* woman then obey all man's commands without argument? Then were she justified in committing murder and every abomination, if such were the will of her only ruler!—And this is to be all her knowledge—all her intellectual repast—all her means of moral improvement. She need know neither God nor his works, provided she knows the will of man, and obeys it.

Claiming that "our first mother in her unfallen state" could not have uttered such blasphemy, Willard moved from criticizing Milton's portrayal of gender relations to his own "tyranny to his daughter in obliging her day after day to read Latin to him without allowing her to learn it, thus making her a mere tool for his selfish mental gratification. . . . I doubt whether any action could be produced from an intelligent American father, of the same character with this. The contrast which my memory gives me of the manners of my own venerated parent to his daughters, strikes me forcibly."

But much as Elizabeth Cady Stanton, a Troy Female Seminary graduate, was unable to persuade Willard to adopt a political feminism in *Advancement of Female Education,* Willard doggedly defines her feminism in terms of woman's God-given capacity "of being morally the best." When men or women act in ways that overlook or trample upon this superiority, wrote Willard, then it should not surprise them if

> some among us of impetuous spirits, madly seek to break the social order, and dissolve the golden link which God himself has instituted, and in which woman, in obedience to her nature, and the express commands of God, acknowledges man as her head. Men of disordered minds, or ambitious views, have encouraged the phrenzy. Hence the ravings of Mary Wollstonecraft, of Frances Wright and Robert Owen; and hence the frantic sect which are now denouncing marriage; and disturbing Paris, under the name of St. Simoniens.

Such "phrenzies" and "ravings," wrote Willard, are the natural result of disturbing "the balance of society . . . by educating the one sex and leaving the other

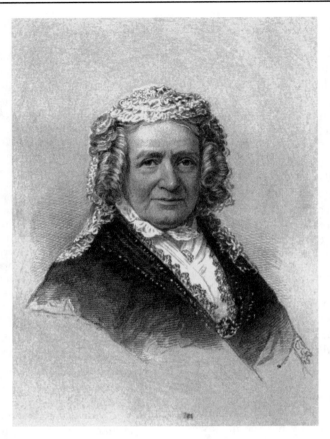

Willard in old age (from John Lord, The Life of Emma Willard, *1873)*

uneducated." Moreover, such inequality reproduces itself as "the son [thinks] little of his unlearned mother;—the brother of his unlettered sister." Since this was the prevailing state of society she found in her tour of France and Great Britain, even despite the writings of Ann Dacier, Anne-Louise-Germaine de Staël, Maria Edgeworth, Hannah More, and Joanna Baillie, Willard concluded that because of its peculiar history, only in America woman "without violating the laws of God, or losing her sense of dependence on the other sex, holds by intellectual and moral dignity her just rank of companionship with man." Since this elevated state of woman—clearly Willard's measure of cultural success—only occurs in America, she suggested that the intellectual renovation of Grecian women should proceed from Willard's American Troy.

While Willard was to make her clearest statement of her understanding of legitimate feminist activism in *Advancement of Female Education,* her *Journal and Letters, from France and Great-Britain* (1833) merges an intellectual journal of how she arrived at those conclusions with a clear, readable, and entertaining narrative of Paris and London during the revolutionary days of the early

1830s. *Journal and Letters, from France and Great-Britain* is essentially an edition of Willard's letters home to her sister Almira Phelps, who was running the Troy school in Willard's absence; Willard's letters to her students; and entries drawn from her journals.

Willard displayed some unease about publishing these materials. She had begun the journals with the intention of "making observations not only for myself, but for my country women; especially for those who were and who had been my pupils." Her experiences in Paris society, however, convinced her that whatever she might have learned during her "short stay abroad, would not be worth presenting to the public." Thus, were it not for the "affecting appeal . . . in behalf of female education in Greece," insisted Willard, she would not have thought of preparing her private journal and letters for publication.

Thus, taking her place once more within the public sphere, Willard naturally resumed her role as a teacher of the nation. Beyond seeking to interest and amuse "the American public," Willard wanted to "correct . . . false standards of public opinion, or erroneous estimates of ourselves, and others." Chief among these

erroneous estimations, to judge from Willard's asides to her readers, were what she wryly described as her readers' "republican curiosity about royalty." Although her account of her introduction to the Queen of France shows that she was also infected with curiosity, Willard seems to have successfully resisted the allure of its monuments and palaces:

> There is a certain something to our ears in the word palaces—things not found in our republican land—which is imposing, and we almost fancy a kind of glory surrounding them, so that when we see them, we are at first disappointed; nothing but stone, and mortar, and window-glass, after all:—it may be in greater quantities than in ordinary houses, and more curiously wrought, but this is all.

Willard clearly strove against the expectations she assumed her intended readership of middle- and upper-class American women would have about a French and English travel narrative written by a fellow American woman. Her description of the banquet she and her fellow travelers gave for the captain of their vessel is noteworthy for her failure to discuss the meal or the guests' finery:

> liberalism is altogether the order of the day here, and really I was so much occupied with the subject, that I cannot be so minute with regard to the dinner as one might expect. The changes of the great political drama, affect me more than those of the dishes.

While historians have not generally shared her assessment, Willard thought that "La Fayette, more than any other man of the present day, is making history for others to write, and for posterity to read." Thanks to her previous acquaintance with General Lafayette in Troy, she had dined at his home, attended the opera in his private box, and witnessed his composure immediately after his unceremonious dismissal from office in late December 1830. Hoping to hear good news on 27 December, the day of his dismissal, Willard visited Lafayette's daughter-in-law. Instead, she wrote, Madame George La Fayette "grasped my hand, and exclaimed, 'Ah! My dear Madame, what will the Americans say to this? America could remember the services of my father for fifty years. France can scarce remember them five months. . . . They say republics are ungrateful, and monarchies are not,—let this treatment of my father bear testimony.'"

Thus, the *Journal and Letters, from France and Great-Britain* traces the course of Willard's disillusionment with French culture and politics. Indeed, after a lengthy stay, courses in French, repeated shopping trips, sight-seeing excursions to schools for young women,

and contact with the upper reaches of Parisian society, Willard found good things to say about the company of Cooper—who, she wrote, positively denied having borrowed the plot of *The Wept of Wish-ton-Wish* "from Miss Sedgwick's *Hope Leslie*"—the Lafayettes, and Belloc.

While Willard reveals a more incisive and urgent tone in her *Advancement of Female Education, Journal and Letters* records the experiences that made her aware of a larger scope for her "devotion to the cause of our sex." Her long-delayed meeting with Belloc marks a major stage in her process of defining the extent of her engagement with feminism and social reform. Writing to her sister about "the deep fountain of sympathy which, once opened in our hearts, flowed on together, because in both, it had previously taken the same course," Willard explains that although Belloc wished to read Willard's *History of America,* no copies were readily available. Instead, Willard says that she "gave her my appeal to the Legislature in favor of female education, and my little volume of poems." Once revealed as a companion in the cause to Belloc and her unnamed companion, the change was as dramatic and revelatory for Willard as any of the political accounts to which she devoted so much energy to recounting. She struggled to find words for the sentiments this second meeting aroused, confessing, "Manners and language with us have not that mobility, which brings forth all the excited soul; and which makes you know that it is truly the soul which is in action." Despite her inability to translate fully the force of the sentiment, she acknowledged its transcendent importance: "In the reality of this newly awakened sensibility for me, it was not so much myself, as the cause to which my life was devoted, that was honored; and I loved them, because they loved that." Of the rest of Paris and its strange contrasts of artistic beauty and moral depravity, Willard prefigured a character in a Henry James novel when she observed after learning about the catacombs underneath the Tuilleries, "every thing here is hollow. Paris itself is hollow, and all in it, except our good La Fayette, and his family."

Willard's experiences in London served to clarify the moral and political boundaries of her engagement with radicals and reform movements. Arriving in London after having experienced the doubtful pleasures of Paris, Willard found herself once again immersed in scenes of political drama. Within days of arriving in London she witnessed a series of "illuminations" of the city in support of reform. Drawn forth, as much to witness the spectacle of most of London lit up, as by the thrilling prospect of being caught up "in a London mob," Willard and her son drove throughout the city in a carriage admiring the "lamps of varied and beautiful

colors," the "blazing gas lights," and the "transparent" paintings, which were "gorgeous in coloring" until "led by the spectacle," they found themselves "just where we had determined not to be, when we set out—at the very spot, and in the very time for a crowd." Willard reported being so taken "with the brilliant show, that we lingered long to enjoy it."

Yet, if Willard found contact with the energies of reform exhilarating in the context of blazing lights and a crush of people, she found it horrifying in closer quarters and expressed in a form more closely related to her own efforts on behalf of women. The most emotionally trying episode of Willard's *Journal and Letters, from France and Great-Britain* involves her encounters with a certain "Mrs. R." and the Scots educator and social theorist, Robert Owen. From her first mention of this woman, Willard questions the mental fitness of one who "dressed in good taste, but with a certain wildness of eye and countenance, which at the first glance, gave me an idea of a fine mind, somewhat disordered."

Like Madame Belloc, "Mrs. R." attempted to garner Willard's sympathy by telling Willard of "her ideas of our deplorable condition." Instead, she shocked Willard by speaking "of men as of a race of brutal selfish, unfeeling tyrants, and commenced a declamation against marriage." Willard countered the radical sentiments with "language too severe for politeness." Perhaps implying that were it not for the relatively progressive state of affairs in the United States, she too might have fallen prey to the same opinions, Willard wrote,

> What can be more horrible for a woman of an intelligent and sensitive mind, loving justice herself, and desiring good, really to believe that there is no benevolence in the government of the universe;—and that men who have the power to govern us, and whom our nature obliges us to love, are our tyrants and enemies.

As "Mrs. R." became an object of pity instead of a sympathetic companion in this interchange, the sequence of Willard's narrative imputes an almost diabolical tyranny to Owen, whom she was surprised to meet at an evening given by Mrs. R.

"Never did I meet a man with a smoother face, or a smoother tongue," wrote Willard. Despite Willard's best efforts to avoid controversial matters, Owen set about making a proselyte of Willard. The forcefulness of Willard's description of the encounter suggests a moment of almost supernatural conflict and temptation, because the arguments she credited Owen with advancing not only attacked her religious beliefs, but also undermined the ideological grounds upon which she had established her theories of education. First, she wrote, Owen tried to lure her into accepting as a given

the stringently Lockean premise that "Man . . . was the creature of circumstance." Willard's response, which epitomizes the romantic response to Lockean rationalism, is a memorable rejoinder:

> You do not even allow to man the dignity of a vegetable, which, though it has its changes, is yet something of itself; and always the same, whatever the soil or the culture by which it is modified. The hawthorn may be stinted or expanded in its growth, but no skill of the gardener can make it a rose.

Undaunted, or perhaps unwary, Owen then advanced "the principle, that all the children born in a community, should be educated by the community at large." Willard recognized he was "making way for the assertion that the restraints of marriage were useless." She could hardly have done otherwise than stridently oppose Owen's reasoning since, if granted, it would have virtually eliminated the rationale for the education of women to which Willard had devoted her life.

Next, Owen sought to bully Willard into agreement with the threadbare argument "that his opinions were prevailing,—the governments of the world would be obliged to yield to them." Had he stopped with this statement, he would have saved himself the embarrassment Mrs. Willard obviously delighted in recounting:

> "In short, [said Owen,] the world had heretofore gone on from error to error, both in philosophy and in morals.—Sir Isaac Newton, whom I had mentioned; and others, who like him, had guided the opinions of the multitude, taught ten errors to one truth."
>
> "But they thought they were teaching truth, did they not Mr. Owen?"
>
> "Undoubtedly."
>
> "And if human nature in its best estate is thus liable to error, how then can Mr. Owen know that *he* is infallible? He is persuaded he is teaching truth—but what of that? So was Sir Isaac Newton. And how can we know that Mr. Owen too, is not teaching ten errors to one truth? Does he claim to be favored with direct revelation from the only sure fountain of truth?"

Willard went on to inform her readers that this "question silenced the whole party, and there was a solemn pause."

As Willard ended this encounter, she reiterated her pity for Mrs. R. further, clearly thinking as much of characters similar to Owen as of the more numerous class of English husbands, Willard noticed that the habits of "the men of England" were calculated to drive women "either to a course of deceit—by which art is brought to cope with tyrannical power;—or to desperation—as in the melancholy case I have described."

Willard returned in 1832 to her duties at the Troy Female Seminary and to a renewed round of activity on behalf of education for women. Partially because of the publication of her *Journal and Letters* and *Advancement of Female Education* and also because of the continued success of her school, Willard emerged as a truly national figure in the middle 1830s. Her writings were reviewed by a number of publications, her career was profiled, and she began contributing occasional articles to *Godey's Lady's Book,* the influential magazine edited by Sarah Josepha Hale. In 1838 she chose her sister Almira Lincoln Phelps to succeed her and retired from her duties as principal of the Troy Female Seminary. The next year she entered into a disastrous second marriage to Dr. Christopher Yates, which was notable primarily because in 1841 she sued for, and was granted, a divorce and the right to resume being known as Emma Willard by the Connecticut State Legislature.

Although officially retired from teaching, Willard continued to investigate new subjects and added scientific texts to an already impressive list of publications. As a national authority on education, she was frequently asked to comment on educational reforms and plans throughout the 1840s and 1850s. Up until the eve of the Civil War, Willard continued revising, reissuing, and producing her histories of America's westward expansion. Profoundly disturbed by the onset of the War Between the States—in part because two of her brothers lived in Virginia, Willard strove valiantly to use her influence to ward off the outbreak of hostilities. After the war, she remained on the campus of the Troy Female Seminary, where, revered by students, she lived until her death on 15 April 1870. Troy Female Seminary was renamed the Emma Willard School in 1898.

Willard's contributions to American culture and education never wholly neglected, nor fully recognized, Emma Willard was an influential woman in the antebellum United States. She provided hundreds of thousands, if not millions, of Americans with their understanding of the historical events and overarching mission of the progress of America. However influential and profitable these texts were and however worthy of study as an object of cultural study, Willard should be remembered also for *Advancement of Female Education* and *Journal and Letters, from France and Great-Britain.* In these works she makes plain the implicit narrative thread of her historiography, in which she reads the progress of civilization, and of America's expansion, as virtually identical with the progressive recognition of the rights of women.

References:

Nina Baym, *American Women Writers and the Work of History, 1790–1860* (New Brunswick, N.J.: Rutgers University Press, 1995);

Baym, "Women and the Republic: Emma Willard's Rhetoric of History," *American Quarterly,* 43 (March 1991): 1–23.

Papers:

The Emma Willard School in Troy, New York, and the Connecticut Historical Society have collections of Emma Willard's letters and manuscripts.

Harriet Wilson

(1827/1828? – 1863?)

Barbara A. White
University of New Hampshire

See also the Wilson entry in *DLB 50: Afro-American Writers Before the Harlem Renaissance.*

BOOK: *Our Nig; or, Sketches from the Life of a Free Black, in a Two-Story White House, North. Showing that Slavery's Shadows Fall Even There. By "Our Nig"* (Boston: Printed by Geo. C. Rand & Avery, 1859).

Edition: *Our Nig; or, Sketches from the Life of a Free Black, in a Two-Story White House, North. Showing that Slavery's Shadows Fall Even There. By "Our Nig,"* edited by Henry Louis Gates Jr. (New York: Vintage, 1983).

Harriet E. Adams Wilson is the first African American woman known to have published a novel in English, a fact not acknowledged until the republication in 1983 of her 1859 autobiographical work. Novelist Alice Walker remarked, "I sat up most of the night reading and pondering the enormous significance of Harriet Wilson's novel *Our Nig*. It is as if we'd just discovered Phillis Wheatley—or Langston Hughes." Wilson's *Our Nig* is significant not only because of its status as a first but also because of its unconventional treatment of racism in the North at a time when most attention to racial inequity was directed toward Southern slavery.

Although *Our Nig* had been recognized by booksellers since its initial publication, it had not been noted that Mrs. H. E. Wilson, listed as the copyright holder, was an African American. The only evidence available about the author's race was the plot of the narrative, the author's appeal in the preface to her "colored brethren universally for patronage," and her statement that she writes to maintain herself and her child. The proof of Wilson's race was found by Henry Louis Gates Jr. and his colleague, David Ames Curtis, who located the death certificate of the author's son, George Mason Wilson, who died of fever in Milford, New Hampshire, in February 1860, only six months after the publication of the book intended to raise money for his support. The death record lists his parents as Thomas and Harriet E. Wilson and his color as black. In the obituary

notice in the *Farmer's Cabinet,* Milford's local paper, Mason is referred to as the "only son of H. E. Wilson." Milford marriage records show that a Harriet Adams of Milford married Thomas Wilson of Virginia on 6 October 1851 in Milford, about nine months before George Mason was born.

Since 1983 more details about Wilson's life have been discovered, including Barbara A. White's identification of the model for the cruel "Mrs. Bellmont" and her family in the novel. But relatively little is known for certain about Harriet Wilson's life. Even her birth date is contested. The 1850 federal census for Milford lists Harriet Adams, a twenty-two-year-old black woman born in New Hampshire, as residing with the family of Samuel Boyles, a white carpenter. This Harriet Adams would have been born in 1827 or 1828. But *Our Nig* ends with the heroine, Frado, leaving New Hampshire, and the novel was printed in Boston and entered into copyright in Massachusetts. Gates and Curtis found in Boston city directories a "Harriet Wilson, widow" living in Boston from 1856 to 1863. This Harriet Wilson has the same address as an African American widow listed in the 1860 federal census; the widow's birthplace is given as Fredericksburg, Virginia, and her age as fifty-two. In his introduction to the second edition of *Our Nig* (1983), Gates favors 1828 as Wilson's probable birth date; the Library of Congress catalogers credit the 1860 Boston census, assigning Wilson the birth date 1808.

The death record of Wilson's son says his mother was born in Milford, so the best guess is that she was born there in 1827 or 1828. Whether she had a black father who died young and a white mother who abandoned her, as Frado does in *Our Nig*, is not known. At any rate, Harriet Adams became indentured as a child to the Nehemiah Haywards, an established Milford farming family, and she appears in the 1840 census for Milford. Although only heads of household were listed by name in 1840, the Hayward family includes for the first time a "free colored person" in addition to the "free white persons"; she is female and at least ten years old

but under twenty-four. The 1840 census does not list any other female "free colored persons" residing in Milford.

The Hayward family corresponds closely to the Bellmonts described in *Our Nig*. There was a patriarch (Nehemiah Hayward Jr./Mr. Bellmont) who had inherited the family homestead; his sister (Sally Hayward/ Aunt Abby Bellmont) who owned a "right in the homestead" and occupied a section of the house; and his wife (Rebecca Hutchinson Hayward/Mrs. Bellmont) who was by all accounts a greedy and difficult person. The eldest son (George M. Hayward/James Bellmont) worked in Baltimore and returned home ill with his wife and child to die an early death in Milford. This son was Wilson's favorite, as James Bellmont is Frado's favorite in the novel, and Wilson seems to have named her own son, George Mason, after him. The most successful Hayward was another brother, Jonas, who became a wealthy industrialist and leading citizen of Baltimore; in *Our Nig* the successful Lewis Bellmont is an ally of his racist mother.

By 1847 Mr. and Mrs. Hayward had moved permanently to Baltimore and Wilson was probably, like Frado in the novel, unable to work and "wasted" by "years of weary sickness." At least she appears in the "Report of the Overseers of the Poor for the Town of Milford, for the Year ending February 15, 1850" as costing the town $43.84. Presumably she had managed to avoid the town paupers' farm and lived with a family reimbursed by the town, probably the family of Samuel Boyles, with whom she was residing at the time of the 1850 census.

There is considerable documentary evidence that the rest of Wilson's life followed literally the path she marks out for Frado in the last two chapters of *Our Nig*. Wilson must also have experienced "the old resolution to take care of herself, to cast off the unpleasant charities of the public." An appendix to the novel signed by an otherwise unidentified person named Allida states that the author moved to W_____, Massachusetts, to sew straw hats. "W" was probably Worcester and the "Mrs. Walker" who, Allida says, provided the author a livelihood and a home was Ann Mattee Walker (1793– 1873), the African American mother of an abolitionist barber in Worcester. Wilson's marriage certificate shows that she then met her husband and returned to Milford to be married. Her child, according to his death certificate, was born in Goffstown, New Hampshire, the location of the county poor farm, so Frado's fate of being "again thrown upon the public for sustenance" seems to have been Wilson's. Thomas Wilson eventually left for good, and Harriet spent the rest of the decade struggling to support her son.

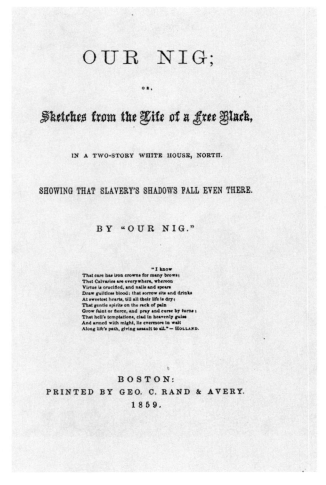

OUR NIG;

OR,

Sketches from the Life of a Free Black,

IN A TWO-STORY WHITE HOUSE, NORTH.

SHOWING THAT SLAVERY'S SHADOWS FALL EVEN THERE.

BY "OUR NIG."

"I know
That care has iron crowns for many brows;
That Calvaries are everywhere, whereon
Virtue is crucified, and nails and spears
Draw guiltless blood; that sorrow sits and drinks
At sweetest hearts, till all their life is dry;
That gentle spirits on the rack of pain
Grow faint or fierce, and pray and curse by turns;
That hell's temptations, clad in heavenly guise
And armed with might, lie evermore in wait
Along life's path, giving assault to all." — HOLLAND.

BOSTON:
PRINTED BY GEO. C. RAND & AVERY.
1859.

Title page for Harriet Wilson's book, the first novel by an African American woman

"Harriet E. Wilson" appears on the February 1855 list of "Support of Poor not at the Pauper Farm," and "Harriet E. Wilson and Child" on the 1856 list. The records of the Hillsborough County Farm show that George Wilson, age three, a "colored" resident of Milford, was admitted for four weeks in the summer of 1855 before he was discharged to his mother. The reports of the Milford overseers of the poor support the idea that Wilson left her son in New Hampshire and went to Massachusetts, as Frado did in the novel. The records indicate that she was gone between February 1856 and the time of the boy's death in 1860. In the appendix to *Our Nig* Allida claims that a kind couple took the boy in and provided for him "without the hope of remuneration," but in reality the town paid approximately $20 a year for the boy's care. There is no death record for Harriet Wilson in Milford or Boston, and her name does not appear in any Milford or Boston records after 1863, although a "Mrs. Wilson" appears on the role of county paupers in that year.

Jonas Hayward, the model for the character Lewis Bellmont in Our Nig *(courtesy of Barbara A. White)*

Before Wilson disappeared, however, she completed her autobiographical narrative *Our Nig*, the "experiment" she undertook for supporting her child. She had it printed by George C. Rand and Avery, a reputable printing company in Boston, and she registered the copyright at the District Clerk's Office in Boston on 18 August 1859. Wilson's expectation of earning money to care for her son was not unreasonable, but the book was not widely distributed and there are no known reviews or even mentions in periodicals of the day. Over half the owners of the copies scholar Eric Gardner has been able to trace were children, and most lived within twenty miles of Milford.

The reception of the second (1983) edition of *Our Nig* was a different story. Most reviewers reacted enthusiastically, though initially some critics viewed *Our Nig* as an unsophisticated and crudely autobiographical work, objecting to the uncertain point of view in the beginning and the abrupt ending. Jill Jones has recently

argued that Wilson's inconsistencies are part of a conscious strategy: "After establishing the veracity of her story in the first person, she constructs a fictional third-person narrator who can project the illusion of authority. She then uses this authority to empower the protagonist, giving her the appearance of autonomy by emphasizing the choices that she can make, and even implying that Frado has choices when she does not." According to Jones, Wilson's strategy "authorizes" the narrator and protagonist until the last chapter, when Frado has too few choices and the plot breaks down.

Although the novel has flaws, it is also subtle and complex, and Wilson enlivens her grim story with continual flashes of wit and irony. One of the most obvious of these is the ironic use of "Our Nig," which Gates in his introduction calls "the most brilliant rhetorical strategy in black fiction" before Charles Chesnutt. Wilson has Frado denigrated by her employers with the epithet "our nig," only to use it as the title of her book that exposes their racism. As Gates states, "Transformed into an *object* of abuse and scorn by her enemies, the 'object,' the heroine of *Our Nig*, reverses this relationship by *renaming herself* not Our Nig but 'Our Nig,' thereby transforming herself into a *subject*."

The narrative opens with the marriage of Frado's parents—Mag, a "fallen" white woman, and Jim, a "kind-hearted African." The protagonist, Frado, is a Northern servant, not a Southern slave. After Jim dies of consumption, the poverty-stricken Mag abandons Frado at the Bellmonts' farm. At the tender age of six she finds herself indentured to the Bellmont family, becoming "our nig" to Mrs. Bellmont, a "she-devil" who overworks and beats her. Although Frado is befriended by some members of the family—Mr. Bellmont, his sister Abby, and the sons James and Jack—the cruelties of Mrs. Bellmont and her vicious daughter, Mary, ruin Frado's health so that she has trouble supporting herself once she escapes the indenture at age eighteen. In the last chapter Frado marries a con man who pretends to be a fugitive slave so he can earn lecture fees from abolitionist groups. He leaves her with a son to feed. So, the author says, having been "deserted by kindred, disabled by failing health, I am forced to some experiment which shall aid me in maintaining myself and child without extinguishing this feeble life": she is writing *Our Nig*.

Wilson insists on making Frado's personal story resonate, connecting it to larger issues of the day, such as the economic domination of whites. Wilson consciously shaped her narrative instead of writing straight autobiography. Aunt Abby Bellmont, for instance, appears in *Our Nig* as Mr. Bellmont's "maiden sister," but her original, Sally Hayward, married a man named Blanchard and was widowed. Wilson presented Aunt

Abby as an old maid for aesthetic reasons, to make her seem more vulnerable to the Haywards and to obviate the necessity of going into a long explanation of her past.

Presumably it was also in the interest of streamlining the narrative that Wilson made another change: she combined aspects of two Hayward brothers, Nehemiah P. and Charles, into one character, Jack Bellmont. It would have been difficult to individualize too many brothers, and Wilson may have suppressed the presence of another Hayward son living with the family when she arrived. Wilson also changed the order of events. Lucretia married in September of 1834, just a month after George Hayward's wedding. In *Our Nig* the marriages occur after a spring visit from James (George) when Frado is nine years old. Frado would thus have been born between summer of 1824 and spring of 1825. Spring 1825 would be the most likely date because almost all the age markers in *Our Nig* are given in the spring—Frado has just turned six when she goes to the Bellmonts in summer; she is seven when she starts summer school; she is "now nine" when James (George) visits in late spring; and she becomes eighteen and finishes her indenture in spring. But a spring 1825 birth date for Wilson is problematical because it contradicts the 1850 census, which gives Wilson's age as twenty-two. The puzzle pieces do not fit together if one tries to assume an exact correspondence between Hayward and *Our Nig* chronologies.

In writing her narrative Wilson used several different models that she found in the literature of her time, most notably *Uncle Tom's Cabin* (1852), which has similar characters. The mischievous young Frado owes a good deal to Topsy and Mr. and Mrs. Bellmont to the St. Clares. In addition, there are continual verbal echoes in *Our Nig* of Harriet Beecher Stowe's famous novel. Probably Wilson also read William Wells Brown's *Clotel,* a novel considered the first by an African American; it was published in England in 1853. Clotel is a pretty, light-skinned mulatta, like Frado, but Wilson makes Frado less genteel (and considerably less wooden as a character). The significance of *Clotel* for Wilson was more likely Brown's inclusion of a poem supposedly written by a Southern white clergyman and entitled "My Little Nig": "I have a little nigger, the blackest thing alive / He'll be just four years old if he lives till forty-five. . . . He gets up early in the morn, like all the other nigs, / And runs off to the hog-lot, where he squabbles with the pigs." There is also an incident in *Clotel,* repeated in *Our Nig,* in which the cruel mistress of Clotel's daughter makes her work uncovered in the hot sun so as to darken her skin.

While Wilson took various details from the novels of the day, she also borrowed from several literary forms, notably the slave narrative and sentimental novel. Like slave narratives, *Our Nig* includes testimonials to the truthfulness of the narrative; scenes of physical punishment documenting owners' cruelty and slaves' suffering; the coming to literacy of the narrator, accompanied by the awakening of religious impulses; and a climax in which the narrator decides to run away, or at the least refuses to be beaten. From the sentimental novel Wilson borrowed melodramatic language, especially in the beginning of the book, and, as Gates points out, the plot, which resembles the best-known sentimental novels of the day, such as the popular *The Wide, Wide World* (1851) by Susan Warner.

There are striking parallels in the circumstances of *Our Nig* and Harriet Jacobs's *Incidents in the Life of a Slave Girl* (1861). As a runaway slave, Jacobs also had to use different names in the narrative to protect herself and her friends, and until the recent discovery of her letters, which show the book to be an autobiography, the work was considered fiction heavily edited by whites and possibly not even authored by a black woman. But in one important respect *Our Nig* differs markedly from *Incidents in the Life of a Slave Girl.* Jacobs told her story to "arouse the women of the North" to political action on behalf of slave women in the South, but Wilson could not tie hers to any political agenda of the day, and neither could she muster any call to action other than a plea to help her son by buying her book. As she anticipated, her story was not destined at first to be widely read. *Our Nig* waited for more than a century for its fullest audience.

References:

Elizabeth Ammons, "Stowe's Dream of the Mother-Savior: *Uncle Tom's Cabin* and American Women Writers Before the 1920s," in *New Essays on Uncle Tom's Cabin,* edited by Eric J. Sundquist (Cambridge: Cambridge University Press, 1986), pp. 155–195;

Elizabeth Breau, "Identifying Satire: *Our Nig,*" *Callaloo,* 16, no. 2 (1993): 455–465;

Barbara Christian, "'Somebody Forgot to Tell Somebody Something': African-American Women's Historical Novels," in *Wild Women in the Whirlwind: Afra-American Culture and the Contemporary Literary Renaissance,* edited by Joanne M. Braxton and Andree Nicola McLaughlin (New Brunswick, N.J.: Rutgers University Press, 1990), pp. 326–341;

David Ames Curtis and Henry Louis Gates Jr., "Establishing the Identity of the Author of *Our Nig,*" in *Wild Women in the Whirlwind: Afra-American Culture and the Contemporary Literary Renaissance,* edited by Joanne M. Braxton and Andree Nicola McLaugh-

lin (New Brunswick, N.J.: Rutgers University Press, 1990), pp. 48–69;

Beth Maclay Doriani, "Black Womanhood in Nineteenth-Century America: Subversion and Self-Construction in Two Women's Autobiographies," *American Quarterly,* 43, no. 2 (1991): 199–222;

John Ernest, "Economies of Identity: Harriet E. Wilson's *Our Nig,*" *PMLA,* 109 (May 1994): 424–438;

P. Gabrielle Foreman, "The Spoken and the Silenced in *Incidents in the Life of a Slave Girl* and *Our Nig,*" *Callaloo,* 13 (Spring 1990): 313–324;

Eric Gardner, "'This Attempt of Their Sister': Harriet Wilson's *Our Nig* from Printer to Readers," *New England Quarterly,* 66, no. 2 (1993): 226–246;

Robert LeRoy Hilldrup, "Cold War against the Yankees in the Antebellum Literature of Southern Women," *North Carolina Historical Review,* 31 (July 1954): 370–384;

Karla F. C. Holloway, "Economies of Space: Markets and Marketability in *Our Nig* and *Iola Leroy,*" in *The (Other) American Traditions: Nineteenth-Century Women Writers,* edited by Joyce W. Warren (New Brunswick, N.J.: Rutgers University Press, 1993), pp. 126–140;

Jill Jones, "The Disappearing 'I' in *Our Nig,*" *Legacy,* 13, no. 1 (1996): 38–53;

Carla L. Peterson, "'Forced to Some Experiment': Novelization in the Writings of Harriet A. Jacobs, Harriet E. Wilson, and Frances Ellen Watkins Harper," in her *"Doers of the Word": African-American Women Speakers & Writers in the North (1830–1880)* (New York: Oxford University Press, 1995), pp. 146–175;

Julia Stern, "Excavating Genre in *Our Nig,*" *American Literature,* 67 (September 1995): 439–466;

Claudia Tate, "Maternal Discourse as Antebellum Social Protest," in her *Domestic Allegories of Political Desire: The Black Heroine's Text at the Turn of the Century* (New York: Oxford University Press, 1992), pp. 23–50;

Priscilla Wald, "'As From a Faithful Mirror': *Pierre, Our Nig,* and Literary Nationalism," in her *Constituting Americans: Cultural Anxiety and Narrative Form* (Durham: Duke University Press, 1995), pp. 106–171;

Barbara A. White, "'Our Nig' and the She-Devil: New Information about Harriet Wilson and the 'Bellmont' Family," *American Literature,* 65 (March 1993): 19–52.

Checklist of Further Readings

Albertine, Susan, ed. *A Living of Words: American Women in Print Culture.* Knoxville: University of Tennessee Press, 1995.

Bardes, Barbara, and Suzanne Gosset. *Declaration of Independence: Women and Political Power in Nineteenth-Century American Fiction.* New Brunswick, N.J.: Rutgers University Press, 1990.

Baym, Nina. *Novels, Readers, and Reviewers: Responses to Fiction in Antebellum America.* Ithaca, N.Y.: Cornell University Press, 1984.

Baym. *Women's Fiction: A Guide to Novels By and About Women in America, 1820–1870.* Ithaca, N.Y.: Cornell University Press, 1978.

Braxton, Joanne. *Black Women Writing Autobiography: A Tradition Within a Tradition.* Philadelphia: Temple University Press, 1989.

Brodhead, Richard H. *Cultures of Letters: Scenes of Reading and Writing in Nineteenth-Century America.* Chicago: University of Chicago Press, 1993.

Brown, Gillian. *Domestic Individualism: Imagining Self in Nineteenth-Century America.* Berkeley: University of California Press, 1990.

Brown, Herbert Ross. *The Sentimental Novel in America, 1789–1860.* New York: Pageant, 1959.

Bryer, Jackson R., Maurice Duke, and Thomas M. Inge, eds. *American Women Writers: Bibliographic Essays.* Westport, Conn.: Greenwood Press, 1983.

Buell, Lawrence. *New England Literary Culture: From Revolution through Renaissance.* New York: Cambridge University Press, 1986.

Cawelti, John G. *Adventure, Mystery, and Romance: Formula Stories as Art and Popular Culture.* Chicago: University of Chicago Press, 1976.

Charvat, William. *The Profession of Authorship in America, 1800–1870,* edited by Matthew J. Bruccoli. New York: Columbia University Press, 1992.

Chase, Richard. *The American Novel and Its Tradition.* Garden City, N.Y.: Doubleday, 1957.

Clark, Gregory, and S. Michael Halloran, eds. *Oratorical Culture in Nineteenth-Century America: Transformations in the Theory and Practice of Rhetoric.* Carbondale & Edwardsville: Southern Illinois University Press, 1993.

Clinton, Catherine. *The Other Civil War: American Women in the Nineteenth Century.* New York: Hill & Wang, 1984.

Clinton. *The Plantation Mistress: Woman's World in the Old South.* New York: Pantheon, 1982.

Clinton. *Tara Revisited: Women, War, and the Plantation Legend*. New York: Abbeville Press, 1995.

Clinton and Nina Silber, eds. *Divided Houses: Gender and the Civil War*. New York: Oxford University Press, 1992.

Cogan, Francis B. *The All-American Girl: The Ideal of Real Womanhood in Mid-Nineteenth-Century America*. Athens: University of Georgia Press, 1989.

Conrad, Susan Phinney. *Perish the Thought: Intellectual Women in Romantic America, 1830–1860*. New York: Oxford University Press, 1976.

Coultrap-McQuin, Susan. *Doing Literary Business: American Women Writers in the Nineteenth Century*. Chapel Hill: University of North Carolina Press, 1990.

Davidson, Cathy N. *Revolution and the Word: the Rise of the Novel in America*. New York: Oxford University Press, 1986.

Dobson, Joanne. *Dickinson and the Strategies of Reticence*. Bloomington: Indiana University Press, 1989.

Douglas, Ann. *The Feminization of American Culture*. New York: Knopf, 1977.

Epstein, William H., ed. *Contesting the Subject: Essays in the Postmodern Theory and Practice of Biography and Biographical Criticism*. West Lafayette, Ind.: Purdue University Press, 1991.

Ezell, Margaret J. M., and Katherine O'Brien O'Keeffe. *Cultural Artifacts and the Production of Meaning: The Page, The Image, and The Body*. Ann Arbor: University of Michigan Press, 1994.

Faderman, Lillian. *Surpassing the Love of Men: Romantic Friendship and Love Between Women from the Renaissance to the Present*. New York: Quill, 1981.

Faust, Drew Gilpin. *Mothers of Invention: Women of the Slaveholding South in the American Civil War*. Chapel Hill: University of North Carolina Press, 1996.

Fiedler, Leslie. *Love and Death in the American Novel*. New York: Criterion, 1960; revised edition, New York: Stein & Day, 1966.

Fisher, Philip. *Hard Facts: Setting and Form in the American Novel*. New York: Oxford University Press, 1985.

Forrest, Mary. *Women of the South Distinguished in Literature*. New York: Derby & Jackson, 1861.

Foster, Edward Halsey. *The Civilized Wilderness: Backgrounds to American Romantic Literature, 1817–1860*. New York: Free Press, 1975.

Foster, Frances Smith. *Written By Herself: Literary Production by African American Women, 1746–1892*. Bloomington: Indiana University Press, 1993.

Friedman, Jean E. *The Enclosed Garden: Women and Community in the Evangelical South, 1830–1900*. Chapel Hill: University of North Carolina Press, 1985.

Gaines, Francis Pendleton. *The Southern Plantation: A Study in the Development and the Accuracy of a Tradition*. New York: Columbia University Press, 1924.

Genovese, Eugene D. *Roll, Jordan, Roll: The World the Slaves Made*. New York: Pantheon, 1974.

Gilbert, Sandra M. *The War of the Words*, volume 1 of her *No Man's Land*. New Haven: Yale University Press, 1987.

Gilbert and Susan Gubar. *The Madwoman in the Attic*. New Haven: Yale University Press, 1979.

Gilmore, Leigh. *Autobiographics: A Feminist Theory of Women's Self-Representation*. Ithaca, N.Y.: Cornell University Press, 1994.

Gilmore, Michael T. *American Romanticism and the Marketplace*. Chicago: University of Chicago Press, 1985.

Goldsmith, Elizabeth C. "Authority, Authenticity, and Publication of Letters by Women." In *Writing the Female Voice: Essays on Epistolary Literature,* edited by Goldsmith. Boston: Northeastern University Press, 1989, pp. 46–59.

Harris, Sharon M. *Redefining the Political Novel: American Women Writers, 1797–1901*. Knoxville: University of Tennessee Press, 1995.

Harris, Susan K. *19th-Century American Women's Novels: Interpretive Strategies*. New York: Cambridge University Press, 1990.

Hart, John. *The Female Prose Writers of America*. Philadelphia: E. H. Butler, 1852.

Hersh, Blanche Glassman. *The Slavery of Sex: Feminist-Abolitionists in America*. Urbana: University of Illinois Press, 1978.

Holliday, Carl. *A History of Southern Literature*. New York: Neale, 1906.

Hubbell, Jay B. *The South in American Literature, 1607–1900*. Durham, N.C.: Duke University Press, 1954.

Jelinek, Estelle C. *The Tradition of Women's Autobiography: From Antiquity to the Present*. Boston: Twayne, 1986.

Kelley, Mary. *Private Woman, Public Stage: Literary Domesticity in Nineteenth-Century America*. New York: Oxford University Press, 1984.

Leypoldt, Augusta H., and George Iles, eds. *List of Books for Girls and Women and Their Clubs*. Boston: Library Bureau, 1895.

Lystra, Karen. *Searching the Heart: Women, Men, and Romantic Love in Nineteenth-Century America*. New York: Oxford University Press, 1989.

Marchalonis, Shirley, ed. *Patrons and Protégées: Gender, Friendship and Writing in Nineteenth-Century America*. New Brunswick, N.J.: Rutgers University Press, 1988.

Martin, Jay. *Harvests of Change: American Literature, 1865–1914*. Englewood Cliffs, N.J.: Prentice-Hall, 1967.

Massey, Mary Elizabeth. *Bonnet Brigades: Women in the Civil War*. Lincoln: University of Nebraska Press, 1966.

Moers, Ellen. *Literary Women*. Garden City, N.Y.: Doubleday, 1976.

Moses, Montrose J. *The Literature of the South*. New York: Crowell, 1910.

Nathan, Rhoda B., ed. *Nineteenth-Century Women Writers of the English-Speaking World*. New York: Greenwood Press, 1986.

Noel, Mary. *Villains Galore: The Heyday of the Popular Story Weekly*. New York: Macmillan, 1954.

Nye, Russell. *The Unembarrassed Muse: The Popular Arts in America*. New York: Dial, 1970.

"Our Women in the War": The Lives They Lived the Deaths They Died. From the Weekly News and Courier. Charleston, S.C.: News and Courier Book Presses, 1885.

Papashvily, Helen Waite. *All the Happy Endings*. New York: Harper, 1956.

Pattee, Fred Lewis. *The Feminine Fifties*. New York: Appleton-Century, 1940.

Pearson, Carol, and Katherine Pope. *The Female Hero in American and British Literature*. New York: Bowker, 1981.

Peterson, Carla L. *"Doers of the Word": African-American Women Speakers and Writers in the North (1830–1880)*. New York: Oxford University Press, 1995.

Rable, George C. *Civil Wars: Women and the Crisis of Southern Nationalism*. Urbana: University of Illinois Press, 1989.

Railton, Stephen. *Authorship and Audience: Literary Performance in the American Renaissance*. Princeton: Princeton University Press, 1991.

Reynolds, David S. *Beneath the American Renaissance: The Subversive Imagination in the Age of Emerson and Melville*. New York: Knopf, 1988.

Reynolds, Moira Davison. *Uncle Tom's Cabin and Mid-Nineteenth Century United States: Pen and Conscience*. Jefferson, N.C.: McFarland, 1985.

St. Armand, Barton Levi. *Emily Dickinson and Her Culture: The Soul's Society*. New York: Cambridge University Press, 1984.

Scott, Ann Firor. *The Southern Lady from Pedestal to Politics, 1830–1930*. Chicago: University of Chicago Press, 1970; expanded edition, Charlottesville: University of Virginia Press, 1995.

Smith-Rosenberg, Carroll. *Disorderly Conduct: Visions of Gender in Victorian America*. New York: Knopf, 1985.

Sterling, Dorothy. *We Are Your Sisters: Black Women in the Nineteenth Century*. New York: Norton, 1984.

Stern, Madeleine B., ed. *Publishers for Mass Entertainment in Nineteenth-Century America*. Boston: G. K. Hall, 1980.

Stern, Milton R. *Contexts for Hawthorne: The Marble Faun and the Politics of Openness and Closure in American Literature*. Urbana: University of Illinois Press, 1991.

Tardy, Mary T. *Southland Writers: Biographical and Critical Sketches of the Living Female Writers of the South*. Philadelphia: Claxton, Remsen & Haffelfinger, 1870.

Tardy, ed. *Living Female Writers of the South*. Philadelphia: Claxton, Remsen & Haffelfinger, 1872.

Wagenknecht, Edward. *Cavalcade of the American Novel: From the Birth of the Nation to the Middle of the Twentieth Century*. New York: Holt, 1952.

Walker, Cheryl. *The Nightingale's Burden: Women Poets and American Culture Before 1900*. Bloomington: Indiana University Press, 1982.

Walker. "Persona Criticism and the Death of the Author." In *Contesting the Subject: Essays in the Postmodern Theory and Practice of Biography and Biographical Criticism,* edited by William H Epstein. West Lafayette, Ind.: Purdue University Press, 1991, pp. 109–121.

Walker, ed. *American Women Poets of the Nineteenth Century: An Anthology*. New Brunswick, N.J.: Rutgers University Press, 1992.

Warren, Joyce, ed., *The (Other) American Traditions: Nineteenth-Century Women Writers.* New Brunswick, N.J.: Rutgers University Press, 1993.

Weibel, Kathryn. *Mirror, Mirror: Images of Women Reflected in Popular Culture.* Garden City, N.Y.: Anchor, 1977.

Welter, Barbara. *Dimity Convictions: The American Woman in the Nineteenth Century.* Athens: Ohio University Press, 1976.

Wilson, R. Jackson. *Figures of Speech: American Writers and the Literary Marketplace, from Benjamin Franklin to Emily Dickinson.* New York: Knopf, 1989.

White, Barbara A. *American Women's Fiction 1790–1870: A Reference Guide.* New York: Garland, 1990.

Yellin, Jean Fagan. *Women and Sisters: The Antislavery Feminists in American Culture.* New Haven: Yale University Press, 1989.

Contributors

Lori Beste . *University of Connecticut*

Miguel A. Cabañas . *College of the Holy Cross*

Robin M. Dasher-Alston . *Philadelphia, Pennsylvania*

Joanne Dobson . *Fordham University*

Christine Doyle . *Central Connecticut State University*

John Gatta . *University of Connecticut*

Susan Goodier . *Cazenovia College*

Julie Elizabeth Hall . *Sam Houston State University*

Amy E. Hudock . *University of California, Berkeley*

Jennifer Hynes . *Beaumont, Texas*

Martin Japtok . *West Virginia State College*

Bradley A. Johnson . *University of Connecticut*

Patricia Larson Kalayjian *California State University, Dominguez Hills*

Paula Kot . *Niagara University*

Janice Milner Lasseter . *Samford University*

Deborah J. Lawrence . *California State University, Fullerton*

Deshae E. Lott . *University of Illinois at Springfield*

Shirley Lumpkin . *Marshall University*

Jennifer Margulis . *Mount Holyoke College*

Barbara McCaskill . *University of Georgia*

Richard V. McLamore . *McMurry University*

Melissa A. Mentzer . *Central Connecticut State University*

Ellen O'Brien . *Roosevelt University*

Laurie Ousley . *State University of New York at Buffalo*

Leslie Petty . *University of Georgia*

Eric Purchase . *Lewiston, New York*

James D. Riemer . *Marshall University*

Katharine Rodier . *Marshall University*

Timothy H. Scherman . *Northeastern Illinois University*

Katharine Capshaw Smith . *Florida International University*

Valerie M. Smith . *University of Connecticut*

Donna S. Sparkman . *Marshall University*

Marcy L. Tanter . *Tarleton State University*

Cumulative Index

Dictionary of Literary Biography, Volumes 1-239
Dictionary of Literary Biography Yearbook, 1980-1999
Dictionary of Literary Biography Documentary Series, Volumes 1-19
Concise Dictionary of American Literary Biography, Volumes 1-7
Concise Dictionary of British Literary Biography, Volumes 1-8
Concise Dictionary of World Literary Biography, Volumes 1-4

Cumulative Index

DLB before number: *Dictionary of Literary Biography,* Volumes 1-238
Y before number: *Dictionary of Literary Biography Yearbook,* 1980-1999
DS before number: *Dictionary of Literary Biography Documentary Series,* Volumes 1-19
CDALB before number: *Concise Dictionary of American Literary Biography,* Volumes 1-7
CDBLB before number: *Concise Dictionary of British Literary Biography,* Volumes 1-8
CDWLB before number: *Concise Dictionary of World Literary Biography,* Volumes 1-4

B

G

Cumulative Index

Martineau, Harriet
 1802-1876.....DLB-21, 55, 159, 163, 166, 190

Martínez, Demetria 1960- DLB-209

Martínez, Eliud 1935- DLB-122

Martínez, Max 1943- DLB-82

Martínez, Rubén 1962- DLB-209

Martone, Michael 1955- DLB-218

Martyn, Edward 1859-1923 DLB-10

Marvell, Andrew
 1621-1678........... DLB-131; CDBLB-2

Marvin X 1944- DLB-38

Marx, Karl 1818-1883 DLB-129

Marzials, Theo 1850-1920 DLB-35

Masefield, John
 1878-1967... DLB-10, 19, 153, 160; CDBLB-5

Mason, A. E. W. 1865-1948 DLB-70

Mason, Bobbie Ann
 1940-DLB-173; Y-87; CDALB-7

Mason, William 1725-1797 DLB-142

Mason Brothers DLB-49

Massey, Gerald 1828-1907 DLB-32

Massey, Linton R. 1900-1974 DLB-187

Massinger, Philip 1583-1640........... DLB-58

Masson, David 1822-1907 DLB-144

Masters, Edgar Lee
 1868-1950 DLB-54; CDALB-3

Mastronardi, Lucio 1930-1979DLB-177

Matevski, Mateja 1929- ... DLB-181; CDWLB-4

Mather, Cotton
 1663-1728....... DLB-24, 30, 140; CDALB-2

Mather, Increase 1639-1723 DLB-24

Mather, Richard 1596-1669 DLB-24

Matheson, Richard 1926- DLB-8, 44

Matheus, John F. 1887- DLB-51

Mathews, Cornelius 1817?-1889....... DLB-3, 64

Mathews, Elkin [publishing house]...... DLB-112

Mathews, John Joseph 1894-1979.......DLB-175

Mathias, Roland 1915- DLB-27

Mathis, June 1892-1927 DLB-44

Mathis, Sharon Bell 1937- DLB-33

Matković, Marijan 1915-1985.......... DLB-181

Matoš, Antun Gustav 1873-1914 DLB-147

Matsumoto Seichō 1909-1992 DLB-182

The Matter of England 1240-1400 DLB-146

The Matter of Rome early twelfth to late
 fifteenth century........... DLB-146

Matthew of Vendôme
 circa 1130-circa 1200 DLB-208

Matthews, Brander
 1852-1929DLB-71, 78; DS-13

Matthews, Jack 1925- DLB-6

Matthews, Victoria Earle 1861-1907..... DLB-221

Matthews, William 1942-1997 DLB-5

Matthiessen, F. O. 1902-1950 DLB-63

Matthiessen, Peter 1927-DLB-6, 173

Maturin, Charles Robert 1780-1824......DLB-178

Maugham, W. Somerset 1874-1965
 DLB-10, 36, 77, 100, 162, 195; CDBLB-6

Maupassant, Guy de 1850-1893....... DLB-123

Mauriac, Claude 1914-1996........... DLB-83

Mauriac, François 1885-1970 DLB-65

Maurice, Frederick Denison
 1805-1872..................... DLB-55

Maurois, André 1885-1967........... DLB-65

Maury, James 1718-1769............. DLB-31

Mavor, Elizabeth 1927- DLB-14

Mavor, Osborne Henry (see Bridie, James)

Maxwell, Gavin 1914-1969 DLB-204

Maxwell, H. [publishing house] DLB-49

Maxwell, John [publishing house]....... DLB-106

Maxwell, William 1908-DLB-218; Y-80

May, Elaine 1932- DLB-44

May, Karl 1842-1912 DLB-129

May, Thomas 1595 or 1596-1650 DLB-58

Mayer, Bernadette 1945- DLB-165

Mayer, Mercer 1943- DLB-61

Mayer, O. B. 1818-1891............... DLB-3

Mayes, Herbert R. 1900-1987........... DLB-137

Mayes, Wendell 1919-1992 DLB-26

Mayfield, Julian 1928-1984........DLB-33; Y-84

Mayhew, Henry 1812-1887 DLB-18, 55, 190

Mayhew, Jonathan 1720-1766........... DLB-31

Mayne, Ethel Colburn 1865-1941 DLB-197

Mayne, Jasper 1604-1672 DLB-126

Mayne, Seymour 1944- DLB-60

Mayor, Flora Macdonald 1872-1932 DLB-36

Mayröcker, Friederike 1924- DLB-85

Mazrui, Ali A. 1933- DLB-125

Mažuranić, Ivan 1814-1890 DLB-147

Mazursky, Paul 1930- DLB-44

McAlmon, Robert
 1896-1956 DLB-4, 45; DS-15

McArthur, Peter 1866-1924 DLB-92

McBride, Robert M., and Company DLB-46

McCabe, Patrick 1955- DLB-194

McCaffrey, Anne 1926- DLB-8

McCarthy, Cormac 1933- DLB-6, 143

McCarthy, Mary 1912-1989........DLB-2; Y-81

McCay, Winsor 1871-1934............. DLB-22

McClane, Albert Jules 1922-1991........DLB-171

McClatchy, C. K. 1858-1936 DLB-25

McClellan, George Marion 1860-1934.... DLB-50

McCloskey, Robert 1914- DLB-22

McClung, Nellie Letitia 1873-1951....... DLB-92

McClure, Joanna 1930- DLB-16

McClure, Michael 1932- DLB-16

McClure, Phillips and Company DLB-46

McClure, S. S. 1857-1949 DLB-91

McClurg, A. C., and Company DLB-49

McCluskey, John A., Jr. 1944- DLB-33

McCollum, Michael A. 1946 Y-87

McConnell, William C. 1917- DLB-88

McCord, David 1897-1997 DLB-61

McCorkle, Jill 1958-DLB-234; Y-87

McCorkle, Samuel Eusebius
 1746-1811.................. DLB-37

McCormick, Anne O'Hare 1880-1954.... DLB-29

Kenneth Dale McCormick Tributes........ Y-97

McCormick, Robert R. 1880-1955 DLB-29

McCourt, Edward 1907-1972 DLB-88

McCoy, Horace 1897-1955............. DLB-9

McCrae, John 1872-1918 DLB-92

McCullagh, Joseph B. 1842-1896........ DLB-23

McCullers, Carson
 1917-1967......DLB-2, 7, 173, 228; CDALB-1

McCulloch, Thomas 1776-1843 DLB-99

McDonald, Forrest 1927-DLB-17

McDonald, Walter 1934-DLB-105, DS-9

"Getting Started: Accepting the Regions
 You Own—or Which Own You," ... DLB-105

McDougall, Colin 1917-1984 DLB-68

McDowell, Katharine Sherwood Bonner
 1849-1883 DLB-202, 239

McDowell, Obolensky DLB-46

McEwan, Ian 1948- DLB-14, 194

McFadden, David 1940- DLB-60

McFall, Frances Elizabeth Clarke
 (see Grand, Sarah)

McFarlane, Leslie 1902-1977 DLB-88

McFee, William 1881-1966........... DLB-153

McGahern, John 1934- DLB-14, 231

McGee, Thomas D'Arcy 1825-1868 DLB-99

McGeehan, W. O. 1879-1933........DLB-25, 171

McGill, Ralph 1898-1969............. DLB-29

McGinley, Phyllis 1905-1978 DLB-11, 48

McGinniss, Joe 1942- DLB-185

McGirt, James E. 1874-1930............ DLB-50

McGlashan and Gill DLB-106

McGough, Roger 1937- DLB-40

McGrath, John 1935- DLB-233

McGrath, Patrick 1950- DLB-231

McGraw-Hill DLB-46

McGuane, Thomas 1939-DLB-2, 212; Y-80

McGuckian, Medbh 1950- DLB-40

McGuffey, William Holmes 1800-1873 ... DLB-42

McHenry, James 1785-1845 DLB-202

McIlvanney, William 1936-DLB-14, 207

McIlwraith, Jean Newton 1859-1938 DLB-92

McIntosh, Maria Jane 1803-1878 DLB-239

McIntyre, James 1827-1906 DLB-99

McIntyre, O. O. 1884-1938 DLB-25

McKay, Claude 1889-1948.....DLB-4, 45, 51, 117

The David McKay Company........... DLB-49

McKean, William V. 1820-1903........ DLB-23

McKenna, Stephen 1888-1967DLB-197

The McKenzie Trust Y-96

McKerrow, R. B. 1872-1940.......... DLB-201

Cumulative Index

S

U

V